THE HAVEMEYERS

TO THE MEMORY OF MY MOTHER
AND TO JOHN REWALD

THE HAVEMEYERS

Impressionism Comes to America

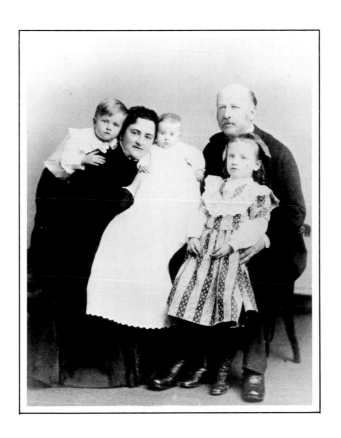

Frances Weitzenhoffer

HARRY N. ABRAMS, INC., PUBLISHERS, NEW YORK

Editor: Patricia Egan
Designer: Judith Henry
Photo Research: Pamela Phillips

Library of Congress Cataloging-in-Publication Data

Weitzenhoffer, Frances.
The Havemeyers : Impressionism comes to America.

Bibliography: p. **726316**
Includes index.
1. Impressionism (Art)—France. 2. Painting,
French. 3. Painting, Modern—19th century—France.
4. Havemeyer, Henry Osborne, 1847–1907—Art collections.
5. Havemeyer, Louisine Waldron Elder—Art collections.
6. Painting—Private collections—New York (N.Y.)
7. Art—Collectors and collecting—United States—
Biography. 8. Metropolitan Museum of Art (New York, N.Y.)
I. Title
ND547.5.I4W43 1986 759.4′075′092′2 [B] 86–7932
ISBN 0–8109–1096–9

ON THE TITLE PAGE:
The Havemeyer family, 1888. Left to right:
Horace, Louisine, Electra, Harry, and
Adaline. Photograph courtesy of J. Watson
Webb, Jr.

Contents

Preface 7
by Charles Durand-Ruel

Foreword 8
by John Rewald

Introduction 11

Acknowledgments 14

Genealogical Chart 16

1 *Louisine Elder and Mary Cassatt Meet in Paris* 19

2 *Louisine Waldron Elder's Marriage to Henry
 Osborne Havemeyer* 29

3 *Paul Durand-Ruel* 36

4 *Early Purchases and New Residences* 44

5 *Harry Havemeyer Meets Mary Cassatt* 53

6 *Harry Havemeyer as Purchaser and Patron* 62

7 *The Havemeyers Move into 1 East 66th Street* 70

8 *Impressionist Progress in America* 82

9 *A Crisis, Followed by Numerous Acquisitions* 96

10 *Development of a Collection; Legal Entanglements* 109

11 *Mary Cassatt in America; Additional Purchases* 123

12 *Expanding Horizons* 138

13 *Patience Rewarded* 152

14 *A Change of Style* 167

15 *Sorrows* 182

16 *Forging Ahead* 199

17 *Triumphs and Disappointments* 215

18 *Passage to Independence* 234

 Appendix 254

 Notes 259

 Selected Sources and Bibliography 271

 Index 279

 Photographic Credits 288

NOTE TO THE READER

Quotations and excerpts marked with an asterisk [*] have been translated from the French by the author, with the assistance of Robin Massee.

Excerpts from Mary Cassatt's letters to the Havemeyers reproduce her original spelling and punctuation.

The word *amateur* has the meaning current in France: private collector.

The voluminous unpublished correspondence between the Durand-Ruels and the Havemeyers and Mary Cassatt constitutes a major source on which this study of the Havemeyer collection is based. Because this material has been so frequently drawn upon here, it was decided not to footnote each letter or cable, but rather to advise the reader that all such documents are contained in the private Durand-Ruel archives in Paris, which comprise as well the records of their New York branch.

Preface

The archives of the Durand-Ruel galleries which cover over a century and a half have always been accessible to serious scholars, and over the years there have been numerous publications whose authors, in the course of their research through our almost unmanageable accumulation of documents, have become our real friends. Among them is John Rewald, who, with his *History of Impressionism,* has "paid back" manifold the help we were able and happy to extend to him. But he has done more: he has sent us his student Frances Weitzenhoffer, whose diligence and dedication, whose courtesy and competence soon won not only my heart but that of my entire family. We all have participated in her discoveries and it was sometimes with genuine pleasure that one of us, coming across some document that related to her work, would put it aside in anticipation of her excitement at seeing it. We have watched her at her task, sometimes tirelessly copying documents too pale to be photocopied, and we have marveled at the intelligence and precision that always lay behind her questions. There never was idle curiosity or guessing; she always knew what she was doing and went straight to her goal.

Of course, what provided me with particularly deep satisfaction was to see this young woman, in tracing the intricate story of the collection of one of our best clients, reserve such prominent roles for my grandfather (Paul), and my father (Joseph) and my uncle (George). Now that our gallery is closed, it is wonderful to know that the creative activities of Paul Durand-Ruel and his two sons will live on in these pages. And since the United States was such a decisive element in my grandfather's struggle for acceptance, it seems a kind of poetic justice that this extensive account of his part in the formation of the Havemeyer collection should be written by an American. The Durand-Ruels have always felt a profound attachment for America; to have been able to contribute our share to the success of Frances Weitzenhoffer's work fills me with great satisfaction and increases the affection and friendship all of us feel for her.

<div align="right">

CHARLES DURAND-RUEL
(1905–1985)

</div>

Foreword

The astonishing appearance of a group of great artists in France, all born more or less within the same decade of the middle of the nineteenth century, did not exactly correspond to a simultaneous manifestation of supporters for their unconventional works. Hence the painful—not to say tragic—gap between these extraordinary innovators and their contemporary public, a gap that resulted in tremendous suffering for the artists who could not find any support because their paintings lacked anecdotal content, slick execution, and "correct" draftsmanship. Whether today's admirers of academic anemia, insipid inspiration, and boringly "perfect" brushwork (and they are numerous once more) will be able to rewrite the history of nineteenth-century art, whether they will be able to insert the names of Bouguereau and Gérome among those of Manet, Monet, and Cézanne, remains to be seen. The fact is that some of the quarrels of a hundred years ago between the pretty and the robust, between genius and unspeakable dullness, are being fought all over again. But at least this time the struggle is not a matter of life and death as it was in the days when the failure of the Impressionists to find a market for their canvases resulted in days without bread and sometimes weeks without paint tubes.

The rare people who bought their works in those days—and it did not even take fortunes to do so since the prices were extremely modest (a square inch by Meissonier cost ten times more than a large painting by Monet!)—these rare people were mostly personal friends, such as their fellow-artist Gustave Caillebotte or Dr. Paul Gachet, the critic Théodore Duret, Georges de Bellio, the opera singer Jean-Baptiste Faure, the merchant Ernest Hoschedé, and—at least as far as Cézanne and Renoir were concerned —Victor Chocquet. It took a great amount of patience and money before their dealer Paul Durand-Ruel, who must also be counted among the personal friends of these painters, succeeded in convincing some trusting clients to buy pictures by the Impressionists. Yet it seems fairly safe to say that their purchases were not made in a spirit of investment since the promise of fabulous increases in value were reserved for the winners of Salon prizes and accumulators of medals. Indeed, fortunes could be and were made with works by Cabanel or Bonheur and even by Millet, provided his paintings were sufficiently sentimental to please that segment of the public which contemplates simpering images through the tears that well up in every sensitive eye.

In America, the situation was, if anything, even worse. The more Mr. William Vanderbilt paid for a dreary European Salon painting, the more his taste and discrimination were acclaimed. Costly daubs by "famous" artists, members of the French Academy of Fine Arts, became obvious status symbols for their owners. Yet, to break with this approach to art not only meant that one had to forfeit any claim to refinement, it also implied that one risked being exposed to ridicule for lack of taste.

In their urge to camouflage the not always highly ethical means through which their immense fortunes had been acquired, the American robber barons transformed themselves into culture heroes and purveyors of art to a sadly deprived nation by importing shiploads of mediocre paintings and cluttering their mansions with genuine or fake antiquities, furniture, bibelots, and pictures. The field of old masters was fraught with dangers; some day a story should be written about how the smartest and richest American nabobs were swindled into acquiring at great cost bogus canvases by any imaginable Italian, Dutch, French, English, or German master. When some of these "collectors" finally learned that expert advice could protect them from being taken in, there began a new era, dominated by Berenson and Duveen, which improved the quality of purchases (but also that of prices), not to mention the prestige of being supplied by such distinguished dealers. In the field of contemporary art, the American magnates were on safer ground, buying yards of boring and insignificant canvases directly from the manufacturers whose "immortality" was usually guaranteed by the French Academy.

Yet, there were a few collectors in America who refused to follow the general taste for tastelessness, who went their own way in establishing their own standards of quality, and who could not be swayed by the fickle fashions of the day. Among these a very special place—if not actually the most important one—was occupied by Louisine and Henry O. Havemeyer, whose collection was unique in many ways (such as mingling old masters with Impressionists), whose civic spirit has seldom been equaled, and whose capacity for neglecting among contemporary painters the acclaimed, bemedaled, and glittering soap bubbles in favor of Manet, Degas, Monet, or Cézanne is almost unrivaled.

It may well have been the Havemeyers' passion for Courbet and Manet which prompted them to be among the first of their countrymen to admire Goya and El Greco, for if there is a link between Goya and Manet (and less obviously between El Greco and Cézanne), this link also exists historically in "reverse," so that the appreciation of Manet or Cézanne can open one's eyes for the genius of Goya or El Greco. Be this as it may, there was at the turn of the century no collection in the United States in which masterpieces by these artists hung literally side by side, not to mention a series of portraits by Rembrandt, a great number of Monets, some of the finest works by Mary Cassatt, and countless drawings, pastels, oils—and later also bronzes—by Degas. Yet, unlike Manet and Goya, Degas and Rembrandt have little in common, so that there is no obvious pattern that presided over the choices of the Havemeyers. In the end, they judged each work on its merits, selecting and rejecting (sometimes unfortunately) what promised to enrich their lives; snobbishness and social considerations never entered into their decisions.

Their incessant preoccupation with their collection—building it up, extending it, and occasionally also eliminating works—was constantly encouraged and guided by their lifelong friend Mary Cassatt. In some instances, particularly where Courbet and

Degas were concerned, the Havemeyer collection reflects Mary Cassatt's own artistic preferences. Yet while gladly and gratefully leaning on her advice, the Havemeyers never acquired anything because Mary Cassatt told them to; they bought only after they had discovered in the work something that promised delectation. And they bought only when *both* agreed on the desirability of a purchase. It is probably true, however, that Louisine's livelier character and possibly deeper commitment to the moderns sometimes succeeded in overcoming her husband's hesitations. And it is doubtless equally true that Louisine, occasionally and diplomatically, agreed to a selection of her husband's when she felt that it meant much to him, for in spite of the fact that, as a true businessman, he would not let himself be carried away by sudden enthusiasms, Henry Havemeyer responded with genuine emotion to the beauty of his paintings. When his widow bequeathed a major part of their collection to the Metropolitan Museum of Art in New York, she insisted that it be known as the H. O. Havemeyer Collection even though she had continued accumulating works of art on her own for some twenty years after her husband's death. In this way, among its many extraordinary aspects, the Havemeyer collection is also a monument to marital harmony.

How all this came about is told in this book. Here is the step-by-step record of the Havemeyer purchases and of the role Mary Cassatt played in them. But here is also much more. The life and the activities of the Havemeyers are described in such a way that their collection can be perceived as what it was: the center of their cultural interests and an integral part of their existence. Thus their children, their friends, the dealers with whom they were in contact, and other things that touched upon their everyday life have been drawn into this study to provide a full-length portrait, so to speak, of this couple who, after all, represent American art lovers at their very best. There were also darker sides to Mr. Havemeyer's business activities—as there were to the activities of most tycoons who in those years amassed fabulous fortunes—and these are part of the general narration, yet no matter what one may think of them, they are overshadowed by the magnificent Havemeyer legacy.

Whether the author retraces the good days or the bad, the joys or the sorrows, the successes or the failures, here is the story of an American collection told within the context of its time. It is based on countless unpublished documents, yet this text actually transcends the subject of this scrupulously minute investigation and offers a new and fascinating chapter of American cultural history. The research through which this was accomplished, thanks to access to previously untapped and partly private archives and to the gracious and generous cooperation of many Havemeyer descendants, is told in the author's Acknowledgments. But what she cannot herself say and what is important to point out, is that she has made excellent use of her patiently assembled documentation and that her superb scholarly achievement is likely to become a model of its kind.

<div align="right">JOHN REWALD</div>

Introduction

Museums have histories of their own, but how little is known of the making of private collections. Guidebooks tell you when the Hermitage was begun, what Napoleon did for the Louvre, how the Spanish king allowed Madrazo to gather paintings from palace and monastery as a nucleus for the great Prado. Yet who knows how those Englishmen, inspired by the cultivated Charles with the art-loving tastes, found the masterpieces that adorn their private galleries! how the Dorias, the Demidoffs, the Liechtensteins and the Wallaces made their collections, or how those Dutch burghers bought and loved their little gems!

Louisine Havemeyer, *Memoirs of a Collector*

When Louisine Waldron Elder Havemeyer, the widow of Henry Osborne Havemeyer, died in her New York residence on January 6, 1929, her will provided that 142 works from her by then internationally famous collection should go to the Metropolitan Museum of Art. But she also asked her heirs, specifically her son Horace, to allow the museum to select further works; by the time the curators had made their choices, the total bequest included 1,972 objects, from Oriental brocades to pictures by Dutch masters, from paintings by El Greco to Islamic tiles, from Japanese prints to bronzes by Degas, from Rembrandt drawings to etchings by Mary Cassatt. According to the will, these treasures did not have to be displayed together but were to be distributed throughout the museum to complete the holdings of the many departments in whose realms they fell. Thus visitors to the Metropolitan Museum hardly ever realize the magnificence of Louisine's gift, among the greatest any museum has ever received.

Even after this bequest, the Havemeyers' vast accumulation allowed their three children to inherit many great works of art and to sell at auction those they did not wish to keep. The total extent of the original Havemeyer collection, therefore, was never really known and to this day no complete record of it has been attempted. Outside of a privately printed, summary catalogue published in a limited edition, no study has been attempted of the collection itself, or of its growth over a span of fifty years, or of its specific character. Until now it has been necessary to rely on Louisine Havemeyer's

sometimes inaccurate account in her *Memoirs of a Collector*. Around 1917, when she wrote these memoirs, Louisine was over sixty years old and was trying to recall events that, in some cases, had occurred more than forty years before. She cannot be faulted for the fact that her dates are usually unreliable, the more so as she was well aware of this. However, Louisine's recollections do provide much background information on the imposing Havemeyer house and on visitors to the collection, as well as interesting anecdotes about a good number of the individual pictures.

The incredible wealth of works the Havemeyers accumulated was assembled in a truly astonishing building that was as unique a creation as the collection itself. The interior of their Fifth Avenue mansion (completed in 1892) had been designed by Samuel Colman and Louis Comfort Tiffany, the latter one of America's most innovative designers. At the time Tiffany and Colman conceived the decor for 1 East 66th Street, the larger part of the Havemeyer collection consisted of seventeenth-century Dutch paintings and the Chinese and Japanese decorative wares that H. O. Havemeyer had bought in bulk.

Although H. O. Havemeyer was among the first Americans to purchase works by Rembrandt and other old masters, the Havemeyers' collection grew to be very different from those of their wealthy contemporaries; from Corot and Courbet on, they acquired a group of then still-contested French painters which did not stop at Manet but extended to Cézanne, all of them represented by outstanding as well as numerous works. Within this modern section, the sober realism of the earlier schools was succeeded by the vivid naturalism that developed in France during the second half of the nineteenth century. While the pictures combined a contemporaneity of subject with a great freedom of execution, they also displayed a unique link between modernity and tradition. Both Louisine and Harry had a predilection for figure pieces: from luscious Courbet nudes to small-scale ballet dancers by Degas, from almost life-size toreadors by Manet to Cassatt's sensitive mothers and children, there is an abundance of the best these artists produced.

The Havemeyer collection owes a great debt to the extraordinary cooperation of Mary Cassatt, and of Paul Durand-Ruel, the Parisian dealer of the Impressionists. Their concerted efforts to secure the most significant works available constitute an extremely important chapter in the history of American collecting. It is also an illustration of the role enlightened patrons can play when assisted by a painter with a keen eye for quality, together with a knowledgeable dealer.

The introduction of Impressionism to America was to be a relatively slow process, though in many ways it was more rapid than in the movement's home country. The driving force behind this progress was Paul Durand-Ruel, to the extent that his American activities on behalf of the Impressionist painters form a vital part of the growing American involvement with these artists. A detailed examination of his role has thus been imperative to provide the general background for the collecting activities of the Havemeyers and some of their contemporaries, such as the Palmers, the Popes, and the Whittemores.

After the death of H. O. Havemeyer in 1907, Louisine developed into a personality in her own right; on many different levels, she was a woman of strength and purpose. Louisine was always bold in her judgments, both in art and in politics, and in the latter

she took an increasingly active role, especially in campaigning for woman's suffrage. A well-nigh perfect example of the American brand of nineteenth-century matron, she was devoted to her family and jealous of her privacy, though public-spirited enough to speak out for a political cause she believed in. Not the least unusual aspect of her nature was revealed by the last codicil to her will, in which her social consciousness was in remarkable combination with her passion for art. Her decision that the unique works of art she and her husband had chosen should be given to the public was a fitting conclusion to a life dedicated to the pursuit of the happiness gained from knowing them so intimately.

While she did not take many people into her confidence, Louisine apparently considered herself to be the custodian of these treasures, knowing that some day many would be turned over to her fellow Americans. The Havemeyers were not collecting for immortality, yet Louisine did feel that by consistently selecting the finest works, she would eventually be helping young painters develop a national art. Louisine Havemeyer's exceptional sensibility plus her farsighted generosity did indeed enable her to make a significant contribution to her country's cultural heritage.

FRANCES WEITZENHOFFER

Acknowledgments

My debt of gratitude to John Rewald can never be properly acknowledged. It was he who originally suggested this topic, and his interest in the progress of my work has never waned. Because of his lifelong cordial relations with such people as Charles Durand-Ruel and Daniel Wildenstein, I was allowed the privilege of using the archives of the Galerie Durand-Ruel and those of the Wildenstein Foundation. In addition to granting permission for access to the invaluable resources of his Paris gallery, Charles Durand-Ruel (died 1985) showed enthusiasm for my research and gave me much encouragement; I was always warmly welcomed and aided by his daughter Caroline Godfroy and his assistant France Daguet.

Of equal importance has been the gracious cooperation and hospitality of the Havemeyer descendants. I wish to convey my sincere appreciation to:

George G. Frelinghuysen, who has lent his support to this project from the very beginning and kindly permitted me to quote from his unpublished memoirs; his brother Peter H. B. Frelinghuysen, for supplying missing information for the Havemeyer-Elder genealogy;

Mrs. Laurance B. Rand and Mr. and Mrs. Horace Havemeyer, Jr., for getting up early in the morning on several occasions to share their recollections with me; Harry W. Havemeyer, for his informative letters;

J. Watson Webb, Jr., whose special enthusiasm and generosity have been boundless. His wealth of information concerning his grandparents has enabled me to come to know them in a way that was previously impossible. Watson has genially tolerated my many frantic telephone calls with yet "one more" question concerning Louisine, as well as my relentless letters filled with queries. He has always provided the correct answers; and in addition has supplied me with a staggering wealth of photographic documents. His untiring helpfulness has made him a major contributor to this book. The spirit of his courtesy was transmitted to Gisèle B. Folsom and Bob Shaw, staff members of the Shelburne Museum, Shelburne, Vermont;

Electra McDowell, William E. Havemeyer, Peter Frelinghuysen, Daniel Catlin, Jr., Linden Havemeyer Wise, and Ann Havemeyer, for their respective parts in the formidable task of assembling the story of their great-grandparents.

Acknowledgments

I am much indebted to the staff of Harry N. Abrams for the production of this book, from Fritz Landshoff's "discovery" of the manuscript to Paul Gottlieb's steady encouragement, together with that of Margaret Kaplan, Leta Bostelman, and Margaret Rennolds; from Pamela Phillips's resourceful pursuit of illustrative material to Patricia Egan's special ingenuity in handling the many complexities the project has raised, and from Elizabeth Robbins's vivid interest in the book to Judith Henry's design for it.

This project has also been assisted by countless friends and colleagues, some of whom I would especially like to thank. Heading the list are: Dr. Harold M. Proshansky, president, The Graduate School and University Center of the City University of New York, who has been an unfailing supporter on many levels; Nancy Little, librarian of M. Knoedler and Co., whose cooperation has been exceptional, and Robert Kaufmann, who demonstrated great expertise in compiling my selected sources and bibliography. Among others I wish to mention: Fred Brown, Dr. Kevin Cahill, Elizabeth Cornell Cochran, Deanna Cross, Philippe Dordai, Mary Lee Duff, Eric Pollitzer, Joseph Rishel, Charles Stuckey, Gary Tinterow, Jayne Warman, and Frances Wolff; Warren Adelson and Donna Seldin of the Coe Kerr Gallery; Christopher Burge, Michael Findlay, Eddi Wolk, and Paul Doros of Christie's, New York, and Susan Seidel, formerly of Christie's; and Anne van der Jagt of the Fondation Custodia, Institut Néerlandais, Paris.

And last, I profoundly appreciate the patience and support of my father and, most of all, of my husband, Max, who has cheerfully endured a steadily declining standard of cooking.

THE HAVEMEYERS

Frederick Christian
Havemeyer, Jr.
(1807–1891)

m. Sarah Louise
Henderson
(1812–1851)

(1) Frederick C.
Havemeyer, III
(1832–1910)

(3) Charles B.
Havemeyer
(1836–1836)

(4) George W.
Havemeyer
(1837–1861)

(6) Catharine B.
Havemeyer
(1843–1926)

(7) Thomas J.
Havemeyer
(1845–1899)

(10) Warren H.
Havemeyer
(1849–1851)
[twin; see (9)]

(2) Mary O.
Havemeyer
(1834–1865)

m. J. Lawrence
Elder
(see *The Elders*)

(5) Theodore
Augustus
Havemeyer
(1839–1897)

m. Emilie
de Loosey
(1840–1914)

(8) HENRY
OSBORNE
HAVEMEYER
(1847–1907)

m. 1 (1870)
Mary Louise
Elder
[divorced;
no issue]
(see *The Elders*)

m. 2 (1883)
LOUISINE
WALDRON
ELDER
(see *The
Elders*)

(9) Sarah L.
Havemeyer
(1849–1933)
[twin; see (10)]

m. Frederick
Wendell
Jackson
(1845–1908)

Charles
Havemeyer
Jackson
(1883–1971)

Louise (Lulu)
Havemeyer
Jackson
(1887–1945)

Adaline Havemeyer
(1884–1963)

m. Peter Hood Ballantine
Frelinghuysen
(1882–1959)

Horace Havemeyer
(1886–1956)

m. Doris Anna Dick
(1890–1982)

Frederica
Louisine
Frelinghuysen
[Emert],
b. 1909

Henry O.
Havemeyer
Frelinghuysen,
b. 1916 [twin]

George
Griswold
Frelinghuysen,
b. 1911

Peter H. B.
Frelinghuysen, Jr.,
b. 1916 [twin]

Doris
Havemeyer
[Catlin]
(1912–1975)

Horace
Havemeyer, Jr.,
b. 1914

Adaline
Havemeyer
[Perkins;
Rand],
b. 1913

Harry
Waldron
Havemeyer,
b. 1929

THE ELDERS

George William
Elder
(1800–1885)
m. Hannah
Riker
(1808–1884)

George William
Elder
(1831–1873)
m. Mathilda Adelaide
Waldron
(1834–1907)

J. Lawrence
Elder
(1832–1868)
m. Mary O.
Havemeyer
(see *The
Havemeyers*)

Mary
Louise
Elder
(1847–1897)
m. HENRY OSBORNE
HAVEMEYER
[divorced; no issue]
(see *The Havemeyers*)

Anne Elder
(1853–1917)
m. Henry Norcross
Munn
(?–1906)

LOUISINE
WALDRON
ELDER
(1855–1929)
m. HENRY
OSBORNE
HAVEMEYER
(see *The
Havemeyers*)

Adaline Mapes
Elder
(1857–1943)
m. Samuel Twyfford
Peters
(1854–1921)

George Waldron
Elder
(1860–1916)
m. Therese Cadwell

Harry T. Peters
(1882–1948)

Louisine Peters
[Weekes; Tcherepnine]
(c. 1884–1960s)

Electra Havemeyer
(1888–1960)
m. James Watson Webb
(1884–1960)

Electra
Webb
[Bostwick]
(1910–1982)

Samuel
Blatchley
Webb,
b. 1912

Lila
Vanderbilt
Webb
[Wilmerding]
(1913–1961)

James
Watson
Webb, Jr.,
b. 1916

Harry
Havemeyer
Webb
(1922–1975)

Louisine Elder and Mary Cassatt Meet in Paris

When Louisine Waldron Elder married Henry Osborne Havemeyer in 1883, she was not a newcomer to the world of art. In her early teens she had often traveled abroad with her family, visiting numerous European galleries, museums, and historical sites. She especially loved excursions that appealed to her romantic nature, when there were hardships to be endured in arriving at a particular destination. Louisine never lost her enthusiasm for travel; later one of her greatest pleasures was the adventurous quest for art works in foreign countries, and the more unorthodox the methods, the more she relished the search.

Louisine Elder was born in New York on July 28, 1855. Her father, George William Elder, was a "merchant"; in 1868 with two partners he formed George W. Elder and Co. Mr. Elder may also have had some holdings in sugar, since his brother Lawrence was the "Elder" in the firm of Havemeyers and Elder, sugar refiners. George W. Elder had married Mathilda Adelaide Waldron, whose family had arrived in New Amsterdam in 1650. The Elders lived at 127 West 21st Street, an attractive residential section of Manhattan. Louisine, the second of four children, had two sisters, Annie (the oldest) and Adaline, and a younger brother, George Waldron. Misfortune struck the family in March 1873 when George W. Elder died at the age of forty-two. He left his family well provided for, having owned some real estate in addition to his business interests. Early in 1874 Mrs. Elder left on a trip to Europe with her three daughters.

Their ultimate destination was Paris. Louisine and her younger sister Adaline were installed at 88, boulevard de Courcelles (facing the Parc Monceau) with the Del Sartre family, who rented rooms to young Americans interested in perfecting their French. Since the Del Sartres did not have enough space for them all, Annie Elder stayed with her mother on the nearby avenue de Friedland. The arrival of the two girls at the

pensionnat was noted by a fellow boarder, Emily Sartain, a Philadelphian studying in the *atelier* of a successful Salon painter; Emily wrote home to her father (an engraver of fine art reproductions) on March 8, 1874: "Madame Del Sartre has an accession to her family, in the person of the two Miss Elders, cousins of Sophie [Sophie Mapes Tolles, a friend and fellow art student of Emily's]. They are very nice and very pretty young girls [Emily Sartain was then thirty-three, whereas Louisine was almost nineteen, and Adaline was seventeen]. They have a handsome carriage with a pair of horses and a servant in livery, pay 750 francs a month for it. It is very nice for me as well as for them. I occasionally get a ride. Last night six of us came home in it from the theatre."[1] In the same letter Sartain again referred to Louisine: "Last Saturday I went to a Musical Soirée at Madame Leonard's, and heard some very distinguished musicians play. . . . Louisine Elder learns singing from Madame Leonard, so she was there with Sophie as chaperone." In subsequent letters to her father, Emily mentioned attending theaters, operas, and other events with the Elders, as well as accompanying them on various sightseeing excursions: "This afternoon I am going out to St. Denis with Annie Elder, and tomorrow all the Elders, Sophie, and I are going out to Fontainebleau for the day."[2] Emily particularly appreciated the Elders' generosity in sharing their carriage, a great luxury for an art student on a stringent budget.

Three years before, in the winter of 1871–72, Emily Sartain had gone to Parma, Italy, and worked with another woman painter from Philadelphia, Mary Cassatt, who had already spent several years in France. By April 1872 Sartain had decided to continue her studies in Paris, while Cassatt had remained in Parma and then made her way to Madrid and on to Seville. There she had worked diligently for six months in a studio located in a ducal palace. She next had gone to Holland and Belgium and settled in Antwerp for the summer of 1873; in the fall she had traveled south to Rome, where she had stayed for about seven months. Finally, by the late spring of 1874, Cassatt was ready to establish herself permanently in Paris and pursue her artistic career.

Mary Cassatt arrived in Paris in June 1874 to look for a studio. It seems that she went to the Del Sartres' to call upon her friend Emily Sartain, who in turn introduced her to Louisine Elder. Having studied painting in Europe for the past two and a half years, the thirty-year-old Mary Cassatt was still under the spell of the works by the great masters she had recently seen. Her infectious talk of Correggio, Parmigianino, Velazquez, Goya, Rubens, and Hals impressed the sensitive Louisine. Mary Cassatt's enthusiasm for painting and her involvement with her own work provoked an immediate response from Louisine, who had found a real-life heroine for her active romantic imagination: "I wondered how she had the courage to go to Spain in the days of the Carlista wars, or to Italy before the bandits were controlled, but she was resourceful, self-reliant, true, and brave and no one had a better or a more truly generous heart."[3]

Mary Cassatt must have been flattered by the effect she had on the young girl, and she enjoyed introducing Louisine to the Paris she knew and loved: "When we first met in Paris," Louisine later wrote, "she was very kind to me, showing me the splendid things in the great city, making them still more splendid by opening my eyes to see their beauty through her own knowledge and appreciation. I felt that Miss Cassatt was the most intelligent woman I had ever met and I cherished every word she uttered, and remembered almost every remark she made. It seemed to me, no one could see art more

understandingly, feel it more deeply, or express themselves more clearly than she did. She opened her heart to me about art while she showed me the great city of Paris."[4]

Not long afterward, Cassatt retreated for the summer to a studio in the countryside, and Sartain went traveling, as did the Elders. By October Emily Sartain had found new and considerably cheaper living quarters (she would stay in Paris one more year), and she glumly informed her father on October 13 that the Elders had sailed for America: "I had a letter from my friends the Elders from Queenstown. They were quite happy about not having been ill on the Channel. I do miss them so much, they were so kind to me in every possible way."[5] Cassatt meanwhile had rented a studio at 19, rue de Laval, which would be her residence for the next three years.

In April 1875 Emily Sartain relayed the following news to her father: "My friends the Elders are coming over [to France] the 30th of June. . . . They are so kind hearted, and not a bit stuck up! But they are coming on the Russia, a very expensive vessel, and difficult to get rooms on."[6] When the Elders arrived in the summer, Cassatt was in Philadelphia visiting her family, but since Louisine stayed on at the Del Sartres' until the end of October, she had ample time to renew her friendship with Mary Cassatt when the latter returned.

Cassatt was then discovering for herself the budding avant-garde movement of Impressionism. Many years later she wrote to Louisine: "How well I remember nearly forty years ago seeing for the first time Degas' pastels in the window of a picture dealer, in the Boulevard Haussmann, I would go there and flatten my nose against that window and absorb all I could of his art. It changed my life. I saw art then as I wanted to see it."[7] Cassatt's enthusiasm for Degas's work knew no bounds. Before meeting the artist herself, she had already become his disciple, and remained so all her life. Her commitment to Degas was the most important and enduring element of her artistic career.

It was only natural that Cassatt should make a convert of Louisine. To share her excitement with her young friend, Cassatt took her to a colorshop (probably *père* Julien Tanguy's on the rue Clauzel), where she could see one of Degas's pastels; she now urged Louisine to buy Degas's *Ballet Rehearsal* (*Répétition de ballet*; Plate 1). Louisine thought that she had developed a rather advanced taste in art under Mary Cassatt's tutelage, but she found this curious pastel (actually pastel and gouache over monotype), with its asymmetrical composition and abruptly chopped-off figures, difficult to comprehend. Her reaction to the picture is best described in her own words: "It was so new and strange to me! I scarcely knew how to appreciate it, or whether I liked it or not, for I believed it takes special brain cells to understand Degas. There was nothing the matter with Miss Cassatt's brain cells, however, and she left me in no doubt as to the desirability of the purchase and I bought it upon her advice."[8] Thus in 1875 Louisine Elder became Degas's first American patron; the pastel had cost 500 francs, then worth about $100.

At the age of twenty, Louisine acquired a taste for collecting that was to remain a lifelong pursuit. Without suspecting that it would grow to such proportions, Mary Cassatt had planted the seed, though before Louisine's marriage her purchases were limited by her small budget. To buy Degas's pastel, she had to ask her two sisters to loan her their monthly allowances which, added to her own, provided the necessary sum. Yet during 1875 Louisine managed to obtain another work by an Impressionist; Monet's *The Drawbridge, Amsterdam* (Plate 2), bought for 300 francs, would be the first painting

by the artist to find a home in America. Subsequently she acquired Pissarro's fan painting *Peasant Girls at Normandy,* apparently purchased from Mary Cassatt, as well as a small gouache by Cassatt, a self-portrait of 1878 (Plate 3).

Louisine was not the sole recipient of Mary Cassatt's cordiality. Another devoted friend and admirer of the artist was the aspiring New England painter May Alcott (younger sister of Louisa May Alcott), who was pursuing her studies in Paris and London. In a letter to her family Alcott described a visit to Cassatt's studio early in November 1876: "Statues and articles of *vertue* filled the corners, the whole being lighted by a great antique hanging lamp. We sipped our chocalat [sic] from superior china, served on an India waiter, upon an embroidered cloth of heavy material. Miss Cassatt was charming as usual in two shades of brown satin and rep, being very lively and a woman of real genius, she will be a first-class light as soon as her pictures get a little circulated and known, for they are handled in a masterly way, with a touch of strength one seldom finds coming from a woman's fingers. . . ."[9]

It seems that Mary Cassatt and Degas actually met in 1877; he had noticed her work at the Salon of 1874 and finally went to see her. Degas invited her to join him and the Impressionists; this she did eagerly, first exhibiting with the Fourth Impressionist show of 1879. She was the only American ever to show with the group. From that time on, Cassatt was not just an admirer of these artists, she became their greatest exponent. With her share of the proceeds from the 1879 exhibition,[10] she bought a painting by Monet and one by Degas.

Yet Cassatt's taste was not limited to the unorthodox band of Impressionists; another of her equally strong enthusiasms was for the work of Gustave Courbet. Louisine Elder had already heard of Courbet before she became aware of Degas, Monet, or Pissarro, for she described in her *Memoirs* how Mary Cassatt, on their very first meeting at Madame del Sartre's, was unable to stay for tea because she was rushing off to Courbet's studio to see a newly completed canvas.[11] "She spoke of him as a painter of such great ability that I at once conceived a curiosity to see some of his pictures."[12] But Louisine did not see any of the artist's work until six years later, when she was in Paris in 1881 and a Courbet exhibition was held in the foyer of the Théâtre de la Gaîté. In her *Memoirs* the event is recorded: "As usual, I owe it to Miss Cassatt that I was able to see the Courbets. She took me there, explained Courbet to me, spoke of the great painter in her flowing generous way, called my attention to his marvelous execution, to his color, above all to his realism, to that poignant, palpitating medium of truth through which he sought expression. I listened to her with such attention as we stood before his pictures and I never forgot it."[13] Cassatt also told Louisine that some day she must own one of his half-length nudes. Courbet was one of the artists for whom Mary Cassatt and Louisine Elder shared a lasting passion.

As Louisine matured, her confidence in her own judgment increased. Once during their annual visit abroad, when she was spending "the season" in London with her mother, she had the temerity to pay a call on Whistler. Louisine's account of this meeting was recorded in her *Memoirs* at least thirty-five years later, and understandably she confused some dates and facts. She thought she had called on Whistler in 1876, the year after she bought her Degas and Monet; it is more likely that her trip to London took place in 1881. In any case, having seen and admired Whistler's *Portrait of Miss*

Alexander, Louisine decided that she must have an example of the artist's work. Being a young woman of initiative, she did not want to leave London without meeting the master himself, and she and her mother went to Whistler's Tite Street studio. Far from intimidated by the eccentric and unpredictable artist, Louisine promptly told him that she had but thirty pounds to spend and asked what she might buy for that sum; she was clever enough to add that her friend Mary Cassatt had already persuaded her to purchase with her pocket money a Degas, a Monet, and a Pissarro. Whistler selected for her five of his Venice pastels on brown paper (Plate 4), carefully putting a title on the back of each and adorning them with his butterfly signature.[14] Louisine's resourcefulness had bought her the best bargain in London, for six pounds per pastel was a very low price even then (she did not know that the artist—as usual—was hard up).

Whistler delivered the framed pastels to Louisine's hotel and stayed for several hours, touching "upon every subject of interest in London at the time, artistic, theatrical, and literary. . . ."[15] Afterward he sent her a copy of his pamphlet *Art & Art Critics* on his controversy with Ruskin, inscribed to "Miss Louisine Elder, with strong faith in her charming championship"; he included the following letter:

> Don't forget to write a line that I may know that you all found yourselves [Louisine, her mother, and a friend of her mother's] comfortably on a noble ship —also that the enclosed inflamatory work reached you safely—and also that you *each* bought a copy of Oscar Wilde's poems—without which you cannot leave this land! You have still time in Liverpool if not already accomplished—"Why certainly"!

> With kindest regards and best wishes to all—and great hopes that you will come back for the season.

> <div align="right">Very sincerely yours
J. McNeill Whistler</div>

> Bon voyage!

> <div align="right">Tite St. Chelsea London
Sept. 21[16]</div>

Louisine was proud of her progressive taste in art and was eager to share her acquisitions with others. She may even have been curious to see how some of her countrymen would react when exposed to the new trends she had discovered in Europe. Already in February 1878, Louisine had lent her Degas pastel *Ballet Rehearsal* to the Eleventh Annual Exhibition of the American Water-color Society, held at the National Academy of Design in New York, listing this work as belonging to G. W. Elder (the initials of both Louisine's deceased father and her younger brother George). It was shown in the West Room together with *Reverie* by one Edward Tofano (of whom nothing is now known), also lent by G. W. Elder. Degas's ballet scene—the very first work of the French moderns to be exhibited in America—came close to being overlooked by the critics. Clarence Cook of the *New York Tribune* reviewed the show no fewer than three times and never mentioned Degas, though he wrote several appreciative

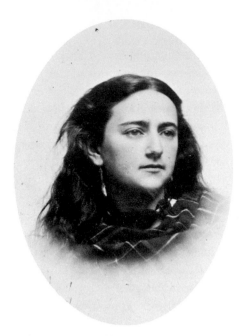

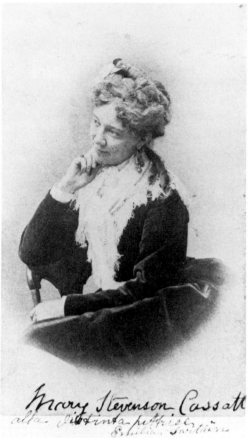

*Above: Louisine Elder, age 13 (?), New York,
c. 1868. Photograph courtesy of
Mrs. Laurance B. Rand*

*Right: Mary Cassatt, age 28, Parma, Italy, c. 1872.
Signed by Cassatt to her friend and fellow
art student Emily Sartain, who would introduce
Cassatt to Louisine Elder in 1874.
Photograph courtesy of the Pennsylvania Academy
of the Fine Arts, Philadelphia*

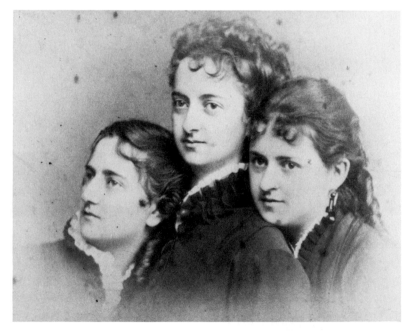

*The Elder sisters: Louisine (left), age 17; Annie (center), age 19; Adaline
(right), age 15. New York, c. 1872. Photograph courtesy of J. Watson Webb, Jr.*

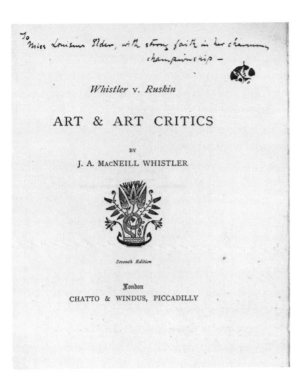

Cover of Art & Art Critics *by J. A.
MacNeill [sic] Whistler, inscribed to Louisine
Elder by the author, 1881. Photograph
courtesy of the Shelburne Museum,
Shelburne, Vt.*

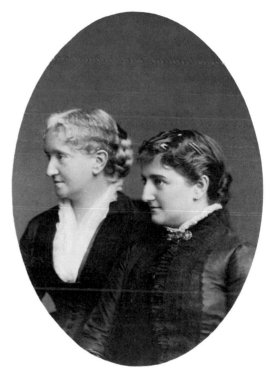

*Above: Louisine and her mother, Mrs. George W.
Elder. Cassel, Germany, 1881, on one of their
annual trips abroad. Photograph courtesy
of J. Watson Webb, Jr.*

Left: Jean-Jacques Henner. Portrait of
Louisine Elder, *age 22, Paris, 1877. Oil on
canvas. Private Collection. Louisine loved this
painting and in later years presented
photographs of it, of which this is one, to
her grandchildren. Photograph courtesy
of Horace Havemeyer, Jr.*

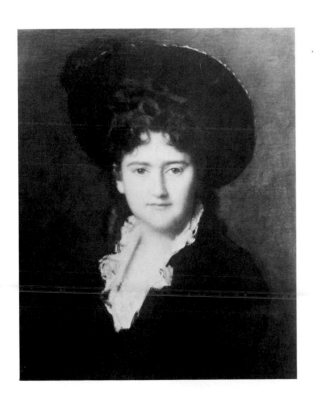

lines on Tofano's *Reverie*. The unnamed reviewer for *Scribner's Monthly*, however, was amazingly receptive: "Among the pictures from abroad, *A Ballet*, by Degas, gave us an opportunity of seeing the work of one of the strongest members of the French 'Impressionist' school, so called; though light, and in parts vague, in touch this is the assured work of a man who can, if he wishes, draw with the sharpness and firmness of Holbein."[17] In 1880 a work entitled *A Study* by Mary Cassatt was lent in the name of Louisine's mother, Mrs. M. A. W. Elder, to the Thirteenth Annual Exhibition of the same American Water-color Society. This was in all likelihood Louisine's self-portrait by Cassatt.

Louisine recalled in her *Memoirs* that she lent her Degas pastel again in the early 1880s, this time to the spring exhibition at the National Academy of Design. The academy's catalogues for that period do not list any work by Degas, and it was not mentioned in reviews; *Ballet Rehearsal* doubtless provoked a reaction similar to that aroused in London by a ballet subject exhibited by an English painter in 1886, when the *Daily Chronicle* commented on the inappropriateness of such a theme: "There is a large full-length picture of a ballet girl in the principal gallery called 'terpsichord' . . . that we are sorry to see there. The art of painting is intended for something better than representations of ballet-girls, and whilst there may be grace in posture in a dance, we decline to think that time and skilled labour are well spent in such designs as the one we are referring to."[18]

Certainly the hanging committee at the National Academy did not share Louisine's admiration for her Degas. When she and her sister visited the exhibition she was horrified: "We finally found our pastel skied upon the wall of a small room and alack! and alas! the delicate gray and green frame had been generously treated to a thick coating of brilliant gold bronze. We entered a protest at once, and learned that 'the rules of the Academy exacted that all pictures exhibited should be provided with gold frames'; ergo the jury—there must have been one Dogberry at least among them—would not admit an Edgar Degas to an exhibition unless he submitted to their 'golden' rule! Of course we were then only in the nineteenth century. . . ."[19] Since Degas had framed her pastel himself, Louisine took pains to have the frame restored to its original condition after the exhibition.

Mary Cassatt did not stop with Louisine Elder in proselytizing for her fellow Impressionists; her older brother Alexander Cassatt was also subject to her promptings. His capacity for art appreciation was much less developed than the young Louisine's, although his financial means were infinitely greater (he was then first vice president of the Pennsylvania Railroad). He had no real interest in Impressionist pictures, and not even his sister's compelling enthusiasm could inspire him to become a genuine collector. Yet the determined Mary Cassatt provided Alexander with some very good paintings in spite of his initial reluctance, and eventually she led him to buy pictures on his own. The earliest account of her efforts to introduce him to the work of the Impressionists is found in her letter to him in November 1880; she deliberately began with racing pictures by Degas, since horses were a passionate interest of his: "Did you get the photographs I sent you? I only sent them to give you an idea of Degas style, I don't

like to buy anything for you, without your having some idea of what it would be like. The pictures from which the photographs were taken have all been sold, & Degas has but one racing picture [of a horse and fallen jockey] finished & that is the large one; I was just thinking of buying you a smaller picture of ladies and children on horseback when a dealer picked it up & I don't see anything else in horse subjects that I can get for you just at present. I feel it almost too much of a responsibility, am afraid you won't like my selection; & Mother does not give me much encouragement as 'au fond' I think she believes picture buying to be great extravagance."[20]

So Mary Cassatt had to cope not only with Alexander's hesitant attitude, but with her mother's as well. In the fall of 1877 Mary's parents and sister Lydia had left Philadelphia to settle permanently in Paris; from then on Mary Cassatt lived with her family in their comfortable apartment. Writing to Alexander on December 10, 1880, Mrs. Cassatt did not conceal her reservations concerning her daughter's collecting activities: "I don't know whether Mary has written to you or not on the subject of pictures. I didn't encourage her much as to buying the large one [6′ × 5′] being afraid that it would be too big for anything but a gallery or a room with a great many pictures in it—but as it is unfinished or rather as a part of it has been washed out & Degas imagines he cannot retouch it without painting the whole over again & he can't make up his mind to do that I doubt if he ever sells it. . . ."[21]

Mary Cassatt was meeting with difficulties on all sides, but Alexander, at least, respected his sister's judgment enough to authorize her to be on the lookout on his behalf. She obtained for him first a Degas (of dancers, not horses), then a Pissarro and a Monet. Mary's father, unlike his wife, who worried that her son would find these works eccentric, was quite enthusiastic about his daughter's purchases, which appealed to his business sense. In a letter of April 18, 1881, he tried to convince Alexander that he was making a sound investment: "Well you must know that in addition to the Pissarro, of which she wrote you she has bought for you a Marine by Monet for 800 francs—It is a beauty and you will see the day when you will have an offer of 8000 for it. . . ."[22] He mentions again the large racing painting by Degas that Mary was trying to acquire for her brother: "Degas still keeps promising to finish the picture you are to have & although it does not require more than two hours work it is still postponed —However he said today that want of money would compel him to finish it at once —You know he would not sell it to Mame [Mary Cassatt's family nickname], & she buys it from the dealer who lets her have it as a favor and at a less price than he would let it go to anyone but an artist. . . ." It is amazing to observe Degas's irrational behavior even toward such a close friend; Mary never did secure the painting of a horse and fallen jockey. Mr. Cassatt, more than the other members of the family, was aware of the significance of the purchases Mary made for her brother, and concluded his letter of April 18 with the statement: "When you get these pictures you will probably be the only person in Philadelphia who owns specimens of either of the masters. Mame's friends the Elders have a Degas & a Pissarro & Mame thinks there are no others in America. If exhibited at any of your Fine Art Shows they will be sure to attract attention." Mary's zeal for buying works by the Impressionists was second only to her commitment to her own painting; the two passions were closely associated.

In Mary Cassatt's life there were notable contradictions. As a painter she was allied with the most avant-garde group of professional artists of the time: becoming dissatisfied early in her career with the reactionary Salon painters, she had enthusiastically joined the Impressionists, once Degas invited her, and for the rest of her life she shunned "establishment" associations of artists. Yet she lived in the bosom of her family in Paris, exactly like any well-bred Philadelphia lady; the Cassatt household was the essence of respectability wherever it was located. Louisine Elder often visited the Cassatts in Paris; she was greatly impressed with Mary's concern for her home and family, which followed the Victorian code, as Louisine later observed: "Her life ever after the Cassatts' arrival was an example of devotion to duty! She held duty high before her as a pilgrim would his cross. No sacrifice was too great for her to make for her family—or for her friends."[23]

It was precisely this dual aspect of Mary Cassatt's personality that appealed so strongly to the young Miss Elder. Louisine was attracted by her friend's example, which showed one could have originality of taste and opinion within the sphere of respectability; this corresponded to Louisine's own ideal and she herself developed exactly along these lines. Mary Cassatt was not simply her art mentor but her model in a personal sense as well. Both women were of impeccable background and lived and dressed accordingly. Louisine took pride in the ladylike appearance of her artist-friend: "Miss Cassatt's tall figure which she inherited from her father, had distinction and elegance and there was no trace of artistic negligence or carelessness which some painters affect. Once having seen her, you could never forget her from her remarkable small foot, to the plumed hat with the inevitable tip upon her head and the Brussel lace veil, without which she was never seen."[24] If either had been in the least bohemian, she would have horrified the other. In spite of Louisine's enthusiasm for new trends in French art, she went in 1877 with her mother to have their portraits painted by the fashionable Salon artist Jean-Jacques Henner, who reputedly received $1,000 "for a simple head." Portraits by a famous artist were considered a "must" among young women of Louisine's social milieu. Both Elders were delighted with the results; strangely enough neither had commissioned a portrait by Cassatt.

Although Louisine Elder profoundly admired Mary Cassatt and they had much in common, Louisine was very different in her appearance and nature. In contrast to the tall, slender artist, Louisine was small and full-bodied and certainly the more sensual of the two. She was a woman of great warmth who was self-assured and modest at the same time; her intelligence was reflected in her alert blue-gray eyes. Louisine's voice was usually soft and affectionate, tinged on occasion with a determined tone. Her cheerful personality was neither deeply introspective nor analytical in its reactions. She had a mind of her own but was far less stubborn in her views than her friend was. All these characteristics enabled Louisine to get along with the temperamental, outspoken, and opinionated Mary Cassatt; they would also help her charm the imposing Henry Osborne Havemeyer.

Louisine Waldron Elder's Marriage to Henry Osborne Havemeyer

O
n Wednesday, August 22, 1883, Louisine Waldron Elder, age twenty-eight, married Henry Osborne Havemeyer, age thirty-five (born in Manhattan on October 18, 1847, and always known as Harry). The ceremony was performed by the Reverend B. M. Yarrington in Greenwich, Connecticut. It seems that Louisine had known her husband from early childhood: Harry's mother had died when he was four years old,[1] and he was first raised by his eldest sister, Mary, who in 1858 married Lawrence Elder, Louisine's uncle; Louisine's parents, George and Mathilda Elder, took care of him after he was fifteen. Thus Louisine and Harry grew up in the same household over several years, though he was often away at boarding school in Stamford, Connecticut. In March of 1870, Harry, then twenty-two years old, married Mary Louise Elder, Louisine's aunt; they had no children and their eventual divorce was doubtless precipitated by Harry's drinking problem.[2]

Harry thereupon went to live with Louisine's younger sister Adaline and her husband, Samuel Peters, a successful coal dealer. Louisine consented to marry Harry on the condition that he never touch another drop, a promise he lived up to for the rest of his life. Divorce not being customary at that time, divorced women were not accepted in fashionable society. The first Mrs. H. O. Havemeyer settled in Stamford, Connecticut, where she was avoided by prominent members of the community. For this reason Louisine and Harry had an informal country wedding; the bride wore a pink gingham dress. To avoid confusion with her divorced aunt, who had taken the name Louise E.

Havemeyer, Louisine (named for her mother's sister who had died young) always signed herself Louisine W. (Waldron) Havemeyer.

At thirty-five, Harry Havemeyer "was already moon-faced, with steely, pale, blue eyes, a firm moustached mouth, and a bulky imposing figure that seemed built to fit a dignified frock coat."[3] Harry's father, Frederick Christian Havemeyer, Jr., himself a product of the apprentice system, saw to it that there was no detail of the sugar refining business that his sons did not learn.[4] Once Harry had received the equivalent of a high school education, his father insisted that he put on overalls and experience every part of the family business, Havemeyers and Elder. Although Harry had been a difficult and uninspired pupil at the Betts School in Stamford, he had a flair for the sugar industry. After working for three years in the refineries, he became assistant sales agent; subsequently he took charge of the buying and selling department of his father's firm. Frederick C. Havemeyer was fortunate in that his elder son Theodore emerged from his apprenticeship well equipped to handle the manufacturing end of the business, while his youngest son Harry had a natural inclination toward its financial interests.

The trade of sugar refining came to Harry Havemeyer and his brothers as a family inheritance. Several branches of the Havemeyer family, who had immigrated from Germany at the beginning of the nineteenth century, were in this business, and Harry's grandfather (and his grandfather's brother) had started the first small-scale sugar "bakery" in Greenwich Village, Manhattan. His father (and his father's cousin) vastly extended the business; acquiring property in Williamsburg, Brooklyn, they began to construct there the group of buildings that later grew into one of the largest sugar refineries in the world. In 1863, the company had become Havemeyers and Elder after Harry's father took in as partners his son Theodore and his son-in-law J. Lawrence Elder. Six years later, at age twenty-two, Harry in turn was admitted to partnership in the firm still known as Havemeyers and Elder, although J. Lawrence Elder had died in 1868. Shortly afterward, Harry's father retired from an active role in the company but he maintained close supervision over its affairs.

Harry, an unusually hard worker, all his life kept long, regular hours at his office, then at 98 Wall Street. His quick, sharp mind led him to split-second decisions; he became known as the shrewdest man in the sugar business. His head was always filled with projects, such as special studies of production and of distribution markets. His business personality was tough and aggressive, his manner abrupt and severe. He seemed never to have a moment to spare and was a man of few words. His elder brother Theodore's disposition was considerably more agreeable; he had the reputation of being the diplomat in the family. It was the belligerent Harry, with his aptitude and energy, who eventually became the virtual head of the firm and earned the title of "Sugar King."

H. O. Havemeyer owed his middle name to his maternal Irish grandmother, Mary Osborne Henderson. He may also have owed some of his forceful characteristics to her. The obstinate Mary Osborne had been disinherited by her family when she married Mr. Henderson, who was not a Roman Catholic; subsequently she and her husband came to America. Their grandson, Henry Osborne Havemeyer, was himself a bit hotheaded (once he was expelled from school after a row with the principal). He had no patience with scholarship, though he obviously had ample intelligence. Harry's father, having

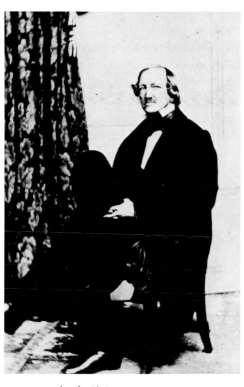

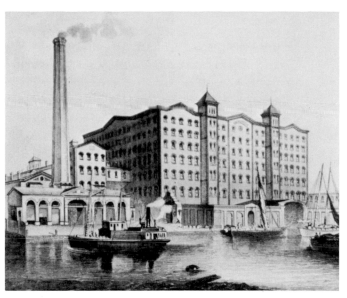

Original sugar refinery of Havemeyers and Elder in
Williamsburg, Brooklyn. The seven-story building stood
on the edge of the East River, flanked by sheds for unloading raw
sugar from sea-going vessels. Fire consumed this brick-and-iron
structure in 1882; it was rebuilt to be the world's largest
sugar refinery. Lithograph, before 1882

Frederick Christian Havemeyer, Jr.,
father of Harry Havemeyer. Photograph
courtesy of Mrs. Laurance B. Rand

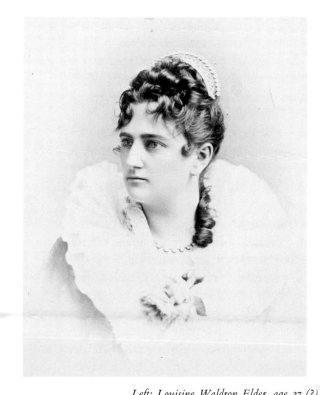

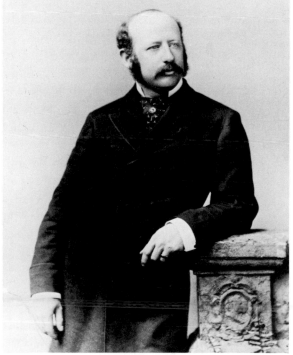

Left: Louisine Waldron Elder, age 27 (?), possibly her engagement picture, c. 1882

Right: Harry Havemeyer, age 35, at the time of his marriage to Louisine Elder, 1883. His two
marriages were thirteen years apart. Photographs courtesy of J. Watson Webb, Jr.

spent two years at Columbia College in New York, maintained his love for literature and the study of Latin, and exposed his son to a certain amount of culture.

Between 1842 and 1856 Frederick C. Havemeyer, Jr., had left the family sugar business in the capable hands of his brother and cousins and had traveled in the United States and abroad, studying the innovations of the sugar-refining industry in Europe. He was also interested in public systems of education, inspecting Old World institutions and methods in the hope that he could benefit public education in America with the knowledge he thus acquired. It is possible that the very young Harry accompanied his father on some of these trips; certainly the older children did. From early on Harry loved music and developed into a skillful violinist. As an adult his daily relaxation consisted in playing the violin, sometimes for as much as three hours. The often implacable businessman had a warm and genial side, yet he showed it only to his family and a narrow group of friends. With those he loved, his "firmness and determination could relax and swing like a pendulum into a gentleness that was touching."[5]

At some time in early manhood Harry began to think about art; perhaps this was during his first marriage, after 1870, when he was furnishing his home at 10 West 45th Street. It was probably at the National Academy of Design or at Samuel P. Avery's Fifth Avenue gallery that Harry first noticed the work of Samuel Colman. This well-traveled artist, inspired by the regions he had seen in Europe and North Africa, painted romantic landscapes as well as large pictures of scenes along the Hudson River and of the American West. Harry's cousin William (son of William Frederick Havemeyer, former partner of Harry's father and three times mayor of the City of New York) was an avid collector of American art, and may have brought Colman's work to Harry's attention. In any case, Harry Havemeyer met the artist; this could have occurred in 1875, when Colman had returned from a journey through Egypt, Algeria, Morocco, Italy, France, and Holland. Many sketches and paintings from these travels were on view that December at Snedecor's Gallery on Fifth Avenue, then one of the foremost art galleries in America. This exhibition was doubtless one of the artistic "events" of the winter, and Harry may have been introduced to Colman on that occasion. There is no proof that he bought any of Colman's work at that time, but the two men became friends, and eventually Harry acquired two paintings, six watercolors, and two prints by Colman.

In 1876 Harry and Samuel Colman visited the Philadelphia Centennial Exhibition; the painter Louis C. Tiffany (Colman's former protégé and traveling companion) may have gone with them.[6] The Centennial Exhibition was the impetus for a growing interest in decorative arts, particularly through its display of treasures from the Orient. Colman's enthusiasm for these must have been infectious, prompting Harry into his first major step in collecting. Louisine later recorded this event, which had taken place well before her marriage:

In 1876, Mr. Samuel Colman with Mr. Havemeyer visited the Centennial Exhibition in Philadelphia. They became interested in the exhibits of China, and especially in those of Japan, with the result that my husband bought many beautiful objects of art and a collection of Japanese textiles, a wonderful lot of brocades of lustrous

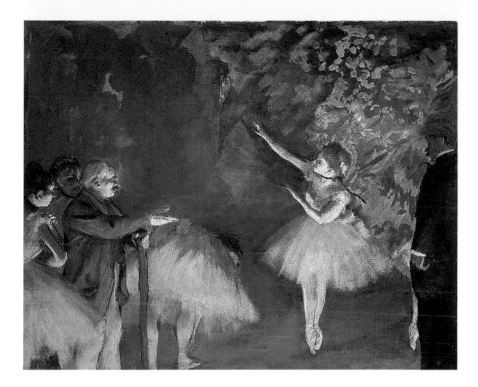

1. EDGAR DEGAS. *Ballet Rehearsal (A Ballet)*. c. 1874. Gouache and pastel over monotype, 21 3/4 × 26 3/4″. The Nelson–Atkins Museum of Art, Kansas City (Acquired through the Kenneth A. and Helen F. Spencer Foundation Acquisition Fund). Formerly owned by Mrs. Havemeyer

2. CLAUDE MONET. *The Drawbridge, Amsterdam*. 1874. Oil on canvas, 21 × 25″. Shelburne Museum, Shelburne, Vt. (photograph by Ken Burris). Formerly owned by Mrs. Havemeyer

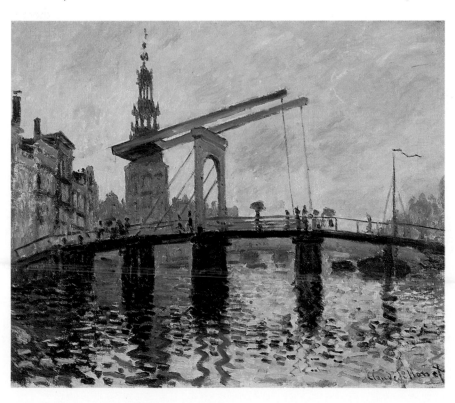

3. MARY CASSATT. *Self-Portrait*. 1878.
Gouache on paper, 23 1/2 × 17 1/2″. The
Metropolitan Museum of Art, New York (Be-
quest of Edith Proskauer, 1975). Formerly
owned by Mrs. Havemeyer

4. JAMES ABBOTT MCNEILL WHISTLER.
The Steps. 1879–80. Fabricated chalks on
brown paper, 7 7/8 × 12″. Freer Gallery of
Art, Smithsonian Institution, Washington,
D.C. Formerly owned by Mrs. Havemeyer

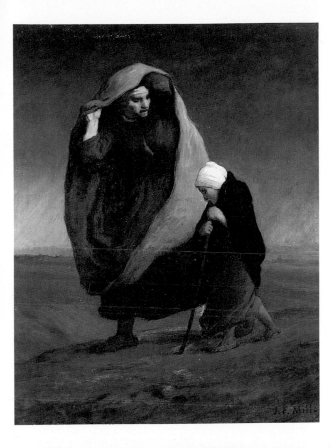

5. JEAN-FRANÇOIS MILLET. (left) *Mother and Child (Les Errants)*. 1848. Oil on canvas, 19 1/2 × 15". The Denver Art Museum (William D. Lippitt Memorial Collection). Formerly owned by Mr. Havemeyer

6. EDOUARD MANET. (below, left) *Boy with a Sword*. 1861. Oil on canvas, 51 5/8 × 36 3/4". The Metropolitan Museum of Art, New York (Gift of Erwin Davis, 1889)

7. EDOUARD MANET. (below, right) *Woman with a Parrot*. 1866. Oil on canvas, 72 7/8 × 50 5/8". The Metropolitan Museum of Art, New York (Gift of Erwin Davis, 1889)

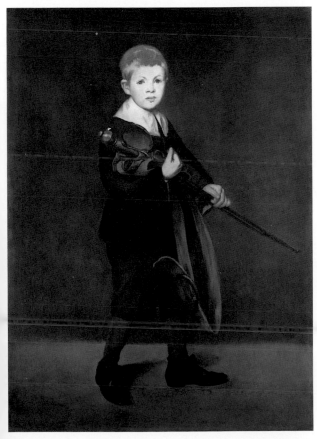

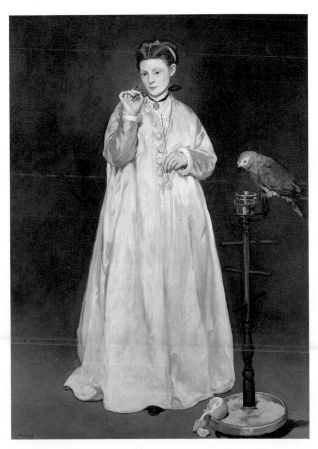

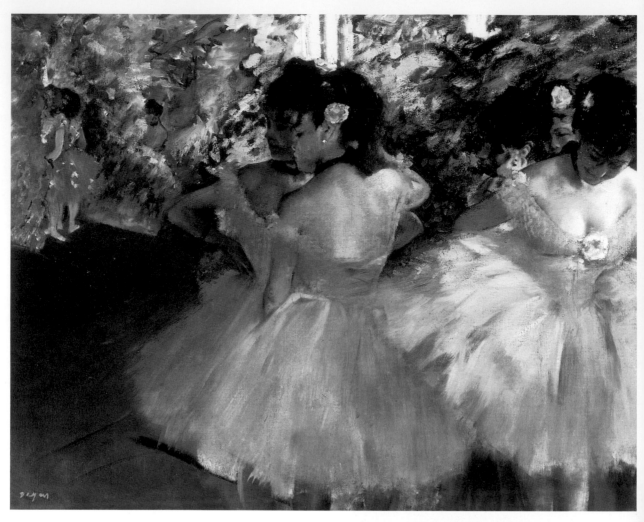

8. EDGAR DEGAS. *Dancers.* c. 1880. Oil on canvas, 23 1/2 × 29″. Hill-Stead Museum, Farmington, Conn. Formerly owned by Alfred A. Pope

9. MARY CASSATT. *The Lady at the Tea Table.* 1883–85. Oil on canvas, 29 × 24″. The Metropolitan Museum of Art, New York (Gift of the Artist, 1923)

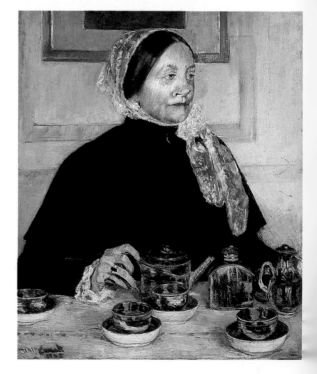

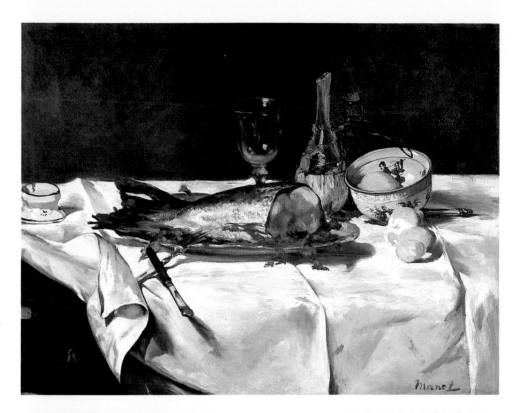

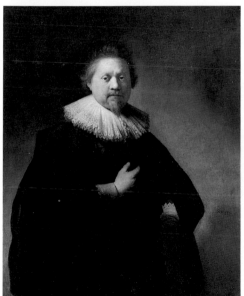

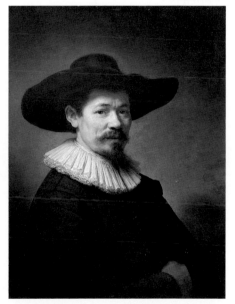

10. EDOUARD MANET. (top) *The Salmon.* 1869. Oil on canvas, 29 × 37". Shelburne Museum, Shelburne, Vt. (photograph by Ken Burris). Formerly owned by Mr. and Mrs. Havemeyer

11. REMBRANDT. (above, left) *Portrait of a Man (Christian Paul van Beresteijn, Burgomaster of Delft).* 1632. Oil on canvas, 44 × 35". The Metropolitan Museum of Art, New York (Bequest of Mrs. H. O. Havemeyer, 1929. The H. O. Havemeyer Collection)

12. REMBRANDT. (above, right) *The Gilder,* or *Portrait of Herman Doomer.* 1640. Oil on wood, 29 5/8 × 21 3/4". The Metropolitan Museum of Art, New York (Bequest of Mrs. H. O. Havemeyer, 1929. The H. O. Havemeyer Collection)

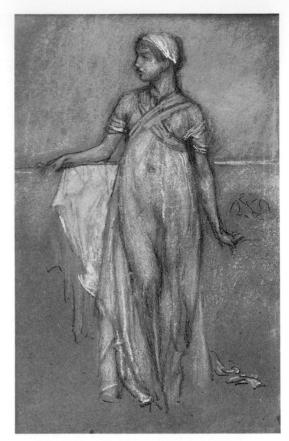

13. JAMES ABBOTT MCNEILL WHISTLER.
The Greek Slave Girl. c. 1870. Pastel on brown
paper, 10 1/4 × 7 1/8". Shelburne Museum,
Shelburne, Vt. Formerly owned by Mr. and
Mrs. Havemeyer

14. GUSTAVE COURBET. *Landscape with
Deer.* 1866. Oil on canvas, 68 1/2 × 82 1/4".
Musée du Louvre, Paris

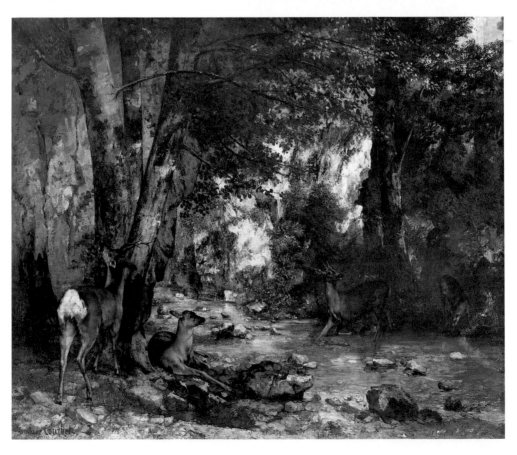

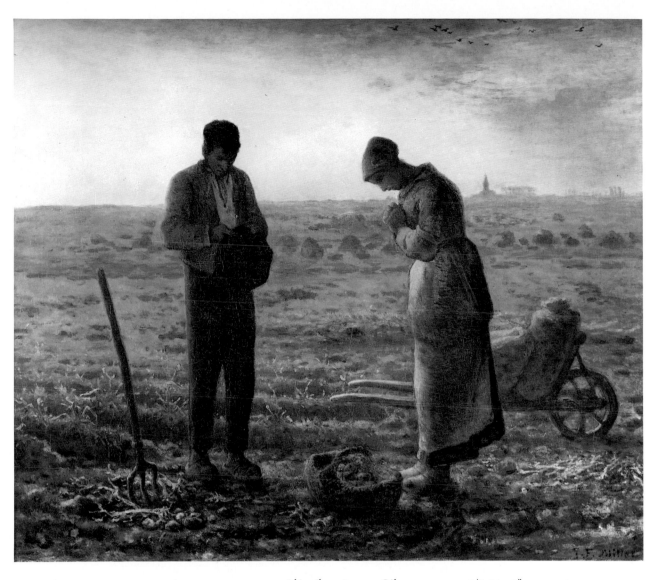

15. JEAN-FRANÇOIS MILLET. *L'Angélus.* 1855–57. Oil on canvas, 21 6/8 × 26″.
Musée du Louvre, Paris

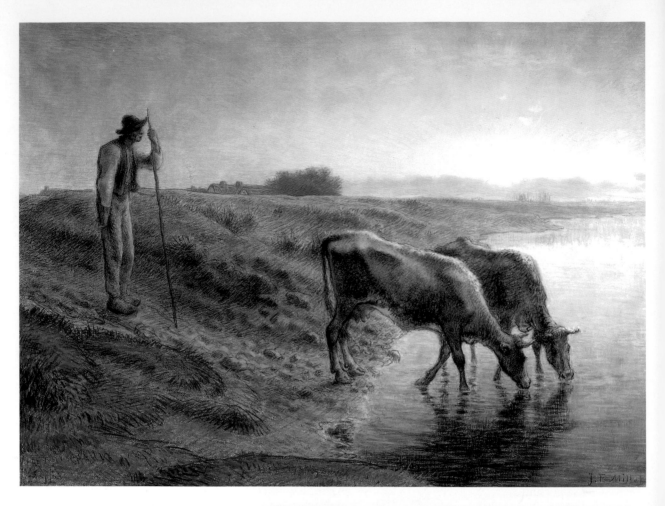

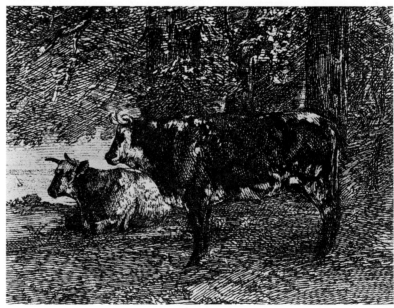

16. JEAN-FRANÇOIS MILLET. *Peasant Watering His Cows on the Banks of the Allier River, Dusk.* c. 1868. Pastel on paper, 28 1/4 × 37″. Yale University Art Gallery, New Haven (Gift of J. Watson Webb, B.A. 1907, and Electra Havemeyer Webb). Formerly owned by Mr. and Mrs. Havemeyer

17. GUSTAVE COURBET. *Landscape with Cattle* (etching based on painting). 1859. Oil on canvas, 27 1/2 × 35 3/8″. Present whereabouts unknown. Formerly owned by Mr. and Mrs. Havemeyer

gold and silver, and rich blues, reds and greens. Never did more splendid fabrics come out of the East.[7]

He also purchased Japanese lacquer boxes, sword guards, and dozens of lacquer inros with raised, inlaid, carved, and applied designs. Harry was responding aesthetically to the three-dimensional form of these objects as well as to their delicate surface workmanship. Having received the initial stimulus from his friend Colman, he was ready to collect in this field. Not one to do things halfheartedly, Harry plunged into the acquisition of Oriental art with zest and energy, soon developing a discriminating and perceptive eye for quality.

In addition to his growing collection of Chinese and Japanese decorative wares, Harry next began to interest himself in French painting. Initially he bought only works by established Salon artists, such as his acquisition in 1879 from M. Knoedler and Co. of *Ladies Caught in the Rain* by Firmin Girard, a pupil of Gleyre. But in 1880 he received from Paris, apparently sent at the Elders' request, a painting by Narcisse Diaz selected by Mary Cassatt.[8] The following year he purchased from Knoedler's no fewer than five paintings by Barbizon artists—two more works by Diaz, and one each by Rousseau, Corot, and Millet (Plate 5)—selecting only one by the Salon painter Jean-Jacques Henner. In 1882 he went a step further, acquiring in September from the same gallery Delacroix's *Arab Rider* for $7,000.

Thus when Louisine Elder and Harry Havemeyer were married in 1883, each of them had independently developed an artistic interest. Mature individuals with distinctive tastes, they chose different ways of expressing them. Harry's major preoccupation was the pursuit of large quantities of Chinese porcelains, bronze pots, rugs, Japanese textiles and tea jars, Cypriote glass, and other such works. He knew his taste and decided quickly, without questioning the price if he believed in the quality of the object. He was convinced that there would never be a sufficient supply of great works of art to fulfill the demand for them and that their value would thus increase over the years.

Louisine's approach was altogether different from the impulsive, extravagant buying of her husband. Her early exposure to avant-garde French painting and European culture had instilled her with a strong desire to be a pioneer. She was not afraid of the new and unfamiliar, and she had a venturesome spirit. Yet she also had the virtue of patience. Although Mary Cassatt had converted her into a most ardent disciple of the moderns, Louisine did not try to bring her husband around to her way of thinking until she sensed he was ready for it. Unlike the impetuous Harry, she could wait years to secure a particular picture, meanwhile relishing its beauty in her memory. For her, experiencing a work of art was of crucial importance; its possession was secondary. Sometimes her frugality deprived her of the pleasure of ownership. As a girl she had had to save and to budget her small allowance to buy a coveted object, and she remained careful about money all her life; she also thoroughly enjoyed bargaining. Fortunately Louisine and Harry Havemeyer's differences in temperament complemented one another, enabling them to develop into a unique collecting team.

It was Harry's voluminous accumulation of Oriental art that kept Louisine busy

during the early years of their marriage, in addition to her new responsibilities as a wife and mother. The Havemeyers had moved into a brownstone at 34 East 36th Street, where their first child, Adaline, was born in July 1884. That same year, Louisine made her initial acquaintance with Japanese tea jars; these she would come to know very well, for eventually her husband acquired some 475 of them. In her *Memoirs,* Louisine recalls that one morning her husband, when leaving for the office, nonchalantly told her that a case of tea jars would be delivered later in the day. He asked her to unpack them, select the ones she preferred, and put the rest in storage. Louisine was completely puzzled as to what a tea jar was, but since Harry said they were beautiful and that she would admire them, she waited anxiously for their arrival. She was not disappointed:

> I opened the case and was surprised to find it contained innumerable small boxes. I opened these small boxes and found they contained each another box inside. Upon opening the second box I found it had a silk bag and upon undoing the silk bag my little "brownie" revealed himself to me. Like a child with a toy I soon had rows of brownies about me, while the little boxes were in a heap upon the floor beside me. What pretty, dainty things they appeared to me! Soft clay bearing the mark of the wheel, with here and there a drip of dark glaze—or a metallic *souffle* covering the entire jar. There were cool dark browns relieved by a splash of most lovely shaded blue or a glow of yellow, or—or—or— indeed I cannot tell you of all their dainty forms or solemn tones; rows of tiny jars as varied as the smile of as many lips, or varied as the twinkle of as many eyes. Never shall I forget that morning with my tea jars, those little jars which were taken from their many wrappings upon some grand occasion when princes knelt before them, when they crawled into the sequestered room and joined in the solemn tea ceremony.[9]

Louisine was entranced with the romantic associations evoked by the tea jars. There were certainly other such discoveries for her during the early years of her marriage and she was eager to learn about the treasures her husband was rapidly accumulating. At this time Harry took the lead in their collecting; she was the more passive partner, faced with the ever-growing problem of finding space for her husband's numerous purchases. As always she approached her task cheerfully. She felt well rewarded for her labors by the pleasure she received from handling the different objects, while at the same time she was expanding her knowledge and understanding of Oriental art.

Most accounts of the Havemeyers claim that they started out collecting the anecdotal paintings then popular, but it seems that early on Louisine attempted to influence Harry against buying fashionable Paris Salon pictures. He did, however, continue to acquire Barbizon paintings[10] and probably also American landscapes suggested by Samuel Colman or William Havemeyer. Louisine's "dowry" had brought him one work each by Degas, Monet, Pissarro, and Cassatt, as well as five Whistler pastels, but she could not then expose her husband to other works by the moderns. At that time it was difficult to find pictures by them in America, and Harry was too busy to go abroad.

On only two occasions—between 1883 and 1885—could Harry have seen works by the Impressionists on his side of the Atlantic. The first was the "Foreign Exhibition"

opened in Boston in September 1883. Paul Durand-Ruel (and perhaps other dealers) included a modest selection of oil paintings and watercolors by the modern French school: two by Manet, three by Monet, six by Pissarro, three by Renoir, and three by Sisley; there were also works by Courbet and Corot. It was in connection with this show that Durand-Ruel made his first trip to America, an event that would have far-reaching consequences for the Impressionists.[11] But their pictures were lost among the Salon paintings and decorative objects surrounding them and went unremarked by the general public. As the Havemeyers had been married only since August 22, it is unlikely that Louisine took her new husband to Boston to see the exhibition.

Yet the following December Harry must have accompanied his wife to the "Pedestal Exhibition" at New York's National Academy of Design, held to raise funds to build the base for Bartholdi's Statue of Liberty, presented by the French government in the preceding fall. A portfolio was offered for sale containing artists' sketches and contributions from distinguished writers, among them Emma Lazarus's renowned poem later engraved on the base of the statue. The "Pedestal Exhibition" consisted of over 5,000 works: in addition to paintings and sculpture, there were armor and arms, old coins and medals, stained glass, illuminated missals, musical instruments, faience and porcelains, tapestries and costumes, also Oriental and even aboriginal art. The country had seen no comparable display since the Philadelphia Centennial seven years before. Harry's brother Theodore lent nine pictures to the European paintings section of the exhibition, including one work each by Alberto Pasini and Jean-Paul Laurens; the Madison Avenue town house of Theodore Havemeyer and his wife, Emilie (daughter of Charles F. de Loosey, former Austrian consul general in New York), had a gallery that was stacked with gilt-framed canvases by celebrated European Salon artists.

William Merritt Chase as chairman, and J. Alden Weir as member of the exhibition's committee on painting and sculpture, had garnered a large representation of Barbizon paintings as well as a selection of pictures by Courbet. But Chase and Weir had also dared to include in the show three canvases by Manet and one by Degas. Two of the Manets, *Boy with a Sword* (Plate 6) and *Woman with a Parrot* (Plate 7), were lent by Erwin Davis, a New York entrepreneur and collector. The third Manet, *Toreador,* belonged to Weir's dealer, Daniel Cottier, who in 1873 had opened a gallery for furnishings and pictures in New York.[12] Possibly the committee borrowed Davis's Degas, *Dancers* (Plate 8), as a gesture of good will toward its owner, who loaned to the "Pedestal Exhibition" no fewer than thirty-seven works. Davis had commissioned Weir to go to Europe in the summer of 1881 on a picture-buying trip and Weir had acquired the two Manets and the Degas for him at Durand-Ruel's in Paris.

These modern paintings were hung prominently and were at least noticed, if not appreciated. Louisine Havemeyer, being among the few who liked such revolutionary works, must have been pleased to see them displayed at the National Academy, and particularly to notice that Davis's picture of dancers by Degas was not "skied" upon the wall as hers had been. A typical reaction to these paintings was expressed by the editor of *The Art Amateur:* "Degas's ugly little ballet girls in pink occupied a place of honor in the large south room facing Manet's *Boy with the Sword,* and a very homely young person holding up her petticoat [Manet's *Woman with a Parrot*]—the title of the picture I do not remember."[13]

Paul Durand-Ruel

Louise and Harry Havemeyer did not acquire any modern works between 1883 and 1885, but Mary Cassatt saw to it that a few canvases by artists she admired made their way into other American collections. She discovered that Annie Riddle Scott, a daughter of her mother's first cousin, was sympathetic to the new art, and that Mrs. Scott, as the widow of Thomas Alexander Scott, former president of the Pennsylvania Railroad, could well afford to buy paintings. Since Annie Scott and her mother, Mrs. Robert Moore Riddle, had been very kind to Mary Cassatt in London in the fall of 1883, the artist asked Mrs. Riddle to pose for her portrait when she visited Paris in November. In the course of these sittings Annie Scott developed an interest in her cousin's work and went to Durand-Ruel's, where she bought Cassatt's painting *In the Box*, representing two young girls at the theater. Her next purchases at Cassatt's instigation were Manet's portrait of a French opera singer, *Emilie Ambre in the Role of Carmen*, and two pastels by Manet, all bought from the artist's estate. Annie Scott greatly benefited from her connection with Cassatt, though she could not bring herself to like her cousin's portrait of her mother (Plate 9; now titled *The Lady at the Tea Table*), finding Mrs. Riddle's nose unduly emphasized.

Mary Cassatt managed to persist in her purchases on behalf of her brother Alexander in spite of all obstacles. On January 5, 1884, she wrote to him that, if the prices were sufficiently low, she hoped to obtain some works from the forthcoming posthumous sale of the contents of Manet's studio. She sent a representative to the sale, who secured two paintings for Alexander for less than 500 francs apiece. One of these was *Italian Woman*, the other was *Portrait of Marguerite de Conflans*, both described by Cassatt as "very decorative"; she also considered them to have been bargains.

Mary Cassatt had previously acquired for her brother a number of paintings by Monet, which had already increased in value. When Frank G. Thomson, a friend and business colleague of Alexander Cassatt, professed an interest in Monet's work, Alexander asked his sister to look for some pictures for Mr. Thomson. She was only too glad to oblige and wrote her brother on April 27, 1884: "I will get the Monets for Mr. Thomson if I can at the price."[1] However, this time she was not successful, and Mr. Thomson obtained his first picture by Monet two years later, purchasing it from

Paul Durand-Ruel in his later years. He opened his first Durand-Ruel gallery in New York in 1888. Photograph courtesy of Charles Durand-Ruel

Durand-Ruel rather than from Cassatt's agent, Arsène Portier, although the latter had offered him some Monets at a special rate. Cassatt had frequently dealt with Portier, a former employee of Paul Durand-Ruel who became a modest, independent dealer, handling works by Delacroix, Daumier, Corot, Manet, and several Impressionists. She also had him show paintings by her colleagues to prospective American buyers, in addition to occasionally entrusting her own canvases to him and asking him to represent her at auctions. When Mr. Thomson did not take advantage of Portier's offer, she was greatly disappointed, informing her brother on September 2, 1886: "Just got a letter from Mr. Thomson, to tell me that Portier brought him two Monets or three cheap but he preferred buying one from Durand at 3000 francs. I feel rather snubbed! I advised him to buy cheap, but I suppose he is the kind to prefer paying dear."[2]

In her own attitude toward money, Mary Cassatt was as hardheaded as the rest of her family. Although the works she was buying were by fellow artists, this did not stop her from trying to get them at the lowest possible price. But she could also be generous; once Durand-Ruel had begun to show her work in 1881, she was ready to lend money to his firm when it came close to bankruptcy after the depression of 1882.

Paul Durand-Ruel suffered repeated reverses during the first half of the 1880s. He had earned an enviable reputation in France and America as the dealer for the School of 1830, whose works had finally met with success, but when he discovered the Impressionists and began to promote them, he lost some of his former clients. After 1870, the date of his first exhibition of paintings by Monet and Pissarro, Durand-Ruel became committed to their work. In spite of the repeated monetary crises he endured, he never wavered in his support.

A man of great integrity, Durand-Ruel had expressed in 1869 his principles of art dealing in the *Revue internationale de l'art et de la curiosité:* "A good dealer must be an enlightened *amateur,* ready—if need be—to sacrifice his own interest to his artistic convictions, as well as someone capable of fighting against speculators rather than involving himself in their schemes."[3]* This lofty idea of his role as apostle of the true

art as well as his passion for painting raised many difficulties; when he could not sell the Impressionists in Paris, he decided to try to launch them in England. During the summer of 1882, he rented a gallery in London to exhibit a few of their pictures. Next, in the spring of 1883 at the Dowdeswell Galleries on New Bond Street, he organized a larger exhibition of sixty-five works by Degas, Manet, Monet, Pissarro, Renoir, Sisley, Boudin, Cassatt, and Morisot. These two shows whetted the appetite of an influential group of British critics, but no collectors were courageous enough to buy.

Paul Durand-Ruel's pioneering spirit, however, was not dampened, and when the opportunity arose in 1883 to send some Impressionist pictures to Boston for the "Foreign Exhibition," he wrote Pissarro in May: "One must try to revolutionize the New World at the same time as the Old."[4]* Pissarro, less convinced that it was a good idea to show such works in America, expressed himself in a letter to Monet of June 12: "A few of our paintings were sent to the Boston exhibition; I have found out from some Americans that it is considered a mediocre display which has little or no influence. I spoke with Durand about this and he told me that it would be a test, and that he was using the occasion to exhibit us, especially since there would be no customs duty."[5]* Durand-Ruel evidently saw nothing to lose in presenting Impressionist works to a new audience.

Unfortunately, the Boston exhibition had a negligible effect on advancing the cause of Impressionism in America. Just as earlier in England, few collectors or dealers were willing to take a risk with the new French movement. This caution became evident in the absence of American participation in the Paris auction of Manet's estate, arranged by Durand-Ruel in February 1884. The modest results of that sale did not help Durand-Ruel's already unstable finances. Some Americans were openly hostile to his handling of the auction, accusing him of exploiting the late artist, and Edward Villiers, critic of the *Art Amateur,* went out of his way to attack him:

> The fact is that certain amateurs and professional dealers hope to see the day come when Manet's work will sell as Millet's work now sells, and therefore they are doing all they can to create fancy prices for his pictures. They imagined, too, because one notable American collector [Erwin Davis] had bought a Manet that the Americans were going to make a rush for them, and the estimable M. Durand-Ruel still entertains that fond hope. This gentleman had in his hands at a time when they sold for nothing all the great pictures of Corot, Delacroix, Millet, and Rousseau; and now he imagines that the future is reserving for the "impressionists" as brilliant an apotheosis as that which Millet and Rousseau are now enjoying, hence his craze for buying the wildest efforts of Manet's brush and of the brushes of Manet's disciples.[6]

The situation was going from bad to worse, as Durand-Ruel recalled in his *Memoirs:* "This Manet auction gives some insight into the public opinion of the time and into the numerous difficulties which I encountered. I don't know how I would have survived all of this, had it not been for the fortunate circumstance that put me in touch, at the end of 1885, with the American Art Association of New York."[7]* Actually it was in the early summer that James F. Sutton, representative of that association, had visited Durand-Ruel and asked him to bring an exhibition of his artists to New York.

James Sutton, son-in-law of R. H. Macy, proprietor of what was then a dry-goods bazaar on 14th Street, had gone into partnership in 1883 with the auctioneer Thomas Ellis Kirby. Their third and least visible partner was R. Austin Robertson, an importer of Oriental wares for Sutton's previous business. They founded their association "for the encouragement and promotion of American art," in the hope that it would create a market for American painting. To emphasize their firm's noncommercial aspect, Sutton and Kirby announced competitions for American artists, persuading a number of wealthy patrons to judge the entries and to pay for the prizes: four awards of $2,500, and ten gold medals (designed by Tiffany and Co.) of $100 each. Among the initial subscribers were William Walters, Charles Dana, Cornelius Vanderbilt, Henry Marquand, John Taylor Johnston, William H. Vanderbilt, and Henry O. Havemeyer.

The first "Prize Fund Exhibition" was held in the spring of 1885 at the American Art Galleries. The award committee selected four artists as winners of the major prizes: Alexander Harrison, Henry Mosler, R. Swain Gifford, and Frank Boggs. At the close of the show, the prizewinning entries were presented to museums or art institutions. Harry Havemeyer was again a contributor to the second "Prize Fund Exhibition" in 1886, together with a number of prominent art patrons, including Jay Gould and Benjamin Altman, as well as the two principal members of the firm, James Sutton and Thomas Kirby. In addition to individual gifts the subscription fund also received donations from the Corcoran Gallery in Washington, D.C., and the Southern Exposition Company of Louisville, Kentucky.

By 1888, at the fourth annual show, the initial interest created by the "Prize Fund Exhibitions" had dwindled; H. O. Havemeyer's name, for example, was no longer on the list of contributors. Only one $2,000 prize was awarded; it went to J. Alden Weir for his painting *Idle Hours,* which was presented to the Metropolitan Museum since eight of the ten subscribers that year were residents of New York. A letter announcing the gift, dated October 15, 1888, from the American Art Association to the museum's director, Luigi Palma di Cesnola, stated: "Hoping the work will receive deserved recognition and be hung to better advantage than the prize painting previously awarded to your institution."[8]

The partners' efforts as cultural impresarios had not brought a run of customers to the American Art Association. Kirby, an auctioneer at heart, decided as early as 1885 that the only help for the business lay in managing sales of elite collections. He was provided with a perfect opportunity by the bankruptcy of a former client, George I. Seney, who suggested to his creditors that they let the American Art Association organize an auction of his pictures, mainly by artists of the Barbizon school. The three nights of the Seney sale (March 31 to April 2, 1885) yielded $406,910, the largest amount from an auction in America up to that time, and it established Kirby's renown as an auctioneer. Yet James Sutton did not want their association to be known only as a firm of public sales, and he decided to look in Europe for some other kind of art to promote, since Americans were still reluctant to buy American paintings. After seeing a number of Impressionist pictures in Paris, he asked a mutual friend to take him to Durand-Ruel; he was particularly impressed by Paul Durand-Ruel's private collection in his apartment on the

rue de Rome. Sutton felt that these strange new paintings would create a sensation in the association's lavish galleries on Madison Square. He found Durand-Ruel interested in his proposal. Unbeknownst to Sutton, the French dealer was then in great financial difficulties and willing to try anything with promise. Durand-Ruel expressed his troubles in a letter to Pissarro of June 9, 1885: "I am still encumbered with business matters. All one gains from these are problems. I would like to be free enough to go to the desert. . . ."9*

However, some of the Impressionists were less enthusiastic than their dealer was about a New York exhibition. Monet did not want to have his most recent paintings sent to America, as he wrote to Durand-Ruel on July 28, 1885: "I have two canvases which I have been working on for a month, but I confess that certain of these pictures I would regret to see sent to the land of the Yankees. I would prefer to reserve a choice for Paris, because it is above all and only there that a little taste still exists."10* Renoir's attitude was more cooperative, though he too was less than enthusiastic.

Among Paul Durand-Ruel's artists only Mary Cassatt urged him to strike out in the New World, reassuring the apprehensive dealer that the venture was just what he needed to get him out of his current plight.[11] But in reality she was not as confident as she pretended, informing her brother on September 21, 1885: "The New York Art Association have offered him their rooms for an exhibition & he is going over to make arrangements. Affairs here he complains are at a standstill & he hopes to have better luck in America. I doubt it however."[12] In the same letter Cassatt provides evidence that earlier in September Durand-Ruel had traveled to New York to inspect the premises and study the situation before deciding to send over several hundred paintings: "I have no doubt that you will see Durand-Ruel by the time you get this, for he wrote to me that he intended going to America & as I was in town a couple of weeks ago I called & gave him your address; he wanted me to give him a letter to you but I thought that quite unnecessary." It is also possible that Durand-Ruel called on the Havemeyers during his visit in the fall of 1885. He must have met Louisine in Paris before her marriage, when she was frequently in the company of Mary Cassatt.

Durand-Ruel was ready to proceed after seeing the luxurious, recently remodeled galleries of the American Art Association and finding the business arrangements more than suitable. The association agreed to cover all exhibition costs—shipping, insurance, publicity, and catalogue—against a commission on any works sold. Durand-Ruel could never have afforded such a project without the financial aid and sponsorship of the association. Because Sutton's organization was quasi-institutional, he persuaded the customs officials to let in duty-free, as temporary imports, the forty-three cases sent from Paris (the high tariff on imported works of art was then a major concern, and a hindrance to American collectors). Durand-Ruel assembled about 300 pictures, valued at $81,799; among these were 23 works by Degas, 17 by Manet, 48 by Monet, 42 by Pissarro, 38 by Renoir, 3 by Seurat, and 15 by Sisley, in addition to paintings by Boudin, Caillebotte, Forain, Cassatt, Guillaumin, and Morisot. He had also included some fifty paintings by "acceptable" artists who had no relation to the Impressionists. Paul Durand-Ruel and his son Charles left Paris on March 13, 1886, to arrive in time to supervise the hanging at the association's galleries.

Slowly, very slowly, Impressionism had been creeping toward America, but on

April 10 the full display of the "Impressionists of Paris" burst upon the puzzled public. The press reacted immediately; the critics in general found the new movement interesting, although some of course dismissed the exhibition as worthless folly. In comparison with the avalanche of contempt his artists had received at home, Durand-Ruel found their reception in New York encouraging and certainly less hostile: "The exhibition was successful in that it aroused immense curiosity and, contrary to what had happened in Paris, provoked neither an uproar or stupid remarks nor raised any protests. . . . The public and all the collectors did not come to laugh, but to see for themselves the notorious paintings that had created such a stir in Paris."[13]* Durand-Ruel also attributed the relative success of the exhibition in America to his being known and respected as the champion of the Barbizon painters, whose work was in great demand. American collectors now were curious to examine the art of his latest protégés. But after several weeks, certain conservative dealers became uneasy about this unexpected attraction in the New York art world and began a campaign to impose the normal import tax of 30 percent on foreign paintings. To avoid these prohibitive duties, Sutton and Durand-Ruel moved all 300 paintings to the National Academy of Design, an institution unquestionably devoted to the "higher ideals" of art. There it reopened on May 25th with twenty-one additional Impressionist paintings, thirteen of these lent by private owners—Alexander Cassatt, Erwin Davis, H. O. Havemeyer, and one anonymous collector—and a new catalogue; Durand-Ruel's name was not mentioned in either the first or the new edition except in the introductory section, where London and Paris newspaper reviews were reprinted.

Among the newly added works, the collector who lent the greatest number was Alexander Cassatt. The Havemeyer loans—Monet's *The Drawbridge, Amsterdam* and Pissarro's *Peasant Girls at Normandy*—were those Louisine Elder had bought as a young woman in Paris; it was characteristic of her to lend her pictures under the name of H. O. Havemeyer, just as she had lent her Cassatt gouache to the Thirteenth Annual Exhibition of the American Water-color Society in her mother's name in 1880. Durand-Ruel probably requested these loans to encourage prospective clients with proof that some of their countrymen had already committed themselves to the new art.

Buyers were not as numerous as lookers who came simply to scoff, but Durand-Ruel managed to sell some $18,000 worth of pictures on which he had to pay $5,500 in duties (an imported work lost its tax-exempt status as soon as it was sold). In his *Memoirs* he mentions the names of some of his customers, such as William Fuller, Erwin Davis, Alden Wyman Kingman, Albert Spencer, Cyrus Lawrence, Desmond Fitzgerald, Henry O. Havemeyer, and James Sutton himself. Since the records are not complete, it is impossible to document precisely which paintings were sold to whom, but without question the show's biggest seller was Monet: Albert Spencer purchased six or even more, Erwin Davis obtained four landscapes, Alden Kingman acquired a dozen of his canvases, and William Fuller bought at least one. In his *Memoirs* Durand-Ruel also accounts for the sale of two pictures by Manet, one of which, *The Salmon* (Plate 10), was bought for 15,000 francs (about $3,000) by none other than Harry Havemeyer.

Paul Durand-Ruel was encouraged by the results of his first attempt at capturing the American market. "I did not make a fortune, but it was a significant success which was encouraging for the future."[14]* From New York he wrote to Fantin-Latour: "Do

not think that Americans are savages. On the contrary they are less ignorant, less close-minded than our French collectors."[15]* He promptly made arrangements for a second exhibition at the American Art Association that same fall, and decided to capitalize on the growing fervor for the Barbizon school by including their paintings, as well as other more conservative works.

Arriving back in Paris on July 18, 1886, Durand-Ruel gave an account of the New York exhibition to Pissarro, who in turn reported their conversation to his son Lucien:

> I talked with Durand-Ruel for a long time about his American venture. What he told me seems quite reasonable: there are two opposite versions of what took place, both are equally exaggerated: he did not make a fortune as if by magic nor did he have to cheat or flee by night. He is pleased that he went to New York himself, and has great hopes for future developments there. It is nonetheless very uncertain. . . .[16]*

But Durand-Ruel's optimistic outlook did nothing to meet the monetary needs of the artists who had been forced to look out for themselves during his absence in America. Monet, Renoir, and even Pissarro were not satisfied with his handling of their affairs, nor were they appeased by his reassurances, which, after all, did not fill their pockets.

In addition to these difficulties, Durand-Ruel ran into a new stumbling block in New York. The next exhibition being scheduled for October, two of his sons, Joseph and Charles, left for America to supervise the arrival of the paintings. Their father was to join them in time for the opening, but his departure was delayed indefinitely by an unexpected contretemps. The hostile New York dealers now joined in a more effective protest against exhibiting French art without payment of customs duty, alleging that Sutton's so-called art association was in reality a business and not entitled to tax exemptions. Certain American artists, however, did not share the dealers' attitude toward foreign shows, feeling that they were important for educational purposes. J. Alden Weir, for instance, had written a letter to the editor of *The Critic* in 1885 expressing his disapproval of the heavy tax on imported art as "unprecedented in the annals of any civilized community"; the unjust tariff did not keep inferior art from entering the country, he charged, but instead prevented "the collector of moderate means from possessing examples of good contemporaneous art."[17]

After a delay of many months, during which the pictures remained in bond, Durand-Ruel was finally allowed to exhibit them duty-free but was not permitted to sell them in the United States. If a collector wished to buy a particular work, it would have to be sent back to Paris and then re-shipped to New York, where—upon entry —the habitual import tax would be levied. This ruling was a severe blow to Paul Durand-Ruel.

The tax controversy delayed the exhibition for so long that by the time it was settled, the galleries of the American Art Association were no longer available; they were needed for the third annual "Prize Fund Exhibition." Once again the show was switched to the National Academy of Design, where it finally opened on May 25, 1887. There the public could now admire works by such artists as Rousseau, Dupré, Daubigny, Courbet, Delacroix, and even Henner, as well as by the Impressionists; the only "first"

for this event were ten large paintings by Puvis de Chavannes. Not just a *succès de scandale,* this French show was received seriously by the New York art world. The inclusion of better-known artists who were also more conservative broadened the appeal of the event, as indicated by a commentary in the American art journal *The Collector:*

> Mr. Durand-Ruel followed his opening exhibition with a really glorious display of great French art at the National Academy of Design. It came, alas for it and for our public! in a season when the town was nearly dead, but still it sowed some seed in fertile ground. It was here that New York first learned of Puvis de Chavannes, and saw the wonderful *Sardanapalus* of Delacroix. It was here, in those sweltering days of early summer, that we were shown Lefebvre's splendid *Diana Surprised,* the nobly symphonic *Eclogue* of Henner, a whole series of the subtle gray harmonies of Eugène Boudin, the *Death of the Bull,* by Falguière, a painting by a sculptor worthy of a monument to itself, masterpieces by Gaillard, Huguet's African scenes, like pictures in a mirror, Manet's *Death of Maximilian,* powerful and awful for its inspiring sentiment and its very desperate defiance of every tradition of painting, and many more canvases equally worthy of enumeration, were there space to spare.[18]

The author of this article mentioned that among the works shown were examples by Monet and Sisley, by Pissarro, Renoir, and "other adherents of the Impressionistic school." However, the critic was perceptive enough to appreciate the importance of Durand-Ruel's unique contribution: "To review this exhibition with an unbiased eye, clouded by no prejudices of school and convention, one could not but admit that the man capable of assembling it was a true art lover as well as an art dealer, and a man who had the courage of his convictions and a sound and honest basis of knowledge of art to rest his convictions upon."

Yet this type of publicity and the increased number of visitors did not help to improve Durand-Ruel's pecuniary situation, since all the pictures had to be returned to Paris. The numerous complications caused him to look for other solutions. He decided that it would be to his advantage to have his own establishment in New York; in 1888 he rented an apartment at 297 Fifth Avenue, which became the first Durand-Ruel gallery in America. After numerous transatlantic trips to see clients and to set up his new firm, he turned over its management to his three sons, Joseph, Charles, and George, while remaining in Paris to try to soothe his disgruntled artists. Having enlarged his base of operations, Paul Durand-Ruel began to recover slowly from his financial difficulties.

Early Purchases and New Residences

In her *Memoirs,* Louisine recollects that one morning her husband announced his intention of viewing Durand-Ruel's 1886 exhibition at the National Academy of Design in the company of Samuel Colman, who he expected would be shocked by the Impressionist pictures.[1] Louisine told him that, on the contrary, she thought they would both be very interested, and asked him to buy her a Manet if he found any for sale. Harry replied that there was no likelihood of his doing any such thing, but after visiting the exhibition he experienced a change of heart, as he reported to his wife that afternoon: "I saw the exhibition this morning. There were two Manets in it, one a boy with a sword and the other a still life [*The Salmon;* see Plate 10]. The still life was very fine and I bought it for you, but I must confess the *Boy with the Sword* [see Plate 6] was too much for me."[2] Although delighted with his purchase, Louisine could not resist asking her husband the price of the *Boy with a Sword;* when she was told $3,500 she was immediately sorry that he had not bought both pictures, but she diplomatically said nothing. Manet's *Boy with a Sword* was listed in the exhibition's catalogue as belonging to Erwin Davis, who must have told Durand-Ruel that he was willing to sell the work if there were any offers. Many years later Louisine loyally defended her husband's failure to buy Davis's picture by stating, "it was at first a little difficult to understand Manet's method of modeling in light. . . ."[3] Subsequently Harry too regretted having passed up the picture at such a reasonable price.

It may seem strange that Harry Havemeyer and Samuel Colman went to Durand-Ruel's show before Louisine herself saw the "Impressionists of Paris." Probably she was prevented from being among the first visitors by the birth of her second child, Horace, on March 19, 1886, three weeks prior to the opening. If Harry had gone to the show with his wife, he would probably have bought both Manets.

A short time before purchasing Manet's *Salmon,* Harry had made another acquisition: Decamps's *The Walk to Emmaus,* bought at the estate sale of Mary Jane Morgan in March 1886. At this auction, Harry found himself in the company of such noted

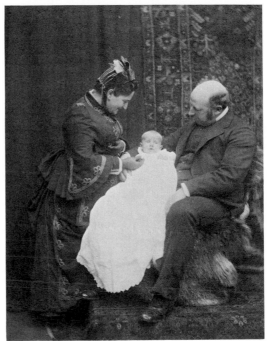

Left: Louisine Havemeyer with her first child, Adaline, born 1884

Right: Louisine and Harry Havemeyer in a photographer's studio, displaying parental pride in their son, Horace, born 1886. Photographs courtesy of J. Watson Webb, Jr.

collectors as his intimate friend William Rockefeller, as well as Charles Dana, Collis P. Huntington, and Charles Crocker: the *New York Times* referred to the event as "the greatest sale ever held in this country."[4] Managed by none other than Thomas Kirby of the American Art Association, the affair carried out Kirby's concept of the elite auction, with a deluxe catalogue that was an innovation in itself: printed on heavy rag paper at a cost of $40,000, it contained 29 etchings, 24 photographs, and descriptions of 2,628 lots. All eleven galleries of the association were needed to display the paintings and decorative objects that the shy, unpretentious widow of Charles Morgan, a steamship magnate, had assembled during her daily shopping excursions to New York dealers (i.e., the Knoedler, Avery, Schaus, and Cottier galleries) and decorators' salons. As reported by the *New York Sun:* "The exhibition of Mrs. Morgan's pictures elicited a greater degree of interest and was attended with more polite excitement than any event of like nature in New York. The spacious galleries could not accommodate the throng of people which flocked thither in all weather, paying double the price of admission commonly charged upon such occasions."[5]

The sale took up three evenings of feverish competition among prospective buyers from all parts of the country and even from abroad. Collis P. Huntington paid $25,500 for Vibert's *The Missionary's Story,* the Corcoran Gallery in Washington, D.C., bought Corot's *Wood Gatherers* for $15,000, and Harry Havemeyer bid $3,100, more than twice what Mrs. Morgan had paid, for Decamps's *The Walk to Emmaus.* Jules Breton's *Communicants,* the star of the sale by far, was bought for $45,000 by Sir Donald Smith of Montreal, a director of the Canadian Pacific Railroad. The total obtained for the

240 paintings of the collection was $885,300; businessmen-art collectors were reassured to see that solid, "acceptable" pictures were an uncommonly good investment.

The results were very different at Paul Durand-Ruel's auction, held but a year later. Needing money for the customs collector after his exhibition in the spring of 1886, he decided to sell 127 works in New York rather than pay their shipping charges back to Paris. The public sale was held on May 5 and 6, 1887, at Moore's Art Galleries at 290 Fifth Avenue, with William P. Moore as the auctioneer; Durand-Ruel probably chose a different auction house to prevent the American Art Association from being accused of crass commercialism. At the auction, in contrast to the crowd and the heated rivalry of the Mary J. Morgan sale, "there were few buyers present, and the bidding was at times rather sluggish, the prices obtained for the most part rather low."[6] For what Harry had paid the previous year for Decamps's picture, he could have purchased here two Monets, two Degas pastels, and a Renoir. The first night only nineteen pictures brought over $200 each; prices were a little better the second evening, sixty-one pictures yielding $28,847.50. American *amateurs* lost this opportunity to buy the works of the new French artists before their prices rose to the heights commanded by their predecessors of the 1830 school.

At the time of Durand-Ruel's 1887 sale, Harry was too busy elsewhere to take his usual interest in art matters. He was organizing the Sugar Trust, the second trust of its kind in America. After the Rockefellers had formed Standard Oil in 1870, Havemeyer was the next pioneer in the creation of trusts. In 1882 a fire had completely destroyed the Williamsburg plant of Havemeyers and Elder, which was then rebuilt into the largest, most modern sugar refinery in the world. The firm was making a sound profit, although many other sugar refineries were losing money in the early 1880s and some even went into bankruptcy. Harry conceived the plan that a union of all owners would diminish waste and preserve gains. It took almost two years of urging on the part of the Havemeyers to resolve the doubts of the seventeen original interests about joining the corporation; after endless discussions among members of the industry, the Sugar Refineries Company was formed in the fall of 1887 with the merger of seventeen plants in Boston, New York, Philadelphia, and New Orleans. Harry had been the driving force behind the venture, but his brother Theodore became the first president of the Sugar Refineries Company. As Franklin Clarkin wrote in *Century Magazine:* "This was a trust in the real sense, in which the stockholders of the different corporations assigned their stock in trust to a board of trustees—to a board that held the voting power of the stocks of the various companies."[7]

After combining the refineries, it became evident that five of the most efficient plants could produce as much sugar as the full seventeen had done previously, since the machinery in some of the plants was relatively obsolete. Thus twelve older refineries were shut down and dismantled; the workers were dismissed. Havemeyers and Elder of Brooklyn remained as the nucleus of the Sugar Refineries Company. The new economics of operation brought in large earnings, and, according to the Havemeyers, the consuming public could buy sugar for less than it had cost before the merger.

With the formation of the Sugar Trust in 1887 Harry Havemeyer gained the reputation in business circles of being one of the most brilliant men of his generation.

The trust earned profits of $25,000,000 during its first two and a half years. As Louisine later recalled: "In or about the eighties a new form of industrial development attracted the eye of the business world and caused more excitement, I may truthfully say, than any long-tailed comet that ever appeared in the darkened skies. The so-called trusts!"[8] The Sugar Refineries Company was organized during the administration of President Grover Cleveland, one of whose close friends happened to be Harry Havemeyer. By ingenuity and force, Harry had achieved remarkable results; now, like a number of other magnates, he turned to the fine arts to show the measure of his success. His handsome profits gave him the leverage to consider old master paintings, which would be proof of the solidity of his financial empire.

Harry Havemeyer started his collection of old masters with two of the largest Rembrandt canvases to have arrived in America: portraits of Christian Paul van Beresteijn, Burgomaster of Delft (Plate 11), and his wife Volkera, perfect symbols of seventeenth-century Dutch materialism. He had seen these two Rembrandts at Cottier and Co., of 144 Fifth Avenue, where they were on exhibition during the fall of 1888. Many New York collectors were vying eagerly for these portraits, but Harry Havemeyer triumphed with the staggering offer to Cottier of $60,000. At the same time he bought Delacroix's *Flight from the Garden of Eden* (or *The Expulsion*) for about $10,000. With these purchases in December 1888, Harry began to collect paintings on a large scale.

At the same time Harry's civic conscience was also developing, a feeling that he should share his new treasures with the citizens of New York. In a newspaper interview immediately after acquiring the two Rembrandts, he said that he would offer the paintings as loans to the Metropolitan Museum of Art. If the museum committee accepted them and New Yorkers reacted favorably, he would even consider presenting the portraits, along with the Delacroix, as gifts to the museum.[9] The previous May, Harry had given the museum a portrait of George Washington by Gilbert Stuart, a work secured through Samuel P. Avery, a dealer and one of the founding trustees of the Metropolitan. Harry was on his way to becoming a respectable collector and patron of the arts.

As the Havemeyer family expanded along with their fortune and their collection, it became necessary to think about a more suitable dwelling. With the arrival of their third child, Electra, on August 16, 1888, and the steady accumulation of quantities of works of art, their brownstone house on East 36th Street had become too confining. The Havemeyers were ready for a larger residence farther uptown, in which they could display and appreciate the many objects they had acquired during the five years of their marriage. Unlike certain financial barons, who had amassed vast fortunes and then built extravagant imitations of European residences to symbolize their social status, the Havemeyers had their own taste and the courage to commission something different. They had no desire to construct an ostentatious château or palazzo, but they did want a spacious home. Harry's long-time acquaintances Louis Tiffany and Samuel Colman were perfectly equipped to provide designs for an altogether original house that would also meet the requirements of the family's way of living.

Just as Harry had pioneered in creating the Sugar Trust, so Louis C. Tiffany was

a pioneer in the field of American interior design. The firm he established was the first in the country to oversee every aspect of decorating and furnishing a residence. Tiffany's own tastes had been broadened during the 1870s by his many trips to Europe and North Africa: in Paris he had become acquainted with the recently discovered arts of the Far East, and in Morocco, Algeria, Tunisia, and Egypt the exoticism of the Moslem world had fired his romantic imagination. In all likelihood Tiffany knew of Whistler's famous Peacock Room in London, completed in 1877; he had seen Whistler's Primrose Room, installed at the 1878 Paris International Exposition. He must have admired S. Bing's display of Japanese ceramics at the same exposition and doubtless visited Bing's shops, where he found a large selection of treasures imported from the Orient.[10] Simultaneously Tiffany's friend Samuel Colman was actively acquiring Oriental porcelain and textiles.[11]

Tiffany was a painter by profession (a pursuit he continued for the rest of his life), but he began to see that he could also exercise his creativity in the decorative arts by expressing his love for color and exotic elements. He was tired of watching his compatriots follow the "sacred" rules of the Western European tradition; he wished to invent a style that would be suitable for the American mode of living in the "modern" industrial age. He felt that the time was ripe to infuse new vitality into the habitually stuffy, High Victorian interiors of the homes of his country's wealthy.

In the fall of 1878 Tiffany launched his first business venture—Louis C. Tiffany and Co., Associated Artists. Besides Tiffany himself, the group included two other painters: his mentor, Samuel Colman, specialist in color decoration and textiles, and Lockwood de Forest, expert in East Indian carvings and fabrics. A fourth member was Candace Wheeler, who supervised the execution of embroideries, "needlewoven tapestries," and loom weaving. Each of these associates was highly skilled, and all were determined to inaugurate a new era in decoration. By the winter of 1882–83, the reputation of Tiffany's firm had gained them the commission to redecorate several rooms in President James Garfield's White House.

Louis C. Tiffany and his colleagues grew famous for their flamboyant schemes of decoration, based predominantly on a blend of exotic motifs and objects with their own productions, such as glass tiles, mosaic wall panels, hand-blocked wallpapers, special lighting fixtures, painted friezes, and rugs and furniture made to order. They became acknowledged as the most artistic of the New York decorating concerns, although there were those—both architects and patrons—who preferred more fashionable decorators to the independent, often unorthodox Associated Artists. Yet the very individualism of each member of this group made it difficult to sustain their collective efforts; by 1883 everyone was going his own way.

Samuel Colman withdrew from the Associated Artists to devote himself to painting in his recently completed home in Newport, Rhode Island, designed by McKim, Mead, and White. Its decor was one of Colman's best efforts: carefully stained woods, Japanese leather-paper on the walls, Jacobean oak paneling, and unusual color schemes and furnishings for every room. The outside of the house was dignified and without affectation; the interior reflected the owner's advanced taste and displayed his distinctive collection to its best advantage. The Havemeyers were fascinated by Colman's Newport residence and kept its concept and appearance in their minds.

However, it was Tiffany who furnished the actual prototype for the Havemeyers' New York City home. The Tiffany family's apartment-mansion was erected by the end of 1885 at the corner of Madison Avenue and 72nd Street. Tiffany had decided upon a Richardsonian-Romanesque style and selected Stanford White (who had worked with Richardson) to build it, except for the entire top section, which Tiffany undertook himself. The resulting structure was Romanesque only in its accentuated massiveness and in the rough masonry of the two lower stories. There was nothing specifically Romanesque in its features other than its large arched entrance gateway. But the strong, imposing exterior was in great contrast with the sumptuous interior that Tiffany had produced in his living quarters and studio on the top floors. Within a traditional space Tiffany gave vent to his exuberant romanticism, using new and unconventional forms and techniques. The results were dazzling and unlike any other New York interior; they reminded one foreign visitor of the Arabian Nights. Louisine was enchanted. In the past several years she had become fed up with the unimaginative homes she was seeing: "I recall saying to Mr. Havemeyer one afternoon after paying a number of visits: 'I felt dizzy and confused as I was ushered into one room after another, for they were all alike. The popular decorator of the day has done them all with impartial similarity.' "[12]

Tiffany's bold and daring effects, such as his pierced Oriental screen-walls, his special lighting fixtures suspended asymmetrically from elaborate chains, and his organic free-standing chimney with its four-sided fireplace, all delighted Louisine. Here was a fellow American who had the ideas and the ability to create a totally new environment of subtle colors and rich textures, and could also incorporate treasures from the Old World. She did not want to bury the French paintings she already owned, and those she hoped to acquire, in some dim interior with maroon wallpaper and oversized walnut furniture like that in so many New York brownstones. From the moment Louisine saw Tiffany's apartment she knew she would take a chance and be original when her opportunity came. She expressed her attitude in her *Memoirs:*

> How often I have wished that those who are building new homes or decorating old ones would try and get away from the old moth-eaten Tudor embroidery or the heavy ornate gold of the French "red brocade period" and try to create something for themselves, or if that is not possible, have faith in someone who has the artistic ability and give him a chance to add another paragraph to art's long and intricate history.[13]

The Havemeyers had taken it for granted that the interiors of their new residence would be done by Tiffany and Colman, but at the end of 1888, when they decided to begin the actual construction, they were at a loss for an architect. It seems that Charles Haight was first suggested to them by Tiffany, whose new firm, Tiffany Glass Co., was then collaborating primarily with architects. In 1884 Tiffany had even worked with Haight on the conversion of the former Leonard Jerome house for use by the Manhattan Club. The Havemeyers were determined to build a house similar to the Tiffany mansion in the style of the Richardsonian-Romanesque revival. Harry liked the idea of solid construction combined with an austere, somber exterior that would give no clue as to

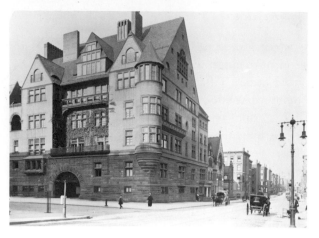
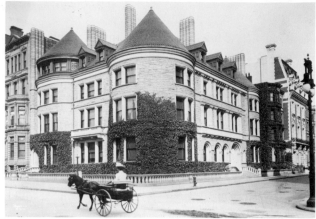

Top left: Tiffany residence, northwest corner of 72nd Street and Madison Avenue, New York. 1885 (now demolished). Architect Stanford White (top floor by Tiffany). This house was the prototype for the Havemeyer residence. Photograph courtesy of the Museum of the City of New York

Top right: Havemeyer residence, 1 East 66th Street, northeast corner of Fifth Avenue, New York. 1890 (now demolished). Architect Charles Haight. Photograph courtesy of the Museum of the City of New York, Byron Collection

Middle left: "Hilltop," the Havemeyers' country house in Connecticut, 1890 (now demolished). Walkway with extended veranda (at left in Tribune *illustration, below), built for the view and the breezes. Photograph courtesy of J. Watson Webb, Jr.*

Middle right: Arched fieldstone portal of the stables at "Hilltop," exemplifying the strong architectural detail. Photograph courtesy of J. Watson Webb, Jr.

Below: "Hilltop," designed by Peabody and Stearns. New York Tribune, *October 19, 1890*

what was going on inside. After all, he was a very private person who cared little for general society and believed "that a man had a right to the quiet enjoyment of his own home."[14]

Most of Charles Haight's previous work had been in the Victorian Gothic style, of which the best examples were his buildings for Columbia College. Haight had no particular affinity to the Romanesque concepts that Richardson had rejuvenated and transformed to meet the demands of "modern" living. Unlike Richardson, Haight felt no need for pioneering design, but was content to adapt historical features according to his conservative theory and make his buildings "shine with new gracefulness through old forms."[15] The neo-Romanesque style became so predominant in the 1880s, however, that Haight was inevitably induced to participate in it. Besides, clients like the Havemeyers did not come along every day, and to build a residence for them that would have interiors designed by Tiffany and Colman was a further challenge. Charles Haight accepted the commission for 1 East 66th Street.

Without being an innovator, Haight had the ability to select what was appropriate for a particular work and patron. He understood the Havemeyers well enough to design a house that had distinction in its simplicity and refreshing avoidance of architectural pretension. The vigor and massiveness of the ample front gave it a generally Romanesque character (in spite of round corner towers with bays that suggested the French Renaissance), as did the rough-faced stone of its rugged walls. The lateral expanse of the building contributed to the impression of solidity and permanence. Apart from the friezelike moldings between the stories, the only decorative features were the engaged columns on the two upper stories and the round archivolts over the central windows and front door of the ground floor. The house had the appearance of a medieval fortress, as if it were intended to protect the inhabitants from intruders. The arched doorway was placed discreetly on the 66th Street side; to enter, visitors had to mount a flight of shallow steps spanning a balustraded dry moat.

The construction of the Havemeyers' residence would not be finished until the spring of 1890, but preparations for the interior were begun well in advance. Although Tiffany was devoting the greater part of his time to his rapidly expanding glass business and Colman was pursuing his painting in Newport, the two were willing to work for their friends, who, they knew, would be the most cooperative of clients. Both men would now have an opportunity to carry out their concepts of interior design on a grand scale, down to the last detail. They also had an easy familiarity with the Havemeyers' taste and possessions, so similar to their own, since the quantities of Oriental decorative wares and artifacts that Harry had continued to buy still formed the larger part of the Havemeyers' collection. Tiffany and Colman had invented ingenious arrangements for displaying their own collections and the Havemeyers were confident that they would do the same for them.

Samuel Colman had encouraged Harry Havemeyer to purchase sumptuous Japanese textiles at the Philadelphia Centennial by telling him, according to Louisine: " 'Some day I will make you a ceiling out of those beautiful silks.' . . . In 1889, thirteen years later, Mr. Colman had all those remarkable stuffs sent to his home in Newport, where in his studio, with the help of many nimble fingers, he had them made into the design he wanted for the various panels of our library ceiling."[16] Colman had had a "dry run"

when he fashioned the Moorish design of his own library ceiling out of Japanese silks, but the Havemeyers' ceiling was to be even more spectacular. He would use what remained of these fabrics as backgrounds in glass cabinets containing Oriental potteries and porcelains. Nothing of beauty was ever wasted, nor was any expense spared: the cost of decorating the interior alone of 1 East 66th Street was to exceed $250,000. The magnitude of the project would keep the house from being ready until two years after the construction was complete, but meanwhile the Havemeyers were far from idle. Not only did they have their town house to contend with, but they also put Colman in charge of the interior decor for their new Connecticut residence, begun in May 1889 and ready for occupancy a year later, in June 1890.

Again, the Havemeyers knew exactly what they wanted: a country house modeled after Colman's Newport home, but on a much larger scale. Probably Colman recommended the Boston architectural firm of Peabody and Stearns, designers of villas in Newport for such clients as Frederick Vanderbilt and Catherine Wolfe. "Hilltop," the Havemeyers' house, was constructed on the highest point of Palmer's Hill, a ninety-acre site (which would be added to over the years) on the dividing line between Greenwich and Stamford, only a little over a mile from Long Island Sound. A three-story house, it had low, spreading proportions, numerous façades, high gables, and six large chimneys dominating the structure; the stables were an architectural complement to the house. The interior with its large well-lit rooms, numerous fireplaces of tile and brick, walls covered with Japanese papers of subdued tones, and delicately constructed furnishings designed by Colman, gave an impression of spaciousness, simplicity, and elegance. The dining room, modeled after those in seventeenth-century Dutch paintings (then Harry's favorite period), had dark paneling, a massive fireplace, and a floor of patterned tiles. As in Colman's house, the library was the principal room, with bookshelves, paintings, and musical instruments.

Across the road from the mansion, barns were constructed to house cows, chickens, and pigs. There were three long greenhouses filled with roses, gardenias, and orchids which soon began winning prizes for the Havemeyers at local flower shows. One section of a greenhouse was a "grapery," and fig trees were growing in big pots. Louisine, a dedicated gardener, took great pride in her award-winning specimens. The Havemeyers also planted acres of fruit trees and vegetables. They were delighted with "Hilltop" and spent much time there while waiting for their town house to be completed.

Harry Havemeyer Meets Mary Cassatt

Having commissioned the construction of his town house and country residence, Harry was more eager than ever to buy works of art, for he would soon have practically unlimited wall space. The purchases that had most pleased him so far were the two Rembrandt portraits, acquired in December 1888. They never failed to move him when he contemplated their individual expressions as well as their rich, resonant colors. After living with them for several months, he concluded that none of his other paintings satisfied him to the same degree as these. He must have more Rembrandts. Not one to do things halfway, Harry decided to look again at what was then considered to be among the finest Rembrandts in America, the portrait of Herman Doomer, the ebony worker and gilder in Amsterdam who had probably made frames for Rembrandt.

The Gilder, or *Le Doreur,* as it was called, had been purchased in Paris by a prominent New York art dealer, William Schaus.[1] In 1883 Schaus, struck by the picture at an exhibition of "One Hundred Masterpieces from Parisian Collections" to which the Duke de Morny had loaned it, had been able to obtain it from him for 210,000 francs (about $42,000). When, on the afternoon of December 27, 1884, Mr. Schaus invited the members of the New York press to a private viewing of his latest acquisition, *The Gilder* received an enthusiastic welcome. The well-known critic Clarence Cook, writing in *The Studio,* praised the dealer's courage for having brought such a significant work to America: "We honor the man Schaus, and are grateful to him who has the boldness and the liberality to assume the purchase of such a royal work, and bring it to a country not only so poor in masterpieces of art as ours, but where he might well doubt if his treasure would be valued at its worth."[2] The *New York Times* also expressed appreciation for Mr. Schaus's efforts: "Chances to study pictures of this kind are rare enough, and the art world ought to feel grateful to the man who has risked so large a sum as must be hazarded in the purchase of a picture so costly."[3]

Mr. Schaus had indeed spent a lot to acquire *The Gilder* because, in addition to the

purchase price, he had been forced to pay $12,500 in duty to the U.S. Customs. Many people thought that the heavy tax on old master paintings was totally unjustified and kept this issue alive for years, as evidenced in *The Collector* of 1892:

> Instead of being grateful to Mr. Schaus for bringing *The Gilder* across the Atlantic, what does our Government do but demand a tax of twelve thousand five hundred dollars on a canvas *painted prior to* A.D. 1700, the era which our Dogberries have fixed upon as the dividing line between free trade and high tariff! Not sure of his rights, or firmly believing that our Government would speedily repay what obviously was wrongly demanded, Mr. Schaus paid this money under protest some years ago. He still knocks vainly at the door of the United States Treasury. . . .[4]

Since in 1884 the tariff on works of art was 30 percent, Mr. Schaus had paid a total of almost $55,000 to secure *The Gilder.* By necessity he had to put a high price on it (reputedly between $70,000 and $100,000), which no doubt accounted for the painting being still in his possession four years later. In March 1889 Harry was finally ready to buy the celebrated picture, his most important single acquisition to date (Plate 12). Immediately after making the purchase, he decided to loan *The Gilder* to the Metropolitan Museum, where his other two Rembrandt portraits had been on exhibit for several months, since his city house was far from finished. On March 7, 1889, William Schaus wrote to Harry as follows:

> It is very generous on your part to loan *this Treasure* to our Museum. Please notice the words underlined. They express my intense feeling and opinion of this painting. You may well be proud in possessing "Le Doreur." As soon as possible I will get the desired document from the Duke de Morny. I am delighted that you are the possessor of the "Doreur" because you can appreciate it. Thousands will have an opportunity to see this Rembrandt when hundreds only would get a glimpse of it in my house.
>
> My parlor looks dismal without that Rembrandt. Its absence will cause me many a sigh. . . .[5]

Rembrandt would always remain the painter whose work aroused the greatest aesthetic response in Harry Havemeyer.

During that month Harry attended the Erwin Davis auction. Davis had by now assembled over 400 works, which more than filled both his Manhattan apartment and his country home; he decided to sell part of his collection (145 "modern" pictures) at the Fifth Avenue galleries of Messrs. Ortgies and Co. on the evenings of March 19 and 20, 1889. The Davis sale offered Harry a wide choice of fine-quality nineteenth-century French paintings—from works by well-known Barbizon artists to a few examples by Courbet, Manet, and even Degas—but he did not take advantage of the opportunity.

Although Harry was a devotee of the old masters, he realized that his wife's taste continued to favor the moderns. Knowing Louisine's fondness for the Venice pastels she had acquired from Whistler himself eight years before, he decided one day in March to stop by the gallery of H. Wunderlich and Co., on Broadway near Union Square,

to see an exhibition of Whistler's "Notes—Harmonies—Nocturnes." A contemporary newspaper account describes the experience of a visitor to this show:

> You go through Mr. Wunderlich's shop, you lift a portiere, and you find yourself in a little square, peachblow-colored room, over the walls of which are scattered, in little flat gold frames, all alike, a quantity of little *Notes* and *Harmonies*. There is a little peachblow vase [Chinese porcelain of a lustrous rosy shade] in one corner and a little light stand with catalogues in another, and that is all. The whole effect is extravagantly simple, and the diffused light and the strange color give one the impression that one is enclosed in the heart of some great pink lotus flower in the bottom of a lake.[6]

Harry responded favorably to this arrangement where Whistler's "Notes" entered into the general scheme of their surroundings. The room in the Wunderlich gallery seemed to have a kinship with certain interiors by Tiffany and Colman—and indeed their style of decoration had its genesis in Whistler's concept of a harmonious ensemble. After looking carefully at the sixty-two works on exhibit, he selected three watercolors and one pastel (Plate 13). Louisine was of course delighted with them and could not help but think how well these Whistlers would look in their new home. Shortly Harry again stopped off at Wunderlich's on his way back from the office, and this time, for a few hundred dollars, bought Whistler's *First Venice Set,* the twelve etchings that had been published by the London Fine Art Society in 1880. He was beginning to develop his own taste for Whistler's watercolors and etchings.

Harry's newfound interest in graphic arts may have prompted him to join the Grolier Club in 1889. This organization, founded five years earlier, had been named after the sixteenth-century French courtier Jean Grolier de Servières, one of the earliest great bibliophiles. The club's constitution defined its purpose as "the literary study and promotion of the arts pertaining to the production of books,"[7] but the Grolier Club also had numerous shows of prints, drawings, posters, pastels, and etchings. Several months after Harry had been elected a member, the club exhibited a selection of Whistler's drawings, watercolors, and pastels; among the lenders were Samuel P. Avery, Charles Freer, Howard Mansfield, and Harry Havemeyer.

The Havemeyers' steady acquisition of works of high quality and the prospect of moving to their new quarters suggested that they give away some of the works they had "inherited." One such painting (probably a gift from Harry's father) was a portrait of the world-renowned German naturalist Alexander von Humboldt, commissioned by a Havemeyer relative in Berlin in 1859 and painted shortly before Humboldt's death by Julius Schrader of the Berlin Academy. Louisine was very pleased when her husband decided to present it to the Metropolitan Museum in April 1889. The Havemeyers may also have given away, traded, or even sold other objects that no longer meant much to them. From now on, Louisine wanted to have only works that she or her husband truly loved and responded to. She thought that the best way to acquire some appropriate additions to their collection would be to go to Europe.

Louisine was longing to see Paris again; after all, she had not been there since her marriage in 1883. The birth of her three children (Adaline in 1884, Horace in 1886, and

Electra in 1888), Harry's formation of the Sugar Trust, and their building activities, among other involvements, had kept her close to home for six years. She had particularly missed Mary Cassatt, to whom she was eager to introduce her husband and children. Harry was also in favor of a trip to Paris in the summer of 1889 because he wanted to see the World's Fair, which had opened there on May 16 and within the month had already been seen by over two million visitors. He had read about some of the wonders of this Universal Exhibition: the largest building ever constructed under a single roof —La Galerie des Machines—providing displays of Western scientific progress; the collection of native villages showing the ways of life as well as the flora and fauna of five different continents; and the art section featuring a special picture exhibition to celebrate the centenary of the French Revolution. But most of all he was curious about the 984-foot Eiffel Tower; this iron structure had taken over two years to build and its controversial form had given rise to a petition (signed by forty-seven eminent artists, writers, and architects) stating that it would disgrace and disfigure Paris. Now that it was completed, some observers said that the Eiffel Tower looked light and graceful in spite of its gigantic size, and had a rather imposing appearance. Harry wanted to judge for himself if the tower was worthy of Paris. In addition to all these enticements, the city's boulevards were now illuminated by electric lights.

The Havemeyer family sailed for France in June 1889; they arrived to find all Paris excited about the Exposition, an unprecedented sensation that was drawing people from the world over. Like hundreds of thousands of others, they visited the fair again and again, but nothing attracted them as much as the "Exposition Centennale des Beaux-Arts" in the palace of the Champ de Mars. This splendid exhibition aroused enthusiasm on both sides of the Atlantic, as evidenced by the commentary in the *New York Times:* "It is a grand and wondrous manifestation, placing France far in advance of all other nations and reviewing for long years her prestige and glory. The collection is the result of the untiring energy and activity of M. Antonin Proust and it has been no idle or easy task."[8]

Monsieur Proust, minister of fine arts, had borrowed works from French museums and collectors, assembling an impressive group of masterpieces. Corot, with forty-five paintings, had the largest representation, but the exhibition also contained (thanks to the intervention of the vanguard critic Roger Marx) a few works by still-controversial artists. Such pictures as Courbet's *The Stone Breakers,* Manet's *Olympia,* Pissarro's *The Road,* and Monet's *The Tuileries* hung alongside paintings by established masters. Although the general response to the as yet "unproven" works was usually tentative, there was no hesitancy in Louisine's reaction; she was altogether pleased to find in such an important display canvases by the painters she had first come to admire as a young girl. Overwhelmed by some of these pictures, she stood before them intently, fixing every detail in her memory so she would be able to recall them whenever she wished. Eventually three of the paintings that she saw here for the first time (a Daumier, a Courbet, and a Manet) would end up in her possession.[9]

Yet as often as Louisine returned to the Exposition Centennale, she probably never visited the Café Volpini next door, where she could have seen works by a "Groupe impressionniste et synthétiste," consisting of close to one hundred pictures, drawings, and watercolors by Gauguin and his circle. Nor did she ever become interested in the

efforts of the younger generation of painters, here forced to organize their own show if they wanted to be seen at the World's Fair.

Harry was greatly impressed by the splendors of the exhibition, yet had his mind fixed on something else: the paintings he intended to buy at the forthcoming Secrétan sale. The auction of the renowned Secrétan collection had been carefully planned to take advantage of the many people who had come to Paris for the Exposition; prices were certain to be higher with American millionaires and foreign dealers bidding against one another. Monsieur Secrétan, a copper magnate in severe financial throes, was being forced by his creditors to disperse his works of art. It was to be a *vente judiciaire* (sale by court order), which meant that the owner could not protect his objects by buying them in or by withdrawing them at the last moment, but had to satisfy his creditors with payment in cash. The Secrétan collection, composed of nineteenth-century French works and Dutch and Flemish old masters, was greatly respected for its fine quality, and it received many tributes in the Paris press. A deluxe catalogue in French and English with a preface by the influential critic Albert Wolff had been printed for the auction, which was to take place on July 1 and following days. Excitement was running high among prospective buyers. A born competitor himself, Harry sensed the intense rivalry among the bidders; still he was determined to capture certain paintings.

It seems that the Havemeyers went to inspect the pre-auction display of the Secrétan collection as soon as they arrived in Paris, for it was there that Harry saw his first painting by Courbet, *Landscape with Deer* (Plate 14). Louisine pointed out this work to her husband, as she later reported in her *Memoirs:*

> He did not appear to be favorably impressed by it; I understand why not now. He was excited over the other pictures in the exhibition, many of which he intended to buy, and could not give the attention to the Courbet which it deserved. I recall that I expressed a desire for this splendid *Landscape with Deer,* and Mr. Havemeyer said to me: "Surely you don't want that great big picture." "But I do," I answered, whereupon he said: "Come over here and look at the DeHooch. That's the sort of thing to buy." You see, Mr. Havemeyer's expressions show that he had not yet reached Courbet. . . .[10]

Harry was attracted only by his favorite Dutch painters and a few choice works by already well-established nineteenth-century French artists. He asked Paul Durand-Ruel to bid on his behalf and gave strict orders to the dealer to go after what he wanted, regardless of price. Then he left on a business trip before the sale began, while Louisine remained in Paris and may have witnessed the event in the company of Paul Durand-Ruel.

The pictures sold on the first night of the Secrétan auction (July 1, 1889) were the "modern" French ones; the attendance was very large and the bidding spirited. The competition for Millet's *L'Angélus* (Plate 15) was the most heated, as there had been a patriotic movement to persuade the French government to keep such a national treasure out of foreign hands. Among the American contenders were Samuel Avery, in addition to a trustee of the Corcoran Gallery in Washington, D.C., and I. Montaignac, the agent of James Sutton; but the painting was finally knocked down to the

French Ministry of Fine Arts for the extravagant sum of $111,000. Sutton was so disappointed over his loss that he immediately offered to donate $10,000 to the poor of Paris if the ministry would resell *L'Angélus* at cost; his offer was rejected. However, after the French government refused to appropriate the money for the purchase, James Sutton ended up with the picture.

Harry differed from more conventional collectors in having no interest in the twenty highly coveted Meissonier paintings, which fetched substantial prices. The artist's *Cavalry Regiment under Napoleon I* went for $38,000 and *Priest Offering Wine* for $18,020, compared with an Ingres painting, *Oedipus and the Sphinx,* that reached only $1,400. Yet high as the Meissonier prices were, in certain cases they showed a loss: *Cavalry Regiment under Napoleon I* had been bought by Secrétan for $70,000, and was sold for only half that sum.

Durand-Ruel managed to obtain for Harry Decamps's *The Experts* ($14,000), Delacroix's *Othello and Desdemona* ($3,000), Millet's pastel *Peasant Watering his Cows* ($5,200; Plate 16), Ziem's *Canal in Holland* ($4,000), and a gouache by Decamps, *Jesus among the Doctors* ($5,700). By the next morning her husband had reconsidered, and he telegraphed Louisine saying, "Buy the Courbet," but he was too late—*Landscape with Deer* had been acquired by the Louvre the night before for $15,200. At the second auction Durand-Ruel captured the old masters Harry wanted, among them De Hooch's *The Visit* for $55,200 and two small panels by Hals for $9,000 each, portraits of Petrus Scriverius and his wife. The total for the two nights' sales was $1,124,213 and it was considered a success, though supposedly Monsieur Secrétan had spent twice that amount on his collection.

Upon his return to Paris, Harry was pleased with his purchases, but when he saw the Courbet that he had missed hanging in the Louvre, he realized his mistake. He immediately asked Durand-Ruel to find him another of similar quality. The task was not easy and the dealer could locate only one Courbet that was then for sale. As Louisine later admitted, "Our first purchase of a Courbet therefore was some cows in a meadow [Plate 17], a fine but not a remarkable Courbet, except that it led to many another picture by the great painter."[11] The experience had taught her husband an important lesson that he did not forget.

In spite of these exciting occurrences, the highlight of Louisine's visit to Paris was her reunion with Mary Cassatt. She was somewhat apprehensive about bringing her best friend and her husband together, since both had unusually strong personalities. But her fears were soon alleviated: "Although the year 1889, when I made my first trip to Europe after my marriage, was an important one for our collection, the most interesting event in it was Mr. Havemeyer's first meeting with Miss Cassatt. It resulted in a friendship which lasted through life. . . ."[12] From the start these two independent people respected and admired one another, and thus laid the foundation for a relationship that became mutually beneficial. The encounter took place in the apartment at 10, rue de Marignan, a block off the Champs Elysées, where Mary Cassatt had moved with her family in March 1887 and which she would maintain as her Paris residence for the rest of her life. The Havemeyers did not call on her until they had been in Paris for some time—undoubtedly the recent riding accident from which the artist was suffering caused

*Above: Fireplace in the Havemeyers'
dining room, 1 East 66th Street, New York.
1892. On mantel and above it, bronzes
by Barye; a Barye lion and
lioness crown the andirons*

*Right: Louisine and Harry Havemeyer,
Paris, 1889. She is wearing her new dress
designed by Charles Frederick Worth. At
Harry's urging, Louisine ordered several
fashionable gowns in Paris.
Photographs courtesy of
J. Watson Webb, Jr.*

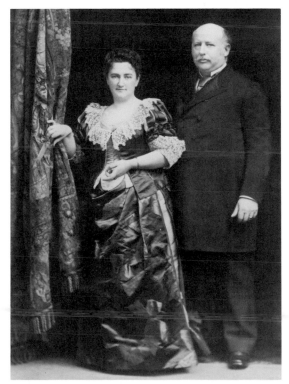

the delay. Louisine vividly recalled every detail of their meeting: "I found her in bed with a broken leg. Her horse had slipped upon the pavement of the Champs Elysées and she sustained a bad fracture of the leg. The poor creature was forced to give up work and lie still for several weeks. She was very dear and cordial. . . ."[13]

Louisine considered the meeting of her husband with Mary Cassatt significant not only in a personal sense but also for the future of their collection: "It is difficult to express all that our companionship meant. It was at once friendly, intellectual, and artistic, and from the time we first met Miss Cassatt she was our counsellor and our guide."[14] With great pride Louisine informed her friend that they had just bought a Courbet landscape. Cassatt immediately rallied to her side by contributing to Harry's indoctrination:

> "What a man [Courbet] was!" she exclaimed. "Just to think he wanted to pull down the Column Vendôme and actually saw it fall. The Parisians are prejudiced against him on account of that and he is not yet fully appreciated, but he is a great man in spite of his politics and they will have to acknowledge it later. . . . Do you remember the Exhibition we went to see years ago in the foyer of the Gaîté Theater? Wasn't it fine! those nudes and half lengths! I will look out for some for you! I should like you to have one or two good Courbets!"[15]

Louisine had now recruited her most valuable ally in increasing the scope of her husband's appreciation for modern art, though none of them, not even Cassatt herself, had any idea what her interest in the Havemeyers' collection would ultimately mean. In this summer of 1889, Mary Cassatt was just beginning her "lookouts."

It is probable that during their conversation Cassatt mentioned the large exhibition of paintings by Monet and sculpture by Rodin that was then being held at the Galerie Georges Petit. In all likelihood she urged her friend to see this retrospective of Monet's work, consisting of 145 pictures dating from 1864 to 1889, lent mostly by private collectors. In addition there were thirty-six pieces by Rodin in plaster, bronze, and marble. Perhaps Louisine visited this important exhibition, but she wisely realized that her husband was not yet ready for Monet; she herself was not particularly attracted to Rodin's sculpture.

Before leaving Paris to travel on the continent, the Havemeyers asked both Cassatt and Durand-Ruel to keep their eyes open on their behalf. Before long the dealer suggested Corot's large *Destruction of Sodom* (Plate 18), a dramatic landscape the artist painted for the Salon of 1844 and reworked in 1857. In his *Memoirs* Durand-Ruel tells how he sold it in 1873 to Count Abraham Camondo for 20,000 francs (about $4,000), bought it back after the count's death from his son for 100,000 francs in 1889, and shortly afterward sold it to Harry for 125,000 francs (about $25,000). The Havemeyers also purchased from him at this time Puvis de Chavannes's still larger *Allegory of the Sorbonne,* some fifteen feet long. Formerly called *The Sacred Grove,* this painting was a reduced version of the mural decoration the artist had made earlier that year for the great amphitheater at the Sorbonne. At the end of October 1889 Durand-Ruel sold to the Havemeyers for 1,500 francs (about $300) a Renoir pastel—*Young Woman Reading* (Plate 19), painted that same year—which he had just bought from the artist for 500

francs. (Later Louisine, who never cared for Renoir's work, would return this pastel to Durand-Ruel.) They also acquired from him a painting by Decamps, *The Good Samaritan,* as well as a Millet pastel, *The Temptation of Saint Hilarion.*

Louisine and Harry had planned to remain in Paris until early winter and doubtless would have made more acquisitions, but they were forced to return home sooner than expected, as Mary Cassatt informed Camille Pissarro on November 27: "The friends who were inquiring about [your] etchings were Mr. & Mrs. Havemeyer who bought so many pictures, they had the misfortune to have a child fall ill with mucous fever & were so anxious about her that they did not have time to see anything before they left. However I spoke to Durand-Ruel about it & told him to show them your etchings in New York."[16] In spite of this interruption, the year had indeed been an important one for the Havemeyers. Their purchases illustrate the catholicity of their taste at that time, ranging from famous old masters such as Rembrandt, De Hooch, and Hals to works by such contemporaries as Renoir, Puvis, and Whistler, without neglecting the earlier decades of the nineteenth century, represented by Corot, Courbet, Delacroix, Millet, and others.

Upon their return from Paris, the Havemeyers visited the "Barye Monument Exhibition" in New York, another large display of French art held to raise funds for erecting a monument to Antoine-Louis Barye in Paris. In addition to showing over five hundred of Barye's bronzes, plasters, waxes, oils, watercolors, drawings, and etchings, there were some one hundred paintings and thirteen drawings by Barye's friends and contemporaries: Géricault, Delacroix, Decamps, Corot, Millet, Rousseau, Dupré, Troyon, Diaz, and Daubigny. The show was managed by the American Art Association, which also supplied Millet's painting *L'Angélus,* recently acquired by Sutton.[17] The rest of the works were lent by American collectors, museums, and dealers; the four major contributors were William Walters, Cyrus Lawrence, James Sutton, and the Corcoran Gallery.

Harry already owned several Barye watercolors, but the show stimulated him to buy some bronzes from Durand-Ruel for the mantelpiece in the dining room of his new city house, and andirons, in the form of a lion and lioness, for the fireplace below. Eventually the Havemeyers owned a sizable group of the artist's paintings, watercolors, and bronzes, then considered a "must" by American collectors. The tremendous success of the "Barye Monument Exhibition" reinforced Harry's conviction that the best investment in nineteenth-century French art was in the works of the masters seen in that show. As far as he was concerned, he was on the right track, but his wife and Mary Cassatt had other ideas.

Harry Havemeyer as Purchaser and Patron

As a collector of old masters, Harry Havemeyer reached the peak of his activities from 1890 through 1892; his passion for Rembrandt and for other popular painters of the Dutch and Flemish schools remained unabated. Unlike certain American "connoisseurs" who were taken in by third- or fourth-rate seventeenth-century works or even outright forgeries, the pictures Harry assembled were of the finest quality. His selections were not casual; he was willing to pay very high prices and he dealt only with reputable galleries, in many instances Durand-Ruel. Although this dealer's name is most often associated with the Barbizon painters and the Impressionists, during the 1890s he took note of the predilection in the American market for Dutch and Flemish masters, trading actively in works by Rembrandt, Jacob van Ruisdael, Adriaen van Ostade, Pieter de Hooch, Gerald Terburg, David Teniers the Younger, and others. He became adept at hunting up available masterpieces still belonging to European nobility; Harry became equally adept at buying them, but he was by no means the only American collector benefiting from the European quest for the constantly ascending dollar. The novelist Henry James observed this phenomenon: "One takes . . . satisfaction in seeing America stretch out her long arm and rake in, across the green cloth of the wide Atlantic, the highest prizes of the game of civilization."[1]

American acquisitiveness eventually was to lead to bitter resentment on the other side of the "green cloth." European scholars became alarmed as an increasing number of national treasures were being drained from their countries (no laws then restricting such exports); museum directors were frustrated at being constantly outbid by dollar-happy Americans. Concern was voiced in the European press and scholarly journals: the renowned Wilhelm Bode, director of Berlin's Kaiser-Friedrich-Museum, wrote in *Kunst*

und Künstler about the "American Competition in the Art Market and Its Dangers for Europe," calling these new buyers "people who now represent the dread of European museums and collectors and who fill the columns of newspapers both here and over there with their deeds." Bode lamented that they tried to dominate the art trade, purchasing

> . . . entire collections through agents, middlemen, and negotiators of a special kind. As they assemble their trusts, they also endeavor to assemble their collections. . . . They need art as advertisement, for their surroundings, and as a distraction. They lack the time, the knowledge, and the leisure to collect themselves; they only have the money with which to obtain anything—so why not also create precious galleries and museums? . . . Those gentlemen from the iron trust stepped indeed with iron feet into the art market, stamping out the old order and creating a peculiar new one.[2]

Bode's special wrath was directed at J. Pierpont Morgan: "the most feared man and the one most besieged by sellers and intermediaries of today's art trade; at the same time the most splendid and until now the most successful speculator in the field of trusts, who has transplanted these also to Europe and, so to speak, has formed a trust of trusts." But Bode went on to mention, in contrast to such threatening figures, some of the respected, "old-fashioned" American collectors, who regularly traveled to Europe, learned to discriminate, and personally made their careful selections. Among these he named Henry Marquand and Henry Havemeyer:

> The special conditions which, in the eighties and at the beginning of the nineties brought numerous art objects of all kinds, such as old master paintings, onto the market or to auctions in Paris and London, were happily taken advantage of by some Americans, insofar as they were willing to pay somewhat higher prices as were then current in Europe. In this way Henry Havemeyer has assembled within a few years the paintings that adorn his very original house designed by Louis C. Tiffany which features a room with nine portraits [actually eight] from Rembrandt's hand.

Bode implied a basic difference between Harry's dedicated collecting and Morgan's arrogant, brash, and indiscreet manner of accumulating his hoard of treasures. Little did Bode know that—where trusts were concerned—Havemeyer was in the same league with the dreaded banker. Harry actually had preceded Morgan, in creating his Sugar Trust as early as 1887, whereas Morgan's activities became prominent only after 1898. According to Gustavus Myers's *History of the Great American Fortunes,* "strong, ruthless men, bold in cunning and cunning in their boldness, were required for the work of crushing out the old cut-throat, haphazard, individualistic competitive system, . . . forceful, dominating, arbitrary men, not scrupling at any means to attain their ends, contemptuous enough of law when it stood in their way, and powerful enough to defy it."[3] This description was applicable to both J. P. Morgan and H. O. Havemeyer except in the realm of art, where Harry retained his gentlemanly behavior while Morgan exercised the imperious methods of wheeling and dealing that he employed in the world of high finance.

Because Harry was frequently willing to pay considerable prices for what he wanted, the Durand-Ruels, during the early nineties, managed to tempt him often. In November 1890, they brought three superb Rembrandts to New York—two portraits of single figures and the artist's well-known *David Playing before Saul*—whose arrival was heralded by the American press. Harry purchased one of them, *Portrait of a Man: The Treasurer,* within the month. On view at Durand-Ruel's New York gallery were also Terburg's *The Glass of Lemonade* and the *Family Concert* by De Hooch, which Harry had bought earlier that year, together with two other works by that artist. Eager to give maximum exposure to these recent imports, the Durand-Ruels willingly lent their two remaining Rembrandt paintings and the picture by Terburg to a Union League Club exhibition in January 1891. The following month, Harry acquired the other Rembrandt portrait, that of an old woman (Plate 20), for $50,000. Although the third Rembrandt, *David Playing before Saul,* was acclaimed as a matchless example of the artist's work, Harry passed it up.

The Durand-Ruels often tried to point out the merits of certain works to Harry, as Joseph Durand-Ruel had done in a letter of July 18, 1890:

> We have now bought the Terborg [sic] *The Glass of lemonade* and hold it now; it was going to be bought by another amateur. Although you own some magnificent pictures of P. de Hooghe [sic] etc. you must not close up your house to some other masters, especially when it is an artist like Terborg who is considered by everybody as one of the very greatest and put in every collection on the same level as Rembrandt and half a dozen others.

But this time they did not succeed in persuading their client. He was adamant in his likes and dislikes, though the quality of his selections was undisputed.

Harry's preference was for single-figure portraits and landscapes or seascapes, with an occasional genre scene by one of his beloved Dutch artists. In *The Collector* of February 1892 a brief article on the Havemeyers' old masters emphasized their quality and their splendid condition, but by then their quantity had increased as well. The collection now held no fewer than five Rembrandt portraits, four paintings by De Hooch, and three works each by Hals and Teniers, in addition to a number of examples by Albert Cuyp, Willem Kalf, Pieter Codde, Jacob van Ruisdael, Jan van Goyen, Adriaen van Ostade, and Aert van der Neer; there was one picture each by Van Dyck, Gainsborough, and Watteau (bought in November 1890), a child's portrait by Greuze, and a Piazza San Marco scene by Guardi. Yet Harry had not limited his purchasing to old master paintings. Besides continuing to acquire Oriental porcelains and pottery, he began to collect Greek works: bronzes, terracotta figurines, glass, and coins. In the March 1891 issue of *The Art Courier* (an occasional supplement to *The Art Amateur*) the following was written about his Oriental and Greek objects: "When Mr. Havemeyer enters his new Fifth Avenue residence, art lovers will be astonished to see how beautiful are his Chinese and Japanese glazes, and how liberal and discriminating his purchases of Greek art objects have been. His cabinets will show, in particular, some fine terracotta groups of figures that are not even generally known to be in this country."[4]

Harry was buying most carefully, always keeping his new home in mind. It was

18. CAMILLE COROT. *The Destruction of Sodom.* 1844; 1857. Oil on canvas, 36 3/8 × 71 3/8″. The Metropolitan Museum of Art, New York (Bequest of Mrs. H. O. Havemeyer, 1929. The H. O. Havemeyer Collection)

19. PIERRE-AUGUSTE RENOIR. *Young Woman Reading.* 1889. Pastel on paper. Private Collection, U.S.A. (photograph courtesy of Galerie Durand-Ruel, Paris). Formerly owned by Mr. and Mrs. Havemeyer

20. REMBRANDT (now considered "Style of Rembrandt"). (left) *Portrait of an Old Woman.* 1640. Oil on wood, 28 × 24″. The Metropolitan Museum of Art, New York (Bequest of Mrs. H. O. Havemeyer, 1929. The H. O. Havemeyer Collection)

21. HONORE DAUMIER. (right) *Corot Sketching at Ville d'Avray.* Pen and ink over crayon, washed with watercolor, 12 1/2 × 9 1/2″. The Metropolitan Museum of New York (Bequest of Mrs. H. O. Havemeyer, 1929. The H. O. Havemeyer Collection)

22. SAMUEL COLMAN and LOUIS COMFORT TIFFANY. (left) Exterior of one door to entrance hall, Havemeyer residence, 1 E. 66th St., New York. 1890–92. Panels of glass, wood, and bronze. School of Art, University of Michigan, Ann Arbor (photograph by Dirk Bakker)

23. SAMUEL COLMAN and LOUIS COMFORT TIFFANY. (right) Detail, interior of one door to entrance hall, Havemeyer residence. 1890–92. Panels of Tiffany glass are surrounded by opalescent glass strips. Many of the pebbles embedded in the elaborate bronze frame were found on the beach by Louisine Havemeyer. School of Art, University of Michigan, Ann Arbor (photograph by Dirk Bakker)

24. LOUIS COMFORT TIFFANY. (above, left) Two elements of Mosaic Frieze, entrance hall, Havemeyer residence. 1890–92. Glass, each element 34 × 22″. Tiffany based his design on a classical motif, the Greek anthemion. School of Art, University of Michigan, Ann Arbor (photograph by Andrew Ross)

25. LOUIS COMFORT TIFFANY. (left) Peacock Mosaic, entrance hall, Havemeyer residence. 1890–92. Glass, 52 × 64 × 4″. School of Art, University of Michigan, Ann Arbor (photograph by Andrew Ross)

26. LOUIS COMFORT TIFFANY. (above) Portion of Balustrade around third-floor stairwell, Havemeyer residence. 1890–92. Gilt bronze, opalescent glass. School of Art, University of Michigan, Ann Arbor (photograph by Dirk Bakker)

27. EDWARD C. MOORE. Portion of set of silver flatware. 1883. As an engagement present for Louisine, Harry Havemeyer commissioned Edward C. Moore, artistic director of Tiffany and Co., to design a set of silver flatware in 1882–83. Moore's extraordinary set for twelve in hammered silver was adapted from Japanese models; he had learned the technique of producing silver in different colors from Japanese craftsmen recruited by Tiffany's. The initials of Louisine's maiden name (LWE) are in raised gold on the back of each piece. Owned by J. Watson Webb, Jr. (photographs by J. Watson Webb, Jr.)

28. LOUIS COMFORT TIFFANY. Ceiling fixture, possibly from billiard room in basement, Havemeyer residence. 1890–92. Leaded glass and bronze. The Neustadt Museum of Tiffany Glass, New York

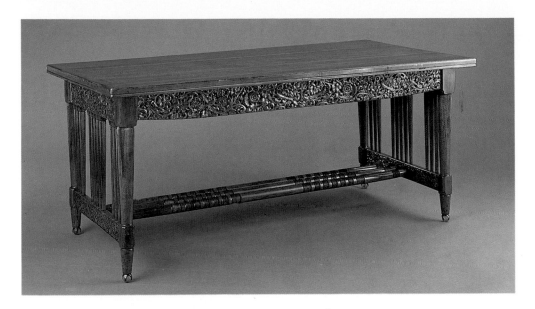

29. SAMUEL COLMAN and LOUIS COMFORT TIFFANY. Table in music room, Havemeyer residence. 1890–92. Stained wood with carved floral motifs, bronze claw feet. Shelburne Museum, Shelburne, Vt. (photograph by Ken Burris)

30. LOUIS COMFORT TIFFANY. Fireplace Screen, Havemeyer residence. 1890–92. Gilt bronze, opalescent glass; 40 × 44 × 2″. The colored glass rods and balls were designed to conduct heat into the room and to project kinetic colored light. School of Art, University of Michigan, Ann Arbor (photograph by Andrew Ross)

31. GUSTAVE COURBET. *Hunting Dogs.* 1856. Oil on canvas, 36 1/2 × 58 1/2″. The Metropolitan Museum of Art, New York (Gift of Horace Havemeyer, 1933. The H. O. Havemeyer Collection)

32. EUGENE DELACROIX. *The Lion Hunt,* 1861. Oil on canvas, 30 × 38 1/2″. The Art Institute of Chicago, Potter Palmer Collection (given in 1922)

no accident that he had acquired five single-figure Rembrandt portraits, for Samuel Colman had designed the library where the Rembrandts were to hang. Harry decided that a few more works by his favorite master were needed to complete what was to become "the Rembrandt room." Once again Durand-Ruel came to his aid; it must have been on Harry's behalf that the dealer approached the eccentric Princesse de Sagan (with whom he could deal only in cash) about her fine pair of Rembrandt portraits of a Dutch admiral and his wife, for which she was asking $100,00. In June 1892 the princess was vacationing in Trouville, and Charles Durand-Ruel went to see her, his pockets lined with bank notes. An agreement was reached and soon after Harry was informed of his latest accessions. Mary Cassatt was very pleased with these portraits; immediately upon her return from a trip to Italy, she wrote to Louisine:

> Poor dear Italy! I thought it sad and much changed! I saw nothing there more beautiful than the Rembrandts Mr. Havemeyer has just bought—what a marvel the woman's portrait is! [Théodore] Duret saw it with me and said he had never seen a finer picture. I wonder who the originals were! Certainly Rembrandt painted that woman before! . . . tell him [Mr. Havemeyer] that such a critic as Duret says that he has two of Rembrandt's finest portraits painted in his very best period. . . .[5]

Either then or soon afterward, Harry purchased a third Rembrandt from the princess: *Portrait of a Young Man in a Broad-brimmed Hat.* Now he felt that his library deserved to be called "the Rembrandt room," since its walls would be hung with eight splendid portraits, the only room of its kind in America. He would never buy another Rembrandt painting.

Although Harry's primary focus was on old masters, he did not neglect nineteenth-century French art. The Durand-Ruels kept him well supplied; their letters were filled with information about "modern" paintings they thought he should consider, but they restricted their suggestions to his clearly stated preferences. Between 1890 and 1892 they were particularly on the lookout for fine specimens of Decamps, Troyon, and Dupré. In February 1891 Harry acquired three works by Decamps, as well as Troyon's *Landscape at Sunset,* which Charles Durand-Ruel had purchased on his behalf for $2,900 at a recent auction of an American collection. In April Harry bought two canvases by Dupré. Previously, Louisine had convinced her husband to buy from Durand-Ruel a Daumier wash drawing, *Corot Sketching at Ville d'Avray* (Plate 21).

The Durand-Ruels did not limit Harry to their own gallery stock, but encouraged him to let them bid at auction if, in their opinion, the quality of a work warranted it. At the Barbedienne sale of June 3, 1892 (held at Durand-Ruel's Paris gallery), they bought a large Decamps pastel for 72,000 francs (about $14,400) and two Barye paintings, *Lion Resting* (9,400 francs) and *Tiger Lying Down* (7,100 francs); two weeks later, all three works were sold to Harry. Evidently Harry was pleased with Durand-Ruel's endeavors, for in January 1892 the dealer acknowledged his client's praise: "I have received your kind letter and thank you for the trust you put in me. I will do all that I can to always deserve it." The association was satisfactory for all concerned.

While Harry was waiting for the interior decoration of his new residence to be completed—a project which took almost two years, until the spring of 1892—he was

liberal about lending his pictures to certain institutions, particularly the Metropolitan Museum. (Later his attitude toward loans would change drastically.) From November 1890 to April 1891, fifteen Havemeyer pictures enhanced the walls of the museum: among them three Rembrandts, two portraits by Hals, De Hooch's *Dutch Interior,* Corot's *The Destruction of Sodom,* and *The Expulsion* by Delacroix. Elsewhere in the museum hung Puvis de Chavannes's large *Allegory of the Sorbonne.* From May through November 1891, twelve Havemeyer pictures were on display at the Metropolitan, including Harry's two newest Rembrandts: *Portrait of an Old Lady* and *Portrait of a Man: The Treasurer.*

Harry Havemeyer was a benefactor to this institution in more ways than as a lender. In the spring of 1891 a petition signed by 30,000 citizens demanded that the museum be open on Sunday for the working classes.[6] The trustees objected violently, mostly on religious grounds; they were afraid of losing the support of numerous churchgoing patrons just when heavy extra expenses would be caused by Sunday openings. Public pressure mounted, however, with most of the city's newspapers and numerous politicians advocating the measure. The trustees were forced to give in: May 31, 1891, became the first open Sunday. In terms of attendance the practice was a huge success. *The Art Amateur* of March 1892 reported the following figures: "Nearly 500,000 persons visited the Museum on Sunday afternoons during the seven months it was open on that day, and the total day and evening visitors for the year numbered 901,203."[7] But the first seven months of the Sunday openings resulted in a deficit for the museum. Money was solicited from a few of their sympathetic patrons, among whom was Harry; in 1892 he donated $10,000, specifically designated to support the Sunday openings.

It seems strange that, in spite of his continual benefactions, as well as his evident qualifications, Harry was not elected to the museum's board of trustees. When the question of his joining the board arose in 1891, Henry Marquand, president of that body, wrote on June 23 to Louis P. di Cesnola, the museum's director: "Havemeyer is a hard man to *get along with!* —though very knowing—I fear he won't do."[8] In truth, perhaps Marquand had enough difficult men to cope with, none more so than the relentless, obstinate Cesnola himself, who had been the museum's first paid director since 1879. Cesnola not only ran the museum with an iron hand, but also sat on the board as its secretary. Another powerful voice among the trustees belonged to John Pierpont Morgan, elected in 1888. His presence alone was enough to keep Harry off the board, no love being lost between the two tycoons. The origin of Harry's particular dislike can be traced to an unpleasant business association in 1882, after a fire had destroyed the Havemeyers and Elder refinery. In order to rebuild it immediately, "H. O. Havemeyer negotiated a pledge from J. P. Morgan and Company of a loan of $1,000,000 upon payment of a fee of $60,000. The money was never needed but no part of the fee was ever returned by Morgan."[9] Havemeyer never forgave Morgan his unbecoming conduct.

The Metropolitan Museum was not the only beneficiary of Harry's generosity during the early 1890s. In 1889 the American Fine Arts Society had been incorporated, formed by a coalition of five art associations: The Society of American Artists, The Architectural League, The Art Students League, The Society of Painters in Pastel, and The New York Art Guild. The driving force behind the establishment of this society

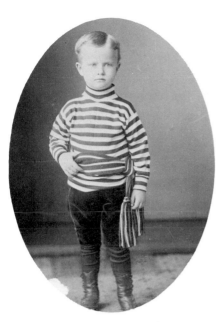

*Louisine and Harry Havemeyer's son, Horace,
age 5 (?), c. 1891. Photograph courtesy of
J. Watson Webb, Jr.*

*H. O. Havemeyer, patron of the arts, early 1890s.
Photograph courtesy of J. Watson Webb, Jr.*

*Above: Label for sugar packaged by Havemeyers and Elder. The firm
became the nucleus of the Sugar Trust and was reorganized
in 1891 as the American Sugar Refining Company,
its incorporation changed from New York
to New Jersey*

*Left: "Sovereigns by the Grace of Dollars."
Top row: "William A. Clark, the Copper King; Henry O.
Havemeyer, the Sugar Pope; William K. Vanderbilt, the Railroad
King." Bottom row: "Andrew Carnegie, the Steel King;
Pierpont Morgan, the Emperor of Trusts; William
Rockefeller, the Oil Divinity." German cartoon, 1903.
Courtesy of J. Watson Webb, Jr.*

was a small group of artists who had studied in Europe but did not belong to the National Academy of Design; they felt strongly that permanent exhibition space was needed for the city's younger, more progressive organizations. The painter Howard Russell Butler was elected president. His first concern was to raise funds to erect a suitable building for exhibitions, schools, and offices.

Butler began his campaign with an appeal for subscriptions. The list of subscribers was impressive but their actual contributions were insufficient. Aided by fellow artists Carroll Beckwith and Eastman Johnson, Butler began "an onslaught on the millionaires of New York,"[10] but found only eight who were willing to pledge $5,000: two Havemeyers, Harry and his cousin William F., George and Cornelius Vanderbilt, Andrew Carnegie, Collis P. Huntington, Charles L. Tiffany, and Darius O. Mills.

By January 1891 the *New York Times* reported that the American Fine Arts Society had been able to purchase a sizable tract of land on West 57th Street between Seventh Avenue and Broadway, with a northward extension to 58th Street, and that the foundations for the building had already been laid. Constantly rising costs of construction forced Butler to invent additional financial schemes to keep the operation afloat. At one point he was so desperate that he asked George Vanderbilt to come to the rescue, whereupon the latter bought a piece of the 57th Street property, donated the money to construct a picture gallery, and officially presented the society with this large exhibition space, known as the Vanderbilt Gallery.

The American Fine Arts Society's building opened on December 3, 1892, with a retrospective of American painting. This was followed by a special loan show from February 13 to March 13, 1893; the committee (on which Harry served) organized a superb selection simply by borrowing works from trustees and others associated with the society. A broad range of both European and American pictures was represented by a variety of schools and countries, extending from seventeenth-century Dutch painters to the Impressionists. The highlight of the exhibition was the Dutch paintings, according to the *New York Times* of February 12, 1893:

> The array of old Dutch masters is such as New York has never seen before, since Messrs. H. O. Havemeyer, Henry Marquand, and Morris K. Jesup of New York, Mr. Johnson of Philadelphia, and the art firms of Durand-Ruel, Cottier and Co., Schaus, Blakeslee, and others have lent their choicest. The famous *Gilder* by Rembrandt and a companion picture of an old woman are promised and doubtless hang this morning on the walls. . . .

Harry also lent one of his four paintings by De Hooch. In the early 1890s he was called upon repeatedly to exhibit his Dutch paintings, then at the height of their popularity in America, and it was particularly gracious of him to part with some of his favorite works, since the interior of his new house was now completed.

During this period Harry was indeed a busy man, actively engaged on many fronts. In the fall of 1888 the attorney general of New York had made objection to the Sugar Trust's attempt to absorb the North River Refining Company, but as a pretext for a much larger issue: that the Sugar Refineries Company (the trust formed by Harry

Havemeyer in 1887) was a "conspiracy and combination" to control arbitrarily the price of sugar against the interests of the people. In November 1890, a suit was brought by the People of the State of New York versus the North River Refining Company; as a result the Sugar Trust was declared illegal under a technical provision of the law stating that "no corporation, through its stockholders or otherwise, had power to give over its rights, powers, and duties to a board of directors."[11] This decision was considered a significant triumph for New York State against monopoly and corporate concentration.

Earlier that year the United States Congress had passed the Sherman Antitrust Act, which declared that any trust or combination was unlawful that prevented competition, restrained trade, or increased the producer's profits at the cost of the consumer. Since this law did not carry a heavy penalty, and was vague and subject to broad interpretation, it proved fairly ineffectual: the magnates succeeded in brushing aside most antitrust legislation, and the decade of the 1890s saw the formation of numerous industrial trusts. The case of the Sugar Refineries Company was one of the rare instances where the tenets of the Sherman Act were successfully enforced.

Harry soon plotted a new course of action. Within less than a year after passage of the Sherman Act, the Havemeyers and their associates reorganized their trust in New Jersey as the American Sugar Refining Company.[12] This new combination of over twenty refineries was incorporated on January 10, 1891; Harry Havemeyer was named its president and chief executive officer. By obtaining a charter across the Hudson River, the Sugar Trust escaped the heavier taxes imposed by New York State; moreover, New Jersey did not tax property that the company held in other states. A Senate committee investigating the affairs of the American Sugar Refining Company held several hearings, but the *New York Tribune* reported on March 25, 1891: "Nobody has seemed to know anything whatever about the trust's business, although the witnesses have included those most largely interested." Apart from some unfavorable publicity, the Sugar Trust had suffered no adverse effects; its profits were greater than ever, and by the turn of the century it would produce more than 50 percent of all sugar refined in the United States. The trust continued to acquire control of other corporations and to form new ones; after 1900 it would buy large interests in the sugar beet industry and also in Cuban sugar cane plantations.

Yet Harry may have paid a price for his business successes. The amount of newspaper coverage the Sugar Trust received from 1888 to 1891 could have been one of the factors that kept him off boards of trustees, such as that of the Metropolitan Museum. It was not considered proper that an art patron's business activities should repeatedly make front page news. As pressures increased, Harry's public manner became noticeably more severe, while his interests in art and music became the focal point of his private social life. He was at his most genial when he received his friends in his new house, where the sumptuous interiors and the dazzling display of the Havemeyer treasures wrought an effect in which he took great pride.

The Havemeyers Move into 1 East 66th Street

Harry Havemeyer was pleased with the interiors of 1 East 66th Street, but Louisine was thrilled with them. Tiffany and Colman had even surpassed her expectations. The family had moved into part of their house in November 1891; the remainder was not finished until the following spring. An amazing amalgam of Japanese, Chinese, Moorish, Byzantine, Celtic, and Viking elements had been skillfully blended into a gleaming yet harmonious atmosphere for the collection. As Louisine put it: "The whole house is a background for the objects it contains."[1] But what a background! Not one square inch had been neglected; Tiffany and Colman attended to every detail and no surface was left untouched. Walls, windows, woodwork, moldings, floors, ceilings, and lighting fixtures, all had been inventively designed. Their decorations as well as the custom-carved furniture corresponded with the soft tones of each room. The time and effort Louisine had devoted to working with the two experts resulted in a dramatic interior that reflected a highly individual and advanced taste. There were none of the European furnishings, hangings, and diverse trappings ordinarily imitated or imported for the homes of most American magnates. The Havemeyers' was a sophisticated interior, very different from the flamboyant showpieces of such notables as the Goulds, Vanderbilts, and Astors, who were too unsure of themselves to forsake the guarantee of Old World accoutrements, and who, unlike the Havemeyers, devoted much time to the endless endeavor of shining in New York society.

The Havemeyers' guests, after passing through double doors inset with squares of translucent glass (Plates 22, 23), were ushered into a spacious hall faced with mosaics (Plate 24) drawn from Byzantine chapels in Ravenna; the mosaic flooring was reputed to have at least a million and a half stones, and the elaborate marble staircase that

ascended the north wall was inspired by one in the Doges' Palace in Venice. Another feature of this dazzling entrance hall was the large rectangular Peacock Mosaic (Plate 25) over the fireplace, on the west wall between the doorways to the music room at left and the library at right.

Yet the most extraordinary feature of the mansion's interior was in the upstairs landing and picture gallery, the perforated metal "flying" or "golden" staircase, hanging from the ceiling by entwined open-work chains. Aline Saarinen has provided a particularly vivid description:

> A narrow balcony with an alcove ran around the second story of the picture gallery. The spectacular staircase was suspended, like a necklace, from one side of the balcony to the other. A curved piece of cast iron formed the spine to which, without intermediate supports, the stair treads were attached. The sides of this astonishing construction, as well as the balcony railing, were a spider web of gold filigree dotted with small crystal balls. The concept of a construction in space was revolutionary indeed for 1890 and its daring was dramatized by a crystal fringe on the center landing which tinkled from the slight motion when the staircase was used.[2]

This two-story gallery was filled with pictures and specially designed cases for the display of colorful Chinese porcelains and Cypriote glass. Between these cabinets were doors that opened into storerooms containing additional porcelains, Japanese decorative wares and artifacts, as well as paintings. One section of the gallery's skylighted top floor (the third story of the house) was devoted exclusively to watercolors.

Another of the house's most resplendent attractions was Colman's decorative scheme for the library, known as "the Rembrandt room." Louisine's own words best illustrate the enormous amount of work that had gone into the creation of her husband's favorite room:

> Mr. Colman made this library of ours a labor of love. He mixed the stains for the walls, he guided the Italians in their wood carving, he modeled the furniture to be reproduced first in wax, and taught the painters how to apply coat after coat of varnish, rubbing each one to a lovely amber transparency which gave it the value of a Chinese porcelain. Mr. Colman selected a piece of bronze he had long admired and a panel by the celebrated Japanese lacquer-worker, Ritsuo, as his inspiration. The softly rounded vase gave him suggestions for the woodwork and moldings, over which you could pass your hand without feeling an edge or outline. The Ritsuo panel, rich in color and of olive tones, he kept always before him, for he colored the oak himself, using the acid stains which he invented, obtaining astonishing results both in beauty and transparency.[3]

The decorative designs for the carved furniture and woodwork were based on Viking and Celtic motifs. Colman placed certain of the Havemeyers' finest Chinese bronzes on imaginative tripods heavily encrusted in blue and green; other specimens stood upon the low bookshelves and above the broad fireplace. Since Colman had conceived of the library as the room where Harry's cherished Rembrandts would hang, all eight portraits

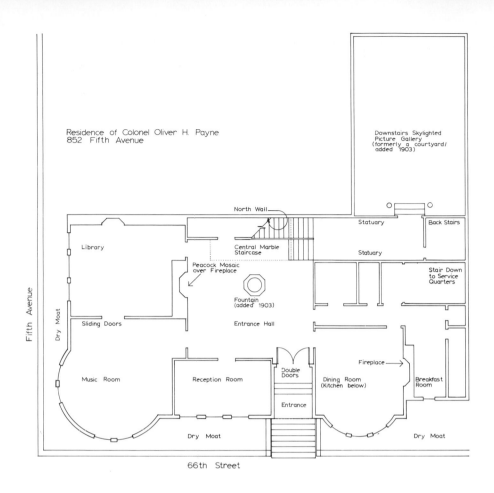

Residence of Colonel Oliver H. Payne
852 Fifth Avenue

Downstairs Skylighted
Picture Gallery
(formerly a courtyard/
added 1903)

North Wall

Statuary

Back Stairs

Library

Central Marble
Staircase

Statuary

Peacock Mosaic
over Fireplace

Stair Down
to Service
Quarters

Fountain
(added 1903)

Sliding Doors

Entrance Hall

Music Room

Reception Room

Double
Doors

Fireplace

Dining Room
(Kitchen below)

Breakfast
Room

Entrance

Dry Moat

Dry Moat

Fifth Avenue

Dry Moat

66th Street

Havemeyer residence, 1 East 66th Street, New York. Built 1889–90, decorated 1890–92.
Above: Plan of first floor. The skylighted picture gallery (at rear, right) and the fountain
with octagonal basin in the entrance hall were added in 1903. Below: Plan of second floor.
Drawings by Philippe Dordai, architect, 1985

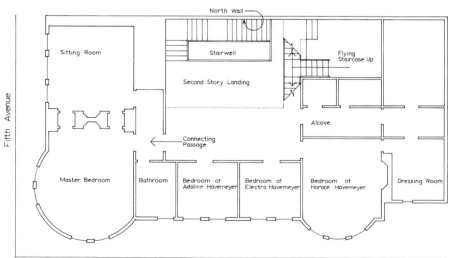

North Wall

Sitting Room

Stairwell

Flying
Staircase Up

Second Story Landing

Alcove

Connecting
Passage

Master Bedroom

Bathroom

Bedroom of
Adaline Havemeyer

Bedroom of
Electra Havemeyer

Bedroom of
Horace Havemeyer

Dressing Room

Fifth Avenue

66th Street

Left: Heavy double doors into entrance hall (see Plates 22, 23). 1892

Right: Third-floor gallery with glass cases, translucent skylight, and balustrades (see Plate 26). 1892. Tiffany's lighting fixtures were suspended asymmetrically on entwined openwork chains. Photographs courtesy of J. Watson Webb, Jr.

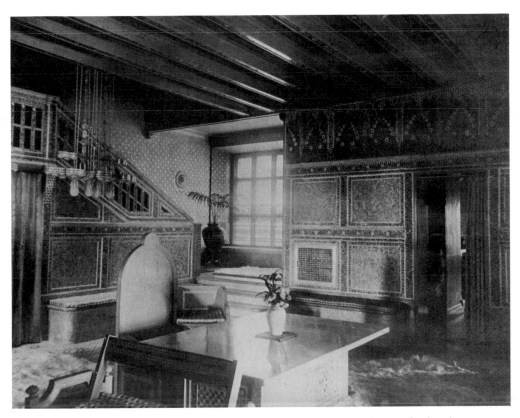

Entrance hall with marble staircase on north wall. 1892. The walls were faced with mosaics (see Plates 24, 25). In 1903 the window at the landing would be removed for a passageway to the new downstairs picture gallery, built in the former courtyard. Photograph courtesy of J. Watson Webb, Jr.

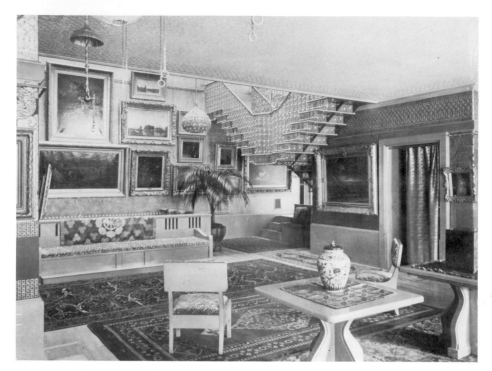

Second-floor picture gallery with "flying" staircase to third floor. 1892. Glittering crystal fringes hung from the staircase and tinkled when anyone walked across the staircase to look more closely at the paintings on the stair wall

Library, known as the "Rembrandt room." 1892. Paintings, from left to right: portraits of Scriverius and his wife, by Hals; Portrait of an Old Woman, by Rembrandt; an unidentified landscape; Portrait of a Man (van Beresteijn), by Rembrandt. On the desk are Chinese bronze jars, a fanciful Tiffany lamp, and Harry's violin case. Photographs courtesy of J. Watson Webb, Jr.

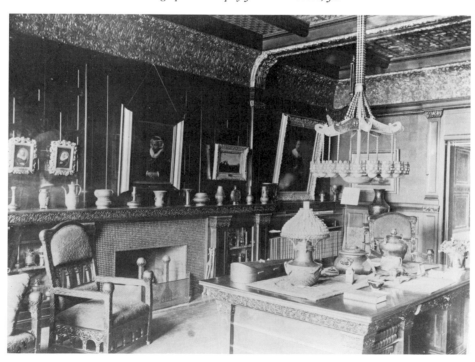

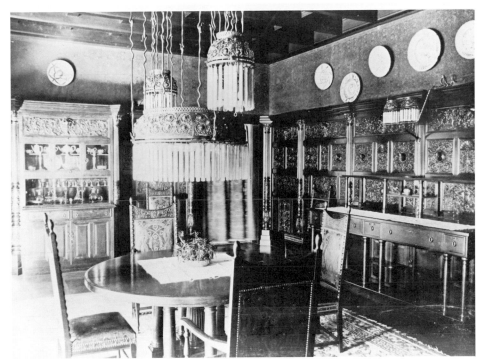

Dining room. 1892. Above the table hung a large bronze fixture with glass prisms, flanked by two smaller ones; other small versions were attached to the walls. Spanish lustered chargers decorated the space between the richly ornamented wall panels and the elaborate wooden ceiling. (For fireplace, see page 59)

Music room. 1892. The predominant tone of the decor was a subdued gold, accented by Tiffany's ice-blue glass chandeliers in the form of queen anne's lace. Sliding doors and portieres connected this room with the library. Photographs courtesy of J. Watson Webb, Jr.

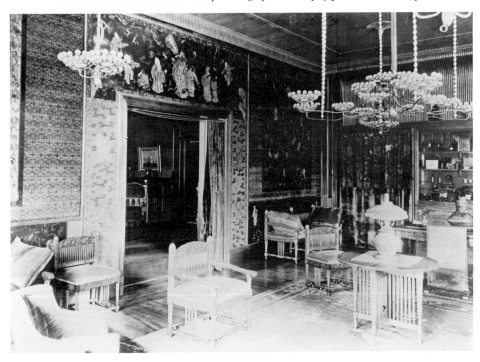

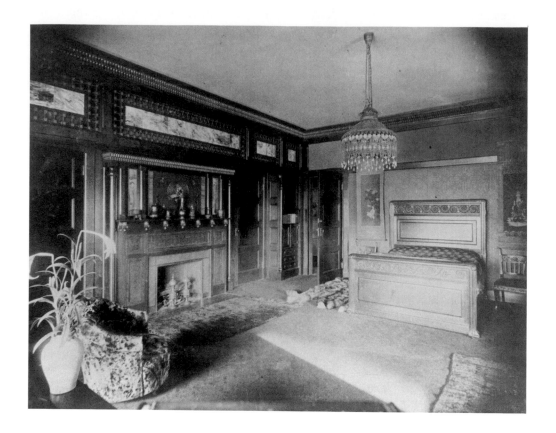

*Master bedroom, in the
round tower above the music room.
1892. Windows faced Fifth Avenue and
66th Street. The fireplace was two-sided,
to warm the adjoining
sitting room*

*Reception room, off the
entrance hall. 1892. Later this room
was hung exclusively with portraits
by Goya. Photographs courtesy
of J. Watson Webb, Jr.*

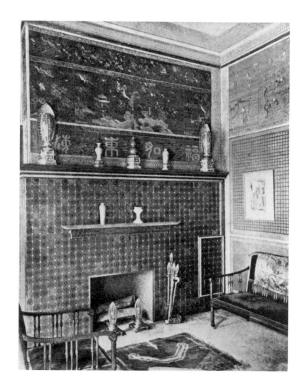

graced the walls, together with additional Dutch paintings, such as Hals's portraits of Scriverius and his wife and De Hooch's *The Visit*. A Byzantine-style pebble-and-glass chandelier suspended over the library table and a fanciful desk lamp contributed to the room's resonant luminescence. It was here, surrounded by his treasures, that Harry played the violin every morning before leaving for the office. As his wife later remarked: "Mr. Havemeyer's library was indeed his castle."[4]

But above these splendors was its ceiling, the library's focal point, composed of Colman's arrangement of lustrous Japanese textiles. His prodigious undertaking had been worthy of his efforts. Louisine subsequently exclaimed:

> How shall I describe the ceiling? It glowed like the rich mosaic of the East, like Saint Sophia and the splendid tombs of Constantinople, like the Palatine Chapel of Palermo, the pride of Roger of Sicily. Like them our ceiling recalled the art of the East both in color and in design. The interwoven pattern of Byzantine prevailed, and when all was completed and fitted into the several panels, the design was outlined by a heavy braid and it held the colors which were so beautifully distributed throughout. Many and many a time have I been questioned about this ceiling which was so full of beauty and brilliancy, so rich and yet so subdued.[5]

The ceiling was separated from the walls by an elaborate frieze inspired by ancient Scandinavian motifs.

The same care and attention to detail were evident throughout the house, from the dining room's hammered silver flatware embellished with flowers, insects, and crawfish, adapted from Japanese patterns (Plate 27), to the intricate filigree of an ornamental screen (Plate 30) and the numerous sets of highly inventive andirons and fire tools (see page 59). Each room was an imaginative composition of seemingly incongruous elements that, when placed together, spun a shimmering web. Colman and Tiffany had made an ultimate effort on their friends' behalf; besides, they found that the Havemeyers' sense for immaculate quality inspired good design.

Louisine took great interest in certain technical procedures and even went so far as to do some of them herself. She was so fascinated with Colman's special method of acid staining that for several years she continued to try it on various woods to see the different effects she could obtain. She also became intrigued by the technique of stenciling, and, taking a pattern from a Chinese rug, she busily stenciled it on the floor of one room, on some draperies, and even on a set of closet doors. Louisine had considerable expertise in displaying works of art; she loved the challenge of deciding which pictures should hang together and which porcelains, bronzes, potteries, and glasswares would enhance one another. She was in many ways part of the Tiffany-Colman team rather than merely its patron.

But her lasting hobby was backgrounds, a subject about which she felt very strongly, as did her two designers. They believed that the background had to be harmonious with the paintings hanging against it, rather than a strident element competing with the works themselves. Louisine was tired of "the murky red velvet which was in vogue with our dealers, and many amateurs also, who could not get away from the

enticing 'red satin brocade.' "[6] She would point with pride to her library's pale olive walls, which provided a sympathetic background for the Rembrandts. Her expertise in showing works to their greatest advantage would win her the admiration of such collectors as Henry Clay Frick, who once told her that his own pictures were not hung as attractively as hers. Many years later, when Mr. Frick was about to begin building his own Fifth Avenue mansion, Louisine good-naturedly offered to give him a few suggestions about backgrounds. Indeed, she became something of a decorator; many aspects of her home displayed the originality of her taste. To get away from the traditional black uniforms for her maids she designed chocolate-colored outfits for them and created a special gold-and-black checkerboard pattern for her coachman's buttons.

Louisine and Harry Havemeyer had an almost obsessive desire to avoid public notice and lead a quiet life; they had no patience with the external glitter of New York's social world. Just the same, the consistent quality of their collection and the effective blending of the works of art with their elegant surroundings made an invitation to 1 East 66th Street highly sought after. The Havemeyers' idea of entertaining had nothing to do with the lavish extravaganzas which took place in some of the luxurious residences lining Fifth Avenue. Shortly after their home was completed, they initiated what was to become their favorite form of socializing, their Sunday afternoon musicales. These events took place in their music room, which displayed Harry's Stradivarius and Guarnerius violins, violas, and cellos, used during the Sunday concerts. The music room had been designed around a collection of Japanese lacquer and Chinese embroideries; a subdued gold was the predominant tone. This time Tiffany's blue glass chandelier resembled an enormous bunch of queen anne's lace with intertwining stems that disappeared into the ceiling, and Colman's carved furniture (Plate 29) had been inspired by an old ivory inro, kept in a showcase in front of which the musicians played.

The concerts, beginning at precisely 3:35, usually presented solo performances and two quartets by well-known chamber-music ensembles. Sometimes Harry himself joined the musicians, and it was he who selected the performing artists and organized the programs. One of his favorite groups seems to have been the Kneisel Quartet of Boston, whom he frequently engaged. During the hour-and-a-half concert the guests divided themselves between the music room and the library, which were interconnected through sliding doors. According to Louisine: "As I looked around I would find the painters grouped about the Rembrandts, while the music lovers came early and made themselves cosy and comfortable in the warm sunlight of the western windows [of the music room]."[7] When the program was over, tea was served in the dining room and the guests were encouraged to wander through the house and enjoy its treasures. Homer Saint-Gaudens recalled these occasions with nostalgic pleasure:

When I was a small boy, I remember going with my father and mother to hear chamber music by the Kneisel Quartet at the Havemeyers in their Rembrandt Room on Sunday afternoons. There was a mingling of artists and men of both means and understanding of the aesthetics that I have failed to come across these days. There were painters like Thomas Dewing, architects like Stanford White, sculptors like Frederick Macmonnies, editors like Richard Watson Gilder.[8]

Louisine was a warm and enthusiastic hostess who immensely enjoyed answering her friends' questions, telling them stories about the works of art and pointing out special features designed by Tiffany or Colman. Harry, not the most sociable of men, would —as soon as he had fulfilled his obligations—retire to his wife's upstairs sitting room and wait for her. But both of them took great pride in the reputation their Sunday concerts acquired, and strove to maintain a high musical standard. Sometimes they gave musicales on a larger scale in the upper gallery. They were also at home to their friends and to properly recommended visitors on Tuesdays during the winter months. The Havemeyers' collection and the extraordinary interiors were hardly a disappointment on the days when there was no music.

One of their guests when their interiors had just been completed was S. Bing, the Parisian dealer in Oriental art who had been sent over by the French government for a survey of American art and architecture. In 1888 Bing's firm had opened a New York showroom where auctions of Oriental articles were conducted by his American representatives. It is most likely that Harry was among his clients, as were Tiffany and Colman. Since Bing and Tiffany were colleagues and found one another's ideas mutually stimulating, it was only natural that the latter would take his European associate to see the Havemeyers' house. Colman and Tiffany's successful blend of Oriental and Western forms was exactly what Bing himself was advocating: he thus greatly appreciated their achievement: "And, despite all this mixture, a visitor is overcome, upon entering, by a subdued atmosphere of peace and quiet."[9]*

Another foreign visitor, in the early autumn of 1893, was Wilhelm Bode, who was preparing a catalogue raisonné of Rembrandt's work. In addition to New York City, his month-long trip to America included Chicago, Washington, Baltimore, Princeton, and Boston, everywhere visiting both public and private collections. Before returning to Germany, Bode made the following statement in an interview for the *New York Times:* "I am quite sure that no other person owns eight examples of the works of Rembrandt as beautiful as the eight Rembrandts which are in one room of Mr. H. O. Havemeyer's house in the Fifth Avenue."[10] Bing and Bode were perhaps the first Europeans to admire the Havemeyer residence, but eventually the visitors included many foreign collectors, museum directors, ambassadors, and cabinet ministers. As Louisine later wrote: "Our collection as well as our house had a far greater reputation abroad than here, and strangers were deeply impressed by the work of Mr. Colman and Mr. Tiffany."[11]

With Louisine so immersed in the demanding and time-consuming activity of decorating her new home, the acquisition of avant-garde paintings did not receive top priority with her, and Harry was unquestionably the family's leading art patron during the early nineties. But his wife did manage to slip in a few works by the "moderns." Since Harry had already rallied to Courbet in the summer of 1889, Louisine thought that the purchase of additional pictures by him would likely meet with least resistance. This, however, was not the case when she wanted to buy her first half-length nude by Courbet, exactly what Mary Cassatt had said she should have but a far cry from the sedate Dutch portraits her husband was then acquiring.

In 1892, as Louisine walked into Durand-Ruel's New York gallery and saw the very

painting that Cassatt had lavishly praised to her more than a decade before at the Courbet exhibition in the foyer of the Théâtre de la Gaîté, she could not believe her eyes. Here again was that lovely, sensuous young girl with her raised arms holding a blossoming branch, and this time Louisine actually had the opportunity to own the work. She had Courbet's *Torso of a Woman* (Plate 33) sent home so Harry could see it; his immediate disapproval was evident, particularly because she was breaking their agreement not to purchase any nudes: " 'Surely you are not going to buy that,' he said. 'I should like to,' I answered. 'I shouldn't do it, if I were you,' he remarked shortly and left me."[12]

Louisine felt "firmly defiant," keeping the picture for a couple of days before returning it. When her husband noticed that the painting had disappeared and inquired as to its whereabouts, he was told that it had been sent back. Then he smugly remarked: " 'I knew you wouldn't want it.' " His complacent attitude was too much for Louisine to bear and she lashed out at him: " 'But I do want it. . . . I want it very much! It is one of the loveliest pictures I have ever seen, and if I had it I would keep it right there in my closet and not hang it in the gallery at all, but just go there and look at it alone by myself.' "[13] The following day the coveted Courbet nude arrived again at 1 East 66th Street with word from the Durand-Ruel gallery that Mr. Havemeyer had requested it sent home to Mrs. Havemeyer. Louisine's victory was total, for the painting was hung in the upstairs gallery rather than in a closet, and before long her husband came to appreciate its qualities to the point where, at a Sunday musicale, he took a friend over to the painting and said: "Next to the Rembrandts—my favorite!' "[14]

Louisine had a much easier time acquiring a landscape by Courbet, for her husband had never forgotten his mistake in passing up the artist's *Landscape with Deer* at the Secrétan sale. The Durand-Ruels were as eager as Mary Cassatt that the Havemeyers should purchase some great works by Courbet, and after Mr. and Mrs. Samuel Peters, Louisine's sister and brother-in-law (a collector of jades and Chinese porcelains), had visited their Paris gallery, Joseph Durand-Ruel wrote to Harry on July 15, 1892:

> I want just now to speak to you about three pictures which we have recently bought; I was going to write you about them anyhow, but Mrs. Peters insisted that I should tell you how much she likes those pictures herself. Mrs. Peters thinks that the Courbet is the finest work of this artist she ever saw. She told me she did not like very much as a rule Courbet's works, but that this one was unusually fine; indeed we placed that picture in the middle of the Rembrandts [the portraits recently acquired from the Princesse de Sagan] and it kept its place entirely.

The picture to which he was referring was a hunting scene (Plate 31), a subject Harry found to his liking. Just from seeing the photograph, the Havemeyers concluded that they wished to purchase it, and Harry immediately cabled to Durand-Ruel. Cabling as soon as he had made a decision was his customary practice of doing business; never a good loser, he did not want to risk having a work escape him once his mind was made up. By August 19, 1892, Durand-Ruel wrote that Courbet's *Hunting Dogs* would be included in his next shipment to New York.

The two other pictures offered to the Havemeyers at that time were Daumier's

The Third-Class Carriage and Delacroix's *Ophelia,* both works of the highest quality. The Havemeyers had seen a more finished version of Daumier's painting in Paris at the 1889 Exposition Centennale, lent by Count Doria. But in the summer of 1892, they were not able to make a decision from the photographs submitted by Durand-Ruel. Not buying Daumier's *The Third-Class Carriage* was a mistake Louisine regretted for many years; in 1913 she would eventually acquire it at the Borden sale in New York for a record-breaking price (see Plate 149).

It appears that the Havemeyers had made another trip to Europe in the spring of 1891. While there is no mention of it in Louisine's *Memoirs*, an entry in Durand-Ruel's Paris register refers to a Havemeyer purchase there in April of that year, the very month that Mary Cassatt had her first individual show at the Galerie Durand-Ruels'. It must have been during this otherwise unrecorded trip that the Havemeyers paid a visit to Degas's studio in the company of Cassatt. On this occasion Louisine apparently selected, for the price of $1,000, a small oil painting, *The Collector of Prints* (Plate 34), a choice that seems to have taken into consideration Harry's taste for portraits of men. Degas asked to keep the work for a while, because he wished to "add a few touches." Yet a year later Mary Cassatt mentioned this painting in a letter to Louisine: "By the way, Degas thinks most seriously of finishing your picture for you. However, when we see his drawings and his fine pastels, we forgive him everything."[15] Cassatt had been through this routine of Degas's before when she tried to get certain works away from him for her brother Alexander; but now Degas was particularly tenacious and, as time passed, even raised the price of the painting, a procedure Harry did not appreciate. As reported by Louisine: "It was of no use! Degas was quite stubborn about it, and the idea was so fixed in his mind that he was entitled to the increase in value that at last Mr. Havemeyer yielded. We felt that we were perhaps fortunate to get the picture back unspoiled, for Degas had a dangerous habit of retouching which sometimes spoiled a picture."[16] Degas held on to his canvas for even longer than Louisine remembered; on October 24, 1894, Cassatt would write to either Joseph or George Durand-Ruel: "I saw Degas, as Durand-Ruel [senior] had requested me to do before his departure, and I did all that I could to persuade him to give up the picture for the Havemeyers. I thought that was absolutely determined, but it seems that he hasn't yet done it."* Not until December 13, 1894, would the Durand-Ruels be able to send the Havemeyers their long-awaited *The Collector of Prints*. No wonder Degas acquired a reputation for eccentric behavior; even his admirers found it trying to do business with him.

Undeterred by such difficulties, Louisine did manage to purchase a few good examples of the new French school while her home was being decorated. Soon her task would become easier as these artists began to receive more favorable critical notice and encouragement in her country; indeed a small nucleus of American collectors had started to buy their works, especially those of Monet. The comprehensive loan exhibit at the Chicago World's Fair of 1893 was to bring "modern" art and Impressionism to the attention of a large body of Americans. It would not be much longer before Louisine was able to pick up speed in acquiring the paintings she so earnestly coveted.

Impressionist Progress in America

In spite of his wife's early interest in the Impressionists and Mary Cassatt's personal involvement with the French group, Harry Havemeyer's conservative nature prevented him from joining the first Americans who supported Durand-Ruel's protégés. Having no desire or ambition to be a pioneer in the field of art appreciation, he preferred to spend his money on works whose value was generally recognized, gladly leaving the Impressionist field to those collectors who had the courage to buy works of the new French school.

Americans, perhaps less encumbered by artistic traditions than the French, were receiving the Impressionists with greater sympathy than they had obtained in their native land. Since 1886, the year of Durand-Ruel's New York exhibition of "Works in Oil and Pastel by the Impressionists of Paris," a small coterie of American painters and patrons had become converts to this revolutionary movement and saw Monet as its leader. Some of these painters, such as Theodore Robinson (in 1887) and Lilla Cabot Perry (in 1889), had actually gone to Giverny to seek out the master himself; they in turn would later help bring Monet and Impressionism to the attention of their fellow countrymen. Meanwhile a few enlightened collectors had begun to feel that there must be something to this new art form and had started to purchase Monet's canvases. Erwin Davis, Albert Spencer, William Fuller, and Alden Wyman Kingman were among those taking the initiative in 1886, boldly acquiring a sizable number of Monet's works out of Durand-Ruel's show. Within a few years, Monet's popularity had taken hold on this side of the Atlantic and he was by far the most heavily represented of the Impressionists in American avant-garde collections.

By February 1891, one of Monet's most ardent supporters, William H. Fuller,[1] was able to organize the first one-man show of the artist's work in America at the Union League Club of New York. It was this club's policy to arrange monthly loan exhibitions, to which the public was admitted on the second Thursday. The weekly journal

L'Art dans les Deux Mondes made the following observation about the importance of the club's artistic activities:

> Each month, this group opens its galleries to a different display: sometimes the work of a single modern master, on occasion a particular school of painters, and at other times various objects, bronzes, tapestries. . . .
>
> This propaganda in favor of what is beautiful ends up forming the taste of the masses, and partly because of the exposure resulting from these exhibitions, American money is thus better directed, more soundly inspired, and rationally applied to great art productions.[2]*

At that time private associations, such as the Union League, the Century, the Lotos, and the Grolier clubs in New York and the St. Botolph Club in Boston, played a vital role in their cities' cultural life, particularly since their exhibition policies were more adventurous than those of the museums, controlled by staid trustees. On October 27, 1886, the same year as Durand-Ruel's innovative presentation, the Union League Club had already displayed two works by artists of the new French school at a reception for the delegates of the French government to the inauguration of the Statue of Liberty. The show, mostly of French pictures, contained one work each by Manet (*The Bull Fight,* now in the Art Institute of Chicago) and by Monet (*Mail Post at Etretat,* unidentifiable), both lent by Durand-Ruel.

The Union League's Monet show of 1891 was concurrent with a selection of paintings by old masters and works by more modern European and American artists, but Monet's thirty-four canvases were hung together in the large assembly room, the club's choicest exhibition space. Among the lenders were many of the artist's earliest and most enthusiastic American collectors: Catholina Lambert (of Paterson, New Jersey), Albert Spencer (who lent anonymously), Alden Wyman Kingman, James Sutton, Cyrus Lawrence, Erwin Davis, William Andrews, Alfred Pope (of Cleveland), and William Fuller himself; there were also loans from the Durand-Ruel and Boussod, Valadon galleries. William Fuller's pamphlet, written as a guide for visitors to the show, focused upon the extreme "truthfulness" in Monet's paintings that established him as the undisputed leader of the new "school of Naturalistic Art."[3] Fuller's appreciation was not shared by the majority of American critics, who frequently objected to the lack of finish and organization in Monet's pictures, which they attributed to his "ocular affliction."[4]

But Monet's small band of supporters was a devoted one and they continued their efforts to make the American public aware of his work. In the catalogue of Durand-Ruel's Monet–Sisley–Pissarro exhibition at the J. Eastman Chase Gallery in Boston, in March 1891, the section on Monet was written by the Bostonian Desmond Fitzgerald, another of the artist's staunch patrons. Fitzgerald, a hydraulic engineer and writer by profession, had been in Paris in the summer of 1889 and had made numerous visits to the large Monet–Rodin exhibition at the Galerie Georges Petit. He probably acquired his first painting by Monet in Paris. In March 1892, the second Monet one-man show in America took place at the St. Botolph Club in Boston, consisting of twenty-one

landscapes, all borrowed from local collectors; five of them belonged to Desmond Fitzgerald.

Durand-Ruel continued to send Impressionist canvases to his New York branch during 1891 and 1892, showing them together with works by more established artists. In February 1892, for example, the Durand-Ruel gallery (then located at 315 Fifth Avenue, at the corner of 32nd Street) displayed two paintings of haystacks in a snow-covered field and a landscape of the valley of La Creuse, all by Monet, in the same room with a selection of easel pictures by Puvis de Chavannes. One block down Fifth Avenue, at Boussod, Valadon and Co., it was also possible to see works by Monet from time to time. This firm of French dealers (successors to the internationally renowned Goupil Gallery in Paris) had opened their New York annex in the fall of 1888, the same year that Durand-Ruel had set up his establishment there; from then on American collectors and artists had more than one place where they could view Impressionist works.

In September 1892, Theodore Robinson's article on Monet appeared in *The Century Magazine*. Robinson was able to describe Monet's technique with authority, since he had often painted close to him while at Giverny. To dispel the widely held opinion that the artist's canvases were merely hasty sketches of vulgar subjects, Robinson insisted:

> To my mind no one has yet painted out of doors quite so truly. He is a realist, believing that nature and our own day give us abundant and beautiful material for pictures; that, rightly seen and rendered, there is as much charm in a nineteenth-century girl in her tennis- or yachting-suit, and in a landscape of sunlight meadows or river-bank, as in the Lefebvre nymph with her appropriate but rather dreary setting of "classical landscape."[5]

By the end of 1892 the art of Monet and his colleagues had established a firm foothold in America and was becoming a vital—if still highly controversial—issue. The year 1893 was to be crucial for Impressionism; an avalanche of interest in the new movement was brought about by the increased number of important exhibitions, beginning with Impressionist pictures displayed in New York at both Boussod, Valadon and Durand-Ruel's. In a room at the former gallery one wall had works by Dutch artists and another a selection of canvases by Monet, Renoir, Raffaëlli, Sisley, and Pissarro. As the editor of *The Collector*, Alfred Trumble, remarked, there was "something for everybody."[6] Durand-Ruel was showing a large number of Barye bronzes and works by Renoir, Degas, and Monet, as well as a few old masters and Barbizon paintings. Both dealers must have felt that "acceptable" artists gave an aura of respectability to their groups of Impressionist works, yet most critics' reaction to the newer canvases remained lukewarm. The reviewer for the *New York Times* was openly hostile to the Renoirs at Durand-Ruel's: "Renoir's figure pieces are somewhat hard to digest; his idea of the form feminine is dumpy and commonplace and the faces of the models are triumphs of dull vulgarity."[7] In Trumble's article on the show at Boussod, Valadon, he even suggested that Pissarro would benefit from a trip back to his native Buenos Aires, mistakenly thinking this to be the artist's place of origin. Only Monet and Raffaëlli received more favorable comments.

Another opportunity in New York to see Impressionist works came during the winter of 1893, at the loan exhibition in the Vanderbilt Gallery of the American Fine Arts Society. In addition to the dazzling array of old and modern masters, ancient bronzes, Oriental wares, and numerous decorative arts, lent by such collectors as Marquand, Altman, Havemeyer, Johnson, and many others (see page 68), the entire end wall of the newly opened gallery was given over to seven canvases by Monet and works by his fellow Impressionists. The *New York Times* was critical of giving these artists such a large representation: "Far too much wall space, for instance, has been accorded the modern French Impressionists, the open-air enthusiasts, who, because purples and pinks have been neglected in the paintings of the immediate past, see almost nothing else by way of colors, and ask to see nothing else."[8] But the pictures themselves benefited from their exposure under the best conditions they had so far received in New York; the recently constructed and spacious Vanderbilt Gallery, with its high ceiling and good lighting, showed off the works to great advantage. (George Vanderbilt himself had succumbed to the Impressionists; in February 1892 he had purchased from Durand-Ruel two Monet landscapes and three paintings by Renoir.)

The skepticism of some critics may have been one reason why, at public auctions, Impressionist paintings continued to bring relatively low prices in comparison with those reached by other modern French pictures. This discrepancy became evident when the collection of Henry M. Johnston of Brooklyn was sold on February 28, 1893; there were seventy-four paintings by Barbizon and various nineteenth-century European artists and only two by Impressionists. Jongkind's *Moonlight in Holland* went for $1,175, and *An October Day in France* by Cazin, who was a contemporary of the Impressionists, brought $2,500, whereas Monet's *Road by the Hillside* was sold to Boussod, Valadon and Co. for $550, and Pissarro's *Springtime* was knocked down to another dealer, L. Crist Delmonico, for $350. Theodore Robinson went to see the Johnston pictures prior to the sale, as he noted in his diary: "At Ortgies a collection to be sold—a good Monet, on the road near Falaise. Sunlight striking on side of hill. . . . A fine Pizarro [sic], naively and soberly painted. —a garden, two little figures, beyond, two houses and low-lying hills. There is a curious charm, sometimes almost inexplicable, in Pizarro. . . ."[9]

That a work by the more conventional landscape painter Jean-Charles Cazin (1841–1901) should have commanded a price four times higher than that paid for one by Monet is not surprising, because American art patrons were steadily being exposed to views such as those expressed by *The Collector:*

My contempt for such a man as Monet is the greater, because I believe he really can see and feel Nature honestly, and that he distorts her for sensational effect. His followers are a rabble, too ridiculous to be even contemptible. With Cazin it is a different matter. He is a painter of technical force, of a temperate and sensitive spirit, and of fine artistic fibre. The objection that has been raised to his work—that it lacks variety—is just; but its foundation is sound and its expression honest and unaffected. Between Cazin and Monet the difference is that of a man who paints Nature for love of her, and a man who paints her for love of the effect he may create. One of our painters, himself a man of conceded artistic eminence, summed

the case of Monet up very simply and effectively. "If," he said, "he sees Nature as he paints her, either his vision must be diseased or that of every other great landscape painter that ever lived; if he does not, he is humbugging the public."[10]

Yet some collectors who had the foresight to disregard the constantly vacillating comments of the critics took advantage of the low prices at which Impressionist canvases could be purchased. One of the most adventurous of these early buyers was Albert Spencer; in February 1888 he auctioned off his collection of sixty-eight Barbizon paintings for a total of $284,025, so that he could concentrate on the Impressionists. Montague Marks felt it necessary to reassure his readers in *The Art Amateur* that Mr. Spencer had not undergone a total change of taste: "Why Mr. Spencer sold his pictures remains unexplained. It is not true that he has become a devotee of the 'impressionist' cult. Mr. Spencer had a few examples of Monet and Pissarro before the sale and he has them yet. That is all."[11] But Albert Spencer had indeed become an avid devotee of Impressionism. In his diary entry of February 3, 1893, Theodore Robinson tells of his visit to the collector's home, in the company of two fellow artists:

> P.M. to Spencer's with Weir and Twachtman. Some fine pictures by Monet, Renoir, & Degas, a drawing by Millet, and a little Boudin. The Monet I liked particularly was this—a hill by the river—luminous yellow sky—two or three little islands—foreground reeds—the whole full of color and charming an uncommon fine example. A good Degas jockeys "pricking o'er the plain" with an uncommon small bit of landscape behind, hill-slopes with white chalk—pits or quarries. A Renoir—a lady on a garden seat—flowers in profusion—the face very sweet . . . —a fine nude (Renoir). . . .

Another collector whom Theodore Robinson would meet in 1893 was Potter Palmer, the real estate developer from Chicago. Although his wife is generally given credit for the advanced taste that their collection showed, Mr. Palmer was equally involved with its excellence. In 1890 Alfred Trumble had lavish praise for this art patron from the Midwest:

> The collection of pictures which Mr. Potter Palmer is forming in Chicago is commencing to attract the curiosity of the general public. Even before the fire [1871], Mr. Palmer was known as a purchaser of works of art, but it is of late years that his acquisitions have assumed their regal character. Native and foreign art combine in his gallery, and it is distinguished by high quality and a discriminating selectiveness that are more desirable than usual in extensive collections.[12]

Mr. Palmer bought primarily works by the French Romantics and Barbizon painters from dealers in Europe and America, but he also had a taste for some nineteenth-century American artists and European Salon painters. It was not unusual for him to bid at the more important New York auctions; at the Albert Spencer sale in 1888 he acquired one painting each by Millet, Diaz, and Rousseau. In March 1889 he bought at the Erwin Davis auction a work by George Inness and a still life by Antoine Vollon.

Through his association with Sara Tyson Hallowell, Potter Palmer may even have been ahead of his wife in taking notice of the Impressionists. Hallowell had been part of the cultural life of Chicago since 1873, when she was appointed secretary of the Interstate Industrial Exposition's art committee, of which Mr. Palmer was president. Her efforts had brought consistently high quality to the shows sponsored by this organization. Dividing her time between America and France, she was well aware of what was going on in the Parisian art world. Originally from Philadelphia, Sara Hallowell knew Mary Cassatt, who had probably introduced her to Durand-Ruel; Hallowell in turn seems to have presented Cassatt to the Potter Palmers. The two women encouraged the Palmers to acquire works by the Impressionists; the Palmers' first purchases—a Degas pastel, *On the Stage* (Plate 35), and a painting by Renoir, *Madame Renoir in the Garden* —were made from Durand-Ruel when the Palmers were in Paris in 1889.

Not long afterward, the enterprising Hallowell decided that the time was ripe to expose the people of Chicago to Impressionism. For the Industrial Exposition's art show of 1890 she borrowed eleven Impressionist works from Durand-Ruel—six paintings by Monet, four by Pissarro, and a pastel by Degas—which hung inconspicuously among five hundred other works. The following year Hallowell was appointed secretary to Halsey C. Ives, director of fine arts for the forthcoming World's Columbian Exposition (she had been offered the directorship but declined the honor, apparently thinking she could accomplish more as Ives's assistant). She had an official part in all art matters, from assembling works for certain foreign exhibits to helping Mrs. Palmer organize the Woman's Building, for whose south tympanum Mary Cassatt would be commissioned to paint a mural depicting "Modern Woman." Hallowell was also in charge of collecting pictures for the fair's special loan show of "Foreign Masterpieces Owned in the United States," a position of even greater significance.

When the Palmers visited France again in the spring of 1891, Hallowell met them there. Bertha Honoré Palmer, the most prominent figure in Chicago society, had come to Europe to promote the World's Fair generally and to solicit exhibits and special appropriations for the Woman's Building in particular, which was to bring together the artistic production of women from many nations. But whenever Mrs. Palmer could spare time from her duties as president of the Board of Lady Managers for the Woman's Building, she and her husband were expertly guided around Paris by Sara Hallowell; they visited artists' studios, galleries, and private dealers. From Durand-Ruel they bought eleven pictures by Monet and three by Boudin, and from Boussod, Valadon a painting of dancers by Degas for $969.

Once the Palmers were convinced that these were artists of genuine merit, they invested wholeheartedly in their work. In 1892, with Sara Hallowell as their Parisian agent, they purchased from Durand-Ruel some fifteen works by Monet, eleven by Renoir, seven by Pissarro, two each by Sisley and Raffaëlli, and one each by Degas, Cassatt, and Zandomeneghi; from Boussod, Valadon they acquired three by Monet and one by Pissarro. But most surprising were the Palmers' purchases of art more recent than Impressionism, by the radical younger generation. In 1892 they also purchased from Durand-Ruel one pastel by Louis Anquetin and one painting each by Maurice Denis and Paul Sérusier, all members of the group of Symbolist-Synthetist artists headed by Gauguin. The boldness of the Palmers' acquisitions made their collection the most

progressive in America. Bertha Palmer found it exciting to buy French avant-garde art, and she knew it would cause a sensation in her Chicago mansion.[13]

Sara Hallowell's work often led her to visit cities in America, and she was on the lookout everywhere for pictures worthy of the Palmers' attention. She was in New York in the spring of 1892 when the American Art Association was preparing an auction to settle the estate of their recently deceased partner, R. Austin Robertson; Hallowell was particularly interested in two pictures by Delacroix, one of her favorite artists. On her advice Mr. Palmer not only purchased them both—*Arab Cavalier Attacked by a Lion* for $6,350 and *The Lion Hunt* (Plate 32) for $13,000—but also three watercolors by Barye and one work each by Charles Jacque and Emile Van Marcke. In addition, he bought Millet's *In Auvergne* for $12,000.

During a trip to New York in December 1892, Hallowell called upon Erwin Davis, who, being in poor health, was selling off some of his collection. Not long before he had parted with a Degas painting of dancers (see Plate 8) that she had not been able to secure for the Palmers; she now wanted to make sure that they did not miss anything else. She also looked at some of Davis's Chinese embroideries in which she thought Bertha Palmer had been interested. But Mrs. Palmer wrote to her in New York on January 5, 1893:

> The Chinese hangings of which you speak are unfortunately not the ones of which I spoke to you. The piece that I remember with so much pleasure was a piece of Spanish embroidery, or Italian, on a violet ground or quite dark heliotrope, with a great deal of yellow in the design. I do not remember the embroidery now, clearly, but only that I considered it one of the most beautiful pieces that I had seen. The large Chinese piece I remember rather distinctly, and they are also more interesting, but there are and have been a number of them in New York. Mr. Havemeyer has a whole room furnished in them, and Vantine had a number which he sold at a very much more reasonable price than Mr. Davis asks.[14]

The Palmers shared Hallowell's appreciation of certain American artists; they owned works by George Inness, James McNeill Whistler, F. Hopkinson Smith, Eastman Johnson, George Hitchcock, and George Fuller, and were looking for others. On January 23, 1893, Theodore Robinson wrote in his diary:

> Potter Palmer called, said he came on Miss Hallowell's say—he was agreeably simple in his ways and words. Said he disposed of a few of his Monets he liked the least—he wanted "to buy pictures he wouldn't lose on" as the Monets and would have something of mine later, would come with Mrs. Palmer in Feb. or March—put my card in his hat, and bid me good-day. . . .
> He asked which Miss Hallowell liked particularly—the "Seine Valley" and considered it the most serious canvas. He liked the "Little Mill" and the "Girl at Little Bridge"—said it was "brilliant."
> I liked the way he spoke of Monet—whose personality and artistic conscientiousness seem to have impressed him.

Another event of that year recorded by Theodore Robinson was the exhibition of paintings and pastels by Monet, Besnard, Twachtman, and Weir at James Sutton's American Art Galleries, opening on May 3; in the show were both loans and works for sale. This was the first appearance of Besnard's paintings in New York; since the critics preferred his sentimental subject matter to that of the other three, he was given more favorable press coverage. Yet, Robinson confided to his diary:

> May 5, 1893. Exhibition at Sutton's—Twachtman's winter things look well—some of his best work. Weir figures are interesting. Some of the Monets delightful. a marine and a canvas of two crooked willows on a river bank. An interesting early view of Rouen rather like a Jongkind. Curiously neutral in color in comparison with his later work. especially a glorious "Antibes." A number of Besnards seemed poor and "fake-up." unpleasant in quality and color.

The sluggish recognition of the Impressionists in America was accelerated by their representation in the Loan Collection of "Foreign Masterpieces Owned in the United States," organized by Sara Hallowell at Chicago's World Columbian Exposition. As soon as she learned that the official French exhibit at the Chicago fair would display primarily Salon prizewinners, Hallowell decided to proceed independently: she would show off the advanced taste and knowledge of certain American connoisseurs by exhibiting a selection of their modern French pictures. Only a person with Hallowell's special skills could have managed such an ambitious undertaking: she had to have a discriminating eye for deciding which pictures should be requested, and great tact and diplomacy in inducing their owners to participate.

Thriving on the challenge she had set for herself, Hallowell started gathering the loans in the fall of 1891. Her travels took her all the way from Boston to St. Louis, with stops in New York, Philadelphia, Washington, Baltimore, and Cleveland. She benefited from the friendly relations that she had with many of the American owners of important French pictures; she drew upon these contacts to help her get what she wanted. Although she may have met the Havemeyers previously, she now recruited Mary Cassatt's help.

Sara Hallowell had reason to expect that Harry Havemeyer would be reluctant to part with any of his paintings. Montague Marks, in the December 1892 issue of *The Art Amateur,* wrote pessimistically: "It is feared that . . . Mr. H. O. Havemeyer and . . . Mrs. W. H. Vanderbilt cannot be counted on. In the case of the former it would almost be too much to expect that this gentleman's splendid new mansion, certain rooms of which have been especially constructed to receive certain paintings, should for nearly a year be despoiled of an integral part of its decoration."[15] But Harry could not say no, once his wife's closest friend had stepped in. On January 6, 1893, Mary Cassatt informed Durand-Ruel: "At the request of Miss Hallowell, whom I had sent to him, Mr. Havemeyer has loaned his large Corot [Plate 18] and the Courbet [Plate 31] that you sold him last summer."*

At the time of the fair, Sara Hallowell felt with justifiable pride that the Potter Palmers' was the most distinguished collection in the country, and from it she borrowed fifteen paintings, mostly Barbizon and a few Impressionist works. She purposely limited

the total number of her more modern selections lest she be accused of having gone overboard. She exhibited only fourteen Impressionist pictures: four by Monet, three each by Manet and Pissarro, two by Degas, and one each by Renoir and Sisley. In addition to the Palmers' loans, she borrowed works from Alexander Cassatt and Frank Thomson in Philadelphia, in New York from Albert Spencer and from the dealer James Inglis of Cottier and Co. She was careful to include paintings by well-established artists: Carolus-Duran, Cazin, Couture, Fromentin, and Fortuny. She even borrowed some works by renowned artists whom the French had left out of their official exhibition of 550 paintings, such as Gérome, Meissonier, and Dagnan-Bouveret.

The World's Columbian Exposition officially opened on May 1, 1893, with an address by President Grover Cleveland before a crowd of nearly half a million. Approximately 150 buildings rose on 550 acres facing Lake Michigan in what is now Jackson Park. The exposition, commemorating the quadricentennial of Columbus's discovery of America, had taken two and a half years of planning and construction. The "White City"—gigantic and elaborate glistening white pavilions in Beaux-Arts classical style, designed by ninety-seven architects—thrilled and amazed the millions of visitors. With the extension of the railroad systems, Americans were now more mobile and the number of tourists at the "White City" was greater than at any previous national event. For the first time the general public was able to witness current international trends; this led to a new cultural awareness.

In spite of the enormous quantity of works from many nations on display in the huge Palace of Fine Arts, Sara Hallowell's Loan Collection of 126 foreign masterpieces attracted great attention from the beginning and was considered the jewel among all the exhibits. The reviews were mixed, but Hallowell had established the fact that Impressionism was here to stay. Her effective blending of fine works covering the entire gamut of French nineteenth-century art presented convincingly the concept that Impressionism had been a natural outgrowth from its predecessors. Her show also confirmed the pervasive influence that Impressionism had on artists in other countries. The movement could no longer be dismissed as the whims of a small band of French artists whose work was being passed on by a handful of dealers; the Impressionists appeared unquestionably as the international leaders in a revolutionary approach to painting. The critic and novelist Hamlin Garland was among those who recognized their far-reaching significance:

> Every competent observer who passed through the art palace at the Exposition was probably made aware of the immense growth of impressionistic or open-air painting. If the Exposition had been held five years ago, scarcely a trace of the blue-shadow idea would have been seen outside the work of Claude Monet, Pissarro, and a few others of the French and Spanish groups.
>
> Today, as seen in this wonderful collection, impressionism as a principle has affected the younger men of Russia, Norway, Sweden, Denmark, and America as well as the *plein-air* school of Giverny. Its presence is put in evidence to the ordinary observer in the prevalence of blue or purple shadows, and by the abundance of dazzling sun-light effects.[16]

But for every step forward there seemed to be another one back; the next blow was delivered surprisingly by Montague Marks, even though he was Sara Hallowell's friend and former champion. In September 1893 Marks, the editor of *The Art Amateur*, heretofore one of the most progressive art journals of the early 1890s, regressed to the worn-out argument already employed ad nauseam by every foe of Impressionism:

It would be very interesting if we could have a report from some oculist of repute as to the actual condition of the eyesight of Monet, Pissarro, Renoir, and others of the "impressionist" school. The measure of its departure from the normal might account for much of the mystery—if mystery there really is on this much-debated subject. For my own part, I grow less and less inclined to believe that there is anything distinctive in the so called "impressionism" of to-day. . . .

Bye and bye, pictures may be painted and sold to fit the special sight of prospective owners. Indeed, the time may come when every picture at an exhibition will bear a tablet instructing the visitor at what distance he is expected to view the painting; and in the case of the work of acutely myopic "impressionists," the visitor may be invited to "drop a penny in the slot" of the frame [for] the use of a binocular glass which will spring out, ready focused, to suit the picture before him.[17]

Such negative reactions had not enough power to block the impact of Impressionism, however, once it had been seen by a large segment of the American press and public. More people were now conscious of the movement, and in the not-too-distant future it would come into its own among the art-oriented citizens of America. Yet one of those who still needed a push in this direction was Harry Havemeyer; like Montague Marks, he maintained his reservations about the soundness of the new art. Harry's attitude was reflected by his acquisitions from the Durand-Ruels during 1893: expensive works by Barbizon and Romantic masters. Among his purchases for that year were a painting by Troyon valued at $45,000, a landscape by Dupré for which he had paid $20,000, and a charcoal drawing as well as a pastel, *Peasant Children at Goose Pond* (Plate 36), by Millet. Although willing to take risks as a businessman, Harry preferred to put his money into "blue-chip" pictures rather than to speculate on the avant-garde.

Harry's prudent policy was reinforced by the severe financial depression in the United States that was then causing high unemployment, business bankruptcies, and bank failures. This economic crisis temporarily stunted the rise in value of Impressionist paintings. A letter from Camille Pissarro to his son Lucien, dated October 3, 1893, provides some information on the French view of the rather bleak American art scene:

I went to see Chène [a dealer located on the rue de la Paix] on arriving, we talked about everything. Chène told me that America is finished in terms of pictures, bankruptcy is everywhere. A gallery just went bankrupt in New York; Chène lost something in it, you can well imagine how discouraged he must feel. So nothing can be expected from that end. He assured me that Durand [-Ruel] was leaving for New York and that he would feel the effects of the overall situation. Very

worried, I went to see him. Seemingly very calm, Durand received me most cordially and told me he was leaving for New York in eight days.[18]*

Paul Durand-Ruel's trip to America in the fall of 1893 would be his first after a four-year absence. During that time his New York branch had been competently managed by his three sons, who, from the beginning, had established a fine reputation, as indicated by a tribute in *The Collector:*

> One sees but little of Mr. Durand-Ruel himself here these days, but he is ably represented by his sons, to whom has been communicated much of those qualities which in their father make him a conspicuous figure in the world of art. They, like him, regard art with a personal as well as a commercial eye. It is not enough to sell a picture with them, but also to know and love the picture that they sell. The vast and varied information of their father has also a reflection in themselves. Curiously enough, with all the keen refinement of their Gallic education, that education which renders it possible for men to be the shrewdest of businessmen without ceasing to be gentlemen, they combine a thoroughly American energy, rapidity of ideas and execution, which do not occur commonly under the slower business conditions of Europe.[19]

Unfortunately, Charles Durand-Ruel, the middle son, had died suddenly in September 1892. He had been the head of the New York branch and his presence was deeply missed.

The combination of the loss of his son and the precarious financial conditions made it necessary for Durand-Ruel to look into the situation on the American side of the Atlantic. He also wished to see the Chicago World's Fair, scheduled to close in November. Upon arriving in New York, Durand-Ruel decided it would be wise to exhibit works of internationally acclaimed and admired artists, reassuring his American clientele with "safe" investments. During the late fall, his Fifth Avenue gallery displayed pictures by Puvis de Chavannes, Breton, Dupré, Corot, and Decamps. The only Impressionist canvases on view were by Claude Monet.

When the French dealer visited the recently completed Havemeyer mansion at 1 East 66th Street, Harry must have shown with pride his collection of established masterpieces, which in many instances Durand-Ruel had helped him acquire. As far as Harry was concerned, he was on the right track, and he had no intention of becoming involved with "experimental" art. Durand-Ruel could look around the house with a sense of satisfaction, having urged his client to take advantage of every favorable occasion when it presented itself; he was also astute enough to see that this was not the time to encourage this strong-willed American to extend his collection to include the Impressionists.

Durand-Ruel had better luck during that difficult year with another client, Harris Whittemore (1864–1927), son and heir of John Howard Whittemore, industrialist and owner of an iron manufacturing firm. As so often before, part of the credit for these sales went to Mary Cassatt, who had met Harris Whittemore in France that spring.[20] It seems that Harris Whittemore, of Naugatuck, Connecticut, was introduced to Cassatt by the husband of his first cousin, Clinton Peters, an aspiring artist who had gone to

Paris to study in the studios of Gérome and Lefebvre. Long before meeting Cassatt, the young Harris Whittemore had taken an interest in the work of the Impressionists, and especially Monet, on his occasional visits to France during two years of study in Germany in the early 1880s. In 1890 he had bought from Durand-Ruel, in Paris, Monet's *The Church at Vernon;* the following year he acquired there, this time on his father's behalf, two more landscapes by the artist—*A Gust of Wind* (Plate 38) and a haystack in mist—each at about $1,000. Early in 1892 Harris bought from them a painting from Monet's Creuse River Valley series, dominated by rocks and hills and lashed by elemental forces of nature. Whittemore's next purchase was made in December 1892 from Boussod, Valadon; this time he selected for his father Monet's *Haystacks in the Morning Sun,* for which he paid $1,250.

When, in Paris in 1893, Whittemore responded enthusiastically to Cassatt's own work, she sent him to the Durand-Ruel gallery where he chose one of her canvases of a mother and child; soon afterward he expressed the wish for a second Cassatt painting, but the artist herself counseled him to wait, as she wanted him to have her "best efforts." During this same trip, which was actually the young Whittemores' extended honeymoon, he bought from Durand-Ruel two works by Degas, two by Manet, and one more by Monet. In spite of her cordial relationship with the Durand-Ruels, Mary Cassatt could not resist the temptation of obtaining pictures by her fellow artists at a bargain rate. Consequently, she put Whittemore in touch with the modest dealer Arsène Portier, who lived and worked out of his apartment in Montmartre. From him the young collector acquired a riverscape by Sisley, *The Dam of the Loing at Saint-Mammès* (Plate 39), as well as works by Degas and Morisot, for a total of 3,100 francs (about $620).[21]

During the rest of 1893, Harris Whittemore remained a regular client of both Boussod, Valadon and the Durand-Ruels. In June he purchased from Boussod, Valadon, among other works, three Monet canvases, and a painting of dancers by Degas, the last one for $1,400. In December he chose three pictures from the Durand-Ruel gallery: one each by Pissarro, Monet, and John Lewis Brown. With Mary Cassatt's encouragement, Whittemore continued to acquire Impressionist paintings and gradually assembled an exceedingly well-selected collection that he hung in his unpretentious house in Naugatuck for the private pleasure of the family and their intimate circle.

A close business associate and long-time friend of John Howard Whittemore's was Alfred Atmore Pope, who was founder and president of the Cleveland Malleable Iron Company. Mr. Pope shared with the Whittemore family an advanced interest in the Impressionists. As early as 1889, Alfred Pope had bought three landscapes by Monet from Boussod, Valadon's New York branch, paying the record price of $3,240 for two of these. His next Monet paintings, one from Durand-Ruel and one from Boussod, Valadon, were acquired during 1891. Mr. Pope lent two of his Monets to the Union League Club exhibition of February 1891, in New York. In 1892, after purchasing two more Monets, he decided to buy works by other Impressionists as well, such as a Degas pastel, *Jockeys* (Plate 37), and a landscape by Sisley; all four came from Durand-Ruel. The following year he went back to Boussod, Valadon, obtaining Pissarro's *Path above Pontoise* for the relatively small sum of $350. Alfred Pope's other known expenditures during 1893 were for still another Monet landscape from Durand-Ruel and for a

painting by Degas, *Dancers* (see Plate 8), the very work that had belonged since 1881 to Erwin Davis, who had sold it the year before to Cottier and Co.

Mr. Pope seemed willing to lend his Impressionist pictures whenever asked; the "Cleveland Art Loan Exhibition" in January 1894 was composed primarily of works by old masters, French academicians, and Barbizon artists, but it also featured Alfred Pope's startling loans: two pictures by Monet and one by Degas. This show was so successful that the Cleveland Art Association was formed to sponsor annual exhibitions.

Alfred Pope went to France in the second half of 1894, but there is no evidence that he met Mary Cassatt, whose painting *The Family* (see Plate 48) he had recently returned to the New York branch of Durand-Ruel after keeping it for only three months (the collector and the artist did not meet until 1898, on one of Cassatt's rare visits to America). Camille Pissarro, in a letter of October 21, 1894, to his son Lucien, provides an account of Mr. Pope's activities: "I ran into Vollard . . . [Ambroise Vollard, who in 1893 had opened a small gallery on the rue Laffitte], he told me the story of this American who came to Paris to find a beautiful Manet at any cost, if the painting met his expectations. All the dealers were exhausted from looking in every corner for the pearl. Finally this nabob purchased *Woman with Guitar* [*The Guitar Player*; Plate 40] from Durand-Ruel for 75,000 francs [about $15,000]. Amazement far and wide!"[22*] In September 1894 Pope bought other works from Durand-Ruel's Paris gallery: a marine by Monet, a Manet drawing, and an etching by Cassatt.

Meanwhile, on the other side of the Atlantic, the year 1894 saw a recovery in America's economy and, in consequence, in the progress of the Impressionists. An indication of their growing popularity was the increasing number of American dealers who entered the field; the exclusivity that Durand-Ruel and Boussod, Valadon had enjoyed now slowly came to an end. One of the "newcomers" was L. Crist Delmonico, who for some time had been buying low-priced Impressionist pictures at auctions. In January 1894 the Delmonico Gallery, at 166 Fifth Avenue between 21st and 22nd streets, presented an Impressionist exhibition of at least three works each by Monet and Sisley, and two each by Pissarro and Renoir. Even the more conservative gallery M. Knoedler and Co. began to purchase Impressionist pictures. Another dealer who saw the potential of this school was James S. Inglis, a partner and—after the death of Daniel Cottier in 1891—president of Cottier and Co. But the most voracious patron of the Impressionists, and particularly of the works of Monet, was James Sutton of the American Art Association. Ever since the partition sale and reorganization of his firm in the spring of 1892,[23] Sutton had been increasingly buying and selling Impressionist pictures. Not only were the walls of his home covered with landscapes by Monet, but also an enormous inventory of the artist's work filled his gallery. In September 1893 Pissarro informed his son: "Sutton, the big American dealer who has one hundred and twenty Monets, has become Durand's rival, they are competing at our expense. . . ."[24*] By 1895 Sutton would withdraw from active participation in the American Art Association (while retaining a financial interest) and deal full-time in Impressionist art. From then on the association became exclusively an auction house managed by Thomas E. Kirby.

Faced with mounting competition on all sides, the Durand-Ruels decided to expand their facilities. For the third time since 1888, when they had opened their first New York branch, they moved a little farther uptown, to the former Lorillard mansion at 389 Fifth

Avenue, on the corner of East 36th Street; their new landlord was H. O. Havemeyer, owner of the mansion, which was remodeled to accommodate the Durand-Ruels. The firm's inaugural exhibition in November 1894, attended by Durand-Ruel senior, consisted of works by old masters and paintings by Boudin, Corot, Courbet, and Daumier, as well as some recent Impressionist canvases. On November 3, 1894, the *New York Times* printed its most favorable review of Impressionism to date:

> . . . Pissarro powerfully ornamental, characteristic, and special; Degas who paints dancers and spectators in motion; Renoir, inimitable designer of little slight women in all the gracefulness of the "mièvrerie" that the eighteenth century liked, but with an enthusiasm as a colorist that only Delacroix had before him expressed; Sisley and Miss Cassatt have struggled valiantly with nature. They have tried to paint trills, ambient air, the transparency of foliage, complicated plays of light, and the human element in nature as it is, uncertain, awkward, forming a mass wherein disappears the conventional importance of the face. Their works form, with Monet's and those of two or three others in the Durand-Ruel galleries, a Salon of individualists of undeniable merit.

By the end of 1894 these artists of "undeniable merit" had made a significant breakthrough, both critically and financially. They began to earn wider appreciation among dealers, critics, and collectors. This must have been reassuring to Harry Havemeyer, who was finally ready in 1894 to abandon many of his Barbizon and Romantic favorites and at last concern himself with the Impressionists.

A Crisis, Followed by Numerous Acquisitions

During 1894 Harry Havemeyer was again deeply embroiled in business entanglements. He had been accused of trying, through substantial campaign contributions, to influence Congressional legislation benefiting his American Sugar Refining Company. On June 12 he went to Washington, where he testified before a special committee of senators appointed to investigate the Sugar Trust. Although he conceded having frequently lobbied on behalf of his interests, he insisted that the methods he employed were well within his rights. He frankly admitted that it was customary for trusts, corporations, and wealthy individuals to contribute periodically large amounts for the "politics of business," and that in state campaigns it was common practice to give these sums to the dominant party.[1] Nevertheless, one of the senators requested additional data on all money, national and local, donated by the American Sugar Refining Company in every state during 1892 and 1893. Harry asked to consult his counsel; when he next appeared before the committee he declined to submit his company's books for examination and to answer any further questions. As a result, the case was sent to the grand jury of the Criminal Court of the District of Columbia, which, in October, issued an indictment against Henry O. Havemeyer, president, and John E. Searles, secretary, of the Sugar Trust. In addition to the accusation of donating large sums of money with strings attached to election campaign committees, the indictments clearly stated what the grand jury contended was the motivation behind such gifts:

> The Grand Jury . . . finds that, on February 1, 1894, and for three years prior thereto, the refining company had been extensively engaged in the business of refining sugars, and, by reason of the act of 1890, had been able to fix a price of

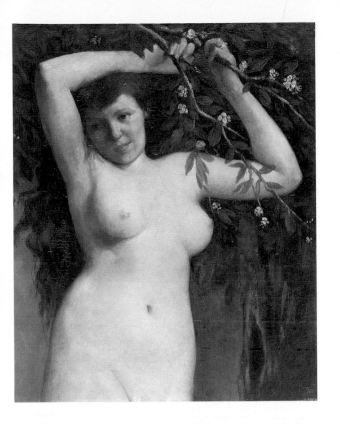

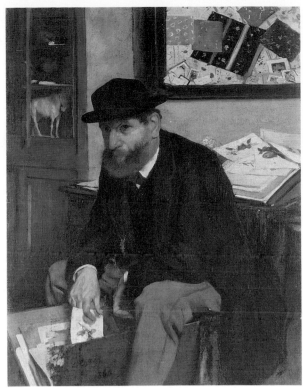

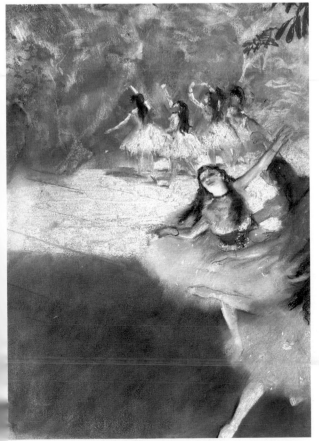

33. GUSTAVE COURBET. (above, left) *Torso of a Woman.* 1863. Oil on canvas, 29 1/2 × 24″. The Metropolitan Museum of Art, New York (Bequest of Mrs. H. O. Havemeyer, 1929. The H. O. Havemeyer Collection)

34. EDGAR DEGAS. (above) *The Collector of Prints.* 1866. Oil on canvas, 20 7/8 × 15 3/4″. The Metropolitan Museum of Art, New York (Bequest of Mrs. H. O. Havemeyer, 1929. The H. O. Havemeyer Collection)

35. EDGAR DEGAS. (left) *On the Stage.* c. 1880. Pastel over monotype on paper, 22 1/2 × 16″. The Art Institute of Chicago, Potter Palmer Collection (given in 1922)

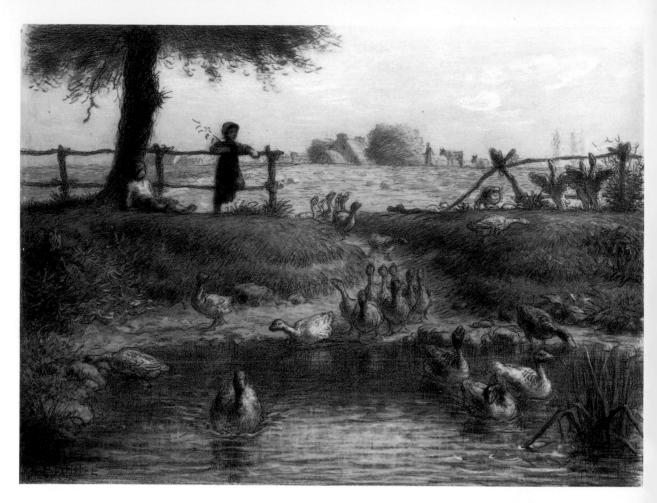

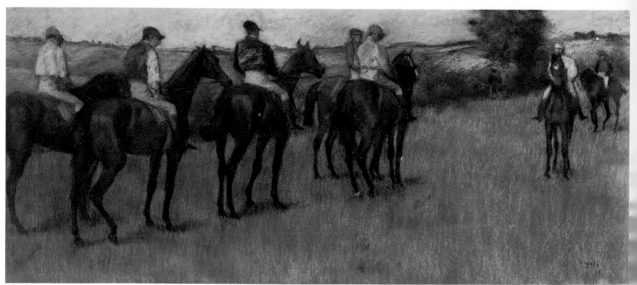

36. JEAN-FRANÇOIS MILLET. (top) *Peasant Children at Goose Pond.* c. 1865–68. Pastel on paper, 15 1/4 × 20 1/2″. Yale University Art Gallery, New Haven (Gift of J. Watson Webb, B.A. 1907, and Electra Havemeyer Webb). Formerly owned by Mr. and Mrs. Havemeyer

37. EDGAR DEGAS. (above) *Jockeys.* 1886. Pastel on paper, 34 × 15 1/2″. Hill-Stead Museum, Farmington, Conn. Formerly owned by Alfred A. Pope

38. CLAUDE MONET. (left) *A Gust of Wind.*
1881. Oil on canvas, 31 7/8 × 25 3/4″. Col-
lection Galerie Marumo. Formerly owned by
Harris Whittemore

39. ALFRED SISLEY. (below) *The Dam of the
Loing at Saint-Mammès.* 1885. Oil on canvas,
15 1/4 × 22″. Collection Mr. and Mrs.
Alan Seligson. Formerly owned by Harris
Whittemore

40. EDOUARD MANET. (above, left) *The Guitar Player.* c. 1867. Oil on canvas, 75 1/8 × 35 3/4″. Hill-Stead Museum, Farmington, Conn. Formerly owned by Alfred A. Pope

41. CLAUDE MONET. (left) *High Tide at Pourville.* 1882. Oil on canvas, 25 7/8 × 32″. The Brooklyn Museum (Gift of Mrs. Horace Havemeyer, 1941). Formerly owned by Mr. and Mrs. H. O. Havemeyer

42. CLAUDE MONET. (above) *Haystacks in the Snow.* 1891. Oil on canvas, 25 3/4 × 36 1/4″. The Metropolitan Museum of Art, New York (Bequest of Mrs. H. O. Havemeyer, 1929. The H. O. Havemeyer Collection)

43. ALFRED SISLEY. (above, left) *Banks of the Seine, near the Island of Saint-Denis.* 1872. Oil on canvas, 15 3/8 × 25″. Private Collection, Switzerland. Formerly owned by Mr. and Mrs. Havemeyer

44. EDOUARD MANET. (left) *Masked Ball at the Opera.* 1873–74. Oil on canvas, 23 1/2 × 28 3/4″. National Gallery of Art, Washington, D.C. (Gift of Mrs. Horace Havemeyer in memory of her mother-in-law, Louisine W. Havemeyer, 1982). Formerly owned by Mr. and Mrs. H. O. Havemeyer

45. EUGENE DELACROIX. (above) *Christ on the Lake of Gennesaret.* 1853. Oil on canvas, 20 × 24″. The Metropolitan Museum of Art, New York (Bequest of Mrs. H. O. Havemeyer, 1929. The H. O. Havemeyer Collection)

46. EDGAR DEGAS. *Landscape with Cows.* 1890–92. Pastel over light monotype on paper, 10 1/4 × 13 7/8″. Private Collection. Formerly owned by Mr. and Mrs. Havemeyer

47. EDGAR DEGAS. *Lakes and Mountains.* 1890–92. Pastel over monotype in oil colors on paper, 10 × 13 3/8″. Collection David Gol, Geneva, Switzerland. Formerly owned by Mr. and Mrs. Havemeyer

48. MARY CASSATT. (left) *The Family*. c. 1887. Oil on canvas, 32 1/4 × 26 1/8". The Chrysler Museum, Norfolk, Va. (Gift of Walter P. Chrysler, Jr.). Formerly owned by Mr. and Mrs. Havemeyer

49. EDGAR DEGAS. (right) *A Woman Ironing*. 1874. Oil on canvas, 21 3/8 × 15 1/2". The Metropolitan Museum of Art, New York (Bequest of Mrs. H. O. Havemeyer, 1929. The H. O. Havemeyer Collection)

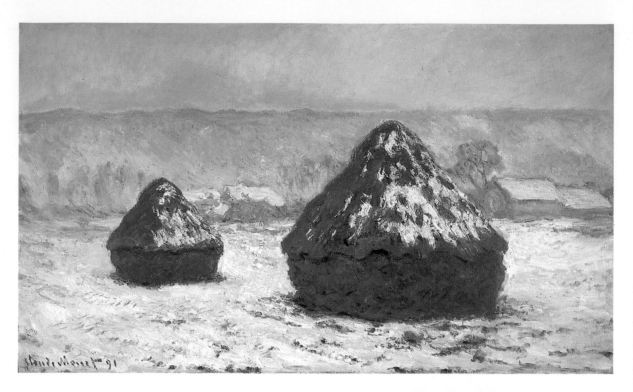

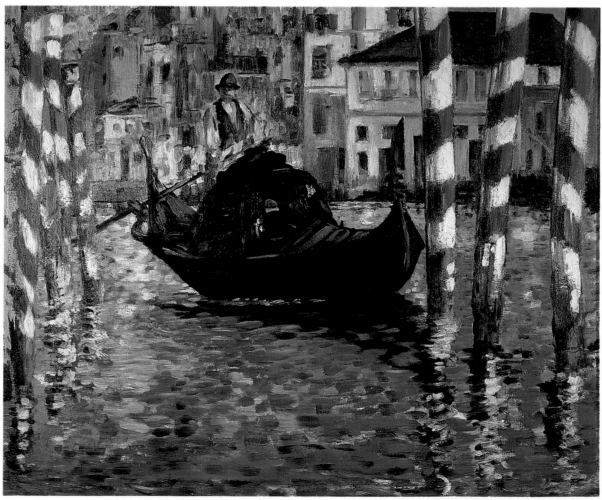

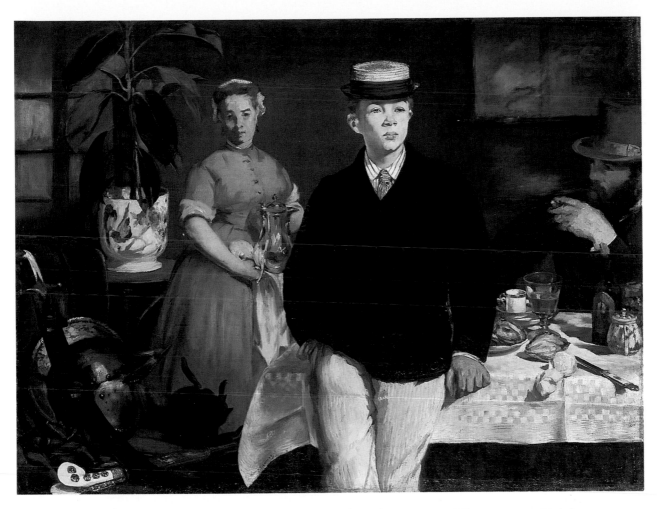

50. CLAUDE MONET. (above, left) *Landscape—Haystacks in the Snow.* 1891. Oil on canvas, 23 × 39″. Shelburne Museum, Shelburne, Vt. (photograph by Ken Burris). Formerly owned by Mr. and Mrs. Havemeyer

51. EDOUARD MANET. (left) *The Grand Canal, Venice (Blue Venice).* 1875. Oil on canvas, 23 1/8 × 28 1/8″. Shelburne Museum, Shelburne, Vt. (photograph by Ken Burris). Formerly owned by Mr. and Mrs. Havemeyer

52. EDOUARD MANET. (above) *The Luncheon in the Studio.* 1868. Oil on canvas, 46 1/2 × 60 5/8″. Bayerische Staatsgemäldesammlungen, Munich. Once owned by Mr. and Mrs. Havemeyer

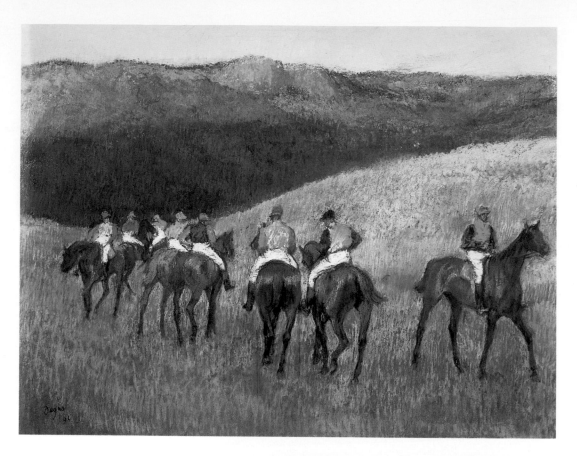

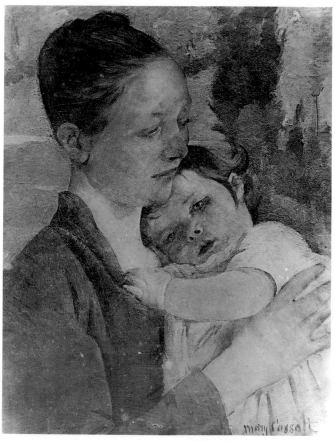

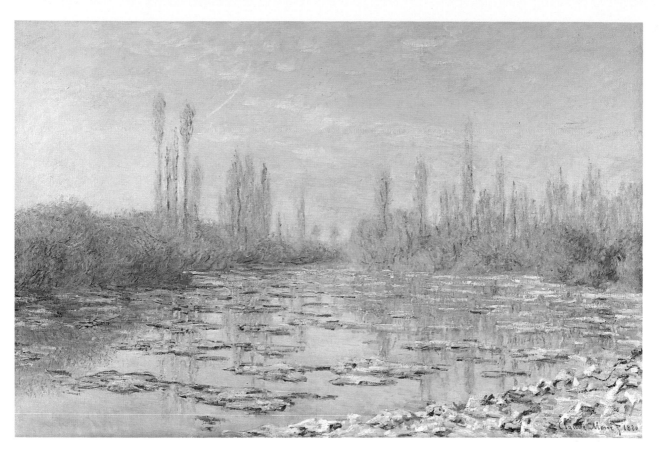

53. EDGAR DEGAS. (above, left) *Racehorses in Training*. 1894. Pastel on paper, 18 7/8 × 24 3/4″. Thyssen-Bornemisza Collection, Lugano, Switzerland. Formerly owned by Mr. and Mrs. Havemeyer

54. MARY CASSATT. (left) *Mother and Child*. 1888. Oil on canvas, 18 1/4 × 15 5/8″. Destroyed in a fire (photograph courtesy of Galerie Durand-Ruel, Paris). Formerly owned by Mr. and Mrs. Havemeyer

55. CLAUDE MONET. (above) *The Floating Ice*. 1880. Oil on canvas, 38 1/4 × 58 1/4″. Shelburne Museum, Shelburne, Vt. (photograph by Ken Burris). Formerly owned by Mr. and Mrs. Havemeyer

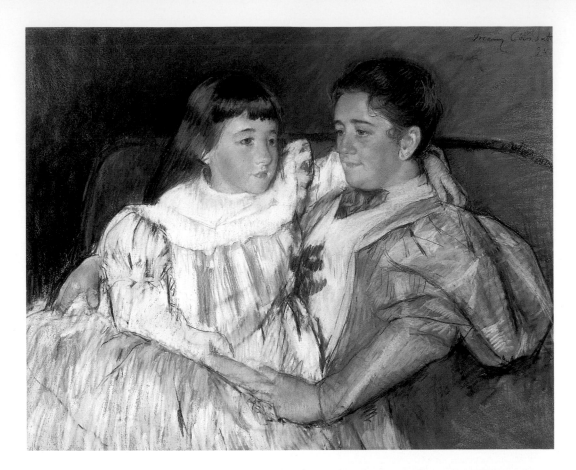

56. MARY CASSATT. *Portrait of Mrs. Havemeyer and Her Daughter Electra.* 1895. Pastel on paper, 24 × 30 1/2". Private Collection, U.S.A. Formerly owned by Mr. and Mrs. Havemeyer

57. MARY CASSATT. *Portrait of Adaline Havemeyer.* 1895. Pastel on paper, 25 1/4 × 21". Private Collection, U.S.A. (photograph courtesy of Coe Kerr Gallery, New York). Formerly owned by Mr. and Mrs. Havemeyer

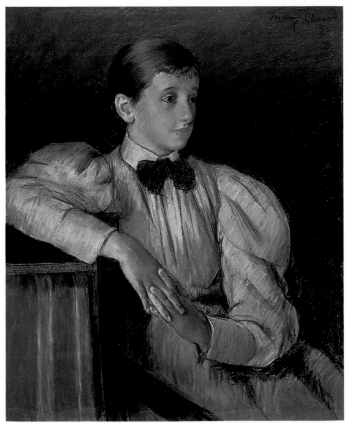

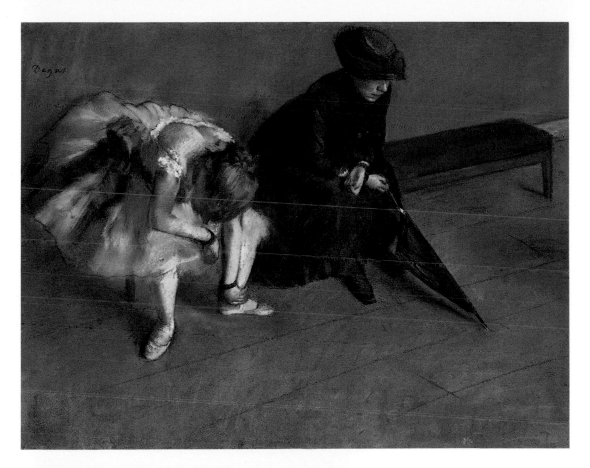

58. EDGAR DEGAS. *Waiting (L'Attente).* c. 1882. Pastel on paper, 19 × 24″. Owned jointly by the Norton Simon Inc. Foundation (Pasadena) and the J. Paul Getty Museum (Malibu). Formerly owned by Mr. and Mrs. Havemeyer

59. HONORE DAUMIER. *The Collector.* Pencil, crayon, wash, and watercolor on paper, 17 1/8 × 13 3/4″. The Metropolitan Museum of Art, New York (Bequest of Mrs. H. O. Havemeyer, 1929. The H. O. Havemeyer Collection)

60. EDOUARD MANET. *Boating*. 1874. Oil on canvas, 38 1/4 × 51 1/4″. The Metropolitan Museum of Art, New York (Bequest of Mrs. H. O. Havemeyer, 1929. The H. O. Havemeyer Collection)

sugar for the higher grades; that its stock became of a value largely in excess of its par value, and so continued to be until certain legislation was proposed in the House of Representatives, which, if enacted into law, would destroy the ability of the corporation to control the product and greatly reduce the value of its stock. The indictments tell of the passage of the bill in the House, its transmission to the Senate and reference to the Finance Committee, and declares that, as the bill passed the House, it would be greatly to the disadvantage of the corporation and lessen its profits and that its stock was greatly impaired in value for the time being. . . .[2]

Harry Havemeyer certainly had his hands full, yet he took a public attitude toward the charges that the entire procedure did not warrant his personal involvement. According to the *New York Times:*

Messrs. Havemeyer and Searles showed little concern yesterday when informed of the indictment. At the office of the Sugar Trust the affair was regarded as a matter for levity not unmixed with contempt. The indicted persons and all associated with them have looked upon proceedings in the Washington courts as not worth serious attention. They rely upon the attorneys of the trust to take care of the trials, and the cost attached will be counted in as one of the unavoidable incidents of business prominence. Mr. Searles said he saw no occasion for speaking at all of the affair, and did not expect to be led into a discussion of it at any time.[3]

But behind the scenes Harry must have been slightly uneasy, for the charges against him were hardly trifling. Fortunately for him, big business was omnipotent in those days, as it would remain until the "muckraking" policies of President Theodore Roosevelt. During the 1890s government officials were usually thwarted in their efforts to regulate corporate abuses, lacking the power to control the corrupt activities of the magnates who continuously succeeded in obtaining immunity from serious prosecution.

Although Harry's indictment had been sensational enough to appear on the front page of the *New York Times* in 1894, the president of the Sugar Trust would not be brought to court until May 1897 at the earliest. His counsel was able to postpone the trial repeatedly by pleading a variety of excuses, among them illness and other engagements, a strategy based on the presumption that public indignation would subside with the passage of time.

Apart from these legal problems, the Havemeyers had other worries; in February 1894 Louisine suffered a severe scalp wound in a collision of two sleighs. The *New York Tribune* reported the accident:

Mr. and Mrs. Havemeyer were driving along upper Seventh Ave., near One-hundred-and-twenty-sixth-st., about 5 o'clock, when a horse and sleigh without a driver whirled wildly round the corner into the avenue. Before Mr. Havemeyer could pull out of the way the horse crashed into his sleigh. Mrs. Havemeyer was thrown into the roadway on a heap of frozen snow. Blood trickled down her face. Mr. Havemeyer, holding on to the reins, was dragged half a block before he could

get control of his frightened horses. . . . Dr. Robert Weir and Dr. Polk were called in to attend Mrs. Havemeyer, who, in addition to the scalp wound, had sustained a severe shock to her nervous system. Mr. Havemeyer had escaped without a scratch.[4]

Before his troubles erupted, Harry had started the year 1894 with an acquisition that was truly bold in comparison to his former relatively conservative policy. On January 16 he purchased from the Durand-Ruel Gallery three paintings by Claude Monet: *High Tide at Pourville* (Plate 41), *Morning on the Seine at Giverny*, and *Haystacks in the Snow* (Plate 42), the last formerly in the Potter Palmer collection. These were the first pictures by the artist that Harry and Louisine acquired jointly, since the only Monet they had owned until then was bought by Louisine before her marriage. From the same source, they also obtained that day Sisley's *Banks of the Seine, near the Island of Saint-Denis* (Plate 43), Manet's *Masked Ball at the Opera* (Plate 44), three works by Degas (two landscape pastels over monotype, and one drawing of dancers), and a colored print by Mary Cassatt, *The Banjo Lesson.* Very likely these were Louisine's selections, for they reflect her taste; her husband, not yet comfortable with such radical choices, picked Delacroix's *Christ on the Lake of Gennesaret* (Plate 45) and a Corot figure piece. Since on that very day the Havemeyers had also sold a still life with apples by Courbet to the gallery, they must have applied this credit toward their new acquisitions.

Louisine was already and would remain particularly fascinated by Manet's large painting of a masked ball, even though her opinion was not widely shared, as she later recalled: "I hung *Le Bal de l'Opéra* in my gallery for a time, but I found that there were many of Puck's foolish mortals still posing as art amateurs in America. I took it down and hung it in my own apartment [the master bedroom suite], where I have studied and enjoyed it, hour after hour, year after year, until I have learned to consider it one of Manet's best if not his greatest work."[5] Both Havemeyers liked their two landscapes in pastel over monotype by Degas (Plates 46, 47) so well that they acquired three more the following month. (Degas, between 1890 and 1893, had produced about fifty landscapes in this medium, in which he first covered a metal plate with colored pigments and, after printing the image on paper, overlaid it with pastel.) It was not Mary Cassatt's urging that made her friends select these works because she did not care for them, preferring Degas's landscapes "when used as a background for his figures."

The other Impressionist pictures the Havemeyers purchased during 1894 were Cassatt's *The Family* (Plate 48), which Alfred Pope had returned to Durand-Ruel, and Degas's *A Woman Ironing* (Plate 49). Doubtless influenced by the rising reputation of the modern French school, Harry was just beginning to get seriously interested when he was interrupted by his legal concerns. The next year he would be able to devote considerable time to collecting, and by then Impressionism had gained a more solid position in the American art world.

Within the first four months of 1895, a succession of important one-man exhibitions were held in New York, all of them receiving a generally favorable response. Contributing to this sudden outbreak of international shows was the lifting of the duty on imported works of art. The National Free Art League, with a membership of more than 1,000 artists as well as hundreds of others interested in the arts, had campaigned

effectively to drum up public support for the free-art clause in the current tariff bill. In a letter to the press on January 1, 1894, the league members had forcefully stated: "American artists think it of importance to the Nation that, as in other civilized countries, works of art should be invited to, and not repelled from, our shores, on account of their educational value for our people in general and especially for our artists and artisans. . . . The era of the World's Columbian Exposition should be marked in America by the complete abolition of our obstructive and unenlightened tax upon the importation of works of art. . . ."[6] By the spring of 1894 (though only until 1897), Congress placed foreign paintings, sculptures, and watercolors on the free lists, while the then most popular art forms—photographs, prints, and engravings—remained subject to import taxes.

It was no coincidence that the Impressionist movement should win public awareness and the personal sanction of Harry Havemeyer at the same time. Previously he could not have been counted among the small but avid group of American patrons who were the earliest collectors of French avant-garde art. Harry's inclination for old masters, Dutch genre scenes, Barbizon landscapes, and certain Romantic painters kept him from the more delicate, evanescent canvases of the Impressionists, and he probably would have remained a conservative collector had his wife not persisted in her own direction. But even Louisine could not arouse his interest in the new French movement while he was convinced he would be throwing his money away. Harry remained aloof until events in America and abroad indicated that these artists had carved out a relatively respectable place for themselves.

An occurrence that helped bring about his change of attitude may have been the news—widely reported in the American press—that a number of Impressionist works would be entering the halls of the Luxembourg Museum in Paris with the Caillebotte Bequest. In 1894 the painter Gustave Caillebotte had died, leaving his collection of sixty-seven paintings by his Impressionist colleagues to the French nation. Although his will had specifically stated that the collection should be kept intact, an avalanche of protests from academic painters, critics, and politicians deterred the state from accepting the entire legacy, and the final compromise in 1896 was for only thirty-eight. In America, however, the very fact of a substantial increase in the number of works by Impressionists in the Luxembourg, whereas previously there had been only three, was interpreted as a "boom" for Impressionism on the international market. In any case, during the first half of 1895, Harry Havemeyer was bombarded with Impressionist propaganda, both at home and in the local press. At last he was ready to succumb.

In New York, January 1895 was the month of Monet, with a retrospective of forty of his landscapes at the Durand-Ruel gallery. The *New York Times* marveled at the vast scope of the artist's influence:

Scoffed, jeered, and laughed at in his earlier days, he has lived to witness a genuine triumph, to see his methods approved, his work imitated, and his pictures sold at substantial figures. There is scarce an exhibition in the last few years but shows in a dozen or more pictures his directing agency; from the greatest of his contemporaries to the humblest student in the schools, few there are who have hesitated to take from him some hint or suggestion.[7]

But the *Times* critic still termed Monet's choice of subject often "unfortunate"; this opinion was shared by the reviewer of *The Art Amateur,* who found some of his landscapes quite monotonous. Yet the critical consensus was that the show was of "uncommon interest"[8] and furnished material for the thoughtful viewer.

On January 12, the opening day of the Monet exhibition, the Havemeyers purchased *Poplars* and *Landscape—Haystacks in the Snow* (Plate 50). The latter had originally belonged to Potter Palmer, who returned it to Durand-Ruel early in 1892; later that year the dealer sold it to Alfred Pope, who probably lent the work to Durand-Ruel's 1895 retrospective with the intention of selling it. The practice of buying and returning paintings was common among American collectors. Although the Havemeyers did less swapping of works than most of their colleagues, at times they too weeded out their collection. The same year that Harry began to take a serious interest in the Impressionists, he consigned to Durand-Ruel two pictures by seventeenth-century Dutch masters and three by nineteenth-century Belgian artists, in addition to four canvases by Barbizon painters and a bronze by Barye. Eventually all of these were disposed of by the dealer, and Harry would continue to consign to him works now unwanted, particularly those by his earlier favorite Barbizon and Romantic artists.

Raffaëlli was the subject of a still larger retrospective, from late February through March 16, containing some 150 oils, pastels, lithographs, etchings, and drawings; it was held at the American Art Galleries on Madison Square. The usually anecdotal subject matter of this artist had great appeal for the New York public, who preferred the diluted form of his "Impressionism." Whereas Monet had been criticized for his sterile subjects, Raffaëlli received high praise: "He is a painter of actual life, and in particular of action and character, the two elements by which principally art may suggest a story. The outer life of Paris, its streets, suburbs, cafés, and theatres, has been his especial study, and no one has succeeded so well in rendering the atmosphere of the great city, its hurry and bustle, and the varied types of humanity that constitute its population. . . ."[9]

Before the exhibition opened, Raffaëlli himself came to New York to give lectures and interviews, and reigned as the art world's hero for that season. He was cordially received by some American painters; Theodore Robinson mentioned in his diary that he went to dinner at J. Alden Weir's to meet the Frenchman. Raffaëlli also visited important collectors, among them the Havemeyers; he was particularly impressed by their interiors designed by Tiffany and Colman, and expressed his admiration in an interview he later gave to an American newspaper correspondent in Paris:

> What are these attempts [at the decoration of his own house and studio] by the side of what has been accomplished in Mr. Havemeyer's palace in New York? There the furniture also has been considered and has its individual form. Taken altogether it forms an abode in the most perfect taste, doing honor to the owner and to the artist who created those things. It will certainly be imitated and perhaps will be the starting point for a decorative style in which our own individuality will have a part, instead of manifesting itself, as is the case with us here, by the owners going so far as to prefer the Louis XVI style to the Louis XIV for his bedroom, or the Louis XIII, to the Henry II for his dining room.[10]

Raffaëlli's presence together with his large exhibition drew far more publicity and had a greater effect on the American art scene than either the Monet or the subsequent Manet show, both held at Durand-Ruel's during that same period. But for those who knew, such as the Havemeyers, the small exhibition of Manet's paintings, in the last three weeks of March 1895, was much more interesting. Durand-Ruel had assembled twenty-eight canvases, some borrowed from French collectors, that Manet had painted from 1862 until shortly before his death. Almost a decade before, just prior to the opening of Durand-Ruel's first New York exhibition, the critic Theodore Child (Paris correspondent for *The Art Amateur*) had referred to Manet as the leader of the "modern French school of art" in an article entitled "The King of the Impressionists"[11] (though technically speaking Manet had never exhibited with the group). But since that pioneering show Monet had eclipsed Manet in the eyes of the American art-conscious public, and had come almost to represent the entire Impressionist movement.

Nine years after Child's 1886 article, the critics were somewhat puzzled at Manet's first one-man exhibition in America. Generally, they did not like the work, yet they were compelled to acknowledge its far-reaching originality:

The pictures possess few charms of color, and neither in composition nor in choice of subject do they particularly appeal. They mark, however, an important departure, and one that has had a wonderful influence on the work of modern men, traces of which may be seen in all the exhibitions for the last thirty years or more. The many pictures gathered together here form a curiously interesting study of the work of an unusual man, a man who, chafing under the restraints of academic traditions, had the courage to break away completely, and with few to understand him, to strike out in new directions.[12]

It seems that Manet was admired more for his fortitude than for his artistic prowess:

The weakness of Manet, as I view it, was that he did not, like Velasquez, build upon his impression, but was content to allow it to remain in its first stage. Yet this weakness was also his strength, for painting what he did and as he did, whatever there was strong in him came out in the full flush of power while his spirit was fresh and its hold hot upon him, and he did not weaken it by attempts at future polish. He was no compromiser. He believed in himself and in his idea of art, and under an avalanche of derision and abuse he carried out his theories. . . .[13]

But there were also critics who, while recognizing some of Manet's qualities, found it hard to forgive him for the unevenness of his work and because certain paintings were, as they put it, "almost childish in their naïveté, dirty in color, and unattractive to the verge of being almost repulsive."[14]

Fortunately, Louisine did not have to depend on such comments to convince her husband of the artist's merits. Harry had grown fond of the still life he had purchased in 1886 at his wife's behest (see Plate 10); he even agreed to let Durand-Ruel include this picture, as well as their newest Manet, *Masked Ball at the Opera* (both lent anony-

mously), in his exhibition. On April 8, after the show had closed, the Havemeyers acquired two more works by the artist: *The Grand Canal, Venice (Blue Venice;* Plate 51) and *The Luncheon (The Luncheon in the Studio;* Plate 52). Three other paintings in the exhibition would eventually end up in their possession: *The Railroad* (see Plate 85), *A Matador Saluting* (see Plate 81), and *The Dead Christ with Angels* (see Plate 118).

Manet's *The Grand Canal, Venice* was a crowd-pleaser that several reviewers had singled out as one of the most attractive pictures in the exhibition. Theodore Robinson mentioned it in a diary entry. Mary Cassatt was also among the painting's admirers; according to Louisine, she "congratulated us when we bought this picture saying she considered it one of Manet's most brilliant works; it was so full of light and atmosphere and expressed the very soul and spirit of Venice."[15] It was this very canvas that would one day inspire Louisine to respond with her *bon mot* to a guest, who asked if she would not rather have a string of pearls than a picture: " 'No,' I said hastily, 'I prefer to have something made by a man than to have something made by an oyster.' " As Louisine herself added: "It was a good rejoinder, I take no credit for it; it was my *Blue Venice* that fairly put the words into my mouth."[16]

Their other purchase on April 8th, Manet's *The Luncheon,* for which they had paid about $7,000, proved to be less satisfactory. Apparently Harry did not care for this painting; Louisine later confessed that she was unable to explain why he decided to give up *The Luncheon:*

> For many years [1895–98] it hung upon the walls of our gallery until one day— for some reason I never understood—Mr. Havemeyer asked me if I objected to his returning it to the Durand-Ruels. I never questioned my husband's decisions, and I acquiesced, of course. Manet's still life in the picture and the boy with the black jacket and straw hat were lost to us forever.[17]

A work that did and would continue to please Harry very much was Degas's *Racehorses in Training* (Plate 53); he himself had selected this pastel at the Durand-Ruel gallery exactly a week before buying Manet's *The Luncheon.*

The last of the individual exhibitions held in New York during the first half of 1895 was devoted to Mary Cassatt. Since 1873, when she had sent three of her pictures to the Cincinnati Industrial Exposition, her countrymen had seen examples of her work only sporadically, when they were included in group shows in New York, Philadelphia, or Boston. Cassatt's paintings had been favorably noticed by American critics on occasion, but in 1893 her mural in the Woman's Building at the Chicago World's Fair had not enhanced her American reputation, the large-scale decoration being generally thought of as "ill-considered." Thus she was especially eager to have a substantial showing of her work in New York. From April 16 to 30, 1895, the Durand-Ruel gallery presented sixty-four of her paintings, pastels, and drypoints, dating from 1878 to her latest efforts.

Among the most sympathetic reviews was the notice in *The Art Amateur* that termed Mary Cassatt one of the best-known living woman painters, who, although "deeply influenced by Manet and Degas has developed a highly personal manner of her own." The critic went on to praise both her early and recent production and singled out

especially her series of drypoints, which "next to Whistler's paintings, are the most distinguished work visibly affected by Japanese art."[18] Other reviewers were harsher with the artist than they had been with some of her French colleagues. In the *New York Times* her latest pictures bore the heaviest attack:

> The work here shown is quite uneven, though rarely, if ever, uninteresting, and it is confined principally to portrait studies out of doors of women and children. The mother and child seem to have had peculiar fascination for this artist, and have afforded her the theme for many canvases. In her earlier studies there seems to be a greater harmony of color and a softer envelopment of atmosphere, which is lacking in the more recent work. These last are frequently hard, crude, and have a tendency toward the brutal. Inharmonious masses of uncomplimentary color are brought side by side and shock the eye. A rude strength, at times out of keeping with the subject, is noticeable, and takes away in a measure from the charm of femininity.[19]

Some commentators seemingly resented it that Mary Cassatt painted with the forcefulness and power of a man. They were not used to such a high level of proficiency and originality from a woman artist and expected her studies of mothers and children to be sentimental, an approach that Cassatt avoided. Alfred Trumble of *The Collector* was one of those who found the absence of "feminine delicacy" in her paintings regrettable: "That I do not agree with Miss Cassatt in viewing the antithesis of merely pretty art as the only cogent protest against artificiality and conventionalism, is because I believe that while beauty and grace of line are not to be found in nature, they are to be preferred to coarser and less lovely themes."[20] Yet Trumble could not help seeing some merit to her art:

> But I like to look at Miss Cassatt's works, all the same, for those individual qualities which no defects or weaknesses of the motives to which they are applied can hide. To praise her as lavishly and unreservedly as her admirers do, is not in me, but to deride her, as others have done, is equally impossible. She exercises her right to express herself in her own way. That her way is not the best way I firmly believe, and I believe also that this will be the verdict of posterity.[21]

Surprisingly, even Theodore Robinson was not overly receptive to Cassatt's pictures, as shown in his diary entry of April 17: "At Durand-Ruels—exhibition of Miss Mary Cassatt—some studies of babies—a bit hard but amusing—souvenirs of Botticelli in the treatment of heads and decorative gowns but one misses a little the *note juste,* the saving integrity seen in a good Monet or Degas."

Mary Cassatt was disappointed by her compatriots' lack of appreciation for her work. Her second show at Durand-Ruel's Paris gallery, in 1893, had received much more attention and praise, as well as earning for her the increased esteem of such fellow artists as Degas and Pissarro. In France she was now considered one of America's most distinguished painters; in her own country she was relatively neglected, except by a small group of loyal supporters, none of whom was more enthusiastic than Louisine. Before

the opening of the Cassatt exhibition in New York, the Havemeyers had acquired two of her works: *Mother and Child* (Plate 54), which Louisine called the "Florentine Madonna," and a pastel, *Baby's First Caress.*

In April 1895, Louisine and Harry added two more paintings by Monet to their collection, but this time their source was not Durand-Ruel. The American Art Association held another liquidation sale on April 25 and following days; James Sutton's withdrawal from active partnership led to the dispersal of the firm's joint property, acquired since the fall of 1892. The association's auction was considered the most notable one in New York of that spring, attracting buyers from many other cities. Montague Marks gave an account of some of the results:

> The modern pictures, with few exceptions, sold at low prices. Mr. H. O. Havemeyer got the two finest Monets—the exquisite *Vue de Rouen* for $2600 and *Melting Ice* [*The Floating Ice*; Plate 55] for $4250. Nearly all the other "impressionist" pictures were knocked down to Mr. Durand-Ruel at prices so absurdly low that it would seem as if an understanding existed between him and some of the other dealers. Mr. Montaignac, who used to be the Paris agent of the American Art Association, made several purchases, but I understand that they were for himself, he having severed his former relations with the New York art firm.[22]

While the prices for the Impressionists were considered low, the value of Monet's important paintings had risen substantially.

Although the Havemeyers had already bought nine major works by Manet and the Impressionists in New York during the first four months of 1895, Harry's collecting instincts were further aroused by a summer trip to Europe. On June 6 the whole family sailed for London on the *Teutonic,* accompanied by Mr. and Mrs. Peters (Louisine's younger sister and her husband). Almost as soon as they arrived, a sale took place at Christie's of an important group of English paintings. Harry left a bid with the well-known dealer Thomas Agnew for Lot No. 70—*Lady Mulgrave,* a celebrated portrait by Gainsborough—giving him a limit of £10,000. When he learned that he had lost the painting at £10,500 to a Mr. Campbell, supposedly the agent for Cornelius Vanderbilt, Harry was furious, blaming Agnew for letting this splendid portrait get away. Once Harry coveted a certain picture, he resented anyone coming between him and the work; henceforth he avoided further business dealings with Agnew's firm.

The Durand-Ruels knew better how to handle their volatile client. In July the Havemeyers stopped in Paris for a few days on their way to Switzerland. Harry looked at some objects which interested him, but he left the negotiations in the hands of Paul Durand-Ruel, who wrote to him in Basel at the Hôtel des Trois Rois on July 18:

> I saw Mr. Gavet this morning; he gave me his lowest price on the different things you noted at his place and he assured me that he cannot go any lower. Here are his prices [in francs]:
>
> | The large tapestry | 190,000 |
> | The marble by Mino da Fiesole | 120,000 |

The case with Italian faience	160,000
The case with medallions	22,000
The piece of furniture of Italian ebony	16,000
The portrait of François Ier	25,000

He told me that were you to take 4 or 5 objects, he would consent to a slight reduction on the total, but if you only bought one, he could not take anything off. I strongly advised him to tempt you by greatly reducing the marble, and at 100,000 f., I thought you would take it immediately and, with this buy, you would probably be encouraged to select something else. I did not make any firm offer.

Please let me know if I can go a little further. Without a doubt, the marble is superb and he has had many serious offers from museums.*

Harry did buy the marble relief of a Madonna and Child by Mino da Fiesole, paying the asking price (about $24,000). Durand-Ruel made it a policy always to check with Harry before making any commitments on his behalf, as well as to execute his orders carefully, as evidenced in this same letter: "I was able to get 1000 f. reduction on the Millet watercolor "Peasant Girl Burning Weeds," which brings the price down to 7000 f. Consequently I bought it according to your instructions."* It is not surprising, therefore, that the Durand-Ruels succeeded in satisfying Harry and kept him as one of their best clients until the end of his days. In late August 1895, the Havemeyers returned from their travels for a longer stay in Paris. On August 27 they purchased Monet's *The Bark of Dante* from Paul Durand-Ruel, who had just acquired the painting from the recently established dealer Ambroise Vollard.

While her husband was occupied with business matters, Louisine must have spent some of her time with Mary Cassatt. She and her children probably stayed with the artist at her château de Beaufresne at Mesnil-Théribus, in the Oise region, fifty miles northwest of Paris. Cassatt had acquired this seventeenth-century manor house, surrounded by forty-five acres, in the spring of 1894; after extensive renovations, she used it as a country residence, where she could indulge in her passion for gardening. She took advantage of the Havemeyer family's visit to paint a pastel portrait of Louisine and little Electra, who had her seventh birthday on August 16 (Plate 56). A little later she also did a pastel of Adaline (Plate 57), one of the artist's most beautiful and appealing portraits (see page 106).

Louisine did not find her friend in the best of form. Mary's mother, long bedridden, had been critically ill during the past months, causing the artist to devote herself to nursing the invalid, often for weeks at a time. Illness and worry had taken their toll on both mother and daughter, as Mary had expressed in a letter dated April 26, 1895, to her painter-friend in Boston, Miss Rose Lamb: ". . . she [Mrs. Cassatt] says to tell you that the woman you knew as my Mother [Lamb had visited Cassatt in 1892] is no more, that only a poor creature is left! Which proves that her head is not quite so affected as she thinks, But there is no doubt that her head *is* affected & the depression is at times very great. In fact life seems very dark to me just now; . . ."[23] Louisine had always admired Mary's mother, and was distressed to see her hopeless condition:

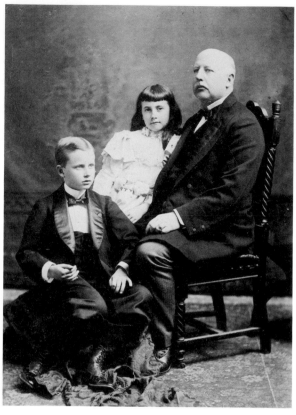

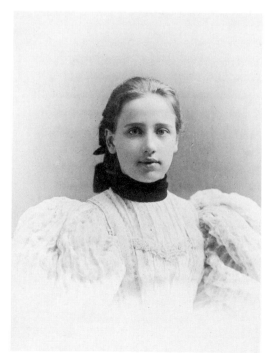

Above left: Electra Havemeyer, age 7, in a photographer's studio, probably in Paris in 1895. This was the only age when Electra wore bangs, as depicted by Mary Cassatt (Plate 56)

Above right: Horace Havemeyer, age 9, Electra Havemeyer, age 7, and Harry Havemeyer, age 48, in a photographer's studio, probably in Paris in 1895

Left: Adaline Havemeyer, age 11, 1895. Cassatt's likeness of Adaline in Plate 57 captures the same wistful mood visible in this photograph, revealing the artist's penetrating gift as a portraitist. Photographs courtesy of J. Watson Webb, Jr.

"In her last illness, I recall sitting beside her holding her thin hand in mine filled with pity for the poor sufferer and with regret that the world must lose such a remarkable woman."[24] Mrs. Robert Simpson Cassatt died on October 21, 1895, at the château de Beaufresne and was buried there in the family tomb, together with her husband, who had died in 1891. In that summer Louisine, with her calm and cheerful disposition, must have provided a welcome relief in the hushed, saddened atmosphere of the Cassatt household. It seems that Louisine accompanied her friend to the spa at Vichy to give Mary a much-needed respite.

Meanwhile Harry and the Durand-Ruels had been busy in Paris lining up paintings that they submitted to Louisine upon her return. On September 19, the Havemeyers made no fewer than eleven acquisitions: six works by Degas, and one each by Corot, Daumier, Millet, Courbet, and Manet. Harry's patronage was justly rewarded by the dealer, as recalled by Louisine many years later in her *Memoirs:*

> During a visit to Europe, Durand-Ruel allowed Mr. Havemeyer to select a number of pictures from his private collection. It was this privilege which placed several of Degas's finest works in our collection. One is called *L'Attente* [*Waiting;* Plate 58]. A ballet girl, waiting to be called, is seated upon a bench and is leaning down to tie her sandal; by her side is another figure, probably her mother. The latter is poorly dressed and is also leaning forward, upon an umbrella, which she holds in her hand in a difficult position. It is rather somber in tone and subject, but is the perfection of art in every detail.
>
> There were two others, also pastels, rather high and narrow, perhaps suggested by the Japanese pillar prints which had reached Paris in those days. One represents a ballet girl in a very difficult pose: resting lightly on one foot she extends the other as she throws her body forward and her gossamer green draperies float around her, describing circles that might suggest an Egyptian bas-relief, and yet fleecy and light, expressive of the movement that lightly threw them up; the wonderful envelopment of air gives them such buoyancy that one stands entranced at the marvelous skill that could produce such an effect and at the wonderful eye that could thrill you with such a piece of color. The pendant is a ballet girl in yellow. I do not think it so fine nor so interesting as the other.[25]

There were three additional works by Degas: a charcoal and pastel drawing, *The Bath,* and two pastels, one of dancers and another landscape pastel over monotype. The rest of their purchases that day included a pastel drawing of a shepherdess by Millet, as well as Daumier's wash drawing, *The Collector* (Plate 59); furthermore they acquired three important paintings: Manet's *Boating* (Plate 60), Courbet's *The Deer* (Plate 61), and Corot's *Greek Girl—Mlle Dobigny* (Plate 62).

Harry Havemeyer had been slow to start, but in the next few years he and his wife, aided by Mary Cassatt and Paul Durand-Ruel, would become the most active collectors of modern French art in America. Having previously been outdistanced by such fellow countrymen as Potter Palmer, Albert Spencer, Harris Whittemore, and Alfred Pope, Harry had suddenly become interested in some of the very painters whose art he had

recently considered to be merely a passing fad. Louisine, of course, was delighted with this turn of events. She had always been confident that in due course her husband would appreciate the artists in whom she herself had believed for many years; now she felt more than compensated for her patience.

Development of the Collection; Legal Entanglements

By 1896 Paul Durand-Ruel's persistence was yielding results: his continuous exhibitions had acquainted a slowly expanding group of Americans with the work of the Impressionists. As Alfred Trumble of *The Collector* put it:

> Mr. Durand-Ruel is a standing example of the virtue of that sort of resolution known as hanging on. Once you fix your mind upon an object, never let it go. Your time may be slow in coming, but it will come. When he first came to New York [in 1886], as a visitor, with a collection of pictures, chiefly impressionistic, of the school founded by Edouard Manet, people laughed at him. Almost the only collector who had the courage to touch them was Mr. Albert Spencer—but Mr. Spencer is a man with nerve steeled in the school of chance. Now you find them everywhere—no collection is complete without its Monet, Renoir, Degas, Besnard, Pissarro. . . .[1]

The editor of this journal had an exaggerated view of the popularity of the Impressionists. Although the movement had its enthusiastic supporters by 1896, there was still a fairly strong reactionary feeling in the air; Trumble himself harbored reservations. Paul Durand-Ruel was more realistic in his appraisal of the American art scene; when a reporter for the Paris edition of the *New York Herald* asked him in the spring of that same year whose works were currently most in demand, he replied:

> That is not very easy to answer. Puvis de Chavannes always finds a ready sale. Nearly everything of his that is not painted to order passes through my hands. But,

then, he is not a great producer. Degas, Claude Monet, and Renoir always command a market, too. Among those who are gone, Manet, who, like Whistler, was refused at the Salon of 1863, is readily bought. The fact is that the number of genuine amateurs is very limited, but really first-class work will always sell. I am rather particular as to what I buy, and if I were less rigorous in my choice, I should certainly have a much larger clientele than is the case at present.[2]

Durand-Ruel had come to realize that the men who were willing to speculate wildly and take high risks in the world of business and finance were often conservative in the realm of art. They felt secure in purchasing paintings by seventeenth-century Dutch and Flemish masters, by English portraitists of the eighteenth century, or by the now well-established Barbizon landscapists. Being an astute businessman himself, Durand-Ruel concluded that the best way to win the collectors' confidence in the French moderns was to display these works together with older masters. American clients were reassured to see paintings by De Hooch, Puvis de Chavannes, and Monet hang in close proximity; it was encouraging to witness that the dealer who had promoted such artists as Corot, Daubigny, Millet, and Rousseau was now urging them to consider canvases by Degas, Pissarro, Renoir, and Cassatt.

Over the years the Durand-Ruel gallery had often mounted shows that appealed to the entire gamut of American taste, but none received more fulsome praise than the exhibition in the late fall of 1896. Alfred Trumble was carried away with enthusiasm:

If there has ever been, in any art dealer's establishment in New York, by which, I mean, in effect, the United States, such an aggregation and display of pictures of the first fire as the Durand-Ruel galleries now hold and make, I certainly have neither seen nor read of it in the records. The main room is in itself an exhibition; it has the aspect of a gallery in a great public museum. The center of one wall is occupied by the magnificent Vandyck, the full-length portrait of the Marquis-Marshal d'Alagri, which I have already written of. On another wall is centered the glorious "Vallée de la Tocques," of Troyon; and on another wall the Courbet masterpiece "La Femme au Perroquet [*Woman with a Parrot*]." That these three pictures should not belong to our Metropolitan Museum is more than a pity. Each is a representative work of its kind. I have seen very few finer Vandycks abroad. I know of no Troyon to equal this one, and the Courbet is far and away ahead of any of his pictures of the figure, not excepting those which belong to the French Government. . . .[3]

After admiring his favorite paintings by the men of 1830 and by the English school —notably Reynolds, Romney, and Hogarth—Trumble proceeded to the work of the Impressionists:

Of examples of the most modern school of France there is never any lack in these galleries. The apostles of the gospel of light have as good a friend in M. Durand-Ruel to-day as those of the gospel of romance had years ago. It is scarcely necessary for me to say at this period of *The Collector*'s existence, that I do not bolt their

gospel whole. As far as I am concerned they ask me to swallow too much. But in spite of the extremes to which they run, there are times when their note is resonant and true.

Trumble's opinion was indicative of the prevailing American attitude: the Impressionists should be approached with caution, for it was too soon to know whether the work of these artists would prove to be of value in the marketplace.

Most wealthy American patrons continued to invest heavily in the art of the fashionable schools and included—if any—only a token representation of the Impressionists in their collections. Georges Sedelmeyer, another French dealer interviewed for the Paris *Herald* by the same reporter as Durand-Ruel had been, was also asked about the pictures most sought by American buyers; he mentioned first the early English school and next the Dutch masters of the seventeenth century. The interview concluded as follows: " 'And the impressionists, M. Sedelmeyer?' But M. Sedelmeyer was reserved, though he vaguely hinted something about impressionism being an incomplete expression."[4] Indeed, Georges Sedelmeyer was too busy selling expensive pictures to rich clients to care whether or not Impressionism was gaining ground in America. Emile Zola gave a description of Sedelmeyer in the notes for his novel *L'Oeuvre*, published in 1886, and since then the dealer's manner of operating had not changed at all:

> Sedelmeyer.—the last word. Has a town house, elegantly furnished, the ultimate chic. Often works on only one painting at a time. . . . Then there is the killing with Americans. Vanderbilt comes to see him.—Don't you have anything new?— No, sir, you have seen all that I have, a few paintings (very few, very fashionable, placed in luxurious rooms). Then he adds confidentially: I do have one that no one has seen, but it is too expensive.—Vanderbilt, piqued: "What do you mean too expensive! Show it to me." And he is shown a painting by an Italian or a Spanish painter, an unknown, which is teeming with hundreds of little figures, well done, very pretty, sparkling. Something specifically for him, which delights him.—How much?—Two hundred and fifty thousand francs.—The American makes a face.— I told you so!—But that evening Vanderbilt orders that the painting be sent to him. It flatters an American's vanity to be able to say that he bought, within the year, the most expensive painting. An American built a museum over there for 13 million. It is now being filled with masterpieces by way of money. All the best paintings are liable to be dispatched to America.[5]*

Zola was doubtless referring to William Henry Vanderbilt, who, between 1874 and 1885 (the year of his death), spent $1,500,000 on his collection of over one hundred paintings —mostly French academic-realist—which hung one on top of the other in the large picture gallery of his mansion at 640 Fifth Avenue.

In contrast to the voracious American millionaires whose mania for outspending each other in their purchases of old masters began to be ridiculed in Europe, the Havemeyers were not only discreet in their acquisitions, but also had the courage to pursue a different path. Their collection reflected a point of view that was unique; Louisine and Harry had come to regard certain of the modern works as extensions of

their old master paintings. From early on, their mentor Mary Cassatt had nurtured and encouraged this concept: "To make a great collection it is necessary to have the modern note in it, and to be a great painter, you must be classic as well as modern."[6] Courbet, Manet, and Degas—unquestionably Cassatt's and Louisine's favorites—were seen as decendants of the major artists of the realist tradition. Cassatt repeatedly emphasized the link between Courbet and Rembrandt: "The man who comes nearest to Rembrandt in modern times is Courbet. . . . He had that large noble touch which is so characteristic of Rembrandt. Not that I think he was so great but they seem to me to arouse the same artistic sensations, though perhaps not to the same degree."[7] Degas's draftsmanship was often compared to that of his classic predecessors; Louisine also saw similiarities between Manet and Paul Veronese, "the father of impressionism in renaissance Venice."[8] For her the conclusive test of the worth of a contemporary work was to hang it beside an old master painting to see if it held its own in such company. But she also appreciated the bold innovative endeavors of subject, composition, and technique in the canvases of the moderns.

Under the constant tutelage of his wife and Mary Cassatt, Harry Havemeyer underwent an evolution of perception; his taste changed to the point where he began to give second place to his purchases of paintings by older masters. The year 1895 was a turning point in the collection of the Havemeyers, when Louisine became the guiding spirit behind their selections. But with characteristic modesty she later wrote in her *Memoirs:* "Miss Cassatt was ever ready to recommend, Mr. Havemeyer to buy, and I to find a place for the pictures in our gallery."[9] The next two years saw acquisitions of more works by Manet and Courbet, and especially by Degas. These pictures—bought in both New York and Paris—ranged in subject from nudes to ballet dancers, from portraits to wooded landscapes. Although Harry was rather hesitant, Louisine encouraged him to choose what he liked, recalling the time when Harry, while still "feeling his way" with Manet, picked two small canvases by him: *Manet's Family Home in Arcachon* (Plate 63) and *Roses in a Crystal Vase* (Plate 64). She went on to say about the still life: "The color is cool and transparent and the delicate petals tremble and quiver; one has fallen off and lies beside the vase. It is a little bit of art such as an amateur prizes as a precious thing and would not part with ever."[10]

While Harry preferred Courbet's landscapes, the more adventurous Louisine was attracted to the artist's nudes; she had coveted them ever since Mary Cassatt had told the young Miss Elder that Courbet's females represented the ultimate technique in flesh painting. To obtain *Torso of a Woman* (see Plate 31), her first nude by Courbet, Louisine had had to wage a major campaign against her husband, but the second time things were easier, for he had meanwhile succumbed to the charms of the fleshy girl holding on to a blossoming branch. Early in 1893 the Durand-Ruels had sent Courbet's *The Woman in the Waves* (Plate 65) to their New York gallery. Louisine was fascinated by this painting of a sensuous young woman; after several years of subtle strategy, she managed to convince her husband that since they already owned one Courbet nude, they might as well have two. Refined Victorian lady that she was, Louisine could transcend strict morality when defending her right to possess a slightly lascivious painting by an artist she admired. She really did not care what the "anti-nudists" thought; her own opinion was that Courbet's nudes were "realistic and frank, but never vulgar."[11] She had no

patience with those who failed to see aesthetic merit in such works as *The Woman in the Waves:* "How often have I heard pseudo-artists inquire with the tone of their voice pointing interrogation points as a musician would handle his staccato: 'Isn't that arm slightly out of drawing?' 'Surely,' someone once answered such a question. 'But you see, it is unusual to find an elbow in a marine.' "[12]

Husband and wife shared a deep admiration for Courbet's portraits. They had recently acquired the likeness of Monsieur Suisse (Plate 66), a former model who had established a Paris studio known as the Académie Suisse, where he employed live models and charged modest fees to the artists. Harry must have been riveted by his intelligent, penetrating eyes, gazing directly out from behind his spectacles and revealing the strength of his character and personality. Louisine's romantic nature was also nourished by this picture: "Ah, the good Suisse could have told . . . of the agonies of producing, of the hardships of an artist's life, and often have I cast glances of appreciation at the good man, whose protégé tried to express his gratitude to his friend by making him one of his finest portraits."[13]

Harry seemed now to develop an even stronger preference for portrait painting than before, no matter in what school or period. The collection would eventually contain more studies of single figures than of any other subject. Apparently it was Harry's practice to spend a long time in front of a favorite portrait, carefully contemplating every detail. After scrutinizing the execution, he would proceed to what gave him the greatest pleasure: the vivid realism the work conveyed. In Harry's aesthetic code, realism was equated with truth and truth with beauty. He delighted in the knowledge that the person depicted had once lived and breathed, and tried to imagine the kind of existence he or she had led. When a portrait was exceptionally fine, Harry experienced a communication with the very spirit of the likeness he was studying so intently; in some instances he even identified with the sitter. His wife also had a predilection for figure pieces; she felt that they reflected the mores of the society which had produced the artist himself. It might have been her early indoctrination by Mary Cassatt which instilled this attitude in Louisine; figures were all-important for Cassatt, and landscapes were to be used only for backgrounds.

During the second half of the 1890s, the Havemeyers made it their habit to take annual trips abroad. In the spring of 1896 Cassatt used the occasion of Louisine's presence in France to begin a portrait of her friend (Plate 67); since this pastel study would not be completed by the time of Louisine's departure, the artist requested a photograph from which to finish it. Cassatt experienced great difficulty in trying to capture the essence of Louisine at age forty. Perhaps she tried too hard, struggling for a result that she realized she never achieved. A much more successful portrait in pastel would be that of Louisine's daughter Adaline in a white hat (Plate 68; page 114), made in 1898–99, when the sitter was fourteen to fifteen years old. Cassatt chose to portray Adaline with her full sensuous lips parted, and discreetly left out the prominent mole on her chin.

For Louisine, the highlights of these European visits were doubtless their picture-buying expeditions in the company of Mary Cassatt. In her *Memoirs* she related in great detail one such foray concerning a work by Degas that was instigated by Arsène Portier, the unassuming dealer better described as an agent or middleman. She had much

*Adaline Havemeyer, age 14–15 (?),
wearing the white hat in which she posed for
Mary Cassatt in 1898–99 (Plate 68). The artist
was so pleased with the portrait that she kept
it for years, finally sending it to Adaline's
daughter to show her how her mother had
looked as a young girl. Photograph
courtesy of J. Watson Webb, Jr.*

*Above: Louisine Havemeyer, age 40,
photographed by her children Adaline and
Horace on May 29, 1896. Photograph
courtesy of J. Watson Webb, Jr.*

*Left: Edgar Degas, age 61–62 (?),
1895–96. Degas was the only French
Impressionist painter with whom the
Havemeyers were well acquainted.
Photograph courtesy of John Rewald*

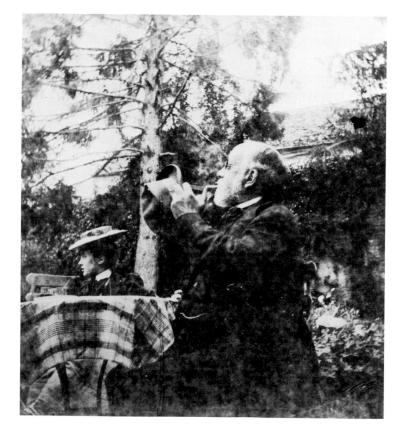

sympathy for Portier and liked his manner of negotiating for a picture while it was still in the hands of the owner, preferring this to buying from a well-known gallery since the excitement was higher and the price considerably reduced. Louisine relished the pursuit of a particular work:

> I recall an interesting afternoon when Portier came to our hotel [the Havemeyers usually stayed at the Crillon in Paris] and proposed that we should go see a Degas, one that the owner "might possibly part with for a price. . . ."
> "What is it?" asked Miss Cassatt keenly.
> "A portrait," answered Portier.
> "The Taigny portrait [Plate 69]," replied Miss Cassatt quickly.
> "Précisément," rejoined Portier.
> "Of course we will go see it," said Miss Cassatt energetically. "It is one of the best things Degas ever did, one of the greatest portraits Degas ever painted. His cousin sat for it and it is like a primitive."
> One could speak his mind before Portier, and we were soon driving to a distant part of Paris where we found one of the most exquisite portraits I have ever seen. It was as if the hand had been eliminated from the production and the mind of the painter had transferred it directly to the canvas. It was, as Miss Cassatt had said, a modern primitive, pure in line, delicate in color and entrancing in its harmonious perfection. Probably suggested by Degas's admiration of [Maurice Quentin de] La Tour, it is just the head and neck done upon gray paper, and then, as if it pleased his fancy, he traced another outline of the same face in an upper corner of the picture, in a way that does not appear strange to anyone familiar with the drawings of Leonardo da Vinci. We lost no time in letting Portier know we approved of it, a fact which immediately delighted the good man who had true artistic instincts and perceptions himself, and delighted to please Miss Cassatt and Mr. Havemeyer, and he told us the price—"Dix mille francs!" he said—two thousand dollars! said Portier timidly. Miss Cassatt, who was accustomed to the old prices, uttered an exclamation. "All right we'll take it," said Mr. Havemeyer promptly, and the affair was concluded. Ah! how many a picture was bought in the same decided way and how many a dollar was saved by doing so.[14]

It was again Portier who escorted Louisine and Harry to a suburban villa, whose occupants owned, among other fine pictures, Manet's portrait of the Irish critic and writer George Moore (1852–1933; Plate 70). Astonished that Portier had managed to locate such a masterpiece, Cassatt quickly explained to the Havemeyers the cause for her excitement:

> "George Moore," she said, "painted a little [Moore had enrolled in classes at the Ecole des Beaux-Arts and later at the Académie Julian before deciding to devote himself to writing], he went to his friends, he even boasted to me, that Manet had invited him to come work in his studio. I was surprised at Manet's doing such a thing, but when I saw the portrait I understood it all. While George Moore was studying in Manet's studio, Manet was studying George Moore and painting a

portrait of him. . . . He did George Moore for all time, . . . Of course, George Moore did not like it and said horrid things about it to me. . . ."15

Louisine and Harry were overwhelmed by this likeness in pastel of the slightly eccentric-looking writer, executed in one sitting in 1879. Harry requested the price and again the reluctant Portier quoted 10,000 francs; without a moment's hesitation, Harry agreed to it. Earlier on that same afternoon, Portier had accompanied the Havemeyers to the home of the Parisian dentist and collector George Viau, from whom they bought a pastel of two dancers by Degas (Plate 71).

Sara Hallowell's activities as an art agent in Paris—she had settled in France not long after the close of the Chicago World's Fair—also brought her into contact with Portier, with whom she occasionally worked. In a letter offering an old master painting to Harry, Hallowell enclosed a message from her colleague:

> In conclusion, I have promised Mr. Portier to tell you of a charming little pastel by Degas which he has. This was painted many years ago and is indeed a little pearl. It is a dancer who holds a bouquet as she salutes her audience. The background is that of the café-concert, I should say, having an open-air landscape effect. The face is vaguely painted, leaving the type to your own imagination, I suppose. For this he asks the reasonable price of 4,000 francs [about $800].16

Louisine and Harry subsequently purchased the pastel.

The Havemeyers had been consistently acquiring works by Degas. Louisine recollected: "Almost all were bought about the time Degas painted them; many were purchased through Durand-Ruel, and others recommended by Miss Cassatt who watched their execution in the studio or saw them in the various exhibitions."17 In 1889 Cassatt had presented Louisine with a monotype by Degas of a nude girl putting on her stocking. Since Cassatt greatly admired Degas's nudes, she was constantly on the lookout for exceptional ones for Louisine to buy. The Havemeyers paid many calls on Degas, usually in the company of Mary Cassatt. Sometimes their visits resulted in acquisitions, such as when they left his studio with three superb drawings on pink paper of ballet dancers. Louisine later wrote about one of these, a little girl practicing at the bar, executed in charcoal and white chalk: "Miss Cassatt persuaded him [Degas] one day we were in his studio to take it from his portfolio and sign it and let us have it. He did so reluctantly."18 Louisine kept the three drawings in a portfolio under the sofa in her upstairs sitting room.

In her *Memoirs,* Louisine gave a description of Degas: "I thought him a dignified-looking man of medium height, a compact figure, well dressed, rather dark and with fine eyes. There was nothing of the artistic *négligé* about him, on the contrary he rather impressed me as a man of the world."19 Degas seems to have been the only French Impressionist whom the Havemeyers knew well. Apparently they had no desire to meet Mary Cassatt's other painter-friends, who may have been too bohemian for their taste, though it seems that they visited Monet in Giverny in 1895. Or perhaps the Havemeyers wished to avoid the role of omnipotent American collectors, whose very presence would arouse intense excitement or even anxiety. The more aristocratic Degas, on the other

hand, was not awed by Louisine and Harry, nor did they feel obligated to make any purchases on their visits.

As far as Harry was concerned, it was fine for his wife to have her fun bargain-hunting, but for more substantial acquisitions, he preferred to deal with Durand-Ruel. Ever since Harry's loss of Courbet's *Landscape with Deer* at the Secrétan sale, Durand-Ruel had a standing request to find him exceptional Courbet landscapes. Recently the dealer had secured for him Courbet's splendid grotto picture, *The Source of the Loue* (Plate 72). During the Havemeyers' European visit in the fall of 1897, Durand-Ruel was trying to obtain a lush forest scene, *The Stream,* but there was a competitor for this landscape, another American collector. Charles Tyson Yerkes, the flamboyant Chicago transportation magnate and wheeler-dealer who bought pictures on a grand scale, also had his eye on it. From London Harry wrote to Durand-Ruel on September 22, 1897: "If you do not buy the Courbet for Mr. Yerkes you may buy it for me up to 50,000 francs." Durand-Ruel did purchase the landscape on October 15, 1897, and four days later sold it to Harry rather than to Yerkes, although the price of 66,950 francs ($13,390) was higher than Harry had anticipated.

Paul Durand-Ruel was responsible for bringing two portraits by Goya to the Havemeyers' attention while they were in Paris that September. Knowing of their love for portraiture, he was sure that they would respond to the work of Goya, that master of psychological and sociological studies of character. Louisine and Harry were indeed dazzled by Goya's likenesses of Don Bartolomé Sureda and his wife (Plates 73, 74), acquiring the pair for slightly less than $8,500, with Mary Cassatt's enthusiastic approval. This purchase marked the beginning of the Havemeyers' interest in Spanish painting which would continuously increase, leading to their buying other remarkable works by Goya (mostly portraits) as well as by El Greco. Later Louisine took great pride in their having been pioneers in collecting Spanish art: "We were, so to speak, to open the market for Grecos and Goyas, at least in the United States."[20]

For the past four years, Louisine and Harry had intermittently been obtaining landscapes by Monet, the only pure *plein-airist* to whom they were really committed. Durand-Ruel was usually their source for these works, but occasionally they acquired them at auction or from other dealers. In Paris on September 23, 1897, they purchased Monet's *Ice Floes, Bennecourt* (Plate 75) from I. Montaignac, who had formerly been the Paris representative of the American Art Association. Louisine and Harry had bought another of Monet's ice floes paintings earlier that year from Durand-Ruel, and in September, at the same time they acquired from him Goya's Sureda portraits, also a version of Monet's *La Grenouillère* (Plate 76). Monet's depiction of this pleasure-spot for boating and bathing at Bougival on the Seine River was among the most light-hearted and carefree pictures to enter the Havemeyers' collection; their only other recreation picture was Manet's *Boating* (see Plate 60).

Apart from a few paintings by Manet and Monet, the Havemeyers did not care in general for the cheerful, unproblematical world of vacationists, of simple rural settings, or of the pleasant everyday life on Parisian boulevards as represented by Renoir, Sisley, and Pissarro. Louisine's dislike for Renoir's paintings would develop in intensity while she remained lukewarm to the other two artists, even though Pissarro was a close associate of Mary Cassatt's. Before her marriage, Louisine had bought one of Pissarro's

works, but she may have been unable to convince her husband to purchase additional pictures by him. In all likelihood Harry considered Pissarro's paintings a poor investment, although both Cassatt and Durand-Ruel tried repeatedly to arouse his interest. Indeed, Durand-Ruel found Pissarro the most difficult of the Impressionists to promote.

Unlike some wealthy picture buyers who had agents assemble entire collections on their behalf, the Havemeyers carefully considered each work of art before their decision was reached. Louisine and Harry could not be pushed into an acquisition that did not have meaning for them, or the price of which was too steep. This independence was both their strength and their weakness: each had a superb eye for quality and deserves credit for the consistently high level of taste evident throughout their collection, but they sometimes passed up great works that Durand-Ruel or Cassatt fervently urged them to buy, only to deeply regret it later on. Subsequently Louisine even went after paintings that she could once have bought for a fraction of their current prices. Like all great collectors, the Havemeyers had their share of triumphs and disappointments.

Harry, although never asked to serve on the board of trustees of the Metropolitan Museum, continued through the 1890s to make donations of works of art to that institution. In March 1893 he and the banker Henry Marquand, art patron and president of the museum, attended a sale of Samuel Colman's paintings and watercolors at the Fifth Avenue Galleries, where he purchased for $700 Colman's large oil *Spanish Peaks, Southern Colorado* in order to present it to the Metropolitan Museum. Sometime in 1896 Louisine gave the museum a choice selection of 159 fragments of old Chinese and Japanese silks and brocades. On December 8 of that year Harry wrote to Mr. Marquand: "Since the Tiffany Glass Co. have been making favrile glass Mr. Louis Tiffany has set aside the finest pieces of their production, which I have acquired for what I consider to be their artistic value. Their number now is such that I am disposed to offer the collection, which is one of rare beauty, to the Metropolitan Museum of Art."[21] Harry's generous gift of fifty-six objects dated between 1893 and 1896 was delivered to the museum one month later. Shortly thereafter Tiffany himself made the arrangements for a special exhibition of his iridescent glass specimens at the museum.

As always, Harry was pursuing his business activities and his art interests simultaneously, but when business pressures reached crisis proportions, art buying slacked off. This happened at certain times during 1897, just as it had in the spring of 1894; his Sugar Trust came repeatedly under attack, and Harry, as its president, was called to its defense. A strong fighter who loved a good battle, he was well equipped to take the witness stand in February and again in May. On the first occasion he was summoned by a special New York State legislative committee, chaired by Senator Lexow from Nyack, that was investigating the affairs of the American Sugar Refining Company, "which stood second to Standard Oil as a successful consolidation of corporations engaged in the same industry."[22]

Harry took his habitual defense under questioning: that his trust was not a monopoly whose object was to destroy competition, that it had lowered the price of sugar for the consumer, and that its initial organization had caused the loss of few jobs. He also denied that his company had been incorporated in New Jersey in 1891 for the sole purpose of avoiding taxes, and he denounced the investigation as a form of persecution.

He was a particularly combative witness, as reported by the *New York Herald:* "At times he displayed some warmth, raising his voice until it could be heard in the hallway. His bearing and manner indicated that he was not at all afraid of what the committee might do."[23] The opening session drew a crowd which filled the Common Council Chamber of the City Hall, and the proceedings were given considerable press coverage. The artist William Glackens made two drawings for the *New York Herald,* illustrating Senator Lexow, various clerks and lawyers, and the chief witnesses, H. O. Havemeyer and his brother Theodore.

Harry's belligerent claims that only a small number of men had been thrown out of work when his American Sugar Refining Company was formed led to legal action against him, as reported by the *New York Tribune:*

> John Bergen, of No. 62 South Tenth Street, has brought suit for $10,000 damages for slander and libel against Henry O. Havemeyer, President of the Sugar Trust. Bergen was formerly a foreman on the wharves of the sugar company. Notice has been served, and an answer put in by John A. Parsons, counsel for Mr. Havemeyer. The complaint is based upon an alleged utterance of Havemeyer in the recent Senate investigation. Bergen, when placed on the stand, stated that there were thrown out of employment from the closing of sugar houses in 1886 between five thousand and six thousand men. President Havemeyer was reported as saying in the courtroom, "what a liar, . . ." and later, "that man is a bigger liar than he looks. . . ."[24]

But that was not all. In May 1897, more than two and a half years since his indictment, Harry was brought to trial for contempt of court because he had refused to answer the questions of a U.S. Senate investigating committee about the exact amounts his company had donated to national and state political campaigns in 1892 and 1893. Another aspect of these charges was whether or not his firm's campaign contributions had been intended to "buy" the votes of some senators for legislation favorable to the interests of the American Sugar Refining Company. This trial took place in the Criminal Court of the City Hall, Washington, D.C. The district attorney conducted the case on behalf of the United States; the defendant, Harry Havemeyer, had hired the services of a team of well-known lawyers, among whom was John Graver Johnson (1841–1917) of Philadelphia.

The contest was a heated one. The district attorney described the Sugar Trust as "a conscienceless octopus reaching from coast to coast, using the leverage of its power in politics, by the admittance of its President as a Republican in Republican States and as a Democrat in Democrat States."[25] The strategy of the defense was to show that Mr. Havemeyer had answered all relevant inquiries and that his refusal to furnish specific data concerning contributions to political campaigns was a matter beyond the committee's jurisdiction. Mr. Johnson made an exhaustive argument on behalf of his client, insisting that the questions put to Mr. Havemeyer were as "impertinent as if he had been asked how many children or how much money he was possessed of." With the skill of an accomplished actor, Mr. Johnson "spoke contemptuously of the indictment as being fuller of innuendo than the most libellous newspaper and denounced the framer of the questions Mr. Havemeyer declined to answer. 'No man,' he said, 'had a right to

frame a question for the purpose of experimenting with the witness and forcing him into recusancy.' "[26]

The trial lasted for three days; on May 27 there was breathless suspense as to its outcome. The reporters delighted in details such as, "The room buzzed with speculation as to what the decision would be. Just before the judge entered, a little girl ran over to Mr. Havemeyer and said she wanted to shake his hand. The sugar magnate took her in his arms and kissed her. He then put her down and she ran back to her mother. 'I don't know who the child is,' said Mr. Havemeyer to his attorney, Mr. Parsons, 'but I think it is a good omen.' "[27] Harry was found not guilty, and the indictment was dismissed on the grounds that the questions of the Senate committee had been properly answered. The consummate skill of the defense's legal team, particularly that of chief counsel John G. Johnson, was given credit for the favorable verdict. Harry and his attorneys were elated. "Certainly it is satisfactory to me, and to every decent man in this and every other community," was Harry's only comment to the press about the court's decision.[28]

This was not the first time that Harry had engaged the services of John G. Johnson, the country's leading corporation lawyer and a fellow patron of the arts. Earlier in the 1890s, when the issue of whether or not the Sugar Trust was a monopoly had been argued before the U.S. Supreme Court, Johnson had presented a successful defense; indeed, the Court had ruled that the American Sugar Refining Company did not restrict others from going into the sugar business and therefore was not a monopoly. Delighted with the favorable outcome, Harry had expected to pay his chief counsel a handsome fee, but Johnson was always unpredictable in charging for his services; his bills were either very high or very low, based on how long it took him to master a particular case. He could well afford his indifference to accepted standards of the legal profession, since he virtually had a monopoly himself: for close to twenty years he had played a major role in almost every important case in corporation law that came to the Supreme Court. His clients were the richest concerns in America, including Standard Oil, J. P. Morgan and Co., the United States Steel Corporation, the Amalgamated Copper Company, the Pennsylvania Railroad, and other great corporations, as well as numerous banks. For his brilliant defense of the Sugar Trust, Johnson could have asked any fee he chose, but according to a story told in legal circles, he charged the "Sugar King" the meager sum of $3,000 and, in addition, a picture from the Havemeyers' collection. Harry insisted on paying his attorney $100,000 rather than give up a painting. John G. Johnson was exceedingly displeased.

Between Harry's two courtroom appearances in February and May 1897, he had suffered the loss of his older brother Theodore, who died suddenly from a severe influenza on April 26 at the age of fifty-eight. Five hours before his death, he had called for a priest and been baptized into the Roman Catholic faith, the religion of his wife. Theodore Augustus Havemeyer, vice president and supervisor of the production end of the American Sugar Refining Company, had always been the quiet support of his more audacious brother. By nature less aggressive and abrupt than Harry, he was widely admired for his cultivated manners. In contrast to Louisine and Harry, Theodore and his Austrian-born wife, Emilie, were prominent in society; their entertainments were

frequent and lavish. For twenty-five years Theodore had been the honorary consul general of Austria-Hungary in New York, succeeding his father-in-law in the post after the latter's death. In addition to their mansion at Madison Avenue and 38th Street, and their large farm at Mahwah, New Jersey, famous for its blooded cattle, Theodore and Emilie owned a handsome summer residence at Newport.

Theodore Havemeyer was a tall, athletic man with snowy whiskers and a smiling countenance, whereas Harry's imposing bulk was matched by his rather grim and determined expression. During the numerous wrangles of the Sugar Trust with legislative committees, Theodore had been both frank and agreeable to the investigators, not antagonizing them as the more insolent Harry often did. Harry must have deeply missed the daily presence of his brother, his closest business associate and confidant.

As involved as he was with art purchases and the Sugar Trust, Harry also had extensive interests in real estate, as a commercial venture and a hobby as well. Among his substantial urban holdings were the St. Paul Building at Broadway and Ann Street, the Havemeyer Building at Cortland and Church streets, and valuable property on Broad Street. He had most recently purchased one hundred acres of land on Long Island, south of Islip, consisting of a sandy stretch of beach known as Bayberry Point on the shore of Great South Bay. It was his grandiose plan to develop this property into a "modern Venice" by creating sites for twelve villas along two large canals that gave each villa direct water access to the bay. The cost of the first step—digging and dredging out the canals—was estimated at close to $300,000. For the site of his own house Harry had chosen the extreme southwest corner overlooking Great South Bay. The plan for the construction of the villas was described in a Sunday supplement of the *New York Times* in May 1897:

> All of them will be of Venetian design, similar to that of Mr. Havemeyer's house, but they will also conform to the general features of the landscape, in that they will be broad and low, not over two stories in height, and wholly without the clusters of pinnacles, turrets, and cupolas which are so often a feature of summer homes by the sea. Broad porticoes will replace the conventional veranda or piazza. The villas will be covered with staff, the material used for the World's Fair buildings, with the natural wood of the timbers showing in places. A feature of the structures will be their small cost. Mr. Havemeyer's house will be erected for $11,000, an insignificant sum in view of the amounts frequently expended on such places by wealthy men. . . .[29]

Harry took pride in his concept of a "modern Venice" and hoped to have the grounds laid out and a few villas ready for occupancy by the season of 1898. He considered absurd the fortunes spent on palatial summer residences at fashionable resorts such as Newport (shunned by Louisine and Harry), and wanted to provide an attractive alternative at a fraction of the price.

In 1897 Harry had been even busier than usual, the year crammed with events and activities ranging from important art purchases, heated sessions on the witness stand, and real estate ventures to the deep sorrow of losing his brother. Early in November he underwent surgery for appendicitis; he was dangerously ill before the diagnosis was

made and the operation performed. The very fact that Harry was in poor health caused a drop in the common stock of the American Sugar Refining Company. However, his operation was successful. After recuperating for several weeks at "Hilltop" in Connecticut, he returned to his desk at 117 Wall Street. The next two years would see him back in full swing, extending himself again on many fronts, particularly in the world of art where he would continue to widen the scope of his taste and broaden his horizons as a collector.

Mary Cassatt in America; Additional Purchases

Harry Havemeyer's growing appreciation for modern French painting had reached the point where he was now eager to share it with one of his closest friends, Colonel Oliver Payne. As Louisine later recalled: "It was during the pleasant evenings we spent together in the early years of our acquaintance that I think the Colonel began to take an interest in pictures."[1] Actually Oliver Payne had already begun a collection of fashionable European Salon paintings before he occupied his mansion next door to the Havemeyers, but once he was their neighbor, Harry, as Louisine put it, would often "suggest a fine picture to him or even let him have one he [himself] had intended to buy, and I have frequently heard Colonel Payne say that he owed many of his finest canvases to Mr. Havemeyer's advice and generosity."[2]

Oliver Hazard Payne was the son of United States Senator Henry Payne of Cleveland and brother-in-law of William Whitney, who had married Payne's sister Flora. A Civil War veteran, oil multimillionaire, and member of several trusts, Colonel Payne was a man of conservative tastes; in art he preferred traditional paintings to which he could easily relate. A letter from Paul Durand-Ruel to Harry Havemeyer, dated August 1896, describes the kind of works Colonel Payne was then purchasing: "I send you to-day by mail a photograph of a picture by DeTroy [an eighteenth-century French portraitist]. I thought that the picture may please Colonel Payne as I know he wants the picture of a pretty woman. If the face of this one, according to the photograph pleases him, we may have the picture sent to New York on approval so that he can see its qualities before buying it."

But Harry, not having the patience of his wife and Mary Cassatt, undertook to accelerate the development of his friend's aesthetic comprehension by purchasing out-

right a number of paintings on his behalf. Since the Colonel, though a confirmed bachelor, was susceptible to the charm of pretty women, Harry felt that he would be better off with feminine subjects by a more "modern" artist, such as Corot. It was probably Mary Cassatt who suggested that Harry ask Sara Hallowell to try to secure a few figure pieces by that master.

Hallowell had decided in the spring of 1894 to live permanently abroad, leaving for Europe with her reputation established as a respected and discriminating critic and an accomplished organizer of exhibitions. The Art Institute of Chicago had appointed her its official foreign agent (as had the museums of St. Louis, Philadelphia, and Boston) with the primary task of sending back the best pictures she could find by American expatriate artists, for display at the Art Institute's annual American Exhibition. The *New York Times* later described Hallowell's role: "The duties and responsibilities of her position are unique. She personally interviews the American painters in Paris, passes judgment on their work, selects the canvases she would have sent to America, then supervises their packing and transportation to this country."[3]

In spite of her job representing American museums, Sara Hallowell was hard pressed financially. The property in the United States owned by her and her mother (who lived with her in France), which had brought in a modest income, had dropped in value during the depression of 1893. Hallowell was grinding out newspaper articles to earn a little extra money, but, hoping to find better use for her talents, she addressed the following letter to Paul Durand-Ruel from Puteaux, a distant Paris suburb, on August 14, 1894:

Dear Mr. Durand-Ruel:—

Apropos of our conversation of a few years ago, I am now anxious to make some business arrangement by which, in making my services available, I can myself profit by my experience and wide acquaintance.

I fear the moment is a bad one for my suggestion, but feeling that my time is being consumed so unprofitably—writing, unless one is a genius, which I certainly am not, is starvation—I conclude to ask, can you suggest any thing? Having such respect for you, your sons and your house, in the event of any business arrangement being considered by you, I am compelled to be entirely frank with you. . . .

Deeply interested in my late work, all my energy went into it rather than to my own personal advantage, except in the matter of experience, position, and wide acquaintance and friendship with the first people in our country. This is all the capital I have, but if it is worth any thing, I am ready to use it if a satisfactory arrangement can be made. Living in the country, however, unable to go about freely, to see people in the evening, together with my time being consumed in writing—for so little money—makes it about impossible for me to do any thing in the matter of commissions. I never before realized how tied were one's hands for the want of ready money. . . .

As I would have to go to Paris to live, modestly of course, either in a small hotel—to board—or in a little apartment of my own, you can see that to control

my time, I must have a little income assured me from the first. My family would remain out here for the present.

I am not at all visionary but rather accustomed to look matters squarely in the face and to expect the worst, yet, I believe I could prove myself valuable to you. Presumption on my part, for—I would not speak of this ordinarily—my family and the honored position of my late Father, as well as my past works, are an open sesame for me to all Americans.

If you consider my proposition, I am entirely ready, if it is thought better, to have any connection which may be held with your house made public, only I am compelled to act promptly in the matter and consequently beg of you to let me hear from you as soon as possible. . . .[4]

On August 20, Durand-Ruel answered her proposal:

At the time we discussed the possibility of using your experience for the benefit of our picture business, we were thinking of opening a branch of our New York firm in Chicago. Events that have occurred since then, and especially the considerable increase in our expenses because of the remodeling of our new premises [in New York] have caused us to abandon *for the moment* any idea of establishing ourselves in Chicago. Under these circumstances, I do not see how we can respond favorably to your request. I understand very well your desire to use your time profitably and I think that due to your many contacts in America you could very often serve as an intermediary between your friends and our firm.[5]*

In the same letter the dealer urged Hallowell to continue writing articles to augment her reputation in France. They did not work out any formal arrangement, but Hallowell maintained close ties with the Durand-Ruel gallery. This connection, as well as her friendship with Mary Cassatt, who could recommend her as an agent for American collectors, enabled Hallowell to become an integral part of the Franco-American art world. Eventually her financial situation took a turn for the better, and she moved with her mother to a large seventeenth-century house with a garden on the boulevard Saint-Michel, in the heart of Paris.

As Sara Hallowell developed her connections with European collectors who had pictures to sell, Harry found it advisable to engage her services in trying to acquire several Corot paintings for Colonel Payne. The Durand-Ruels, as it happened, offered Harry the chance in March 1896 to purchase two nudes and one portrait by Corot, all owned by a Belgian *amateur*; Harry did not take advantage of this proposal, but later, realizing his mistake, he asked Sara Hallowell (by then living in a Paris apartment) to deal directly with the Belgian collector. Unaware that Harry was negotiating privately, the Durand-Ruels meanwhile secured the three Corots for a German client who advanced them the money. Extremely disappointed, Harry implored both Hallowell and even the Durand-Ruels to get these paintings back. On January 18, 1897, Joseph Durand-Ruel informed Mr. Havemeyer:

After exchange of several telegrams with him [the German buyer] I sent you a cable telling that I could let you have the pictures at 125,000 francs [$25,000] and that I would take them back at the same price if they did not please you. I am sure to sell them again at the same price if Colonel Payne does not decide to keep them, as they are all three of an extremely fine quality. . . .

We would have bought the pictures long ago if we had the money to pay for them, but we cannot always buy everything fine, having already so much money invested in our stock. You told me that Colonel Payne would not buy any picture without seeing it, while we have almost always to pay for them before we can take them[;] sometimes they remain for sale only for a few days even for a few hours and we have to decide on the spot.

If Colonel Payne would give us commission to buy some extremely fine things we would only propose them if they were really fine and we would always guarantee him against pecuniary loss if they did not please him.

In some cases we may avail ourselves of a quick opportunity to buy a thing a great deal less than the price named by the owner, taking the moment when he is depressed by some circumstances or . . . in immediate need of money. . . .

In the end Colonel Payne decided against the Corot portrait but bought the two nudes. Thus this episode was more or less satisfactorily resolved; Colonel Payne became the owner of two superb paintings: *The Golden Age* (Plate 77) and *Woman and Cupid.* Whereas Corot's silvery landscapes were then highly sought after, his figure studies were less widely appreciated. Harry was so pleased with his purchases on behalf of Colonel Payne that he immediately commissioned Durand-Ruel to buy at the Henri Vever sale on February 2 and 3, 1897, a Corot nude (*Bacchante by the Sea*; Plate 78) for himself. Apparently he was overcoming his negative attitude toward paintings of nudes; moreover, those by Corot were less provocative than those by Courbet.

Not every transaction involving Colonel Payne was quite so complicated. In 1898 Paul Durand-Ruel acquired Degas's *The Dance Lesson* (Plate 79), previously owned by Jean-Baptiste Faure, the well-known baritone of the Paris Opéra and an early French collector of the Impressionists; the dealer warmly recommended to the Havemeyers this exquisite depiction of a class of dancers and their ballet master.

In a magnanimous gesture, Harry decided to relinquish this picture to Colonel Payne, convinced his friend would come to admire Degas's art by living with such an exceptional work. For $25,000 the Colonel purchased *The Dance Lesson,* about which Mary Cassatt wrote to the Havemeyers: "Durand-Ruel just returned from Vienna where he saw a Ver Meer von Delft [probably Vermeer's *A Painter in His Studio*], which he says is beautiful. Two million marks was asked or refused for it, I forget which. Col. Payne's Degas is more beautiful than any Ver Meer I ever saw. Tell him that."[6]

But Harry's strategy did not work as he anticipated. Although grateful to his friend, Colonel Payne remained indifferent to Degas's painting, as later reported by Louisine:

For many a long year afterward, whenever the Colonel dropped in for a neighborly chat he would refer to his indebtedness to Mr. Havemeyer for allowing him to acquire the picture. After my husband's death the Colonel and I were looking at

the *Foyer* [*The Dance Lesson*] and the Colonel said to me: "Your husband knew that I did not appreciate Degas as he did, but he knew that I could not do it. One day as we were looking at it together, he began telling me what a wonderful picture it was and trying to convince me how great Degas was. I don't know just what I said or did, but suddenly he stopped and said: 'Don't let us talk any more about it.' I fear I disappointed him; Mr. Havemeyer spoke very gently but there was something about him that struck me as unusual."

I knew, for Mr. Havemeyer said to me several times: "If ever you have a chance, get that picture back. The Colonel does not care for it and would rather buy one of the English school." The Colonel promised I should have it back but alas, he never let me have it![7]

Colonel Payne's first purchase of a work by Degas and the Havemeyers' numerous acquisitions were not the only important artistic events of 1898. Early in that year the "godmother" of the Havemeyer collection, Mary Cassatt, arrived in America for the first time in more than two decades. Having decided that she should see her native land once more, she sailed for New York at the end of December 1897. On January 4, 1898, Philadelphia's *Public Ledger,* in a column called "New York Letter," printed the following notice:

Among the arrivals on the Bretagne to-day was Miss Mary Cassatt, who has lived and studied art abroad for many years. She left for Philadelphia, where she will visit her family. Miss Cassatt's portraits—usually of women and children—are well known to lovers of art. She began her art studies in Philadelphia, but for many years has lived abroad, studying under Degas and influenced by the technique of Manet and Claude Monet.[8]

On January 14, from her brother Gardner's town house at 1418 Spruce Street, Philadelphia, Mary Cassatt wrote to her painter-friend in Boston:

My Dear Miss Lamb,

Your very kind letter reached me in Paris just as I was about to leave for this country. I have been here about ten days & so flurried & hurried that I am only now beginning to take possession of myself again. I am a bad sailor and the passage was dreadful.

I lost my Mother two years ago, in October, & was so bereft and so tired of life that I thought I could not live, now I know I must & I am here to see quite a new world & renew old ties, & to work. I hope to see you soon, for there is a question of my going to Boston to do a pastel portrait of a child, & I look forward to talks with you with so much interest. I return to France in the spring, I hope to my own place, for we bought a home near Bachivillers before I lost my Mother —& then she died, & only there do I come to life. This is a curious experience to me, after twenty-two years absence everything is so different that I wonder if I really remember anything. . . .[9]

Before leaving for Boston, Mary Cassatt visited the Havemeyers in New York. Louisine must have been delighted to have her dearest friend and mentor as her guest and finally to show Cassatt all the treasures assembled at 1 East 66th Street, which she had never visited before.

Among the two friends' greatest pleasures were expeditions to see paintings by their favorite artists. Louisine took full advantage of the presence of her staunchest ally: she later recalled one such occasion: "Miss Cassatt and I helped Mr. Havemeyer through the ordeal of deciding upon a large Manet by just buying one 'big one' for him ourselves. On a wintry morning [in January 1898] during one of her very rare visits to America, Miss Cassatt and I were taking a walk together and as we passed the Durand-Ruel gallery she suggested we should drop in and see if they had received any new pictures."[10] Joseph Durand-Ruel greeted the two women and did not disappoint them when he produced Manet's *The Port of Calais* (Plate 80). Harris Whittemore had purchased this picture from the Durand-Ruels in 1893, but traded it back for a painting by Whistler. Cassatt, appalled that anyone could prefer Whistler to Manet, urged Louisine strongly not to miss such an opportunity: " 'You must buy it, my dear, Mr. Havemeyer must not lose it.' "[11] Backed by the persuasive Mary Cassatt, Louisine came to a quick decision; she bought *The Port of Calais* on the spot without even consulting her husband. But that was only the half of it; her courage rising, Louisine went a step further, and evidently relished the subsequent episode that she recorded in her *Memoirs:*

> . . . rather elated with my purchase [*The Port of Calais*], I said something that had been on my mind for many a long day. I pointed to Manet's *El Espada* [*A Matador Saluting*; Plate 81]—the bullfighter stands in the ring holding his sword, covered with the red cape, in his hand and doffs his cap, probably to the royal family, before attacking the bull. "I think we ought to buy that picture," I said.
>
> "Why don't you?" quietly rejoined Miss Cassatt.
>
> "I fear Mr. Havemeyer would think it too big," I answered.
>
> "Don't be foolish," said Miss Cassatt. "It is just the size Manet wanted it, and that ought to suffice for Mr. Havemeyer; besides, it is a splendid Manet, and I am sure he will like it if you buy it."
>
> "Very well," I said, "I will buy it, and now let us go home and tell him."
>
> I think we enjoyed "telling Mr. Havemeyer" what we had done quite as much as we had enjoyed buying the pictures. I made a little bow and, imitating his manner, repeated the words he always said when he presented a picture to me. "Mr. Havemeyer," I said, "Manet's *Bullfighter* is yours." He smiled so genially at us that Miss Cassatt said to me quickly: "What did I tell you?" But Mr. Havemeyer, not understanding what she meant, said to me: "It is no doubt a very fine picture, but now, my dear, it is up to you to hang it." Hanging it meant a lot of work which I enjoyed, but I was obliged to change many pictures.[12]

With this purchase of Manet's *A Matador Saluting,* Harry overcame his objections to the artist's large canvases, as Louisine later recalled:

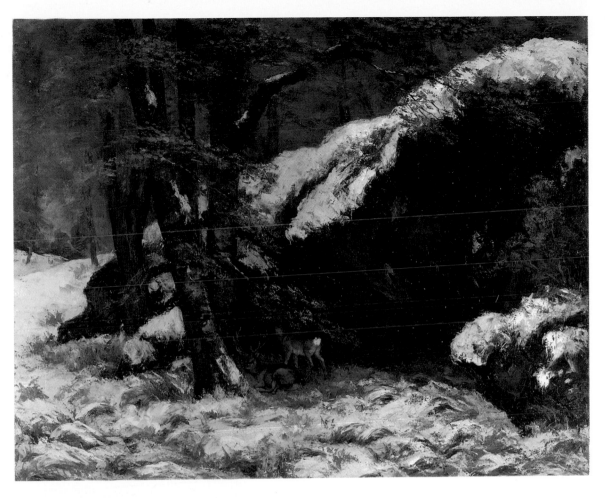

61. GUSTAVE COURBET. *The Deer*. c. 1865. Oil on canvas, 29 3/8 × 36 3/8″. The Metropolitan Museum of Art, New York (Gift of Horace Havemeyer, 1929. The H. O. Havemeyer Collection)

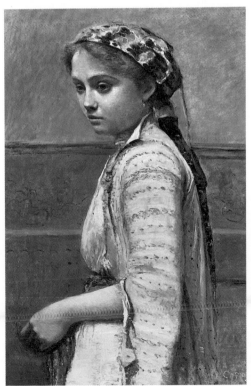

62. CAMILLE COROT. *Greek Girl—Mlle Dobigny*. c. 1868–70. Oil on canvas, 32 3/4 × 21 1/2″. Shelburne Museum, Shelburne, Vt. Formerly owned by Mr. and Mrs. Havemeyer

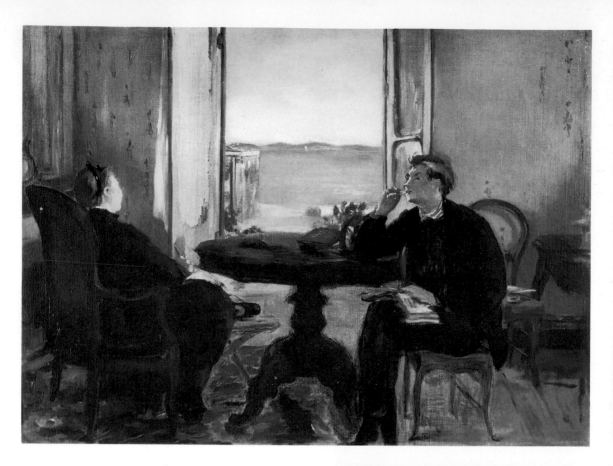

63. EDOUARD MANET. *Manet's Family at Home in Arcachon*. 1871. Oil on canvas, 15 1/2 × 21 1/8″. Sterling and Francine Clark Institute, Williamstown, Mass. Formerly owned by Mr. and Mrs. Havemeyer

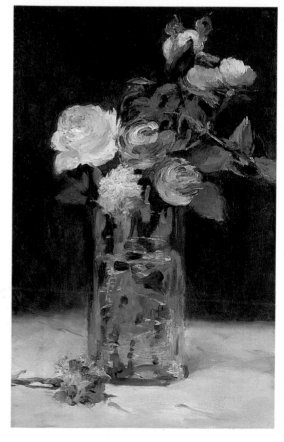

64. EDOUARD MANET. *Roses in a Crystal Vase*. 1883. Oil on canvas, 22 × 13 3/4″. Private Collection, U.S.A. Formerly owned by Mr. and Mrs. Havemeyer

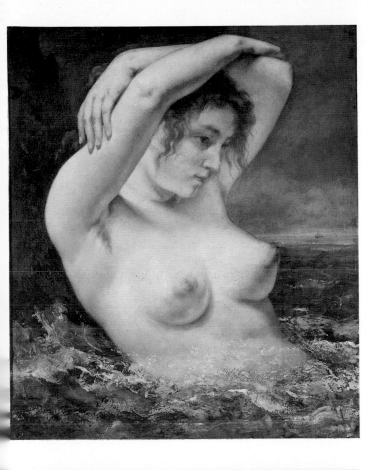

65. GUSTAVE COURBET. *The Woman in the Waves.* 1868. Oil on canvas, 25 3/4 × 21 1/4″. The Metropolitan Museum of Art, New York (Bequest of Mrs. H. O. Havemeyer, 1929. The H. O. Havemeyer Collection)

66. GUSTAVE COURBET. *Monsieur Suisse.* 1861. Oil on canvas, 23 1/4 × 19 3/8″. The Metropolitan Museum of Art, New York (Bequest of Mrs. H. O. Havemeyer, 1929. The H. O. Havemeyer Collection)

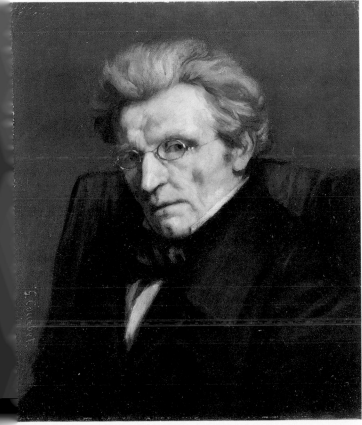

67. MARY CASSATT. (left) *Portrait of Louisine Havemeyer.* c. 1896. Pastel on paper, 29 × 24″. Shelburne Museum, Shelburne, Vt. Formerly owned by Mr. and Mrs. Havemeyer

68. MARY CASSATT. (right) *Portrait of Adaline Havemeyer in a White Hat.* 1898–99. Pastel on paper, 25 1/2 × 21″. Private Collection, U.S.A. (photograph courtesy of Coe Kerr Gallery, New York). Formerly owned by Mr. and Mrs. Havemeyer (see photograph, page 114)

69. EDGAR DEGAS. (left) *Portrait of the Artist's Cousin (Mme René De Gas [Estelle Musson]).* 1873. Pastel on light brown paper, 25 × 22 7/8″. The Metropolitan Museum of Art, New York (Bequest of Mrs. H. O. Havemeyer, 1929. The H. O. Havemeyer Collection)

70. EDOUARD MANET. (right) *Portrait of George Moore.* 1879. Pastel on canvas, 21 3/4 × 13 7/8″. The Metropolitan Museum of Art, New York (Bequest of Mrs. H. O. Havemeyer, 1929. The H. O. Havemeyer Collection)

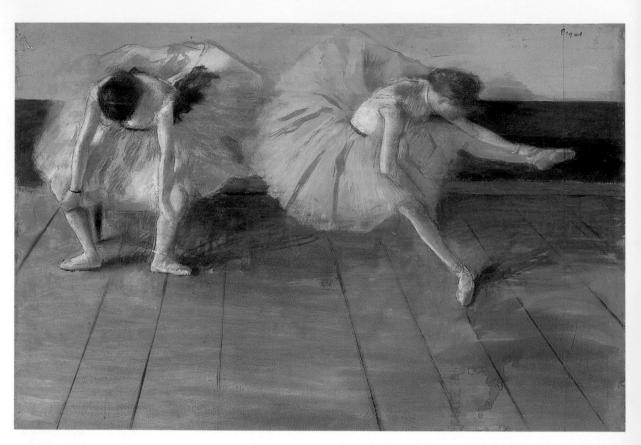

71. EDGAR DEGAS. (left, above) *Two Ballet Girls.* c. 1879. Pastel on paper, 18 1/8 × 26 1/4″. Shelburne Museum, Shelburne, Vt. (photograph by Ken Burris). Formerly owned by Mr. and Mrs. Havemeyer

72. GUSTAVE COURBET. (left, below) *The Source of the Loue.* 1864. Oil on canvas, 39 1/4 × 56″. The Metropolitan Museum of Art, New York (Bequest of Mrs. H. O. Havemeyer, 1929. The H. O. Havemeyer Collection)

73. FRANCISCO DE GOYA. (above, left) *Don Bartolomé Sureda.* c. 1805. Oil on canvas, 47 1/8 × 31 1/4″. National Gallery of Art, Washington, D.C. (Gift of Mr. and Mrs. P. H. B. Frelinghuysen in memory of her father and mother, Mr. and Mrs. H. O. Havemeyer, 1941). Formerly owned by Mr. and Mrs. Havemeyer

74. FRANCISCO DE GOYA. (above, right) *Doña Teresa Sureda.* c. 1805. Oil on canvas, 47 1/8 × 31 1/4″. National Gallery of Art, Washington, D.C. (Gift of Mr. and Mrs. P. H. B. Frelinghuysen in memory of her father and mother, Mr. and Mrs. H. O. Havemeyer, 1941). Formerly owned by Mr. and Mrs. Havemeyer

75. CLAUDE MONET. *Ice Floes, Bennecourt.* 1893. Oil on canvas, 25 1/2 × 39 3/8". Private Collection. Formerly owned by Mr. and Mrs. Havemeyer

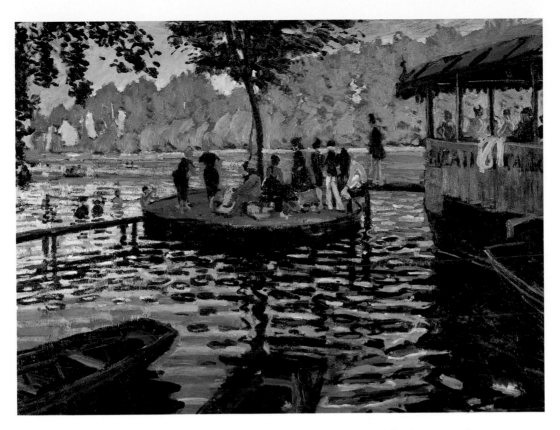

76. CLAUDE MONET. *La Grenouillère*. 1869. Oil on canvas, 29 3/8 × 39 1/4″. The Metropolitan Museum of Art, New York (Bequest of Mrs. H. O. Havemeyer, 1929. The H. O. Havemeyer Collection)

77. CAMILLE COROT. *The Golden Age.* c. 1855–60. Oil on canvas. Present whereabouts unknown (photograph courtesy of Galerie Durand-Ruel, Paris). Formerly owned by Col. Oliver H. Payne

78. CAMILLE COROT. *Bacchante by the Sea.* 1865. Oil on wood, 15 1/4 × 23 3/8″. The Metropolitan Museum of Art, New York (Bequest of Mrs. H. O. Havemeyer, 1929. The H. O. Havemeyer Collection)

79. EDGAR DEGAS. *The Dance Lesson.* c. 1874. Oil on canvas, 32 5/8 × 29 7/8″. Private Collection, New York. Formerly owned by Col. Oliver H. Payne

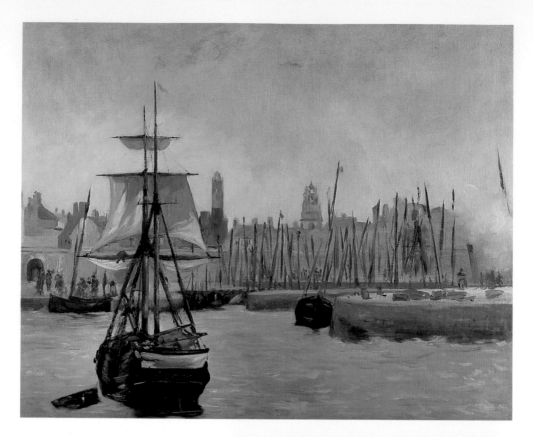

80. EDOUARD MANET. *The Port of Calais.* 1871. Oil on canvas, 32 1/8 × 39 5/8″. Private Collection. Formerly owned by Mr. and Mrs. Havemeyer

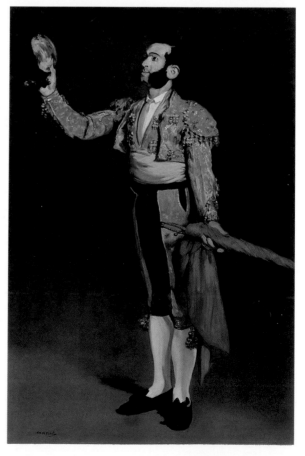

81. EDOUARD MANET. *A Matador Saluting.* 1866 or 1867. Oil on canvas, 67 3/8 × 44 1/2″. The Metropolitan Muscum of Art, New York (Bequest of Mrs. H. O. Havemeyer, 1929. The H. O. Havemeyer Collection)

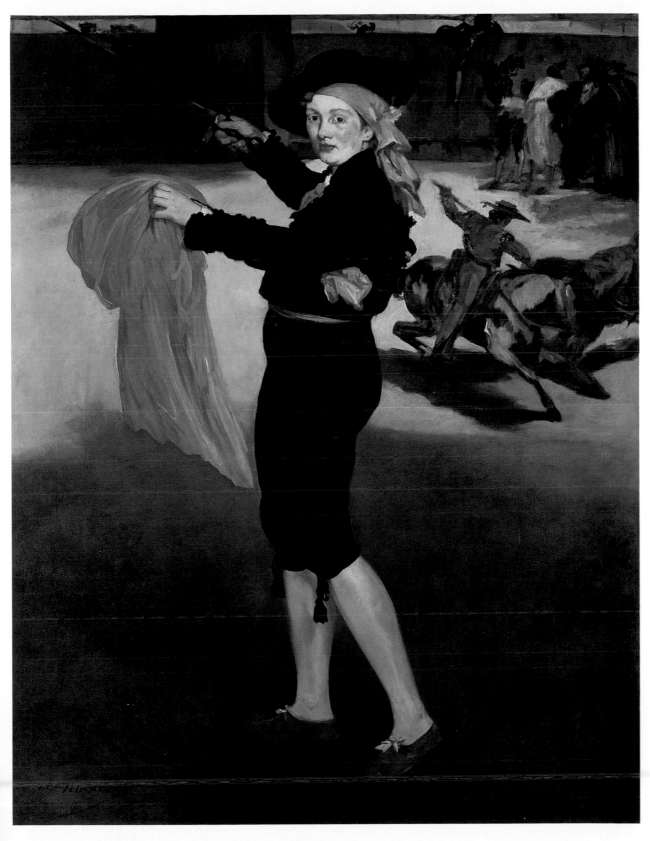

82. EDOUARD MANET. *Mlle V . . . in the Costume of an Espada.* 1862. Oil on canvas, 65 × 50 1/4″. The Metropolitan Museum of Art, New York (Bequest of Mrs. H. O. Havemeyer, 1929. The H. O. Havemeyer Collection)

83. EDOUARD MANET. *Young Man in the Costume of a Majo.* 1863. Oil on canvas, 74 × 49 1/8″. The Metropolitan Museum of Art, New York (Bequest of Mrs. H. O. Havemeyer, 1929. The H. O. Havemeyer Collection)

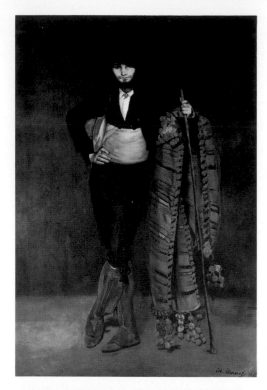

84. EDOUARD MANET. *In the Garden.* 1870. Oil on canvas, 17 1/2 × 21 1/2″. Shelburne Museum, Shelburne, Vt. (photograph by Ken Burris). Formerly owned by Mr. and Mrs. Havemeyer

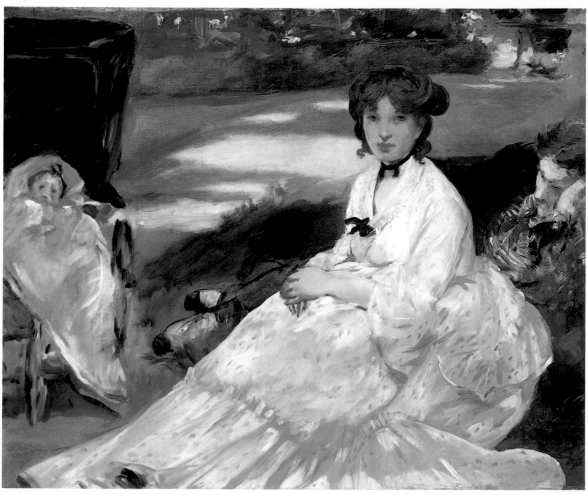

85. EDOUARD MANET. *The Railroad (Gare Saint-Lazare).* 1872–73. Oil on canvas, 36 1/2 × 45". National Gallery of Art, Washington, D.C. (Gift of Horace Havemeyer in memory of his mother, Louisine W. Havemeyer). Formerly owned by Mr. and Mrs. H. O. Havemeyer

86. CLAUDE MONET. *Snow at
Argenteuil.* 1874. Oil on canvas,
19 3/4 × 25 3/4″. The Lefevre
Gallery, London. Formerly
owned by Mr. and Mrs. Have-
meyer

87. EDGAR DEGAS. *The Dance
Class.* 1874. Oil on canvas,
33 1/2 × 29 1/2″. Musée d'Or-
say, Paris

Shortly after, Mr. Havemeyer bought the most important of our large Manets, *Mlle V. in the Costume of a Toreador* [*Mlle V . . . in the Costume of an Espada*; Plate 82]. It was painted after Manet's return from Spain, where he undoubtedly studied Velazquez, and, I believe, determined to paint a large picture of a bullfight, which project was never completely realized but to which we owe both our *Bullfighter* and *Mlle V.* This picture of *Mlle V.* is one of the greatest and most difficult things Manet ever did.[13]

Harry paid some $30,000 for this work showing a young woman dressed in picturesque man's clothing, which became Louisine's favorite painting in the entire collection. The next year Harry would buy another of Manet's Spanish subjects, *Young Man in the Costume of a Majo* (Plate 83), a life-size figure that made "a worthy pendant to the 'Bullfighter.' "[14]

Cassatt's visit had spurred the Havemeyers into acquiring an entire group of significant works by Manet. At the auction of the Gustave Goupy collection at the Hôtel Drouot on March 30, 1898, Durand-Ruel secured for them two more paintings by the artist. Harry wrote to express his satisfaction on April 27: "I am not aware whether I acknowledged the receipt of the pictures by Manet, the Marine [*The "Kearsarge" at Boulogne*] and the Garden [*In the Garden*; Plate 84]. Both are fine. The Marine pleases me, especially. Should an opportunity occur to buy another fine Manet marine, I hope you will send me a photograph and particulars." Harry liked the Civil War subject of Manet's seascape: the sinking of the *Alabama* (a Confederate cruiser) in 1864 by the *Kearsarge* (a Union ship) outside the harbor of Cherbourg. This event of the American war had received much attention in the French press.

Harry's next purchase of a Manet was not another marine but *The Railroad* (*Gare Saint-Lazare*; Plate 85), sent to America for Durand-Ruel's Manet exhibition in 1895. Louisine later explained in her *Memoirs* that at the time of purchase they had to defend the work to those who could not understand anyone buying a picture of an "unattractive" child whose back is turned to the viewer and who, in addition, has a "homely" mother and an "unappealing" dog. The Havemeyers were often asked why they spent good money (they had paid $20,000) for a canvas showing an iron railing and clouds of steam puffing out from almost invisible engines, when they could have obtained "a gorgeous academic, an imposing English portrait, or some splendid Eastern scene, for the same price."[15] But for Louisine, Harry's acquisition of *The Railroad* showed her husband's new level of appreciation for Manet's work: "The *Gare St. Lazare* [*The Railroad*] Mr. Havemeyer bought to please himself, for the painter had become an open book to my husband and he recognized the *Gare St. Lazare* as one of Manet's greatest achievements, the ripened fruit after many years of growth, when, as Frenchmen say, he had 'found his way.' "[16]

While Louisine was taking pleasure in the evolution of her husband's taste, Mary Cassatt found genuine gratification in helping the Havemeyers acquire such pictures. But she surely had greater satisfaction as a professional artist in seeing a show of her work held while she was in America. On February 28, 1898, the Durand-Ruels opened in their New York gallery an exhibition of Cassatt's paintings, pastels, and etchings; the

artist received her most favorable notices to date from American critics. *The Art Amateur,* for instance, praised the show in its April issue: "There is, indeed, no artist living who might not be proud of some of the pictures. Miss Cassatt has a marked predilection for the painting of robust women and healthy children. She despises prettiness; but though some of her models might be called ugly, all are full of life and vigor, and no one can deny that she makes beautiful pictures of even the most common-place."[17] The cover of their May issue even featured a painting by "the impressionist from Pennsylvania"—*Mother and Child* (see Plate 54)—a portrait study that the Havemeyers had owned for three years. They lent at least two other pictures to Cassatt's exhibition: their pastel *Baby's First Caress,* also purchased from the Durand-Ruels in 1895, and their pastel *Portrait of Adaline* (see Plate 68), which a *New York Times* reviewer specifically mentioned.

Mary Cassatt was finally achieving recognition in her own country. She was at the height of her creative powers in the 1890s, and the decade was the busiest and most prolific of her life. In her role as adviser, she would become more active after the turn of the century, making special trips to different countries in search of paintings for Louisine and Harry.

Following her stay in Boston, Cassatt visited the Whittemores (who had commissioned portraits of several family members) in Naugatuck, Connecticut, and there met Mr. and Mrs. Alfred Atmore Pope and their daughter Theodate, with whom the artist would become a close friend, although Theodate was considerably the younger. Cassatt returned to France in the spring of 1898 and would cross the ocean only once again, in 1908. She preferred to see her American friends in Europe rather than subject herself to the dreaded Atlantic voyage.

Keeping in constant touch with events in her homeland through her letters, which would become more numerous after 1900, Cassatt delighted in bringing her friends together on occasion, especially to share an appreciation for one another's collections. In a letter dated March 14 (most likely 1899) to Mrs. John Howard Whittemore, the mother of Harris, she wrote: "Tell Mr. Harris he must go and see Mrs. Havemeyer when he is in New York. She will be very glad to see him and show him their new Degas. They are superb and their Manets too."[18]

The Havemeyers, perhaps stimulated by having Mary Cassatt close at hand, with her strong convictions on the merits of modern French painting, entered into a particularly active period of buying during 1898 and 1899. In addition to the seven canvases by Manet mentioned above, and more than half a dozen works by Degas, including his painting *The Ballet of "Robert le Diable,"* they went on to acquire examples by Corot, Courbet, Monet, and Cassatt herself. In March 1898 they bought Monet's *Snow at Argenteuil* (Plate 86; page 237) from Boussod, Valadon, from whom they had also purchased *Dancer Tying Her Slipper* (Plate 88), a pastel by Degas. In most instances, however, their source for pictures remained the Durand-Ruel galleries in New York and Paris.

Within a year of Colonel Payne's purchase of Degas's *The Dance Lesson,* the Havemeyers were given an opportunity to buy an earlier version of this subject. On July 7, 1899, Paul Durand-Ruel wrote to Harry as follows:

I will call your attention to another work of Degas [*The Dance Class*; Plate 87], of which you must have seen a photograph as it was sent to New York. . . . It is of the same quality as the one we sold to Colonel Payne. It was painted in 1875 [actually 1874] and is so clear in color that it almost looks painted only yesterday. Pictures of that high class and of that period by Degas will be absolutely impossible to find at any price in a few years; even now I do not know where I could get another one of that quality even by paying a much higher price than what we ask for this one. We could deliver in New York that picture of Degas for 16,000 dollars, duties paid.

In the same letter Durand-Ruel offered the Havemeyers another canvas by Degas:

As for the small painting by Degas [*The False Start*; Plate 89], it is one of the finest pictures we ever had by him; it was painted in 1864 and you know that the works of Degas of that period are almost impossible to find now. It was bought through Mr. Rouart from Degas, by one of his partners who would not have sold it for any price; we were able to secure it only after his death and of course we had to pay a big price for it. I will deliver the picture to you in New York for 10,000 dollars, duties paid.

Henri Rouart's "partner," or more correctly his friend and colleague, from whose estate both these Degas paintings came, was the artist Jacques-Emile-Edouard Brandon, who had exhibited with the Impressionists in 1874 and was also a friend of Degas.

In spite of Durand-Ruel's prodding, Harry was not tempted and replied on July 24: "I am in receipt of your letter of July 7th. I have submitted the same to Mrs. Havemeyer, and regret having to announce that we do not care to acquire either of the Degas. The jockey on the horse passing the grand stand [*The False Start*] looks admirable, but the price of ten thousand dollars delivered seems extremely high. You naturally understand that without the opportunity to see these pictures we are somewhat embarrassed about them."

It seems strange that the Havemeyers decided to turn down these splendid works, and their excuse was also peculiar, as they had already bought pictures after only looking at photographs of them. They had not actually seen *The False Start*, but they certainly were familiar with Colonel Payne's Degas; the *Dance Class* they were being offered was very similar. They may have hoped that Mary Cassatt would come across works of comparable quality for less money. Disappointed by their decision, Paul Durand-Ruel explained his position to Harry on August 25, 1899:

I did not answer earlier your letter of the 24th of July having been absent from Paris when it came. I understand as you say that you should be embarassed [sic] about buying the painting of Degas *Jockey near the grandstand* without seeing it. My reason for not sending that painting to New York is that I offered it to nobody but yourself wishing to keep it for me if possible; accordingly if you had not taken it after seeing it I would have had to return it here; losing the amount of duties, however, before placing it in my apartment I offered it to you in case you would

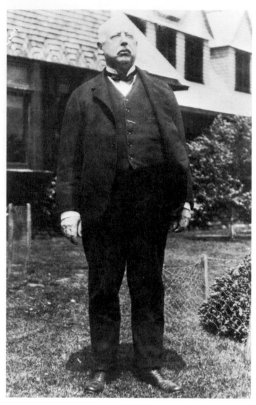

Above left: Harry Havemeyer at "Hilltop," late 1890s. Note also the decorative treatment of the shingled roof

Above right: Louisine Havemeyer at "Hilltop," probably winter 1898

Below left: Harry Havemeyer at "Hilltop," probably winter 1898

Below right: Louisine and Harry Havemeyer taking a walk in the snow at "Hilltop," probably winter 1898.
Photographs courtesy of J. Watson Webb, Jr.

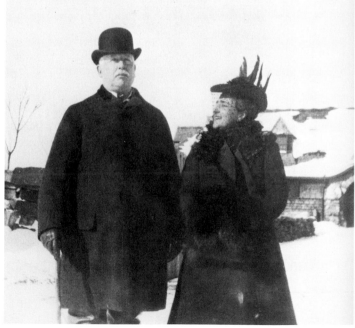

want it for yourself. It is a superb painting of the early period of the artist and it is considered as one of his master pieces.

Durand-Ruel was particularly anxious for the Havemeyers to obtain fine early works by Degas, since he felt guilty about an unpleasant incident that had occurred at the beginning of 1899, concerning the artist's painting *The Pedicure* (Plate 92).

The year had started off well enough, with the Havemeyers' purchase of three superior Degas pastels: *The Dance Lesson* (Plate 90), which had formerly belonged to Renoir; *Dancers at Their Toilette* (Plate 91); and *At the Milliner's* (Plate 94), posed for by Mary Cassatt. On January 3 Harry wrote Paul Durand-Ruel to tell him how pleased he and his wife were about these acquisitions. But in the same letter he expressed interest in another picture by Degas: "In looking over the photographs which Joseph [then in New York] submitted of DeGas' works, she [Mrs. Havemeyer] was struck with the Pedicure. The price of 62,500 francs [$12,500] seems to me very large. I have written Miss Cassatt about the quality of the work, and in the meantime would suggest your endeavoring to get a lower price from the owner [James Burke, an affluent Englishman and a friend and patron of Bernard Berenson, on whose advice he had bought this picture in 1892]. It seems to me very high for the importance of the work." Ten days later (January 13, 1899) the dealer relayed the following news to Mr. Havemeyer:

> I regret having to inform you that the *Pédicure* by Degas was sold to Mr. de Camondo. He paid the price we had asked Joseph to quote to you; we only showed it to him when we thought you had decided against it.
>
> Works by Degas and Manet are more and more sought after in Paris and all over Europe: and we cannot find any more at any price.*

Paul Durand-Ruel was in no mood to haggle over the cost of *The Pedicure* when so important a client as Count Camondo was ready to buy the picture at the asking price. Scion of a family of bankers who had acquired their title in Italy, Count Isaac de Camondo was a discerning collector of works of art from many periods, from the Middle Ages to the Impressionists. The dealer may also have felt that—times having changed—Harry should realize that to get the best available works, he would have to act quickly without bargaining. Durand-Ruel had cabled Harry to buy *The Pedicure* for $12,000 immediately or risk losing it, but Harry had not heeded this warning. To cushion the blow, the dealer made Harry another proposal in his letter of January 13:

> We wrote Joseph asking him to talk to you regarding the painting [*Rehearsal in the Studio*; Plate 95] and the pastel [*Rehearsal on the Stage*; Plate 93] which belong to the May collection and that we strongly urge you to authorize us to buy on your behalf. They will be fairly expensive, but they are both superb and in my opinion are worth 25 thousand dollars. I feel very strongly about this matter and I am sure you would not have cause to regret the purchase. My biggest fear is that these two remarkable works will be snatched up by someone else before your decision.*

These two pictures had been in the Ernest May auction in 1890, but both had been bought in. Harry did not seem to understand that the Durand-Ruels could buy such expensive works from an owner only for the account of a client who would reimburse them immediately. Moreover, time was a factor; if the owner received another good offer, he was under no obligation to wait for the Durand-Ruels'.

On receiving Paul Durand-Ruel's letter, Harry had only one emotion: anger! On January 24 he penned the following response:

Dear Sir:

I have your communication of the 13th of January, bearing upon the sale of *Le Pédicure*. In all frankness I must state that nothing surprised me more than the sale of this picture while negotiations were still pending with myself. The photograph was shown to Mrs. Havemeyer by your son Joseph, and at her request I authorized you to open negotiations for the picture. Miss Cassatt had brought it to Mrs. Havemeyer's attention some years ago, as a remarkably fine work of the artist. Immediately upon receipt of your cable, I sent the photograph to Miss Cassatt, to ascertain if it was the picture she had spoken to Mrs. Havemeyer about, and wrote you of the fact, requesting you in the interval to obtain a lower price. It seems to me that while this was transpiring you offered the picture to some one else. This picture was not in the market. It was brought into the market on a commission from myself. I do not think you had any right to offer this picture to anyone until I had definitely declined its purchase. It will undoubtedly grieve you that Mrs. Havemeyer is extremely affected by this transaction.

Yours truly,
H. O. Havemeyer

Paul Durand-Ruel replied on February 3: "I am very sorry to hear that you are upset over not getting the *Pedicure* by Degas, but as I wrote you on January 13th, I had not shown the painting to anyone else until I had heard from you and I only showed it to Mr. de Camondo when I was certain that you had decided against it. I myself almost lost the painting because of the extra time I was obliged to ask for while waiting for your answer."* Meanwhile, on January 25, Harry had instructed Joseph Durand-Ruel to cable his father in Paris: "Havemeyer says use your discretion about buying May two Degas not exceeding 125,000 francs [$25,000] for the two quality necessarily superb otherwise not." It was a relief to Paul Durand-Ruel to inform Harry in the same letter: "I am happy that I could make it up to you by the acquisition of the two Degas from the May collection; they are two masterpieces, but there again it was hard not to let them get away from me."*

Harry could not resist mentioning the incident of *The Pedicure* again on February 20, but his words were relatively mild considering his earlier abrasiveness: "I have your letter of the 3rd of February, bearing in part upon *Le Pédicure*. I will only have to refer you to my letter for the facts as far as this side of the water is concerned in the matter." He had indeed been soothed by the acquisition of Degas's pictures from the May collection: "I am very much pleased with the two Degas. They certainly are admirable." He also advised Paul Durand-Ruel that he had decided to obtain another work by Degas

of dancers: "I authorized Joseph to buy the two figures, one by the piano and one sitting on it [*Dancers at Rest*; Plate 96], although I considered the price extreme. I am not quite familiar with the ruling price of Degas. They appear to be very irregular—very extreme and then again comparatively low." As angry as he had been about *The Pedicure,* he realized that he could not sever relations with the Durand-Ruels, who for many years had remained his most consistent and reliable source for the finest pictures of every school.

Harry Havemeyer now had to pay substantially more for modern French pictures which, until recently, could hardly be sold for even the most meager prices. Paul Durand-Ruel observed in a letter to Harry of December 22, 1899: "There is actually in Paris a kind of fever which has taken possession of all the amateurs and dealers in objects of art and consequently a high increase has taken place on the paintings and especially of those of the new school. We must be there all the time, still more to seize the occasions of purchasing than to sell." Both in Paris and New York, the Durand-Ruels were buying up works for their inventory from the same collectors to whom, in many cases, they had originally sold them.

The firm's American clients seem constantly to have brought their pictures back, either as part of a trade or simply because they no longer cared for them. The Havemeyers often took advantage of these returns, the more so as earlier works by the moderns were becoming scarce. Monet's *The Green Wave* (Plate 97), for example, was a painting that Mary Cassatt had purchased in 1883 on behalf of her brother Alexander; in 1898 he returned it to the Durand-Ruels, who thereupon sold it to the Havemeyers. And again, Louisine and Harry acquired three pictures on March 10, 1899, that had belonged to Catholina Lambert, a silk manufacturer who lived in a lavish English-style castle on a hill overlooking Paterson, New Jersey, where he housed a vast collection that was more dazzling by its magnitude than its quality. Two of these Lambert paintings were Monet flower pieces that Alden Wyman Kingman had bought at the first Impressionist exhibition in New York in 1886. Kingman returned them to Durand-Ruel's New York branch in 1892; they were subsequently acquired by Lambert, who kept them until 1899. Thus within thirteen years Monet's *Sunflowers* and *Chrysanthemums* had hung in three different American collections.

The other work the Havemeyers bought that day was one by Renoir, which Durand-Ruel had sold to Catholina Lambert in 1892. *By the Seashore* (Plate 98) remained the only painting by Renoir in the Havemeyer collection, though Louisine regretted its purchase all her life. In 1927, when Paul Durand-Ruel's young grandson Charles was paying his first visit to the Havemeyer residence, Louisine greeted him with these words: "I knew your grandfather, your father [Joseph] and your uncles as well as your brother Pierre. You are therefore the third generation and the 6th Durand-Ruel that I have met. So welcome. But never try to sell me a Renoir! I do not like him and I still hold it against your uncle George who forced me to buy one. I am still sorry."[19]

Often the procedure followed by the Havemeyers was that one of the younger Durand-Ruels in New York would show them photographs of pictures, while Cassatt would look at the originals in Paris. Either Louisine or Harry would then request her opinion and, when the response was positive, have the painting shipped to America. If

the work was on consignment from an impatient owner, Paul Durand-Ruel would approach Mary Cassatt (who spent the summers at her château de Beaufresne) to find out how matters were progressing. Thus, on August 18, 1898, he wrote to her about Courbet's *Portrait of Jo* (*La Belle Irlandaise*; Plate 99):

> I have just received the following information from America. I was told that Mr. Havemeyer has seen the photograph of Courbet's woman with a mirror that we recently showed you, that he likes the subject but before making up his mind he is waiting for the opinion of someone to whom he has written, requesting that this person look at the painting.
>
> I think it must be to you that Mr. Havemeyer wrote. I would be very pleased then to find out if you feel that this painting should be bought because it does not belong to me and the owner has recently inquired about taking it back. I have been able to obtain a few extra days to have time to consult with you.*

Mary Cassatt evidently thought highly of Courbet's painting, for it arrived at Durand-Ruel's New York branch in October 1898 and was lent to the Union League Club of New York for their November exhibition "Old Master and Modern Paintings." By the end of December it was delivered to 1 East 66th Street.

Meanwhile the Durand-Ruels had been on the lookout for fine examples by Mary Cassatt. On February 20, 1899, Mr. Havemeyer wrote concerning one of her paintings, sent to New York for his inspection: "I bought the Cassatt with three figures and landscape [Plate 100], as I consider it an admirable work. My wife is very much pleased with it." In June of that year Harry was shown a photograph of another Cassatt; he requested that it be shipped to New York so that he "could look at it with a view to buying it." But this time the Havemeyers decided to purchase the work, *The Oval Mirror* (Plate 101), before it was shipped, expediting the negotiations with a telegram as usual. On July 7, 1899, Paul Durand-Ruel acknowledged Mr. Havemeyer's proposal:

> We received a cable from our New-York house about the Cassatt, number of photograph 1284, offering us 2000 dollars for the picture delivered in New-York. We accept the offer: the picture will leave tomorrow.
>
> We asked Degas his opinion about the picture; he considers it the finest work that Mary Cassatt ever did; he says it contains all her qualities and is particularly characteristic of her talent.

Durand-Ruel did not know, however, what Degas had told the artist. Mary Cassatt herself relayed to Louisine his exact words, and Louisine recorded them in her *Memoirs:* "When he saw my *Boy before the Mirror* [*The Oval Mirror*] he said to Durand-Ruel: 'Where is she? I must see her at once. It is the greatest picture of the century.' When I saw him he went over all the details of the picture with me and expressed great admiration for it, and then, as if regretting what he had said, he relentlessly added: 'It has all your qualities and all your faults—c'est l'Enfant Jésus et sa bonne anglaise [It is the little Jesus and his English nurse].'"[20]

This three-sided relationship among client, dealer, and artist-adviser was and would

remain the cornerstone of the Havemeyer collection. Assisted by Paul Durand-Ruel and Cassatt, Louisine had slowly but steadily broadened the scope of her husband's taste until he was now a genuine admirer of Courbet, Manet, Degas, Cassatt, and Monet. By the turn of the century the nature of the Havemeyer collection was firmly established; Louisine and Harry would continue to purchase works reflecting their consistent taste, based on a central idea. From no matter what school and period, they selected pictures that reflected a direct observation of the real world as opposed to those adhering to an academic tradition embedded in the antique, historical, or religious past. They avoided paintings that were anecdotal, sentimental, or vacuous, and acquired naturalistic land-scapes and still lifes, though they were particularly responsive to portrayals of people, either as penetrating studies of character or as engaged in daily pursuits and integrated with their environment. This precept made it possible for their modern works to hang in complete harmony with their older masters; there was an aesthetic kinship among all the Havemeyer paintings and a shared quality of monumentality.

Expanding Horizons

The Paris Universal Exhibition of 1900 was the major event of that year; Harry Havemeyer always enjoyed such spectacles, but there is no proof that he and his family went to it, though Mary Cassatt had hoped to welcome them in Paris. Louisine, in her *Memoirs,* speaks of her husband's fascination with Courbet's *Stone Breakers,* which he supposedly admired at the 1900 exhibition, but the picture was not shown there that year; she must have confused the 1900 Centennial with the Paris World's Fair of 1889, when it had been exhibited. The Havemeyers certainly did visit Paris in 1901, while traveling in Europe from February until May.

Harry came home one day in January 1901, announcing that, being tired and wanting a break, he wished to take his wife abroad for several months. The reason for his fatigue and need for a change of scene was that a long and bitter battle between the sugar and coffee trusts had just been settled. When the Arbuckles, who controlled the world's trade in packaged coffee, began to refine and package sugar also under the Arbuckle brand, Harry considered this a threat to his own interests. He in turn took control of several coffee-roasting plants in 1897 in an effort to crush the Arbuckles. The resulting three-year competition was a disaster for both sides that ended up costing these rivals a total of approximately $25,000,000. Finally, early in 1901, John Arbuckle called on H. O. Havemeyer at 1 East 66th Street and agreed to limit severely the daily output of his refined sugar, in return for Harry's consent to reduce significantly his involvement in coffee roasting. Thus one of the most heated controversies in American industry, which had grown to alarming proportions, at last was brought to a close.

On January 30 the Havemeyers, in the company of Louisine's older sister, Annie Munn, sailed on the *Kaiserin Augusta Victoria* for Madeira, Gibraltar, Algiers, and Genoa; Mary Cassatt joined them in Genoa for a trip through Italy and Spain. As the artist informed Durand-Ruel on February 24 from Naples: "We have traveled very fast; until now one day for each city. Mr. Havemeyer is very anxious to obtain a Velasquez which he certainly will not be able to get in Rome, nor elsewhere in Italy. . . . He wants to go to Constantinople via Venice and Vienna and then to Paris before proceeding to Spain. It's while in Paris that he hopes you'll have something to offer him."*

In Florence Mary Cassatt had run into an old acquaintance, a fellow artist who had been forced by financial difficulties to give up his sculpting of *putti* and to go to work for a large gallery. Of German origin, A. E. Harmisch had spent much of his life in Italy and was married to a considerably younger Italian woman; the two had not prospered and were living in poverty on the top floor of a high building called "Suicide House" overlooking the Arno. Mary Cassatt and the Havemeyers soon decided that the combined talents of the knowledgeable Harmisch and his ingratiating wife (who claimed connections with the Florentine nobility) would be useful in ferreting out paintings in Italy; through them they hoped to penetrate into some vast estates where dealers had not been permitted to "apply their rakes."[1] Harry engaged Harmisch as his agent; in time Harmisch would give up his gallery job to work exclusively for the Havemeyers.

For Louisine, it was as if another of her romantic fantasies was being fulfilled, and she was delighted; the Havemeyers' collecting appetite had been whetted by the great paintings they saw in the museums and churches of Italy, but thus far the established dealers had nothing to offer. Now Harmisch and his wife could provide the cloak-and-dagger atmosphere that so appealed to Louisine, in addition to possibly locating important pictures. She later confessed in her *Memoirs:* "I should blush to write what were my hopes, for only then did I begin my novitiate of picture hunting; visions of great finds haunted my thoughts and I was considering a choice of which masters I should select."[2] Harmisch certainly filled Louisine's expectations when he arranged outings such as a secret visit to the dilapidated palazzo of an impoverished Italian noble with a "family treasure" to sell; better yet was their arduous journey into the Tuscan hills where, disguised as wine merchants, they sneaked into a chapel in a vineyard to catch a glimpse of a "masterpiece" that eventually they acquired. Louisine relished these unorthodox quests for works of art, and it is understandable that she was highly susceptible to what Harmisch had to offer; it is less clear why her husband and Mary Cassatt also exercised poor judgment, placing full trust in him. Actually, Cassatt was genuinely impressed by Harmisch's eye for quality and his "erudition." She expressed this opinion in a letter to Louie (as she always called Louisine Havemeyer) on February 6, 1903: "I have great confidence in him [Harmisch] & am sure he would not willingly buy what was not first class for you, we are all fallible, but that we cannot help. . . ." In the same letter she compared Harmisch favorably to another art representative: "Mrs. Jack Gardner [of Boston] has an agent a Mr. Berenson. I am not sure if I spell the name rightly, who lives near Florence, & who boasts he is incorruptible; I was told he took no *small* commission, but occasionally made a big haul. . . . I believe Harmisch thoroughly honest. . . ."[3]

It will never be known whether Harmisch was himself taken in by what he thought to be works by such masters as Titian, Veronese, Andrea del Sarto, Raphael, Mino da Fiesole, and Donatello, or whether he had advantageous arrangements with the sellers. In either case the result was the same. Over many subsequent years the Havemeyers secured through his efforts what Louisine thought were "some of the finest pictures we ever owned,"[4] whereas most of these works proved to be by lesser or even unknown artists, or from the school of the masters to whom they were attributed. Mrs. Havemeyer

lived her entire life with these illusions. Once in a while Harmisch did obtain for them a genuine painting, such as Veronese's *Boy with a Greyhound* (Plate 102), a purchase that particularly pleased Louisine because it was also a great bargain.

Although the Havemeyers passed through Paris, where they left Louisine's sister comfortably installed in Mary Cassatt's apartment, they did not take time to go picture hunting there but decided to proceed to Spain. The Prado was a revelation for them; Mary Cassatt, who had been to Madrid as a young woman, went so far as to say that this incomparable museum offered " 'an orgy of art.' "[5] Among the wealth of Flemish, Italian, and especially Spanish treasures that dazzled and delighted the Havemeyers, they discovered what for them was a new master: El Greco. They were irresistibly drawn to his portraits and of course Harry's possessive instinct was aroused. Knowing that there was as yet little interest in El Greco and Goya, he felt that they must take immediate advantage of such a rare opportunity, urging his travel companions to begin their lookouts.

His wife's initial purchase of a work by El Greco was a small canvas of *Christ Bearing the Cross,* for which she paid slightly more than $250, including the frame; Mary Cassatt had spotted it hanging in the doorway of an antique shop. The two friends were pleased with their find and Louisine, carrying the picture in her arms, rushed to the hotel to show it to her husband: "Mr. Havemeyer did not think much of it, nor did he hesitate to say so. He made several remarks at dinner which rather piqued Miss Cassatt and me and were perhaps the very reason that he afterward acquired so many examples of Greco and Goya. If anyone about him had any determination or ability, there was no one like Mr. Havemeyer for getting a lighted fuse into it."[6]

A few days later, Louisine and Harry left for some sightseeing in the south of Spain, Mary Cassatt preferring to remain in Madrid. In Toledo, where they at last located the little church with El Greco's *Burial of Count Orgaz,* Harry Havemeyer had what could be described as a spiritual experience. This masterpiece moved him to the depths of his being; he stood perfectly still for a long time, absorbing its every detail and feeling in communication with its creator. Finally, he heaved a sigh laden with emotion and whispered to his wife: "One of the greatest pictures I have ever seen; yes, perhaps the greatest."[7] As they continued southward to Seville, Cadiz, and Cordova, the image of El Greco's painting remained so vividly imprinted upon his memory that it diminished his response to everything they were now looking at. He was also preoccupied with the problem of how to go about finding important El Grecos to buy. Their last stop was in Granada; they spent several thousand dollars there for Moorish tiles supposedly from a villa of Emperor Charles V. In her *Memoirs,* Louisine good-naturedly admitted that for long they lived "in happy ignorance"[8] of having been duped by the owner of the antique store, who delayed two years in sending the Havemeyers their 250 cases of made-to-order copies.

Meanwhile, back in Madrid, Mary Cassatt had not been idle; she could hardly wait to tell Louisine and Harry what she had accomplished. Ingeniously, she had managed to meet Joseph Wicht, who was well acquainted with the Spanish nobility (he had once been offered a position at court), his godmother being either an intimate friend of an Infanta or possibly the Infanta herself. He was familiar with the complicated, even exasperating, procedures of doing business in Spain. Best of all, he knew where to find

El Grecos, Goyas, and other old masters, and he even spoke English. This time Mary Cassatt had come across someone who did not lead them astray. Wicht arranged for Cassatt to see, among other works, El Greco's portrait of a cardinal wearing tortoiseshell spectacles, and his landscape of Toledo, as well as several portraits by Goya, and Goya's majas seated on a balcony, a picture she asked him about, having remembered it from her visit to Spain twenty-eight years before. The Havemeyers would eventually possess many of these very paintings that Wicht initially showed to Mary Cassatt. Negotiations for buying pictures in Spain often took years, however, because major works sometimes had several owners within one family who could not agree on the price—or, once they reached a decision, changed their minds at the last moment.

Although Wicht was not a connoisseur of pictures (as he openly acknowledged), he was very useful to Louisine and Harry. The only Spanish painting that they would be able to buy within a few months was a man's portrait by Goya; this they owed to Wicht. It would prove a severe blow to them when Wicht was killed in a hunting accident the following year; their agents in the future would be less efficient. But now, on their return to Paris in the spring of 1901, the three resourceful travelers—Louisine with her small El Greco painting under one arm and some Hispano-Moresque plates under the other, all wrapped in newspaper—were saturated with memories of the fantastic paintings they had seen and with excitement about the possibility of obtaining some of them.

In the realm of Spanish art, Harry would reveal himself a true pioneer collector. With the French moderns he had been hesitant until they obtained a certain level of critical and financial acceptance, but with El Greco and Goya he showed himself ready to take the plunge. The Havemeyers' trips to Italy and Spain had been stimulating on every level, aesthetically, intellectually, sensually, and culturally. Harry Havemeyer, released from his demanding business schedule, had committed himself to art for perhaps the longest span of time in his life, and been able really to concentrate on what he was seeing. These trips seem to account for an acceleration in his artistic perception, just as his visit to Paris in 1889 had made him aware of the art of Courbet.

The Havemeyers were back in Paris in April for the opening of the Champ de Mars Salon in the Grand Palais, where Maurice Denis's *Homage to Cézanne* was attracting much attention. The painting depicted a still life by Cézanne on an easel with a group around it that included younger artists, as well as the critic André Mellerio and Cézanne's dealer Ambroise Vollard. This exhibit was not Louisine and Harry's only opportunity to take notice of Cézanne, but it was evidence that the painter was beginning to receive public recognition.

There were other indications that Cézanne's star was slowly rising among the "progressives" of the Parisian art world. His prices at auctions had gone up substantially; at the sale in 1899 of the well-known collection of Count Doria, none other than Claude Monet paid the astonishing price of 6,750 francs ($1,350) for a winter landscape by Cézanne. Shortly afterward, Monet encouraged Count Camondo, Harry's arch rival as a collector, to purchase Cézanne's *House of the Hanged Man* for about the same amount at the estate sale of Victor Chocquet, Cézanne's long-time friend and passionate patron. Monet also convinced Paul Durand-Ruel to take advantage of the large offering of Cézannes, more than thirty works, at the Chocquet sale; the dealer bought about half

of the pictures, although he did not put them immediately on the market. Harry Havemeyer must have known of these events, both of which had been widely reported.

Mary Cassatt herself owned an extremely beautiful still life by Cézanne (Plate 103). She would say in 1910 that she had acquired this painting some twenty-five years before, but it seems more likely that she bought it during the 1890s. Having met Cézanne at Giverny in 1894, Cassatt, though startled by his appearance and horrified by his table manners, was impressed by his artistic integrity. Louisine must have spent considerable time studying her friend's still life; she recalled it hanging in Cassatt's drawing room together with several works by Degas and a gesso relief by Donatello propped on an easel in a corner.[9] Certainly Mary Cassatt and Louisine had frequent discussions about Cézanne and his work. Perhaps Louisine also saw the two Cézanne landscapes displayed in the Luxembourg Museum after 1896 in the Caillebotte Bequest.

According to a newspaper interview with Louisine shortly before her death in 1929, she was the Havemeyer who first went to Vollard's and requested to be shown some Cézannes.[10] Vollard's own recollections directly contradict this account, telling of Harry coming alone to his shop in 1898 and selecting two pictures by Cézanne. The solitary Havemeyer who went to Vollard's gallery to satisfy a curiosity about the work of the still-controversial Cézanne was most probably Louisine. She may have kept her visit secret at the time, thinking that her husband would not yet be responsive to Cézanne's vision.

In any case Cassatt and Louisine must have decided in the spring of 1901 that Harry should become personally acquainted with Vollard's little shop on the rue Laffitte. Mary Cassatt alerted the dealer of his impending arrival: "I've been talking to Mr. Havemeyer about you. So do put all your best things aside for him. You know who I mean by Havemeyer?"[11] However, on this occasion the Havemeyers were not quite ready for the best of Cézanne; following their practice when first acquiring the work of a particular artist, they started off modestly. They probably selected two still lifes of flowers (Plates 104, 105), neither of which was revolutionary. Indeed, one of them, *Flowers in a Glass Vase,* looked like a Manet both in its brushwork and color tonalities, which was perhaps why it appealed to Harry. They may also have chosen then Cézanne's Auvers landscape (Plate 106), another early and unexceptional picture. But it was important that they had begun buying Cézanne's paintings; their choices were among the first works by him to find a permanent home in America.

After this initial visit, the Havemeyers went often to Vollard's little shop. They were encouraged by Mary Cassatt, who recognized the thirty-four-year-old dealer's astuteness and admired his aggressive entrepreneurship. Relatively new at the vocation of art dealing (he had opened his gallery in 1893), Vollard was willing to take risks and to follow the advice of artists. Encouraged by Monet, Renoir, and Pissarro, he had organized Cézanne's first one-man show in 1895. Although he had since earned the respect of the avant-garde in the Parisian art world, he was still having difficulties making ends meet in 1901, as Cassatt well knew.

Harry Havemeyer must have appreciated Vollard's uncommon shrewdness, for he allowed himself gradually to be won over by the persuasive dealer. Vollard may even have managed to convince the Havemeyers to acquire two other significant paintings by Cézanne: *Still Life with Ginger Jar and Eggplants* (Plate 107) and *Landscape with*

Viaduct (Plate 108), in which the background reminded Harry of a fresco he had recently admired in Pompeii.[12] Harry evidently realized the importance of Vollard's efforts to introduce new styles of art and did not want him to have to abandon his enterprise. He must have advanced the struggling dealer a substantial sum of money, because ten years later, Mary Cassatt would write to Louisine: "Vollard has made a fortune. . . . He hasn't forgotten Mr. Havemeyer having saved his financial life in 1901. You remember when he [Harry] came back from Italy."[13] Harry may have made an arrangement whereby he would reduce Vollard's debt by selecting pictures from him over the next several years.

The Havemeyers were in a buying mood that spring, and Durand-Ruel had been looking forward to showing his discerning American clients a superb selection of French nineteenth-century works. Harry's new association with Vollard in no way interfered with his long-standing commitment to Paul Durand-Ruel, whom he trusted and respected. His opinion was shared by Mary Cassatt, who stated in a letter to Louisine: "I also think Durand-Ruel would *not* sell a false picture."[14] Again indulging their preference for figure pieces, the Havemeyers chose several representations of women, ranging from Corot's demure *Portrait of Mlle Dobigny—The Red Dress* (Plate 109) to Manet's pastel of the "Parisienne" Isabelle Lemonnier, and from Cassatt's tranquil scene of a young mother sewing (Plate 110) to Degas's unconventionally posed nude, *Woman with a Towel* (Plate 111)—though Harry supposedly disapproved of such subjects. They bought landscapes as well, one by Corot and one by Millet called *Spring,* but Harry would dispose of the latter the next year. They also picked a splendid early work by Monet, *The River Zaan at Zaandam* (Plate 112); this was their third picture by the artist acquired during the first half of 1901; before leaving for Europe, they had obtained from Durand-Ruel's New York branch two more recent Monets, both of the same scene, *Bridge over a Pool of Water Lilies.* After living with the two very similar canvases for a year, they kept the one they preferred (Plate 113) and returned the other.

Since the beginning of the new century, Monet's work seemed to hold a particular attraction for Louisine and Harry. At their behest the Durand-Ruels had purchased two works by Monet in 1900 at an auction in New York: *Haystacks at Giverny* (Plate 114) for $2,300, and *Old Church at Vernon* for $3,100. By the end of 1901, they had acquired three more of his paintings, all dating from the 1870s; among them was a view of the Seine at Asnières with barges in the foreground (Plate 115). Mary Cassatt would soon write to Harry: "Louie wants me to keep a look out for fine Monets. I have just heard of someone who has several good early pictures . . ."[15] Louisine and her husband were fully aware that Monet's prices, as well as his reputation, were rapidly escalating and that good buys of his work would become increasingly rare. In April 1901, an early Monet brought a record bid in Paris, which was reported in both the French and American presses. The *New York Sun* announced: "There was much felicitation among the Monet admirers yesterday upon the news from Paris that at an auction sale at the Hotel Drouot 30,000 francs [about $6,000] had been paid on Monday for one of Monet's paintings, a picture of Zaandam, Holland."[16]

The Havemeyers' three-month European sojourn was pivotal in the development of their collection during the next six years. The Italian journey had rekindled their interest in old masters, temporarily eclipsed by their concentration on the French

moderns in the second half of the 1890s. Their visit to Spain had sparked their enthusiasm for El Greco and Goya, and their stopover in Paris had reinforced their commitment to French nineteenth-century painting, as well as furthered the range of their appreciation to include the works of Cézanne. They were now advancing on all three fronts in establishing their comprehensive collection of the art of these periods, which in their opinion complemented and were related to one another. The Havemeyers now entered their most active phase of buying.

After Louisine and Harry returned home in May 1901, most of their correspondence with the Durand-Ruels and Mary Cassatt concerned old masters, among them El Greco and Goya; there were also intermittent references to works by French moderns. Cassatt spent much time and energy looking out for her friends' interests; she was in constant touch with Harmisch and forwarded his letters to New York. In June 1901 Cassatt made a twenty-four-hour visit to Madrid, and went on from there to Italy: "You must not be surprised at my going off to see pictures for Mr. Havemeyer. I said I would and I mean it. Besides it is an excellent wit sharpener, good for an artist and all in the day's work,"[17] she wrote to Louisine. After Joseph Wicht's sudden death in 1902, Paul Durand-Ruel would be called upon to handle the Havemeyers' negotiations in Spain, a task that required the seventy-year-old dealer to make numerous exhausting trips.

With their picture-buying pursuits in the competent hands of Mary Cassatt and Paul Durand-Ruel, the Havemeyers went to spend their summer (from July 4th to Labor Day, 1901) at Bayberry Point near Islip, on the south shore of Long Island, where Harry Havemeyer had built his "modern Venice." By then ten of the twelve houses planned had actually been erected, five on each side of the central canal. The architect was Grosvenor Atterbury, who had followed the suggestions of Louis C. Tiffany in his four slightly varied designs for these "Moorish" stuccoed villas, all of them provided with ample porches, patios, and verandas to take advantage of the prevailing breezes. According to the tasteful prospectus: "Trees and vegetation are conspicuous by absence. Not only would they detract from the harmony of the design, but more utilitarian purposes are subserved; they draw mosquitoes and other pests. It is hoped to keep the Point free from winged insects."[18] Harry Havemeyer had worked out a cooperative plan for administering the grounds and other services for the villa owners, including a custodian to take care of the entire property. A buyer could acquire all this and more for $20,000 to $25,000, depending on the size of the house selected.

The Havemeyers themselves occupied a "B" villa at the end of half-mile-long Bayberry Point, with an unobstructed view of Great South Bay. In a letter to Louisine of August 30, Mary Cassatt remarked: "The photos you sent are the first idea I have of your house, it is oriental, & Adaline on the balcony looks Eastern enough for Algiers or Egypt."[19] Harry, an avid yachtsman, loved his informal villa by the sea, with its boat house and pergola, and spent much time with his children sailing, swimming, and horseback riding. His wife, however, much preferred their Connecticut home, "Hilltop," where the landscape was more to her liking and she could indulge her great pleasure in gardening.

Harry's idea of providing relatively modest summer residences run by a cooperative association as an alternative to the unabashed splendor of Newport's lavish mansions

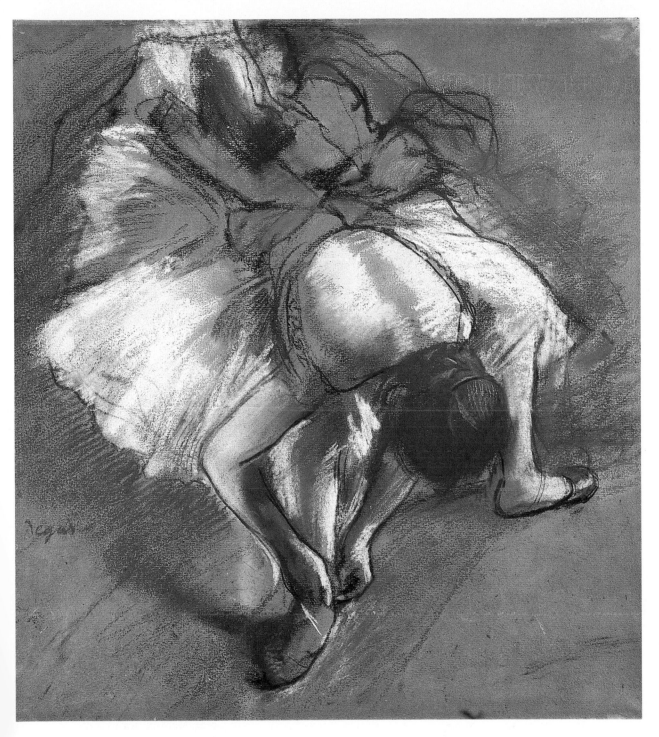

88. EDGAR DEGAS. *Dancer Tying Her Slipper.* 1887. Pastel and black chalk on buff paper, 18 5/8 ×
16 7/8″. Private Collection, U.S.A. Formerly owned by Mr. and Mrs. Havemeyer

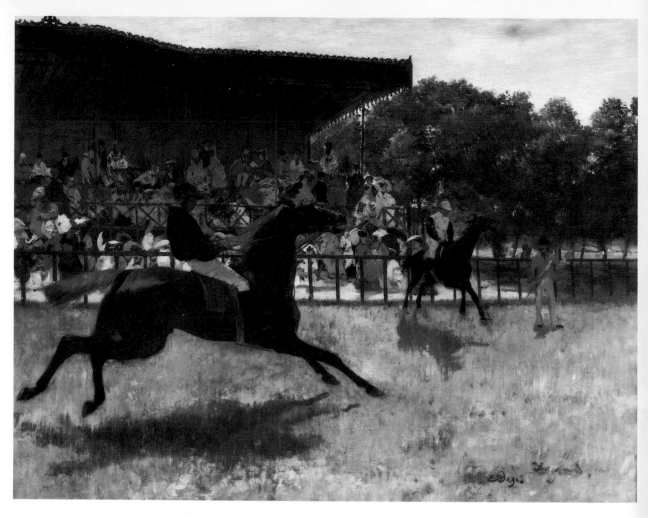

89. EDGAR DEGAS. *The False Start.* 1864. Oil on panel, 12 5/8 × 15 7/8″. Yale University Art Gallery, New Haven (John Hay Whitney, B.A. 1926, Collection)

90. EDGAR DEGAS. (above, left) *The Dance Lesson.* c. 1877–78. Pastel on paper, 25 7/16 × 22 3/16″. The Metropolitan Museum of Art, New York (Anonymous Gift, The H. O. Havemeyer Collection, 1971)

91. EDGAR DEGAS. (above) *Dancers at Their Toilette.* 1880. Pastel on paper, 24 3/4 × 18 1/2″. The Denver Art Museum (Anonymous Gift). Formerly owned by Mr. and Mrs. Havemeyer

92. EDGAR DEGAS. (left) *The Pedicure.* 1873. Oil colors diluted with turpentine, on paper mounted on canvas, 24 × 18″. Musée d'Orsay, Paris

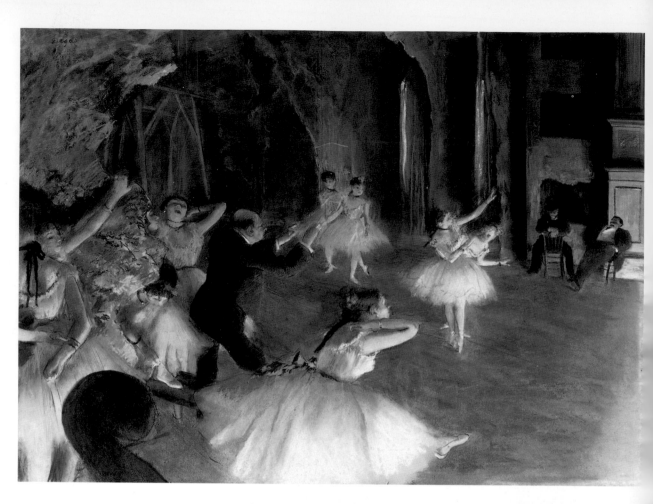

93. EDGAR DEGAS. (left, above) *Rehearsal on the Stage.* c. 1872. Pastel over brush-and-ink drawing on paper, 21 × 28 1/2″. The Metropolitan Museum of Art, New York (Bequest of Mrs. H. O. Havemeyer, 1929. The H. O. Havemeyer Collection)

94. EDGAR DEGAS. (left) *At the Milliner's.* 1882. Pastel on paper, 30 × 34″. The Metropolitan Museum of Art, New York (Bequest of Mrs. H. O. Havemeyer, 1929. The H. O. Havemeyer Collection)

95. EDGAR DEGAS. (above) *Rehearsal in the Studio.* c. 1874. Oil on canvas, 17 1/4 × 23″. Shelburne Museum, Shelburne, Vt. (photograph by Ken Burris). Formerly owned by Mr. and Mrs. Havemeyer

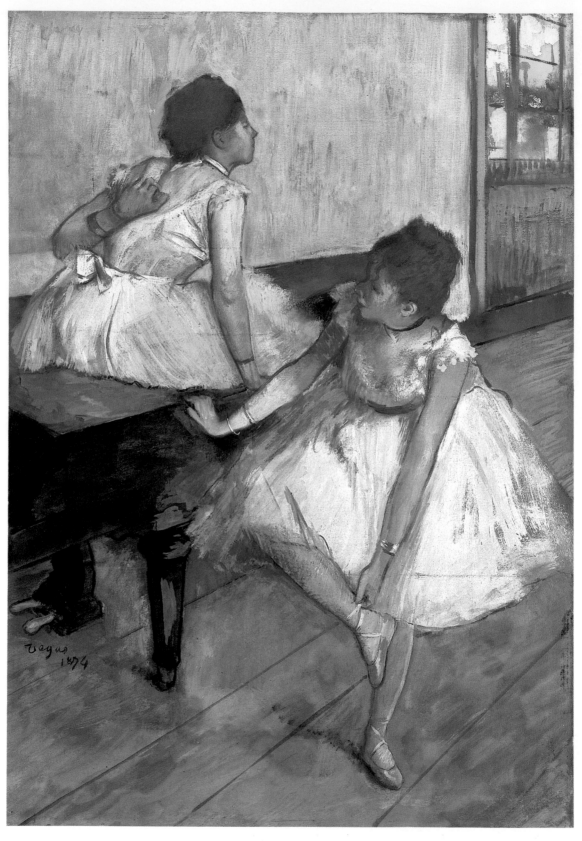

96. EDGAR DEGAS. *Dancers at Rest.* c. 1874. Oil and gouache on paper laid down on canvas, 18 1/8 ✕ 12 3/4″. Gemälde-Galerie Abels, Cologne. Formerly owned by Mr. and Mrs. Havemeyer

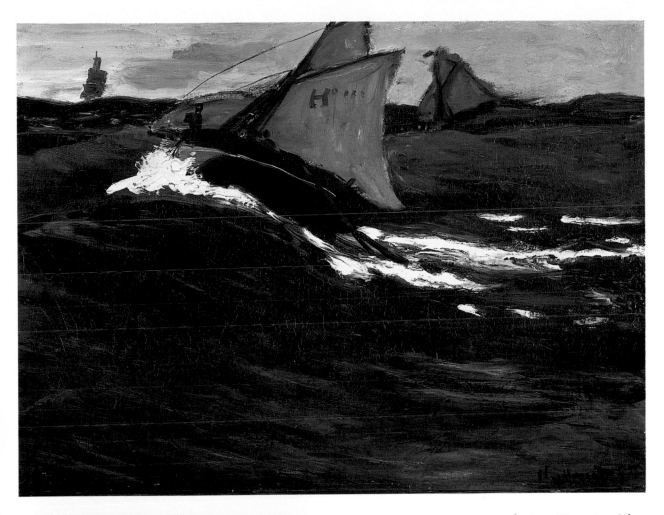

97. CLAUDE MONET. *The Green Wave.* 1865. Oil on canvas, 19 1/8 × 25 1/2″. The Metropolitan Museum of Art, New York (Bequest of Mrs. H. O. Havemeyer, 1929. The H. O. Havemeyer Collection)

98. PIERRE–AUGUSTE RENOIR. *By the Seashore.* 1883. Oil on canvas, 36 1/4 × 28 1/2″. The Metropolitan Museum of Art, New York (Bequest of Mrs. H. O. Havemeyer, 1929. The H. O. Havemeyer Collection)

99. GUSTAVE COURBET. *Portrait of Jo (La Belle Irlandaise)*. 1866. Oil on canvas, 22 × 26″. The Metropolitan Museum of Art, New York (Bequest of Mrs. H. O. Havemeyer, 1929. The H. O. Havemeyer Collection)

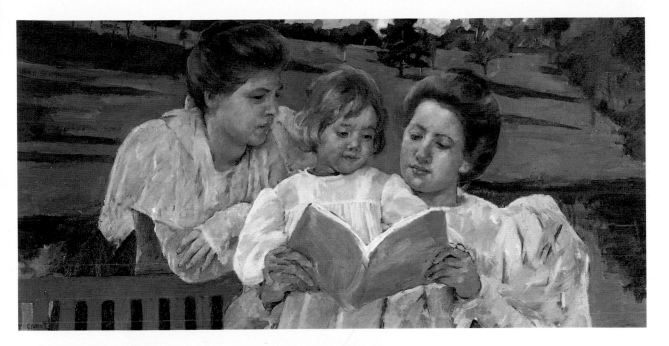

100. MARY CASSATT. *Landscape with Three Figures (Family Group Reading).* 1898. Oil on canvas, 22 × 44″. Philadelphia Museum of Art (Given by Mr. and Mrs. J. Watson Webb). Formerly owned by Mr. and Mrs. Havemeyer

101. MARY CASSATT. *The Oval Mirror.* c. 1899. Oil on canvas, 32 1/8 × 25 7/8″. The Metropolitan Museum of Art, New York (Bequest of Mrs. H. O. Havemeyer, 1929. The H. O. Havemeyer Collection)

102. PAOLO VERONESE. (above) *Boy with a Greyhound.* 1570s. Oil on canvas, 68 3/8 × 29 1/2″. The Metropolitan Museum of Art, New York (Bequest of Mrs. H. O. Havemeyer, 1929. The H. O. Havemeyer Collection)

103. PAUL CEZANNE. (right, above) *Still Life with Bottle.* c. 1890. Oil on canvas, 23 5/8 × 28 3/4″. Private Collection (photograph courtesy of E. V. Thaw, New York). Formerly owned by Mary Cassatt

104. PAUL CEZANNE. (right) *Still Life, Flowers.* 1879–80. Oil on canvas, 16 1/8 × 13″. Collection Franz Heinz, Munich. Formerly owned by Mr. and Mrs. Havemeyer

105. PAUL CEZANNE. (far right) *Flowers in a Glass Vase.* 1872–73. Oil on canvas, 16 1/8 × 13″. Timken Art Gallery, San Diego. Formerly owned by Mr. and Mrs. Havemeyer

106. PAUL CEZANNE. (left, above) *Winter Landscape of Auvers.* c. 1873. Oil on canvas, 24 × 19 5/8″. Private Collection. Formerly owned by Mr. and Mrs. Havemeyer

107. PAUL CEZANNE. (left) *Still Life with Ginger Jar and Eggplants.* 1893–94. Oil on canvas, 28 1/2 × 36″. The Metropolitan Museum of Art, New York (Bequest of Stephen C. Clark, 1960). Formerly owned by Mr. and Mrs. Havemeyer

108. PAUL CEZANNE. (above) *Landscape with Viaduct (Mont Sainte-Victoire).* 1882–85. Oil on canvas, 25 3/4 × 32 1/8″. The Metropolitan Museum of Art, New York (Bequest of Mrs. H. O. Havemeyer, 1929. The H. O. Havemeyer Collection)

109. CAMILLE COROT. (above, left) *Portrait of Mlle Dobigny—The Red Dress.* 1865–70. Oil on panel, 30 3/4 × 18 1/2″. Shelburne Museum, Shelburne, Vt. (photograph by Ken Burris). Formerly owned by Mr. and Mrs. Havemeyer

110. MARY CASSATT. (above, right) *Young Mother Sewing.* 1901. Oil on canvas, 36 3/8 × 29″. The Metropolitan Museum of Art, New York (Bequest of Mrs. H. O. Havemeyer, 1929. The H. O. Havemeyer Collection)

111. EDGAR DEGAS. (right) *Woman with a Towel—Back View.* 1894. Pastel on paper, 37 3/4 × 30″. The Metropolitan Museum of Art, New York (Bequest of Mrs. H. O. Havemeyer, 1929. The H. O. Havemeyer Collection)

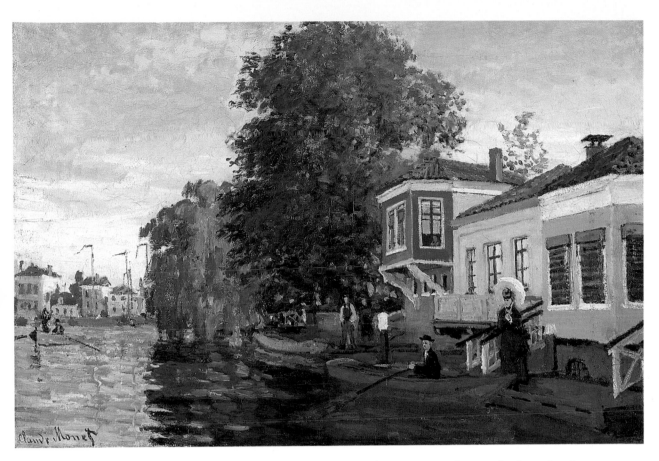

112. CLAUDE MONET. *The River Zaan at Zaandam.* 1871. Oil on canvas, 18 1/4 × 26". The Mehmad
Collection. Formerly owned by Mr. and Mrs. Havemeyer

113. CLAUDE MONET. *Bridge over a Pool of Water Lilies.* 1899. Oil on canvas, 36 1/2 × 29″. The Metropolitan Museum of Art, New York (Bequest of Mrs. H. O. Havemeyer, 1929. The H. O. Havemeyer Collection)

114. CLAUDE MONET. *Haystacks at Giverny.* 1884. Oil on canvas, 26 × 32 1/8″. Private Collection, Houston. Formerly owned by Mr. and Mrs. Havemeyer

was apparently too far ahead of its time. Or possibly these "Moorish" houses did not appeal to those who could afford them, but were still too expensive for people with restricted means. Although several villas were rented, none was sold until decades later.[20] And, to add to his problems, Harry was sued in October 1901 by the town boards of Islip and Babylon to recover title to land under the waters of the bay in front of his "modern Venice." Harry had acquired title to the property from New York State in 1894; the local authorities now claimed that the land in question had never belonged to the state but was instead town property.

When summer was over, the Havemeyers resumed their art purchasing. The renown of their collection was growing proportionately; Louisine and Harry had chosen to remain on the fringes of "fashionable" New York society, but their invitations to see their treasures were increasingly sought after. Sometimes a visit came at an inopportune moment, like that of Isabella Stewart Gardner during the first half of January 1903. Louisine always reserved Saturday mornings for house cleaning, a practice that was habitual with her, and she was quite put out when Mrs. Gardner of Boston wrote requesting an appointment for that very time, but Harry decided that a guest should be permitted to come at her own convenience.

Mrs. Gardner had recently celebrated the opening of "Fenway Court," her sumptuous Italianate palace-museum in Boston, and she now wanted to scrutinize personally the Havemeyer residence she had heard so much about; in other words, she was anxious to check out the competition. There was no love lost between "Donna Isabella," as Henry James called the imperious Mrs. Gardner, and the always unassuming Louisine, who, immediately after Mrs. Gardner departed, must have vented her feelings in a letter to her closest friend. Mary Cassatt, as always, was not reticent about expressing in her reply her very definite opinion:

> Of course Mrs. Jack Gardner did not like to see the riches in your house, & her pictures must have increased in number if she has the "best" collection of Old Masters in America. . . . As to the moderns *Zorn* Helleu & Sargent are her admirations, as for Whistler she carried off a picture from his studio by force (you can imagine the scene between two such "poseurs") & the next day he sent word what the price was, she grinned & paid,—but it staggered even her. . . . They love to talk her over in Boston. The love of Art is a pose, & her blunders about music were laughed about in my hearing, "she knows it all," as you say. No my dear, you & I are about the only two, I saw no others . . . well Louie dear we two must just do the best we can, helped by men.[21]

In November 1903 Mrs. Gardner's agent-adviser Bernard Berenson and his wife also visited at 1 East 66th Street. The occasion was noted by Mary Berenson in her journal: "saw the Havemeyer things—an awful Tiffany house!—Rembrandts, Monets, Degases ad infinitum—no real taste . . ."[22] Since the Berensons had left their Florentine villa and crossed the Atlantic expressly to convince as many rich Americans as possible to acquire Italian pictures, specifically when selected by "B. B.," they had little use for the Havemeyers, or the Havemeyers for them. On the other hand, they naturally were

very impressed by their Boston patron's new museum, as Mary Berenson wrote in her diary: "In beauty and taste it ["Fenway Court"] far surpassed our expectations, which were high. . . . I thought there was remarkably little that was not of Bernard's choosing, but that little annoyed him immensely and hurt him too."[23]

More frequent and sympathetic visitors to the Havemeyers were Mr. and Mrs. Alfred Pope from Cleveland, who also maintained a New York apartment. Mr. Pope's exquisite taste was reflected in his small but choice group of modern paintings; at the turn of the century his favorite artists seemed to be Monet and Whistler. On their annual trips abroad the Popes usually visited Mary Cassatt, who wrote to Louisine: "I have just seen the Popes who must be on their way home, & whom I strongly urged to go & see you this winter, they seem to think you would consider it a bore but I asked Mr. Pope if he thought you saw many people who appreciated your collection as he does."[24] The Popes' country house in Farmington, Connecticut—"Hill-Stead," designed by Stanford White with the enthusiastic assistance of Theodate Pope—was completed in 1901. Once settled in the country the Popes spent less time in New York, but whenever the opportunity presented itself they called upon the Havemeyers for a special viewing of the most recent acquisitions.

The Popes' daughter Theodate, who would later open an office as an architect, reputedly the first woman in America to do so, was in Europe for the better part of 1903. Theodate often saw Mary Cassatt, who took an interest in the cultural development of her young friend, constantly urging her to visit various museums. The enterprising Theodate, however, had a mind of her own and the two women had one highly charged dispute over the role of art in society. Theodate saw art only in terms of decoration, and was firmly against the amassing of pictures, an attitude diametrically opposite to the concepts held sacred by Mary Cassatt. They continued their debate by letter after Theodate left for England, and Cassatt heatedly penned the following:

> You say "no collection can be interesting as a whole"—There again you are thinking of decoration, but I know two Frenchmen who are thinking of a journey to New York, *solely* to see the Havemeyer collection because *only there* can they see what they consider the finest modern pictures in contact with the finest old Masters, pictures which time has consecrated & only there can they study the influences which went to form the Modern School, or at least only there see the result—You see how others look on collections.[25]

Still upset, Mary Cassatt informed Louisine of what had transpired:

> I wish you could have heard Miss P—'s conversation here. Her fad now is that pictures are a bore. Rooms must be pictures, and bare walls are the things. She is made ill by the glitter of the gold frames, on the walls in her father's house and she complacently told me that the poor man was much discouraged and would probably never buy another picture! The monstrous selfishness of her attitude, depriving her father of one of his greatest pleasures never seemed to strike her! I hinted to her very plainly that ignorance was the trouble with her. . . . She wants to know if your collection is not to be thrown open to the Public? She

believes all pictures should be in public galleries! . . . As for Miss P., her father's money, and her natural conceit with a strongly developed laziness are what are ruining her and I am afraid she will never give her parents much happiness.[26]

Her anger unleashed, Cassatt was able to put to rest her divergence of opinion with Theodate, and soon they resumed their former friendship. But Louisine evidently did not think highly of Theodate, as she wrote much later: "Miss Cassatt was perfectly right, she [Theodate] never did give her parents any happiness but going her own way, she left them free to lead their own lives and her father did continue to buy pictures and very fine ones. Degas, Manet, and Cassatt."[27]

Meanwhile the Havemeyers added rapidly to their group of these same French moderns in 1903. From mid-March to the end of April they again went to Europe and offered to take Mary Cassatt on another trip; since the artist was immersed in her painting to prepare for a group show at the Bernheim-Jeune gallery, she declined the invitation. The Havemeyers on this trip concentrated on northern Italy and Paris. While in Paris, they bought pictures by Manet, Degas, and Puvis de Chavannes from the Galerie Durand-Ruel, and two more Cézanne paintings, their first documented purchases of works by that artist. Cézanne's *The Abduction* (*L'Enlèvement*; Plate 116), an intensely sensuous, romantic landscape with nude figures, had previously belonged to Emile Zola. Vollard had bought it at Zola's estate sale early in March 1903, and soon afterward Durand-Ruel obtained it from him, apparently at the Havemeyers' request. Durand-Ruel also purchased from Vollard on their behalf Cézanne's *Man in a Straw Hat—Portrait of Gustave Boyer* (Plate 117), another early work by the artist, showing the influence of Manet.

Before their European trip the Havemeyers had purchased several pictures from the New York branch of Durand-Ruel, among them another Monet, *The Thames at Charing Cross Bridge* (Plate 120), a Degas portrait of a man, and three Corot figure pieces, including *L'Italienne* (Plate 119). Then, on February 7, 1903, they bought Manet's large *Dead Christ with Angels* (Plate 118), because Louisine felt it imperative to keep such an important Manet in America. She hung the imposing painting in various locations in her home but found that "it crushed everything beside it and crushed me as well." Finally, concluding that "it would be impossible to live with that mighty picture,"[28] she put the work into storage until eventually she sent it on extended loan to the Metropolitan Museum. Also early in 1903 the Havemeyers consigned for sale to the Durand-Ruel gallery two works by Decamps and one by Millet; they had already disposed in that way of six watercolors by Barye and two pastels by Millet. Evidently they were again weeding out the works they found unsatisfying or not up to the standard they had set for themselves.

As ingenious as Louisine had always been with the hanging and placing of works of art, the constant and rapid accumulation of new pictures necessitated an addition to their residence. Upon their return in May 1903, the Havemeyers began the construction of a gallery on the main floor (see page 72) to accommodate some of the paintings they had just acquired and those they anticipated purchasing, particularly by El Greco and Goya. The addition was fraught with complications. On July 16, Mary Cassatt wrote to Paul Durand-Ruel: "She [Louisine] has been extremely busy recently, and is having

Top: Bird's-eye View of Bayberry Point,
on Great South Bay, midway between
Bay Shore and Islip, Long Island, c. 1898.
Ten villas were built from four different
designs, varied in size and in their position
on the canal. This drawing illustrated
the prospectus. Courtesy of
William E. Havemeyer

Above: Villas at Bayberry Point, canal front
view with boat house, c. 1920. The stucco
walls of the villas are now covered with ivy.
Photograph courtesy of William E.
Havemeyer

Right: Cover of prospectus for Bayberry
Point, c. 1898. Architect Grosvenor Atterbury
was given "suggestions" by Louis C. Tiffany;
the landscape architect was Nathan F. Barrett.
Courtesy of William E. Havemeyer

MOORISH
HOUSES
at Bayberry Point
Islip. L.I.

*Left: Harry Havemeyer at Bayberry Point, c. 1903. Harry's concept of cooperative
living was avant-garde for the time; he proudly thought of his little colony as an
advanced social experiment. Communal services were to cost each owner $100 yearly*

*Right: Louisine on the balcony of the Havemeyers' villa at Bayberry Point, c. 1903.
Photographs courtesy of J. Watson Webb, Jr.*

NATURAL LAWS GOVERNING TRUSTS.

*The Havemeyer–Arbuckle sugar and coffee controversy, a long and costly battle.
Cartoon courtesy of J. Watson Webb, Jr.*

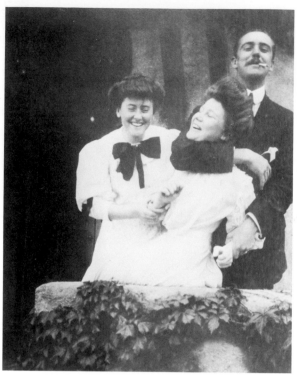

Electra Havemeyer, left, with friends at
Bayberry Point, c. 1904. Photograph courtesy
of J. Watson Webb, Jr.

Adaline Havemeyer, age 20,
summer 1904. Photograph courtesy
of J. Watson Webb, Jr.

Horace and Electra Havemeyer, left and center, with a friend, c. 1904. They are
standing near a boat house at Bayberry Point. Photograph courtesy of J. Watson Webb, Jr.

much difficulty with the workmen of the new gallery."* The construction was completed in November.

The new main floor gallery had formerly been a courtyard at the back of the house. This rectangular space was connected with the entrance hall by a corridor, which was filled with French and Italian statuary of the fourteenth and fifteenth centuries; at the end, set at a right angle, was the spacious skylighted addition, illuminated at night by large hooded chandeliers. This gallery could not be seen until one actually reached it by walking down three or four marble steps, flanked by a pair of antique columns. Within a short time the gallery would contain a microcosm of the Havemeyer collection: a mixture of old master paintings (figure pieces by Veronese and Rubens) and works by El Greco and Goya, together with a number of Courbet portraits and landscapes, Renoir's *By the Seashore*, and one landscape each by Monet and Cézanne. It was here that a visitor could immediately see the extraordinary range of the Havemeyer collection.

Patience Rewarded

Once the Havemeyers' large main floor gallery had been completed, they were particularly anxious to possess certain works by El Greco and Goya that, in some cases, they had been negotiating for since their trip to Spain in 1901. Much of their correspondence during 1904 concerned the trials and tribulations of finally obtaining these paintings, and the letters exchanged between Harry Havemeyer and Paul Durand-Ruel illustrate the dealer's endeavors, retracing each month his occasionally frustrating and often tedious transactions; they also show that to the elderly Durand-Ruel goes full credit for getting at long last the Havemeyers' most important pictures out of Spain. It was not easy for a man of Harry's temperament to wait indefinitely for something he greatly wanted; his letters from this period often reflect his disgust and impatience faced with the red tape and delays that ensued.

On April 1, 1904, Paul Durand-Ruel informed him about a portrait by Goya of the Marquesa of Pontejos [National Gallery of Art, Washington, D.C.]:

I had seen this painting in Madrid, but it was not for sale. A short time ago, I was told that were I to offer 125,000 francs [$25,000] I might have a chance of getting it. The Marquesa of Martorell who owns it has already twice refused 100,000 francs for it. . . . Any day now, those who have made these offers could increase them. I am therefore advising you of the situation and asking if you will authorize me to buy it for you. To close the deal, I ought to go to Madrid with the money. I shall try to get the painting for less than 125,000 francs, but I doubt this will be possible. . . .

If I do go to Madrid, I shall again see the other beautiful paintings that might be of interest to you, but have not been for sale at any price. I shall keep you posted concerning any changes that may occur in the conditions imposed by the owners of these remarkable works. I would be grateful if you could let me know by telegram your decision one way or the other, so that I may be free to act; there is no time to lose and I would like to be in Madrid from the 12th to the 15th, no later; after the 15th, it will be impossible for me to leave Paris because of the public auctions I must conduct. . . .*

Harry answered on April 11: "I have received yours of the 1st of April, and Mrs. Havemeyer and I reached the conclusion to cable you as we did this day to buy the *Marquesa of Pontejos* providing the quality and preservation are satisfactory, for not exceeding 125,000 francs, and as you wrote you were going to Madrid, to cable us the price of the *Cardinal* by Greco."

Paul Durand-Ruel obviously made his proposed trip to Spain, for Harry wrote to him on April 27:

This morning I was in receipt of a letter from Miss Cassatt, stating what Joseph had told her in reference to your visit to Madrid.

With respect to these important pictures "Goya," "Greco," or any other unusual picture of merit, I should prefer if you would give me your opinion over your own hand. I wish to imply no reflection upon Miss Cassatt or Joseph, or any one else, but these matters are more clearly understood when they come direct.

On May 6, Paul Durand-Ruel responded:

I have often consulted Miss Cassatt because she knows your tastes well and she herself has good judgment; but I have duly noted your wish and shall arrange to always write you myself when it is a matter of expressing my opinion on an important work that I think should be bought. . . .

I presume I shall soon know your decision regarding the Cardinal by Greco. If you should decide to buy it, you will own one of the most beautiful works by this painter, and I would be very happy to see it in your gallery.*

On the same day Harry was informing the dealer:

I received your letter of April 27th this morning, and immediately cabled you to buy the "Greco" for 225,000 francs [about $45,000].

It seems to me that the mistake is made of an offer on these pictures at the full value one is willing to give. It is always desirable to bring a man to declare the lowest price which he will take, and if within the limit, then buy the picture, as otherwise they merely use the offer as a basis of dealing with somebody else to get a higher price.

Durand-Ruel acted at once upon Harry's instructions, and notified him on May 10:

I did indeed receive your cable of May 6th saying "Buy Greco 225."

I immediately cabled Madrid to ask my correspondant to inform by telegram the Count of Paredes de Nava, who is in Italy, that I had agreed to buy his portrait of the Cardinal at his price. I now must wait for the Count, once he receives the cable, to give the order to deliver the painting. As soon as Madrazo [artist, expert, and agent for Durand-Ruel in Spain, as well as brother of Raimundo de Madrazo y Garreta, a famous Spanish painter of the period] has it in his possession, he has been ordered by the Count of Paredes de Nava to quickly make a copy of it, which

was an explicit condition for the sale, a condition that I had to accept. This will take about fifteen days.

As soon as I have news from the Count, I shall cable you and ask you to send the money to Paris. Every precaution will be taken for the painting's safety in Madrid as well as during its shipment to Paris.*

A few days later Harry sent the 225,000 francs to Durand-Ruel, who meanwhile had received confirmation from the picture's owner. As soon as El Greco's *Cardinal* (Plate 121) was secured, Harry turned his attention to works by Goya, as he let Durand-Ruel know in no uncertain terms on May 19: "What I wish you to concern yourself about is a portrait [the *Marquesa of Pontejos*] by Goya, which you went to Madrid to secure, and likewise "Les Femmes au Balcon," by the same artist. Both of these pictures would interest me—and so far as I know at present, [are] the only pictures that do." On May 31 the dealer replied to Harry Havemeyer:

Yesterday I received the painting by Greco [*The Cardinal*] and it arrived in perfect condition. I immediately wrote to Miss Cassatt; she is coming to see it and will let you know her impression; I am sure it will be favorable.

I have not forgotten the two Goya paintings . . . ; I shall be informed as soon as there might be a possibility of obtaining them.*

This possibility presented itself the next month; in June, Paul Durand-Ruel sent the following cable to Mary Cassatt at her country house: "Received cable Madrid offering opportunity majas balcony 250,000 francs [about $50,000] owner's daughter marrying July 2 needs money urgent to make a decision cabling HOH advising to authorize immediate purchase several competitors ready to buy when they know painting available. Leaving for Madrid tomorrow to try to get lower price."*

But Paul Durand-Ruel's report on his trip to Madrid turned out to be disappointing, and Harry replied on July 25:

Yours of the 12th of July, bearing upon your visit to Spain, on account of the "Majas au Balcon" by Goya, is received. I am sorry you failed in your mission. . . . The 250,000 francs that I cabled to you were for a specific purpose—that of buying the "Majas au Balcon," and I want it reserved for that purpose. . . .

I hope you secured the loyalty of those of the trustees of the Duke with whom you are acquainted; that will preclude a sale or disposition of the picture without your having, as you should have, an opportunity to possess. I hope your agent down there is following this up very carefully. I should think the tutor could render admirable aid in this respect. I should deplore the loss of the picture.

I have often cautioned you about exposing my pictures to anyone; while we are negotiating for important pictures the exposure of my pictures, such as the "Cardinal" cannot but do us damage. Outside of Miss Cassatt I prefer that no one whatever at any time shall see my acquisitions.

I do not doubt but that the newspaper hubbub about the "Cardinal" advanced

the price on the Goyas, and has caused hesitancy on the part of the trustees, which would otherwise not have been experienced.

In the meantime, while waiting and hoping for the arrival of their coveted Spanish pictures, the Havemeyers took a comprehensive view of their holdings and decided that they needed an important work by Ingres to round out their collection of nineteenth-century French paintings. Toward the end of August Mary Cassatt alerted the Durand-Ruels to this wish and within a few days Joseph Durand-Ruel wrote the artist, then still at her château de Beaufresne, that he soon hoped to offer the Havemeyers a portrait by Ingres of a young woman painted in Rome in 1811. On September 8, Paul Durand-Ruel advised Cassatt to watch her mail for a photograph of this Ingres portrait, and then relayed the following information, which in all likelihood concerned the likeness of *Madame Panckoucke* (Plate 123):

This painting has not been offered to anyone, and its owner is not at all thinking of selling it, however he is an elderly man whose only concern is getting his house in order. Thus, even though it is a family portrait, I think he might decide to part with this masterpiece if he were given a serious offer. It would be pointless and even dangerous to propose less than 150,000 –200,000 francs; a lesser offer would certainly be refused and if it were disclosed, other people might enter into the competition.

I am asking you to keep this matter absolutely secret and to speak of it to no one but Mr. Havemeyer, if you think it would interest him.*

Although the photograph of the work passed Mary Cassatt's inspection, and Paul Durand-Ruel, too, found it very fine, Harry curtly informed the dealer: "The photo of the 'Ingres' was received and carefully scrutinized by Mrs. Havemeyer. While the painting of the body and drapery is very beautiful, she thinks the face lacks charm, being rather sweet and insipid. At the possible price of 150,000 francs [about $30,000] mentioned, it is out of the question. Should a very much lower price finally result, you might again bring it to her attention."

But October 1904 brought the Havemeyers the outcome they had long been hoping for. On the 9th, Paul Durand-Ruel returned once more to Madrid, where he finally was able to conclude the negotiations for Goya's *Majas on a Balcony* (Plate 122), notifying the Havemeyers by cable. At the time he was in Spain, Louisine and Harry were receiving the shipment of El Greco's *Cardinal* together with two old master portraits Durand-Ruel had bought for them at the Alfred Mame sale in Paris earlier that year. Upon the victorious dealer's return to Paris, Mary Cassatt wrote him that Mrs. Havemeyer was delighted with the *Cardinal* and the two portraits (by Clouet and Antonello da Messina), and was overjoyed with the news concerning the Goya. Harry was equally pleased. Yet they never did obtain Goya's *Marquesa of Pontejos*.

Goya's *Majas on a Balcony* had to be relined, and was not delivered until shortly before Christmas at the Galerie Durand-Ruel, where it remained only a week before being shipped to New York. Cassatt, back at her country house, was unable to see the

painting before its departure, but she asked Durand-Ruel to alert Roger Marx, the critic and collector who was also general inspector of French museums and whose opinion she valued, as she wrote Louisine: "I particularly wanted Marx to see the Goya. After expressing his great admiration, he said he was deeply impressed with the fact that the flesh was painted like a miniature whereas the rest of it was so broadly treated. You will see the point of this remark. It is always worth while to show him a picture for he says something new."[1] As usual, Cassatt conveyed the Havemeyers' response to the anxious Paul Durand-Ruel, who, in February 1905, gratefully acknowledged her report: "I am delighted with the news you relayed concerning the appreciation of the magnificent Goya. It gives me encouragement to search for other beautiful works, but these are more and more difficult to come by."*

Included in the case with the *Majas on a Balcony* was a forceful self-portrait by Cézanne (Plate 124). Cassatt had arranged for Vollard to deliver the picture to Durand-Ruel in time to have it packed with the Goya. Vollard and Cassatt may have selected this painting for the Havemeyers, following Cézanne's notable display of thirty pictures at the second annual Salon d'Automne of 1904, where he was honored with a special room. The Salon d'Automne was unquestionably the artistic event of the year, as it showed the works of younger, more radical painters and a few of their chosen precursors, such as Cézanne. Cassatt was pleased that Cézanne was now achieving some deserved recognition and she may have wanted her friends to own another painting by him. The artist would die two years later.

At this time, and from the same Spanish family from whom he had just obtained the Havemeyers' great Goya painting, Durand-Ruel acquired El Greco's very large *Assumption of the Virgin* (Plate 125), a work originally "discovered" by Cassatt in 1901. Since the dealer could not cover the purchase price of the picture, he had asked Harry to come to his aid; Harry had responded on July 25, 1904: "The 100,000 francs I offered to advance for the purchase of the 'Assumption' was for your account, the picture, of course, to be my security. I will not participate in the venture—any profit that might arise would be solely for your account. I did it as an act of friendship." As El Greco's painting was more than thirteen feet high unframed, it was impossible for the Havemeyers to hang it, even in their new gallery; thus a buyer, evidently a museum, was needed.

When Louisine requested her husband's permission to write the Metropolitan Museum's trustees offering El Greco's *Assumption,* he answered: "You can do as you like; you know what they are."[2] Nonetheless, she took it upon herself to contact Samuel P. Avery, one of the museum's founding trustees with whom the Havemeyers had a cordial relationship, and who, she thought, would be sympathetic to her proposal. Avery, however, on behalf of the museum, declined her offer to buy El Greco's *Assumption of the Virgin* for the low price of $17,000. His reason was that the museum, was then negotiating for a "finer one,"[3] El Greco's *Adoration of the Shepherds*—supposedly the same picture that Mrs. Jack Gardner had turned down despite Berenson's recommendation. Louisine was furious and disgusted with the museum; justifiably, she saw no comparison between the two works, either in price or in quality.

Yet Mary Cassatt continued convinced that El Greco's *Assumption* belonged in the Metropolitan. She encouraged Paul Durand-Ruel to try again, pointing out that there were recent changes in the board's membership: Louis P. di Cesnola, the Metropolitan's

strong-willed director for the past twenty-five years, had died in November 1904, and the day after his death John Pierpont Morgan had been elected president of the board of trustees, a position he would occupy until his own death in 1913. Durand-Ruel and Cassatt hoped for a new era at the museum which, according to Cassatt, now had an annual income of $250,000 to spend on acquisitions, but Harry remained less optimistic. He must have been deeply resentful that he had never been asked to serve on the museum's board, a group of wealthy and powerful men; with Morgan as its new, autocratic leader, Harry would certainly continue to be overlooked.

Urged by Mary Cassatt, Durand-Ruel tried to spark Morgan's interest in the *Assumption,* although he expressed doubts to her early in December 1904:

> I agree with you about Mr. Pierpont Morgan and think that now he is at the head of the Metropolitan, he should make it a point to purchase works of top quality such as my Greco. I wrote him regarding this matter. My son also wrote him from New York and he answered that he would come see it, but you know how busy these big businessmen are and he could easily forget his promise. It would help if he were advised by people with taste, such as Mrs. Havemeyer, but I don't know if she is well enough acquainted with him to have any influence.
>
> It would also be desirable for Mr. Havemeyer to serve on the museum's board. He should accept this office now that the famous general Cesnola has died. He was the one who blocked everything.*

By the middle of December, the dealer confided to Mary Cassatt that he had become impatient with Morgan: "The unfortunate thing is that he is so absorbed by business matters that he doesn't have time to think of anything else and he is circumvented by the Duveens, who, it is said, do as they please with him. Mr. Havemeyer should be on closer terms with him in order to give him a little artistic education."* Durand-Ruel was naïve in thinking that Morgan would avail himself of either Louisine's or Harry's expertise. In 1905 the Metropolitan Museum bought the other El Greco, *Adoration of the Shepherds.*

Meanwhile Cassatt and Durand-Ruel had switched their efforts to the Art Institute of Chicago, and in 1906 that museum acquired El Greco's *Assumption,* reportedly for nearly $40,000. The purchase funds were provided by Mrs. Albert Arnold Sprague, who gave the work to the museum in memory of her husband. Louisine, as a friend of Mrs. Sprague, felt somewhat vindicated at last; Cassatt, for her part, was relieved that the painting had found a home in an American museum instead of ending up in Berlin, as she had feared.

Not only had Harry Havemeyer's attitude toward the Metropolitan Museum hardened with the passage of years, but also his policy about lending pictures. Although he had been quite liberal with loans when he first began to collect, this was no longer the case after the turn of the century. He now firmly believed that his treasures should remain in his house for the enjoyment of his family and their selected guests. As Louisine later wrote: "He therefore had no hesitation in answering *no* to a request, or in dropping a letter from a stranger into the wastebasket. While he was a delightful and most genial host, his strong character, rendered still more forcible by his business career, made

others rather afraid to approach him, and I am afraid some thought him brusque."[4]

Sometimes people wishing to meet the Havemeyers would turn to Mary Cassatt as a go-between, as did Carl Snyder in 1904, who was employed by the August F. Jaccaci Company; together with John LaFarge, Jaccaci was preparing a fifteen-volume work entitled *Concerning Noteworthy Paintings in American Private Collections.* This ambitious project, based on presenting outstanding pictures from fifty important collections, was to have about 500 pages and 50 photogravures in each volume, accompanied by a separate bibliography; the privilege of owning this lavish set would come by subscription only for a mere $15,000, payable at $1,000 upon delivery of each volume. Begun in 1903, the task was so large that it would take years of preparation, and in the end it seems that only the first two volumes appeared.

Yet work on this enterprise was at its peak in 1904. Carl Snyder had called upon Mary Cassatt in Paris, and she, finding his project worthwhile, had given him a note to Mrs. Havemeyer. Not long after his return to New York, Snyder wrote Cassatt to bring her up to date on his progress in securing the cooperation of various collectors:

> The only disappointment we have had is from your good friends the Havemeyers. Is there any way of gaining their friendship too? . . . We have Mr. Johnson, Mrs. Gardner, Mr. Pope, Mr. Whittemore, Mr. Hutchinson, in Chicago, Angus [?] and others in Montreal, we have Mr. Terrell, Mr. Havemeyer's good friend and Mr. John W. Simpson, his attorney—surely the company is good, and the character of the work high. I saw Mrs. Havemeyer—thanks to your kindly note and I saw the pictures, and how beautiful, and how finely chosen they are! But Mrs. Havemeyer, though I think very kindly disposed herself, could give me little encouragement about her Mister Man! As I told you, when Mr. LaFarge wrote a year or more ago, he gave a very flat no. I told Mrs. Havemeyer naturally, of your cordial interest and of your saying you hoped that they might give their consent now, but she seemed to think it would do little good [for her to talk to Mr. Havemeyer]. I asked her if you could say what you liked to him (I'm told most people don't) and she said you could and *do.* I wish you could say something that would bring him a change of heart now! Could you?[5]

Evidently Cassatt did intercede; among the Jaccaci papers there are notes about six paintings belonging to the Havemeyers: two portraits by Hals, acquired at the Secrétan sale in 1889; Decamps's *The Good Samaritan,* purchased from Durand-Ruel that same year; *Saint Cecilia* by Rubens, bought in 1898; and two Manet paintings obtained in 1898 at the Gustave Goupy auction: *The "Kearsarge" at Boulogne* and *In the Garden* (see Plate 84). Perhaps it was Harry who limited the editors' selection to these half-dozen works, for twelve paintings from the Pope collection were featured in the first published volume of 1907. According to Snyder, Alfred Pope was especially pleased with the photogravures and generally interested in the undertaking.

Harry's loan policy at this time could be described as highly discriminatory. To most requests his answer was negative, but there were occasional exceptions, such as the Whistler Memorial Exhibition at Copley Hall in Boston, held in February to March 1904 (the artist had died in July 1903). Charles Lang Freer, the prolific collector in

Detroit, assisted the executive committee of the Copley Society in soliciting loans of Whistler's paintings, watercolors, pastels, and drawings from American and foreign owners (Freer had been the artist's devoted friend and patron). In addition to lending two pastels (*The Palace* and *Greek Girl*), Harry agreed to serve on the exhibition's honorary committee.

But later in 1904, when Mr. Edward R. Warren of the Copley Society wrote to Charles Freer about the possibility of borrowing other works from the Havemeyer collection, Freer answered as follows:

> Now, concerning Mr. Havemeyer's consenting to lending his group of Degas' pictures, I hardly know what to say. I can tell you, however, in strict confidence, that, on general principles, Mr. Havemeyer is strongly opposed to lending anything from his collection. However, you will remember that he contributed to the Whistler Memorial, and apparently, with no small pleasure. On the other hand, however, I attended a recent meeting of the Committee in charge of the Comparative Exhibition [native and European old master portraits], which is to open in New York on the 14th [of November] instant, and, if I might be allowed to expose a secret of that meeting, I could say that the general sentiment was that Mr. Havemeyer would not loan from his collection, even for this very important exhibition, to which almost every other person who has been invited has contributed most generously. I do not mention this disparagingly, for Mr. Havemeyer is really a very generous and noble collector. I simply mention it as evidence of his general disinclination in such matters. Now, I hardly know what more to say on the subject, unless it be to advise you to write him a letter, setting forth your desires, and asking his co-operation in just the same manner you would approach him on a matter of business. You will be sure in any event to receive courteous treatment . . .[6]

There is no indication that Mr. Warren's quest was successful; the more treasures Harry accumulated, the more reluctant he became to part with any of them, even for a limited period. At the same time he seems to have become more difficult to deal with concerning additions to the collection.

Jean-Baptiste Faure, once a celebrated baritone of the Paris Opéra and now seventy years old—and possibly depressed by the death of his wife—informed Paul Durand-Ruel in 1905 that he was willing to sell some of his large holdings of Manet's work. Faure had begun to acquire the artist's canvases in 1873 and at one time had owned sixty-eight of his pictures. Durand-Ruel, an old friend of Faure's, acting as his agent, naturally alerted Harry to this opportunity. Durand-Ruel himself was interested in buying Faure's entire group of Manets, yet decided first to offer three important paintings to Harry, hoping that his participation would make the transaction easier. He cabled his estimates for the works he wished Harry to buy, but on March 29 he learned from his client:

> I received your cable valuing the three Manets of the Faure collection at $60,000, and I regard the value preposterous so I immediately wired you to disregard me.

This morning Mrs. Havemeyer wished me to write you that for the "Bonbock," "Printemps" and the "Virgin with the Rabbit" [Manet's copy after Titian's painting in the Louvre] she would give $30,000 and would not give more. She appears to be interested in them, which I am not.

Durand-Ruel did not give up, and wrote on March 31: "The 300,000 franc price [$60,000] is indeed very high, but I based it on amounts already refused by Faure and on the price he is now asking for the entire group. A dealer whom I know offered him 120,000 francs [about $24,000] for the *Bon Bock* [Plate 126]; *Springtime* is worth more, because it is an absolutely exquisite and charming work, which is rare in a Manet."*

The determined dealer continued to negotiate with Faure, from whom he now tried to secure the three Manet pictures for 200,000 francs (about $40,000). Faure, however, was not in the mood to make concessions. Durand-Ruel, at a loss for what to do next, tried to enlist the aid of Mary Cassatt, who wrote to Louisine in July 1905: "Durand-Ruel wants to see me to talk about Faure's Manets to impress upon Mr. Havemeyer that the offer he makes is too low and he may miss the three he wants. Now Mr. Havemeyer has seen the pictures and therefore is perfectly able to judge for himself. I must confess personally I would not 'faire des folies' [go overboard] for the Bon Bock."[7] She then expressed herself on the subject to the dealer:

> About the Manet paintings from the Faure collection, I do not think Mr. Havemeyer is very taken with them, at least from the way he talks about them. The fact is, it is difficult to find Manets as beautiful as the ones they already have. The *Bon Bock* is not worth most of their Manets; I believe that is also your opinion.*

This time Durand-Ruel had to proceed without the support of his usual staunch ally.

By August 1, the situation took a new turn, as evidenced in Harry's letter to the dealer: "I cabled you today that I would take the *four* Manets—'Bonbock,' 'Port au Bordeaux,' 'Printemps,' and 'The Virgin with the Rabbit' for 250,000 francs." The persevering Durand-Ruel made this new offer to Faure, which would have given Harry four paintings for about $50,000, but even though Faure agreed this time to some reduction, the dealer informed Harry that it was impossible for him to buy all four works at such a low price.

Ever diplomatic, Durand-Ruel blamed the numerous difficulties on the ailing Faure: "It is thus impossible for us to conclude the deal under these conditions and we shall wait until Faure comes back to more reasonable terms."* But at the end of this letter of August 5, he implored Harry to consider paying 300,000 francs for the four works. On August 21, Mr. Havemeyer fired off the following letter:

> In response to yours of the 5th of August, I cabled you authority to purchase Manets "Revoked." This is the conclusion Mrs. Havemeyer and I have reached.
>
> If the "Port of Bordeaux" and the copy of the "Virgin and the Rabbit" are ever for sale, we might entertain them.
>
> As others undoubtedly will appreciate the "Bonbock" more than we do, our retirement might aid rather than demoralize your effort to acquire the collection.

115. CLAUDE MONET. *Barges at Asnières.* 1873. Oil on canvas, 22 × 29 1/2". Private Collection, U.S.A. (photograph courtesy of Coe Kerr Gallery, New York). Formerly owned by Mr. and Mrs. Havemeyer

116. PAUL CEZANNE. *The Abduction (L'Enlève-ment)*. 1867. Oil on canvas, 35 1/2 × 46″. Fitzwilliam Museum, Cambridge, England (Provost and Fellows of King's College, Cambridge, on loan to the Fitzwilliam Museum). Formerly owned by Mr. and Mrs. Havemeyer

117. PAUL CEZANNE. *A Man in a Straw Hat—Portrait of Gustave Boyer*. c. 1871. Oil on canvas, 21 5/8 × 15 1/4″. The Metropolitan Museum of Art, New York (Bequest of Mrs. H. O. Havemeyer, 1929. The H. O. Havemeyer Collection)

118. EDOUARD MANET. *The Dead Christ with Angels.* 1864. Oil on canvas, 70 5/8 × 59". The Metropolitan Museum of Art, New York (Bequest of Mrs. H. O. Havemeyer, 1929. The H. O. Havemeyer Collection)

119. CAMILLE COROT. *L'Italienne* (or *La Juive d'Alger*). c. 1870. Oil on canvas, 18 1/2 × 14 3/4″. Private Collection, U.S.A. Formerly owned by Mr. and Mrs. Havemeyer

120. CLAUDE MONET. *The Thames at Charing Cross Bridge.* 1899. Oil on canvas, 25 × 35 3/8″. Shelburne Museum, Shelburne, Vt. Formerly owned by Mr. and Mrs. Havemeyer

121. EL GRECO. *Cardinal Don Fernando Niño de Guevara* (or *Cardinal Bernardo de Sandoval y Rojas*). c. 1600.
Oil on canvas, 67 1/4 × 42 1/2″. The Metropolitan Museum of Art, New York (Bequest of Mrs. H. O.
Havemeyer, 1929. The H. O. Havemeyer Collection)

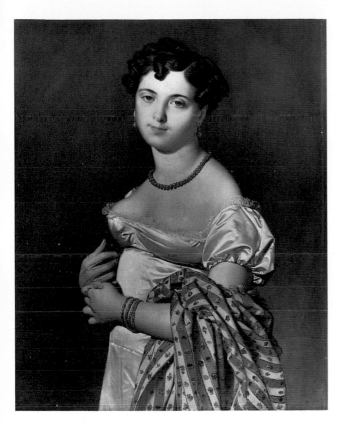

122. FRANCISCO DE GOYA. (left) *Majas on a Balcony.* c. 1805–12. Oil on canvas, 76 3/4 × 49 1/2″. The Metropolitan Museum of Art, New York (Bequest of Mrs. H. O. Havemeyer, 1929. The H. O. Havemeyer Collection)

123. JEAN-AUGUSTE DOMINIQUE INGRES. (above, left) *Madame Panckoucke.* 1811. Oil on canvas, 35 1/2 × 28″. Musée du Louvre, Paris

124. PAUL CEZANNE. (above, right) *Self-Portrait.* c. 1875. Oil on canvas, 28 7/8 × 15″. The Hermitage, Leningrad. Formerly owned by Mr. and Mrs. Havemeyer

125. EL GRECO. *Assumption of the Virgin.* 1577. Oil on canvas, 158 × 90". The Art Institute of Chicago
(Gift of Nancy Atwood Sprague in memory of Robert Arnold Sprague)

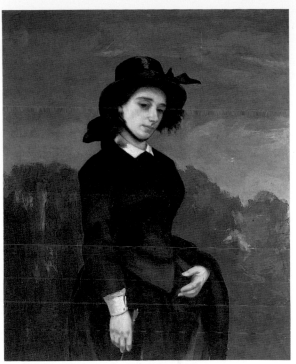

126. EDOUARD MANET. *Le Bon Bock.* 1873. Oil on canvas, 37 1/4 × 32 3/4″. Philadelphia Museum of Art (Mr. and Mrs. Carroll S. Tyson Collection).

127. GUSTAVE COURBET. *A Lady in a Riding Habit (L'Amazone).* 1856. Oil on canvas, 45 1/2 × 35 1/8″. The Metropolitan Museum of Art, New York (Bequest of Mrs. H. O. Havemeyer, 1929. The H. O. Havemeyer Collection)

128. EDOUARD MANET. (far left, above) *Portrait of Mlle Lemaire.* c. 1880. Pastel on paper, 20 7/8 × 17 3/4". Shelburne Museum, Shelburne, Vt. Formerly owned by Mr. and Mrs. Havemeyer

129. GUSTAVE COURBET. (left, above) *Portrait of a Man.* 1865. Oil on canvas, 16 1/4 × 13 1/8". The Metropolitan Museum of Art, New York (Bequest of Mrs. H. O. Havemeyer, 1929. The H. O. Havemeyer Collection)

130. PAUL CEZANNE. (left) *The Banks of the Marne.* 1888–90. Oil on canvas, 25 1/2 × 31 7/8". The Hermitage, Leningrad. Formerly owned by Mr. and Mrs. Havemeyer

131. PAUL CEZANNE. (above) *Still Life: Flowers in a Vase.* c. 1885. Oil on canvas, 18 1/4 × 21 7/8". Private Collection, New York. Formerly owned by Mr. and Mrs. Havemeyer

132. MARY CASSATT. (above) *Portrait of Louisine Peters*. c. 1900. Pastel on paper, 17 1/4 × 21". Collection of Sandy and Karen Blatt. Formerly owned by Mr. and Mrs. Samuel T. Peters

133. JEAN-AUGUSTE DOMINIQUE INGRES. (right, above) *The Turkish Bath*. 1859; 1863. Oil on canvas, diameter 42 1/2". Musée du Louvre, Paris

134. CAMILLE COROT. (right) *Bacchante in a Landscape*. c. 1865. Oil on canvas, 12·1/8 × 24". The Metropolitan Museum of Art, New York (Bequest of Mrs. H. O. Havemeyer, 1929. The H. O. Havemeyer Collection)

135. NICOLAS POUSSIN (now considered "Style of Poussin"). *Orpheus and Eurydice.* Oil on canvas, 47 1/2 × 70 3/4″. The Metropolitan Museum of Art, New York (Bequest of Mrs. H. O. Havemeyer, 1929. The H. O. Havemeyer Collection)

136. EDGAR DEGAS. *Dancers at the Bar.* 1877–79. Pastel on paper laid down on board, 26 × 20 1/8″.
Private Collection, U.S.A. Formerly owned by Mr. and Mrs. Havemeyer

137. GUSTAVE COURBET. *Madame de Brayer.* 1858. Oil on canvas, 36 × 28 5/8″. The Metropolitan Museum of Art, New York (Bequest of Mrs. H. O. Havemeyer, 1929. The H. O. Havemeyer Collection)

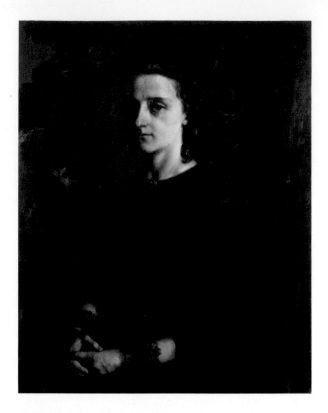

138. CLAUDE MONET. *London, Houses of Parliament: Seagulls.* 1903. Oil on canvas, 31 7/8″ × 36 1/4″. The Art Museum, Princeton University (Bequest of Mrs. Vanderbilt Webb). Formerly owned by Mr. and Mrs. Havemeyer

And Mary Cassatt seconded the Havemeyers' decision in a letter to Louisine: "I am rather glad the Manet deal fell through. I think you ought to see the pictures again before deciding. . . ."[8]

Paul Durand-Ruel finally persuaded Faure to accept a price of 800,000 francs (about $160,000) for his twenty-four Manets, and in November 1905 he gave the Havemeyers one more chance to acquire the four Manet paintings at 300,000 francs, but they remained steadfast. The following year the dealer did have the last word when he informed Mr. Havemeyer: "We have sold in Berlin for a higher price than the one that was quoted to you last winter, the 'Port de Bordeaux' by Manet belonging to Faure, through Mr. von Tschudi, the director of the Museum. We have sold also several others and we are now negotiating for the sale of a few more, including 'La Vierge au lapin.' " *Bon Bock* also ended up for a time in Berlin in the Eduard Arnhold collection; *Le Printemps* would be sold in 1909 by Durand-Ruel to the Havemeyers' close friend and neighbor, Colonel Oliver H. Payne.

In 1905 Harry Havemeyer had other cares besides negotiations for Faure's Manet paintings. After the turn of the century, his American Sugar Refining Company had extended its holdings to include the beet sugar industry, by acquiring an interest in beet sugar factories in Michigan, Utah, and California. He had also participated in the formation of the Great Western Sugar Company of Denver in 1903, and now he was anxious to travel west to inspect his beet sugar factories and mining properties. He arranged for a special train including two private cars, the "Edgewere" and "Carrizo," to carry a party consisting of his wife and their three children, together with Mr. and Mrs. W. B. Thomas (a business associate of Harry's) and their two daughters. The journey began toward the end of September, stopping first at Niagara Falls and Chicago; they arrived in Colorado Springs on October 1. An incident from their trip was reported on the front page of the *New York Times*:

> Henry O. Havemeyer, President of the American Sugar Refining Company, and the members of his party nearly met death by a dynamite explosion yesterday [October 4] 500 feet under ground in the great Portland Mine at Cripple Creek. W. B. Thomas of Boston was the most seriously injured. . . . The fact that Mr. and Mrs. Havemeyer were a few feet further away than Mr. Thomas saved them from an experience as painful as his. As it was both were severely shocked, and the entire party had to be assisted to the surface.
>
> Mr. and Mrs. Havemeyer and friends were curiously inspecting the mine's rock crevices. They walked within five feet, it is said, of the stick of dynamite. When the explosion occurred the chamber became dense with smoke. The shrieks of the women penetrated to an upper level of the mine, and were heard by the miners. . . . Probably all that saved the party from death was the peculiar position in which the stick was placed and the fact that several of the members had scattered to other parts of the chamber before the explosion took place.[9]

After recovering from this near fatal disaster, the Havemeyer family proceeded to the Grand Canyon and then to California, traveling from Los Angeles along the coast

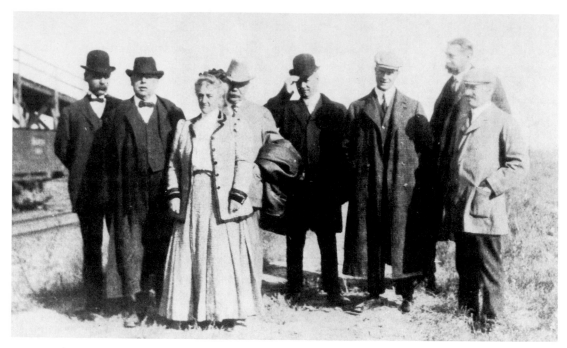

The Havemeyers and their party touring the West, October 1905. Harry Havemeyer is second from left with Louisine next to him; Horace is third from right. Photograph courtesy of J. Watson Webb, Jr.

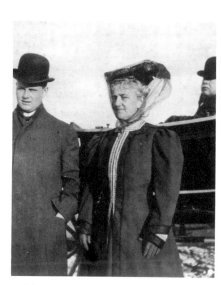

The Havemeyers in Egypt, 1906. Left to right: Horace, Louisine, and Harry seated in the car. They were near the Great Pyramids of Giza, outside Cairo. Photograph courtesy of J. Watson Webb, Jr.

Harry Havemeyer inspecting the interior court of the Mortuary Temple of Ramesses III at Medinet Habu, 1906. Photograph courtesy of J. Watson Webb, Jr.

Harry Havemeyer as a tourist in Egypt, 1906. Photograph courtesy of J. Watson Webb, Jr.

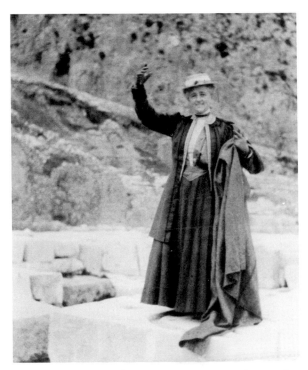

Left: Louisine Havemeyer at the Temple and Theater of Apollo in Delphi, Greece, 1906.
Electra Havemeyer entitled this photograph, "Mother as Delphic Oracle"

Right: Harry Havemeyer cruising the Greek islands aboard the Aphrodite, *1906. Photographs*
courtesy of J. Watson Webb, Jr.

to San Francisco. Electra relished their horseback excursion into the Grand Canyon; she also enjoyed riding with her father to the top of Pikes Peak. They returned during the second half of October by way of Salt Lake City and Denver; there Harry celebrated his fifty-eighth birthday on October 18th by attending a concert with Louisine. Not long after returning from this trip, Harry became totally preoccupied with his constantly expanding business empire, which had lately branched out into gaining possession of vast properties in Alaska with rich copper mines.

It may have been during the Christmas season that Harry felt he needed another respite from the relentless demands of his high-pressured activities and decided this time to remove himself far from everyday concerns by taking his family to Egypt and Greece. Since U.S. citizens then required the equivalent of a passport only for Egypt and for Russia, Harry obtained this official document from the Department of State on January 10, 1906, thus being assured that he, his wife, and two minor children would be given "lawful Aid and Protection" in case of need. Adaline Havemeyer chose to stay home.

Their first destination was Egypt, where they remained through most of February. Unlike those American millionaires who traveled with an entire retinue to accommodate their needs, the Havemeyers discarded these trappings and concentrated on sightseeing and on experiencing as much as they could of the cultural life of a foreign country. Louisine preferred to travel with only one suitcase (a crocodile Gladstone bag) and to buy clothing when needed from the nearest shop. She did not hesitate to mount a camel at the Great Pyramids of Giza nor to climb in and out of the rock-cut tombs at Luxor to examine their extraordinary mural paintings.

The party then went on to Greece, whose ancient civilization the Havemeyers so admired, as seen in naming their younger daughter Electra. By mid-April they were in Vienna, attending the opera, visiting palaces and museums, and making up for the food they had not eaten in Egypt. On April 13, Mary Cassatt wrote from Paris to her nephew's wife, Minnie: "I am expecting the Havemeyers and already the art dealers are all agog."[10]

The Havemeyers stayed more than three weeks in France and bought enough works of art to fill four packing cases. One afternoon, as later recounted by Louisine, Mary Cassatt arrived at their hotel and announced: " 'Duret [Théodore Duret, critic, collector, occasional agent, and the first historian of the Impressionists] has left a Courbet at my apartment for you to see. Your wife may like it,' she said, turning to my husband, 'but I doubt if you do. It is a portrait of a woman; . . . it is very quiet, the only color is the blue sky and her red cheeks. . . . Will you come up to the apartment and have a look at it?' "[11] Louisine recalled that as they drove to the rue de Marignan, Cassatt was more anxious about their liking the picture than they had ever seen her before; she even seemed apologetic for asking them to accompany her, repeating that the portrait was different from any Courbet they knew. Just before entering her dining room, where she had hung *A Lady in a Riding Habit* (*L'Amazone*; Plate 127), Mary Cassatt said to Louisine: "Well, it is not dear anyway, only fifteen thousand francs [about $3,000], and if you don't like it, I will buy it myself."[12]

Before looking at the painting, Louisine had already resolved to respond favorably, if only to reassure her apprehensive friend. But she did not have to fake her wholehearted approval; even Harry expressed frank appreciation. According to Louisine:

"Then Miss Cassatt's eyes sparkled and she glowed with enthusiasm, and we had a grand hour of it. I think Miss Cassatt feared we would not understand and admire it as she did. . . ."[13] Harry told Mary Cassatt to have Duret ship the portrait to New York, but she so loved the picture that she asked to keep it until she had made a study of it. Consequently, *A Lady in a Riding Habit* did not arrive at 1 East 66th Street for quite some time.

A dealer they called on often was Dikran Kelekian (born in Turkey of Armenian parents), whose gallery for antiquities was located at 2, Place Vendôme. Harry had been for some time a good customer of Kelekian's in both Paris and New York, where the antiquarian had opened a Fifth Avenue branch after coming to America to participate in the 1893 Chicago World's Fair. About 1900, Kelekian had introduced his client to the beauties of Persian potteries; their resonant color, intricate decoration, and translucent glazes appealed immensely to Harry and also to his son Horace, who had begun his own collection of ancient Persian ceramics. On this visit in the spring of 1906, Harry acquired fifty-seven pieces of Near Eastern glazed earthenware, consisting of assorted bowls, jugs, jars, plates, and vases; he also bought seven Arabic bronzes.

Kelekian was a good friend of Mary Cassatt's, who would soon write to Louisine:

I saw Kelekian yesterday morning, I am fascinated by his place, and he is so very "taking," he showed me several most *exquisite* pieces of glass (Cyprian) oh! *such* beauties so dainty so *lovely* in color, one a blue small [?] looks like pottery glorified, he says he is going to keep them until Mr. Havemeyer comes over, if he sends them they may be stolen at the Custom house! He went to Aix [-les-Bains, where Morgan was taking the cure] to see Mr. Morgan, but Mr. M. tells him he don't [sic] see why he (M) should play second fiddle to Mr. Havemeyer, . . .[14]

It is extraordinary to read that J. Pierpont Morgan envied the decorative wares Kelekian sold to Harry, when he himself, during April and May 1906, had spent about $750,000 for works of art in Paris. Harry's purchases were almost meager in comparison to Morgan's prodigious buying habits.

The Havemeyers and Morgan were in Paris at the same time, but it is unlikely that their paths crossed. Before leaving for home, Louisine and Harry acquired yet another Goya portrait from Paul Durand-Ruel (ultimately they would own twelve portraits by Goya) and a Manet pastel, *Portrait of Mlle Lemaire* (Plate 128). In addition, Harry bought two Chinese vases with iridescent green glaze and a Japanese black lacquer writing box from S. Bing.

The Durand-Ruels always served as general bill-paying agents for the Havemeyers while they were in France, who preferred to leave substantial sums with them rather than be constantly bothered with changing money while "en vacance." The day before their departure Joseph Durand-Ruel wrote to Harry at his hotel: "According to your request, I enclose your account with us up to date. It includes, I think, every item, except the bills from the Garage du Bois de Boulogne for the keeping of your auto." The Durand-Ruels also attended to shipping most of the Havemeyer purchases, Kelekian, Bing, and other dealers delivering their acquisitions to the gallery so that they could be sent together.

On May 9, the Havemeyers sailed home on the *Kaiser Wilhelm II,* returning from their extended sojourn in good spirits. Louisine and Harry, as collectors, were now riding the crest of a wave. Meanwhile several of their long-awaited Spanish paintings had arrived and their 1 East 66th Street residence was resplendent with its wide-ranging treasures. Within the coming months they would be celebrating several important family events, and leading the most active social life of their married years. At this moment neither Louisine nor Harry had any premonition of the adversity that the not-too-distant future would bring.

A Change of Style

Not long after the Havemeyers returned from Europe in 1906 the family went to Bayberry Point on Long Island for the summer; on the other side of the Atlantic, Mary Cassatt was diligently keeping up her "lookouts." She relayed to Louisine, apropos a Chardin portrait, that she was finding the task increasingly difficult: "You have grown to love force so much in Art, that I am not sure you would care for this, it is perfection of a sober kind. It is not easy to keep up to the standard you have before your eyes always."[1] Cassatt was more confident that they would like two drawings of dancers by Degas that she had asked Vollard to reserve for them. Louisine and Harry may have been steadily acquiring works from Vollard against the sum that the dealer owed to Harry since Harry's advance of 1901. Mary Cassatt now frequently served as intermediary with Vollard; in 1905 she had selected Courbet's *Portrait of a Man* (Plate 129), because she felt the solidly constructed yet sensitive head would particularly please Harry. During the summer of 1906, she informed her friends that Vollard was sending them "some photos of Cézannes which he says he can get."[2] The dealer was most likely referring, among other works, to two landscapes—one probably *The Banks of the Marne* (Plate 130)—and a floral still life (Plate 131). About this time, Vollard also looked through Cassatt's own earlier works, purchasing a significant number of them.

In September 1906 Harry had to make another trip to Denver, and Louisine and her older sister Annie Munn decided to accompany him. Their first stopover, Detroit, was planned for making a visit to the industrialist Charles Lang Freer. Freer's offer of his collection (predominantly of Whistler's work and art of the Near and Far East) to the Smithsonian Institution had recently been accepted, though difficulties with the institution's regents had been ironed out only thanks to the intervention of President Theodore Roosevelt. Freer had stipulated that he should retain a life interest in the collection and continue to make additions to it, and he also promised both the funds and the plans for erecting a gallery that would bear his name. The news of this munificent gift certainly impressed Louisine and Harry, making them especially anxious to examine Freer's comprehensive holdings of ancient glazed potteries and his Chinese and Japanese paintings and screens.

Left: Charles Freer residence, 33 Ferry Street, Detroit, Michigan, 1892. Architect Wilson Eyre

Right: Skylit gallery, Charles Freer residence, 1911. Photographs courtesy of Freer Archive, Smithsonian Institution, Washington, D.C.

The Boston critic and historian Ernest Fenollosa, who was Freer's then most trusted adviser for Oriental art, wrote to Freer shortly before the guests arrived from New York:

> It will be very interesting to have the Havemeyers with you next week, to see your collection. I think it will make H.O.H.'s few hairs stand up, to see it! It's a charitable thing to keep him in mind that people do exist who know something, beside himself. Should my name be mentioned, I should be glad to have you tell him of my prospective book [*Epochs of Chinese and Japanese Art,* of which he had just completed a rough draft], if you care to.[3]

In 1900 Fenollosa, who had lived in Japan for a decade (1880–90) and then served as curator of Oriental art at Boston's Museum of Fine Arts, had begun to give lectures in various American cities on Japanese and Chinese history, literature, and art, tirelessly trying to stimulate a taste for Far Eastern culture. Having traveled across the country, Fenollosa had decided he would give a series of lectures in New York, and he turned to Freer for advice on making the necessary arrangements. Among those in that first "little New York group who had listened to Fenollosa tell them of Japan's marvelous civilization and of her great actors and actresses,"[4] was Louisine Havemeyer. By 1904, Fenollosa had made New York his base of operations, hoping that he would have better chances there of enlisting wider, more appreciative audiences.

But no disciple could surpass Charles Freer's almost obsessive commitment to the art and culture of the Far East. Initially it had been Whistler (regarded by Fenollosa as "the interpreter of East to West"[5]) who had influenced the sensitive, cultured industrialist from Detroit to acquire Oriental as well as American art. During the 1890s that flamboyant artist had molded the much younger Freer—his chief patron—in his own image to such a degree that the collector's choice of objects often reflected Whistler's taste. By disposition, both men were attracted to the perfectionism and

exquisite refinement of Oriental civilization that provided them with the basis for a life style. Whistler was a confirmed aesthete and a staunch advocate of art for art's sake; Freer, reticent and wary in contrast to his bombastic mentor, yet shared many of his beliefs and attitudes. About 1900, after executing a lucrative merger among thirteen railroad supply companies and subsequently selling his interests for a fortune, the forty-four-year-old Freer had retired from business. For the rest of his life he was free to dedicate himself exclusively to his private world of art and beauty, without the jarring distractions of heavy industry.

Freer's dark shingle-and-stone mansion at 33 Ferry Street had been completed in 1892, the same year the Havemeyers' New York residence was finished. The decoration of his house had prompted Freer, formerly a collector of prints, to widen his horizons significantly. He recruited the services of his artist-friends Dwight Tryon and Thomas Dewing to help him achieve a unified decor, in which no inharmonious element would intrude. For the reception hall, Freer commissioned seven mural-sized muted panels by Tryon, while the small parlor was hung with Dewing's scenes of dimly lit interiors. Freer's absorbing predilection for the delicate, evanescent, and evocative work of Whistler, Tryon, and Dewing, together with the innocent, idealized young women painted by Abbott Thayer, caused Mary Cassatt to remark: "The poor man knows absolutely nothing about pictures."[6]

When the Havemeyers arrived in Detroit on September 24, 1906, they were cordially greeted by their host, who proudly gave them a tour of his residence. His meticulous attention to detail had even extended to the colors of the mansion's exterior walls (purple, blue, and gray, blended with a certain amount of surface rust and stain to soften the effect).[7] Afterward Louisine and Harry were eager to begin their viewing, but Charles Freer had his own method of displaying his treasures:

> The visitors would sit with him on low window seats in a serene, skylit gallery. Nothing cluttered its space: its walls were bare. At a summons, his former coachman Stephen would bring out one or two objects—a Chinese painting and an ancient piece of pottery, a Japanese screen or a Whistler "Nocturne." The guests would give themselves to enjoyment of these for a leisurely stretch before Stephen was bid to replace them with one or two other objects. As the sun set and the light waned on a lovely Kakemono, Stephen served the blend of tea the host had perfected—2/3 of the best Ceylon with 1/6 of the best Japanese and 1/6 orange pekoe. Sometimes there might be champagne or Chateau Yquem, imported monthly with explicit care to vineyard and vintage. Since the host believed that neither Whistler's paintings nor Oriental art could be seen properly in artificial light, the gallery was not used after dinner.[8]

The Havemeyers were overwhelmed by what they saw, and Freer was elated at having such receptive guests, as he reported shortly after their departure to his friend Charles Morse, a fellow collector of Japanese prints:

> I have known the Havemeyers for a number of years, in fact, 15 or more, but not at all well until their late visit. They certainly are most sympathetic and amazingly

interesting. Mrs. Havemeyer's taste is most exquisite, and, of course, her long attention to artistic matters has equipped her more thoroughly for the enjoyment of fine Oriental things than any other lady I have ever known. Mr. Havemeyer is an extraordinary man. No one can be more deeply touched by beauty than he, provided, he is in a mood to enjoy it. He told me that there are times in his life when he cannot disengage himself from most active material things; then there are periods when music seems the only thing in life, and again times when other fine arts are his sole desire. I am glad to say that he was in the latter mood while here and his appreciation and enthusiasm was boundless. . . .

My Ririomins [the Japanese pronunciation of Li Lung-mien, a Northern Sung painter of the late 11th–early 12th centuries; Freer owned sixteen portraits of Buddhist saints by Ririomin], unfortunately, are in New York, being photographed by Fenollosa, and both Mr. and Mrs. Havemeyer are so anxious to see them that I have decided to leave them in the Lincoln Warehouse until about the middle of October, when the Havemeyers will be back from Denver. Stephen is to go to New York about that time to bring home the pictures and to have a vacation of some days, and it has been arranged for Stephen to take the Ririomins to the Havemeyer house for a little exhibition and the Havemeyers have kindly volunteered to show Stephen their collection. Isn't this a fine arrangement?[9]

Still glowing with satisfaction, Freer, on the same day, also gave an account to Fenollosa:

Naturally, I showed only the cream of the collection, which included all of the better screens and Kakemono and about 25 per cent of the potteries. The few pieces of lacquer and bronze were also shown, and a few of the Whistlers. They were certainly tremendously impressed by the finer Japanese and Chinese paintings, and frankly said that they had never before seen so many things of Oriental production for which they cared so much. The Koyetsu screens and the early Buddhistic and Chinese paintings really staggered Mr. Havemeyer. . . . Mrs. Havemeyer spoke most kindly of you and frankly acknowledged her indebtedness for the knowledge she had obtained from your visits and lectures.[10]

Harry Havemeyer had revealed a deeply personal aspect of his nature to Charles Freer, a part of himself that was usually hidden from others, with the exception of his family and Mary Cassatt. Sensing a kinship of artistic sensibilities, the imposing, impetuous Havemeyer and the fastidious, temperate Freer let down their guards and opened up their collectors' souls. What the two men experienced was best expressed by Louisine, when many years later she wrote about Freer:

I wonder if the public can ever know the joy of being really intimate with a masterpiece! There is an exhilaration, an inspiration about being able to touch it, to examine it, to turn it to one side and then to the other, to put it in this light and then in that, looking for new beauties, talking it over with some one who

"knows." It is the best way to learn its merits, the surest education, and would make collectors of us all![11]

Neither the "Sugar King" nor the former industrialist had amassed art for the reasons of many self-made tycoons: status, social aspiration, or investment. Although their tastes in Western painting were diametrically opposed (except for Whistler), the two collectors reached a common ground in the area of Oriental art, a shared appreciation that was rare. Both men had a deep-rooted love and respect for skilled craftsmanship, mastery of execution, and integrated form and decoration; they also had a capacity to respond to color and texture. Surface nuance—the infinite range of tones—was Freer's overriding concern, whereas aesthetic unity—a work's total harmony and proportion—was more important to Harry. They each found spiritual nourishment and mental stimulation from the endless discoveries to be made within a single Oriental object or painting; every viewing yielded a different reward to a discerning eye and an inquisitive mind. The introspective, transcendental nature of Eastern art offered Havemeyer a refuge from his highly charged business activities; for Freer, who no longer had to contend with feverish pressures, it provided the confirmation of his chosen values and established way of living.

After a very intense but extremely gratifying three days with Charles Freer, the Havemeyers left Detroit for Denver by way of Chicago, where they stopped to visit the Art Institute. Subsequently Louisine reported to Mary Cassatt, who responded in her characteristically opinionated fashion:

> Your letter from Colorado Springs is here, I read it with so much interest. I was sure you would like the Greco [*The Assumption of the Virgin*], did not we work hard to get it to America? It never would have got there had it not been for Mr. Havemeyer. Durand-Ruel has just sent me word that the sale is definite and he has received his first installment of the price. It is a pity it is not better placed, a red brick wall sounds horrid. I wish I could have seen Mr. Freer's screens, he isn't an eagle and his associates in the Art world are enough for me.[12]

Before closing her letter, Cassatt again returned to the subject of Charles Freer, of whom she was a consistent critic: "No Mr. Freer is not 'très fort' I am sorry he gives his screens to a Museum, I hate to think of their being behind glass cases, it is a mistake."

But for the Havemeyers, their visit to Detroit had made a lasting impression, and may even have been partially responsible for bringing about a significant occurrence the following year, as Fenollosa informed Freer:

> Most interesting of all, Mr. and Mrs. Havemeyer have entirely changed their policy of keeping their Oriental treasures shut away from the public, and have had two afternoons of exhibiting to friends, at both of which I have been present, and [been] urged to explain [word missing] meanings. Moreover Mrs. Havemeyer has told me that I may photograph for lantern slides anything in her collection! This liberality is doubtless due to your notable example, for which I owe you endless thanks.[13]

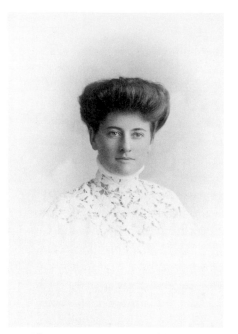

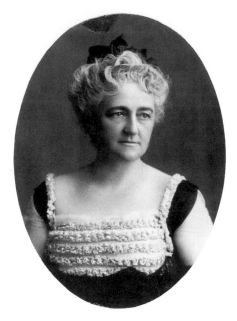

Electra Havemeyer, age 18 (?), c. 1906.
Photograph courtesy of J. Watson Webb, Jr.

Louisine Havemeyer, mother of a bride-to-be
and a debutante, 1906. Photograph courtesy of
Mrs. Laurance B. Rand

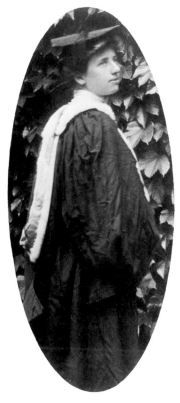

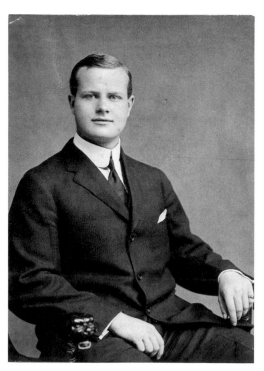

Adaline Havemeyer as a college graduate,
1905. She received her B.A. from Bryn
Mawr, where she majored in French and
Spanish and was captain of the hockey team.
Photograph courtesy of J. Watson Webb, Jr.

Horace Havemeyer, age 20 (?), c. 1906.
Photograph courtesy of J. Watson Webb, Jr.

It was true that the usually private Havemeyers, beginning in the fall of 1906 and throughout the next year, demonstrated a sudden expansiveness, almost an eagerness, to open their home to a wider range of guests. Their change in attitude was brought about by a variety of reasons, in addition to Charles Freer's positive influence. Louisine and Harry had taken a vow upon their marriage, that because of Harry's divorce, they would shun society before society could shun them; but circumstances had changed since 1883 —their wealth, their family, and their collection.

During the past twenty-three years the Havemeyer fortune had tremendously increased. Under Harry's leadership the American Sugar Refining Company had grown and prospered; in 1906 it was manufacturing over 50 percent of the sugar consumed in the United States. According to one source, "The Sugar Trust continued so absolutely secure in its monopoly that it was easily able to crush all competitors, dictate tariff schedules, and extort, in the course of trade, an annual profit placed by some authorities at $55,000,000 a year. . . ."[14] Harry enjoyed the power, prestige, and influence his success had earned in the worlds of finance and business; he now served on the boards of banks and of other companies.

Louisine, despite her husband's very great resources, scrupulously avoided all personal extravagances and capricious indulgences. She never arrived at luncheons wearing blazing jewels worth millions, as Mrs. Jack Gardner had been known to do; although Harry gave his wife beautiful jewelry, she rarely wore any. Louisine had no wish to live like the rich "swells"; she felt that excellence was an achievement not to be obtained through money. To her, the lavish balls, banquets, and other pretentious affairs of New York's glittering society were an expensive waste of time and effort. But in November 1906 Louisine's older daughter Adaline's engagement was announced, her niece Louisine Peters (Plate 132) was getting married, her younger daughter Electra was becoming a debutante, and her son Horace had reached the age of eligible bachelorhood; she knew the moment had come to venture into formal, large-scale entertaining. Louisine brought to this new task her habitual originality and organizational skills.

It seems that Adaline's decision to marry Peter Hood Ballantine Frelinghuysen, a tall, handsome, 1904 Princeton graduate from the dynastic New Jersey family, came as somewhat of a surprise. Louisine did not even notify Mary Cassatt, who only found it out from a newspaper account: "Am I not right in supposing that Adaline's engagement which I saw announced in the 'Herald' this evening [November 8] meets with your approbation? I think from something you said in Paris that it does, and I am so glad. Very best wishes and my love to the Bride, she will I hope be very happy in the new state." Yet in the same letter, Cassatt again referred to the announcement: "I do wonder just how you are feeling about Adaline."[15]

Probably Louisine's reaction was one of mixed emotions, happiness and relief combined with a tinge of regret. Her elder daughter had always been her most difficult, complex child. Whereas Harry doted on the beautiful and spirited Electra, and Louisine adored their only son Horace, Adaline was to some degree left out, or at least she felt that she was. Her mother, determined to demonstrate the abilities of "modern" women, had pushed her first-born from an early age; Adaline had been given art lessons, music lessons, and other extra courses. A firm believer in the value of female education as a

weapon against male domination, Louisine had insisted that her daughter attend college, and Cassatt had reinforced her friend's decision: "I trust Adaline has news of the success of her examinations [for college entrance], what a trial for a nervous young girl. No doubt you are right and college will benefit her, it will give her more serious interest in life than mere amusement."[16] And so, at the age of seventeen, a reluctant Adaline had been sent off to Bryn Mawr.

As a collegian, Adaline distinguished herself by her athletic prowess, according to a contemporary newspaper: "Miss Adaline Havemeyer is the champion hockey player of Bryn Mawr. . . . She led the 1905 team to victory against the sophomores. Miss Havemeyer is one of the best athletes in Bryn Mawr. She is an excellent horsewoman and can play golf and tennis as well as hockey."[17] Still, Adaline felt resentment toward her mother and at times did not come home for vacations. Unfortunately, she also fell in love with a young man of whom her father disapproved; he threatened to disinherit her, and the high-strung young woman was forced to give him up. The year after her college graduation in 1905, when the rest of her family made their extended trip to Egypt, Greece, and Europe, Adaline had refused to go with them. During their absence she saw a great deal of Peter Frelinghuysen, and by the fall of 1906 she had made up her mind to marry him; this time her parents agreed.

Never one to dwell on what could have been, Louisine now took on the duties of the mother of an engaged young woman, which meant presiding over numerous festivities, helping to select her daughter's trousseau, and supervising countless wedding preparations before the chosen date, February 7, 1907. In addition, arrangements had been made for Electra, now eighteen, to be introduced to society, and that called for still more parties and new dresses. Slightly overwhelmed by the magnitude of all these events, Louisine must have voiced some complaints to Mary Cassatt, who sympathized with her friend: "I do feel for you having to go out and entertain against your tastes, but it won't last long I am sure."[18] A week later, Cassatt condemned the evils of an active social life: "The trouble of society is the late hours. I think that dreadful, it uses one up more than anything else. Why are we not sensible, but it is too much to expect."[19] Adaline, however, was enjoying herself immensely; for once she, rather than her parents' art collection, was the center of attention in the family. Mary Cassatt wrote Louisine her own analysis of the young woman:

> I would like to send you Adaline's letter, only I want to keep it myself, you would feel rewarded, you and Mr. Havemeyer for all you are doing for her. Poor dear child, she seems supremely happy. You see she evidently has the power of attracting people, and that implies a sort of necessity to use that power, hence she likes society and feels in her element in it. I am sure you will enjoy seeing her going through this experience.[20]

By December Electra was attending debutante parties every evening, and the "gaieties" for Adaline were in full swing—luncheons, teas, dinners, and dances. Louisine had plenty to occupy her, but she kept up with other interests, as evidenced by a newspaper account:

Mrs. Henry O. Havemeyer and Mrs. Charles Alexander are tremendously keen about the Fortnightly Club, which meets to discuss all the problems of the day. Mrs. Havemeyer, who is the mother of a bride-to-be, and also of a debutante, is very busy at present. But no rush of invitations is allowed to interfere with what she considers her sacred duty, the entertaining of the Fortnightly members.[21]

The one activity Louisine did not pursue was art buying, and Mary Cassatt was sensitive to this turn of events: "With life crowding so on you, Art must go to the wall. . . . Well you have your hands full and no time for pictures."[22] Yet she had been part of the Havemeyers' collecting quests for so long that she could not keep from discussing pictures, even though she knew how occupied Louisine was. She sent Louisine a photograph of Ingres's *The Turkish Bath* (Plate 133) belonging to Prince Amédée de Broglie, whose current financial difficulties, Cassatt thought, might make him willing to sell his painting. Louisine acknowledged receipt of the photo and expressed her opinion, to which Cassatt replied at once:

I was sure you would like the "Bain Turque" of course I have seen the picture that is what made me send you the photo, it is not a large picture, the figures are small, I don't see why you should not own it, I confess I long to have you [own it], it is so rare a thing, and you would have one of the most extraordinary pictures of Ingres. If you could get that and a fine Poussin I think you would have the most unique collection of French Art in existence, you have that now, but this picture and a fine Poussin would finish it as it were. *I* think with you that it is so naively innocent, it remains to be seen what Mr. Havemeyer thinks, I am sure the oriental feeling will appeal to him.[23]

Some two weeks later, on December 18, 1906, Cassatt again importuned Louisine:

What I want to know is what Mr. Havemeyer thought of the Turkish Bath. I feel as if you were flying from me and I were trying my best to catch hold of your skirt and keep you until I could ask you a few questions. I am afraid you won't stop, and I won't have you again until Lent more than two months off, by that time you will need a trip over here to rest you.[24]

Rarely, if ever, had Cassatt been neglected by her closest friend, and she felt isolated and lonely in her country home. These sensations would become even stronger after the death of her brother Alexander on December 28, 1906. It was not until 1911 that Ingres's late masterpiece, *The Turkish Bath,* was acquired by the Louvre.

With the new year, the pace of the Havemeyers' social life became somewhat frenzied. In January 1907 they hosted a cotillion in the downstairs picture gallery (their house had been elaborately decorated with flowers and greenery), then gave a dinner for two hundred guests, followed by another cotillion and supper at Sherry's restaurant on Fifth Avenue at 44th Street. The latter event was commented upon in a newspaper's "Social Notes": "Novelty was lent to Mrs. H. O. Havemeyer's dinner dance last night by the presence of only a very few married people. The guests were in the main the

young friends of Miss Electra Havemeyer, for whom the entertainment was given."[25] Within the month another society column printed the following item: "Mrs. H. O. Havemeyer is giving a series of musicales on Sunday afternoons at her residence, 1 East 66th Street. From 75 to 100 invitations are sent out for each Sunday. This winter the Kneisel Quartet is playing at these chamber recitals."[26]

Indeed, the Havemeyers' entertaining seemed to pick up momentum as it went along. Having spent close to a quarter century in systematically building up their collection in relative privacy, suddenly they wanted more people to see their home and its treasures. And their achievement was so unique and overwhelming that few visitors could fail to be deeply impressed. A tour of the house offered more than an array of masterpieces, it also showed the owners' perception of relationships among paintings of different schools and periods, such as could be found nowhere else.

There had been quite a few changes since the Havemeyers had first moved into their mansion, changes that step by step enhanced the interior and created a better framework for the steadily expanding collection. The rectangular entrance hall decorated with mosaics now had a new feature: a fountain that "splashed but a few drops at a time"[27] into an octagonal basin filled with ferns and orchids from their Connecticut greenhouses. This fountain was probably added in 1903 when the spacious picture gallery was constructed (see downstairs floor plan, page 72). In the small reception room to the left of the mosaic hall, facing on 66th Street, there had been another change: its soft yellow walls covered with old Chinese satin were now hung exclusively with Goya portraits. Actually no room, hallway, alcove, or other space (including storerooms) had not received its share of additional or rehung works of art during the past fourteen years.[28] In Harry's library or "Rembrandt room," for instance, several of the Dutch genre and landscape paintings had been gradually replaced by such pictures as Holbein's *Portrait of Jean de Carondelet*,[29] Bronzino's *Portrait of a Young Man*, a sixteenth-century Flemish *Lady with Lap Dog*, and a man's portrait by Antonello da Messina. Embellishing the cream-colored enamel-like wall (formerly covered with a patterned fabric) alongside the central marble staircase were now canvases by Courbet, Manet, Monet, and other moderns. Even the breakfast room had not been overlooked; in a glass-fronted cabinet were relatively recent acquisitions, such as two twelfth-dynasty Egyptian stone sculptures; another cabinet was filled with Japanese lacquers. In the dim light of the first floor of the house, some of these treasures were difficult to see.

The ground floor was hung predominantly with larger, more formal paintings; in the private rooms on the second floor were the smaller, more intimate works, especially the favorites of the family members (see second floor plan, page 72). The children's bedrooms contained numerous pictures by Degas, and others by Corot, Courbet, Cassatt, and Cézanne. In the master suite, Louisine and Harry's bedroom with adjacent sitting room, hung Corot's *Bacchante by the Sea* (see Plate 78) and his *Bacchante in a Landscape* (Plate 134), Manet's *Masked Ball at the Opera* (see Plate 44), and canvases by Courbet, Degas, and Cassatt, together with a seventeenth-century Dutch genre painting. The passage linking their bedroom and sitting room was lined with several pale shimmering Monets: a misty riverscape, ice floes, and haystacks in the snow. For Harry, Monet's glistening, totally atmospheric works showed an inner sensibility and a transcendental vision that was Oriental, akin to Chinese painting.

The north wall of the second-story landing was covered with paintings that hung one above the other up to the third floor, connected by the gilded "flying" staircase. Among the "acres" of pictures near this suspended structure, Puvis de Chavannes's large *Allegory of the Sorbonne* had now been joined by Manet's *Boating* (see Plate 60). The translucent skylight on the top floor permitted the paintings and decorative wares in the upstairs gallery to be better lighted than those on the main floor (except for the ones in the newly constructed picture gallery). In 1907 there was no other house in America offering such a combination of extraordinary works; it was then the *only* place to see numerous examples by Goya and Cézanne.

The whirlwind of Havemeyer festivities culminated in Adaline's marriage on February 7, 1907, at St. Thomas's Church on Madison Avenue, followed by a reception at 1 East 66th Street, where 350 wedding presents were on display. Louisine was radiant in a Worth gown of burgundy cut velvet trimmed with old lace falling from the sleeves and around the neckline; her special gift to Adaline was a diamond tiara. The newlyweds sailed for Europe on February 26 for a honeymoon of several months.

Louisine and Harry had planned to go away at the same time, yet Mary Cassatt informed her niece Minnie on February 26: "I expected to join the Havemeyers in Spain in March but Mr. Havemeyer is too busy repulsing the attacks on the Sugar Trust to leave home and if they do come, it will be later and for a very short visit."[30] The Havemeyers had been flying high, but soon after Adaline's wedding, they were brought abruptly down to earth. A $30,000,000 suit, filed by the Pennsylvania Sugar Refining Company against the American Sugar Refining Company for restraint of trade under the Sherman Antitrust Act, reflected the trust-busting climate of Theodore Roosevelt's presidency.

The antitrust law, enacted in 1890, had remained dormant during the previous administration of President McKinley, and domestic politics had reflected the interests of big business. But McKinley was assassinated in September 1901; his successor, the former vice president Theodore Roosevelt, began to wield what would be called his "Big Stick" policy against giant industrial combines. His first important target had been the Northern Securities Company, a holding company of large northwestern railroads; among the powers behind it were J. Pierpont Morgan, James H. Hill, and Edward H. Harriman. A Federal court had found the Northern Securities Company in violation of the Sherman Antitrust Act and ordered its dissolution, a decision upheld by the Supreme Court in 1904. The public admired this demonstration of the government's right to control powerful companies; Roosevelt realized that vigorous action against "the predatory rich" and their business interests could win him the support of middle-class America.

Roosevelt's crusade against the trusts lagged during 1904, when the Republican campaign chest needed contributions from big business for his reelection. In his second term, however, the president accelerated his trust-busting program. It reached a crescendo in 1906 with legal actions taken against the Standard Oil Company and the American Tobacco Company, among others; in all, twenty-five antitrust suits would be instigated under Roosevelt. The litigation against these corporations lasted for years; even when verdicts favorable to the government were eventually rendered, the results were rarely drastic, but meanwhile the public had the satisfaction of thinking that

wrongdoing in big business was being addressed. Roosevelt's policy, together with exposés by the writers and journalists he termed "muckrakers," succeeded in alerting the country to numerous social injustices, especially the abuses of huge trusts.

Harry Havemeyer had become used to being in the public eye. With unwavering determination and the help of expert counsel, he had survived and even emerged victorious from numerous legal battles over the years. Thus in March 1907 he was angered at having to face charges from the Pennsylvania Sugar Refining Company that his company had been part of a successful conspiracy to gain control of this major competitor. The Department of Justice and the president himself shared Harry's opinion that the matter was not worth dealing with; the *New York Times* reported on March 25: "The Administration is too busy hunting the bad railroads just at present to bother itself with the alleged misdeeds of that hoary old sinner the Sugar Trust."[31] But the plaintiff for the Pennsylvania concern persisted and Harry was forced to engage a notable array of counsel, headed again by John G. Johnson, for the forthcoming trial in the federal district court in Philadelphia.

These events took up several months; Paul Durand-Ruel, as well as Mary Cassatt, had meanwhile been waiting patiently for the end of the Havemeyers' nuptial festivities before recommencing their discussions of art matters. In his first post-wedding communication of February 19, 1907, Durand-Ruel strongly recommended five pictures (by Daumier, Manet, Renoir, Degas, and Cézanne) that would soon go on the auction block in the sale of the Parisian dentist-collector George Viau, from whom the Havemeyers had purchased a Degas pastel many years before. Though familiar with these remarkable works, Louisine and Harry did not heed Durand-Ruel's advice. On March 19, Joseph Durand-Ruel wrote Harry about a Courbet painting that his father had just seen in Brussels, comparing it in quality to the artist's *Landscape with Deer* (see Plate 14), the picture Harry had so regretted losing to the Louvre at the Secrétan sale of 1889. Interestingly enough, Harry must have asked again about the Manets from the Faure collection, because Joseph's letter gave a full report on the pictures that had been sold and those still available. But since the Havemeyers were going to France and Italy in April, they preferred to wait until then to make any purchases.

This trip, though hasty, yielded significant acquisitions and also brought about reunions with Mary Cassatt and with the newlywed couple. In Italy they secured a pair of paintings by Poussin (Plate 135; now attributed to him). From Durand-Ruel the Havemeyers bought no fewer than four Courbet paintings: two landscapes, a still life, and a woman's portrait; two works by Degas, one of which may have been his pastel *Dancers at the Bar* (Plate 136); and a Cézanne still life, referred to as *Fruits*. With the purchase of this picture, they now owned thirteen works by Cézanne.

Before sailing for home, the Havemeyers and Mary Cassatt, together with Théodore Duret, seem to have made a one-day trip to Brussels in "grande vitesse"[32] to inspect Courbet's portrait of Madame de Brayer, a Polish exile who had married a Belgian. Louisine was again treated to the kind of picture-hunting excursion she so relished; she listened attentively while Duret and Cassatt discussed various topics in art and French history. As the conversation flowed around him, Harry would occasionally interject a remark to suggest yet another side of whatever question was being heatedly debated.

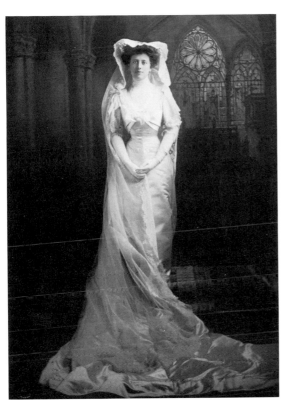

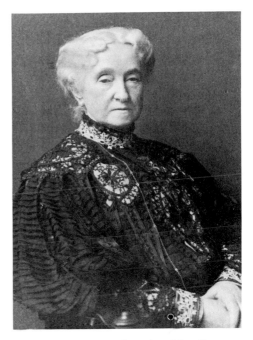

Adaline Havemeyer Frelinghuysen, married on February 7,
1907, at St. Thomas's Church, New York. Photograph
courtesy of J. Watson Webb, Jr.

Louisine Havemeyer's mother, Mrs. George
W. Elder, in her later years. Photograph
courtesy of J. Watson Webb, Jr.

Harry Havemeyer on his property at Commack, near Huntington, Long Island,
November 1907. Photograph courtesy of J. Watson Webb, Jr.

This quick journey resulted in the Havemeyers' acquiring *Madame de Brayer* (Plate 137), the portrait Duret thought was Courbet's finest, although Cassatt reserved that opinion for the artist's *A Lady in a Riding Habit* (see Plate 127), purchased by Louisine and Harry the previous year.

Upon their return, Harry was faced with a strike at the Havemeyers and Elder refinery in Brooklyn. The 2,000 foreign-born laborers had been receiving 15 cents an hour and were demanding a 3-cent raise to 18 cents, but they quickly accepted a compromise of 1½ cents when the general manager threatened to close down the plant. What worried the "Sugar King" much more than the week-long strike was the investigation, several months later, by the federal district attorney into his company's method of weighing raw sugar on the docks for determining customs duties. This would lead to charging the American Sugar Refining Company with systematic fraud since 1901 for manipulating the weight of sugar, and thereby reducing the duty on every cargo; documentary evidence of this practice was obtained on November 20, 1907, by a special agent of the Treasury Department, who raided the Brooklyn docks of the refinery where raw sugar was being unloaded from steamships and weighed for the assessment of duty. He found that company employees had covertly inserted steel springs into holes in the beams of seventeen wooden platform scales, causing them to register lighter weights. These springs—easily removed—could decrease the weight of 1,000 pounds of raw sugar by five to twenty-five pounds. Harry was gravely concerned. Mary Cassatt commented on this problem in a letter to Paul Durand-Ruel:

> I have sad news about what is going on in New York and even more or less all over America concerning the affairs of the Sugar Trust. It is very hard for my poor friend and the children. I hope that all this will blow over and that it can be proved that he didn't know anything about it. What a struggle life is over there.*

In addition to these troubles, the country's booming economy suddenly experienced a severe crisis. In October 1907 numerous banks were threatened with failure; many were the suicides of investors ruined overnight. Financial collapse and a stock market catastrophe were narrowly averted through the intervention of J. Pierpont Morgan. The gloomy mood pervading Wall Street at this time seemed to be reflected in the Havemeyers' house: Louisine's mother became so ill that she lost her will to live, and a difficult pregnancy forced Adaline to spend months in bed at 1 East 66th Street. Between visiting her sick mother and caring for her daughter, Louisine had her hands full. She was also greatly worried about her husband.

Toward the end of November, Harry decided to go to Commack, Long Island, where he owned 300 wooded acres, purchased a number of years before. "Merrivale," with its small stone lodge, had become his favorite place for rest and seclusion and for hunting game birds. There he raised and shot pheasants in season (some of which Mary Cassatt received as her annual Christmas gift); he also had a stable for trotting horses on the property. This time Horace went with his father to "Merrivale" for a shoot. Without warning Harry was stricken with severe abdominal pains. When the local doctor could not help, Horace called his mother, who immediately brought out the family's New York physician and surgeon. Even they could not alleviate the patient's

agony, and diagnosed the case as hopeless. On December 4, 1907, at 3 o'clock in the afternoon, Henry O. Havemeyer died; he was sixty years old. At his bedside were his wife, his son Horace, and his daughters Electra and Adaline, the latter with her husband Peter. An autopsy revealed the cause of death as acute nephritis (kidney failure) with uremia. Two days later Louisine's mother passed away.

FIFTEEN

Sorrows

In her hour of deepest grief, Louisine received a cable from Mary Cassatt: "I too mourn a friend."[1] The artist was sadly affected by the tragic event, as she wrote to her niece Minnie on December 14, 1907:

I feel very badly at not having written to you before but the sudden death of Mr. Havemeyer has been a dreadful shock, and I seem to have no thoughts since then but to cable and write to his heartbroken wife and children. Mrs. Havemeyer lost her Mother on the day of her husband's funeral. She had been dreading her Mother's end, but little thought her husband would be the first to go, she must be so stunned by that blow that she can hardly feel the other as she would have done if it had come first, still the double loss will be a great grief.

I lose in Mr. Havemeyer a friend and am sincerely grieved, but of course my feeling I have is swallowed up in sympathy for her. . . . The suicides one sees in the papers are appalling, and no doubt these troubles hastened Mr. Havemeyer's death.[2]

Not long afterward she expressed her profound feelings in a letter to Electra; there was no more touching tribute to Harry Havemeyer than Mary Cassatt's words:

Dearest Electra
All day I have been thinking of you these first holidays, after such a loss, as yours, are hard to live through. You were such a darling of your Father's, his youngest, how you must miss him; you are so young and were so gay, to be so dreadfully and so suddenly bereaved. I do feel for you so deeply. I think constantly of your Father and of your Mother, of our travels together, he was always kind and thoughtful and good humored, it was a pleasure to be with them both; you must have so many pleasant memories of your journeys with him, memories you will cherish through life, and all your home life when he was with you, oh! it is much to have had such a Father to love you. Now, in these first days one is only tortured by the feeling of loss, but later you will find comfort in every thought of him. Your

dear Mother, it was like her to send me a cable today, I was anxious about her and about Adaline, it is good to know you are all well. If only I were near your Mother as soon as I can cross with a reasonable prospect of not being ill, I will go to her. She has you near her and you must be such a help to her and to poor dear Horace. You must all of you, all the cousins too be sad over your dear Grandmother's loss, such a breaking of family ties, two deaths together.

May this coming year bring comfort to all your sore hearts. My love dearest Electra to you and your dear dear Mother and Horace.

<div style="text-align: right">

Always your affectionate friend
Mary Cassatt[3]

</div>

But the new year of 1908 did not bring relief to the suffering Havemeyer family. Adaline Frelinghuysen gave birth to twin girls, Louisine's first grandchildren, who both died within a few days. There seemed to be no end to Louisine's miseries. Shortly before his death Harry had told his youngest child, "Boss, take care of your mother," and now the twenty-year-old Electra, having inherited her father's strength and determination, did exactly that. Applying his philosophy of carrying on in a crisis, she devoted herself to her mother and assumed many of the latter's duties and responsibilities. It was Electra who had the sad task of writing a detailed account of the loss of Adaline's babies to Mary Cassatt. And it was also she who decided that a change of scenery might help her mother, making hasty arrangements for a trip to Europe. Mary Cassatt eagerly awaited their arrival, as she informed her niece on March 5:

> I was going over to poor Mrs. Havemeyer but she is coming here. It is only the unexpected that happens; I am looking forward to meeting Mrs. Havemeyer and Electra and Mrs. Munn [Louisine's older sister] on Tuesday. They are on the Kaiser W. it will be dreadfully sad. Last April I went to meet them, and Mr. Havemeyer was there too and no happier woman than Mrs. Havemeyer, had I ever known, now she is so sad and broken, it is for her health they are coming. . . .[4]

The trip was not very successful, and by May, Louisine and Electra were back in New York. Mary Cassatt's accumulated losses of her own family members had intensified her interest in spiritualism, a movement that had the support of so respected a scholar as the philosopher-psychologist William James of Harvard. Cassatt regularly attended séances, believing firmly in the power of psychic mediums to communicate with the dead. She found comfort and exhilaration in sessions that transported her into a mysterious realm where she felt herself in contact with universal forces. Cassatt decided to try to recruit Louisine into spiritualism and began with Electra, attempting to persuade the young woman of the scientific soundness of psychic research. Cassatt was convinced that Louisine would find consolation in consulting a medium, as she wrote to her bereaved friend in June 1908: "Yes I certainly think those who have gone before can see our joys and sorrows, I go beyond I think they can help us."[5]

In the fall of 1908, Mary Cassatt resolved that she would "screw up her courage" and make another transatlantic journey to be with Louisine on the first anniversary of Harry's death. She booked passage for November. Before her departure Cassatt had a

great many things to do. Durand-Ruel was organizing a retrospective of her work in Paris for November. Among other requests, Joseph Durand-Ruel asked the artist for a list of her pictures owned by *amateurs* that she wished to borrow for this show. On her list were Degas, Vollard, and the collector Rouart; Cassatt herself was supplying five paintings.

In addition to her own concerns, Cassatt remained deeply involved with those of her friends. The Cassatt–Havemeyer correspondence during this period was primarily letters between the artist and Electra. It seems that the young woman wanted to acquire a large Goya painting that she had seen in Paris, but Cassatt informed Electra on October 15 that she was relieved the purchase had not taken place:

> Now that I know what you wanted the large Goya for I think it is just as well you did not buy it. My idea is that it is too soon to give Anything in memory of your Father, your Mother is not yet able to judge with calmness what is best to be done, and it is not the time therefore for you three children to buy such a picture to add to what she gives. After all you all partake in the gift she will make, let her reflect on that and when she has made up her mind and given something you will always be able to add to it if you wish later. My own feeling is that loan exhibitions such as they have in England do quite as much good, and until the Directors of the Metropolitan show more judgment and taste it is better not to *give*. [6]

In the same letter Cassatt—constantly preoccupied with Louisine's health—urged Electra to plan another European trip for 1909: "She [Louisine] has never been in Tunis and only a day in Algiers, it might interest her to see new places. I do so feel for her, and of course I know it is too soon for her to be cheerful, just think her whole life's occupation almost has been torn from her, she must have time to adapt herself to new conditions."

But Louisine still had one important occupation, that of attending to her collection, and she asked the Durand-Ruel gallery to recommend someone she could employ from time to time to hang pictures. Her sudden widowhood seems to have brought Louisine's innate frugality to the surface, although she had been left more than well provided for. She felt compelled to sell certain pictures in order to be able to buy a painting of Saint Martin by El Greco. On November 30, 1908, Joseph Durand-Ruel, who was now in the New York gallery, acknowledged receipt of nine works Louisine had decided to dispose of. In addition to earlier Dutch, French, Italian, and Spanish pictures, there were two canvases by Monet and one by Decamps, the latter with an asking price of $11,000, the highest in the group. Had she sold all nine at her prices, Louisine would have obtained a little over $40,000. As it happened, only two pictures from this group were actually sold. The gallery would buy back for $5,000 Monet's *London, Houses of Parliament* (Plate 138), purchased by Harry the year before he died, and eventually one other picture was sold in Italy. Following Joseph's advice, Louisine now consigned Decamps's *The Oak Tree and the Reed,* a canvas by Cazin, and a Renoir pastel (see Plate 19); these three works were acquired by the Durand-Ruels, who paid $500 for the Renoir. All told, Louisine received $17,500.

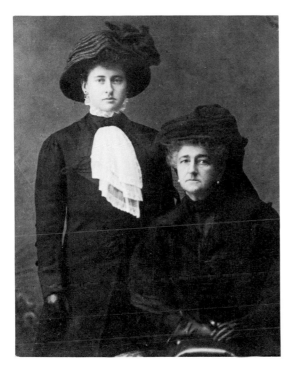

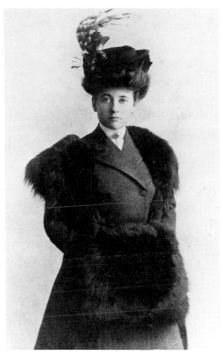

Left: Electra Havemeyer and Louisine Havemeyer in deep mourning, December 1907

Right: Electra Havemeyer in mourning, 1908. After her father died Electra had one of his cuff links made into a pin, which she wore on her collar. Photographs courtesy of J. Watson Webb, Jr.

Electra Havemeyer, left, and Louisine Havemeyer on their trip abroad in 1909, probably in Tunis, North Africa. Photograph courtesy of J. Watson Webb, Jr.

Mary Cassatt managed to arrive in New York to console her friend on the sad date (December 4) of Harry's death, but the sixty-four-year-old artist was still a poor sailor and had to be carried off the boat. She was forced to recuperate in bed at 1 East 66th Street for some time. Once recovered, Cassatt enjoyed her stay at the Havemeyer residence, where she invited some of her relatives to come and see the pictures. Louisine later described an overnight visit she and Cassatt made to "Hill-Stead," the Connecticut home of their mutual friends, the Popes:

> It was a notable gathering and all interested in things psychic and supernormal. After dinner we gathered about the open fire for coffee and cigars. My host sat beside me, and had a cigar, the longest I had ever seen; it seemed long enough to last until morning. Knowing what might happen if Miss Cassatt was once lured into the conversation, I quietly resolved that I would recommend breaking up when that cigar showed signs of waning. Well it was not long before the subject of spiritualism was broached, the ball began to roll, and shortly we were all listening to Miss Cassatt, who was soon holding her audience, including me, who forgot the watchtower, until I looked at my host to find he was shaking the ashes from the very end of his cigar and about to put it out, "Oh," I gasped, "Have you finished your cigar already?" "This is my second one," he said quietly. What time can it be I thought and almost as I said it the old timepiece on the stairway tolled out two. I jumped up and my only thanks for giving the company a chance to get a few hours sleep that night were looks of disappointment and readiness to continue under the spell of Miss Cassatt's conversation.[7]

Cassatt spent the Christmas holidays at her brother Gardner's home in Philadelphia and also went to his recently acquired country estate at nearby Berwyn. Shortly after the new year Mary Cassatt returned to France; she would never again cross the Atlantic.

With the departure of her friend, Louisine's precarious mental health took a turn for the worse. Absolutely certain that spiritualism and faith-healing were the only recourse, Cassatt urged Electra to have her mother continue her treatments with a faith healer in Cambridge, Massachusetts; she suggested that Louisine go to Cambridge and stay there for a week in order to have daily sessions of the "mind cure." Meanwhile Mary Cassatt herself was making travel arrangements for Louisine and Electra's forthcoming trip abroad. Electra had begun to take Spanish lessons in anticipation of her visit and Cassatt, who planned to accompany them to Spain, also vowed to study the language.

A significant cause of the decline of Louisine's delicate health was the relentless press coverage of the affairs of the American Sugar Refining Company. The trial of the Sugar Trust in the federal court had begun in New York in 1908, the government claiming that the company, by tampering with the scales, had in recent years evaded paying duty on about 41,000 tons of sugar, and the federal authorities were suing to impose heavy penalties. The long trial was reported regularly in detailed articles, not to mention occasional scathing editorials. And at the same time, the Pennsylvania Sugar Refining Company's on-again off-again suit under the Sherman Antitrust Act, to recover

$30,000,000, triple damages for the closing of its Philadelphia refinery, was going on in federal court in Philadelphia. Accounts of this suit alternated with the government's case against the American Sugar Refining Company; members of the Havemeyer family could rarely read a newspaper that did not contain a reference to one suit or the other.

Against some decisions of fate there is no appeal. Louisine learned to accept bravely her sudden widowhood and to live with it. But other, less inexorable calamities may for that very reason have been more difficult to face; doubtless the sensational exploitation of the Sugar Trust scandal, following so soon on Harry's death, was one of these. Louisine had been in no way involved in the misdeeds of the trust, and could not herself take up its defense. While there was a battery of lawyers to fight for the trust, it did seem as though Louisine and her family were the principal victims of the deplorable affair. To be exposed almost daily to newspaper reports of actions against the Sugar Trust undermined Louisine's health and her mental resiliency. She suffered immeasurably from these attempts to defile her late husband's name. Horace and Electra decided that their mother's health made it imperative that she leave the country to escape the barrage of unfavorable publicity, and in February 1909 Electra and Louisine sailed for Brussels, their first stop in Europe. Louisine was so distraught that during the crossing she tried to throw herself overboard; she was saved only by Electra's intervention.

Whereas Electra devoted herself to caring for Louisine, Horace took on the enormous burden of Harry's business interests; as the sole male executor of his father's estate, he also administered a number of family trust funds. Harry, despite the acute pain of his last days, had counseled his son as to directing his life; the sight of his father's great courage in the face of death profoundly impressed the twenty-one-year-old Horace. Shortly afterward he became a director of the American Sugar Refining Company and assumed the presidency of the firm of Havemeyers and Elder, positions for which he had several years' preparation.

For Horace, although he had passed the entrance examinations for Harvard at age seventeen, had gone to work for his father instead, carrying on a Havemeyer tradition by learning the sugar business from the ground up. Like his father, Horace began his apprenticeship at the family refinery in Brooklyn, and spent a year and a half gaining experience in all aspects of sugar manufacturing. Later, he worked his way through the departments of the Sugar Trust's New York office at 117 Wall Street, where he demonstrated an astute and analytical grasp of the firm's financial structure as well as considerable executive ability. In 1905, having been appointed sales manager for all the offices of the American Sugar Refining Company at nineteen years of age, Horace concentrated on increasing corporation sales. But Harry's unexpected death put his young son's business acumen to a real test; suddenly Horace had much more to contend with than selling sugar.

The hostile press coverage of the Sugar Trust trials did not affect only Louisine; Horace too faced the onslaught with stoic resolution, turning his pain inward. He kept in mind his father's axiom, "It doesn't matter in life how you get knocked down, it only matters how you get up again." He was anxious to terminate the trials, whatever the judgments, in order to return to a semblance of a normal existence. Thus Horace was relieved when the verdicts finally came in, thinking that his company's substantial restitution would end this persecution. In April 1909, the government won its suit: the

American Sugar Refining Company was penalized over $2,000,000. Yet the Department of Justice, in accepting this settlement, reserved the right to a criminal prosecution of the individuals (some of them chief employees of the Sugar Trust) charged with initiating specific frauds. This decision dashed Horace's hopes for a clean slate.

In June, immediately after the Sugar Trust's first large payment to the government, the suit brought by the Pennsylvania Sugar Refining Company was settled out of court, the American Sugar Refining Company agreeing to the following conditions: payment of $2,000,000 in cash, cancellation of a loan of $1,250,000, and return of $7,000,000 worth of securities held as collateral. These combined payments were among the largest ever awarded in litigation in the federal courts.

The government's Sugar Trust trial had disclosed a network of corruption that extended from high-ranking politicians and Customs House officials to the customs weighers and the dock workers on the pier. As a result, the government decided to do away with the customs weighers and to substitute electric machines that would automatically register the weight of imported goods. Sugar was not the only commodity imported under fraudulent conditions; the press periodically uncovered similar cases in other importations. Shortchanging the government was a popular activity among those who thought they could succeed in it.

The two lawsuits were settled while Louisine and Electra were abroad. Horace had done his share to end a festering situation and when his mother returned she would no longer have to fear a constant barrage of adverse publicity. Indeed Louisine had been severely ill upon her arrival in Brussels in February 1909; Mary Cassatt used the words "nervous breakdown" to describe Louisine's condition and wrote to her in Belgium to encourage her recovery: "Now dearest Louie go on with your good fight we all are trying to help you, all we can and you will get on board the 29th [Louisine was sailing to Sicily with a stopover in Tunis] once more yourself. Such is the prayer of your old friend."[8] Trying to give Louisine something meaningful to look forward to, Cassatt added: "Ah! My dear you have that before you to see the children develop on the lines their Father would have wished, what a comfort is there. I too feel it, have a glow of satisfaction to think his love of all things beautiful continues in them."

Electra certainly had inherited her parents' taste for collecting, and it would grow to staggering proportions over the years. During her travels she corresponded frequently with James Watson Webb, her number-one suitor, to whom she openly expressed her innermost thoughts:

> I would like to be so rich that I could buy any works of Art I wanted. I know you don't approve of my views but nothing to me is more fascinating than to feel that one really was a remarkable person. How anyone can like Jewels when they can buy pictures. You must learn to care for Art.[9]

While in Italy, Electra became interested in acquiring a portrait of a child by Goya. Durand-Ruel's agent in Madrid, Ricardo de Madrazo, had sent her a photograph that she forwarded to Mary Cassatt, who liked the work but cautioned Electra about making an offer, strongly recommending that Paul Durand-Ruel should handle the negotiations:

"Let the old gentleman do the buying for you. Many times has your Father said to me —'I have always found the old man straight,' so let him do the bargaining." She went on to reassure the novice collector: "I do think you do very right to begin on a fine Goya and especially a rare one as a child's portrait."[10] Electra followed this advice and Durand-Ruel, together with De Madrazo, succeeded in securing for her Goya's portrait of a little girl dressed in white (Plate 139), about which she wrote to Watson Webb:

> I spent a very large sum for a fine picture by Goya (I don't know if you know the painter) and I dread to think what you would say. It is a portrait of a small girl of six, too cunning and sweet but really very fine. I am so pleased to feel that I am starting a collection as [that is] certainly what I intend doing with Father's money.[11]

Changing her original plan, Mary Cassatt decided not to go to Spain with Louisine and Electra, who were now traveling by car from Florence across the mountains to Nice, and then to Pau; from there they planned to go on into Spain. During their journey letters flowed back and forth between Electra and Mary Cassatt, who was forced to pass on some disappointing news: El Greco's painting *Saint Martin and the Beggar* (National Gallery of Art, Washington, D.C.), a work Louisine particularly coveted, was suddenly promised to another American collector, the streetcar magnate Peter A. B. Widener (1834–1915) of Philadelphia. Louisine was extremely anxious to obtain this picture because it had been among the last ones that she and her husband had considered together. Cassatt, still in the middle of complex negotiations on her friend's behalf, was crushed when they unexpectedly lost the work, as she informed Electra:

> I am so sorry for your disappointment and for Horace for this morning he wrote to say or rather I received a letter from him saying that he hopes your Mother secures the Greco. "Don't let her leave without it if it can be purchased at anything like a reasonable price. Mother is inclined to try and buy a thing too cheap." Of course one wants to get things at the lowest; but your Mother has never had much experience about the money part. . . . The only thing for you to do is *to go by all means to Illescas* and see the Saint Ildefonso. Everyone who has seen it pronounces it *superior* to the St. Martin. Durand-Ruel says it can be bought.[12]

Arriving in Madrid after first visiting Seville, which Electra did not find to her taste, Louisine and her daughter took a dusty motor ride to the nearby town of Illescas to look at El Greco's *Saint Ildefonso,* as Cassatt had suggested. Although the picture more than consoled Louisine for her loss of the other El Greco, she later recounted the outcome of her quest: "At one moment it seemed as if it [*Saint Ildefonso*] would come to our collection, but the usual collusions and combinations started and I was obliged to relinquish the idea."[13]

Louisine's health was steadily improving, as Cassatt remarked to Electra on April 2: "The longer you stay over here the better for your Mother, it is just the best thing in the world for her to travel."[14] Electra confirmed Louisine's progress in a letter to Watson Webb: "Mother really is so much better that you wouldn't know her."[15] As

Louisine began to feel more like herself, her eagerness for collecting was rekindled. Through the efforts of De Madrazo, who showed her almost every great Goya in Madrid, she at last acquired Goya's *Portrait of the Princess of La Paz* (Plate 140). Thrilled with her purchase, Louisine had it sent to Paris for her friend to see. Cassatt was equally delighted with it and remarked: " '*That* is fine, *there* is style; it is wonderful,' and looking at its elaborate Spanish frame of black and gold, she continued, 'When a picture can stand a frame like that, you may be sure it is fine.' "[16]

Louisine, determined to acquire as many as possible of the works in which her husband had shown an interest, now turned to El Greco's *View of Toledo* (Plate 141). Mary Cassatt had first mentioned it to the Havemeyers in 1901; six years later Durand-Ruel had finally obtained the picture from its Spanish owner. Harry had cabled the dealer in August 1907, requesting his lowest price, and Durand-Ruel had replied that he could deliver the *View of Toledo* to New York for $14,000. But for some reason Harry had not made up his mind. In April 1909, however, his widow, upon seeing El Greco's only pure landscape, did not hesitate about buying it. Louisine thought the town of Toledo she had visited looked exactly as it did in El Greco's painting, considering the artist's dramatic interpretation of the scene to be not visionary but a detailed and factual rendering.

Before leaving Paris, Louisine also secured a portrait by Courbet; in her *Memoirs* she recorded the circumstances of her coming across this picture:

> I found myself one day with Miss Cassatt in the Galerie [Georges] Petit looking at a collection that was to be auctioned off the following day. It was the most dreadful lot of trash I ever saw; the paint would have served a better purpose if it had been applied to the side of a house. Miss Cassatt said to me: "Isn't it astonishing that there are people in Paris who will buy stuff like that?" And then added, "Ah, there's one Courbet." For we had come to see a Courbet that in some mysterious way had been put into that collection. Perhaps the collector fancied a resemblance to someone he knew, or a friend, who was a better judge than he, had advised the purchase. I do not know, but it was there; and there I first saw *La Femme au Gant,* the portrait of Mme Crocq, and I bought it the following day.[17]

Paul Durand-Ruel bid for the painting on her behalf, paying approximately $10,000 for this full-length portrait of a Frenchwoman in a black silk gown, green shawl, and bronze slippers (Plate 142). Louisine was to hang it in her downstairs gallery at 1 East 66th Street, in a "choice spot."

In addition to picture buying in Paris, Louisine and her daughter also went to see special exhibitions and private collections. Electra provided Watson Webb with an account of one such visit:

> I had such an interesting time yesterday. We went to the house of Madame Cassin, the wealthiest courtisane in France, and I met the lady myself. She owns a tremendous house on the Champs Elysées near the Arc de Triomphe as large as the Astoria hotel. She had this marvellous collection of pictures. She is about 70 years old now. Such luxury you have never seen.[18]

Electra and her mother sailed home on the *Mauretania* toward the middle of May. This European trip had accomplished its main purpose: to restore Louisine's equilibrium. She was returning to America in possession of her habitual strength of character and sense of humor, ready to face whatever might occur. Her time of indifference and depression now behind her, Louisine's zest for life rebounded, and with it what she considered almost her sacred duty: to continue to add important works to her collection. Despite a few disappointments, she had made a good beginning during her travels; in addition to the two portraits by Goya and Courbet and the landscape by El Greco, she had purchased from Trotti, a dealer in old masters whom Mary Cassatt knew through Théodore Duret, a figure piece by Rubens.

One of her first acts upon returning to New York was to consign to the Durand-Ruels two of her Cézanne paintings, a self-portrait (see Plate 124) and a landscape with the river Marne (see Plate 130). In early June these works were sent to Paris, where their chance of being sold would be better. The art critic for the *New York Sun* lamented their hasty departure:

> It is a pity that before Joseph Durand-Ruel went to France he did not exhibit publicly the two new Cézannes he recently purchased in this country; but both pictures soon followed him to Paris, where they will command a big price. In America no one cares for Cézanne, that is cares to bid against French *amateurs*. Where these splendid examples came from we may only guess. M. Durand-Ruel did not divulge the name of the former owner. . . .[19]

The critic's view of the market for Cézanne paintings in France was exaggerated; although the Durand-Ruels did sell the two paintings by August 1909, Louisine received only $3,000. As Paul Durand-Ruel wrote to her, justifying the low sum:

> I am happy that we have been able to sell so rapidly your two paintings by Cézanne, because in spite of all the noise made around this artist, there are still very few buyers for his works, especially when they are not of great quality. It is only in Germany and in Russia that his canvases reach the high prices one hears about, something I do not understand.*

What Durand-Ruel neglected to tell Louisine was that he had indeed sold her two paintings to a Russian collector, Ivan Morozov, for $6,000! In this rare instance Louisine did not get a square deal, and years later she expressed in her *Memoirs* her disappointment with a "dealer" to whom she had sold "three" of her "best Cézannes for only three thousand dollars."[20]

In all fairness to the Durand-Ruels, the sum had been for two rather than three paintings and the idea to sell these works was not theirs, but Mary Cassatt's. It was surely during Louisine's 1909 visit to Paris that she had been prompted to dispose of some of her Cézannes, since Cassatt's previous admiration for this artist had undergone a reversal. Cassatt had written to Théodore Duret in 1904 that she had no intention of selling her Cézanne still life, but now she did exactly that; shortly thereafter Louisine sold two of her Cézannes. Cassatt's indignation had been aroused by Cézanne's new staunch

Left: Mary Cassatt, left, and Mme Joseph Durand-Ruel outside the château de Beaufresne at Mesnil-Théribus, the artist's 17th-century manor house northwest of Paris, c. 1910

Right: Mme Joseph Durand-Ruel, left, Mary Cassatt, unidentified lady in doorway, and young Marie-Louise Durand-Ruel, right, at the château de Beaufresne, September 1910. Mary Cassatt's little black dog (so disliked by Louisine) is on the steps.
Photographs courtesy of Galerie Durand-Ruel, Paris

supporters who dared to rate him above the masters Cassatt revered: Courbet, Manet, and Degas. Nor did she approve of the new wave of Cézanne collectors, such as Gertrude and Leo Stein. In 1908 Cassatt had attended one of the Steins' Saturday "evenings" at 27, rue de Fleurus and found herself, much to her distaste, among dealers, collectors, and young painters of assorted nationalities, together with a crowd of her hosts' friends, relatives, and acquaintances. But what really horrified Cassatt was the abundance of "dreadful" paintings, particularly by Matisse and Picasso, among which were also works by Cézanne; in the eyes of the highly judgmental Mary Cassatt, the Cézannes suffered by association. The "farceur" Matisse even collected Cézanne's paintings and watercolors!

In 1910 Cassatt would write to an artist-friend from Philadelphia, who was then in Florence:

> The dealers had nothing else to sell so boomed Cézanne as against such men as Manet. To be sure those who have the money buy Manets. I sold my Cézanne for which I paid 100 francs twenty-five years ago (I was one of the first to see merit in his pictures), for 8,000 francs [about $1,600] and immediately added something to it and bought a Courbet. Cézanne's nude figures are almost a copy of some of Greco's; he was always more influenced by pictures than nature, except in his still life.[21]

Mary Cassatt, now sixty-six years old, could not extend her once progressive attitude to the art of any painters more recent than the Impressionists. She felt threatened by Cézanne's influence on the young generation and thought his work was overestimated

for the wrong reasons. Naturally Cassatt's disdain for the avant-garde art of the early twentieth century affected Louisine's point of view, but Louisine kept her own counsel; she valued her remaining eleven Cézannes and did not consider selling them.

During her months abroad Louisine had informed other dealers and agents besides the Durand-Ruels that she intended to pursue collecting activities in the three areas of her greatest interest: El Grecos and Goyas, European old masters, and French moderns. She was also on the lookout for Gothic sculpture (a current enthusiasm she shared with Mary Cassatt), as well as for Persian and other antiquities. Consequently, there was a continuous exchange of letters between Louisine and the dealers in several countries who brought their wares to her attention. A hard bargainer, Louisine was also aware that the international art market had become more competitive and that prices were constantly rising for objects of top quality. She remembered what her husband had been fond of saying: "It takes nerve as well as taste to be a collector."

Louisine now divided her time between her art interests and her family. In the fall of 1909 she lent three of her Dutch paintings to the Hudson–Fulton exhibition at the Metropolitan Museum, a display of seventeenth-century Dutch masters celebrating the tricentennial of Henry Hudson's discovery of the Hudson River. Her visits to the museum to see this show may have given her the idea of offering its assistant director, Edward Robinson, the anonymous loan of her large Courbet painting *The Woman with a Parrot* (Plate 143), kept in a closet ever since it was bought from Durand-Ruel in 1898. In her *Memoirs,* she described how she had persuaded her husband to purchase *The Woman with a Parrot,* which the Durand-Ruels were about to send back to France:

> I begged Mr. Havemeyer to buy the picture, not to hang it in our gallery lest the anti-nudists should declare a revolution and revise our Constitution, but just to keep it in America, just that such a work should not be lost to the future generations nor to the students who might with its help, and that of other pictures, some day give a national art to their own country.[22]

Having acquired the picture with this intention, Louisine felt the time had come to implement it. But the painting had to be approved by the museum's trustees, some of whom the assistant director feared would be shocked by Courbet's luscious nude sprawled on a rumpled mattress. To spare Louisine any embarrassment and to maintain her anonymity, Mr. Robinson had the painting brought to the museum, where the trustees could inspect it without knowing who owned it. Within a few weeks the matter was arranged to everyone's satisfaction, and the chairman of the Committee of Painting formally requested of Louisine the loan of Courbet's *The Woman with a Parrot.*

The veil of sorrows that had been hanging over Louisine's personal life was finally lifting. She was less haunted by grief and memories. There were again joyous events. On August 7, 1909, her first living grandchild, Frederica Louisine Frelinghuysen, was born in Morristown, New Jersey; this time the baby was in flourishing health. The end of the year brought another reason for celebration when Electra formally announced her engagement to James Watson Webb, eldest son of Dr. W. Seward Webb and Mrs. Lila Vanderbilt Webb, on December 12, 1909. The twenty-five-year-old James Watson

Webb, a Yale graduate of 1907, had spent the past year in the West acquainting himself with railway management—railroading was, after all, the accepted career for a Vanderbilt. He did not yet have his own money, but he certainly had ample expectations.

Electra had known the Webbs for some years; in 1905 she had attended lavish parties at "Shelburne House" (an impressive 110-room mansion overlooking an estate of thousands of rolling acres in Shelburne, Vermont), at first as the guest of Watson's younger brother Seward. After Harry Havemeyer's death, Electra found escape from the sadness within her own family by joining the Webbs in their extravagant and active sporting life. She cruised Lake Champlain on Dr. Webb's steam yacht and played on his golf course (the first private course to be built in America), and rode to hounds with J. Watson Webb's private pack. Her beau was now Watson Webb, who showed her his father's stud farm for breeding hackneys. Dr. Webb had given up the practice of medicine on marrying Commodore Vanderbilt's granddaughter Lila, and had become deeply interested in horse breeding. In an enormous wood-and-stone barn, the size of Madison Square Garden in New York, he had built an indoor riding and exercise ring; the Vanderbilt-Webb collection of polished and glittering carriages filled a coach house that looked like a German castle. The ebullient side of Electra's nature, in contrast to the sensitive, artistic side, relished these outdoor pursuits and she shared the Webbs' enthusiasm for sports, animals, and the countryside.

Electra hoped that she would be able to interest her chosen mate in art. Louisine was less optimistic. She was pleased about her daughter's engagement and liked Watson Webb, whom her late husband had met and approved of; she had less liking for the ostentatious "Vanderbilt" style of life. Watson's family had imported a butler from Blenheim Castle, for instance, whereas Louisine had never even employed a butler, limiting her resident household staff to four maids, including the cook. Yet Electra was making a sound match and Louisine was delighted to witness the return of her daughter's cheerful disposition. Mary Cassatt shared Louisine's attitude as she wrote in a congratulatory letter to Electra on December 8, 1909:

Dear Electra,
I was in Paris yesterday & Lulu [Electra's cousin, daughter of Mrs. Frederick Wendell Jackson, Harry's sister] told me the happy news. I haven't your letter yet but one from your Mother, & won't wait to let you know how glad I am. Of course your engagement could not come as a surprise. I was sure last year that you had, if not altogether made up your mind, still you were near it. I think this is the very best thing that could happen for you all. I don't know Mr. Webb but I liked his looks & I have every confidence in your excellent judgement. Then your Mother is very happy over it. I do hope my dear Electra that you are going to be very happy. I think you have had such sorrows in these last two years, & I hope now you will have a calm & smooth road before you. One must have sorrows in this life & perhaps it is better to have them in youth & later on be spared. I trust Horace is not feeling badly over losing his sister, this time last year he could not bear even the thought of it. Lulu said you were to live with your Mother that would be the very best thing for you all to keep together. Every one has kind things to say of

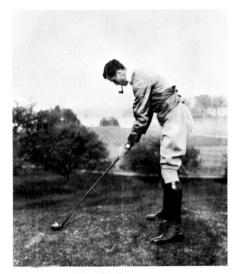

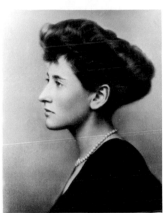

Above: Electra Havemeyer's notarized receipt for
her first purchase of a painting, Goya's Portrait
of a Little Girl (Plate 139), in April 1909.
Courtesy of Havemeyer descendants

Above right: James Watson Webb on the first
tee of the family's private golf course
at Shelburne, Vt., c. 1909

Right: Electra Havemeyer at the time of her
engagement to James Watson Webb, December 1909.
Photographs courtesy of J. Watson Webb, Jr.

your future Mother in law, & you are already friends with your future family, that
is such a good thing.

I wish your Father knew but he does no doubt & it would have pleased him,
how I feel about the way his memory is treated I cannot write, but his friends know
how false all these attacks are, I am glad I never see the papers; I hope your Mother
is bearing up well.

Lots of love dear Electra & kind regards to Mr. Webb, I hope I shall know
him better some day.

Always your affectionate friend

Mary Cassatt[23]

On the same day Cassatt wrote to Louisine, and after expressing her thoughts on
Electra's engagement, she added: "It [Electra's marriage] will be a new interest for you
& then go in for the Suffrage, that means great things for the future."[24] Cassatt was
firmly committed to woman's rights and thought that Louisine should join the move-
ment. She closed her letter with a reference to the unfavorable press that the Sugar Trust
was again receiving: "I am *outraged* at what they [certain newspapers] have been saying.

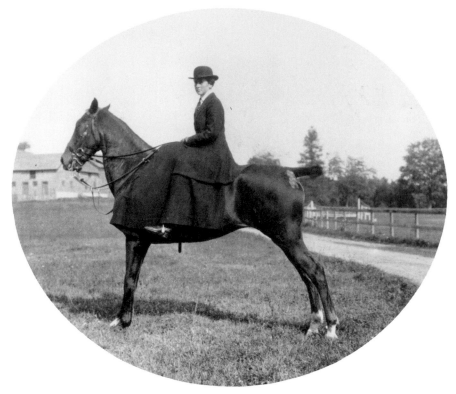

Electra Havemeyer at Shelburne, October 1909. Photograph courtesy of J. Watson Webb, Jr.

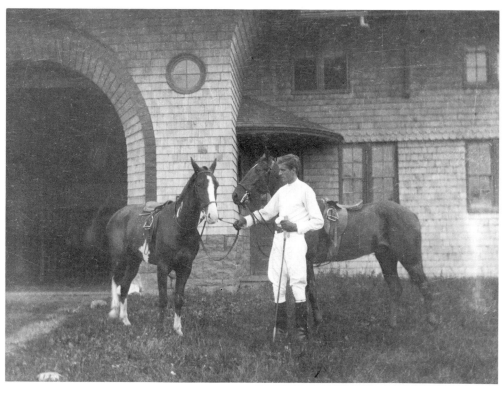

James Watson Webb in front of the enormous wood-and-stone barn at Shelburne, c. 1900. Photograph courtesy of J. Watson Webb, Jr.

But dearest Louie we know it isn't true and everyone with sense knows it too." The *New York Sun* had recently given its entire front page and two columns on its second page to an article that began with the paragraph: "The Sugar Trust has stolen boldly and enormously, as the subjoined article shows, from the United States Treasury for at least twenty years. It stole with the assistance of officials employed by the United States. It was nursed and protected in its stealings by powerful politicians."[25] The article went on to ridicule the "trivial" sum (over $2,000,000) that had been accepted by the government as restitution from the American Sugar Refining Company, a corporation with approximately $90,000,000 of capital. But such attacks were becoming yesterday's news; the Havemeyer family had learned to shrug them off and now carried on as usual, as did the Sugar Trust.

Besides, Louisine was soon to be the Havemeyer featured in the press, and in an exceedingly complimentary manner, thanks to Professor Ludwig Justi, newly designated as director of the Berlin National Gallery. Immediately following his appointment, he had rushed to New York in November 1909 to see the Hudson–Fulton loan exhibition before it closed and, during his brief stay, to visit a significant number of American private collections in Philadelphia, Boston, and New York. George Durand-Ruel had written to Louisine at "Hilltop," in Connecticut, for permission to take Justi to 1 East 66th Street: "He has heard so much about your collection that he asked me as a special favor if you would allow him to see it. Dr. Justi is a great admirer of Manet, Monet, Degas, etc. He has taken the place of Dr. von Tschudi, and in spite of the opposition of the German Emperor and his followers will be able I believe to do something for French Modern Art in Berlin."

Justi saw, among others, the collections of Henry C. Frick, Mrs. Jack Gardner, Louisine Havemeyer, John G. Johnson, J. P. Morgan, Colonel Oliver Payne, and Peter A. B. Widener. Upon his return to Berlin, he was interviewed by a correspondent for the *New York Times;* in the article, which appeared on January 23, 1910, Justi described the riches he had seen at 1 East 66th Street:

Though I observed in all American collections a delightful combination of good taste in both selection and display, one of the private collections that most deeply impressed me was that of Mrs. Havemeyer in New York. She has not a picture that may not be described as a gem. The very large majority of them, I found, had been purchased by her years before it became the fad to own this or that particular master, and because she bought early she bought cheap. Her gallery is a monument to American artistic taste. I should call her one of the real pioneers of the art life of your country. Her house is an epitome of luxury tempered by good taste. Nothing is overdone. It is richness and refinement rolled into one.

My progress through Mrs. Havemeyer's home was a series of revelations. I would say to myself, "there can surely be nothing finer." Yet one apartment seemed to outdo the other. It was all very wonderful. What struck me as a gallery director was the success with which Mrs. Havemeyer has solved what we called the "wall problem." She has succeeded in hanging her pictures in a perfectly ideal way, color schemes and lighting effects, wainscoting and molding being always tasteful and harmonious. But most impressive of all was the fact that this palace of treasures is

ruled by a woman of real art understanding. Mrs. Havemeyer is artistic through and through. American womankind has cause to rejoice in her.[26]

Understandably Louisine was elated by Justi's praise and pleased that he had appreciated the integration of her collection with its surroundings, as she took special pride in the decorative effects she had contrived. She sent a copy of this article to Mary Cassatt, who was glad that Justi had "spoken out" but found her greatest pleasure in the fact that his statements would no doubt "make Mrs. Gardner furious."[27] The German museum director had made favorable but only cursory mention of the latter's collection.

Louisine, no longer immersed in reminiscences, resumed her firm grasp on the present. Early in the new year she had to focus her attention on wedding preparations; the marriage of Electra and J. Watson Webb took place on February 8, 1910, at St. Bartholomew's church on Park Avenue, with a reception limited to the immediate families at 1 East 66th Street. Since her husband's death and for the rest of her life, Louisine wore mostly black or white, but for Electra's wedding she chose a dress of purple moiré and a matching hat (mauve was the only color permissible for mourning). She also wore several strings of exquisite pearls that Harry had given her in 1893, after seeing the necklace displayed by a French jeweler at the World's Columbian Exposition in Chicago. Composed then of five strands of pearls and a diamond clasp, the necklace had cost Harry $100,000 and it was Louisine's most cherished piece of jewelry. Eventually she gave each of her daughters one string; Electra received hers as a wedding gift. Louisine retained three strands to wear on special occasions.

With the marriage of her second daughter, Louisine realized that all of her children would soon have their own families, and although she looked forward to the role of grandmother, she was determined to maintain her independence through activities she would find self-fulfilling. A woman of resourcefulness and fortitude, Louisine now resolutely applied these traits to carving out a life for herself.

Forging Ahead

On February 18, 1910, Louisine Have-meyer received a threatening letter:

> We demand $2,500 from you a Black Hand contribution. If not paid we will blow up your house and kill all your family. We have 488 members scattered all over the world and you cannot escape us. Do not tell the police or anybody else or your family will suffer and we will not let up on you even if you offer us $100,000. Rich people pay our demands, they have no more trouble and we protect them. Do as we ask or we will blow up your house and destroy everybody in it with revolver or with dagger, or send you poinsend [sic] food.

Here a break in the letter contained a picture of a dagger-pierced heart, a revolver, a bottle marked "poison," and a crude black hand. In the second part of the threat were precise instructions:

> After you pay $2,500 you will be free of all expense. Take twenty-five $100 bills on Feb. 24 Thursday evening between 8 and 9 P.M. Deposit it in a tin box and place it under some wood leafs [sic] on the ground close to the park wall at the first lightpost at the right hand of the small entrance to Central Park, between Sixty-sixth and Sixty-seventh Streets, oposite [sic] your house, and let it stay there till you will get a letter from us that we received it.
>
> BLACK HAND[1]

This blackmail letter was a serious matter; when Louisine called police headquarters and read her letter over the telephone, the police were gravely concerned. The notorious Black Hand, a Sicilian gang of extortionists and kidnappers which for decades had terrorized their fellow Italians in Italy and the United States, had now apparently selected a prominent New York woman as their blackmail target. The police had determined that the Black Handers did not usually kill their victims with revolvers or knives but preferred to use bombs. The gang's blackmail letters generally threatened

death, but if no money was forthcoming, they resorted to a bomb explosion as their customary method of execution. The police, not wanting the gang to see them near the Havemeyer residence, did not visit it; instead Louisine went to a hotel and there met a detective who outlined their plan. Louisine was to fill a tin box with a wad of green paper wrapped in marked dollar bills and to prepare to take it to Central Park in accordance with the directions of the Black Hand letter. Assured that detectives would be watching her every minute, she agreed to her part in their scheme to trap her blackmailers.

Shortly before nine o'clock in the evening of February 24, Louisine left her home, crossed Fifth Avenue to Central Park, and deposited the tin box under some leaves at the designated spot. She then returned to 1 East 66th Street, leaving three detectives hidden near the park wall. They did not have to wait long. At nine-fifteen two boys entered the park and poked beneath the leaves until the larger one uncovered the tin box. When the boys left and walked up Fifth Avenue, they were pounced upon by the detectives. The elder boy, aged thirteen, clutching the tin box, seemed to take his arrest stoically; the younger, aged nine, wept bitterly and cried for his mother. The thirteen-year-old had in his pocket a list of blood-curdling adventure stories and admitted that he liked reading such books. After their arrest, the police called Louisine and gave her a description of the boys alleged to be the culprits. She wondered if they were the same youngsters who, the year before, had stolen tires and robes from her automobile, and had had charges pressed against them by her chauffeur. She promised to give evidence in Children's Court against these two mischief-makers. The police praised Louisine's coolness and courage during her ordeal.

Louisine had been supported through this alarming Black Hand episode by her son Horace, the only Havemeyer child still residing at 1 East 66th Street. With Adaline and her family ensconced in their thirty-eight-room, three-story house near Morristown, New Jersey, and Electra and J. Watson Webb living in Chicago since their wedding trip, Louisine and Horace drew even closer; she took as much interest in her son's business affairs as he did in her art collecting. Far from being a possessive, domineering parent, however, Louisine was more than eager that her shy, introspective son would turn his attention to starting a family of his own. She decided to encourage the matter by celebrating his twenty-fourth birthday with a dinner and theater party on March 19, 1910. Horace was completely opposed to the festivity and told his mother he would not attend, but in the end he did, and so met twenty-year-old Doris Anna Dick, who came from a family connected on both sides with the sugar business. Doris had been one of the first graduates of the Miss Spence School in Manhattan and a debutante of the 1910 season; she was considered a "fragile" young lady. Their courtship did not become serious until the two spent many afternoons sailing and horseback riding together that summer; on January 4, 1911, the engagement of Doris Dick and Horace Havemeyer was made official. The date for their wedding was set for February 28 at the Church of the Incarnation; the newlyweds would live at 1 East 66th Street.

Perhaps his impending marriage caused Horace to make some radical changes in his business career at this time. In November 1910 he had announced his resignation from the board of directors of the American Sugar Refining Company. The *New York*

Times's front page headline stated: "Last Havemeyer Out of Sugar Trust. The Family Owns Little of the Stock Now, but is in Beet Sugar Companies. Sold Out Very Long Ago."[2] The article explained that the Havemeyer family was retaining substantial interests in independent companies, rivals of the American Sugar Refining Company. Horace intended to participate in the management of one such concern, the National Sugar Refining Company, because he, his mother, and his sisters had inherited all the common stock—some 95,000 shares, worth $10,000,000—of that corporation. Harry Havemeyer had acquired this stock in 1900 upon the reorganization of the National Sugar Refining Company, but the shares were represented by certificates issued in the name of that company's president, who had endorsed them for transferral at any time to H. O. Havemeyer.

When Horace presented his family's certificates for the 95,000 shares in December 1910 and asked that these be formally transferred to the Havemeyer heirs so that they could vote the stock themselves, his demand was turned down. A month later, at the National Sugar Refining Company's annual meeting, the executors of the H. O. Havemeyer estate were not allowed to vote for the directors of their choice, which included Horace Havemeyer. Furthermore, the Havemeyer heirs suddenly found themselves the defendants in a lawsuit instituted by the American Sugar Refining Company. The Sugar Trust claimed that their former president, H. O. Havemeyer, had illegally obtained these shares of the National Company through stock juggling rather than through any cash transaction. Horace contended that the Sugar Trust, which owned a majority of preferred stock in the National Company, was opposing his family's voting rights in order to maintain control and prevent the National Company from becoming a major competitor. After months of testimony, the Havemeyers' 95,000 shares of common stock in the National Sugar Refining Company were invalidated by court decree. Horace, having resigned from the Sugar Trust, was now left without any financial interests in the sugar refining business; he would soon turn instead to the developing beet sugar industry in the Western states, and to companies producing raw sugar in the Caribbean in such regions as Cuba and Puerto Rico.

During this litigation, the issue of trusts again became front page news: "Big Trusts Marked for House Inquiry. Rules Committee Favors Investigation of Steel Corporation's Methods and Profits. Roosevelt May Be Called. Sugar Combination and American Woolen Company Also on the List for Probing by House Committees."[3] The article reported that a nine-member committee headed by Representative Thomas Hardwick of Georgia was to investigate whether the American Sugar Refining Company had been "doing business in violation of the anti-trust law and of the Customs Acts, and whether the trust has crushed out competition among refining companies and so increased the price of sugar over the price that prevails in other countries." The activities of Congress were fueled by the recent U.S. Supreme Court decisions to dissolve both the Standard Oil Company and the American Tobacco Company; gone were the days when industrialists, bankers, and businessmen wielded more power and political influence than the president himself. The Taft administration (1909–1913) would bring forty-five antitrust suits. No one was more aware of these changes in the business climate than Horace; summoned to appear before the Hardwick Committee, he made the following statement to the press: "The day of monopolistic combination is past. The country, the public,

The only Havemeyer building still
extant is their garage in New York. Built
by W. J. Wallace and S. E. Sage in 1895, a
broad arch of decorative brickwork gives access
to the former stable and carriage house. In
1905 the Havemeyers changed over
from a carriage to an automobile

Doris and Horace Havemeyer at Bayberry Point, Long Island, summer
1911, several months after their marriage. They lived with Louisine
Havemeyer until about 1919. Photograph courtesy of J. Watson Webb, Jr.

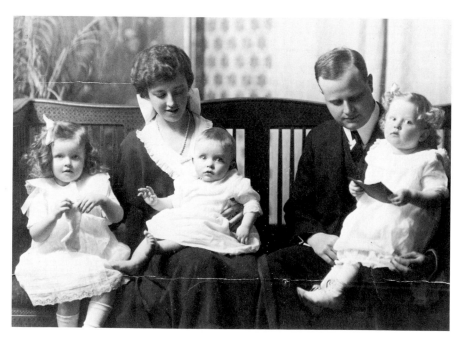

Horace Havemeyer's family in 1914. Louisine Havemeyer's eighth grandchild,
Horace Havemeyer, Jr., was born on July 14, 1914, at Islip, Long Island. Left to right:
"Little Doris"; Doris Havemeyer holding Horace, Jr.; Horace Havemeyer with
his second daughter, Adaline. Photograph courtesy of J. Watson Webb, Jr.

and the great industrial enterprises themselves demand competition."[4] He emphasized that he was now independent of the Sugar Trust and planned to do business as its competitor.

Horace resented the repeated attacks on his father that were made during the Hardwick Committee's investigation by prominent Sugar Trust officials, past and present, who testified at the hearings. Encouraged by Louisine, he welcomed the chance to answer publicly the stinging criticisms of Harry's business career and character, as reported by the *New York Times* of June 21, 1911:

> Horace Havemeyer stamped himself on the Hardwick Sugar Investigating Committee to-day as a virile successor of the founder of the trust. He did defend his father forcibly and effectively, and moreover he impressed himself on the members of the committee and the spectators as a boy who might some day be a giant captain of industry in the same sugar world in which his sire was easily king.[5]

Horace, seeming deliberately to involve his mother in the proceedings, was quoted:

> My father did not tell anyone what he intended to do or why he did certain things —except this—he did tell my mother and my aunt, Mrs. Peters, my mother's sister. My aunt has told me much of this which confirms my own recollections of the circumstances. No one knew what he was doing or what he planned to do but these two women. He told them from time to time nearly everything connected with his business.[6]

After years of bearing in silence the relentless attacks on her husband's reputation, his widow must have wanted it known that she had been fully aware of his business dealings and had wholeheartedly approved of them. Louisine was proud of her son's efficient defense; the depth of his feelings and his strong sense of responsibility had enabled him to overcome his natural diffidence. But Horace would shun notoriety for the rest of his life and take care to stay out of the public eye.

At this time Louisine especially appreciated kind words from those who had known Harry personally. She received one such letter from Dikran Kelekian, the dealer in antiquities:

> Mr. Havemeyer I am never tired of repeating it, was the ablest and most intelligent collector I ever knew. His nobility of character served him well in matters where weaker people lose their way. Many times when reading extraordinary flattering letters I have been receiving in praise of my catalogue [of Persian potteries] I have thought regretfully how glad he would have been to see this *triumph* of the art he was one of the first to understand and support and when I hear the dastardly manner in which his memory has been attacked by people inferior to him in every way, I wish doubly that he were there to shame them into silence.[7]

Louisine's most reliable source of sympathy and encouragement had heretofore been Mary Cassatt, but recent circumstances had greatly altered her oldest friend. Cassatt's

trip to Egypt early in 1911, with her younger brother Gardner and his family, had ended in disaster: Gardner was unwell for most of their voyage up the Nile, and when he arrived in Paris he was desperately ill, dying on April 5 at the Hôtel Crillon. His loss was shattering for Mary Cassatt, for he was the last close member of her family. Louisine announced that she would come at once to console her, but Cassatt cabled back: "Doctor orders rest and to be alone so grateful dear Louie come later when I am well Love Mary."[8] Yet Cassatt was unable to overcome her depression and sense of loss for a long while. Moreover, she was ridden with pains in her legs, apparently brought about by incipient diabetes, which forced her to adhere to a strict diet, and she suffered from many smaller disorders. These illnesses weakened her morale and preoccupied her; art was no longer her priority. Although her health stabilized at times, allowing her to work again and renew her fervent interest in politics and art, she began a gradual decline from which she would not fully recover.

By August Cassatt, then at her country house fifty miles northwest of Paris, was strong enough to receive a visit from Louisine. The latter was shocked to see the changes in her friend; Cassatt, who was sixty-seven, for the first time looked old, whereas Louisine at fifty-six was gaining in vibrancy and energy, having survived her tribulations and learned to live with her sorrow. Filled with compassion for her friend's condition, Louisine nursed and comforted her. In many ways the younger Louisine became Cassatt's surrogate mother, lavishing warmth and attention on her grieving, dispirited friend. The painter was grateful for this soothing care and the two must have spent hours discussing their main concerns: artistic matters and woman's suffrage.

Before returning home toward the end of September, Louisine stayed in Paris for a couple of weeks, visiting galleries and collections. She was anxious to concentrate again on art buying, now that her three children were married and her son had settled his complex business problems to the best of his ability, if not successfully. Louisine reestablished contact with the critic and private dealer Théodore Duret, requesting him to be her special Parisian scout for Courbet paintings. She also asked the Durand-Ruels to look for outstanding works by Cassatt, Degas, and Monet. But the art market had evolved considerably during the past few years; the Impressionists were now sought after, as reflected in the rising prices their works commanded and the scarcity of available paintings of high quality. Louisine would now have to compete at auctions for hotly contested pictures by the very artists she had patronized decades ago. Although the new fervor for Impressionism was in some way a tribute to Louisine's daring and advanced taste, her own collecting became more difficult and infinitely more costly. Nevertheless, her determination to fill in gaps in her collection with early, middle, or later works by the painters of her choice, forced her to overcome her innate frugality and adjust to the new prices. The strong-willed Louisine went "forging ahead" (a favorite expression of her husband's).

On occasion she would be thwarted. In February 1912, Louisine decided in New York that she would bid on a Corot figure piece and a Courbet marine at the March 2 sale in Paris of the Dollfus estate. She had seen these pictures the previous autumn, in a specially constructed gallery with the rest of the impressive Dollfus collection. From the twenty Corots that were to be sold Louisine selected the *Woman with the Pearl,* considering it a masterpiece—perhaps Corot's most beautiful portrait—and she felt

strongly about securing it. Mary Cassatt shared her opinion. Louisine first commissioned Joseph Durand-Ruel to bid up to 130,000 francs on her behalf, then cabled him just before the sale to go as high as 200,000 (approximately $40,000), unaware that the Louvre had made an "arrangement" with the Dollfus heirs to obtain the painting for 150,000 francs. The Louvre's participation in the sale caused many French contenders to abstain from bidding and prompted the auctioneer to bring down his hammer the moment the bid of 150,000 francs was reached, cutting off any higher offers. Crushed by her loss, Louisine wrote of her disappointment to Mary Cassatt, who replied: "You see the French retired before the Louvre but you would not have had to do that."[9] Cassatt, however, did not take into consideration that Louisine's bidder had been Joseph Durand-Ruel, who also did not want to compete against the Louvre. She did secure Courbet's *The Wave* (Plate 145) at the sale for 16,000 francs (about $3,100). She vowed that in future, if she really wanted a certain work, no person or institution would stop her.

Louisine also had bought recently a Courbet landscape (Plate 146) through Théodore Duret, whom she did not tell of her Courbet purchase at the Dollfus sale. In April 1912 Duret wrote her that whoever had bought Courbet's *Wave* had gotten a painting worth only half of her new landscape, for which he had obtained the same price. Louisine must have found his salesmanship amusing; nonetheless he was a reliable and continual source of first-rate works by Courbet. Through his efforts Louisine would acquire, between the end of 1911 and the beginning of 1913, at least half a dozen Courbet paintings—four seascapes and landscapes, one nude, and one still life.

Louisine's purchases stimulated her and gave her a sense of achievement; it was a comfort to return to the activity that she and Harry had pursued so passionately throughout their married life. But she also embarked on an interest that would prove to be another means of self-realization. From 1910 onward she became progressively concerned with the cause of woman's suffrage.

Mary Cassatt had been steadily urging her "to go in for the Suffrage," although Louisine had been aware of the issue since her youth, as she would later acknowledge:

> I came by right of heritage to the suffrage cause. My mother and her associates were interested in it and were friends of the pioneers of the movement. Susan B. Anthony and Lucy Burns were familiar names to me in my childhood. I was for a long time a fellow "pensionnaire" with Lucretia Mott's granddaughter in a French family in Paris, and Mrs. Harriot Stanton Blatch, daughter of Elizabeth Cady Stanton (she who inserted the equal-suffrage clause in the woman's constitution and, therefore, was the cause of the ensuing struggle), was the head of my first political party and my guide and friend for many years.[10]

The "party" she referred to was the Women's Political Union, formed in New York City in 1907 for the purpose of establishing an association "in which all persons interested in gaining civil and political equality for women might unite."[11] Under the dynamic leadership of its president, Harriot Stanton Blatch, the organization initiated

Woman Suffrage Parade down Fifth Avenue at 51st Street, New York, 1912.
Behind the women are marchers from the men's league for woman suffrage.
Photograph courtesy of New-York Historical Society

the Fifth Avenue parades in 1910; this successful form of agitation grew larger and more important every year.

The Women's Political Union was constantly seeking ways of attracting publicity, of arousing curiosity in its activities, and of generating revenue to support them. It may have been Harriot Stanton Blatch who first suggested the idea of exhibiting a group of Havemeyer paintings and charging a benefit entrance fee; Louisine was immediately in favor of the plan: "It goes without saying that my art collection also had to take part in the suffrage campaign. The only time I ever allowed my pictures to be exhibited collectively was for the Suffrage cause."[12] Since Harry had been a firm believer in the enfranchisement of women, she felt that she could lend their paintings now in good conscience.

On April 2, 1912, a loan exhibition of "Paintings by El Greco and Goya" opened at the gallery of M. Knoedler and Co. The nineteen-day show consisted of three portraits and the *View of Toledo* by El Greco and eight figure pieces by Goya, all loaned anonymously by Louisine. She spared no effort to draw public attention to this money-raising venture:

My posters were beautiful! After the fashion of France I adopted the three-striped poster—only, instead of the French tricolor, I used our party's colors, the purple, white, and green. I well remember how delighted I was to see the fine effect they made hanging on each side of the entrance to the gallery, as well as in the most

important windows on Fifth Avenue, where with a great deal of tact and a little assurance I managed to place them.[13]

But the mere fact that proceeds were for the cause of woman's suffrage created opposition to the exhibit, much to Louisine's frustration: "As a proof of the deep and bitter animosity against us among certain classes, I may say that some of our best-known and important collectors not only refused to attend the exhibition, but threatened to withdraw their patronage from the dealer who had kindly loaned me his gallery."[14] Instead of dampening Louisine's crusading spirit, these attitudes strengthened her resolve to counter such views by persistently exposing the philistines to the precepts for which she and her fellow suffragists were struggling.

On an aesthetic level the show was a valuable confirmation of Louisine's conviction concerning the importance of hanging works of art in a favorable setting:

> I went to the galleries to place the pictures and I will only say the background was little better than red. It fairly hurt me to see my paintings hung against it. Poor little Princess [Goya's *Princess of La Paz*; see Plate 140], what a change it made for her! She faded and paled like a drooping flower. Even the elaborate frame which she stood so well could not sufficiently protect her from that dreadful background. She sank back and seemed to disappear in timid embarrassment. Although I was shocked as I gazed upon the dainty royal lady, I made no remark but began comparing the other paintings. How differently they all looked; I could scarcely believe they were the same pictures that had left my home that very morning. The portrait of the Cardinal [by El Greco; see Plate 121], in his magnificent red robes was the only one which was not greatly injured by that background.[15]

One of the visitors wrote to Ricardo de Madrazo in Madrid (the agent shared by Louisine and the Durand-Ruels for Spanish paintings), describing the splendid exhibition; Madrazo sent Louisine his congratulations and the news that Paul Durand-Ruel had recently obtained a beautiful man's portrait by Goya and a superb *Saint Martin* by El Greco. Mary Cassatt also mentioned these works, particularly praising Goya's portrait of a major dressed in "a wonderful uniform and gold embroideries."[16] Before long Louisine had bought the picture, and around the same time, from the Cottier Gallery in New York for $8,000, the artist's large canvas *A City on a Rock* (Plate 144).[17] Perhaps her appetite for Spanish paintings had again been whetted by the Knoedler exhibition, in spite of the unsatisfactory backgrounds.

December 1912 brought Louisine an opportunity to acquire some exceptional pictures in the estate sale in Paris of the painter and engineer Henri Rouart, an old friend of Degas who had assembled a famous collection of nineteenth-century French works. The auction, Mary Cassatt had said, would "bring together all the *amateurs* of Modern Art."[18] Realizing that the stiff competition would force Louisine to face high bids for these pictures, Cassatt counseled her friend: "I wanted to tell you about the Cézanne prices. It *cannot* last. Why don't you make a selection [of your Cézannes] & don't deal with either the D.R.'s or Vollard, but with Bernheim [Bernheim-Jeunes, Parisian dealers

in modern art, active since the turn of the century] & get good prices & put your money into something really fine in the Rouart sale?"[19] But Louisine had come to regret deeply having sold her landscape and portrait by Cézanne in 1909; this time she could not be swayed, though Cassatt persisted:

> As to the Rouart sale I cannot advise you, you will see for yourself when you get the catalogue. Of course I know you are able to buy anything you want without selling your Cézannes still I strongly advise you to sell. . . . I think you might send them over here & I could have them in my apartment for them [the Bernheim-Jeunes] to show. The whole [Cézanne] boom is madness and must fall.[20]

Louisine chose not to heed Cassatt's advice, and did not part with any of her remaining eleven paintings by Cézanne.

As the date for the Rouart auction drew closer, Louisine emphasized to Joseph Durand-Ruel, then in New York, how imperative it was that his firm keep absolutely confidential any purchases she might make. Being assured that it was a house rule never to divulge such information, Louisine submitted her list of bids; in each instance she went substantially higher than the estimates. Among her choices, which Joseph transmitted to Paris, were three paintings by Degas and one each by Courbet, Delacroix, and Manet, plus a pastel by Degas. On December 9, Joseph alerted Louisine:

> I am sorry to say that Paris cabled they obtained nothing to-day out of our numerous orders. . . . From the cable, though of course I have no further details, I infer that either the pictures brought very high prices, or that the heirs of Mr. H. Rouart, who are quite wealthy and were very much attached to the pictures, have purchased back a large number which they did not wish to let go. Please let me know whether you wish to increase your bids for tomorrow. No. 177, *Dancers at the Bar,* Degas, is likely to bring a very large price if the others sold so well. No. 189, Delacroix, will also be tomorrow.

On December 10, 1912, Paul Durand-Ruel purchased on behalf of an unknown buyer Degas's *Dancers Practicing at the Bar* (Plate 147) for the record price of $95,700, the highest amount ever paid for the work of a living artist. Rumors as to the mysterious purchaser's identity appeared in the press on both sides of the Atlantic, but Durand-Ruel would only say that he had received an unlimited order from America to outbid any competitors. The underbidder seems to have been the Spanish painter José María Sert (1876–1935). The aged Degas, when asked how it felt to have his picture knocked down at such an astronomical price, simply replied that he felt like the horse that has won the Grand Prix and gets nothing for it but his oats. On December 13, Horace Havemeyer sent a draft for 478,500 francs ($95,700) to the Galerie Durand-Ruel for his mother's account. Three days later, at the second part of the Rouart sale, Durand-Ruel bought for $11,000 Degas's pastel *At the Café-Concert: The Song of the Dog* (Plate 148) for the same anonymous client; Louisine had secured this work for the sum she originally allotted.

Meanwhile, Mary Cassatt and the rest of the international art world were trying

139. FRANCISCO DE GOYA (now considered "Attributed to Goya"). (left) *Portrait of a Little Girl.* Oil on canvas, 32 3/4 × 23″. Private Collection, U.S.A. Formerly owned by Electra Havemeyer Webb

140. FRANCISCO DE GOYA (now considered "Attributed to Goya"). (right) *Portrait of the Princess of La Paz.* Oil on canvas, 40 × 31″. Shelburne Museum, Shelburne, Vt. Formerly owned by Mrs. Havemeyer

141. EL GRECO. *View of Toledo.* c. 1604–14. Oil on canvas, 47 3/4 × 42 3/4″. The Metropolitan Museum of Art, New York (Bequest of Mrs. H. O. Havemeyer, 1929. The H. O. Havemeyer Collection)

142. GUSTAVE COURBET. *Madame Auguste Crocq* (or *Cuoq; Mathilde Desportes*). 1857. Oil on canvas, 69 1/2 × 42 1/2″. The Metropolitan Museum of Art, New York (Bequest of Mrs. H. O. Havemeyer, 1929. The H. O. Havemeyer Collection)

143. GUSTAVE COURBET. *The Woman with a Parrot.* 1866. Oil on canvas, 51 × 77″. The Metropolitan Museum of Art, New York (Bequest of Mrs. H. O. Havemeyer, 1929. The H. O. Havemeyer Collection)

144. FRANCISCO DE GOYA (now considered "Style of Goya"). *A City on a Rock.* Oil on canvas, 33 × 41″. The Metropolitan Museum of Art, New York (Bequest of Mrs. H. O. Havemeyer, 1929. The H. O. Havemeyer Collection)

145. GUSTAVE COURBET. *The Wave.* 1865–69. Oil on canvas, 25 3/4 × 26 3/4″. The Brooklyn Museum (Gift of Mrs. Horace Havemeyer, 1941). Formerly owned by Mrs. H. O. Havemeyer

146. GUSTAVE COURBET. *The Russet Wood*. Oil on canvas, 46 × 35 1/2″. Collection Mr. Richard Shelton, San Francisco. Formerly owned by Mrs. Havemeyer

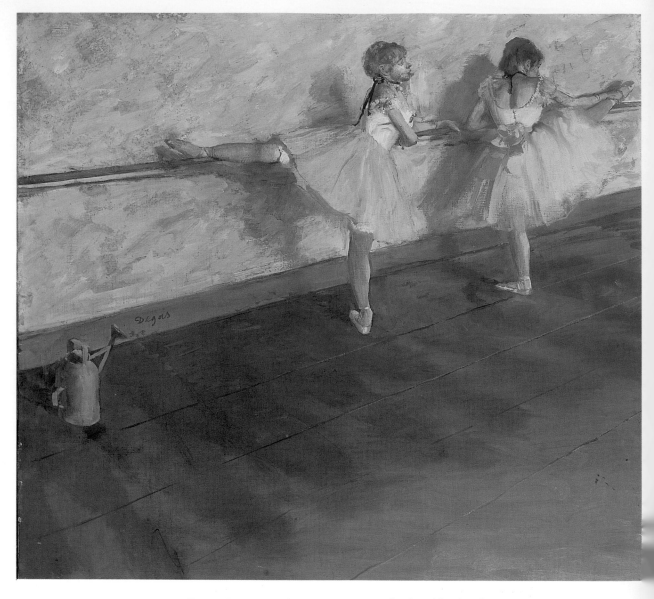

147. EDGAR DEGAS. *Dancers Practicing at the Bar.* c. 1876–77. Oil colors diluted with turpentine, on canvas, 29 3/4 × 32″. The Metropolitan Museum of Art, New York (Bequest of Mrs. H. O. Havemeyer, 1929. The H. O. Havemeyer Collection)

148. EDGAR DEGAS. *At the Café-Concert: The Song of the Dog.* 1875–77. Gouache, pastel, and monotype on joined paper, 22 5/8 × 17 7/8″. Private Collection, U.S.A. Formerly owned by Mrs. Havemeyer

149. HONORE DAUMIER. *The Third-Class Carriage.* 1863–65. Oil on canvas, 25 3/4 × 35 1/2″. The Metropolitan Museum of Art, New York (Bequest of Mrs. H. O. Havemeyer, 1929. The H. O. Havemeyer Collection)

to guess the new owner of Degas's *Dancers Practicing at the Bar*. Louisine soon wrote to Cassatt, letting her in on the secret, and on Christmas Day, 1912, the latter replied: "I have yours with the news, there is no danger of my speaking of it for I have contradicted it several times. Well you did right I think. . . . What I should like to know is, who bid against you."[21] The next day Cassatt wrote to Paul Durand-Ruel, stating what she thought was the reason behind Louisine's astonishing acquisition: "It was a matter of sentiment, since her husband had wanted it."* In any case, Louisine had asserted herself, making the most staggering purchase of her life without anyone's advice. Degas's *Dancers Practicing at the Bar* was and remained the costliest painting in the Havemeyer collection; only Rembrandt's *Gilder,* bought by Harry in 1889, came close to it.

Within two months Louisine would pay another record price for a work by a nineteenth-century French painter; this time the artist had been dead for over thirty years. The sale of the collection of the late Matthew Borden, held at the Plaza Hotel in New York on February 13 and 14, 1913, contained many Barbizon works and other pictures, among them Honoré Daumier's *The Third-Class Carriage*. Durand-Ruel had offered this painting to Louisine and Harry in 1892, but they, for whatever reasons, had turned it down, and he did not sell it until four years later to Borden. Now Louisine wanted to make up for what she considered a serious omission. In the intervening twenty years she had not found a significant painting by Daumier, whose work she greatly admired.

On a cold February day, Louisine invited her sister Adaline Peters to go with her to take a look at Daumier's *The Third-Class Carriage* (Plate 149), exhibited in the auction house before the sale. Mrs. Peters had also seen this picture at the Durand-Ruels in Paris in the summer of 1892, and had urged the Havemeyers to buy it then. The two sisters were touched by Daumier's poignant rendition of the solitude and resignation of the poor travelers enduring the discomforts of a "modern" railway car. Louisine particularly responded to the artist's vigorous technique of integrating color and drawing, and noticed the pencil lines visible beneath the paint where the glaze was thin. After studying for a long time Daumier's treatment of the hapless victims of public transportation, Louisine was glad that they had taken a streetcar to the auction house and insisted on riding home in one. She commissioned Joseph Durand-Ruel to obtain Daumier's *The Third-Class Carriage,* which sold at the record price of $40,000. She could have bought the painting in 1892 for $9,000—a costly mistake.

The year 1913 witnessed the inauguration of Woodrow Wilson as twenty-eighth president of the United States and the establishment of a federal income tax through the ratification of the Sixteenth Amendment to the Constitution. It also featured New York's sensational "International Exhibition of Modern Art," offering Americans their first comprehensive display of European contemporary art and its nineteenth-century antecedents. The month-long "Armory Show," with some 1,300 works, of which one-third were foreign (predominantly French), opened to the public on February 17 and immediately became the talk of the town. The vast space of the National Guard's new armory on 25th Street and Lexington Avenue was crammed with pictures hung frame to frame and with an abundance of free-standing sculptures. As it had been over thirty years before, when Impressionism first crossed the Atlantic, the American art

world was now outraged by the bewildering works of the Post-Impressionists, repulsed by the violent colors of the Fauves, and shocked by the startling distortions of the Cubists. Neither the public nor in most instances the critics were prepared for such a brutal assault on their comfortable aesthetic ideas. Matisse, who was exceptionally well represented with thirteen paintings, received the most vitriolic blasts, while Duchamp's *Nude Descending a Staircase* became the butt of endless jokes, cartoons, doggerel, and even contests. As a result of the almost daily press coverage, "the galleries were full of people who came once to gape, artists who came to study or deride, and celebrities who came as much to be seen as to see."[22]

Although Louisine did not lend any of her pictures to the Armory Show (Durand-Ruel had provided most of the Impressionist works), she must have attended it. She may have been invited to a special viewing by Arthur B. Davies, president of the Association of American Painters and Sculptors and organizer of the exhibition, for Davies had been to 1 East 66th Street several times. Visiting the show, Louisine doubtless focused on its positive aspect, that of providing an overview of recent European art for those who had not seen it before. Yet she could not relate to the controversial new movements, her situation being that described by the aging nineteenth-century French critic Théophile Gautier: "Confronted with the startling examples [of the new art], those with some integrity ask themselves if, in art, one can understand anything but the works of the generation with which one is contemporaneous, that which was twenty when you were the same age. . . ."[23]

Louisine had formed her collecting habits almost forty years before, when she had been bold and innovative; now she felt she could leave the current avant-garde art to a new generation of patrons. She wished for them the same stirring excitement and challenge that she had experienced in looking and studying, then selecting or rejecting, always hoping to end up with promising talent. Her own energies were now being directed toward accumulating in depth the work of artists she had "discovered" long before; she was no longer a pioneer collector, but, in contrast to those who used the Armory Show to give vent to their ingrained prejudices, Louisine maintained an open mind. She must have communicated her not altogether negative impressions to Cassatt, for she received in reply a vicious attack on Matisse:

> As to what you write about pictures, I think you flatter Matisse, [Richard] Strauss after all *is* a musician now Matisse is a "farceur." If you could see his early work! Such a commonplace vision such weak execution, he was intelligent enough to see he could never achieve fame, so shut himself up for years and evolved this and has achieved notoriety. My dear Louie, it is not alone in politics that anarchy reigns, it saddens me, of course it is in a certain measure our set [the Impressionists] which has made this possible. People have been persuaded that composition, pictures, were not necessary that sketches hints were enough. Certain things should not have left the artists studio nor his portfolios. Then the public accepted everything. This I could talk better than write.[24]

Cassatt's scorn for contemporary art manifested itself often, and Matisse represented for her, as for many American reactionary critics, the ultimate violation of all accepted

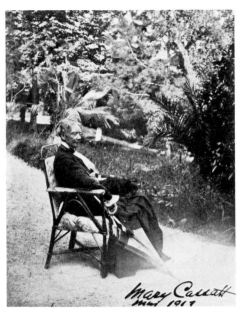

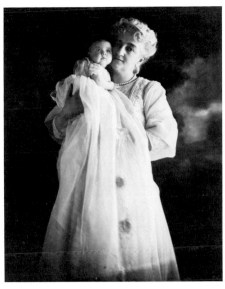

Mary Cassatt in the south of France, May 1913. Photograph courtesy of Galerie Durand-Ruel, Paris

Louisine Havemeyer and her second grandchild, Electra Webb, born on November 3, 1910, in Chicago. Photograph courtesy of J. Watson Webb, Jr.

Dining room of Electra and Watson Webb's "Woodbury House," Syosset, Long Island, c. 1914. The beehive ceiling, inlaid sideboard, ornamental screen, and tiled fireplace were imported from Spain. On the table is a polo trophy; Watson Webb was one of the leading polo players in America

"Living-hall" of "Woodbury House," c. 1914. A combined hall and living room featuring uncomfortable chairs and stuffed elk heads. Photographs courtesy of J. Watson Webb, Jr.

and recognizable art forms. Turning her back on the "perverted" art of the present, Cassatt may not even have known that two of her own pictures had been included in the Armory Show, a painting lent by Durand-Ruel and a watercolor lent by John Quinn, the lawyer-collector who was a substantial backer of the exhibition.

Louisine's policy as a lender was selective. After refusing to participate in the Armory Show, she sent no fewer than eight Manet paintings at the end of November 1913 to Durand-Ruel's inaugural exhibition in their new premises at 12 East 57th Street. To celebrate the move the gallery held a loan show of paintings by Manet. Cassatt wholeheartedly approved of Louisine's decision:

> I am very glad you are lending your Manets to the Durand-Ruels for their opening, I hope they will have a good one. They have always been so conservative and honest. I like Joseph I like him better than his Father. The old man has been tenacious, but not generous to painters though he has given money too—but he thinks when artists sell to others it is treason to him. Yet he would not buy the things from Degas that Vollard gladly took and sold again at large profits. Vollard is a genius in his line he seems to be able to sell *anything*. [25]

Whether Louisine shared her friend's opinions of Vollard is not known, but certainly she had a loyal and trusting friendship with Paul Durand-Ruel and much warmer relations with him than with Vollard.

Louisine's anonymous loans to the Durand-Ruel show—almost half the exhibition —included *The Railroad* (see Plate 85). This work, which the Havemeyers had originally had to defend when it was attacked for its "ugliness" and "ineptitude," now elicited lavish praise from the *New York Times* critic: "The picture is the simplest, most logical, and most nearly faultless in workmanship of modern French genre. It is the acme of realism without the introduction of a single trivial detail. Not a line, spot, or color could be taken away without diminishing the beauty of the composition."[26] After the Armory Show, Manet looked like an old master. Louisine deeply admired his work and her favorite painting in her entire collection seems to have been Manet's *Mlle V . . . in the Costume of an Espada* (see Plate 82).

The year 1913 had been a busy one for Louisine, highlighted by marching up Fifth Avenue on May 3 in the largest suffrage parade New York City had ever seen, assisting at the births of two more grandchildren (she now had seven), receiving a visit from her old friend and fellow collector Charles Freer, traveling upstate to help establish a broader organization for the Women's Political Union, accompanying her son Horace on a business trip to Denver, and listening to the fiery speech of Emmeline Pankhurst, the militant English suffragist who had come to America on a lecture tour. Another absorbing activity for Louisine was helping Electra decorate her new fifty-two-room mansion, "Woodbury House," near Syosset, Long Island.

At the beginning of 1911, after Electra had received a legacy of over $4,000,000 from her father's estate, she, her husband, and their infant daughter had abruptly left Chicago, where they had lived modestly since their marriage on Watson's monthly salary of seventy-five dollars from the Northwestern Railroad. Returning to New

York, the young Webbs stayed with Watson's parents at 680 Fifth Avenue in the house William Vanderbilt had built for his daughter Lila (Watson's mother). A son was born in 1912 and, anticipating the arrival of their third child, Electra and Watson had concluded that they must have their own house; they commissioned the architects' firm of Cross and Cross to build a gabled English Tudor mansion on the 222 acres of land they had bought on Long Island.

Electra was certain that she did not want her new house furnished in the "early Pullman" style of her in-laws' residences, but she did not realize until too late that instead she would get "early Louisine." According to a letter Electra had written to Watson from Europe in 1909, her mother had been planning a home for her since before she was officially engaged: "Mother and I have very interesting talks as to how my future house will be built—I am afraid you wouldn't care for it. I am very anxious to find a carved marble Hall in Spain. They are terribly rare and expensive but very lovely."[27] Evidently their quest for Spanish treasures was successful, because the dining room of "Woodbury House" was decorated with Moorish elements—an oaken beehive ceiling, inlaid sideboard, ornamental screen, and tiled fireplace—that had come from a villa built for Charles V near Granada. To carry out this Moorish theme throughout the house Louisine recruited the services of Tiffany Studios, even though Cassatt advised against it: "Much as I admire Tiffany Glass, I confess I don't like his furniture, if I were Electra I would not have him make me any."[28]

Electra did not have the heart to curb her mother's enthusiasm for creating another interior similar to 1 East 66th Street. It never occurred to Louisine that her own decor, having been designed more than two decades before, might not appeal to a younger generation. Matters worsened when Louisine conferred with her "co-mother-in-law," Lila Vanderbilt Webb, who added her touch by placing large uncomfortable chairs in the living room and hanging stuffed elk heads everywhere, particularly over doorways. "Woodbury House" ended up as the joint production of Electra's mother, her mother-in-law, and Louis Tiffany; Electra loathed it.

As their Long Island house was nearing completion, Electra and Watson decided they would need a place where they could feel more at ease. They had been spending many weekends at the senior Webbs' country mansion in Shelburne, Vermont. Watson kept his private pack of foxhounds there and they both loved the outdoor life of sports and animals, but the young couple was tiring of the lavish way of life at "Shelburne House," with its elaborate black-tie dinners and endless parties. They asked Watson's parents if they could have the use of a small brick house, built originally in 1847, on the southern end of the vast property. To their delight, Electra and Watson were given this old Vermont house and 1,000 surrounding acres; they decided to build onto the house at once, so that they could entertain their own friends more informally. From having been too accommodating about her Long Island residence, Electra had learned her lesson; the "Brick House" would be her creation and hers alone. She was determined to fill it with the works that gave her pleasure: early American furniture, hooked rugs, hand-painted wallpaper, patchwork quilts, pewter, glass, carved eagles, and ceramics, all indigenous to New England and appropriate for the architecture of the house.

Louisine, appalled by her daughter's unorthodox taste, referred to these rustic pieces as "kitchen furniture." Doubtless Electra's newfound interest in collecting anonymous

American arts and crafts came in reaction to her mother's collecting of masterpieces. Faced with the overpowering combination of Havemeyers on one side and Vanderbilt-Webbs on the other, a less forceful person than Electra might have been neutralized, but her theory was, "if you want a thing enough you can get it." She was conscious of her special heritage, as she had once written to Watson: "Just think of the courage I have to expect to keep on in Father's footsteps in the way of collecting Art. Very few appreciating it and all discouraging me, and so hard to find. But still."[29] Identifying herself with her father's pattern of art buying rather than her mother's, she had his proclivity for amassing objects in bulk. In 1913 Electra started acquiring Americana because she had the "Brick House" to furnish; she would later develop such a passion for these works that she was able to establish a museum of folk art in Shelburne. She was already on her way toward becoming a tastemaker in her own right.

Louisine's horror at her daughter's quest for "American trash" was mitigated by the pleasure she took in Electra's principal residence on Long Island. She could not know that within seven years her determined daughter would auction off "Woodbury House" and its furnishings. Convinced that Electra and her family were now suitably housed, Louisine was ready, early in 1914, to direct her considerable energies elsewhere. Thinking about another exhibition to benefit woman's suffrage, this time she developed a most ambitious project, and since she wanted to discuss her plan with Paul Durand-Ruel and Mary Cassatt, she decided to go to France. Her next grandchild was not expected until July, so she had a few free months; she booked passage to arrive in Genoa on March 20, proceeding directly to Mary Cassatt's rented villa in the south of France.

Whereas Louisine was anticipating with pleasure her visit with her oldest friend, for the first time Mary Cassatt was dreading Louisine's arrival. After two unproductive years filled with illness, Cassatt had finally started to paint again and was making brightly colored pastels with bold, free strokes that she considered to be among her best works. She could not help seeing Louisine's stay as an interruption, fearing that she would not have enough energy to travel and converse with her visitor and still manage to paint. Cassatt's feelings were those of a consummate professional artist whose working time was sacred, particularly since she no longer had the physical stamina of her younger days. In early March she wrote to Joseph Durand-Ruel, apropos Louisine's arrival: "I am nervous and fear a relapse. I have such need for tranquility, and to finish my poor work. I am discouraged. It seems that I have nothing left to offer."* But what neither Louisine nor Mary Cassatt anticipated was that they would have no opportunity to see one another again for many years; the Great War that soon prevented their meetings would also cause the world as they knew it to vanish.

SEVENTEEN

Triumphs and Disappointments

On March 21, 1914, Louisine arrived at
the Villa Angeletto in Grasse filled with apprehension as to the state of Mary Cassatt's
health. She had not seen her friend for more than two years and had meanwhile been
inundated with letters from Cassatt describing endless symptoms. Much to her relief,
Louisine was soon able to write an affirmative report to Paul Durand-Ruel in Paris:
"I am very happy to find Miss Cassatt so well. She is better than I had dared expect.
Though she doesn't have the strength to do as much as in the past, she looks well and
has the fortitude to work."* Louisine asked Durand-Ruel to send her the catalogues
for the forthcoming estate sale of the vast collection belonging to Roger Marx, critic
and former general inspector of French museums, who had died the previous year.
Louisine inquired about the dates of the Marx sales, so she could arrange to be in Paris
for these events. Louisine's letter also contained warm wishes for Durand-Ruel's con-
tinued good health at eighty-three and for that of Joseph and his family; she gave him
reassuring news of his other son George, whom she had seen in New York the very
day of her departure. Touched by Louisine's genuine concern for the well-being of all
the Durand-Ruels, the dealer responded with an affectionate tribute:

> Your support and your friendship have always been precious to me and I have never
> forgotten that it is in great part because of you and your regretted husband that
> I was able to get myself out of the terrible situation I was in for many years, while
> trying to sustain my great artists and have their talents recognized.*

He told her that the catalogues of the Marx collection were not yet ready but that he
would send them to her with his estimates as soon as possible.

In the meantime Louisine and Mary Cassatt settled into a routine. Cassatt's fears
that Louisine's visit would interrupt her painting were quickly allayed, for Louisine

encouraged Cassatt to work as much as her weakened health would allow, Louisine later described her visit:

> We spent several months together in that lovely villa overlooking the Riviera, where she was painting her last pictures, living her last year of artistic activity before the failure of her sight began. She painted in the morning, I wrote. Then we took a walk with the dreadful little terrier she had [Louisine was mistaken; Cassatt's dogs were always Belgian griffons]. In the afternoon we motored hither and thither over those military alpine roads and after an early supper we talked and talked until her maid and my maid came and fairly took us away to bed. She was still the great conversationalist.[1]

Louisine, who actively disliked Cassatt's beloved dogs, continued: "She had many snarly cantankerous terriers during our long friendship but it always seemed to me the succeeding one was worse than its predecessor. Until at last, in 1914, she had a little fiend whom, even she, had to handle with gloves, but whose black glossy coat induced her to put him in several pictures."

During Louisine's sojourn, Cassatt was working on a pastel *Mother and Sleeping Child* (Plate 150); Louisine took a vivid interest in the process:

> She was painting a baby in its Mother's arms. She, the Mother, and good Mathilde [Mathilde Valet, Cassatt's faithful housekeeper-companion] were all tired amusing the baby who had no desire to be painted, even by Miss Cassatt. I went into the studio one morning and saw the whole picture had changed. The composition was no longer "de face." The little one had cuddled down into its Mother's neck and was fast asleep, caring little that we saw only her dimpled back, the drooping arm, and the pretty pink toes peeping out from under Mama's arm. The repose and abandonment of sleep were exquisitely expressed and there was absolute harmony from toe to crown. "Oh," I exclaimed, "you have changed the whole composition." "I had to," was the answer. "I spanked her three times and she cried herself to sleep. I am going to do her just so."[2]

When the pastel was completed, the artist sent it to the Galerie Durand-Ruel, from whom Louisine subsequently bought it. Louisine never took advantage of her friendship with the artist by purchasing pictures directly from her. Except on the rare occasions when Cassatt made a present of a work to her or one of her daughters, Louisine acquired almost all of her Cassatts from the Durand-Ruels or at auction. She particularly prized this pastel, ending her description: "It was one of the last she did and very masterful in technique. I always think of the spanking when I look at that picture. It must have been a funny process from Miss Cassatt's gentle hands."

It would seem natural that during their leisurely weeks together Mary Cassatt might undertake a portrait of Louisine; possibly she did so, but was dissatisfied with her efforts, just as she had been with her finished pastel of her friend, executed in 1896 (see Plate 67). About this portrait Cassatt had subsequently written to Louisine: "You will make such a splendid old woman, but I won't be there to paint you. I might have succeeded

there, though I did not come near your maturity."[3] Indeed, in Cassatt's portrait of Louisine at the age of forty-one the sitter seems swallowed up by her voluminous dress, by far the picture's most dominant feature, whereas her face plays a decidedly secondary role. Cassatt had been correct, however, in assuming that Louisine would become a handsome older woman. Now nearing fifty-nine, with snow-white hair impeccably coiffed (her only feature about which she was vain), alert eyes, and glowing skin, she had a look of both dignity and character. Her short figure was now less full than during her childbearing years and her manner of dress was of total simplicity. Her mellow voice radiated friendliness and compassion; her sense of humor was always apparent.

Compared with the older and rather frail Cassatt, who had to husband her energy for her work, Louisine was brimming with vitality. She took off on excursions when the spirit moved her; early in April she departed for Florence. Cassatt informed Joseph Durand-Ruel that Louisine intended to go to Montreux (by way of Grenoble) to see her ailing sister-in-law Emilie de Loosey Havemeyer, widow of Harry's older brother Theodore, and even seemed peeved that Louisine went traveling without her: "I do not have the strength to follow her on her travels. She doesn't understand this, but I have realized that I am not capable of doing what she does. It is impossible for most American women to stay put."*

Back at the Villa Angeletto from Italy, and the day before leaving for Montreux, Louisine wrote to Joseph Durand-Ruel on April 17 to relay her decisions about the Marx sales. She wanted three prints, one by Degas and two by Cassatt, and two pictures: Cassatt's *Mother Wearing a Sunflower* (Plate 151), for which she would bid up to 15,000 francs (about $3,000), and Degas's pastel *A Woman Having Her Hair Combed* (Plate 152), for which she was willing to pay 100,000 francs (about $20,000): "I hope to have better luck than at the Rouart sale, but I very much want this work [Degas's nude] because Mr. Havemeyer admired it." In her next letter, written from Montreux on April 24, Louisine notified Joseph: "For the Degas nude you can go a little more if necessary to have it. I want the picture and don't want to lose it." She also authorized him to increase her bid on the Cassatt painting. Originally she had planned to be in Paris for the Roger Marx print sale (April 27–May 2), but she now decided to go from Montreux to Germany, and asked him in the same letter:

> Are there any private collections in Berlin, I should see, and if so would a line from you to Drs. Friedländer or Bode make it possible for me to see them? Both have been received at my house and might be willing to make an effort in my behalf. While I am in Berlin I would like to see all that is desirable.

On April 28, Joseph wrote to Louisine in Munich that he would alert Bode and Max Friedländer of her impending arrival in Berlin, as well as the dealer Paul Cassirer, who for years had promoted the French Impressionists in Germany.

From Munich Louisine proceeded to Dresden, where she saw the important modern collection of a retired cotton merchant, Oscar Schmitz.[4] Louisine would always remain a perpetual student of art; she used travel as a chance to see as many great paintings as possible, to keep developing her eye and sharpening her perceptions. Another great pleasure for her in Germany was the opera; she was thrilled to attend performances of

La Bohème and *Aïda* on consecutive nights in Dresden's Opera House, one of the finest in Europe. Arriving in Berlin, she spent much time in museums, comparing their old masters to some of her own; of the private collections, the highlight for her was that of Eduard Arnhold, for he owned, among other paintings by Manet, *Le Bon Bock* (see Plate 126), which the Havemeyers had rejected in 1905.

While traveling in Germany Louisine kept in touch with Joseph Durand-Ruel, who told her on April 30 that they had secured the three prints she wanted from the Marx sale. The Degas etching, a self-portrait, had actually been sold to another collector in Joseph's absence; when told of the loss, Joseph offered the buyer more money, knowing Louisine's eagerness to possess this print. On May 2, she reassured him that he had done the right thing:

> I felt badly about the error, but I am glad you bought the portrait for me even if you had to pay so much for it. I felt worse that you were unable to attend the sale, and fear your dear Father is not improving [Paul Durand-Ruel had fallen ill]. I hope to hear good news and I am thinking of him and send him my best wishes. Please give my strict orders about the *Nude* of Degas. I should feel very badly to lose it. It is important to my collection.

Louisine did not want her near loss to occur twice.

Although Louisine had expected to be in Paris by May 10, her plans were altered by the sudden death of her sister-in-law in Montreux; she now had to return there to pick up Emilie Havemeyer's grandson, who had been visiting her. Louisine offered to bring the child from Switzerland to Paris, whence he would proceed to America. Emilie de Loosey Havemeyer, Austrian by birth, had been left well provided for by her husband Theodore. Her sumptuous New York mansion (one of her four residences) was filled with fine furniture, Gobelin tapestries, and many Salon paintings that she had chosen on the advice of a "celebrated" Viennese artist. Contrary to Louisine, her sister-in-law had lavish tastes; during the 1890s she had kept some twenty-five servants busy in her New York house alone with her frequent large-scale entertaining. After becoming a widow in 1897, she preferred to spend most of her time in France and Switzerland, maintaining residences in both countries; her life style continued on a rather extravagant level and she managed to go through her entire inheritance, dying a million dollars in debt. Harry Havemeyer had never cared for Emilie and saw little of her, but his nephew and namesake Henry Osborne Havemeyer had been his favorite among his brother's nine children. Out of loyalty to her husband's family, Louisine now tried to help in any way she could; on May 13 she left Montreux with her grandnephew in tow.

In Paris she was greeted with the news that Joseph Durand-Ruel, following her instructions, had bought for her account the two pictures she had wanted by Cassatt and Degas from the Roger Marx sale: Cassatt's *Mother Wearing a Sunflower* and Degas's *A Woman Having Her Hair Combed*. Louisine's Paris visit was off to a good start. Waiting for her at the Hôtel Crillon was a letter from Mary Cassatt, still in Grasse, who was preparing to return to her apartment on the rue de Marignan. Cassatt urged Louisine to pay a call on La Ferrière, her long-standing couturière, assuring her frugal friend that prices there were very reasonable. Whereas Cassatt had always taken a lively

interest in clothes, Louisine was oblivious to the latest fashions. She had dressed elegantly to please Harry, but even then her younger sister Adaline Peters, herself a very chic dresser, had to prompt her occasionally to spruce up. Though Louisine was willing to spend $95,000 on a picture, she would not dream of squandering money on elaborate outfits. As a friend of Louisine's later wrote: "She enjoyed economizing in the unimportant to feel quite at ease in the worthwhile expenditure."[5] In May 1914 Louisine had set her mind on buying art, not dresses.

She began at once to make the rounds of Paris dealers. From Gimpel and Wildenstein she acquired a *Portrait of a Young Woman in White* by David (Plate 153) and from Paul Rosenberg Courbet's *Alphonse Promayet*, one of the artist's "fine portraits . . . which reveals his analogy to Rembrandt."[6] On May 28 she bought from the Galerie Durand-Ruel two pastels by Mary Cassatt, the work whose execution she had watched (see Plate 150) and another larger pastel, paying $3,000 for them. Louisine also obtained, probably from Trotti, a work by Rubens, and added a thirteenth-century head of a king to her holdings in Gothic sculpture.

During Louisine's stay with Cassatt in Grasse, the two had talked for hours about Louisine's plan for a special Degas loan show in Durand-Ruel's New York gallery to benefit the Women's Political Union, in which she was taking an ever more active part. Louisine had had the idea for the exhibition at the beginning of 1914 and had discussed her proposal with George Durand-Ruel in New York, who in turn informed his brother in Paris. Subsequently Joseph Durand-Ruel and Mary Cassatt had exchanged views; Cassatt expressed her opinion to Louisine on February 15:

> J. Durand-Ruel wrote about your idea of an exhibition of Degas in favor of the suffrage. It is "piquant" considering Degas [sic] opinions. If you could get Col. Paine [sic] to lend his Degas & have the Pope's also and a lot of yours it would make a stir. . . . I do think it will be a great thing to have the Degas exhibition.[7]

Sometime during her visit at the Villa Angeletto, Louisine had decided that the show would have greater impact if it combined the work of Mary Cassatt with that of Degas. Cassatt was not receptive to this proposition at first, partly because she feared that a sufficient number of her pictures would not be available. But Louisine, never one to give up easily, employed strategies of persuasion:

> In 1914 when she left the Riviera and returned to Paris, I suggested that she should go through all the store closets in her apartment and into the big chest in the corridor where she kept her drawings and the studies for her pictures and see what would come forth. Mathilde, the faithful, was given the task, and faithfully did she accomplish it.[8]

Louisine was correct in thinking that such a search would yield rewards, for in addition to drawings and colored prints, an important picture was rediscovered:

> When I entered her apartment one afternoon, Miss Cassatt showed me *The Lady at the Tea Table* [see Plate 9] and said: "Tell me what you think of that." I looked

and answered: "Very fine. An early work. Why have you never shown it before?"
"The family did not like it, and I was so disappointed. I felt I never wanted to see
it again. I did it so carefully and you may be sure it was like her—but—no one
cared for it," she said sadly. "Well, I care for it," I said hotly, "and so will others
if they know anything," and I insisted that it should be shown.[9]

At Louisine's instigation, *The Lady at the Tea Table* (a portrait of Mrs. Robert
Moore Riddle) was sent to the Durand-Ruel's on the rue Laffitte, where it was the
"sensation" of the Cassatt show that opened on June 8; two Paris museums offered to
buy it, but the artist eventually presented it to New York's Metropolitan Museum. The
first visitor was Degas, who looked attentively at the works on display and then asked
Paul Durand-Ruel to remember him to the painter.

In the meantime Louisine had worn down Cassatt's resistance to a Degas–Cassatt
exhibition in New York; the artist gave her consent, promising to lend the pictures she
still owned: three paintings, including *The Lady at the Tea Table,* and a pastel. Her
parting words to Louisine were, "Go home and work for the suffrage. If the world is
to be saved, it will be the women who save it."[10] Louisine sailed for New York resolved
to carry out her friend's bidding.

In August 1914, less than two months after Louisine's return, the World War began
on the Western Front with lightning offensives by the German army that swept through
Belgium, Luxembourg, and into northern France. The fighting became heavy at Liège;
Mary Cassatt had high expectations for the Belgians, as she wrote to Louisine from
Mesnil-Théribus on August 13: "The battle in Belgium will be fought out long before
you get this. May it be a crushing defeat for Germany. That I think the whole world
will pray for."[11] Cassatt, like many others in Europe, thought the war would be over
quickly; she remained at her country home, situated in alarming proximity to the
Western Front. Then, according to Louisine, "she was forced to leave it suddenly one
morning as the Germans were within a few kilometers. . . ."[12] She first went to Dinard
(on the Channel, near Saint-Malô) where she "helped the good Mayoress feed the
refugees that poured into the city from Belgium."[13] Louisine, only too glad to be of
service, sent money to Mary Cassatt for the cause. From Dinard, Cassatt reported:

> Your kind letters have all "dropped in"—the first written was the last to reach me.
> I was touched by your anxieties over my fate. Here I am still in this "bicoque"
> [shanty] longing so much to get back to Beaufresne, but what the English call the
> "ding dong" of battle is still raging around me with dreadful slaughter.
>
> Of course, every question is subordinated to the war, but never more than now
> was suffrage for women the question of the day—the hope of the future. Surely,
> surely, women will wake to a sense of their duty and insist upon passing upon such
> subjects as war, and insist upon a voice in the world's government![14]

Sharing her friend's sentiments, Louisine had become increasingly involved in the
work of "her party," the Women's Political Union. The party did not think the passage
of a Constitutional amendment was then a practical possibility, but committed itself
instead to the policy of winning female suffrage state-by-state through referendums. The

energies of the Women's Political Union were now being directed at a major campaign in New York State to enlighten the male electorate and to arouse public sympathies on the issue of woman suffrage, hoping to win the franchise in a state referendum in November 1915.

Encouraged by Harriot Stanton Blatch, president of the Women's Political Union, Louisine began to develop from being a participant behind the scenes into becoming one of her party's increasingly visible members. She later recalled the circumstances of her debut as an "orator" on February 28, 1914:

> It was Mrs. Blatch who insisted that I could speak; that I must speak; and then saw to it that I did speak. I think I spoke just to please her. How well I remember that first time that I spoke to an audience! It was at a large meeting at my own house, and Miss Helen Todd, of California [Wyoming, Colorado, Idaho, Utah, Washington, and California were the first six states to grant the franchise to women], in order to answer our antisuffrage critics, was to tell us what the women of her State had already done with the vote. I was to introduce Miss Todd, and as I stood trembling amid the elaborate draperies of purple, white, and green, the colors of the Women's Political Union, if any one had asked me if I were upon the platform or the platform upon me, I should have given it to the platform.[15]

But Mrs. Blatch, herself a seasoned campaigner, sensed that Louisine's dignified appearance, friendly manner, and habitual good humor, combined with her genuine belief in the cause, would more than likely turn her into an effective speaker once she had some experience. Mrs. Blatch's instincts about her new recruit proved accurate, as Louisine went on to acknowledge:

> I mention it [her debt to Mrs. Blatch] to prove that one can learn to speak. Often when I stood upon a platform—sometimes very weary—and I was obliged to stop and think what *was* my subject for that occasion, but once started I forgot everything else and thought only of what I wanted to say. I enjoyed the speech as much as any one, and, although I frequently felt elated, never, I can truly say, did I feel conceit.

Louisine's speaking career started tentatively with only a few engagements in 1914. In November she delivered a ten-minute address in Greenwich, Connecticut, which she described to Mary Cassatt, who replied from Paris: "I have yours about your musicale & your speech. Do lean Louie on the fact that German 'Kulture' [sic] was purely masculine, and for that reason must disappear."[16] Cassatt was then particularly resentful of the Germans, because her devoted Alsatian-German housekeeper Mathilde had been forced to flee to Italy (Mathilde would ultimately spend the war in neutral Switzerland). Cassatt then decided that with her reduced household staff (her chauffeur was about to be drafted) and other wartime hardships she would be better off in the south of France. She returned to the Villa Angeletto in Grasse late in November 1914, still hoping that the "awful business" would soon be over. Although Louisine continued to cable and write, urging her friend to sail for New York, the determined Cassatt had no intention

of leaving France. One of her chief concerns was the safety of her four pictures that the Durand-Ruels were sending over for the Degas–Cassatt exhibition.

Meanwhile the scope of Louisine's benefit exhibition for female suffrage had expanded; instead of limiting it to works by Cassatt and Degas, she decided to add a selection of old masters. Cassatt was strongly in favor of this: "I advise you to put a Ver Meer of Delft near the Degas and let the public look first at the one and then at the other. It may give them something to think about."[17] The show now also changed its location; originally Louisine had intended to hold her Degas–Cassatt exhibition at the New York gallery of the Durand-Ruels. Once it was transformed into "Masterpieces by Old and Modern Painters" she decided to move it to M. Knoedler and Co. at 556 Fifth Avenue. On December 29, 1914, she wrote to Roland Knoedler: "I want to thank you again for your offer of the galleries during the month of April [1915] for Suffrage. I will make the exhibition a worthy one of which I hope you may be proud."[18]

Throughout the winter of 1914–15, Louisine was preoccupied with the complex organization of her benefit loan show. She thought up a number of schemes for publicity and raising money, occasionally trying one out on Cassatt, who, as always, expressed her frank opinion: "I really cannot give any of those [her four pictures] to be raffled for nor do I think it a good thing, it is lowering Art. You ought to do well without that. . . . No don't lower the exhibition by anything like that. Keep it very high."[19] Louisine's raffle idea was discarded. But her greatest difficulty was in obtaining the loan of pictures. Some of her good friends were refusing to cooperate. Unable to convince them, Louisine enlisted the aid of her staunch ally; Mary Cassatt did what she could to help: "I enclose a letter to Mrs. Pope [widow of Alfred Pope, who had died in 1913] and also, one to the Colonel [Oliver Payne, Louisine's next-door neighbor], *he* disappoints me much."[20] Neither Colonel Payne nor Mrs. Pope yielded to Cassatt's strong appeals. Louisine was frustrated but not defeated. She had better luck with other collectors—Harris Whittemore, Joseph Widener (son of Peter), Henry Frick, and Mrs. Montgomery Sears of Boston and Paris, all of whom supplied works by Degas. Mrs. Sears also lent three pastels by her old friend Mary Cassatt. The other works in the show's modern section would come from Louisine, Cassatt, and the Durand-Ruels. All loans were to be anonymous.

Even though she was mostly concerned with the rapidly approaching exhibition, Louisine began in 1915 to give one, if not more, speeches each month on behalf of the suffrage campaign. Her speech of February 23 was commented upon by Cassatt: "I have a letter from Annie [Munn, Louisine's older sister], she says you speak so well. I was sure you would. Annie is tepid over the suffrage and thinks that the exhibition is less interesting than the poor, if she could prove to me that every dollar spent to see pictures would be given to the poor were there no exhibition, yes, but that isn't the case."[21]

It had been decided by the organizing committee that an admission fee of one dollar would be charged at the Knoedler show. To help raise additional funds for the Women's Political Union Louisine reluctantly agreed to give a talk on Degas and Cassatt. She later admitted her trepidations:

To contrast the old [masters] with the modern gave me a most attractive programme; but nevertheless, probably on account of the enthusiasm it excited and the wide publicity the exhibition received, I was very much frightened at this venture into a new field of oratory so different from anything I had ever attempted before. It was very easy to talk about the emancipation of women, but art was a very different and difficult subject.[22]

Knowing that the New York art critics would be only too eager to challenge her remarks, especially on Degas, Louisine sought the advice of the "dean" of critics Royal Cortissoz, who counseled her to write down her speech ahead of time. She had never before written a speech and was horrified at the prospect, but she knew Cortissoz was right. After reading her "maiden midnight effort," Cortissoz pronounced the speech "sluicy."

Although encouraged by Cortissoz's response, Louisine still felt the need of a dry run before actually facing her audience. Harriot Stanton Blatch later gave an account of Louisine's practice session:

Mrs. Havemeyer was modest and conscientious in the extreme. She wanted credit to be done the great cause she espoused. She insisted I should hear the speech and give her the benefit of criticism. She wanted to rehearse on the very spot where she was to speak the next afternoon at the opening of the exhibition [April 6, 1915]. I was greatly pleased with the rehearsal. She was not so happy. She wanted me to be severe. I refused, as I assured her, not because I was afraid of her, or afraid of upsetting her, but because I found her so frank, simple, and dead in earnest, that I wanted her to be completely herself. I wanted whatever growth she made in the future to be the outcome of her own experience, to spring from her own brain and heart.[23]

The loan collection of "Masterpieces by Old and Modern Painters" opened on April 6 with a private viewing. Knoedler's large ground-floor gallery contained twenty-three works by Degas and eighteen by Cassatt; the two smaller rooms displayed eighteen paintings by such artists as Bronzino, Van Dyck, Holbein, De Hooch, Rembrandt, Rubens, and Vermeer. Four pictures were still missing from the old master section because a violent snowstorm had held up their transportation. Fortunately the weather had lightened on the afternoon of Louisine's address: "When at five o'clock to the minute, Mrs. Havemeyer in a gown of salmon satin with a velvet tippet and a picture hat, stepped upon an improvised rostrum, she faced an audience of about eighty persons."[24] Louisine's talk lasted for nearly an hour; she did not read from the speech she had prepared for the critics, but instead spoke extemporaneously. In her "Remarks on Edgar Degas and Mary Cassatt" she skillfully combined personal anecdotes about each artist, insights into their working methods, and a perceptive analysis of specific pictures. Louisine emphasized the fact that the exhibition provided a unique opportunity to compare older schools of painting with the French moderns. She admonished her listeners to use the occasion to expand their artistic horizons: "You must come here and

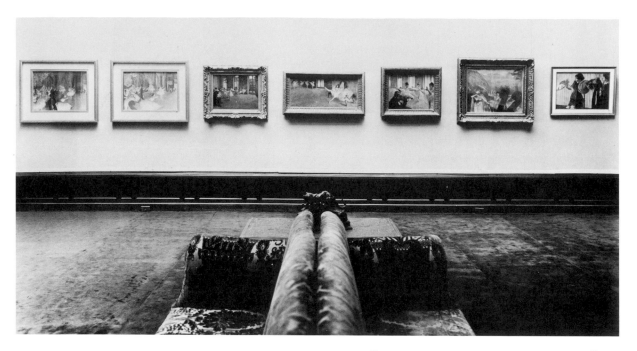

INSTALLATION PHOTOGRAPHS OF THE ANONYMOUS LOAN EXHIBITION OF "MASTERPIECES BY OLD AND MODERN PAINTERS,"
HELD IN 1915 AT M. KNOEDLER AND CO., NEW YORK, FOR THE BENEFIT OF WOMAN SUFFRAGE.
Photographs courtesy of M. Knoedler and Co.

*Above: Wall with works by Degas. Three belonged to Louisine Havemeyer: the two
ballet scenes at far left and the milliner's scene at far right. Third from left,* Dancing Rehearsal, *lent
by Harris Whittemore (now Fogg Art Museum, Cambridge); center,* Before the Ballet, *lent by Joseph Widener
(now National Gallery of Art, Washington, D.C.); third from right,* The Rehearsal, *lent by Henry Clay Frick
(now Frick Collection, New York); second from right,* Aria and Ballet of the Opera L'Africaine
[by Meyerbeer], *lent by Durand-Ruel Gallery (now Dallas Museum of Art)*

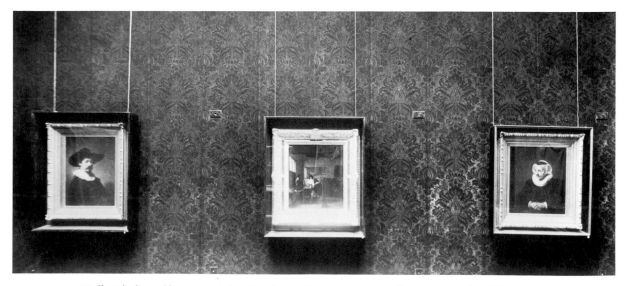

Wall with three old master paintings lent by Louisine Havemeyer. Left to right: Rembrandt's Herman
Doomer (The Gilder), *De Hooch's* The Visit, *and Rembrandt's* Portrait of an Old Woman
(all now Metropolitan Museum of Art)

Wall of same room, with works by Mary Cassatt. Lady at the Tea
Table *(now Metropolitan Museum of Art) is in the center. Among Louisine Havemeyer's loans were:*
third from left, Mother and Child *(later destroyed by fire); fifth from left,* Young Mother Sewing *(now*
Metropolitan Museum of Art); fourth from right, The Oval Mirror *(now Metropolitan Museum of Art);*
third from right, Mother Nursing Her Child *(now Art Institute of Chicago); far right,* Mother
Wearing a Sunflower *(now National Gallery of Art, Washington, D.C.). The pastel at far left,*
Mother in a Striped Head Scarf Embraced by Her Baby, *was bought by Louisine from the*
Durand-Ruel Gallery during the exhibition

look, and look with an eye that will grow more intelligent at each visit. You will never
'learn art,' as many express it, with your backs toward the pictures, as I have seen visitors
do frequently in galleries, while they rhapsodize with some friend in a silly manner."[25]
Her talk was warmly received, and was praised unanimously in the press.

Louisine felt exhilarated, but did not let her success go to her head. Mrs. Blatch
admired her unwavering dedication:

> A wise campaigner, Mrs. Havemeyer did not forget the object of the exhibition.
> In each interview with reporters, in all personal contacts with paper boys, packers,
> dray men, the guests at the opening, and the head of the gallery, she made it plain
> that she was enthusiastic about winning the vote for women.[26]

Yet Louisine's achievement lay in two distinct spheres, as she herself recognized: "I think
I did a bit of good in an art way also, and I felt very happy afterward when some one
would say to me: '*You* made me understand Degas for the first time.' "[27] Joseph
Durand-Ruel, who was in the audience, was so impressed by her speech that he had
an abridged version printed and sent it to his European clients; extra copies were sold
for the benefit of the cause. The publicity generated by her talk sparked interest in the
exhibition, making Louisine's triumph complete.

April 1915 seemed to be Louisine's month for rewards; she was lauded from all

sides, sometimes by those not given to flattery; even Mary Cassatt paid her a compliment:

> My dear Fabre, the naturalist [Jean Henri Fabre (1823–1915), author of *Souvenirs entomologiques*] says that if you are destined to do something you meet the people who can help you. Now you are destined to accomplish something & I have probably been a help, just as you and Mr. Havemeyer have been to me. The constant preoccupation with your collection developed my critical faculty. . . . You will be a [sic] anchor till the last, perhaps I may be too.[28]

Another still less likely source of flattery was the collector Dr. Albert C. Barnes of Pennsylvania. Barnes (1872–1951) had not yet acquired the chip on his shoulder and the hostility toward most of the world for which he later became famous, but he had a contradictory, aggressive personality and a volatile temper. His discovery of the antiseptic Argyrol had made him a millionaire overnight; soon he became boastful about his pictures, even though he had only recently begun to collect works by such artists as Renoir, Cézanne, Matisse, and Picasso. Yet Barnes genuinely loved art and had committed himself to building a collection that embodied his "own, much and intensely-worked-for viewpoint."[29] He understood the importance of developing a discriminating eye, and to achieve this aim by losing "no opportunity to look at paintings everywhere."[30] Barnes's article "How to Judge a Painting," which appeared in *Arts and Decoration* during the run of Louisine's exhibition, stated:

> For instruction, one naturally turns to the great private collections like Weidener's [sic], Johnson's, Havemeyer's, Frick's, Altman's (now in the Metropolitan Museum), most of which are to be freely seen by applicants. They are all superb, with the Havemeyer easily first in importance in art rather than names, and each collection reflects its owners predominant characteristic. The Weidener and Frick are swagger, the former excelling in blue-bloodedness of great pictures by names conjured with by the experts and dealers in old masters. In these two collections, especially the Weidener, almost every painting is pedigreed, catalogued, certified by experts. They contain, in best examples, the great art of the past only. They are essentially millionaires' collections. . . . Havemeyer's is the best and wisest collection in America. There are less old masters there than in the others, but that is more than compensated for by the large number of paintings by the men that make up the greatest movement in the entire history of art—the Frenchmen of about 1860 and later, whose work is so richly expressive of life that means most to the normal man alive today. One could study art and its relations to life to better advantage in the Havemeyer collection than in any single gallery in the world.[31]

Louisine was exceedingly impressed by the sincerity and keenness of Barnes's response to her pictures; he had recognized the essence of the Havemeyer collection, its concentration on paintings devoted to the direct observation of the real world. Yet she remained aware of the wiles of this voracious collector. Years later, when Barnes had developed an overwhelming passion for the work of Renoir, he offered her a

substantial price for *By the Seashore* (see Plate 98), Louisine's single painting by that artist. She replied without hesitation: "Thank you, Dr. Barnes, when I need $10,000, I'll let you know."[32]

The Knoedler speech had enhanced Louisine's self-confidence; she now felt up to accepting other challenges in the public arena. Her engagements on behalf of her party's campaign through New York State for female suffrage became more frequent and her speeches longer. In early June Mrs. Blatch had a new publicity idea, a "Torch of Liberty" that would be carried from Montauk Point to Buffalo as a statewide symbol of the freedom the suffragists were seeking. The Liberty Torch made a rather hasty debut on the far eastern tip of Long Island; Louisine was recruited to transport it to the western limits of New York State. But she was asked to make an unscheduled appearance in Manhattan before the start of her ten-day tour. Louisine vividly recalled holding aloft for the first time what soon became a celebrated piece of wood:

As I ran, the torch was thrust into my hand; I was "boosted" onto the stand, while about thirty cameras were trying to "snap" me. All I recollect was that I had an intense desire to step out of the lunch-wagon [used for a speaker's stand] and walk upon the numberless straw hats that spread out before me like an endless field of grain. The luncheon-hour had assembled one of the largest audiences I ever spoke to, and almost every man wore a straw hat. I suppose the new situation excited me; I lifted the torch as high as I could and for once I did not have to think—the words came to me as if by inspiration; I could not utter them fast enough; I feared the moments would pass before I had told those men all I wanted them to hear.[33]

That day Louisine and the Liberty Torch left for upstate New York in her chauffeur-driven landaulet, which came to be called the "Jewel Box" and served often as a speaker's podium. She delivered an average of seven speeches a day for a week and a half, at garden parties, clubs, the state fair, and on street corners; the torch, playing a vital part in each of her rousing performances, "leaped into notoriety with bounds and strides."[34] By the time the "Jewel Box" rolled into Chautauqua County, the Liberty Torch's reputation had preceded it, and the great meeting hall at Chautauqua was filled with a vast audience who "surged around the platform where I spoke, and as I finished my speech they begged to be allowed to hold the torch, which they did with deep reverence, causing a delay of over an hour in our schedule."[35]

New York State's Torch of Liberty became such a popular drawing card that the New Jersey branch of the Women's Political Union asked to borrow it; the decision was made that the torch would be exchanged between New York City and Jersey City, from tugboats moored at the states' boundary line halfway between the east and west shores of the Hudson River. Louisine was selected to represent her party at the ceremony, and set sail on August 7, wearing a flowered hat and a sash with "Votes for Women." The mid-river transfer did not take place quite as smoothly as anticipated. There was an embarrassing delay when the New Jersey participants found they needed a license for their tugboat to cruise; Louisine, waiting in choppy water, became wretchedly seasick and had to lie down. Just as she was feeling ready to "commit" herself to the waves, the New Jersey tug pulled alongside, and Louisine bravely stood up and

Louisine Havemeyer holding the "Torch of Liberty" while speaking to a straw-hatted male audience in New York, summer 1915. For photograph source, see n. 10, Ch. XVI

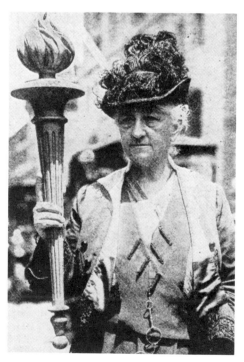

Louisine Havemeyer and the "Torch of Liberty," 1915. For photograph source, see n. 10, Ch. XVI

Louisine Havemeyer's "Ship of State," the emblem she devised in 1915 after relinquishing the "Torch of Liberty." Photograph courtesy of George G. Frelinghuysen

The mid-river transfer. Louisine Havemeyer, right, passing the "Torch of Liberty" to a member of the New Jersey branch of the Women's Political Union, August 7, 1915. For photograph source, see n. 10, Ch. XVI

rallied her strength for the cause. Leaning over the side of the tug, she passed her now beloved Liberty Torch to a fellow suffragist from the neighbor state, then made a stirring presentation speech. The situation had been saved and had turned into the spectacular publicity event that suffragists on both sides of the river had hoped for.

Inspired by the success of the torch, Louisine soon developed another emblem, the "Ship of State" (modeled on the *Mayflower*), with battery-powered wiring that lighted up its thirty-three tiny electric bulbs. Louisine's ship would rest dark beside her until she spoke of an enlightened future bringing the vote for women. Then she pressed a button and the ship was ablaze; wherever she went the crowds loved her dramatic finale, and Louisine once again felt like a heroine.

Yet in spite of the vigorous campaign waged by the Women's Political Union and the other suffragist associations, "the day of doom" came on election day in November 1915, when the female suffrage proposition was defeated in New York State. Louisine would learn to accept the loss philosophically, but at the time her disappointment was crushing, particularly since she and so many others had expended so much energy and effort. With the negative outcome of the referendum, Louisine's party altered its course; it was amalgamated with and absorbed by the Congressional Union (which in turn would become the National Woman's Party), an organization whose sole aim was the passage of the Susan B. Anthony Federal Suffrage Amendment in the nation's Congress. Louisine, having lost faith in state politics, would now devote her talents and enthusiasm to the nationwide campaign for an amendment to the United States Constitution.

Louisine's intense preoccupation with the suffrage cause throughout 1915 had left little time for anything else, but after the defeat of the referendum she returned to her

other interests. In March 1916, she bought Courbet's *The Source* (Plate 154), for 50,000 francs (about $10,000), a work the Durand-Ruels' New York gallery had recently received on consignment from a French dealer. She resumed an active correspondence with Théodore Duret which led to the acquisition of several more paintings by Courbet. Mary Cassatt, who occasionally traveled from Grasse to Paris, also had her part in Louisine's purchases during the war years. Although suffering from increasingly impaired sight (in October 1915 she had undergone the first of a number of unsuccessful operations for cataracts), Cassatt managed to climb Duret's steep stairs to look at Courbet's *The Knife-Grinders,* an early work that her friend was considering. Since Louisine had only a photograph from which to judge the painting, she depended upon Cassatt's and Duret's recommendations; on August 7, 1916, she informed Duret:

> I have just cabled you that I shall take *The Knife-Grinders* by Courbet [Plate 155]. Without doubt, Miss Cassatt was mistaken about the price [Cassatt had reported the price at 12,000 francs whereas it was actually 20,000 francs, about $4,000] and I am relying on you that the picture is beautiful and should be in my collection. It is from a period of the painter of which I have few examples. But that is not what concerns me, I am more interested in the artistic side of the master and I hope to receive it soon. I am certain that it must be beautiful.[36]*

It is possible to detect some hesitation in Louisine's letter, though she must still have hoped that *The Knife-Grinders* would be comparable to the majestic simplicity of Courbet's *The Stone Breakers* that she had admired in Dresden. Despite assurances of Duret—whose financial interest in the deal was obvious—and the favorable opinion of Cassatt—whose eyesight was now poor—Courbet's *The Knife-Grinders* is in fact a particularly awkward and unsatisfactory painting. The question is moot whether Louisine realized this (after all, she owned so many superb figure pieces by Courbet) and was charitably hiding her disappointment or whether she really meant what she said when she later wrote to Duret: "*The Knife-Grinders* has finally arrived! A beautiful picture which makes me think of *The Stonebreakers* that I saw two years ago. . . ."[37]* Nevertheless she noted in her *Memoirs* that the painting did not have "the wonderful light and shade of *Les Casseurs* [*The Stone Breakers*]."[38]

On the other hand, Louisine owed her new acquisition of three outstanding works by Degas to Mary Cassatt's initiative. No longer able to paint, Cassatt relished more than ever the pursuit of pictures, an occupation that took her mind off the horrors of war and her many problems. In 1915 an artist-dealer and friend of Degas's, Michel Manzi, had died, leaving a wife and daughters, whom he had told to apply first to Mary Cassatt, should they need to sell any pictures. When the Manzi heirs subsequently approached her, she excitedly wrote to Louisine:

> I advise you to buy one of the finest Degas. It is much in the style of a Vermeer and quite as interesting, very quiet and reposeful. It is a beautiful picture [Plate 156]. A woman in black seated upon a sofa against the light the model was a sister of Berthe Morisot, not handsome, but a Degas! The picture has never been shown.

. . . Then there is another thing I am to see, another picture, small, *danseuses* [Plate 157], very fine in execution.[39]

About *The Dancing Class,* Cassatt told Louisine that Degas had refused to look at it even years ago, saying it reminded him of the days when he was young and had his eyes. Cassatt considered these works to be of exceptional quality and urged Louisine to purchase them, in spite of the high price the Manzi family wanted for them. She soon met with the heirs and convinced them to come down slightly in price as well as to "add to the bargain" an oil sketch on pink paper. Louisine could not refuse, when Cassatt insisted: "I am doing this for you, dear! I really think it is a chance and your collection of Degas ought to be very complete with these two pictures and the pastel [i.e., oil sketch]; it, too, is a fine thing."[40] The transaction was completed within a month or two and the pictures were shipped before the United States entered the war in April 1917. Louisine was enchanted with both paintings: *Madame Gobillard-Morisot* quickly became one of her favorites: "It seems to me it is not a picture, it is not a portrait, it is an inspiration. Degas never did anything like it again. I doubt if he ever could, I doubt if *ever* any painter could do such a picture. It is forever! it is an art epoch in itself."[41]

A few months after Louisine had received these paintings, Degas died, on September 27, 1917, at the age of eighty-three. During his last years the artist's physical and mental condition had deteriorated; unkempt and nearly blind, he had compulsively wandered about Paris until finally he was forced to remain in bed. Mary Cassatt glumly informed an American painter-friend: "His death is a deliverance but I am sad he was my oldest friend here, and the last great artist of the 19th Century—I see no one to replace him . . ."[42] Degas's passing added one more to Cassatt's irreparable losses: her immediate family members, her health, French civilization as she knew it, her eyesight, and, worst of all, her ability to paint. Deprived of these emotional attachments and of her work, Cassatt's outlook at times became admittedly bleak: "I am glad to know that you are busy if one can work life is still worth living, if one cannot it is indeed a burden,"[43] she wrote to Louisine. Repeatedly Louisine begged her friend to come to America to escape the war, but Cassatt saw it her duty to remain in France.

Louisine was also experiencing her share of concerns and losses. Her younger brother George Waldron Elder died suddenly in the spring of 1916; a year later her older sister Annie (Mrs. Henry N. Munn) suffered a fatal heart attack on May 15, 1917. Charles Freer offered heartfelt condolences: "The going onward of one's dearest kin is always a terrible blow no matter what preparation is made in advance—and the continued absence is the greatest of voids. But your courage is wonderful, and I am wishing you lots of strength for the late winter brought you great care and the springtime deep sorrow."[44] Louisine would indeed need her strength to keep up the morale of her daughter Electra, when Electra's husband was sent to France as a captain in the 311th Field Artillery.

The deaths of her brother and sister may have prompted Louisine to write her will, leaving everything to her children. She was also motivated to proceed with her *Memoirs,* wanting her family to have a first-hand account of the collection that she considered

her life's work. Louisine tried to record her failures and successes with equal sincerity, in this displaying her characteristic modesty, her charm, and her sense of humor. Yet her strong personality is not often evident in *Sixteen to Sixty, Memoirs of a Collector*; as a writer she was self-conscious, expressing herself in a manner suitable to a Victorian lady, in contrast to her spontaneous and highly spirited public speeches. Her writing is sentimental, even saccharine in tone, with occasional flights of fancy such as an invented conversation between Manet and Veronese ("Father Paul"), inspired by Manet's *Blue Venice* (see Plate 51). Louisine would not have accomplished all that she did had she been merely as sweet and uncomplicated as she portrayed herself; in reality she was a woman of action, determination, and independent ideas. She had a rare sense of social responsibility and full commitment to the causes she chose.

From the onset of the war in Europe, Louisine had contributed money for refugees and for wounded French soldiers. The American Ambulance Field Service in France had been backed by private donations in the United States before America entered the war in April 1917. Louisine sent checks regularly for medical supplies, and secured aid from many friends. She maintained strong opinions on issues pertaining to the war, as indicated by a letter from Charles Freer of August 20, 1917:

> You are most kind to ask me back to Palmer Hill ["Hilltop," Louisine's residence in Connecticut] again so soon. You know I love it and would enjoy greatly seeing you and chatting with you. I am dying for another fight and you are a mighty fighter but our next set must not be over war details—our strength such as it is, must be exerted toward the goodness and beauty of life—its revival and upbuild.[45]

By then the "mighty fighter" was engaged in war work; her activities were numerous, according to her own account:

> I spoke continuously, while the war lasted, on Liberty Loans, [the Woman's] Land Army, food conservation, economy and relief, and conducted a "jam campaign" in which the women of several [Connecticut] counties . . . made and shipped, the first year of our war, thirty thousand pounds of jam to the wounded soldiers at the front, and the second year increased it to forty thousand pounds. I also started and won out in a running fight of four years with the administration in order, for the sake of efficiency, to secure for our Army Nurses Corps relative rank similar to that in the Canadian and Australian armies.[46]

The war services performed by Louisine and by women across the nation, both at home and abroad, accelerated social change for the suffragists, causing restrictions and taboos against women to begin to crumble.

But the idealism aroused by the world conflict and the constant talk of democracy, liberty, and justice did not bring victory to the suffragists; the vote would not be won without a bitter struggle. Louisine's war efforts never diverted her mind and energies from her suffrage goals. She served on the Advisory Council of the National Woman's Party, whose members continued to work exclusively for the enfranchisement of women and, in 1917, started to picket at the White House gates or in front of the

Capitol. Their picketing went on day after day in all kinds of weather for over a year and a half, causing a storm of protest and hostility, but serving to keep suffrage activities in the public eye. These militants even made headlines when some from their ranks were arrested and, after refusing to pay a fine, sent to jail. Louisine approved of such actions; she admired the courage of this "valiant body of women" and shared their impatience at the interminably slow progress of the proposed Federal Suffrage Amendment.

EIGHTEEN

Passage to Independence

After the armistice of November 11, 1918, the middle of January 1919 saw the beginning of the Peace Conference in Paris, but Louisine's son-in-law Watson Webb remained in France with the 311th Division. Electra Webb and her four children had moved into the house of the late Colonel Oliver Payne, next door to 1 East 66th Street, and she was doing her best to find influential people who could expedite her husband's discharge. Meanwhile she wrote daily to Watson, detailing her activities and those of other family members. During the second week in February, Electra sent him the following report:

> I wanted to write you last night but somehow I am disgruntled with the whole world so thought best to get a good nights rest first. I have been frightfully upset over Mother. She went down to Washington on suffrage and of course got arrested and was sentenced to five days in jail or pay a $5 fine which she wouldn't do, so she went to jail. Of course most people think it a joke but I felt dreadfully also she decided to go on a hunger strike which drove me crazy. Horace was in Cuba, Doris melted into tears and Adaline was peeved in Morristown so I had the brunt of it. Well to make a long story short after many telephones to the jail I persuaded her to come home and she is back having spent one night in the detention house and one night in jail. Of course it was all in the papers and I was really very upset over the whole thing.[1]

Louisine's arrest was front page news. Alice Paul, head of the National Woman's Party, anticipating defeat of the Federal Suffrage Amendment in the Senate, had summoned Louisine to Washington, where she was to take part in a dramatic demonstration the day before the Senate vote. This demonstration consisted in the burning in effigy of President Wilson in front of the White House, and it was expected that the perpetrators would be arrested and jailed. After their release, Louisine and several

demonstrators, together with others who had previously undergone incarceration, were to tour the country in a railroad car called the "Prison Special" to attract national publicity by describing their "degrading" treatment. Alice Paul specifically wanted Louisine as a speaker on this trip, but to qualify she had first to be imprisoned.

At half-past four on the designated Sunday afternoon a procession of a hundred women, headed by Louisine bearing the American flag, marched to the White House sidewalk, where an urn filled with burning firewood was placed. One of the participants advanced and dropped into the flames a small paper cartoon of the President, whom they blamed for not having exerted enough influence over recalcitrant senators. The "bluecoats" began to haul away the "petticoats,"[2] but a certain Captain Flathers was reluctant to arrest the dignified sixty-four-year-old Louisine; she was having difficulty striking a match to ignite the bundle of wood she was supposed to throw on the urn, and her fellow culprits were handing her already burning bundles. Finally the police captain succumbed, and led her away with thirty-nine others destined for the station-house. Before entering the "black maria," Louisine managed to say:

> Every Anglo-Saxon government in the world has enfranchised its women. In Russia, in Hungary, in Germany itself, the women are completely enfranchised, and thirty-four are now sitting in the new Reichstag. We women of America are assembled here today to voice our deep indignation that while such efforts are being made to establish democracy for Europe, American women are still deprived of a voice in their government here at home.[3]

While Louisine was being tried and sentenced, the Senate was debating the Woman's Suffrage Amendment; it was defeated by one vote.

In spite of the conditions in a jail "discarded ten years before as unfit to hold a human being,"[4] Louisine had every intention of serving her five-day sentence, yet after spending one night in a dank cell sleeping on a dirty straw bed she was besieged by communiqués from her family:

> But those telegrams, oh, those telegrams! From them I gleaned I had stripped the family tree, I had broken its branches, I had torn up its roots and laid it prostrate in the sorrowing dust. What had the whole treeful of innocents ever done that I should treat them thus? Did I realize I had lost my citizenship? That telegram forgot that citizenship (real citizenship) was what I was fighting for—and theirs as well as mine! . . . Did I know I could never *never* escape being on an oyster-shell in society? Sacred Mammon! the curse was crushing! But there were other telegrams which did hurt—tore at my heart. . . . Also there were comforting telegrams: . . . "Don't mind us, although we are heart-broken, if you think you should stay."[5]

Since Alice Paul was satisfied that she had qualified for the "Prison Special," Louisine paid the fine in lieu of the rest of her sentence. Before leaving for home, she contributed an additional $500 (she had already given $1,000) for the expenses of the "Prison Special," and promised to try to be ready on the following Sunday to depart with her

fellow "Prison Specialists." Upon her return from Washington, Louisine was not exactly hailed by her relatives as a conquering heroine. Though most of them welcomed her back and listened to her reasons for having joined the protest, she had to defend her actions to those who accused her of disgracing the family name.

Louisine, relying on her own judgment, was convinced of the soundness of her policies. She sought no further sanction, and after recovering from her ordeal, she prepared once again to forge ahead:

> The next week with only the qualified consent of the "family tree" which by this time had stiffened up a little from its storm-and-stress experience, I again took my grip and started for Washington. I had just time to board the Prison Special, which was about to start for its trans-continental trip. The car accommodated twenty-nine and there were twenty-nine of us on board.[6]

The group of speakers on the "Democracy Limited, the Prison Special" spent twenty-nine strenuous days touring the country, telling the story of their arrests, describing prison conditions, and pleading for enfranchisement. According to Louisine, they "threw out anchor in any State where senators or representatives could be won, or where it was necessary to win over constituents to instruct their senators or representatives in Washington."[7] In most instances the suffragists spoke to packed houses, and Louisine was usually first on the program to warm up the crowd. The local police in every city treated the "Prison Specialists" with consideration. Although Louisine usually refused to be photographed, she made an exception in Detroit when told that the captain of the traffic police had asked to meet her: as she posed beside the severe-looking captain, she suddenly had an idea for publicity: " 'Not on your life, Captain,' " she exclaimed, " 'We are not going to be photographed like that. They might think you are arresting me. We will be shaking hands.' "[8] The "Prison Special" ended its tour in New York City, where 3,500 women crowded into Carnegie Hall to give the campaigners a hearty reception. Louisine began her address at the rally by triumphantly announcing: "The militants are here and we haven't broken anything, not even broken down."[9]

Through her participation in the suffrage struggle Louisine had become increasingly independent. Certain family members resented her defiance and her combative public manner, traits not "appropriate" to a grandmother of her social position. Her son-in-law Peter Frelinghuysen seems to have been outraged, refusing to have a "jailbird" in his house; when Louisine went to the Frelinghuysens' residence in Morristown, she had to wait outside in the car. But such hostilities did not keep Louisine from her suffrage activities. After passage of the Woman Suffrage Amendment in the House of Representatives on May 21, 1919, and in the Senate on June 4, she entered into the intense campaign for ratification of the Nineteenth Amendment by the necessary thirty-six state legislatures. Traveling widely, she gave speeches, lobbied special committees, and picketed the Republican National Convention in Chicago, carrying a banner that read: "Theodore Roosevelt Advocated Woman Suffrage. Has the Republican Party Forgotten the Principles of Theodore Roosevelt?"[10] Louisine's fierce commitment to female enfranchisement did not cease until the Woman Suffrage Amendment was proclaimed part of the Constitution of the United States in August 1920. After that, she became

Louisine Havemeyer and captain of traffic police in Detroit, on a stop of the "Democracy Limited, the Prison Special," 1919. For photograph source, see n. 2, Ch. XVIII

Louisine Havemeyer, member of the National Woman's Party Advisory Council, picketing the Republican National Convention in Chicago, 1920. Photograph courtesy of George G. Frelinghuysen

Collector's label for the Havemeyer Collection (HOH); Monet's Village Street *(Plate 86: Snow at Argenteuil) identified and numbered in Louisine's handwriting. Photograph courtesy of Christie's, New York*

Louisine Havemeyer with five grandchildren (except for seated girl at far right) at "Ne–Ha–Sa–Ne," the Webbs' summer camp in the Adirondacks (Lake Lila in background), summer 1923. Photograph courtesy of J. Watson Webb, Jr.

a staunch advocate of women's rights, convinced that suffrage was only the first step in filling the needs of womanhood in society.

Even Mary Cassatt was stunned by the lengths to which Louisine had gone for the suffrage cause. Not long after Louisine's arrest and railroad trip in 1919, Cassatt expressed her opinion in a letter to the daughter of one of her American doctors: "I hear very often from Mrs. Havemeyer who has given me news of you but she is immersed in politics which I gravely regret, not that I am not strongly for suffrage but there are limits."[11] Age was making Cassatt indifferent to certain issues she had felt strongly about before, although that was not the case in matters concerning art; there she maintained her vital interest. She was becoming especially cranky and more vindictive toward her nieces and nephews, whom she considered unworthy of inheriting her pictures since they had no appreciation or understanding of those the family already possessed.

During the war Cassatt had asked the Durand-Ruels to safeguard three of her works by Degas: a pastel of a nude in a tub (Plate 158), a bust-length portrait of a young woman, and a silk fan with dancers. In 1917 she had sold all three for $20,000 to Louisine, and George Durand-Ruel had them shipped to New York six months after the armistice. When her sister-in-law Lois (Alexander's widow) died early in 1920 and one of their three children began to dispose of his share of the family's pictures, Cassatt felt more than justified in having channeled her holdings by Degas into the Havemeyer collection. She confided to Louisine: "How glad I am you have the Degas, it is a relief & I must sell my only remaining [Cassatt] picture, then there will be nothing left."[12]

Louisine was delighted to own the works by Degas that had belonged to Mary Cassatt. Her knowledge that she would eventually obtain them had probably kept her from bidding in 1918 and 1919 during the four sales of the contents of Degas's studio. Cassatt was, moreover, not impressed by what was being auctioned, as she commented to her friend in May 1918: "I send with this the account of the first day's sale of Degas [sic] *atelier*. The prices were high for there was nothing of his best, when one thinks of how nobody would buy when you first began! But that is the way with everything."[13] Cassatt also assured Louisine that her nude woman in a tub was far superior to any of the less finished nudes found in Degas's studio. Out of the first of two auctions of Degas's own impressive collection, however, comprising works principally by nineteenth-century artists from Ingres to Van Gogh, Louisine had made one purchase: Cassatt's intricately posed *Girl Arranging Her Hair* (Plate 159), for which Joseph Durand-Ruel paid about $4,600 on her behalf. This was the very painting which Degas had exchanged with Cassatt for his pastel of the nude in a tub.

In the same sale were two splendid paintings by Ingres (Degas had owned twenty canvases by the artist), portraits of Jacques-Louis Leblanc and his wife. Although Louisine had always coveted an important Ingres, she did not bid on these for two reasons: she knew that the Metropolitan Museum was interested in the pair and had even requested Cassatt's opinion of them, and she had already purchased Ingres's likeness of Joseph-Antoine Moltedo (Plate 160) from Théodore Duret. Duret had offered this painting to the Havemeyers (through Mary Cassatt) in 1905, but Louisine and Harry had turned it down because they specifically wanted an attractive woman's portrait, and preferred to wait. Yet after her husband died, Louisine, never having been able to secure

a female portrait, had acquired *Joseph-Antoine Moltedo,* about which she had written to Duret in 1916: "Ingres's portrait still gives me more and more pleasure like so many other canvases I owe to your energy."[14]*

Louisine continued to deal with Duret, now eighty-two years old. She inaugurated the decade of the 1920s with a purchase through the auspices of the elderly agent-critic, Courbet's *The Young Bather* (Plate 161), apparently painted from the same model as his *Woman with a Parrot.* At last Louisine no longer had to put a full-length Courbet nude in the closet! She maintained her confidence in Duret's integrity, despite Cassatt's recent warning that his motive for strongly recommending a picture in some instances was his commission. But Cassatt agreed that *The Young Bather* was a splendid addition to the collection and "not dear" besides.

Toward the end of 1920 Louisine was offered a Courbet still life by the Paris dealer Paul Rosenberg. This *Still Life—Fruit* (Plate 163) was the very picture Louisine had lost in December 1912 to an "unknown party" at an auction in Brussels. Exceedingly disappointed, she had written to Duret shortly afterward that she wanted an important Courbet painting of fruits; he soon located one at Paul Rosenberg's, who proved to be the successful anonymous bidder at the Brussels auction. Duret urged her to purchase it and Rosenberg lowered his price to $8,000 (neither realizing that she had been the underbidder), but Louisine declined, still annoyed that she had lost the picture at $6,000. The work was sold in Austria. Her resentment had subsided by 1920, however, and when Paul Rosenberg offered her the painting again, she decided not to press her luck and bought it for about $17,000.

Emboldened by his sale of Courbet's still life to Louisine, Paul Rosenberg went a step further in a letter of February 13, 1921:

> I am happy to see that you are satisfied with the purchase, and it is one of his very best paintings of this kind. Courbet's works are growing in the esteem of the *amateurs* and everybody agrees now, that he is one of the greatest artists of the last century. Another modern painter is growing also, and is going to have the same influence as Courbet and Cézanne, it is Picasso. I feel certain that if you would see reproductions of some of his paintings and drawings you would like to add them to your splendid collection. I would be very pleased to send you several reproductions.[15]

But Louisine was not up to buying anything by Picasso. In 1921 she had neither the time nor the inclination to devote her energies to an entire new area of collecting. Her tastes being firmly rooted in French art of the nineteenth century, she was not able to expand it to the avant-garde movements of the next century. Her strong preference for the representational style that predominated throughout the Impressionist period made her avoid subjective paintings that used bright color arbitrarily to express inner reality, and she responded neither to the mysterious dreams and fantasies of the Symbolists nor to any of the Post-Impressionists. She had never even considered the works of such artists as Redon, Van Gogh, and Gauguin, or those of Toulouse-Lautrec, Bonnard, and Vuillard. Louisine's range of appreciation was almost parallel to Mary Cassatt's, whose capacity to absorb innovations stopped with the Impressionists. Although Louisine

remained a supporter of Cézanne in spite of her friend's change of view, Cassatt's constant indoctrination against other modernists and their immediate precursors prevented her from taking a serious interest in their work. Instead Louisine preferred to seek out the best examples she could find by the artists to whom she was already committed. In January 1921 she purchased from Durand-Ruel Degas's extraordinary *Woman with Chrysanthemums* (Plate 162); two years later she would obtain from them the same artist's *Mlle Marie Dihau* (Plate 167), a portrait of the concert singer and pianist. These two works were exactly the kind of penetrating studies of personality and mood that Louisine preferred above all else.

The early 1920s saw no slackening in Louisine's activities; on the contrary, she was busier than ever. She had not been to Europe since 1914, prevented by the war and also by her continuous involvement with the cause of female enfranchisement. Her one concern about not having visited France in the past six years was the welfare of Mary Cassatt. She even referred publicly to the reduced condition of her oldest friend in a speech on Cassatt to the National Association of Women Painters and Sculptors, delivered on April 20, 1920, during their twenty-ninth exhibition. Her address to this group of women artists, founded in 1889, conveyed the most personal and intimate portrait of Cassatt that Louisine would ever give. She spoke about the painter herself and their relationship rather than about her pictures; she closed with the following words:

> Almost blind, unable to work nor even to enjoy the work already done, deeply distressed over the cruel war axioms and unhappy about the future, my heart is indeed sad when I think of my dear friend. As I cannot go to her, I beg her to come to me and I cherish the letters which only I can read. I believe I could read them in the dark, part by feeling. I have learned to type mine and one can constantly hear the click click as I keep her in touch with all that is going on about me. The end I trust is far off, but short or long the joy and gladness of our lifelong friendship will make the close bright for us, come what will. Memory, the staff of the old, will sustain us.[16]

Louisine was eager to further Cassatt's slowly increasing reputation in America. She may even have originated the idea of a show of Cassatt's graphic work that the Grolier Club of New York exhibited from January 28 to February 26, 1921. A special committee, chaired by William M. Ivins, Jr. (curator of prints at the Metropolitan Museum), assembled some 180 prints in the largest, most complete viewing of her graphic production to date. In addition to soft-ground etchings and drypoints, her own set of ten color prints was shown in an extended number of states, with the preliminary drawings for five of them. Among the lenders were the Durand-Ruel gallery, the New York Public Library (Avery Collection), Harris Whittemore, the art critic Elizabeth Luther Cary, and other collectors from New York and Pennsylvania; Louisine contributed eleven prints. On "Ladies Day" (Saturday, February 12) she gave a talk, "Recollections of Miss Cassatt and Her Work." The attendance was 307 people, more than a Grolier Club event had ever attracted before. The press praised the artist's technical mastery as well as her

150. MARY CASSATT. (above, left) *Mother and Sleeping Child.* 1914. Pastel on paper, 26 5/8 × 22 1/2″. The Metropolitan Museum of Art, New York (Bequest of Mrs. H. O. Havemeyer, 1929. The H. O. Havemeyer Collection)

151. MARY CASSATT. (above, right) *Mother Wearing a Sunflower.* c. 1905. Oil on canvas, 36 1/4 × 29″. National Gallery of Art, Washington, D.C. (Chester Dale Collection). Formerly owned by Mrs. Havemeyer

152. EDGAR DEGAS. (left) *A Woman Having Her Hair Combed.* c. 1885. Pastel, 29 1/8 × 23 7/8″. The Metropolitan Museum of Art, New York (Bequest of Mrs. H. O. Havemeyer, 1929. The H. O. Havemeyer Collection)

153. JACQUES-LOUIS DAVID. (above, left) *Portrait of a Young Woman in White*. c. 1800. Oil on canvas, 49 1/4 × 37 1/2″. National Gallery of Art, Washington, D.C. (Chester Dale Collection). Formerly owned by Mrs. Havemeyer

154. GUSTAVE COURBET. (above, right) *The Source*. 1862. Oil on canvas, 47 1/4 × 29 1/4″. The Metropolitan Museum of Art, New York (Bequest of Mrs. H. O. Havemeyer, 1929. The H. O. Havemeyer Collection)

155. GUSTAVE COURBET. (opposite, above) *The Knife-Grinders*. 1848–50. Oil on canvas, 34 3/4 × 40 7/8″. Columbus Museum of Art (Museum Purchase: Howald Fund). Formerly owned by Mrs. Havemeyer

156. EDGAR DEGAS. (opposite, below) *Madame Gobillard (Yves Morisot)*. 1869. Oil on canvas, 21 3/8 × 25 5/8″. The Metropolitan Museum of Art, New York (Bequest of Mrs. H. O. Havemeyer, 1929. The H. O. Havemeyer Collection)

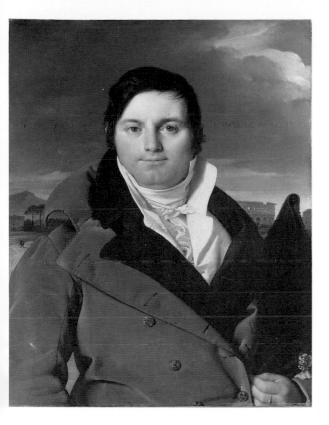

157. EDGAR DEGAS. (opposite, above) *The Dancing Class*. 1872. Oil on panel, 7 3/4 × 10 5/8″. The Metropolitan Museum of Art, New York (Bequest of Mrs. H. O. Havemeyer, 1929. The H. O. Havemeyer Collection)

158. EDGAR DEGAS. (opposite, far left) *Woman Bathing in a Shallow Tub*. 1885. Pastel on paper, 32 × 22″. The Metropolitan Museum of Art, New York (Bequest of Mrs. H. O. Havemeyer, 1929. The H. O. Havemeyer Collection)

159. MARY CASSATT. (opposite, left) *Girl Arranging Her Hair*. 1886. Oil on canvas, 29 1/2 × 24 1/2″. National Gallery of Art, Washington, D.C. (Chester Dale Collection). Formerly owned by Mrs. Havemeyer

160. JEAN-AUGUSTE DOMINIQUE INGRES. (above, left) *Joseph-Antoine Moltedo*. 1810. Oil on canvas, 29 5/8 × 22 7/8″. The Metropolitan Museum of Art, New York (Bequest of Mrs. H. O. Havemeyer, 1929. The H. O. Havemeyer Collection)

161. GUSTAVE COURBET. (above, right) *The Young Bather*. 1866. Oil on canvas, 51 1/4 × 38 1/4″. The Metropolitan Museum of Art, New York (Bequest of Mrs. H. O. Havemeyer, 1929. The H. O. Havemeyer Collection)

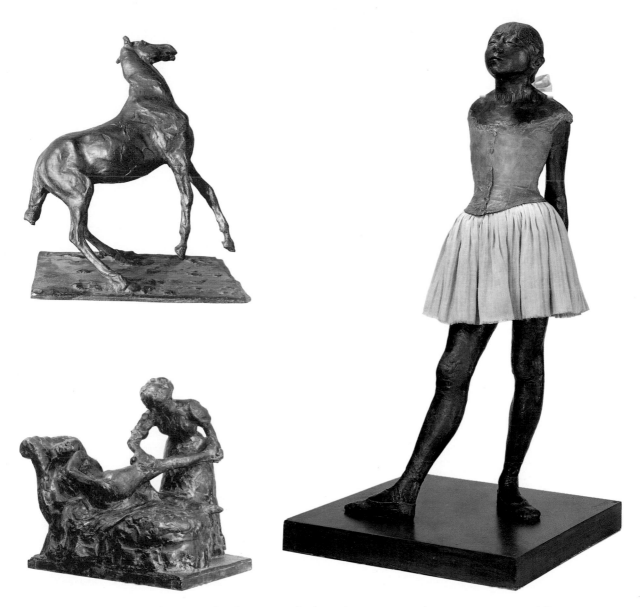

162. EDGAR DEGAS. (opposite, above) *Woman with Chrysanthemums.* 1865. Oil on canvas, 29 × 36 1/2″. The Metropolitan Museum of Art, New York (Bequest of Mrs. H. O. Havemeyer, 1929. The H. O. Havemeyer Collection)

163. GUSTAVE COURBET. (opposite, below) *Still Life—Fruit.* 1871. Oil on canvas, 22 × 28 1/2″. Shelburne Museum, Shelburne, Vt. (photograph by Ken Burris). Formerly owned by Mrs. Havemeyer

164. EDGAR DEGAS. (above, top left) *Rearing Horse.* c. 1865–81 (cast 1919–21). Bronze, height 12 1/8″. The Metropolitan Museum of Art, New York (Bequest of Mrs. H. O. Havemeyer, 1929. The H. O. Havemeyer Collection)

165. EDGAR DEGAS. (above, left) *The Masseuse.* After 1895 (cast 1919–21). Bronze, height 16 1/4″. The Metropolitan Museum of Art, New York (Bequest of Mrs. H. O. Havemeyer, 1929. The H. O. Havemeyer Collection)

166. EDGAR DEGAS. (above, right) *Little Dancer of Fourteen Years.* c. 1881 (probably cast 1922). Bronze with muslin, tulle, and satin ribbon, height 37 1/2″. The Metropolitan Museum of Art, New York (Bequest of Mrs. H. O. Havemeyer, 1929. The H. O. Havemeyer Collection)

167. EDGAR DEGAS. (above) *Mlle Marie Dihau*. 1867–68. Oil on canvas, 8 3/4 × 10 3/4". The Metropolitan Museum of Art, New York (Bequest of Mrs. H. O. Havemeyer, 1929. The H. O. Havemeyer Collection)

168. GUSTAVE COURBET (now considered "Style of Courbet"). (right) *Portrait of a Lady in Black*. Oil on canvas, 54 × 39 1/2. Present whereabouts unknown. Formerly owned by Mrs. Havemeyer

intimate subjects. Cassatt was gratified that her prints were at last receiving some deserved recognition, for she had written to Louisine: "After all what I did in that line *is* original."[17] The Grolier Club exhibition also went to the Art Institute of Chicago.

Exactly a year after the suffrage victory of August 1920, Louisine left for France. Besides her strong desire to see Mary Cassatt, she wanted to inspect the complete set of Degas's posthumously cast sculpture, now finished and put on view from May to June 1921, at Hébrard's gallery on the rue Royale. Of the great many brittle wax figures found in Degas's studio after his death, seventy-two salvageable ones had been cast into bronze by the "lost wax" process at the foundry of Adrien A. Hébrard, thus saving them from disintegrating. Although public reaction to the first series of bronzes (eventually more than twenty series would be cast) was not altogether favorable, Mary Cassatt was effusive in her praise: "Degas' statues are as fine, and as great as anything the Greeks or Egyptians ever did. They will constantly increase in appreciation and value," she reported to Louisine.[18] Cassatt had deferred another eye operation for the chance to study Degas's bronzes; after visiting the gallery, she wrote to Hébrard:

> I must tell you how much I enjoyed the exhibition of Degas's sculpture. It is very rare in the history of art that an artist has equal talent for painting and for sculpture. I do not know of any other example. All artists and all collectors are indebted to you for the admirable work you have done by reproducing so perfectly these fragile waxes in bronze.[19]*

Cassatt's enthusiasm for Degas's figurines was so keen that she may have immediately reserved the whole collection of seventy-two pieces for her friend. Among Louisine's papers is a handwritten draft for a cable addressed to Hébrard: "Deeply touched. Please accept my warm gratitude. Havemeyer."[20]* In any case, she did buy the complete set, designated "A," shortly after arriving in Paris toward the end of August, and she was grateful to Mary Cassatt for having served again as the "godmother" of her collection. In 1921 Louisine became the first owner on either side of the Atlantic of all Degas's bronze sculptures, those remarkable studies in form, movement, and balance of dancers, of horses, of female figures, and several portraits or studies of heads (Plates 164, 165).

Louisine divided her stay between Paris and Mary Cassatt's country house at Mesnil-Théribus. She was greatly relieved that Mathilde Valet had at last been allowed to return from Switzerland and was there as housekeeper-companion for her beloved "Mademoiselle." In spite of numerous operations, cataracts continued to cloud Cassatt's eyes; she sometimes dictated her correspondence to Mathilde or, now, to Louisine. The two old friends had no idea that they would not see one another again, though Mary Cassatt was to live for five more years.

While in Paris Louisine purchased four pictures by Courbet from Théodore Duret, who also found for her several wash drawings and watercolors by Constantin Guys. Among the Courbet paintings was *Portrait of a Woman, called Héloïse Abélard*; in a letter to Duret of January 10, 1922, Louisine expressed her delight with the work: "*Abélard*

(the woman) is superb. I go so often to the gallery to look at her, that I assure you I lose a good deal of time. I owe you a debt of gratitude for having given her up."[21]* In the same letter, she described to Duret her forthcoming political activities:

> I am going to New Orleans in the month of April to free the vote from all the impediments that they [the men] have imposed on it. It is necessary to pass a "bill" in the legislature. If you will allow me, I shall send you a report of what happens there. I guarantee you that with all my interests, I lead quite a life! Highly stressful.*

The year 1922 would prove to be an unusually significant one for Louisine. It began with the exhibition at the Grolier Club of "Prints, Drawings and Bronzes by Degas," from January 26 to February 28, made possible by her anonymous loan of the seventy-two statuettes that had been filling her dining room. She also provided seventeen drawings and pastels, two silk fans with dancers, and four prints. Naturally there was speculation as to who owned the bronzes, but the Grolier Club had specifically asked the press to refrain from guessing. Louisine was anxious to see what the American reaction would be to Degas's statuettes, and wrote to William M. Ivins, Jr., again the chairman of the exhibition committee:

> I received a letter from M. Hébrard in which he says Degas did sculpture *all his life*. Miss Cassatt corroborates that statement. She also says she considers Degas a greater sculptor than a painter, and believes his sculpture will live longer than his paintings and pastels. . . . Fine criticism from a fine critic! I am curious to see if they are understood and appreciated here.[22]

The Grolier Club held a special press preview on January 21; newspaper articles began to appear a few days after the official opening: "Form. A Painter's Mastery of It in Plastic Art"[23] was Royal Cortissoz's headline in the *New York Tribune*; "General Enthusiasm for the Bronzes in the Display Is Not Without Its Significance to Students of the Times,"[24] began Henry McBride's review in the *New York Herald*; "The bronzes are wonderful studies of poise and motion and throw a flood of light upon the artist's whole method and scheme of drawing,"[25] stated W. G. Bowdoin in the *World*. The public's response to the show was so enthusiastic that its run was extended. Louisine was gratified with the American debut of her Degas bronzes.

At some time in 1922 Louisine bought Degas's *Little Dancer of Fourteen Years* (Plate 166), cast separately in bronze. This little dancer had originally been modeled in wax in 1880; it was the only piece of sculpture Degas ever exhibited, sending it to the Impressionist show of 1881, where it was attacked for its "too vivid" realism. The Havemeyers had long been interested in acquiring the celebrated statuette, ever since Louisine had come upon it in its glass case on a visit to Degas's studio. In 1903 Louisine wanted to buy the *danseuse* for the center of her newly constructed downstairs picture gallery. She insisted on the original wax version, whereas Degas claimed that the wax was so blackened that the piece had to be cast in bronze or plaster, with fresh wax over the surface. To resolve the difficulties of dealing with Degas, Louisine wrote to Mary Cassatt, who in turn asked Paul Durand-Ruel to try to convince him to fix up the

original work. But Degas remained unyielding and Louisine did not get the *Little Dancer*. Years later, she vainly tried again to rescue the wax statuette from its slow disintegration in the artist's studio.

Soon after Degas's death in 1917, Mary Cassatt suggested to Louisine that she should acquire his sculpture of the little *danseuse* if it could be restored. Negotiations followed between Louisine and Degas's heirs—with Cassatt as the intermediary—for almost three years, the heirs vacillating as to whether the dancer should be sold as a unique piece or cast in bronze like the smaller wax figures. The heirs finally decided to have the dancer cast, but the complicated process was not undertaken until the other pieces had been finished. Having waited almost twenty years, Louisine obtained in 1922 her bronze version of Degas's *Little Dancer of Fourteen Years*.

While Louisine was in Paris in the early fall of 1921, her name had been suggested for the cross of the Legion of Honor. She did not understand that she was supposed to submit to the French consul general in New York a list of people in support of her nomination and provide him with a summary of her services to France. Being advised of her omission, she wrote in April to the consul general: "If you feel you can send the necessary word [to France] I will appreciate it very much. I am sure there are many like Mr. Robert de Forest, President of the Metropolitan Museum and member of the Grolier Club, Mr. Louis Tiffany, also Miss Mary Cassatt of Paris to whom you can refer as to my merit for the ribbon."[26] Louisine began her summary as follows: "It was a great pleasure to work for France during the war and perhaps a greater one to have been interested in her art for over a generation."[27]

Describing first her numerous activities on behalf of the war effort, from her "jam campaign" to securing aid for medical supplies at the front, she proceeded to her cultural pursuits:

> In Art I have been a patron of French art since 1875 when I bought my first picture of Degas for 500 francs and he wrote and thanked Miss Cassatt saying "he greatly needed the money." I am still buying works of that great master. I bought the first Manet sold in America. When the Metropolitan Museum told me they had been requested to have an exhibition of Courbet's work in commemoration of his "Centenaire" they said it would only be possible if I would lend my Courbets. I answered, "If France desires the exhibition I will open my gallery and you may take what you need." They took nineteen Courbets and the exhibition [April 7 to May 18, 1919] was a great success. As a patron of French art I can refer you to Arsène Alexandre, Théodore Duret, and the art dealers of Durand-Ruel, and M. Benedite of the Luxembourg Museum.

In May 1922 Louisine received the cross of the Knight of the Legion of Honor, an award that meant a great deal to her because she felt she had spent a lifetime earning it. She wore the tiny red ribbon with pride, sewn onto the collar of her dresses and coats. In 1927 Louisine would generously present Manet's *Portrait of Clemenceau* to the Louvre, and the next year she was promoted to the rank of Officer in the French national order.

But in June Louisine herself brought about the most consequential occurrence of 1922, by making an important change in her will (see Appendix). There would be, altogether, three codicils. Ever since Harry's death in 1907 she had been thinking of establishing a memorial to her husband in the form of a gift to the Metropolitan Museum, contemplating this as early as 1908. Mary Cassatt had withheld her approval, warning her that such a gesture was premature and that the museum's trustees were incapable of appreciating the Havemeyer paintings. Nevertheless, in July 1919, Louisine had written her first codicil, selecting 113 works—old masters and modern pictures, more than twelve marble sculptures from different periods, and a quantity of European and Far Eastern decorative objects—to be bequeathed to the Metropolitan Museum. Struggling to make a representative sampling from her enormous trove of treasures, she had asked Cassatt for help, who replied: "I wish I could advise you as to what would be the best for a Museum in your collection. Almost everything would be fine. In the French school I would begin with Poussin & then skip to the 19th century, your Courbets, an Ingres & then Corot Degas Manet Monet. You certainly have a choice. If only we could talk it over."[28] Louisine followed these guidelines, except for excluding works by Monet and adding two paintings and two pastels by Cassatt, as well as four paintings by Cézanne. In homage to her husband's taste, Louisine chose mostly figure pieces and portraits rather than landscapes or still lifes. Three years later, in June 1922, Louisine wrote a second codicil that added twenty-nine pictures: six were old masters, the rest were by French nineteenth-century artists, including eight paintings by Monet.

But the most astounding part of the Havemeyer legacy was to come in the third codicil, dated August 18, 1922. This time Louisine did not designate individual objects; instead, she authorized and empowered her son Horace to give to the museum "all such other pictures, paintings, engravings, statuary and works of art" not previously specified, as he might "appoint to it."[29] Horace, in other words, in cooperation with his sisters, was to add any items he chose to the Havemeyer bequest. This third codicil was Louisine's declaration of faith in the fair-mindedness and generosity of her children; she counted on their knowing that she wanted the museum to have the best of everything she owned, and her children's participation would make of the gift a family affair. She had only two conditions, that the works in the bequest be known as the "H. O. Havemeyer Collection," and that they be put on permanent exhibition.

This munificent donation was the more remarkable in that the Metropolitan Museum had never shown the slightest courtesy to Harry, and had consistently avoided naming him a trustee when vacancies occurred on its board. Evidently Louisine was not one to hold a grudge, and the museum, moreover, had established a new regime in 1913, after the death of Harry's arch enemy J. P. Morgan, who had ruled the board for many years. Robert W. de Forest was elected as the new president of the board, a lawyer who "had become the city's unrivaled 'Captain of Philanthropy,' the most public-spirited New Yorker of his generation."[30] Louisine, having a strong social conscience of her own, admired De Forest for his charitable concerns and also liked him personally, finding him level-headed and practical in his approach to administering the museum. He was firmly opposed to bequests from status-hungry tycoons stipulating that, toward

their self-glorification, their gifts be kept perpetually together. Louisine shared De Forest's point of view, recognizing that the best interests of the museum's collections and of public education lay in integrating the displays, not in segregating works through restrictions imposed by the donors.

In 1914 Louisine's brother-in-law Samuel T. Peters (husband of her younger sister Adaline) had been elected to the Metropolitan Museum's board of trustees. Peters was a discerning collector of early jades and Oriental potteries and porcelains. He had been elected a benefactor of the museum in 1911 when he presented it with more than 250 pieces of jade; he followed this in 1913 by a second gift, and after his election he made additional donations in 1915 and 1916. Her brother-in-law's seven-year term on the board, until his death in 1921, had probably caused Louisine to regard the Metropolitan more favorably; it was after all the only museum having truly national stature in America. No doubt Peters introduced her to De Forest, knowing that the two would have much in common, and certainly her brother-in-law had encouraged Louisine to make a bequest in memory of Harry, assuring her that such a memorial in his native city would have pleased him.

Over the recent years Louisine had had more frequent contact with members of the museum staff. Her participation in the Cassatt and Degas exhibitions at the Grolier Club had led her to know William M. Ivins, Jr., the incisively brilliant curator of prints. Ivins and Louisine were fellow believers in the importance of looking at works of art rather than reading or writing about them, and both found it deplorable that many people tried to learn about pictures through books rather than through studying the actual works. Louisine also knew well Bryson Burroughs, curator of European paintings and himself a painter, especially through her part in the 1919 "Courbet Centennial Exhibition." In addition to her anonymous loan of sixteen out of the forty pictures,[31] she helped Burroughs plan the show and related events, such as the private reception at her home for guests of Mr. De Forest and friends of the museum.

Throughout the early 1920s Louisine continued to deal with Burroughs and Ivins as an anonymous contributor to their special museum loan shows. In the spring of 1920 she lent to the Metropolitan's "Fiftieth Anniversary Exhibition" two paintings by Poussin, *View of Toledo* by El Greco, and *Rêverie* by Corot; yet, when the painter Charles Sheeler wrote to Burroughs requesting permission from the anonymous owner to photograph the El Greco landscape, Louisine's answer was: "I object to anyone's having a photograph of El Greco's *Toledo*. Kindly see that none are given and none allowed to be taken."[32] The following year she sent Courbet's *Madame de Brayer* to the museum's "Exhibition of Impressionist and Post-Impressionist Paintings."

Because Louisine's participation was in every instance anonymous, few visitors to the Metropolitan were aware of her many and valuable loans. The trustees, however, recognized her cooperation by electing her a benefactor of the museum in 1924. Royal Cortissoz wrote later about Louisine's consistent practice of anonymity: "She wanted no kudos. It was enough for her that she was able to enrich an exhibition and thereby assist a good cause. Thanked in private for what she had done she would laugh and say 'What does it matter?' Then she would launch upon excited discussion of the artist who happened to be at the moment in question."[33]

Louisine's innate modesty manifested itself in other aspects of her life. A member of the National Woman's Party described an event that took place in 1923, depicting her characteristic behavior:

On a bleak, dreary, storm ridden February morning . . . a quiet little figure in black stepped off an early morning train and slipped out of the Chicago station. Reporters and camera men, notified that Mrs. H. O. Havemeyer was coming to Chicago to address a mass meeting, were all lined up, but not one of them even noticed her. They were too busy stopping all likely candidates—busy, important-looking women.

It was bitter freezing weather. The reporters camped at our headquarters asking innumerable questions, demanding a condensed encyclopedia of all the legal disabilities of women, as the Equal Rights campaign had only recently started. Mrs. Havemeyer attended a breakfast, luncheon, tea, and dinner in her honor, at all of which she spoke. In between she managed to steal a few minutes to go to her room to mend her dress, and to change for the evening. . . . Yet not once, despite the constant strain on her, did she plead fatigue, nor fail to charm her audiences and everyone that met her, with her graciousness, her charm, her lively wit and her infectious laugh.[34]

Louisine's deep convictions had enabled her to come into her own as an older woman; she had a personal standard of independence and simplicity that were rare among those who could afford to live in idleness and luxury. She was now reaping rewards and satisfactions from her lifetime achievements, when suddenly an incident occurred which caused her much pain.

In October 1923 Cassatt's housekeeper Mathilde discovered a group of twenty-five old copper drypoint plates in the back of a closet. Cassatt, assured by Mathilde, as well as by an American artist-friend and by her printer Delâtre, that the plates showed evidence of never having been printed (her own eyesight was too weak to examine them closely), had Delâtre pull six sets of them and sent two sets to New York. She asked Louisine to show them to William Ivins, to whom she expected to sell a set for $2,000. Ivins recognized at once that the proofs were made from worn-out plates—indeed, the museum already owned earlier and better impressions of them. Louisine tried to break this news gently to Cassatt, suggesting that her friends must have been misled as to the condition of the plates, and tactfully explaining that for the sake of her reputation these prints should not be designated as "new" work. Mary Cassatt stubbornly refused to accept Ivins's judgment, but what was even worse, in her opinion, was that her best friend had taken his side! She was indignant at Louisine's "disloyalty" in supporting Ivins's evaluation, and vented her wrath in a letter to Joseph Durand-Ruel on January 19, 1924:

Mrs. Havemeyer assures me that all they want is to safeguard my reputation! to prove that I am not a forger! I will never forgive that. I answered that I could take care of my own reputation and that she should take care of hers. Poor woman, she

didn't utter a word, make a gesture, nothing that one might have expected. But since she has become a politician, journalist, speaker, she is no longer anything.*

Cassatt remained inflexible in her belief in the prints and would not admit to being in the wrong; on the contrary, she continued to defend herself and her collaborators, turning the issue into a matter of principle that extended beyond the prints and became a defense of her artistic integrity. Her outrage only increased with Louisine's efforts to soothe her, until the artist—almost eighty years old—ended their relationship, as she informed Joseph Durand-Ruel on March 1, 1924: "Now, I wanted to ask you, if you had any intention of borrowing a pastel or a painting from Mrs. Havemeyer [for a forthcoming Cassatt exhibition at the Durand-Ruel gallery in New York] not to do so, for I have broken off completely with her."* Louisine was crushed and deeply saddened by the irrational state of her cherished friend. A few years earlier the art dealer René Gimpel had quoted in his diary a recent visitor to Mary Cassatt as saying " 'she's become a viper.' "[35] Louisine bore in dignified silence this breakup of a lifelong friendship; she never spoke a word against Cassatt nor held her responsible for her vindictive attitude, fervently hoping it would pass.

For the first time since she had become a collector almost fifty years ago, Louisine could not discuss art matters with Mary Cassatt. She had also lost her friend and dealer Paul Durand-Ruel, who had died in 1922. With the original triangular relationship, which had so long formed the cornerstone of the Havemeyer collection, now irretrievably broken, Louisine turned to Théodore Duret, to whom she confided in June 1924: "As always, I rely on you for advice and encouragement in continuing to buy paintings. Modern art has become worse, American art dominates everything here, and I find myself alone in the appreciation of any art whatever."[36]* She had recently bought from Duret a Courbet portrait of a lady in black (Plate 168), about which she wrote in the same letter: "I like my portrait, the Courbet, very much. Except for the eyes which are a bit disturbing it is a very beautiful canvas. I call her Mme X and say painted in '58—is that correct?"* Louisine had let her guard down with the purchase of this painting; continuing to trust Duret, she could not imagine that he might sell her a questionable work, but *Portrait of a Lady in Black* was not a genuine Courbet and the old Duret most likely knew it. He repeatedly refused to tell her who the sitter was or to provide any information concerning the painting.

The Courbet portrait was not the only instance of Louisine's becoming less than careful; her bargain hunting left her with a group of highly doubtful pictures. Between 1922 and 1925 she bought, through a framer and restorer in New York whom she had patronized for many years, what she herself referred to as "flotsam and jetsam of war results,"[37] a number of so-called "old masters," among them works attributed to Rembrandt, Goya, Titian,[38] and Van Dyck.

On July 28, 1925, Louisine quietly marked her seventieth birthday with a family celebration at "Hilltop" in Connecticut. She usually spent her summers on that estate near Greenwich, where she kept busy raising bees and collecting their honey, and grafting branches from one fruit tree onto another. Louisine loved gardening and took delight in her cuttings and plantings. In the evenings she sat at her typewriter making

up moralistic fairytales for her grandchildren, and she also studied Italian, which she was determined to learn (she had known French and German since girlhood). Occasionally she visited her children at their summer residences; her happiest hours were spent with her grandchildren, whose talents she persistently encouraged. Much later her grandson George Frelinghuysen described Louisine as he remembered her during his teenage years:

> Grandma Louisine made a lasting impression on me. How well I recall her bowing to a cat in a window for luck, knocking on wood and murmuring the word *Unberufen* to ward off evil, contorting her tongue into a three-leaf clover and daily pinning a fresh flower [a full-blown rose] atop her white hair. There was also her hot weather expression, "I'd like to take off my skin and sit in my bones."
>
> Though her parsimony was innate, Grandma often would take from the purse that dangled between her skirt and petticoat (usually rebound by her with a worn out typewriter ribbon), a crisp five dollar bill. "Try to keep half of it for a rainy day," she'd advise, stating that one should save pennies to have dollars. "Never forget," she'd warn, "the wheel of Fortune goes around."[39]

In the same year Louisine undertook a project of enormous magnitude, that of meticulously setting her house into order. Using collector's labels of her own design, she painstakingly wrote identifications for her myriad possessions in brown ink and pasted or tied one onto every item (see page 237). She marked with a "Z" each object she considered worthy of her future Metropolitan Museum bequest (subject to Horace's approval), excepting those she had specifically designated in her will. She composed voluminous "Notes to My Children" filled with explicit instructions as to her wishes but making allowance for possible oversights: "If in selecting I have neglected some important piece I beg my children to cede it to the museum, as I may not have been aware of its importance."[40] Her plan also allowed for those works she wanted each of her children to inherit:

> Any object not marked is not to be given to the [museum's] Collection; except those marked otherwise (grandchildren, etc.) all objects are to be divided between you three. Please don't have one word of dissension about them. If you all want the same thing make three lots and draw. If you can't agree, sell and buy in. Don't dispute—throw them away first. There are plenty for all. I had to have certain things to round out the [museum's] Collection. When I could, I left some to give to you three children.[41]

She then made detailed lists of suggested items that should go to each child, basing her selections on their individual tastes and what they already owned.

Toward the end of 1925 Louisine seems to have injured herself quite severely in a fall. The French governess whom Electra had for her children, Mlle Marthe Giannoni, moved into 1 East 66th Street to keep Louisine company and assist her. During her convalescence Louisine wrote to Mary Cassatt and Mathilde Valet at Cassatt's country residence outside Paris, and on December 26, 1925, Mathilde answered Louisine, enclos-

*Louisine Havemeyer, age 68, 1923. Photograph courtesy of
J. Watson Webb, Jr.*

*Letter from Mary Cassatt to her lifelong
friend Louisine Havemeyer, April 30, 1926.
Louisine wrote on it in pencil: "My Mary's
last letter." Photograph courtesy of
Havemeyer descendants*

ing several pages from Cassatt that were very difficult to decipher. It was possible to make out occasional phrases—"dear Louie" and the close of her letter, "Much love to you all Mary Cassatt."[42] In subsequent letters the devoted Mathilde continued to report on Mary Cassatt's deteriorating mental and physical condition. In January 1926 the two temporarily returned to Paris, which Cassatt now often confused with Philadelphia. Her end seemed at hand when she lapsed into a diabetic coma, but she came out of it. In the spring, Louisine was informed that Cassatt had been very pleased with the contents of her last letter and had replied to Mathilde: " 'Yes, you are right, Mrs. Havemeyer is my best friend.' "[43]* Cassatt had tried to write on the page opposite Mathilde's note, dated April 30, 1926, but her writing was now totally illegible. Louisine marked on it "My Mary's last letter," although Cassatt attempted to write to her once more. Mary Cassatt died on June 14, 1926; twelve days later Mathilde wrote to Louisine: "I am sure, in spite of the fact that she had many friends, nobody in the world loved her as Madame [Louisine] and I have loved her, and she knew it well."[44]* Louisine was deeply affected by the loss.

In 1927 Louisine suffered a mild stroke. Having always had robust health, she had no patience with doctors and was against taking pills, so these had to be slipped into her tea or coffee by her nurse or Mlle Giannoni. She had become an avid movie buff, and her taste for the cinema increased with the slower pace of life necessitated by her illness. One of her favorite pastimes was going to the movies with her eleven-year-old grandson J. Watson Webb, Jr., who would eventually have a distinguished career in film making. When young Watson was away in boarding school in Aiken, South Carolina, she often wrote him: "I miss you here. There are some A-No. 1 movies. I hate to go without you."[45] She was enthralled with talking pictures, the first of which appeared in the fall of 1927.

Louisine's letters to her grandson Watson show that she had not lost her valiant spirit nor her sense of humor: "I have had trouble with one eye but it is about well. We are *all* doing something. I am making the best of it, others are making the *most* of it. I think they are ahead. I voted yesterday & put one woman in, God bless her." After her signature, "Louisine W. Havemeyer" (as she almost always signed herself), she added a postscript: "Keep the sig. You may get heaps for it some day."[46] But she also had periods of depression. When Electra donated the town hall of Shelburne, Vermont, to the memory of her father, Louisine was not well enough to attend the dedication ceremony on November 30, 1927. She spent the summers of 1927 and 1928 in a rented house on Long Island to be near Electra and her family, whose suburban home was then in Westbury; she could no longer go alone to her beloved "Hilltop."

Louisine continued to enjoy receiving visitors who came to see the internationally renowned collection. Her large, dark house, its interiors designed by Tiffany almost forty years before, now seemed a bizarre setting for the timeless art it contained. The elaborate Moorish and Oriental motifs, mosaic flooring and paneling, colored lighting fixtures suspended by entwined chains, stencil-decorated furniture, staircases with railings encrusted with mother-of-pearl—all these belonged to another era. Louisine had aged more gracefully than her residence. According to one frequent guest: "It was a joy to linger among her treasures in her company, to observe the light touch with which she presided over them, to feel her sympathy and understanding."[47] The range of her

visitors during the 1920s extended from John Galsworthy to the German painter Karl Hofer, and from the French painters Pierre Bonnard and Maurice Denis to the art historian Julius Meier-Graefe. While Meier-Graefe was studying certain pictures, early in 1928, he took out a small pad and began making notes. Louisine startled him by the suddenness of her request: "Please put that book into your pocket. I don't want anybody to write about my collection."[48]

In the spring of 1928 Louisine convinced her family that it would be good for her to go abroad; she left for Paris in May, accompanied by Mlle Giannoni. Before her departure she wrote to her grandson George Frelinghuysen: "My job is to get strong & well & leave all my nerves that have given me so much trouble behind me. I shall work hard to do it."[49] In 1926 she had sent money to Mathilde for trees to be planted by Cassatt's tomb, and one of her main reasons for this trip to France was to visit the resting place of her lifetime friend, who was buried at Mesnil-Théribus in the family vault. She placed rambler roses on the tomb, because roses had been her friend's favorite flowers. The year before, Louisine had lent five pictures to the "Mary Cassatt Memorial Exhibition" (held from April 30 to May 30, 1927) at the Museum of Art in Philadelphia. She had written, at the museum's request, a personal reminiscence of the artist for its *Bulletin* of May 1927; she also granted permission to reprint there her 1915 Knoedler speech on Cassatt. Uncharacteristically, she allowed her name to be listed in the *Bulletin* among the other contributors.

In spite of her resolve to improve her health, Louisine's arteriosclerosis continued its advance. Her bouts of depression became more frequent. By November 1928, she was confined to 1 East 66th Street. Shortly after the new year she came down with bronchopneumonia. Already weakened by heart disease, she was not able to fight off the severe lung infection. On January 6, 1929, at 4:00 P.M. the seventy-three-year-old Louisine W. Havemeyer quietly passed away in the presence of her three children. Funeral services were held at St. Bartholomew's Church on January 9, and she was buried next to Harry in Greenwood Cemetery, Brooklyn.

Among the numerous tributes that appeared in newspapers and art journals, that by the critic Royal Cortissoz, who had known her well, was the most perceptive:

> A collector in whom there glowed the fires of an artist has been lost in Mrs. H. O. Havemeyer. She loved fine things from her earliest years and all her life long she pursued them with an ardor which was by itself one of the most endearing qualities of her nature. . . . She was intimate for years with the late Mary Cassatt, who aided her especially in accumulating the works of the French Impressionists, and it has sometimes been said that Miss Cassatt was largely responsible for the collection. There never was a sillier legend. Mrs. Havemeyer thought her own thoughts, garnered her own impressions, framed her own convictions. It helped her to have the counsel of Miss Cassatt . . . but, in essentials, she and her husband were the "only Begetters" of the great collection that bears their name.[50]

The board of trustees of the Metropolitan Museum immediately voted to accept the 142 works listed specifically in the first two codicils of Louisine's will, but that was only the beginning. In addition to heeding the "Z" with which Louisine had marked her

proposed choices for the museum's collection, Horace—according to the museum's director Edward Robinson—consulted the curators of the appropriate departments, "to advise and assist him in making his selection, a task which occupied several months, owing to the very large and diversified amount of material involved."[51] Determined that the museum should get exactly what it wanted, Horace and his sisters went even further, donating works from their own inheritances. The size of the Havemeyer bequest eventually swelled to 1,972 objects. A temporary exhibition of the H. O. Havemeyer Collection was held in 1930 and Robinson stated in the introduction to the catalogue:

> The additions thus made to the bequest under the authorization of the third codicil consist of ninety-nine paintings, drawings, and pastels; a collection of 183 prints, ancient and modern, including thirty-four Rembrandts; . . . seventeen examples of Spanish ceramics, together with other works of the decorative arts; and, last but not least, a large and invaluable collection of the arts of China and Japan, which in its range and the high quality of its specimens might well furnish a museum in itself, including as it does screens, paintings, sculptures, porcelains, pottery, bronzes, lacquers, and textiles, as well as a large number of sword guards, knife handles, swords, and other objects of kindred nature.[52]

Robinson omitted mention of the seventy (out of the set of seventy-two) bronze statuettes by Degas, and the bronze of the *Little Dancer of Fourteen Years,* all added in accordance with Louisine's third codicil.

The exhibition lasted eight months, from March 10 to November 2, 1930, the only time the bequest was ever seen together in its entirety; the Havemeyer paintings and objects were then distributed to the museum's departments and put on display among other related works. Aware of the museum's problem of insufficient space, Horace again demonstrated the greatest consideration by liberally interpreting his mother's will. He exempted certain items, such as "Japanese and Chinese screens, prints, paintings, leathers, and etchings, as well as the bronzes of Degas,"[53] from being on permanent display, as long as they were readily available for examination upon demand. The Havemeyer Bequest enriched almost every department of the museum, but the departments of European paintings and of prints benefited the most; in their sheer quality, these treasures may have been the museum's greatest gift.

Adaline, Horace, and Electra honored what their mother had written at the beginning of her "Notes to My Children":

> Dearchildren [sic],
> As each of you acquired a home of your own I gave to you works of art to beautify it, believing it would be the wish of Father to have me do so. These objects are yours and the disposition you finally make of them, your responsibility.
> In order to show Father's great ability as an art collector we decided to offer his native city as a memorial to him a collection of the objects he bought to beautify his home and to stimulate and inspire him, as they did in the activities of his business life.

You have aided me in this by your sympathy and counsel and an unselfishness which only such great love as you bore him could stimulate.

We have tried to select the best example of each painter, the finest specimens of pottery, porcelain or glass, and in sculpture unique works by China and Greece and some remarkable Gothic works as well as several renaissance bas-reliefs.

I know you are as much interested in this Memorial as I am and I beg you to help me still, and after I am gone to see it is properly placed in the Metropolitan Museum of Art, New York City.

I have made very few stipulations in my will in regard to the placing or care of the Collection because I believe there are those who are as intelligent and as interested as I, in the care and conservation of a valuable gift.

Please do all you can to further my wishes on this subject.

Affectionately,

L. W. Havemeyer, Mother

Appendix

*Extracts from the three codicils to the Will
of Louisine W. Havemeyer
dated July 31, 1917*

First Codicil dated July 24, 1919

I, the undersigned, LOUISINE W. HAVE-MEYER, do make, publish and declare the following as and for a CODICIL to my Last Will and Testament dated the 31st day of July, 1917:

FIRST: In memory of my husband Henry O. Havemeyer and to constitute with such additions thereto as may hereafter be made by me and my children, what shall be known as "H. O. HAVEMEYER COLLECTION," I give and bequeath to the Metropolitan Museum of Art, incorporated by Chapter 197 of the Laws of 1870 as amended by Chapter 219 of the Laws of 1908 of the Legislature of the State of New York, the following works of art [starred items were withdrawn and/or replaced]:

Four paintings by Rembrandt, viz:
1. Man's Portrait: "The Gilder."
2. Female Portrait: "Old Woman" [now considered "style of Rembrandt"].
3. Man's Portrait: Nicolas von Beerensteyn.
4. Woman's Portrait: Volkera von Beerensteyn.

Two paintings by El Greco, viz:
1. Man's Portrait: Cardinal Niño de Guevera.
2. Landscape: View of Toledo.

One Painting by Peter de Hooghe, viz:
Intérieur, from the Secrétan Sale.

Two paintings by Franz Hals, viz:
A Man's Portrait and a Woman's Portrait (both small) being of Scriverius and his wife respectively.

Five paintings by Goya, viz:
1. Las Majas au Balcon, a group of two men and two women.
2. Female Portrait of his cousin: Dona Narcisa de Goicoechea.
3. Female Portrait: Queen Maria Luisa of Spain, in yellow dress [now considered copy after Goya].
4. Female Portrait: Princesse de la Paz[*].
5. Landscape, fantastique: City on a Rock, three flying figures and an attacking mob below [now considered "style of Goya"].

Two paintings by Peter Paul Rubens, viz:
1. Man's Portrait (Polish King) [now considered "workshop of Rubens"].
2. St. Cecilia, with two cherubs, all singing [now considered "workshop of Rubens"].

One painting by Antonello da Messina, viz:
Portrait of a Man (small) [now considered by Hugo van der Goes].

One painting by Andrea del Sarto, viz:
Madonna and Child and Saint[*].

One Painting by Bronzino, viz:
Man's Portrait: Duke of Urbino.

One painting by Fra Filippo Lippi, viz:
Madonna and Child and Saint [now considered "follower of Fra Filippo Lippi"].

Three paintings by Corot, viz.
1. Sodom: Large picture.
2. Nude (from the Vever Collection).
3. Mother, Nurse, and child on knee—three figures[*].

Two paintings by Nicolas Poussin, viz:
1. Landscape: Story of Orpheus and Eurydice [now considered "style of Poussin"].
2. Landscape: Companion to former [now considered by Francisque Millet].

One painting by Clouet, viz:
Portrait of Man (small)[*].

One painting by Ingres, viz:
Man's Portrait: Napoleon's Cousin,—Colosseum in background.

One painting by Lucas Cranach, viz:
Man's Portrait: "Man with a Rosary."

The following marbles:
1. Bas relief: Madonna and Child. By Mino da Fiesole.
2. Bas relief: Madonna (and child) with Angels. By Desiderio da Settignano.
3. Madonna and Child. By Donatello—Stucco[*].
4. Madonna and Child.

Six Gothic Marbles, viz:
1. Angel's head and bust.
2. King's head (to neck only, with crown and beard).
3. King's head (to neck only) without beard.
4. (Entire figure) of small 1/2 life Saint, one hand missing, with color on the statue.
5. (Entire figure) of Woman with color on it, called "Foolish Virgin"[*].
6. Queen's figure to bust with color, one hand raised to face.

A Greco-Roman Marble, viz:
Head of Dying Man, sometimes called "The Dying Alexander"[*].

Two Chinese marbles, viz:
1. Kuan-Yin, White Stone, T'ang period.
2. Another smaller, in Black Stone, T'ang period.

Seven Pastels by Degas, viz:
1. Nude: Figure on Yellow sofa and a maid combing her hair—from the Marx sale.
2. Nude: Après le Bain—a woman wiping her feet.
3. Nude: figure, back view and holding a white towel across her back.
4. La Modiste—A Woman trying on hats before a mirror and another one showing them to her.
5. La Leçon du Foyer, (the one in Pastel, there being two on this subject).
6. Portrait of a Woman: His cousin and a Woman's face sketched in the background.
7. Nude—Woman in tub bending down—formerly owned by Mary Cassatt.

Six Paintings by Degas, viz:
1. Danseuses à la Barre from Rouart Sale.
2. Pink and Green: Five Ballet Girls in Wings of Theatre and a part profile of a man.
3. La Bouderie: Small interior, man and woman by table, and a picture of a horserace.
4. The Designer of Prints, small interior, man with hat, seated by portfolio.
5. Woman in Black seated on a sofa with an open door in background.
6. La Repasseuse: Woman ironing.

Two oil paintings by Mary Cassatt, viz:
1. Boy before mirror and woman.
2. Little girl leaning on her mother's knees, some yellow flowers and out of door background.

Two pastels by Mary Cassatt, viz:
1. Mother and Child—Mother in red coat with a black edge, with a white cloth over her hair. The nude boy stands on her knee with his arms about her neck, boy fullfront, late one. Done in Grasse 1914.
2. Mother and Child—Mother in purplish coat holding a sleeping child in her arms. Back of child is seen. Done in Grasse 1914.

Four paintings by Edward Manet, viz:
1. Christ aux Anges.
2. Torero Saluant—man bullfighter—life size.
3. Mlle V. en Costume d'Espada—Woman bull fighter and figures in background.

4. Jeune homme en costume de Majo—life size.

Two pastels by Manet, viz:
1. Man's portrait: "George Moore."
2. Woman's portrait: Mlle Lemonnier with pink rose decolleté.

Seven paintings by Courbet, viz:
1. La Femme au Perroquet.
2. La Source, 1/2 life [size]. Nude woman back view in Landscape with stream.
3. Woman's Portrait: "Louise Colet."
4. Nude: La Branche de Cerisiers.
5. Large Hunting Landscape of Man, Dogs, & Game: "After the Hunt."
6. Nude: Woman in the sea with arms over head "La Vague."
7. Woman's Portrait: La Belle Irlandaise.

Four paintings by Cézanne, viz:
1. Landscape—A large tree in foreground and a bridge or aqueduct in the background.
2. Portrait of a man with hat.
3. Still life: White cup, green vase and fruit on white table cloth.
4. Marine: Sea and a bit of coast.

Three pieces of Japanese Lacquer work by Ritsuo of the 17th Century, viz [now considered "attributed to Ritsuo"]:
1. Cabinet decorated with lacquer, etc.
2. A long narrow wooden temple panel, decorated with horses and men etc. in lacquer.
3. A long narrow wooden temple panel, decorated —representing the "Creation of Horses"—Man with gourd out of which issue horses.

From my collection of Cyprian glass, twenty-five pieces to be selected by my son Horace.

Four pieces of Italian faience. To be selected by my son Horace.

Six Hispano-Moresque Plates or Plaques—to be selected by my son Horace.

SECOND: With reference to each of the foregoing articles bequeathed to the Metropolitan Museum I direct that the identification of it by my Executors or a majority of them shall be conclusive, both upon the Museum and upon my estate; that until

its delivery to the Museum my Executors shall be liable only for ordinary care of it, and that it shall not be their duty to insure it against loss or damage by theft, fire or other casualty; and that if not accepted within one year after my death by the Museum for permanent exhibition it shall revert to my estate, and pass under the first provision of Article Second of my said Will.

THIRD: I further express to the Trustees of the Metropolitan Museum my earnest wish that none of the works of art hereby bequeathed to it shall at any time be subjected to any process of varnishing, retouching or other alteration from the condition in which I leave them; unless the same shall in the judgment of expert artists, not dealers, be necessitated by some process of decay.

. . .

Second Codicil dated June 26, 1922
I, the undersigned, LOUISINE W. HAVE-MEYER, of the City of New York, do make, publish and declare the following as and for a SECOND CODICIL to my Last Will and Testament dated the 31st day of July, 1917, in addition to the first codicil thereto dated the 24th day of July 1919:

FIRST: In addition to the paintings and other works of art bequeathed by me to the Metropolitan Museum of Art by the first codicil of my said Will, I further give and bequeath to the said Museum as a part of the "H. O. HAVEMEYER COLLECTION" in said codicil referred to, the following [starred items were withdrawn and/or replaced]:

Two paintings by Rembrandt, viz [both now considered "style of Rembrandt"]:
1. Admiral: With Hat and Feather.
2. His Wife: With pearls.

Four paintings by Veronese, viz:
1. Portrait of His wife (full bust with stars on lace —seated, not full length) [now considered by Francesco Montemezzano].
2. Portrait of Boy and Dog.
3. Portrait, Full length (seated) Woman in White[*].
4. Portrait, Woman Seated, Sea View at Right Hand side, not full length[*].

Eight paintings by Monet, viz:
1. Flower Piece ⎱ Pendants
2. Flower Piece ⎰

3. The White Glaçons in Alcove, the one Monet sent to my husband.
4. The Hay Stacks (now at my house in Connecticut).
5. The Poplars (now at my house in Connecticut).
6. The Green Wave.
7. Bougival: A very early period—a party of men and women on a small island in Seine.
8. Pond Lilies and a Bridge.

Two paintings by Manet, viz:
1. Copy of Delacroix's "Barque of Dante."
2. The Man in the boat—a woman beside him.

One drawing by Millet, viz:
Girl with Sheep from Faure Collection.

One oil painting by Puvis de Chavannes, from which the fresco in the Paris Sorbonne was done.

Seven paintings by Courbet, viz:
1. Portrait of Mme Brayer.
2. Portrait of Heloïse Abélard. An Old Woman in Lace Cap with Pink Ribbons [now considered "style of Courbet"].
3. Portrait of his friend known as the Swiss, "Le Suisse."
4. Flower Piece: A Basket of Blossoms [now considered copy after Courbet].
5. Large Landscape, Source de la Loue:—a River.
6. Fruit Piece: Four red and one green apple [now considered "style of Courbet"].
7. Nude Woman holding a tree and standing in brook looking down.

One painting by Renoir, viz:
Portrait of young girl seated by seashore.

One painting by Pissarro, viz:
Nude seated in woods.

Two oil paintings by Degas, viz:
1. Ballet girls seated and cello on the floor.
2. Flower piece (rather large) with a woman seated by table known as La Femme au Chrysanthèmes.

SECOND: With reference to each of the articles by this or by the first codicil to my will bequeathed to the Metropolitan Museum, I direct that the identification of it either by my executors or by the majority of them or by my son Horace, shall be conclusive both upon the museum and upon my estate, and that the remaining provisions of Article Second of the said first codicil and those of Article Third thereof shall likewise apply to the additional articles by this codicil bequeathed to the Museum.

. . .

Third Codicil dated August 18, 1922
I, the undersigned, LOUISINE W. HAVE-MEYER, of the City of New York, do make, publish and declare the following as and for a Third Codicil to my last Will and Testament dated the 31st day of July, 1917, in addition to the first codicil thereto dated the 24th day of July, 1919 and the second codicil thereto dated the 26th day of June, 1922:

FIRST: In addition to the paintings and other works of art bequeathed by me to the Metropolitan Museum of Art by the first and second codicils to my said Will, I further give and bequeath to the said Museum as part of the "H. O. HAVEMEYER COLLECTION" in said codicils referred to, all such other pictures, paintings, engravings, statuary and works of art by my Will bequeathed to my surviving children, and not otherwise specifically disposed of by the codicils thereto, as my son Horace Havemeyer may by deed execute within one year after my death appoint to it, and I hereby authorize and empower him so to appoint the same or any thereof.

SECOND: In all other respects I hereby ratify and republish my said Will and the said two codicils thereto.

IN WITNESS WHEREOF I have hereunto set my hand and seal this 18th day of August 1922.
(signed) Louisine W. Havemeyer

. . .

The Metropolitan Museum declined six of the paintings, one each by or attributed to Clouet, Andrea del Sarto, Goya, and Corot, and two to Veronese, as well as four of the sculptures that Louisine had designated for it in her first two codicils. According to Robert W. de Forest, president of the board of trustees, their acceptance would have been unjust to the Havemeyer family since the museum did not need these particular objects. Two of the sculptures and two figure pieces by Goya and Corot were retained by Adaline Frelinghuysen and Electra Webb; the six remaining works were included

in the Havemeyer estate sale of April 1930. The auction catalogue listed the two portraits by Veronese as questionable, and merely attributed the *Madonna and Child with Saint John* to Andrea del Sarto (in 1922 the Metropolitan had purchased a similar but authentic work by that artist). The attribution of the Clouet portrait was changed to "follower of Bartholomeus Bruyn." Upon Horace Havemeyer's request, the curator of paintings Bryson Burroughs submitted to him a list of substitute pictures in the order of their desirability. Horace's final selection for the museum included Goya's *Head of Lopez* (now considered "style of Goya"), Delacroix's *Christ on the Lake of Gennesaret,* Daumier's *The Third-Class Carriage,* Courbet's *Madame Marie Crocq,* and his *Alphonse Promayet.* In February 1930 Horace Havemeyer was elected a trustee of the Metropolitan Museum of Art; he served as an active member for seventeen years, until, in 1947, he asked to be made an honorary trustee. His special interests were in the rehanging and placement of paintings and in new methods of cleaning works of art. He was also elected a benefactor of the museum in 1929, as his mother had been in 1924.

Louisine's supremely generous bequest accomplished, the three Havemeyer heirs made their personal selections among the great number of works that remained. They based their choices on Louisine's guidelines in her "Notes to My Children." In addition to an abundance of paintings, drawings, watercolors, and prints, they had a vast supply of Oriental decorative wares, Italian majolica, Tanagra figures, Tiffany favrile glass, Barye bronzes, ancient coins, Near Eastern potteries and textiles, and a myriad of other objects from which to choose. They also divided the contents of 1 East 66th Street, each selecting from the furniture, rugs, draperies, silver, china, glassware, linens, and books.

Yet there remained enough in Louisine's estate to organize a five-part auction—spread over ten days —of everything that her children had not taken.

More than $374,000 was brought in by the five parts of the dispersal sale, four of which were held at the American Art Association–Anderson Galleries at 30 East 57th Street. Part V, made up of miscellaneous furnishings and decorations in 1 East 66th Street, took place on the premises; the catalogue for the house sale stated: "All lots, including fixtures, architectural details, paneling, mosaic work, etc., must be taken down and removed by the purchaser at his own risk and expense, and are sold only *in situ.* "

Standing room was at a premium on the evening of April 10, 1930, when Part I, consisting primarily of 119 paintings, yielded $241,000. The major buyer among the crowd that packed the auction room was Chester Dale, who not only acquired three pictures by Cassatt and one by Monet, but also paid $26,000 for David's *Portrait of a Young Girl in White* and the surprisingly high sum of $24,000 for Cézanne's *The Abduction.*

Three months after the sale the newspapers announced that the "Palace of the Sugar King" was doomed to give way to an apartment house. Included for demolition along with 1 East 66th Street were the residences of Electra Webb at 852 Fifth Avenue (originally owned by Colonel Oliver Payne), and of Horace Havemeyer at 853 Fifth Avenue. Together the three houses formed a northeast corner site of 100 feet on Fifth Avenue by 125 feet on 66th Street, one of the largest and most valuable plots then available. Other Fifth Avenue mansions owned by notables of the period shared the fate of the Havemeyer residence; a chapter in the social and cultural history of New York City came to a close.

Notes

CHAPTER I

1. Emily Sartain to John Sartain, March 8, 1874. Archives of American Art (Moore College of Art, Philadelphia).
2. Emily Sartain to John Sartain, April 24, 1874. Archives of American Art (Moore College of Art, Philadelphia).
3. Louisine Havemeyer's unpublished chapter on Mary Cassatt, p. 2. This chapter, containing "Extracts from Miss Cassatt's Letters," in the possession of the Havemeyer descendants, was originally intended for Louisine Havemeyer's *Sixteen to Sixty: Memoirs of a Collector* (New York: privately printed, 1961); cited hereafter as Louisine Havemeyer's unpublished chapter on Mary Cassatt.
4. *Ibid.,* pp. 2–3.
5. Emily Sartain to John Sartain, October 13, 1874. Archives of American Art (Moore College of Art, Philadelphia).
6. Emily Sartain to John Sartain, April 27, 1875. Archives of American Art (Moore College of Art, Philadelphia).
7. Louisine Havemeyer's unpublished chapter on Mary Cassatt, p. 9.
8. Louisine Havemeyer, *Sixteen to Sixty: Memoirs of a Collector* (New York: privately printed, 1961), pp. 249–50; cited hereafter as Louisine Havemeyer, *Memoirs.*
9. Caroline Ticknor, *May Alcott: A Memoir* (Boston: Little, Brown, 1928), pp. 151–52.
10. Although only a few works were sold out of the exhibition, there was a profit (after expenses) of over 6,000 francs from entrance fees and catalogue sales. Each of the sixteen participants received 439 francs. The month-long display (April 10–May 11, 1879) was well attended, though most came out of curiosity or for amusement. See John Rewald, *The History of Impressionism,* 4th rev. ed. (New York: The Museum of Modern Art, 1973), p. 424. It is unlikely that Louisine Elder attended the Impressionists' fourth show, in the spring of 1879, since she does not mention it in her *Memoirs.*
11. Cassatt could have been rushing off in 1874 to see a new Courbet painting, but not one that he had "recently finished in his studio." In 1871 the artist had been sentenced to six months in prison for his part in the destruction of the Vendôme Column in the heart of Paris. After his confinement ended, Courbet fled in 1873 to Switzerland, where he died in 1877.
12. Louisine Havemeyer, *Memoirs,* p. 190.
13. *Ibid.*
14. These pastels were in the unsold surplus from Whistler's exhibition of fifty-three pastels of Venice at the Fine Art Society, London, in January 1881. Since all five had been in this show, they could not possibly have been bought before 1881.
15. Louisine Havemeyer, *Memoirs,* pp. 210–11.
16. Louisine gave both these documents (she had pasted the letter inside the pamphlet) to her daughter Electra in 1924. The inscribed copy of *Art & Art Critics* and Whistler's letter to Louisine Elder have been made available through the courtesy of the Shelburne Museum, Shelburne, Vermont.
17. *Scribner's Monthly* 15 (April 1879): 888–89. According to Hans Huth ("Impressionism Comes to America," *Gazette des Beaux-Arts* 29 [April 1946]: 235), the art section of *Scribner's Monthly* was under the directorship

of Richard Watson Gilder, an unusually per-
ceptive and progressive critic.

18. Anonymous article, *London Daily Chron-
icle,* December 3, 1886, quoted by A. Ludo-
vici, *An Artist's Life in London and Paris,
1870–1925* (New York: Minton, Balch, 1926),
p. 172.

19. Louisine Havemeyer, *Memoirs,* p. 251.

20. Mary Cassatt to Alexander Cassatt, Novem-
ber 18 [1880]. Archives of American Art
(Philadelphia Museum of Art).

21. Mrs. Robert Simpson Cassatt to Alexander
Cassatt, December 10 [1880]. Archives of
American Art (Philadelphia Museum of Art).

22. Robert Simpson Cassatt to Alexander Cas-
satt, April 18, 1881. Archives of American Art
(Philadelphia Museum of Art).

23. Louisine Havemeyer's unpublished chapter
on Mary Cassatt, p. 5.

24. *Ibid.,* pp. 7–8.

CHAPTER II

1. Henry O. Havemeyer's parents, Mr. and Mrs.
Frederick C. Havemeyer, Jr., had ten chil-
dren; Henry was their eighth child, the youn-
gest surviving son. Henry's mother, Sarah
Henderson Havemeyer, died in 1851, leaving
his father with children ranging from nine-
teen to two years of age.

2. Information courtesy of J. Watson Webb, Jr.,
who learned this from his mother, Electra
Havemeyer Webb; however, the fact is de-
nied by the descendants of Electra's brother,
Horace Havemeyer.

3. Aline B. Saarinen, *The Proud Possessors* (New
York: Random House, 1958), p. 145.

4. Four of Frederick C. Havemeyer's five sons
—George, Theodore, Thomas, and Harry—
and his nephew Charles H. Senff would be
connected with the sugar business. George
died in an accident at the refinery in 1861.

5. Louisine Havemeyer, *Memoirs,* p. 39.

6. Samuel Colman and Louis Tiffany both ex-
hibited paintings and watercolors at the Phil-
adelphia Centennial. It is not certain that
Tiffany had any formal instruction in paint-
ing from Colman, but the two were close
friends and young Tiffany spent much time in
Colman's studio. For Tiffany's career as a
painter, see Gary Reynolds, *Louis Comfort
Tiffany: The Paintings* (New York: Grey Gal-

lery and Study Center, New York Univer-
sity, 1979).

7. Louisine Havemeyer, *Memoirs,* p. 16.

8. By assigning the year 1880 (instead of 1883)
to Cassatt's letter of November 18 to her
brother, Nancy Mowll Mathews has estab-
lished that the artist selected a Diaz painting
for Harry Havemeyer rather than for Loui-
sine, as previously assumed. Indeed, Cassatt
speaks specifically of sending a Diaz painting
"to the Elders, for Mr. Havemeyer." See *Cas-
satt and Her Circle, Selected Letters,* ed. Nancy
Mowll Mathews (New York: Abbeville,
1984), pp. 152–54.

9. Louisine Havemeyer, *Memoirs,* p. 16.

10. A documented purchase of a Barbizon paint-
ing in October 1885 was Daubigny's *Evening
on the Marne,* bought by Harry Havemeyer
from M. Knoedler and Co.

11. For the information, not previously known,
that Paul Durand-Ruel went to Boston in
1883, I am grateful to his grandson Charles
Durand-Ruel.

12. Of Scottish origin, Daniel Cottier (1839–91)
began his career as a decorator and manufac-
turer of glass; he opened a decorating firm in
London in 1869. In his New York branch he
and his partner James S. Inglis (1853–1907)
handled works by Corot, Daubigny, Rous-
seau, Monticelli, and Delacroix, as well as old
masters and certain American painters.

13. Montague Marks, "My Note Book," *The Art
Amateur* 15 (June 1886): 2.

CHAPTER III

1. Mary Cassatt to Alexander Cassatt, April 27
[1884]. Archives of American Art (Philadel-
phia Museum of Art).

2. Mary Cassatt to Alexander Cassatt, Septem-
ber 2 [1886]. Mr. Thomson would remain
faithful to Durand-Ruel and continue to pur-
chase Monets from his galleries in New York
and Paris.

3. Lionello Venturi, ed., *Les archives de l'impres-
sionnisme,* 2 vols. (Paris: Durand-Ruel, 1939),
I: 17–18.

4. Camille Pissarro, *Lettres à son fils Lucien,* ed.
John Rewald (Paris: Albin Michel. 1950),
p. 47n.

5. Camille Pissarro to Claude Monet, June 12,
1883, quoted by Gustave Geffroy, *Claude*

Monet: sa vie, son oeuvre, 2 vols. (Paris: G. Crès, 1924), II: 10–11. From 1790 to 1913 (except from 1894 to 1897), the U.S. Customs taxed imports of foreign art, considered as luxury items, with duties varying between 10 and 30 percent. In 1909 original works more than twenty years old became exempt; after 1913 all duties on imported art were abolished.

6. Edward Villiers, "Paris Art Topics," *The Art Amateur* 10 (March 1884): 109.

7. Venturi, ed., *Archives,* II: 214.

8. Archives, Department of American Paintings and Sculpture, Metropolitan Museum of Art, New York.

9. Paul Durand-Ruel to Camille Pissarro, June 9, 1885, quoted by F. Daulte, "Le marchand des Impressionnistes," *L'Oeil* 66 (June 1960): 75.

10. Venturi, ed., *Archives,* I: 295.

11. This information was provided to the author by Charles Durand-Ruel during a conversation in Paris on February 8, 1979.

12. Mary Cassatt to Alexander Cassatt, September 21 [1885]. Archives of American Art (Philadelphia Museum of Art).

13. Venturi, ed., *Archives,* II: 216.

14. *Ibid.,* p. 217.

15. See Daulte, "Le marchand des Impressionnistes," p. 75.

16. Pissarro, *Lettres,* p. 105.

17. Dorothy Weir Young, *The Life and Letters of J. Alden Weir,* ed. and introduction by Lawrence W. Chisolm (New Haven: Yale University Press, 1960), p. 167.

18. "Picture Sellers and Picture Buyers," *The Collector* 2 (December 15, 1890): 44. Although this review was written in 1890, it is representative of the American critical response to Durand-Ruel's second exhibition in 1887.

CHAPTER IV

1. Louisine mistakenly gives the date of Durand-Ruel's first exhibition at the National Academy of Design as 1889 instead of 1886. See Louisine Havemeyer, *Memoirs,* p. 220.

2. *Ibid.,* p. 221.

3. *Ibid.*

4. *New York Times,* March 6, 1886, p. 5.

5. *The Sun,* March 7, 1886, p. 9.

6. *New York Times,* May 6, 1887, p. 8.

7. Franklin Clarkin, "The So-called Sugar Trust," *The Century Magazine* 43 (January 1903): 471.

8. Louisine Havemeyer, *Memoirs,* p. 26.

9. The Rembrandts were exhibited at the Metropolitan Museum in 1889, but were not given to the museum during Harry's lifetime. They were part of Louisine's bequest in 1929. Delacroix's *The Expulsion* was sold at the Havemeyer estate auction in 1930; its present whereabouts is unknown.

10. Of German origin, S. Bing went to Paris before 1871 and acquired French citizenship. After his trip to Japan in 1875, he opened two shops in Paris, where he became a well-known dealer and importer of Oriental art.

11. Colman's collection consisted of Japanese and Chinese ceramics, Persian objects, ivory carvings, Japanese bronzes, Oriental swords and armor, and paintings by Rembrandt, Corot, Delacroix, and Roybet. These were displayed throughout the house, alongside his own paintings.

12. Louisine Havemeyer, *Memoirs,* p. 12.

13. *Ibid.*

14. *Ibid.,* p. 22.

15. Montgomery Schuyler, *A Review of the Work of Charles C. Haight* (New York: Architectural Record, 1899), p. 48.

16. Louisine Havemeyer, *Memoirs,* p. 16.

CHAPTER V

1. Of German origin, William Schaus had arrived in New York in 1847 from Paris as the representative of Goupil and Co. In time he opened his own gallery at 204 Fifth Avenue; at first he sold prints, but later he imported works by such masters as Van Dyck, Goya, Géricault, Delacroix, Corot, Rousseau, Diaz, and Dupré.

2. Clarence Cook, "Rembrandt's Le Doreur," *The Studio,* 1885 (reprinted in an undated pamphlet, Library, Metropolitan Museum of Art, New York).

3. *New York Times,* February 19, 1885, p. 4.

4. Kate Field, quoted in *The Collector* 3 (April 1892): 163. Field was waging a vigorous crusade against the duty on foreign works of art; her goal was to make Congress repeal the statute.

5. William Schaus to H. O. Havemeyer. Ar-

chives, Department of European Paintings, Metropolitan Museum of Art, New York.

6. Unidentified newspaper clipping enclosed in a copy of the catalogue of Whistler's exhibition, *Notes—Harmonies—Nocturnes* (New York: H. Wunderlich, 1889). Frick Art Reference Library, New York.

7. Brander Matthews, *Bookbindings Old and New: Notes of a Book-Lover, with an account of the Grolier Club of New York* (New York: Macmillan, 1895), p. 294.

8. *New York Times,* June 24, 1889, p. 2.

9. These three were: a version of Daumier's *The Third-Class Carriage,* lent by Count Doria; Courbet's *Woman with a Parrot,* lent by Jules Bordet; and Manet's *Boating,* lent by V. Desfossés. In the show there were also several privately owned paintings that later she would greatly covet but never obtain, such as Manet's *Olympia* and Corot's *Woman with the Pearl* (both of which she ultimately lost to the Louvre), and Courbet's *The Stone Breakers* (which went to the Gemäldegalerie in Dresden; it was destroyed in World War II).

10. Louisine Havemeyer, *Memoirs,* p. 191.

11. *Ibid.*

12. Louisine Havemeyer's unpublished chapter on Mary Cassatt, p. 1.

13. *Ibid.,* p. 14. Summer 1888, the date usually given for Cassatt's riding accident, is based solely on an undated letter from Degas to Henri Rouart. In this case Louisine's date (summer 1889) is the more reliable, for she and her husband certainly made their first trip together to Paris in that year. Louisine could not have gone to France the previous summer, since her daughter Electra was born in August 1888. As she wrote: "My first meeting with Miss Cassatt in Paris after my marriage is indelibly graven on my mind" (*ibid.*).

14. *Ibid.*, p. 1.

15. *Ibid.,* p. 15.

16. Mary Cassatt to Camille Pissarro, November 27 [1889]. Courtesy of Galerie Schmit, Paris.

17. *L'Angélus* was exhibited in New York and in other American cities as the property of the American Art Association. Sutton and Kirby earned a fortune in entrance fees and in sales of engravings of the work. When Alfred Chauchard, owner of a Paris department store, offered them $150,000 in the fall of 1890, they decided to return *L'Angélus* to

France. Chauchard willed the picture to the Louvre.

1. Henry James, quoted by Hilton Kramer, "Going Beyond the 'Edifice Complex,'" *New York Times Magazine,* May 7, 1978, p. 61.

2. Wilhelm Bode, "Die amerikanische Konkurrenz im Kunsthandel und ihre Gefahr für Europa," *Kunst und Künstler,* 1902–3; reprinted in *Kunst und Künstler: Aus 32 Jahrgangen einer deutschen Kunstzeitschrift* (Mainz: Florian Kupferberg Verlag, 1971), pp. 17–25.

3. Gustavus Myers, *History of the Great American Fortunes* (3 vols., 1910 [rev. ed. New York: Modern Library, 1936]), p. 584.

4. "Notes for Collectors," *The Art Courier* 24 (March 1891): 2.

5. Louisine Havemeyer's unpublished chapter on Mary Cassatt, p. 22. Louisine dated this letter 1890, but the correct date is early July 1892, when Cassatt went with Duret to see the Rembrandts at Durand-Ruel's gallery before they were packed for shipment to America.

6. This had been a heated issue since 1881 when 10,000 people signed a petition advocating that both the Metropolitan and the Natural History museums should be open on Sundays. In 1885 the city's Board of Estimate had even threatened to cut off city funds unless these museums acquiesced to the public demand. For a more detailed account of the controversy surrounding the practice of Sunday openings, see Calvin Tomkins, *Merchants and Masterpieces* (New York: E. P. Dutton, 1973), pp. 75–79.

7. "News and Notes," *The Art Amateur* 26 (March 1892): 111.

8. Henry Marquand to Louis P. di Cesnola. Archives of the Metropolitan Museum, New York.

9. Henry O. Havemeyer (son of Theodore Augustus Havemeyer), *Biographical Record of the Havemeyer Family, 1600–1945* (New York: privately printed by the Scribner Press, 1944), pp. 67–68. Biographies of J. Pierpont Morgan make no mention of this occurrence.

10. Archives of American Art (Howard Russell Butler Collection).

11. Myers, *Great American Fortunes,* p. 582.

12. In setting up his new Sugar Trust, Harry Havemeyer called upon the services of corporate lawyer John Randolph Dos Passos (father of the writer John Dos Passos), whose fee was reputedly the largest of its kind. Obviously pleased with Dos Passos's work, Harry appointed him counsel for the American Sugar Refining Company. See Townsend Ludington, *John Dos Passos: a Twentieth Century Odyssey* (New York: E. P. Dutton, 1980), p. 9.

CHAPTER VII

1. Louisine Havemeyer, *Memoirs,* p. 19.
2. Saarinen, *The Proud Possessors,* p. 157.
3. Louisine Havemeyer, *Memoirs,* p. 17.
4. *Ibid.,* p. 24.
5. *Ibid.,* p. 16.
6. *Ibid.,* p. 19.
7. *Ibid.,* p. 11.
8. See Frederick A. Sweet, *Miss Mary Cassatt: Impressionist from Pennsylvania* (Norman: University of Oklahoma Press, 1966), p. 154.
9. S. Bing, *La Culture artistique en Amerique* (Paris: privately printed, 1896), p. 82n.
10. *New York Times,* October 11, 1893, p. 1.
11. Louisine Havemeyer, *Memoirs,* p. 51.
12. *Ibid.,* p. 192.
13. *Ibid.*
14. *Ibid.,* p. 193.
15. Louisine Havemeyer's unpublished chapter on Mary Cassatt, p. 23.
16. Louisine Havemeyer, *Memoirs,* p. 153.

CHAPTER VIII

1. William H. Fuller, a director of the National Wall Paper Company, had a sizable collection of English and Barbizon paintings (which he sold at auction in 1890) before he developed an interest in Monet's work. At his death in 1902, he owned at least eleven of the artist's canvases, some purchased directly from Monet.
2. "Causerie," *L'Art dans les Deux Mondes,* March 28, 1891, p. 222.
3. William H. Fuller, *Claude Monet* (New York: Gilliss Bros., 1891), p. 7.
4. Alfred Trumble, "Claude Monet," *The Collector* 2 (February 15, 1891): 91.

5. Theodore Robinson, "Claude Monet," *The Century Magazine* 44 (September 1892): 698.
6. Alfred Trumble, "Something for Everybody," *The Collector* 4 (February 1, 1893): 102.
7. *New York Times,* January 23, 1893, p. 4.
8. *New York Times,* March 10, 1893, p. 4.
9. Entry dated February 24, 1893, Theodore Robinson, Diary MS, 1892–96, Frick Art Reference Library, New York. Quotations from Robinson's diary in this and subsequent chapters refer to this source.
10. "The Rise of the Curtain," *The Collector* 2 (October 1, 1891): 225.
11. Montague Marks, "My Note Book," *The Art Amateur* 18 (April 1888): 105.
12. Alfred Trumble, "Picture Sellers and Picture Buyers," *The Collector* 2 (November 15, 1890): 23.
13. Although the Palmers bought the bulk of their Impressionist collection from Durand-Ruel in 1892, they continued to purchase works by these artists, usually from the same firm. In 1893 they bought nine Monets (four were directly from the artist), one Renoir, and one Cassatt, and in 1894, four paintings by Monet, one by Renoir, and three by Pissarro; all were from Durand-Ruel.
14. Bertha Palmer to Sara Hallowell. Archives, Chicago Historical Society.
15. Montague Marks, "My Note Book," *The Art Amateur* 28 (December 1892): 2.
16. Hamlin Garland, "Impressionism," *Crumbling Idols* (Chicago: Stone and Kimball, 1894), p. 121.
17. Montague Marks, "My Note Book," *The Art Amateur* 29 (September 1893): 80.
18. Pissarro, *Lettres,* pp. 312–13.
19. Alfred Trumble, "Picture Sellers and Picture Buyers," *The Collector* 2 (December 15, 1890): 44.
20. On January 25, 1955, Harris Whittemore, Jr., wrote to Frederick A. Sweet, then curator of American Painting and Sculpture at the Art Institute of Chicago: "My father met Miss Cassatt when he was in Europe in the first half of 1893." Archives of American Art (Frederick Sweet Papers), Smithsonian Institution, Washington, D.C.
21. This and other previously unknown information concerning the Whittemores is to be found in the essay by Michael A. Findlay and

Missy McHugh for Christie's auction catalogue, *Important Impressionist Paintings from the Collection of Harris Whittemore,* New York: November 12, 1985. The catalogue reproduces an unpublished letter from Mary Cassatt to Harris Whittemore (postmarked "AVR 93"), in which she urges her young acquaintance to stop by Portier's apartment to see "drawings by Degas and other things that may interest you."

22. Pissarro, *Lettres,* p. 353. Obviously Pissarro had no idea that the previous year this same American had purchased one of his works from Boussod, Valadon and Co.

23. The auction to settle the estate of his late partner, R. Austin Robertson, also included paintings and sculptures from James Sutton's private holdings. Sutton apparently took advantage of the occasion to unload works that no longer interested him, such as bronzes and watercolors by Barye as well as paintings by Rousseau, Diaz, Dupré, Corot, Decamps, Millet, and Delacroix.

24. Pissarro, *Lettres,* p. 309. The figure of 120 paintings by Monet seems somewhat exaggerated.

CHAPTER IX

1. See *New York Tribune,* June 13, 1894, p. 4.
2. *New York Times,* October 3, 1894, p. 4.
3. *New York Times,* October 2, 1894, p. 1.
4. *New York Tribune,* February 18, 1894, p. 7.
5. Louisine Havemeyer, *Memoirs,* p. 220.
6. *New York Times,* January 1, 1894, p. 9.
7. *New York Times,* January 14, 1895, p. 4.
8. See Alfred Trumble, "Footnotes of a Fortnight," *The Collector* 6 (January 15, 1895): 90.
9. "Exhibition of the Work of Raffaëlli," *The Art Amateur* 32 (April 1895): 135.
10. "Raffaëlli on American Art," *The Collector* 6 (September 1, 1895): 294–95. Raffaëlli's comments appeared originally in *The Sun,* August 21, 1895.
11. Theodore Child, "The King of the Impressionists," *The Art Amateur* 14 (April 1886): 101–2.
12. *New York Times,* March 17, 1895, p. 13.
13. "The Ides of March," *The Collector* 6 (March 15, 1895): 159–60.
14. *New York Times,* March 12, 1895, p. 4.
15. Louisine Havemeyer, *Memoirs,* p. 226.
16. *Ibid.,* pp. 228–29.
17. *Ibid.,* p. 225.
18. "My Note Book," *The Art Amateur* 32 (May 1895): 158.
19. *New York Times,* April 18, 1895, p. 4.
20. Alfred Trumble, "May-Day Facts and Fancies," *The Collector* 6 (May 1, 1895): 208.
21. *Ibid.* Trumble also stated that "the recent death of Mme. Berthe Morizot [sic] leaves Miss Mary Cassatt, as far as her sex is concerned, practically in undisputed possession of the field both have cultivated so long."
22. Montague Marks, "My Note Book," *The Art Amateur* 33 (June 1895): 2.
23. Mary Cassatt to Rose Lamb, April 26, 1895. Archives, Department of Prints and Drawings, Museum of Fine Arts, Boston. A former pupil of William Morris Hunt, Rose Lamb painted portraits and landscapes in Boston, chiefly during the 1870s and 1880s.
24. Louisine Havemeyer's unpublished chapter on Mary Cassatt, p. 6.
25. Louisine Havemeyer, *Memoirs,* pp. 258–59.

CHAPTER X

1. "News and Views," *The Collector* 8 (April 1897): 165.
2. "Talks with Paris Art Dealers," *The Collector* 7 (June 1, 1896): 236.
3. "News and Views," *The Collector* 8 (December 15, 1896): 49.
4. "Talks with Paris Art Dealers," *The Collector* 7 (June 1, 1896): 236.
5. Emile Zola, *L'Oeuvre,* Notes et commentaires de Maurice LeBlond (Paris: Bernouard, 1928), pp. 421–22 (Notes diverses du Manuscript de *L'Oeuvre*).
6. Louisine Havemeyer's unpublished chapter on Mary Cassatt, p. 13.
7. *Ibid.,* p. 31.
8. Louisine Havemeyer, *Memoirs,* p. 227.
9. *Ibid.,* p. 195.
10. *Ibid.,* p. 222.
11. *Ibid.,* p. 198.
12. *Ibid.,* p. 197.
13. *Ibid.,* p. 199.
14. *Ibid.,* pp. 260–61. In Louisine's *Memoirs,* the name of the dealer Arsène Portier was transcribed incorrectly as Pottier, who was a transatlantic shipper for works of art, employed by both the Havemeyers and Mary Cassatt.

15. *Ibid.,* p. 234.

16. Sara Hallowell to Harry Havemeyer, August 13, 1896. Courtesy of Horace Havemeyer, Jr.

17. Louisine Havemeyer, *Memoirs,* p. 257.

18. Louisine Havemeyer, "Notes to My Children," p. 31. Courtesy of J. Watson Webb, Jr.

19. Louisine Havemeyer, *Memoirs,* p. 251.

20. *Ibid.,* p. 135.

21. H. O. Havemeyer to Henry Marquand, December 8, 1896, quoted by Stuart P. Feld, " 'Nature in Her Most Seductive Aspects': Louis Comfort Tiffany's Favrile Glass," *The Metropolitan Museum of Art Bulletin* 21 (November 1962): 101.

22. *New York Herald,* February 6, 1897, p. 3.

23. *Ibid.*

24. *New York Tribune,* April 17, 1897, p. 7.

25. *New York Times,* May 28, 1897, p. 3.

26. *New York Tribune,* May 27, 1897, p. 7.

27. *New York Tribune,* May 28, 1897, p. 1.

28. *New York Times,* May 28, 1897, p. 3.

29. *New York Times Sunday Supplement,* May 23, 1897, p. 14.

CHAPTER XI

1. Louisine Havemeyer, *Memoirs,* p. 33.

2. *Ibid.*

3. *New York Times,* December 31, 1905, mag. sec., pt. 3, p. 6.

4. Sara Hallowell to Paul Durand-Ruel, August 14, 1894. Archives, Galerie Durand-Ruel, Paris. Hallowell's address on the letterhead was 11, rue Lemaître, Puteaux-Seine.

5. Paul Durand-Ruel to Sara Hallowell, August 20, 1894. Archives, Galerie Durand-Ruel, Paris.

6. Louisine Havemeyer's unpublished chapter on Mary Cassatt, p. 24.

7. Louisine Havemeyer, *Memoirs,* p. 264.

8. *Public Ledger,* January 4, 1898, p. 18.

9. Mary Cassatt to Rose Lamb, January 14, 1898. Archives, Department of Prints and Drawings, Museum of Fine Arts, Boston.

10. Louisine Havemeyer, *Memoirs,* p. 222.

11. *Ibid.,* p. 223.

12. *Ibid.,* pp. 223–24.

13. *Ibid.,* p. 224.

14. *Ibid.*

15. *Ibid.,* p. 239.

16. *Ibid.,* p. 237.

17. "Exhibitions," *The Art Amateur* 38 (April 1898): 107.

18. Mary Cassatt to Mrs. John Howard Whittemore, March 14 [1899]. Archives of American Art.

19. Charles Durand-Ruel's unpublished "Memoirs."

20. Louisine Havemeyer, *Memoirs,* p. 244.

CHAPTER XII

1. Louisine Havemeyer, *Memoirs,* p. 83.

2. *Ibid.,* p. 110.

3. Mary Cassatt to Louisine Havemeyer, February 6 [1903].

4. Louisine Havemeyer, *Memoirs,* p. 108.

5. *Ibid.,* p. 131.

6. *Ibid.,* p. 138.

7. *Ibid.,* p. 141.

8. *Ibid.,* p. 147.

9. Louisine Havemeyer's unpublished chapter on Mary Cassatt, p. 16.

10. Edith de Terey, "Mrs. Havemeyer's Vivid Interest in Art," *New York Times,* February 3, 1929, pt. 8, p. 13.

11. Ambroise Vollard, *Recollections of a Picture Dealer* (Boston: Little Brown, 1936), p. 139.

12. *Ibid.,* p. 142.

13. Mary Cassatt to Louisine Havemeyer, July 6 [1913].

14. Mary Cassatt to Louisine Havemeyer, February 6 [1903].

15. Mary Cassatt to Harry Havemeyer, February 3, 1903.

16. "Monet's Gain in Favor," *New York Sun,* April 17, 1901, p. 7.

17. Louisine Havemeyer's unpublished chapter on Mary Cassatt, p. 27.

18. Mr. Havemeyer's prospectus for his "Moorish Houses at Bayberry Point" was issued in 1898 or 1899, just after the villas had been completed. William Havemeyer kindly made available to me his copy of his great-grandfather's prospectus.

19. Mary Cassatt to Louisine Havemeyer, August 30 [1901].

20. According to William Havemeyer, the first sale of a Bayberry Point villa was in 1939 for the reduced price of $6,000.

21. Mary Cassatt to Louisine Havemeyer, February 2 [1903].

22. David Alan Brown, *Berenson and the Connois-*

seurship of Italian Painting (Washington, D.C.: National Gallery of Art, 1979), p. 17.

23. *Ibid.,* pp. 18–19.

24. Mary Cassatt to Louisine Havemeyer, August 30 [1901].

25. Mary Cassatt to Theodate Pope [June 1903]. Hill-Stead Museum, Farmington, Conn.

26. Louisine Havemeyer's unpublished chapter on Mary Cassatt, p. 25.

27. *Ibid.*

28. Louisine Havemeyer, *Memoirs,* pp. 236–37.

CHAPTER XIII

1. Louisine Havemeyer's unpublished chapter on Mary Cassatt, p. 29.

2. Louisine Havemeyer, *Memoirs,* p. 155.

3. *Ibid.*

4. *Ibid.,* p. 22.

5. Carl Snyder to Mary Cassatt, July 5, 1904. Archives of American Art (August F. Jaccaci Papers).

6. Charles L. Freer to Edward R. Warren [November 1904]. Freer Archive, Freer Gallery of Art, Smithsonian Institution, Washington, D.C.

7. Louisine Havemeyer's unpublished chapter on Mary Cassatt, p. 32.

8. *Ibid.*

9. *New York Times,* October 5, 1905, p. 1.

10. Mary Cassatt to her niece by marriage, Minnie Drexel Fell Cassatt, April 13, 1906. Archives of American Art (Frederick Sweet Papers).

11. Louisine Havemeyer, *Memoirs,* p. 201.

12. *Ibid.,* p. 202.

13. *Ibid.*

14. Mary Cassatt to Louisine Havemeyer, June 2 [1906].

CHAPTER XIV

1. Mary Cassatt to Louisine Havemeyer, July 19 [1906].

2. Mary Cassatt to Louisine Havemeyer, July 27 [1906].

3. Ernest Fenollosa to Charles Freer, September 25, 1906. Freer Archive, Freer Gallery of Art, Smithsonian Institution, Washington, D.C.

4. Louisine Havemeyer, *Memoirs,* p. 93.

5. Ernest Fenollosa, "The Collection of Mr.

Charles L. Freer," *Pacific Era* 1 (November 1907): 61.

6. Mary Cassatt to Louisine Havemeyer, June 2 [1906].

7. See David Park Curry, "Artist and Patron," *James McNeill Whistler* (Washington, D.C.: The Freer Gallery of Art, 1984), pp. 19–20.

8. Saarinen, *The Proud Possessors,* pp. 120–21.

9. Charles Freer to Charles Morse, September 27, 1906. Freer Archive, Freer Gallery of Art, Smithsonian Institution, Washington, D.C.

10. Charles Freer to Ernest Fenollosa, September 27, 1906. Freer Archive, Freer Gallery of Art, Smithsonian Institution, Washington, D.C.

11. Louisine W. Havemeyer, "The Freer Museum of Oriental Art," *Scribner's Magazine* 73 (May 1923): 532.

12. Mary Cassatt to Louisine Havemeyer, October 17 [1906].

13. Ernest Fenollosa to Charles Freer, March 12, 1907. Freer Archive, Freer Gallery of Art, Smithsonian Institution, Washington, D.C.

14. Myers, *Great American Fortunes,* pp. 582–83.

15. Mary Cassatt to Louisine Havemeyer, November 8 [1906].

16. Mary Cassatt to Louisine Havemeyer, June 19 [1901].

17. Unidentified newspaper clipping, scrapbook of Electra Havemeyer Webb. Courtesy of J. Watson Webb, Jr.

18. Mary Cassatt to Louisine Havemeyer, November 23 [1906].

19. Mary Cassatt to Louisine Havemeyer, November 30 [1906].

20. Mary Cassatt to Louisine Havemeyer, December 18 [1906].

21. Unidentified newspaper clipping, scrapbook of Electra Havemeyer Webb. Courtesy of J. Watson Webb, Jr.

22. Mary Cassatt to Louisine Havemeyer, November 8 [1906].

23. Mary Cassatt to Louisine Havemeyer, November 30 [1906].

24. Mary Cassatt to Louisine Havemeyer, December 18 [1906].

25. Unidentified newspaper clipping, scrapbook of Electra Havemeyer Webb. Courtesy of J. Watson Webb, Jr.

26. *Ibid.*

27. Louisine Havemeyer, *Memoirs,* p. 13.

28. The only existing photographs of the interior of 1 East 66th Street were taken in 1892 when

a selection was published in the *Architectural Record.*

29. This painting, given to the Brooklyn Museum by Horace Havemeyer, is now attributed to Jan Cornelisz Vermeyen of the Dutch School.

30. Mary Cassatt to her niece by marriage, Minnie Drexel Fell Cassatt, February 26, 1907. Archives of American Art (Frederick Sweet Papers).

31. *New York Times,* March 25, 1907, p. 3.

32. Louisine Havemeyer, *Memoirs,* p. 188.

CHAPTER XV

1. Louisine Havemeyer's unpublished chapter on Mary Cassatt, p. 1.

2. Mary Cassatt to her niece by marriage, Minnie Drexel Fell Cassatt, December 14, 1907. Archives of American Art (Frederick Sweet Papers).

3. Mary Cassatt to Electra Havemeyer, undated. This unpublished letter was made available through the generosity of J. Watson Webb, Jr.

4. Mary Cassatt to her niece by marriage, Minnie Drexel Fell Cassatt, March 5, 1908. Archives of American Art (Frederick Sweet Papers).

5. Mary Cassatt to Louisine Havemeyer, June 11 [1908].

6. Mary Cassatt to Electra Havemeyer, October 15 [1908]. Archives, Shelburne Museum, Shelburne, Vermont.

7. Handwritten copy of a speech on Mary Cassatt given by Louisine Havemeyer on April 20, 1920, to the National Association of Women Painters and Sculptors at the Fine Arts Building, 215 West 57th Street. This unpublished document was made available through the generosity of Havemeyer descendants.

8. Mary Cassatt to Louisine Havemeyer, undated letter. Archives, Shelburne Museum, Shelburne, Vermont.

9. Electra Havemeyer to James Watson Webb, who was then living in Milwaukee, Wisconsin. March 11, 1909. Courtesy of J. Watson Webb, Jr.

10. Mary Cassatt to Electra Havemeyer, March 7 [1909]. Archives, Shelburne Museum, Shelburne, Vermont.

11. Electra Havemeyer to James Watson Webb, April 27, 1909. Courtesy of J. Watson Webb, Jr.

12. Mary Cassatt to Electra Havemeyer, undated letter. Archives, Shelburne Museum, Shelburne, Vermont.

13. Louisine Havemeyer, *Memoirs,* p. 167.

14. Mary Cassatt to Electra Havemeyer, April 2 [1909]. Archives, Shelburne Museum, Shelburne, Vermont.

15. Electra Havemeyer to James Watson Webb, March 26, 1909. Courtesy of J. Watson Webb, Jr.

16. Louisine Havemeyer, *Memoirs,* p. 174.

17. *Ibid.,* pp. 199–200.

18. Electra Havemeyer to James Watson Webb, May 2 [1909]. Courtesy of J. Watson Webb, Jr.

19. *New York Sun,* June 11, 1909, p. 6.

20. Louisine Havemeyer, *Memoirs,* p. 8.

21. Mary Cassatt to Adolph Borie, July 27, 1910. Archives, Philadelphia Museum of Art.

22. Louisine Havemeyer, *Memoirs,* p. 196.

23. Mary Cassatt to Electra Havemeyer, December 8 [1909]. This unpublished letter was made available through the generosity of J. Watson Webb, Jr.

24. Mary Cassatt to Louisine Havemeyer, December 8 [1909].

25. *New York Sun,* November 11, 1909, p. 1.

26. *New York Times,* January 23, 1910, pt. 5, p. 2.

27. Mary Cassatt to Louisine Havemeyer, March 10 [1910].

CHAPTER XVI

1. *The Evening World,* February 25, 1910, p. 2.

2. *New York Times,* November 17, 1910, p. 1.

3. *New York Times,* May 4, 1911, p. 1.

4. *Horace Havemeyer, 1886–1956* (New York: privately printed by the North River Press, 1957), pp. 24–25.

5. *New York Times,* June 21, 1911, p. 3.

6. *Ibid.*

7. Dikran Kelekian to Louisine Havemeyer, December 16, 1910.

8. Mary Cassatt to Louisine Havemeyer, April 12, 1911.

9. Mary Cassatt to Louisine Havemeyer [March 1912].

10. Louisine W. Havemeyer, "The Suffrage

Torch, Memories of a Militant," *Scribner's Magazine* 71 (May 1922): 528.

11. Harriot Stanton Blatch and Alma Lutz, *Challenging Years: The Memoirs of Harriot Stanton Blatch* (New York: G. P. Putnam's Sons, 1940), p. 136.

12. Louisine W. Havemeyer, "The Suffrage Torch, Memories of a Militant," p. 529.

13. *Ibid.*

14. *Ibid.*

15. Louisine Havemeyer, *Memoirs,* p. 177.

16. Mary Cassatt to Louisine Havemeyer [March 1912].

17. This painting is currently in the Metropolitan Museum of Art; in 1979 its attribution was changed to "Style of Francisco de Goya y Lucientes."

18. Mary Cassatt to Louisine Havemeyer, January 16 [1912].

19. Mary Cassatt to Louisine Havemeyer, September 6 [1912].

20. Mary Cassatt to Louisine Havemeyer, October 2 [1912].

21. Mary Cassatt to Louisine Havemeyer, Christmas Day [1912].

22. Milton W. Brown, *The Story of the Armory Show* (Greenwich, Conn.: The Joseph H. Hirshhorn Foundation, New York Graphic Society [1963]), p. 116.

23. Rewald, *The History of Impressionism,* p. 187.

24. Mary Cassatt to Louisine Havemeyer, Easter [March 1913].

25. Mary Cassatt to Louisine Havemeyer, December 4 [1913].

26. *New York Times,* December 7, 1913, pt. 10, p. 15.

27. Electra Havemeyer to J. Watson Webb, March 8, 1909. Courtesy of J. Watson Webb, Jr.

28. Mary Cassatt to Louisine Havemeyer, March 12 [1913].

29. Electra Havemeyer to J. Watson Webb, March 13, 1909. Courtesy of J. Watson Webb, Jr.

CHAPTER XVII

1. Handwritten copy of Louisine Havemeyer's speech on Mary Cassatt to the National Association of Women Painters and Sculptors, April 20, 1920, Fine Arts Building, 215 West 57th Street, New York. Courtesy of Havemeyer descendants.

2. Handwritten first draft of Louisine Havemeyer's "Remarks on Edgar Degas and Mary Cassatt," delivered on April 6, 1915, at M. Knoedler and Co., New York, in connection with the loan exhibition "Masterpieces by Old and Modern Painters." Courtesy of Havemeyer descendants.

3. Mary Cassatt to Louisine Havemeyer, undated [1899] (date supplied by the author). Unpublished letter, made available through the generosity of Havemeyer descendants.

4. For the complete catalogue, see *The Oscar Schmitz Collection* (Paris: privately printed for Wildenstein Galleries [1936–37]).

5. Blatch and Lutz, *Challenging Years,* p. 237.

6. Louisine Havemeyer, *Memoirs,* p. 199.

7. Mary Cassatt to Louisine Havemeyer, February 15, 1914.

8. Louisine Havemeyer, "Mary Cassatt," *The Pennsylvania Museum Bulletin* (May 1927): 381–82.

9. Louisine Havemeyer, "Remarks on Edgar Degas and Mary Cassatt."

10. Typed copy of speech by Louisine Havemeyer, "The Waking Up of Women," 1923 or 1924. Courtesy of Havemeyer descendants.

11. Mary Cassatt to Louisine Havemeyer, August 19 [1914].

12. Louisine Havemeyer's unpublished chapter on Mary Cassatt, p. 32.

13. *Ibid.,* pp. 32–33.

14. *Ibid.,* p. 33.

15. Louisine W. Havemeyer, "The Suffrage Torch, Memories of a Militant," p. 528.

16. Mary Cassatt to Louisine Havemeyer, November 11 [1914]. Louisine had resumed her Sunday afternoon musicales in 1910, more than two years after Harry's death.

17. Louisine Havemeyer, "Remarks on Edgar Degas and Mary Cassatt."

18. Louisine Havemeyer to Roland Knoedler, December 29, 1914. Archives, The Knoedler Library, New York.

19. Mary Cassatt to Louisine Havemeyer, February 1, 1915.

20. Mary Cassatt to Louisine Havemeyer, February 28 [1915].

21. Mary Cassatt to Louisine Havemeyer, March 12 [1915].
22. Louisine W. Havemeyer, "The Suffrage Torch, Memories of a Militant," p. 529.
23. Blatch and Lutz, *Challenging Years*, p. 236.
24. *New York Tribune*, April 7, 1915, p. 9.
25. Louisine Havemeyer, "Remarks on Edgar Degas and Mary Cassatt."
26. Blatch and Lutz, *Challenging Years*, p. 236.
27. Louisine W. Havemeyer, "The Suffrage Torch, Memories of a Militant," p. 530.
28. Mary Cassatt to Louisine Havemeyer, April 14 [1915].
29. Albert C. Barnes, "How to Judge a Painting," *Arts and Decoration* 5 (April 1915): 249.
30. *Ibid.,* p. 246.
31. *Ibid.*
32. Saarinen, *The Proud Possessors,* p. 221.
33. Louisine W. Havemeyer, "The Suffrage Torch, Memories of a Militant," p. 534.
34. *Ibid.,* p. 535.
35. *Ibid.*
36. Louisine Havemeyer to Théodore Duret, August 7, 1917. Fondation Custodia (Collection F. Lugt). Institut Néerlandais, Paris.
37. Louisine Havemeyer to Théodore Duret, October 20, 1916. Fondation Custodia (Collection F. Lugt). Institut Néerlandais, Paris.
38. Louisine Havemeyer, *Memoirs,* p. 193.
39. *Ibid.,* pp. 264–65.
40. *Ibid.,* p. 265.
41. *Ibid.,* p. 267.
42. Mary Cassatt to George Biddle, September 29 [1917]. Archives, Philadelphia Museum of Art.
43. Mary Cassatt to Louisine Havemeyer, May 27 [1917].
44. Charles L. Freer to Louisine Havemeyer, May 27 [1917].
45. Charles L. Freer to Louisine Havemeyer, August 20, 1917. Written from the Berkshire Inn, Great Barrington, Mass.
46. Louisine W. Havemeyer, "The Suffrage Torch, Memories of a Militant," p. 528.

CHAPTER XVIII

1. Electra Havemeyer Webb to James Watson Webb [February 1919]. Courtesy of J. Watson Webb, Jr.
2. Louisine W. Havemeyer, "The Prison Special, Memories of a Militant," *Scribner's Magazine* 71 (June 1922): 665.
3. Inez Haynes Irwin, *Up Hill with Banners Flying* (Penobscot, Maine: Traversity Press, 1964; original ed., *The Story of the Woman's Party,* 1921), p. 415.
4. Louisine W. Havemeyer, "The Prison Special, Memories of a Militant," p. 670.
5. *Ibid.,* pp. 672–73.
6. *Ibid.,* p. 674.
7. *Ibid.,* p. 675.
8. *Ibid.,* p. 676.
9. *New York Times,* March 11, 1919, p. 10.
10. Irwin, *Up Hill with Banners Flying,* p. 460.
11. Frederick Sweet, *Miss Mary Cassatt: Impressionist from Pennsylvania,* pp. 193–94.
12. Mary Cassatt to Louisine Havemeyer, April 9, 1920.
13. Mary Cassatt to Louisine Havemeyer, May 9, 1918.
14. Louisine Havemeyer to Théodore Duret, October 20, 1916. Fondation Custodia (Collection F. Lugt). Institut Néerlandais, Paris.
15. Paul Rosenberg to Louisine Havemeyer, February 13, 1921.
16. Handwritten copy of Louisine Havemeyer's speech, April 20, 1920. Mary Cassatt was not officially a member of the National Association of Women Painters and Sculptors, but she had been invited to participate in certain exhibitions, especially during the 1890s. In 1914, Louisine Havemeyer had been among the patronesses for the organization's benefit show held at M. Knoedler and Co. This information was kindly provided by Aurora Dias Jorgensen, archivist for the National Association of Women Artists, Inc., the organization's current name.
17. Mary Cassatt to Louisine Havemeyer, April 4, 1920.
18. Louisine Havemeyer's unpublished chapter on Mary Cassatt, p. 34.
19. A copy of Cassatt's undated letter (in French) to Hébrard, possibly dictated to Mathilde Valet, exists among Louisine Havemeyer's papers. Courtesy of Havemeyer descendants.
20. Louisine Havemeyer's handwritten draft (in French) for an undated cable to Hébrard. Courtesy of Havemeyer descendants.
21. Louisine Havemeyer to Théodore Duret, January 10, 1922. Fondation Custodia (Col-

lection F. Lugt). Institut Néerlandais, Paris.

22. Louisine Havemeyer to William M. Ivins, Jr., undated. Grolier Club Archives.

23. Royal Cortissoz, *New York Tribune,* January 29, 1922, pt. 4, p. 7.

24. Henry McBride, *New York Herald,* February 5, 1922, pt. 3, p. 5.

25. W. G. Bowdoin, *The World,* January 29, 1922, pt. 3, p. 7.

26. Handwritten draft of a letter from Louisine Havemeyer to the French consul general, New York, April 16, 1922. Courtesy of Havemeyer descendants.

27. Handwritten draft of Louisine Havemeyer's summary for the French consul general. Courtesy of Havemeyer descendants.

28. Mary Cassatt to Louisine Havemeyer, May 24, 1919.

29. Last Will and Testament of Louisine W. Havemeyer. Third Codicil dated August 18, 1922, p. 15. Courtesy of Havemeyer descendants.

30. Calvin Tomkins, *Merchants and Masterpieces,* p. 186.

31. In her summary for the Legion of Honor, Louisine stated that she lent nineteen Courbets for the Centennial Exhibition. The museum's catalogue lists only sixteen paintings furnished anonymously by Louisine. Three works may have been added at the last minute, too late to appear in the catalogue. See *Loan Exhibition of the Works of Gustave Courbet* (New York: Metropolitan Museum of Art, 1919).

32. Louisine Havemeyer to the director of the Metropolitan Museum, Edward Robinson, June 11, 1920. Archives, Metropolitan Museum of Art.

33. Royal Cortissoz, *New York Herald Tribune,* January 13, 1929, pt. 7, p. 10.

34. Rebecca Hourwich, "An Appreciation of Mrs. Havemeyer," *Equal Rights* 14 (February 2, 1929): n.p.

35. René Gimpel, *Diary of an Art Dealer,* intro. by Sir Herbert Read, trans. by John Rosenberg (New York: Farrar, Straus and Giroux, 1966), p. 130.

36. Louisine Havemeyer to Théodore Duret, June 1, 1924. Fondation Custodia (Collection F. Lugt). Institut Néerlandais, Paris.

37. Louisine W. Havemeyer, "Notes to My Children," p. 33.

38. During Part I of the ten-day Havemeyer estate sale on April 10, 1930, the bidding for lot number 113, a Doge's portrait attributed to the "School of Titian," stopped at $400. The purchaser, Dr. Wilhelm Valentiner, director of the Detroit Institute of Arts, was convinced that the painting was an original Titian; after cleaning, when his opinion seemed vindicated, the portrait's worth was estimated at $150,000. The painting is now considered to be by Tintoretto.

39. George Frelinghuysen's unpublished "Memoirs."

40. Louisine Havemeyer, "Notes to My Children," p. 5.

41. *Ibid.,* p. 25.

42. Mary Cassatt to Louisine Havemeyer, December 26, 1925. Courtesy of Havemeyer descendants.

43. Mathilde Valet to Louisine Havemeyer, April 30, 1926. Courtesy of Havemeyer descendants.

44. Mathilde Valet to Louisine Havemeyer, June 28, 1926. Courtesy of Havemeyer descendants.

45. Louisine Havemeyer to J. Watson Webb, Jr. [November 1927]. Courtesy of J. Watson Webb, Jr.

46. *Ibid.*

47. Royal Cortissoz, *New York Herald Tribune,* January 13, 1929, pt. 7, p. 10.

48. Edith de Terey, "Mrs. Havemeyer's Vivid Interest in Art," *New York Times,* February 3, 1929, pt. 8, p. 13.

49. Louisine Havemeyer to George Frelinghuysen, May 21, 1928. Courtesy of George Frelinghuysen.

50. Royal Cortissoz, *New York Herald Tribune,* January 13, 1929, pt. 7, p. 10.

51. Edward Robinson, "Introduction: The H. O. Havemeyer Collection," *The H. O. Havemeyer Collection, A Catalogue of the Temporary Exhibition* (New York: The Metropolitan Museum of Art, 1930), p. ix.

52. *Ibid.*

53. Minutes of the meeting held December 16, 1929, by the Metropolitan Museum's board of trustees concerning "exception to the terms of the will of the late Louisine W. Havemeyer, regarding permanent exhibition." Courtesy of Havemeyer descendants.

Selected Sources and Bibliography

This book began as a doctoral dissertation (Weitzenhoffer, Frances. *The Creation of the Havemeyer Collection, 1875–1900,* submitted to the Graduate Faculty in Art History. . . . The City University of New York, 1982; University Microfilms International, Ann Arbor, Mich., c. 1982: no. 1416). As such, it contained a meticulous bibliography and notes. The lists here are an attempt to simplify and shorten that bibliography, to which has been added material documenting the period—not covered by the dissertation—from 1900 to 1929, the date of Mrs. Havemeyer's death. Despite the efforts of the Havemeyers to remain private persons, there was, in the various New York papers and in art journals, a great amount of information about them; some of this has been eliminated from this "Selected Sources and Bibliography" as irrelevant to the study of the Havemeyers and their collection. For the reader wishing to find more on the subject, the dissertation cited above is a rich source.

ABBREVIATIONS

AAA: Archives of American Art, Smithsonian Institution, Washington, D.C.
AAG: American Art Galleries, New York
CLF: Charles L. Freer
EH[W]: Electra Havemeyer [Webb]
FAAG: Fifth Avenue Art Galleries, New York
GD-R, NY: Durand-Ruel Gallery, New York

GD-R, P: Galerie Durand-Ruel, Paris
HH: Horace Havemeyer
HOH: Henry Osborne (H. O.) Havemeyer
LWH: Louisine Waldron Elder [Havemeyer]
MC: Mary Cassatt
MK: M. Knoedler and Co., New York
MMA: Metropolitan Museum of Art, New York

NAD: National Academy of Design, New York
NYEP: *New York Evening Post*
NYH: *New York Herald*
NYS: *New York Sun*
NYT: *New York Times*
NYTr: *New York Tribune*
PD-R: Paul Durand-Ruel
PMA: Philadelphia Museum of Art

1. Interviews by the Author

PARIS: The late Charles Durand-Ruel (PD-R's grandson), unpublished memoirs (typewritten); the late Baron Henry Petiet (private print collector and dealer, who handled most of the graphic work from the Vollard estate); Jean de Sailly (son of MC's friend and neighbor at the château de Beaufresne).

HAVEMEYER FAMILY MEMBERS: George Griswold Frelinghuysen, Santa Fe, N.M. (HOH and LWH's grandson, son of Adaline Havemeyer Frelinghuysen), unpublished memoirs; Henry O. H. Frelinghuysen, Far Hills, N.J. (same as above); Peter Frelinghuysen, New York, N.Y. (HOH and LW's great-grandson, son of Peter H.B. Freylinghuysen, Jr.); Mrs. Adaline Havemeyer Rand (Mrs. Laurence B.), New York, N.Y. (HOH and LWH's granddaughter); Horace Havemeyer, Jr., New York, N.Y. (HOH and LWH's grandson); William E. Havemeyer, New York, N.Y. (son of Horace Havemeyer, Jr.); J. Watson Webb, Jr., Shelburne, Vt. (HOH and LWH's grandson); the late Mrs. Electra W. Bostwick, New York, N.Y. (HOH and LWH's granddaughter, sister of J. Watson Webb, Jr., and daughter of EH[W]); Mrs. Electra McDowell, New York, N.Y. (daughter of Mrs. Electra W. Bostwick).

NEW YORK, OTHERS: The late Mrs. Percy C. Madeira, Jr., Berwyn, Pa. (MC's niece, daughter of her brother Gardner); the late William M. Milliken, Cleveland (former director, Cleveland Museum of Art, who visited LWH frequently at 1 East 66th St.); the late A. Hyatt Mayor (former Curator of Prints and Drawings, MMA).

2. Legal Documents (chronological)

New York City Directories, 1866–75.

State Census, New York County, 6th Election District, 16th Ward, 1870. For George W. Elder and family.

George W. Elder. *Last Will and Testament.* Probated April 8, 1873. Copy from Office of the Clerk of the Surrogate's Court, City of New York.

Record of the marriage of HOH to Louisine W. Elder. Office of the Town Clerk, Greenwich, Conn. Book no. 2, p. 354, 1883.

State Census, New York County, 1905. For HOH and family, 1 East 66th Street.

HOH. *Last Will and Testament.* Probated Jan. 16, 1908. Copy from Office of the Clerk of the Surrogate's Court, City of New York.

Certificate of death of LWH. 1929. On file in the Dept. of Health, City of New York, Bureau of Vital Records.

LWH. *Last Will and Testament.* Probated Jan. 18, 1929. Courtesy of Horace Havemeyer, Jr.

3. Documents, Mostly Unpublished

All documents below are unpublished (except HOH's prospectus) and are courtesy of the Havemeyer descendants, some of whom chose to remain anonymous.

MC to LWH, undated letter [1899]; Dec. 26, 1925.

MC's undated letter [1921] (in French) to Adrien A. Hébrard, possibly dictated to her housekeeper, Mathilde Valet.

MC to EH[W], undated letter [Dec. 1907]. Courtesy of J. Watson Webb, Jr.

MC to EH[W], Dec. 8 [1909]. Courtesy of J. Watson Webb, Jr.

Sara Hallowell to HOH, Aug. 13, 1896. Courtesy of Horace Havemeyer, Jr.

HOH's prospectus, "Moorish Houses at Bayberry Point," published c. 1898. Courtesy of William E. Havemeyer.

LWH, first draft for speech, "Remarks on MC," delivered April 6, 1915, at MK, at loan exhibition "Masterpieces by Old and Modern Painters." Handwritten.

LWH, speech, "CLF, an Appreciation" [1919]. Typewritten.

LWH, speech on MC given on April 20, 1920, to the Nat'l. Assoc. of Women Painters and Sculptors at the Fine Arts Bldg., 215 W. 57th St. Handwritten copy.

LWH, summary for the French consul general of New York, April 1922. Handwritten draft.

LWH to the French consul general, New York, April 16, 1922. Handwritten draft.

LWH, speech, "The Waking Up of Women" [1923–24]. Typewritten.

LWH, "Notes to My Children" [1924–25]. Courtesy of J. Watson Webb, Jr.

LWH to her grandson J. Watson Webb, Jr. [Nov. 1927]. Courtesy of J. Watson Webb, Jr.

LWH to her grandson George G. Frelinghuysen, May 21, 1928. Courtesy of George G. Frelinghuysen.

LWH, unpublished chapter on MC (intended for her *Memoirs*). Courtesy of Mrs. Electra McDowell (LWH's great-granddaughter).

Mathilde Valet (MC's housekeeper) to LWH: April 30, 1926 (in French); June 28, 1926 (in French).

EH[W], scrapbooks. Courtesy of J. Watson Webb, Jr.

EH[W] to James Watson Webb: March 8, 1909; March 11, 1909; March 13, 1909; March 26,

1909; April 27, 1909; May 2 [1909]; [February 1919]. Courtesy of J. Watson Webb, Jr.

4. Documents in Public and Private Collections

AAA. New York Branch: (Microfilmed from AAA. Smithsonian Institution, Washington, D.C., unless otherwise noted. Location of original material is at end of each citation, in parentheses.

MC: Letters: to her brother Alexander (Aleck), 1883–91 (PMA);

to Harris Whittemore and to his mother, Mrs. John Howard Whittemore, 1893–1924 (J. H. Whittemore Co., Naugatuck, Conn.);

to Minnie Drexel Fell Cassatt, her niece by marriage to Robert Kelso Cassatt, 1903–12,

to Adolphe Borie, July 27, 1910 (PMA);

to George Biddle, Sept. [1927] (PMA).

Alexander Johnson Cassatt, MC's brother: Letters to his wife Lois, 1871–84 (PMA).

Katherine Kelso Cassatt (Mrs. R. S.), MC's mother: Letters to Alexander J. Cassatt, 1878–91 (PMA).

Robert Simpson Cassatt, MC's father: Letters to Alexander J. Cassatt, 1878–91 (PMA).

Howard Russell Butler Collection: Biographical material, newspaper clippings, and documents on the formation of the American Fine Arts Society.

August F. Jaccaci: Notes, correspondence, and other documents concerning *Noteworthy Paintings in American Private Collections,* including letters from MC and LWH to August Jaccaci; and correspondence between MC and Carl Snyder.

William M. Milliken: *Autobiography,* Part 1 (Typewritten; unmicrofilmed).

Aline Saarinen Papers: Letters, documents, genealogies, notes from interviews with Mrs. P. H. B. Frelinghuysen and Mrs. J. Watson Webb (LWH's daughters); other material concerning Havemeyer chap. in *The Proud Possessors* (Washington, D.C.: unmicrofilmed).

Frederick Sweet Papers: Correspondence in the form of research queries concerning MC (Washington, D.C.; unmicrofilmed).

Carl Snyder: letter to MC, July 5, 1904.

Chicago Historical Society: Mrs. Potter Palmer to Sara Hallowell, Jan. 5, 1893.

Fondation Custodia (Collection F. Lugt), Institut Néerlandais, Paris:

MC: 6 undated letters (in French) to Théodore Duret.

LWH: 11 letters (in French) to Théodore Duret, 1916–24.

Freer Gallery of Art, Smithsonian Institution, Washington, D.C.: CLF: Letters: to Edward R. Warren [November 1904]; to Charles Morse, Sept. 27, 1906; to Ernest Fenollosa, Sept. 27, 1906. Ernest Fenollosa: Letters to CLF, Sept. 25, 1906; March 12, 1907.

Frick Art Reference Library, New York: Theodore Robinson. *Diary.* Manuscript. 1892–96.

GD-R, P:

PD-R and sons (Joseph and George): Copies of letters to HOH and LWH, HH, MC, Sara Hallowell. Books nos. 4–49, 1888–1928.

MC: Collected letters to the Durand-Ruels, 1891–1925.

Misc. correspondence (replies rec'd): Letter from Sara Hallowell to PD-R, Aug. 14, 1894; 18 letters from HOH to GD-R, P, 1896–1905; 9 letters (3 in French) from LWH to Paul, Joseph, and PD-R, 1909–15; 2 letters from HH to GD-R, P, 1912 (unpublished).

Book of cables sent and rec'd between GD-R, P and GD-R, NY, 1898–1925 (unpublished).

Account Books with names of American clients: Book I, 1889–92; Book II, 1892–97; Book III, 1897–1905.

Stock Books: Book I, 1888–89; Book II, 1890–92; Book III, 1893–94.

GD-R, NY:

Joseph and George Durand-Ruel: Copies of letters to HOH, LWH, and HH. Books nos. 1–22, 1904–32 (unpublished).

Account Books, 1888–94.

Stock Books, 1888–93; 1894–1905; 1904–25.

Grolier Club, New York: LWH to William M. Ivins, Jr. (undated).

Hill-Stead Museum, Farmington, Conn.: Letters from MC to Mrs. Alfred A. Pope and Theodate Pope, 1898–1915.

MK Archives: LWH to Roland Knoedler, Dec. 29, 1914.

MK Library Archives: Painting stock books, no. 3, 1875–83; no. 4, 1883–89.

MMA. General Archives:

Correspondence between MMA officials and the Havemeyers; newspaper clipping file concerning the Havemeyer Bequest.

Henry Marquand to Louis P. di Cesnola, June 23, 1891.

LWH to Edward Robinson, Director, MMA, June 11, 1920.

MMA. Archives, Dept. of American Paintings & Sculpture:

American Art Association to Luigi P. di Cesnola, Oct. 15, 1888.

MMA. Dept. of European Paintings:

William Schaus to HOH, March 17, 1889.

Files on individual paintings in the Havemeyer Bequest; documents and correspondence concerning the bequest.

MMA. Formerly in the National Gallery of Art, Washington, D.C.:

MC: Collected letters to LWH, incl. a few to HOH, 1900–20.

CLF: Letters to LWH, 1916–18.

Collected letters from various art agents and dealers (A. E. Harmisch, Ricardo de Madrazo, Dikran Kelekian, Paul Rosenberg, Théodore Duret) to LWH, 1901–22.

Moore College of Art, Philadelphia:

Emily Sartain: Letters to her father, John Sartain, March 8, 1874; April 24, 1874; Oct. 13, 1874; April 27, 1875.

Museum of Fine Arts, Boston:

MC to Rose Lamb, April 26, 1895; Jan. 14, 1898.

Galerie Robert Schmit, Paris:

MC to Camille Pissarro, Nov. 27 [1889].

Shelburne Museum, Shelburne, Vt.:

MC: Collected letters to EH[W], Oct. 15 [1908]; undated [Feb. 1909]; March 7 [1909]; undated [1909]; April 2 [1909].

5. Books and Articles

Books are published in New York unless otherwise indicated.

Anon. "Exhibition of the Work of Raffaëlli." *The Art Amateur,* 32 (April 1895): 135.

Anon. "Exhibitions." *The Art Amateur,* 38 (April 1898): 107. [Cassatt]

Anon. "The Ides of March." *The Collector,* 6 (March 15, 1895): 159–60. [Manet]

Anon. "Notes for Collectors." *The Art Courier* (an occasional suppl. to *The Art Amateur*), 24 (March 1891): 2.

Anon. "The Old Cabinet." *Scribner's Monthly,* 15 (April 1878): 888–89. [Degas]

Anon. "Raffaëlli on American Art." *The Collector,* 6 (Sept. 1, 1895): 294–95.

Anon. "The Rise of the Curtain." *The Collector,* 2 (Oct. 1, 1891): 225. [Monet, Cazin]

Anon. "Talks with Paris Art Dealers." *The Collector,* 7 (June 1, 1896): 236. [Durand-Ruel interview]

Barnes, Albert C. "How to Judge a Painting." *Arts and Decoration,* 5 (April 1915): 214–20, 246, 248–50.

Bing, Samuel. *Artistic America, Tiffany Glass and Art Nouveau.* Intro. by Robert Koch. Cambridge: MIT Press, 1970.

Blatch, Harriot Stanton, and Lutz, Alma. *Challenging Years: The Memoirs of Harriot Stanton Blatch.* G. P. Putnam's Sons, 1940.

Bode, Wilhelm. "Die amerikanische Konkurrenz im Kunsthandel und ihre Gefahr für Europa." *Kunst und Künstler,* 1902–3; reprinted in: *Kunst und Künstler: Aus 32ᵉ Jahrgangen einer deutschen Kunstzeitschrift.* Mainz: Florian Kupferberg Verlag, 1971, pp. 17–25.

Breeskin, Adelyn Dohme. *The Graphic Work of Mary Cassatt: a Catalogue Raisonné.* H. Bittner, 1948.

———. *Mary Cassatt: a Catalogue Raisonné of the Oils, Pastels, Watercolors, and Drawings.* Washington, D.C.: Smithsonian Press, 1970.

Brimo, René. *L'Evolution du goût aux Etats-Unis.* Paris: James Fortune, 1938.

Brown, Milton W. *The Story of the Armory Show.* Greenwich, Conn.: Joseph H. Hirshhorn Foundation and New York Graphic Society [1963].

Burnett, Robert N. "Henry Osborne Havemeyer." *Cosmopolitan,* 34 (April 1903): 701–4.

Cassatt and Her Circle: Selected Letters. Ed. by Nancy M. Mathews. Abbeville Press, 1984.

Child, Theodore. "The King of the Impressionists." *The Art Amateur,* 14 (April 1886): 101–2.

Clarkin, Franklin. "The So-called Sugar Trust." *Century Magazine,* 43 (Jan. 1903): 470–77.

Cook, Clarence. "Rembrandt's Le Doreur." *The Studio,* 1885; reprinted in an undated pamphlet, Library, MMA.

Daulte, François. "Le Marchand des Impressionistes." *L'Oeil,* 66 (June 1960): 54–61, 75.

Degas, Hilaire Germain Edgar. *Lettres de Degas.* Ed. by Marcel Guérin. Paris: Editions Bernard Grasset, 1945.

Faxon, Alicia. "Painter and Patron: Collaboration of Mary Cassatt and Louisine Havemeyer."

Woman's Art Journal, 2 (Fall 1982/Winter 1983): 15–20.

Feld, Stuart P. " 'Nature in Her Most Seductive Aspects': Louis Comfort Tiffany's Favrile Glass." *Bulletin, MMA,* 21 (Nov. 1962): 101–12.

Fenollosa, Ernest. "The Collection of Mr. Charles L. Freer." *Pacific Era,* 1 (Nov. 1907): 57–66.

Fuller, William H. *Claude Monet.* Gilliss Bros., 1891.

Garland, Hamlin. *Crumbling Idols.* Chicago: Stone and Kimball, 1894.

Geffroy, Gustave. *Claude Monet: sa vie, son oeuvre.* 2 vols. Paris: Les Editions G. Crès, 1924.

Gimpel, René. *Diary of an Art Dealer.* Intro. by Sir Herbert Read. Farrar, Straus and Giroux, 1966.

Hale, Nancy. *Mary Cassatt: a Biography of the Great American Painter.* Garden City: Doubleday, 1975.

Havemeyer, Henry O. [son of Theodore A. Havemeyer]. *Biographical Record of the Havemeyer Family, 1600–1945.* Privately printed, Scribner Press, 1944.

H. O. Havemeyer Collection: Catalogue of Paintings, Prints, Sculpture and Objects of Art. Portland, Maine: privately printed, Southworth Press, 1931.

Horace Havemeyer, 1886–1956. Privately printed, North River Press, 1957. Courtesy of J. Watson Webb, Jr.

LWH. "The Freer Museum of Oriental Art." *Scribner's Magazine,* 73 (May 1923): 529–40.

———. "Mary Cassatt." *The Pennsylvania Museum Bulletin,* 22 (May 1927): 373, 377–82.

———. "The Prison Special, Memories of a Militant." *Scribner's Magazine,* 71 (June 1922): 661–76.

———. "Remarks on Edgar Degas and Mary Cassatt." Speech, MK, April 6, 1915.

———. *Sixteen to Sixty: Memoirs of a Collector.* Privately printed for the family of LWH and the MMA, 1961.

———. "The Suffrage Torch, Memories of a Militant." *Scribner's Magazine,* 71 (May 1922): 528–39.

Hourwich, Rebecca. "An Appreciation of Mrs. Havemeyer." *Equal Rights,* 14 (Feb. 2, 1929): n.p.

Howe, Winifred E. *A History of the Metropolitan Museum of Art.* 2 vols. MMA, 1946.

Huth, Hans. "Impressionism Comes to America."

Gazette des Beaux-Arts, 29 (April 1946): 225–52.

Irwin, Inez Haynes. *Up Hill with Banners Flying.* Penobscot, Maine: Traversity Press, 1964; original ed., *The Story of the Woman's Party,* 1921.

Janis, Eugenia Parry. *Degas Monotypes.* Cambridge: Fogg Art Museum, Harvard Univ., 1968.

Kaufmann, Edgar, Jr. "At Home with Louis Comfort Tiffany." *Interiors,* 117 (Dec. 1954): 118–25, 183.

King, Moses. *Notable New Yorkers of 1896–1899.* Bartlett, 1899.

Koch, Robert. *Louis C. Tiffany: Rebel in Glass.* Crown Pub., 1964.

Kysela, John D., S. J. "Sara Hallowell Brings 'Modern Art' to the Midwest." *The Art Quarterly,* 27 (1964): 150–67.

Lemoisne, Paul André. *Degas et son oeuvre.* 4 vols. Paris: Paul Brame et C.M. De Hauke, 1946–49.

Ludington, Townsend. *John Dos Passos: a Twentieth Century Odyssey.* E. P. Dutton, 1980.

Ludovici, A. *An Artist's Life in London and Paris, 1870–1925.* Minton, Balch, 1926.

Lynes, Russell. *The Tastemakers.* Harper and Bros., 1955.

McFadden, Elizabeth. *The Glitter and the Gold.* Dial Press, 1971.

McMullen, Roy. *Degas, His Life, Times, and Work.* Boston: Houghton Mifflin, 1984

Manet, Julie. *Journal (1893–1899).* Paris: Librairie C. Klincksieck, 1979.

Mather, Frank Jewett. "The Havemeyer Pictures." *The Arts,* 16 (March 1930): 445–83.

Matthews, Brander. *Bookbindings Old and New: Notes of a Book-Lover, with an account of the Grolier Club of New York.* Macmillan, 1895, pp. 291–335.

Myers, Gustavus. *History of the Great American Fortunes.* 3 vols. 1910 [rev. ed. Modern Library, 1936].

Norton, Thomas E. *100 Years of Collecting in America: the Story of Sotheby Parke Bernet.* Harry N. Abrams, 1984.

Noteworthy Paintings in American Private Collections. Ed. by John LaFarge and August F. Jaccaci. 2 vols. August F. Jaccaci, 1907.

Pissarro, Camille. *Lettres à son fils Lucien.* Ed. by John Rewald. Paris: Albin Michel, 1950.

Rewald, John. *Degas: Works in Sculpture.* Pantheon Books, 1944.

————. *The History of Impressionism.* 4th rev. ed. Museum of Modern Art, 1973.

————. "Theo Van Gogh, Goupil and the Impressionists." *Gazette des Beaux-Arts,* 81 (Jan.–Feb. 1973): 1–108.

Riordan, Roger. "Miss Mary Cassatt." *The Art Amateur,* 38 (May 1898): 130–33.

Robinson, Theodore. "Claude Monet." *Century,* 44 (Sept. 1892): 696–701.

Ross, Ishbel. *Silhouette in Diamonds: the Life of Mrs. Potter Palmer.* Harper, 1960.

Rouart, Denis, and Wildenstein, Daniel. *Edouard Manet.* 2 vols. Lausanne–Paris: Bibliothèque des Arts, 1975.

Saarinen, Aline B. *The Proud Possessors.* Random House, 1958.

Schack, William. *Art and Argyrol: The Life and Career of Dr. Albert C. Barnes.* New York, London: Thomas Yoseloff, 1960.

Schuyler, Montgomery. *A Review of the Work of Charles C. Haight.* Architectural Record, 1899.

Sutton, Denys. "The Discerning Eye of Louisine Havemeyer." *Apollo,* 82 (Sept. 1965): 230–35.

Swanberg, W. A. *Whitney Father, Whitney Heiress.* Charles Scribner's Sons, 1980.

Sweet, Frederick A. *Miss Mary Cassatt: Impressionist from Pennsylvania.* Norman: Univ. of Okla. Press, 1966.

Ticknor, Caroline. *May Alcott: A Memoir.* Boston: Little, Brown, 1928.

Tomkins, Calvin. *Merchants and Masterpieces: the Story of the Metropolitan Museum of Art.* E. P. Dutton, 1973.

Trumble, Alfred. "Claude Monet." *The Collector,* 2 (Feb. 15, 1891): 91.

————. "Footnotes of a Fortnight." *The Collector,* 6 (Jan. 15, 1895): 90. [Monet]

————. "May-Day Facts and Fancies." *The Collector,* 6 (May 1, 1895): 208. [Cassatt]

————. "News and Views." *The Collector,* 8 (Dec. 15, 1896): 49. [Durand-Ruel Gallery]

————. "News and Views." *The Collector,* 8 (April 1, 1897): 165. [PD-R]

————. "Picture Sellers and Picture Buyers." *The Collector,* 2 (Dec. 15, 1890): 44. [Durand-Ruel and sons]

————. "Something for Everybody." *The Collector,* 4 (Feb. 1, 1893): 102. [Boussod, Valadon exhibition]

Venturi, Lionello, ed. *Les archives de l'impressionnisme.* 2 vols. Paris: Durand-Ruel, 1939.

Villiers, Edward. "Paris Art Topics." *The Art Amateur,* 10 (March 1884): 109.

Vollard, Ambroise. *Recollections of a Picture Dealer.* Boston: Little, Brown, 1936.

Wildenstein, Daniel. *Claude Monet: biographie et catalogue raisonné.* 3 vols. Lausanne–Paris: Bibliothèque des Arts, 1974.

Young, Dorothy Weir. *The Life and Letters of J. Alden Weir.* Ed. & introd. by Lawrence W. Chisolm. New Haven: Yale Univ. Press, 1960.

Zola, Emile. *L'Oeuvre.* Notes et commentaires de Maurice LeBlond. Paris: Fr. Bernouard, 1928.

6. Exhibition and Sales Catalogues (chronological)

The following are published in New York unless otherwise specified.

Illustrated Catalogue of the 11th Annual Exhibition of the American Water-color Society. NAD, 1878.

Illustrated Catalogue of the Art Department, Foreign Exhibition. Boston: Mills, Knight, 1883.

Catalogue of the Pedestal Fund Art Loan Exhibition. NAD, 1883.

Prize Fund Exhibition Catalogue. AAG, 1885; 1886.

Works in Oil and Pastel by the Impressionists of Paris. AAG, 1886.

Works in Oil and Pastel by the Impressionists of Paris. NAD Special Exhibition, 1886.

Geffroy, Gustave, and Mirbeau, Octave. *Claude Monet, A. Rodin.* Paris: Galerie Georges Petit, 1889.

Whistler's "Notes"—"Harmonies"—"Nocturnes." H. Wunderlich and Co., 1889.

Works of Barye and 100 Masterpieces of his Contemporaries. AAG, Nov. 1889–Jan. 1890.

Exhibition of Paintings by Old Masters and Modern Foreign and American Artists, Together with an Exhibition of the Work of Monet the Impressionist. Union League Club, 1891.

"Loan Collection: Foreign Masterpieces Owned in the United States." *The Official Catalogue of the World's Columbian Exposition.* Chicago: W. B. Gonkey, 1893.

Dissolution Sale Catalogue: the Artistic Property Belonging to the American Art Association. American Art Association, 1895.

Catalogue de tableaux modernes, collection de Gustave Goupy. Paris: Hôtel Drouot, 1898.

Catalogue of Oil Paintings by American Artists Belonging to William F. Havemeyer. FAGG, 1899.

Catalogue of a Loan Exhibition of Paintings by Old Dutch Masters. MMA, 1910.

Loan Exhibition of Paintings by El Greco and Goya (Benefit for American Women War Relief Fund and Belgian Relief Fund). MK, 1915.

Loan Exhibition of Masterpieces by Old and Modern Painters. MK, 1915.

Loan Exhibition of the Works of Gustave Courbet. MMA, 1919.

Prints, Drawings and Bronzes by Degas. The Grolier Club, 1922.

Important Paintings from the Havemeyer Estate . . . , Part I. American Art Association, 1930.

Furnishings and Decorations from the Estate of Mrs. II. O. Havemeyer: on the premises, 1 East 66th Street. American Art Association, 1930.

The H. O. Havemeyer Collection: a Catalogue of the Temporary Exhibition. MMA, 1930.

The Oscar Schmitz Collection. Paris: privately printed by Wildenstein Galleries [1936–37].

Cent ans d'Impressionnisme: Hommage à Paul Durand-Ruel, 1874–1974. Paris: GD-R, P, 1974.

Sutton, Denys. *Paris–New York: a Continuing Romance.* Wildenstein Gallery, 1977.

Shapiro, Barbara Stern. *Mary Cassatt at Home.* Boston: Museum of Fine Arts, 1978.

Brown, David Alan. *Berenson and the Connoisseurship of Italian Paintings.* Washington, D.C.: National Gallery of Art, 1979.

Reynolds, Gary A. *Louis Comfort Tiffany: the Paintings.* Grey Art Gallery and Study Center, New York Univ., 1979.

Gerdts, William H. *American Impressionism.* Seattle: Henry Art Gallery, Univ. of Washington, 1980.

Isaacson, Joel. *The Crisis of Impressionism, 1878–1882.* Ann Arbor: Univ. of Michigan Museum of Art, 1980.

Impressionist Paintings and Drawings from the Estate of Doris D. Havemeyer. Sotheby Parke Bernet, 1983.

Manet, 1832–1883. MMA, 1983.

Curry, David Park. "Artist and Patron." *James McNeill Whistler.* Washington, D.C.: Freer Gallery of Art, Smithsonian Institution, 1984, pp. 11–33.

Findlay, Michael A., and McHugh, Missy. *Important Impressionist Paintings from the Collection of Harris Whittemore.* Christie's, 1985.

Lindsay, Suzanne G. *Mary Cassatt and Philadelphia.* Philadelphia: PMA, 1985.

7. Newspaper Articles (chronological)

"Death of George W. Elder." NYEP, March 26, 1873, p. 3.

"The Pedestal Art Loan." NYT, Dec. 2, 1883, p. 2.

"The Mary Jane Morgan Sale." NYT, March 6, 1886, p. 5.

"A Wondrous Art Sale." NYS, March 7, 1886, p. 9.

"The Durand-Ruel Picture Sale." NYT, May 6, 1887, p. 8.

"Boussod-Valadon Company Incorporated to Exhibit and Sell Pictures in Evasion of Tariff." NYT, April 15, 1888, p. 1.

"The Centennial Picture Exhibition." NYT, June 24, 1889, p. 2.

"The Havemeyers' Connecticut Countryhouse." NYTr, Oct. 19, 1890.

"Decorating the Havemeyer House." NYT, Nov. 8, 1891, p. 16.

"Art Notes." NYT, Jan. 23, 1893, p. 4.

"Modern Pictures at the Loan." NYT, March 10, 1893, p. 4.

"Criticised by an Expert." NYT, Oct. 11, 1893, p. 1.

"Letter from the National Free Art League." NYT, Jan. 1, 1894, p. 9.

"Paintings by Monet." NYT, Jan. 14, 1894, p. 4.

"Mrs. H. O. Havemeyer's Cut in the Scalp." NYTr, Feb. 18, 1894, p. 7.

"Mr. Havemeyer Testifies." NYTr, June 13, 1894, p. 4.

"H. O. Havemeyer Is Indicted." NYT, Oct. 2, 1894, p. 1.

"Sugar Trust Indictments." NYT, Oct. 3, 1894, p. 4.

"Paintings of Artists of Undeniable Merit Exhibited." NYT, Nov. 3, 1894, p. 4.

"Paintings by Edouard Manet." NYT, March 12, 1895, p. 4.

"In the World of Art." NYT, March 17, 1895, p. 13.

"Pictures by Mary Cassatt." NYT, April 18, 1895, p. 4; April 21, 1895, p. 13.

"Henry O. Havemeyer Angry." NYH, Feb. 6, 1897, p. 3.

"Death of Mrs. Mary Louise Havemeyer." NYT, Feb. 12, 1897, p. 1.

"Suit Against H. O. Havemeyer." NYTr, April 17, 1897, p. 7.

"T. A. Havemeyer Dead." NYTr, April 27, 1897, p. 7.

"Henry O. Havemeyer's Venice." NYT Sunday Suppl., May 23, 1897, p. 14.

"Mr. Havemeyer's Trial." NYTr, May 27, 1897, p. 7.

"Mr. Havemeyer Not Guilty." NYT, May 28, 1897, p. 3.

"Mr. Havemeyer Goes Free." NYTr, May 28, 1897, p. 1.

"H. O. Havemeyer's Illness." NYTr, Nov. 5, 1897, p. 7.

"New York Letter." *Philadelphia Public Ledger,* Jan. 4, 1898, p. 18.

"Monet's Gain in Favor." NYS, April 17, 1901, p. 7.

"Havemeyer Family in Mine Explosion." NYT, Oct. 5, 1905, p. 1.

"Miss Sara Hallowell Unique in the Art World." NYT, Dec. 31, 1905, mag. sec., pt. 3, p. 6.

"H. O. Havemeyer Dies at L. I. Home." NYT, Dec. 5, 1907, p. 3.

"Henry O. Havemeyer Dead." NYS, Dec. 5, 1907, pp. 1–2.

"Art Notes." NYS, June 11, 1909, p. 6.

"Sugar Trust, Constant Thief." NYS, Nov. 11, 1909, p. 1.

"Has America a Real Knowledge of Art?" NYT, Jan. 23, 1910, pt. 5, p. 2.

"Mrs. Havemeyer's Own Trap Caught by 'Black Handers.'" *The Evening World,* Feb. 25, 1910, p. 2.

"Last Havemeyer out of Sugar Trust." NYT, Nov. 17, 1910, p. 1.

"Big Trusts Marked for House Inquiry." NYT, May 4, 1911, p. 1.

"Young Havemeyer Foe of Sugar Trust." NYT, June 21, 1911, p. 3.

"Earlier Works of Manet Are on View in the Loan Exhibition at the Durand-Ruel Galleries." NYT, Dec. 7, 1913, pt. 10, p. 15.

"Loan Exhibition of Paintings by El Greco and Goya at Knoedler's." NYT, Jan. 13, 1915, p. 8.

"Mrs. Havemeyer Talks of Artists." NYTr, April 7, 1915, p. 9.

"Col. Oliver H. Payne, Capitalist, Is Dead." NYT, June 28, 1917, p. 11.

"Militants Demand a Special Session." NYT, March 11, 1919, p. 10.

"Charles L. Freer, Art Collector, Dies." NYT, Sept. 26, 1919, p. 13.

Bowdoin, W. G. "Grolier Club Shows the Work of Edgar Degas." *The World,* Jan. 29, 1922, pt. 3, p. 7.

Cortissoz, Royal. "Forms. A Painter's Mastery of It in Plastic Art." NYTr, Jan. 29, 1922, pt. 4, p. 7.

McBride, Henry. "General Enthusiasm for the Bronzes in the Display Is Not Without Its Significance to Students of the Times." NYH, Feb. 5, 1922, pt. 3, p. 5.

"Mrs. Havemeyer Dies in Her Home." NYS, Jan. 7, 1929, p. 27.

"Mrs. Havemeyer, Art Patron, Dies." NYT, Jan. 7, 1929, p. 29.

Cortissoz, Royal. "Masterpieces Sent There from America." *New York Herald Tribune,* Jan. 13, 1929, pt. 7, p. 10.

De Terey, Edith. "Mrs. Havemeyer's Vivid Interest in Art." NYT, Feb. 3, 1929, pt. 8, p. 13.

Kramer, Hilton. "Vollard: Dealer for the Demigods." NYT *Magazine,* June 5, 1977, pp. 28–30, 82, 84.

Index

Pages on which family pictures appear are in *italics*. Illustrated works of art are indicated by plate number

Agnew, Thomas, 104
Alcott, May, 22
Alexander, Mrs. Charles, 175
Alexandre, Arsène, 243
Altman, Benjamin, 39, 85, 226
American Art Association, 45, 46, 88, 117; *see also* Sutton, James F.
American Art Galleries, 39, 89, 100
American Fine Arts Society, 66, 68, 85
American Sugar Refining Company, 69, 120, 122, 161, 173; charges against, 96, 118–19, 177–78, 180, 186–88, 197; Horace Havemeyer and, 187, 200–201, 203; *see also* Sugar Trust
American Water-color Society, 23, 26, 41
Andrews, William, 83
Anquetin, Louis, 87
Anthony, Susan B., 205, 229
Antonello da Messina, 155, 176
Arbuckle, John, 138, *149*
Armory Show (1913), 209–10, 212
Arnhold, Eduard, 218
Art Amateur, 35, 64, 66, 86, 89, 91, 100; on Cassatt, 102–3, 130; on Manet, 35, 38, 101
Art dans les Deux Mondes, 83
Arts and Decoration, 226
Astor family, 70
Atterbury, Grosvenor, 144
Avery, Samuel P., 47, 55, 57, 156, 240; gallery, 32, 45

Barbizon artists, 33–35, 39, 54, 85, 86, 89, 209; Durand-Ruel

and, 41, 42, 62, 84, 91, 110; Havemeyer's interest in, 91, 95, 99, 100
Barnes, Albert C., 226–27
Bartholdi, Frédéric A., 35
Barye, Antoine-Louis, *59,* 61, 84, 88, 100, 147; *Lion Resting,* 65; *Tiger Lying Down,* 65
Bayberry Point, Long Island, 121, 122, 144, *148–50,* 167, *202*
Beckwith, Carroll, 68
Berenson, Bernard, 133, 139, 145–46, 156
Berenson, Mary, 145–46
Bergen, John, 119
Berlin, National Gallery, 161, 197
Bernheim-Jeune gallery, 147, 207–8
Besnard, Paul Albert, 89, 109
Bing, S., 48, 79, 165
Black Hand, 199–200
Blakeslee gallery, 68
Blatch, Harriot Stanton, 205, 206, 221, 223, 225, 227
Bode, Wilhelm, 62–63, 79, 217
Boggs, Frank, 39
Bonnard, Pierre, 239, 251
Borden, Matthew, 81, 209
Botticelli, Sandro, 103
Boudin, Eugène, 38, 40, 43, 86, 87, 95
Boussod, Valadon gallery, 83, 84, 85, 87, 93, 94, 130
Bowdoin, W. G., 242
Brandon, Jacques-Emile, 131
Breton, Jules, 92; *Communicants,* 45
Broglie, Amédée de, 175
Bronzino, Il, 223; *Portrait of a Young Man,* 176

Brown, John Lewis, 93
Burke, James, 133
Burns, Lucy, 205
Burroughs, Bryson, 245
Butler, Howard Russell, 68

Caillebotte, Gustave, 40, 99, 142
Camondo, Abraham, 60
Camondo, Isaac de, 133, 134, 141
Carnegie, Andrew, *67,* 68
Carolus-Duran, Emile-Auguste, 90
Cary, Elizabeth Luther, 240
Cassatt, Alexander, 26–27, 36, 41, 81, 90, 135, 175, 238
Cassatt, Gardner, 186, 204
Cassatt, Lois, 238
Cassatt, Lydia, 27
Cassatt, Mary, 61, 82, 198, 208–9, 243, 244; Adaline Havemeyer and, 105, 113, 173, 174; Alcott on, 22; in America, 127–30, 183, 186; Cézanne and, 142, 156, 191–93, 207–8, 240; characteristics of, 22, 28, 37, 123, 145, 171, 217–18, 222; Courbet and, 22, 79, 80, 112, 180, 192; death, 250; Degas as friend, 22, 27, 103, 116, 133, 136, 220, 231; dogs, *192,* 216; drypoint plates incident, 246–47; Durand-Ruels and, 37, 40, 143, 160, 188–89, 207, 212; Duret and, 65, 164, 178, 230, 239; Electra (Havemeyer, Webb) and, 105, 184, 188–89, 194–96, 213; as entrée to Havemeyers, 158; exhibitions, 38, 40, 81,

102–4, 129–30, 147, 184, 219–20, 222, 223, *225,* 240–41, 245, 251; eyesight, 216, 230, 231, 240, 241, 246; family relations, 26–28, 36, 37, 105, 107, 127, 135, 175, 204, 238; favorite artists, 112, 192; on Freer, 169, 171; Hallowell and, 87, 89, 124, 125; health, 203–4, 214–17; H. O. Havemeyer and, meeting, 56, 58, 60; on H. O.'s death, 182–83, 188; influences on, 102, 127; Lamb and, 105, 127; last letter to Louisine, *249,* 250; Louisine Elder and, 20–23, 28, 33; Metropolitan Museum and, 156–57, 184, 220, 244; in old age, 238, 240, 241, 246–47, 250; photos of, *24, 192, 211;* Pissarro and, 61, 103, 117, 118; Pope family and, 130, 146–47, 186, 222; reviews of, 95, 102–3, 130; spiritualism, 183, 186; Vollard and, 142, 143, 156, 167, 184, 207, 212; war years, 220, 221, 230, 231, 238; Whittemore and, 92–93; woman's rights, 195, 204, 205, 220, 221, 238; works, 34, 87, 94, 110, 176, 204, 244: *Baby's First Caress,* 104, 130; *Banjo Lesson,* 98; *Family,* 94, 98; pl. 48; *Girl Arranging Her Hair,* 238; pl. 159; *In the Box,* 36; *Lady at the Tea Table,* 36, 219–20, *225;* pl. 9; *Landscape with Three Figures (Family Group Reading),* 136; pl. 100; *Mother and Child,* 104, 130, *225;* pl. 54; *Mother and Sleeping Child,* 216, 219; pl. 150; *Mother in a Striped Head Scarf Embraced by Her Baby, 225; Mother Nursing Her Child, 225; Mother Wearing a Sunflower,* 217, 218, *225;* pl. 151; *Oval Mirror,* 136, *225;* pl. 101; *Portraits: of Adaline Havemeyer,* 105; pl. 57; *of Adaline Havemeyer in a White Hat,* 113, 130; pl. 68; *of Louisine Havemeyer,* 113, 216–17; pl. 67; *of Louisine Peters,* 173; pl. 132; *of Mrs. Havemeyer and Her Daughter Electra,* 105; pl. 56;

Self-Portrait, 22, 26, 41; pl. 3; *Young Mother Sewing,* 143, *225;* pl. 110
Cassatt, Minnie Drexel Fell, 164, 177, 183
Cassatt, Robert Simpson (Mary's father), 27
Cassatt, Mrs. Robert Simpson (Mary's mother), 27, 107
Cassirer, Paul, 217
Cazin, Jean-Charles, 90, 184; *October Day in France,* 85
Centennial Exhibition, Philadelphia (1876), 32–33, 35, 51
Century Club, New York, 83
Century Magazine, 46, 84
Cesnola, Louis P. di, 39, 66, 156–57
Cézanne, Paul, 141–42, 144, 151, 176, 177, 226, 239, 244; Cassatt's views of, 142, 156, 191–93, 207–8, 240; works: *Abduction,* 147; pl. 116; *Banks of the Marne,* 167, 191; pl. 130; *Flowers in a Glass Vase,* 142; pl. 105; *Fruits,* 178; *House of the Hanged Man,* 141; *Landscape with Viaduct (Mont Sainte-Victoire),* 142–43; pl. 108; *Man in a Straw Hat—Portrait of Gustave Boyer,* 147; pl. 117; *Self-Portrait,* 156, 191; pl. 124; *Still Life, Flowers,* 142; pl. 104; *Still Life: Flowers in a Vase,* 167; pl. 131; *Still Life with Bottle,* pl. 103; *Still Life with Ginger Jar and Eggplants,* 142; pl. 107; *Winter Landscape of Auvers,* 142; pl. 106
Chase, J. Eastman, gallery, 83
Chase, William Merritt, 35
Chicago, Art Institute of, 124, 157, 171, 241
Chicago World's Fair (1893), 81, 92, 99, 165, 198; Hallowell's activities, 87, 89–90, 116
Child, Theodore, 101
Chinese art, 32, *74,* 252, 253; paintings, 167, 170; porcelains, 33, 64, 71, 80; textiles, 78, 88, 118
Chocquet, Victor, 141
Christie's gallery, London, 104
Cincinnati Industrial Exposition (1873), 102

Clark, William A., *67*
Clarkin, Franklin, 46
Cleveland, Grover, 47, 90
Cleveland Art Association, 94
Clouet, Jean, 155
Codde, Pieter, 64
Collector, 43, 54, 64, 84, 85, 103; on Durand-Ruel, 43, 92, 109, 110
Colman, Samuel, 32–34, 44; interiors and designs, 47–49, 51–52, 55, 65, 70–72, 77–79, 100; pls. 22, 23, 29; *Spanish Peaks, Southern Colorado,* 118
Columbian Exposition, World, *see* Chicago World's Fair
Cook, Clarence, 23, 53
Copley Society, Boston, 158–59
Corcoran Gallery, Washington, D.C., 39, 45, 57, 61
Corot, Camille, 33, 37, 38, 98, 110, 124, 125, 130, 244; exhibitions, 35, 56, 61, 92, 95; works: *Bacchante by the Sea,* 126, 176; pl. 78; *Bacchante in a Landscape,* 176; pl. 134; *Destruction of Sodom,* 60, 66, 89; pl. 18; *Golden Age,* 126; pl. 77; *Greek Girl —Mlle Dobigny,* 107; pl. 62; *L'Italienne,* 147; pl. 119; *Portrait of Mlle Dobigny–The Red Dress,* 143; pl. 109; *Rêverie, 245; Woman and Cupid,* 126; *Woman with the Pearl,* 204–5; *Wood Gatherers,* 45
Cortissoz, Royal, 223, 242, 245, 251
Cottier and Co., 35, 45, 47, 68, 90, 94
Courbet, Gustave, 54, 61, 98, 126, 130, 151, 176, 244; admired: by Cassatt, 22, 79, 80, 112, 180, 192; by H. O. Havemeyer, 79, 139, 141; by Louisine Havemeyer, 22, 58, 79, 112, 204, 208; exhibitions, 35, 42, 60, 95, 243, 245; works: *Alphonse Promayet,* 219; *Deer,* 107; pl. 61; *Hunting Dogs,* 80, 89; pl. 31; *Knife-Grinders,* 230; pl. 155; *Lady in a Riding Habit (L'Amazone),* 164–65, 180; pl. 127; *Landscape with Cattle,* 58; pl. 17; *Landscape with Deer,* 57, 58, 80, 117, 178; pl.

14; Portraits: *of Jo (La Belle Irlandaise)*, 136; pl. 99; *of a Lady in Black*, 247; pl. 168; *of Madame Auguste Crocq*, 190, 191; pl. 142; *of Madame de Brayer*, 180, 245; pl. 137; *of Monsieur Suisse*, 113; pl. 66; *of a Man*, 167; pl. 129; *of a Woman, called Héloïse Abelard*, 241–42; *Russet Wood*, 205; pl. 146; *Source*, 230; pl. 154; *Source of the Loue*, 117; pl. 72; *Still Life— Fruit*, 239; pl. 163; *Stone Breakers*, 56, 138, 230; *Stream*, 117; *Torso of a Woman*, 80, 112; pl. 33; *Wave*, 205; pl. 145; *Woman in the Waves*, 112–13; pl. 65; *Woman with a Parrot*, 110, 193, 239; pl. 143; *Young Bather*, 239; pl. 161
Couture, Thomas, 90
Critic, 42
Crocker, Charles, 45
Cross and Cross, architects, 213
Cubists, 210
customs duties on artworks, 40, 41, 42, 46, 54, 98–99
Cuyp, Albert, 64

Dagnan-Bouveret, Pascal, 90
Dana, Charles, 39, 45
Daubigny, Charles-François, 42, 61, 110
Daumier, Honoré, 37, 56, 95, 178; *Collector*, 107; pl. 59; *Corot Sketching at Ville d'Avray*, 65; pl. 21; *Third-Class Carriage*, 80–81, 209; pl. 149
David, Jacques-Louis, *Portrait of a Young Woman in White*, 219; pl. 153
Davies, Arthur B., 210
Davis, Erwin, 35, 38, 41, 44, 82, 83; sales of collection, 54, 86, 88, 94
Decamps, Alexandre, 65, 92, 147; *Experts*, 58; *Good Samaritan*, 61, 158; *Jesus among the Doctors*, 58; *Oak Tree and the Reed*, 184; *Walk to Emmaus*, 44, 45, 46
De Forest, Lockwood, 48
De Forest, Robert, 243, 244–45
Degas, Edgar, *114*, 207; Cassatt as friend, 22, 27, 103, 116, 133, 136, 220, 231;

characteristics of, 27, 82, 116–17, 242–43; exhibitions, 35, 38, 40, 87, 90, 94, 219, 222–25, 242, 245; Havemeyer favorite, 22, 34, 112, 137, 147, 167, 176, 204; last years and death, 231; pastel technique, 98; posthumous sale of studio, 238, 241–43; sculpture, 241–43, 252; works, 46, 54, 84, 95, 103, 109, 110, 142: *At the Café-Concert: Song of the Dog*, 208; pl. 148; *At the Milliner's*, 133; pl. 94; *Ballet of "Robert le Diable,"* 130; *Ballet Rehearsal*, 21, 23, 26; pl. 1; *Bath*, 107; *Before the Ballet*, 224; *Collector of Prints*, 81; pl. 34; *Dance Class*, 131; pl. 87; *Dance Lesson* (c. 1874), 126–27, 130; pl. 79; *Dance Lesson* (c. 1877–78), 133; pl. 90; *Dancer Tying Her Slipper*, 130; pl. 88; *Dancers*, 35, 88, 94; pl. 8; *Dancers at Rest*, 135; pl. 96; *Dancers at the Bar*, 178; pl. 136; *Dancers at Their Toilette*, 133; pl. 91; *Dancers Practicing at the Bar*, 208, 209; pl. 147; *Dancing Class*, 231; pl. 157; *Dancing Rehearsal*, 224; *False Start*, 131; pl. 89; *Jockeys*, 86, 93; pl. 37; *Lakes and Mountains*, 98; pl. 47; *Landscape with Cows*, 98; pl. 46; *Little Dancer of Fourteen Years* (sculpture), 242–43, 252; pl. 166; *Madame Gobillard (Yves Morisot)*, 230, 231; pl. 156; *Mlle Marie Dihau*, 240; pl. 167; *Masseuse* (sculpture), 241; pl. 165; *On the Stage*, 87; pl. 35; *Pedicure*, 133–35; pl. 92; *Portrait of the Artist's Cousin (Mme René de Gas [Estelle Musson])*, 115; pl. 69; *Racehorses in Training*, 102; pl. 53; *Rearing Horse* (sculpture), 241; pl. 164; *Rehearsal*, 224; *Rehearsal in the Studio*, 133–34; pl. 95; *Rehearsal on the Stage*, 133–34; pl. 93; *Two Ballet Girls*, 116; pl. 71; *Waiting*, 107; pl. 58; *Woman Bathing in a Shallow Tub*, 238; pl.

158; *Woman Having Her Hair Combed*, 217, 218; pl. 152; *Woman Ironing*, 98; pl. 49; *Woman with a Towel—Back View*, 143; pl. 111; *Woman with Chrysanthemums*, 240; pl. 162
Delacroix, Eugène, 37, 38, 42, 43, 61, 95, 208; *Arab Cavalier Attacked by a Lion*, 88; *Arab Rider*, 33; *Christ on the Lake of Gennesaret*, 98; pl. 45; *Flight from the Garden of Eden (Expulsion)*, 47, 66; *Lion Hunt*, 88; pl. 32; *Ophelia*, 81; *Othello and Desdemona*, 58; *Sardanapalus*, 43
Delâtre, printer, 246
Delmonico, L. Crist, 85, 94
De Loosey, Emilie, *see* Havemeyer, Emilie de Loosey
Del Sartre family, 19–22
Denis, Maurice, 87, 251; *Homage to Cézanne*, 141
Dewing, Thomas, 78, 169
Diaz, Narcisse, 33, 61, 86
Dick, Doris, *see* Havemeyer, Doris D.
Dollfus collection, 204–5
Donatello, 139, 142
Doria, Count, 81, 141
Dowdeswell gallery, 38
Duchamp, Marcel, *Nude Descending a Staircase*, 210
Dupré, Jules, 42, 61, 65, 91, 92
Durand-Ruel, Charles (Paul's son), 40, 42, 43, 65, 92
Durand-Ruel, Charles (Paul's grandson), 7, 135
Durand-Ruel, George, 43, 81, 135, 197, 215, 219, 238
Durand-Ruel, Joseph, 81, 128, 155, 191, 205, 238; Degas pictures and, 133–35, 218; letters to Havemeyers, 64, 80, 125–26, 165, 178; in New York gallery, 42, 43, 184, 208, 209; relationships, 135, 212, 215, 217, 225, 246–47; Spanish pictures and, 153, 171
Durand-Ruel, Mme Joseph, *192*
Durand-Ruel, Marie-Louise, *192*
Durand-Ruel, Paul, 36 43, *37*, 85, 91–95, 100, 243; on Americans, 41–42; art-dealing principles, 37–38; Barbizon artists and, 41, 42, 62, 84, 91,

110; Cassatt and, 37, 40, 143, 160, 188–89, 207, 212; at Chocquet sale, 141–42; *Collector* on, 43, 92, 109, 110; customs problems, 40–42, 46; death, 247; exhibitions, 35, 37, 38, 40–44, 82–84, 92, 99–103, 110, 129–30, 184, 212, 219; Faure collection and, 126, 159–61, 178; Hallowell and, 87, 124–25; Havemeyers' relationship with, 57, 62, 65, 92, 95, 104–5, 107, 117, 131, 135–37, 143, 165, 191, 212, 215, 217, 218; Impressionists and, 37–44, 62, 84, 92, 94, 109–10, 118, 210; New York gallery, 43, 92, 94–95; Payne and, 123, 125, 126; pictures lent by, 35, 68, 210, 212, 222, 224, 240; Spanish artists and, 144, 152–57, 189, 190, 207

Duret, Théodore, 65, 191, 238–39; Courbet pictures and, 164, 165, 178, 180, 204, 205, 230, 239, 241, 247; personal relationships, 242, 243

Dutch old master paintings, 47, 52, 57, 110, 111, 176; H. O. Havemeyer's love of, 62, 64, 68, 99; *see also* Rembrandt

Duveen family, 157

East 66th St. house, 47, 49, 61, 63–65, 70–81, 166, 197; bedrooms, 76, 176; Berenson on, 145; ceiling fixtures, 78; pl. 28; described (1907), 176–77; (1920s), 250; dining room, 59, 75, 77; entrance doors, 70, 73; pls. 22, 23; entrance hall, 70–71, 73, 176; pls. 24, 25; exterior, 50, 51; fireplace equipment, 59, 77; pl. 30; floor plans, 72; garage, 202; music room, 75, 78; pl. 29; picture galleries, 71, 72, 147, 151, 176, 190, 242; Raffaëlli on, 100; reception room, 76, 176; "Rembrandt room," 63, 65, 71, 74, 77–79, 176; silverware, 77; pl. 27; staircases, stairwells, 70–71, 73, 74, 177; pl. 26

Eiffel Tower, Paris, 56

Elder, Adaline, 19, 20, 24; *see also* Peters, Adaline E.

Elder, Annie, 19, 20, 24; *see also* Munn, Annie E.

Elder, George Waldron, 19, 23, 231

Elder, George William, 19, 23, 29

Elder, Mrs. George William, 25, 179, 180, 181, 182

Elder, Lawrence, 19, 29, 30

Elder, Louisine, 19–26, 28, 40, 41; photos of, 24, 25, 31; portrait of, 25; wedding, 19, 29, 33; *see also* Havemeyer, Louisine Waldron

Elder, Mary Louise, *see* Havemeyer, Louise E.

Elder, Mathilda, 19, 25, 26, 29

Fabre, Jean Henri, 226

Falguière, Jean-Alexandre-Joseph, *Death of the Bull,* 43

Fantin-Latour, Ignace Henri, 41

Faure, Jean-Baptiste, 126, 159–61, 178

Fauves, 210

Fenollosa, Ernest, 168, 170, 171

"Fenway Court," Boston, 146

Fitzgerald, Desmond, 41, 83, 84

Flemish art, 62, 110, 140; *Lady with Lap Dog,* 176

Forain, Jean Louis, 40

"Foreign Exhibition," Boston (1883), 34–35, 38

Fortnightly Club, New York, 175

Fortuny, Mariano, 90

Freer, Charles, 55, 158–59, 167–71, 173, 212, 231, 232; house of, Detroit, 168, 169

Frelinghuysen, Adaline H., 180, 181, 183, 200, 234, 252; before marriage, *see* Havemeyer, Adaline

Frelinghuysen, Frederica, 193

Frelinghuysen, George Griswold, 248, 251

Frelinghuysen, Peter Hood Ballantine, 173, 174, 181, 236

Frick, Henry C., 78, 197, 222, 224, 226

Friedländer, Max, 217

Fromentin, Eugène, 90

Fuller, George, 88

Fuller, William, 41, 82, 83

Gaillard, René, 43

Gainsborough, Thomas, 64; *Lady Mulgrave,* 104

Galsworthy, John, 251

Gardner, Isabella Stewart (Mrs. Jack), 139, 145, 156, 158, 173, 197, 198

Garfield, James, 48

Garland, Hamlin, 90

Gauguin, Paul, 56, 87, 239

Gautier, Théophile, 210

Géricault, Jean Louis, 61

Gérôme, Jean Léon, 90

Giannoni, Marthe, 248, 250, 251

Gifford, R. Swain, 39

Gilder, Richard Watson, 78

Gimpel, René, 247

Gimpel and Wildenstein, art dealers, 219

Girard, Firmin, *Ladies Caught in the Rain,* 33

Glackens, William, 119

Gleyre, Charles, 33

Gothic sculpture, 193, 219, 253

Gould, Jay, 39; Gould family, 70

Goupil Gallery, Paris, 84

Goupy, Gustave, 129, 158

Goya, Francisco de, 141, 144, 152–53, 165, 193, 206; in E. 66th St. house, 147, 151, 176, 177; Electra Havemeyer and, 184, 188–89; mentioned, 20, 140, 247; works: *City on a Rock,* 207; pl. 144; *Doña Teresa Sureda,* 117; pl. 74; *Don Bartolomé Sureda,* 117; pl. 73; *Majas on a Balcony,* 154–56; pl. 122; *Marquesa of Pontejos,* 152–55; *Portrait of a Little Girl,* 189, 191; pl. 139; receipt for, 195; *Portrait of the Princess of La Paz,* 190, 191, 207; pl. 140

Goyen, Jan van, 64

Great Western Sugar Company, 161

Greco, El, 117, 140–41, 144, 147, 151, 152, 192, 193; *Adoration of the Shepherds,* 156, 157; *Assumption of the Virgin,* 156–57, 171; pl. 125; *Burial of Count Orgaz,* 141; *Cardinal Don Fernando Niño de Guevara,* 153–55, 207; pl. 121; *Christ Bearing the Cross,* 140; *Saint Ildefonso,* 189; *Saint Martin and the Beggar,* 184, 189, 207; *View of Toledo,* 190, 191, 206, 245; pl. 141

Greek art works, 64

Greuze, Jean-Baptiste, 64
Grolier Club, New York, 55, 83, 240–43, 245
Guardi, Francesco, 64
Guillaumin, Jean Baptiste, 40
Guys, Constantin, 241

Haight, Charles, 49–51
Hallowell, Sara, 87–91, 116, 124–25
Hals, Frans, 20, 61, 64, 66; portraits of Petrus Scriverius and his wife, 58, *74, 77,* 158
Hardwick, Thomas, 201, 203
Harmisch, A. E., 139, 140, 144
Harriman, Edward H., 177
Harrison, Alexander, 39
Havemeyer, Adaline, 34, 55, 144, 164; engagement and marriage, 173, 174, 177, *179;* photos of, *45, 106, 114, 150, 172, 179;* portraits of, 105, 113, 130; pls. 57, 68; *see also* Frelinghuysen, Adaline H.
Havemeyer, Adaline (Horace's daughter), *202*
Havemeyer, Doris (Horace's daughter), *202*
Havemeyer, Doris D. (Horace's wife), 200, *202,* 234
Havemeyer, Electra, 47, 56, 164, 173, 174, 176, 181–84, 186–91; collector, 184, 188–89, *195;* engagement and marriage, 193–95, 198; photos of, *106, 150, 172, 185, 195, 196;* portrait of, 105; pl. 56; *see also* Webb, Electra H.
Havemeyer, Emilie de Loosey, 35, 120–21, 217, 218
Havemeyer, Frederick C., Jr., 30, *31,* 32
Havemeyer, Henry O. (Harry): business activities, 46–47, 56, 161, 164, 201, 203, *see also subheads* real estate ventures; Sugar Trust; Cassatt and, meeting, 56, 58, 60; characteristics of, 30, 32, 66, 69, 79, 104, 119–21, 123–24, 152, 157–58, 170, 183; childhood, 29, 30, 32, 173; civic activities, 39, 55, 68; collector, 63, 107, 193, 252; death, burial, 180–81, 183, 187, 251; Durand-Ruel and, *see under* Durand-Ruel, Paul; estate of, 201, 212; family

relationships, 173, 218; friendships: with Colman, 32; with Freer, 169–71; with Payne, 123–27, 161; El Greco admirer, 141; ill with appendicitis, 121–22; Kelekian on, 203; legal battles, 68–69, 96–97, 119–20, 177–78, 180; marriage to Louisine Elder, 19, 28, 29, 33; marriage to Mary Louise Elder, 29, 30; memorial to, 184, 244, 250–53; Metropolitan Museum and, 47, 55, 66, 69, 118, 156, 157, 244; Oriental art enthusiast, 32–34, 64, 88, 171; photos of, *31, 45, 59, 67, 106, 132, 149, 162, 163, 179;* picture-lending policy, 65–66; real estate ventures, 95, 121, 144–45; Rembrandt enthusiast, 47, 53–54, 62, 64, 65, 80; taste in architecture, 47, 49, 51; as violinist, 32, 77–79; *see also* Havemeyer collection; Havemeyer family
Havemeyer, Horace, 44, 55, 165, 173, 180, 181, 183, 189, 234; business activities, 187, 188, 200–201, 203, 208, 212; characteristics of, 200, 203; engagement, 200; H. O. Havemeyer Collection and, 244, 248, 252; photos of, *45, 67, 106, 150, 162, 172, 202*
Havemeyer, Horace, Jr., *202*
Havemeyer, Louise E., 29–30
Havemeyer, Louisine Waldron: at age 59, 217; arrest and imprisonment, 234–36, 238; birth of her children, 34, 44, 47, 55–56; blackmail letter to, 199–200; at Cassatt's tomb, 251; characteristics of, 33, 79, 107, 112, 164, 173, 184, 191, 198, 204, 218, 219, 221, 232, 245–46, 248, 250; death, 251; on Degas, 21, 116; Freer on, 169–70; gardening, 52, 144, 247; as grandmother, 193, 198, *202, 211,* 212, *237,* 247–48, 250; honors, 243, 245; husband's illness and death, 180–83; influence on husband, 108, 112, 137; interior decorating, 47–49, 51–52, 70, 213; jewelry, 102, 173, 198; languages, 248; last

visit with Cassatt, 241; last years, 248–51; leisure, 52, 77–78, 144, 217–18, 247–48, 250; life style, 78, 173, 194, 219; *Memoirs of a Collector* by, 231–32; as mother, 173–74, 200; "Notes to My Children" by, 248, 252–53; on owning masterpieces, 170–71; photos of, *45, 59, 114, 132, 149, 162, 163, 173, 185, 211, 228, 229, 237, 249;* picture hanging by, 77–78, 128, 147, 197; picture-lending policy, 212; portraits of, *25, 28, 105, 113, 216–17;* pls. 56, 67; sleigh accident, 97–98; speaking career, 221–23, 225, 227, 232, 236, 240, 246; Sugar Trust and, 187, 188, 195, 197, 203; war services, 232, 243; widowhood, 182–88, 204; Will of, 231, 244, 248, 252; as woman's rights advocate, 204–7, 212, 220–23, 227–29, 232–36, 238, 242, 246, *see also* Elder, Louisine; Havemeyer collection; Havemeyer family
Havemeyer, Mary, 29
Havemeyer, Theodore, 30, 35, 46, 119–21, 217, 218
Havemeyer, William, 32, 34
Havemeyer, William Frederick, 32, 68
Havemeyer collection, 111–12, 137, 146, 151, 251; Barnes on, 226; bequest to Metropolitan, 244, 250–53; Cassatt as mentor of, 21, 107, 112, 127, 244, 251; collector's label, *237,* 248; costliest painting, 209; first picture purchased, 21, 22, 33, 243; Jaccaci and LaFarge on, 158; Justi on, 197–98; photographing of, 245; picture selection techniques, 33, 113, 115, 117, 118, 135–36, 142; writing about, Louisine's objections, 251
Havemeyer family: houses, *see* Bayberry Point; East 66th St. house; "Hilltop"; social life, 78–79, 145, 173–77
Havemeyers and Elder, sugar refiners, 19, 30, *31,* 46, 66, 180, 187; label of, *67*

Hébrard, Adrien A., 241, 242
Henderson, Mary Osborne, 30
Henner, Jean-Jacques, 33, 42;
 Eclogue, 43; *Portrait of
 Louisine Elder, 25,* 28
Hill, James H., 177
"Hilltop," Connecticut house,
 50, 51, 122, *132,* 144, 232, 247
Hitchcock, George, 88
Hofer, Karl, 251
Holbein, Hans, 26, 223; *Portrait
 of Jean de Carondelet,* 176
Hooch, Pieter de, 57, 61, 62, 68,
 110, 223; *Dutch Interior,* 66;
 Family Concert, 64; *Visit, 58,*
 77, *224*
Hudson–Fulton exhibition,
 Metropolitan Museum, 193,
 197
Humboldt, Alexander von, 55
Huntington, Collis P., 45, 68

Impressionism, Impressionists,
 104, 204, 239, 251; Cassatt
 and, 21, 26–28, 82, 251;
 Durand-Ruel and, 37–44, 62,
 84, 92, 94, 109–10, 118, 210;
 exhibitions, 22, 34–35, 40–44,
 82, 84, 85, 89–90, 131, 135,
 242, 245; gains in America,
 40–41, 81–95, 98, 99, 109,
 111; mentioned, 126, 133,
 192, 209, 217; reviews of, 26,
 85, 90, 91, 95, 110–11
Inglis, James, 90, 94
Ingres, Jean-Auguste, 238, 244;
 Joseph-Antoine Moltedo,
 238–39; pl. 160; *Madame
 Panckoucke,* 155; pl. 123;
 Oedipus and the Sphinx, 58;
 Turkish Bath, 175; pl. 133
Inness, George, 86, 88
Interstate Industrial Exposition,
 87
Ives, Halsey C., 87
Ivins, William M., Jr., 240, 242,
 245, 246

Jaccaci, August F., 158
Jackson, Mrs. Frederick W., 194
Jackson, Lulu, 194
Jacque, Charles, 88
James, Henry, 62
James, William, 183
Japanese art, 48, 70, 71, 103,
 252; lacquerware, 33, 78;
 paintings, 167–70; tea jars,

34, 64; textiles, 32–33, 51–52,
 77, 118
Jerome, Leonard, 49
Jesup, Morris K., 68
Johnson, Eastman, 68, 88
Johnson, John G., 85, 119–20,
 158, 178, 197, 226
Johnston, Henry M., 85
Johnston, John Taylor, 39
Jongkind, Johann, 89; *Moonlight
 in Holland,* 85
Justi, Ludwig, 197–98

Kalf, Willem, 64
Kelekian, Dikran, 165, 203
Kingman, Alden, 41, 82, 83, 135
Kirby, Thomas, 39, 45, 94
Kneisel Quartet, 78, 176
Knoedler gallery, 33, 45, 94,
 206–7; suffrage benefit show
 at, 222, 223, *224, 225,* 227,
 251
Kunst und Künstler, 62–63

LaFarge, John, 158
Lamb, Rose, 105, 127
Lambert, Catholina, 83, 135
La Tour, Maurice Quentin de,
 115
Laurens, Jean-Paul, 35
Lawrence, Cyrus, 41, 61, 83
Lazarus, Emma, 35
Lefebvre, Jules, *Diana Surprised,*
 43
Legion of Honor, French, 243
Leonardo da Vinci, 115
Lexow, New York State
 senator, 118, 119
Li Lung-mien, 170
London *Daily Chronicle,* 26
London Fine Art Society, 55
Long Island, *see* Bayberry
 Point; "Merrivale";
 "Woodbury House"
Lotos Club, New York, 83
Louvre, Paris, 58, 160, 175, 178,
 205
Luxembourg Museum, Paris, 99,
 142, 243

MacMonnies, Frederick, 78
Macy, R. H., 39
Madrazo, Ricardo de, 153,
 188–90, 207
Mame, Alfred, 155
Manet, Edouard, 35–38, 54, 93,
 109, 110, 112, 133, 137, 143,

192, 208, 243, 244; estate of,
 posthumous sale, 36, 38;
 exhibitions, 35, 38, 40, 44,
 90, 101; in Faure collection,
 159–60, 178; influence of,
 102, 127, 142, 147; reviews
 of, 35, 38, 101, 212; works:
 Boating, 107, 117, 177; pl. 60;
 Bon Bock, 160, 161, 218; pl.
 126; *Boy with a Sword,* 35,
 44; pl. 6; *Bull Fight,* 83; *Dead
 Christ with Angels,* 102, 147;
 pl. 118; *Death of Maximilian,*
 43; *Emilie Ambre in the Role
 of Carmen,* 36; *Grand Canal,
 Venice (Blue Venice),* 102,
 232; pl. 51; *Guitar Player,* 94;
 pl. 40; *In the Garden,* 129,
 158; pl. 84; *Italian Woman,*
 36; *"Kearsarge" at Boulogne,*
 129, 158; *Luncheon in the
 Studio,* 102; pl. 52; *Mlle V
 . . . in the Costume of an
 Espada,* 129, 212; pl. 82;
 *Manet's Family at Home in
 Arcachon,* 112; pl. 63; *Masked
 Ball at the Opera,* 98, 101–2,
 176; pl. 44; *Matador Saluting,*
 102, 128, 129; pl. 81;
 Olympia, 56; *Port de
 Bordeaux,* 160, 161; *Port of
 Calais,* 128; pl. 80; Portraits:
 of Clemenceau, 243; *of George
 Moore,* 115–16; pl. 70; *of Mlle
 Lemaire,* 165; pl. 128; *of
 Marguerite de Conflans,* 36;
 Printemps, 160, 161; *Railroad
 (Gare Saint-Lazare),* 102, 129,
 212; pl. 85; *Roses in a Crystal
 Vase,* 112; pl. 64; *Salmon,* 41,
 44, 101; pl. 10; *Toreador,* 35;
 Virgin with the Rabbit, 160,
 161; *Woman with a Parrot,*
 35; pl. 7; *Young Man in the
 Costume of a Majo,* 129;
 pl. 83
Manhattan Club, New York, 49
Mansfield, Howard, 55
Manzi, Michel, 230, 231
Marcke, Emile Van, 88
Marks, Montague, 86, 89, 91,
 104
Marquand, Henry, 39, 63, 66,
 68, 85, 118
Marx, Roger, 56, 156, 215, 217,
 218
Matisse, Henri, 192, 210, 226

May, Ernest, 134

McBride, Henry, 242

McKim, Mead, and White, architects, 48; *see also* White, Stanford

McKinley, William, 177

Meier-Graefe, Julius, 251

Meissonier, Jean Louis, 90; *Cavalry Regiment under Napoleon I,* 58; *Priest Offering Wine,* 58

Mellerio, André, 141

Memoirs of a Collector, see *Sixteen to Sixty*

"Merrivale," Commack, Long Island, *179,* 180

Metropolitan Museum of Art, New York, 39, 110, 156–57, 184, 220, 240, 243; board of trustees, 66, 69, 118, 156, 157, 244; Havemeyer gifts, 47, 55, 66, 118, 244, 248, 251–53; Havemeyer loans, 47, 54, 66, 147, 245; Hudson–Fulton exhibition, 193, 197; Sunday openings, 66

Millet, Jean-François, 38, 61, 86, 107, 110, 147; *Angélus,* 57–58, 61; pl. 15; *In Auvergne,* 88; *Mother and Child (Les Errants),* 33; pl. 5; *Peasant Children at Goose Pond,* 91; pl. 36; *Peasant Girl Burning Weeds,* 105; *Peasant Watering His Cows,* 58; pl. 16; *Spring,* 143; *Temptation of Saint Hilarion,* 61

Mills, Darius O., 68

Mino da Fiesole, 104, 105, 139

Monet, Claude, 21–23, 27, 34–38, 82–87, 89–95, 116, 127, 151, 244; Durand-Ruel and, 40, 42, 46; exhibitions, 35, 37, 38, 40, 41, 43, 60, 82–85, 87, 89, 90, 92, 94, 101; as favorite, 137, 143, 146, 176; mentioned, 46, 103, 109, 110, 141–43, 151, 204; reviews of, 83–86, 95, 99–100; works: *Barges at Asnières,* 143; pl. 115; *Bark of Dante,* 105; *Bridge over a Pool of Water Lilies,* 143; pl. 113; *Chrysanthemums,* 135; *Church at Vernon,* 93; *Creuse River Valley series,* 93; *Drawbridge, Amsterdam,* 21–22, 41; pl. 2;

Floating Ice, 104; pl. 55; *Green Wave,* 135; pl. 97; *Grenouillère,* 117; pl. 76; *Gust of Wind,* 93; pl. 38; *Haystacks at Giverny,* 143; pl. 114; *Haystacks in the Morning,* 93; *Haystacks in the Snow,* 98; pl. 42; *High Tide at Pourville,* 98; pl. 41; *Ice Floes, Bennecourt,* 117; pl. 75; *Landscape—Haystacks in the Snow,* 100; pl. 50; *London, Houses of Parliament: Seagulls,* 184; pl. 138; *Mail Post at Etretat,* 83; *Morning on the Seine at Giverny,* 98; *Old Church at Vernon,* 143; *Poplars,* 100; *River Zaan at Zaandam,* 143; pl. 112; *Road by the Hillside,* 85; *Snow at Argenteuil,* 130, *237;* pl. 86; *Sunflowers,* 135; *Thames at Charing Cross Bridge,* 147; pl. 120; *Tuileries,* 56; *Vue de Rouen,* 104

Montaignac, I., 57, 104, 117

Moore, Edward, silverware designed by, pl. 27

Moore, William P., 46

Moorish art, 70, 140, 144, 145, 213, 250

Morgan, J. Pierpont, *67,* 120, 165, 177, 180; collection, 63, 197; Metropolitan Museum and, 66, 157, 244

Morgan, Mary Jane (Mrs. Charles), 44–46

Morisot, Berthe, 38, 40, 93, 230

Morny, Duke de, 53, 54

Morozov, Ivan, 191

Morse, Charles, 169

Mosler, Henry, 39

Mott, Lucretia, 205

Munn, Annie E., 138, 167, 183, 222, 231; before marriage, *see* Elder, Annie

musicales, 78–79, 176

Myers, Gustavus, *History of the Great American Fortunes,* 63

National Academy of Design, New York, 23, 26, 32, 35, 41–44, 68

National Association of Women Painters and Sculptors, 240

National Free Art League, 98–99

National Sugar Refining Company, 201

National Woman's Party, 229, 232, 234, *237,* 246

Neer, Aert van der, 64

Newport, Rhode Island, 48, 51, 52, 122, 144–45

New York Herald, 109–10, 119, 242

New York Public Library, 240

New York Sun, 45, 143, 191, 197

New York Times, 45, 53, 56, 68, 124; on the Havemeyers, 79, 97, 122, 161, 178, 197–98, 200–201, 203; reviews in, 84, 85, 95, 99–100, 103, 130, 212

New York Tribune, 23, 69, 97–98, 119, 242

Nineteenth Amendment, 236

Northern Securities Company, 177

North River Refining Company, 68, 69

Oriental art, 32–35, 167–71, 176, 245, 250; *see also* Chinese art; Japanese art

Ortgies and Co. gallery, 54, 85

Ostade, Adriaen van, 62, 64

Palmer, Bertha Honoré, 87–90

Palmer, Potter, 36–90, 98, 100, 107

Pankhurst, Emmeline, 212

Paris, expositions: International (1878), 48; Universal (1900), 138; World's Fair (1889), 56–57, 81, 138

Paris *Herald,* 111

Parmigianino, 20

Parsons, John A., 119, 120

Pasini, Alberto, 35

Paul, Alice, 234, 235

Payne, Henry, 123

Payne, Oliver H., 123–27, 130, 131, 161, 197, 219, 222; house of, 234

Peabody and Stearns, architects, 52

Pennsylvania Railroad, 26, 36, 120

Pennsylvania Sugar Refining Company, 177, 178, 186–87, 188

Perry, Lilla Cabot, 82

Persian art, 165, 193, 203

Peters, Adaline E., 29, 80, 104, 203, 209, 219, 245; before marriage, *see* Elder, Adaline

Peters, Louisine, 173; pl. 132

Peters, Samuel, 29, 80, 104, 245

Petit, Georges, gallery, 60, 83, 190

Philadelphia Museum of Art, 251

Philadelphia *Public Ledger,* 127

Picasso, Pablo, 192, 226, 239

Pissarro, Camille, 22, 23, 27, 34, 86, 90–95, 109, 110, 142; Cassatt and, 61, 103, 117, 118; Durand-Ruel and, 38, 40, 42, 117–18; exhibitions, 35, 37, 38, 40, 43, 83, 87, 90, 94; reviews of, 84, 95; works: *Path above Pontoise,* 93; *Peasant Girls at Normandy,* 22, 41; *Road,* 56; *Spring-time,* 85

Pissarro, Lucien, 42, 91, 94

Pompeii, fresco, 143

Pope, Alfred, 83, 93–94, 98, 100, 107, 158, 219; Cassatt and, 130, 146–47, 186, 222

Pope, Theodate, 130, 146–47

Portier, Arsène, 37, 93, 113, 115, 116

Post-Impressionists, 210, 239, 245

Poussin, Nicolas, 175, 244, 245; *Orpheus and Eurydice,* 178; pl. 135

"Prison Special," 235–36, *237*

"Prize Fund Exhibitions," New York (1885–88), 39, 42

Proust, Antonin, 56

Puvis de Chavannes, Pierre, 43, 61, 84, 92, 109, 110, 147; *Allegory of the Sorbonne (The Sacred Grove),* 60, 66, 177

Quinn, John, 212

Raffaëlli, Jean-François, 84, 87, 100–101

Raphael, 139

Redon, Odilon, 239

Rembrandt, 61–66, 79, 80, 223, 247, 252; Courbet as link with, 112, 219; "Rembrandt room," E. 66th St. house, 63, 65, 71–72, *74,* 77–79, 176; works: *David Playing before Saul,* 64; Portraits: *of Herman Doomer,* or *Gilder,* 53–54, 68,

209, *224;* pl. 12; *of a Man (Christian Paul van Beresteijn, Burgomaster of Delft,* 47, 53, 54, *74;* pl. 11; *of a Man: The Treasurer,* 64, 66; *of an Old Woman,* 64, 66, *74, 224;* pl. 20; *of a Young Man in a Broad-brimmed Hat,* 65

Renoir, Pierre-Auguste, 46, 85–87, 91, 109, 110, 133, 142, 178, 226; Durand-Ruel and, 42, 46; exhibitions, 35, 38, 40, 43, 90, 94; Louisine Havemeyer on, 61, 117, 135; reviews of, 84, 95; works: *By the Seashore,* 135, 151, 226–27; pl. 98; *Madame Renoir in the Garden,* 87; *Young Woman Reading,* 60–61, 184; pl. 19

Richardsonian-Romanesque architecture, 49, 51

Riddle, Mrs. Robert M., 36, 220; *see also* Cassatt, Mary: *Lady at the Tea Table*

Ritsuo, lacquer worker, 71

Robertson, R. Austin, 39, 88

Robinson, Edward, 193, 252

Robinson, Theodore, 82, 84–86, 88–89, 100, 102, 103

Rockefeller, William, 45, 67

Rockefeller family, 46

Rodin, Auguste, 60, 83

Romantic artists, 86, 91, 95, 99, 100

Roosevelt, Theodore, 97, 167, 177–78, 201, 236

Rosenberg, Paul, 219, 239

Rouart, Henri, 131, 184, 207–8, 217

Rousseau, Théodore, 33, 38, 42, 61, 86, 110

Rubens, Peter Paul, 20, 151, 191, 219, 223; *Saint Cecilia,* 158

Ruisdael, Jacob van, 62, 64

Ruskin, John, 23

Saarinen, Aline, 71

Sagan, Princesse de, 65, 80

St. Botolph Club, Boston, 83–84

Salon art and artists, 28, 33–35, 86, 89, 123, 218

Salons: d'Automne (1904), 156; 1844, 60; (1863) 110; (1874) 22

Sartain, Emily, 20, 21

Sarto, Andrea del, 139

Schaus, William, 53, 54; gallery, 45, 68

Schmitz, Oscar, 217

School of 1830, 37

Schrader, Julius, 55

Scott, Annie Riddle, 36

Scribner's Monthly, 26

Searles, John E., 96, 97

Sears, Mrs. Montgomery, 227

Secrétan sale (1889), 57–58, 80, 117, 158, 178

Sedelmeyer, Georges, 111

Seney, George I., 39

Sert, José María, 208

Sérusier, Paul, 87

Seurat, Georges, 38

Sheeler, Charles, 245

Shelburne, Vermont, 194, 213, 214, 250

Sherman Antitrust Act, 69, 177, 186

"Ship of State," *228,* 229

Simpson, John W., 158

Sisley, Alfred, 87, 95, 117; exhibitions, 35, 38, 40, 43, 83, 84, 90, 94; works: *Banks of the Seine,* 98; pl. 43; *Dam of the Loing at Saint-Mammès,* 93; pl. 39

Sixteen to Sixty, Memoirs of a Collector (L. W. Havemeyer), 12, 232

Sixteenth Amendment, 209

Smith, Donald, 45

Smith, F. Hopkinson, 88

Smithsonian Institution, Washington, D.C., 167

Snedecor's Gallery, 32

Snyder, Carl, 158

"Sovereigns by the Grace of Dollars" (cartoon), 67

Spencer, Albert, 41, 82, 83, 86, 90, 107, 109

Sprague, Mrs. Albert Arnold, 157

Standard Oil Company, 46, 118, 120, 177, 201

Stanton, Elizabeth Cady, 205

Statue of Liberty, 35, 83

Stein, Gertrude, 192

Stuart, Gilbert, 47; *Portrait of George Washington,* 47

Studio, 53

Sugar Trust, 46–47, 56, 63, 173; Arbuckle coffee competition, 138, *149;* government attacks on, 68–69, 96, 97, 118–21,

177–78, 180, 186–88; press attacks on, 195, 197; *see also* American Sugar Refining Company

Sutton, James F., 38–42, 57–58, 61, 83, 89, 94, 104

Symbolists, 85, 239

Taft administration, 201

Teniers, David, the Younger, 62, 64

Terburg, Gerald, 62; *Glass of Lemonade,* 64

Thayer, Abbott, 169

Théâtre de la Gaîté, Paris, 22, 80

Thomas, W. B., and family, 161

Thomson, Frank G., 36–37, 90

Tiffany, Charles L., 68

Tiffany, Louis C., 32, 47–49, 55, 63, 118, 144, 243; E. 66th St. house interiors by, 49, 51, 63, 70, 71, 73–76, 77–79, 100, 145; pls. 22–26, 28–30; house of, 49, 50; Tiffany and Co., 39, 48, 49, 118, 213; "Woodbury" interior by, 213

Titian, 139, 160, 247

Todd, Helen, 221

Tofano, Edward, *Reverie,* 23, 26

Tolles, Sophie Mapes, 20

"Torch of Liberty," 227, 228, 229, 229

Toulouse-Lautrec, Henri de, 239

Trotti, art dealer, 191, 219

Troy, Jean-François de, 123

Troyon, Constant, 61, 65, 91; *Landscape at Sunset,* 65; *Vallée de la Tocques,* 110

Trumble, Alfred, 84, 86, 103, 109, 110–11

trusts, 46, 47, 69, 201, 203; cartoons on, 67, 149

Tryon, Dwight, 169

Twachtman, John Henry, 86, 89

Union League Club, New York, 64, 82–83, 93, 136

Valet, Mathilde, 216, 219, 221, 241, 246, 248, 249, 251

Vanderbilt, "Commodore" Cornelius (d. 1877), 194

Vanderbilt, Cornelius, II (d. 1899), 39, 68, 104

Vanderbilt, Frederick, 52

Vanderbilt, George, 68, 85

Vanderbilt, William Henry (d. 1885), 39, 111, 213

Vanderbilt, Mrs. William Henry, 89

Vanderbilt, William K., 67

Vanderbilt family, 70, 194, 214

Vanderbilt Gallery, American Fine Arts Society, 68, 85

Van Dyck, Anthony, 64, 110, 223, 247

Van Gogh, Vincent, 238, 239

Velazquez, Diego, 20, 101, 129, 138

Vermeer, Jan, 126, 222, 223, 230

Veronese, Paolo, 112, 139, 151; *Boy with a Greyhound,* 140; pl. 102

Vever, Henri, 126

Viau, George, 116, 178

Vibert, Pierre, *Missionary's Story,* 45

Villiers, Edward, 38

Vollard, Ambroise, 94, 105, 141–43, 147, 156, 167, 184, 207, 212

Vollon, Antoine, 86

Vuillard, Edouard, 239

Walters, William, 39, 61

Warren, Edward R., 159

Watteau, Jean-Antoine, 64

Webb, Electra (daughter of Electra H. Webb), 211, 212

Webb, Electra H., 200, 230, 234, 248, 250, 252; before marriage, *see* Havemeyer, Electra; taste in art, 212, 213–14

Webb, J. Watson, 188–90, 193–94, 198, 200, 230, 234; photos of, 195, 196

Webb, J. Watson, Jr., 250

Webb, Lila V., 193, 194, 213

Webb, W. Seward, 193, 194

Webb family houses, 211, 212–13; summer camp, 237

Weir, J. Alden, 35, 42, 86, 89, 100; *Idle Hours,* 39

Wheeler, Candace, 48

Whistler, James Abbott McNeill, 48, 61, 88, 103, 110, 128, 145, 146; *Art & Art Critics* (pamphlet), 23, 25; Freer and, 158–59, 167–71; interiors by, 48, 55; Louisine Elder's visit with, 22–23; works: *First Venice Set,* 55; *Greek Slave Girl,* 55, 159; pl. 13; *Palace,* 159; *Portrait of Miss Alexander,* 22–23; *Steps,* 23, 54; pl. 4

White, Stanford, 49, 78, 146

Whitney, Flora Payne, 123

Whitney, William, 123

Whittemore, Harris, 92–93, 107, 128, 130, 222, 224, 240

Whittemore, John, 92, 130, 158

Whittemore, Mrs. John, 130

Wicht, Joseph, 140–41, 144

Widener, Joseph, 222, 224

Widener, Peter A. B., 189, 197, 222, 226

Wilde, Oscar, 23

Wilson, Woodrow, 209, 234, 235

Wolfe, Catherine, 52

Wolff, Albert, 57

woman's suffrage movement, 195, 204–7, 212, 227, 232–38, 242; exhibitions benefiting, 206, 207, 214, 220–25, 224, 225; parade, 206

Women's Political Union, 205–6, 212, 219–22, 227; *see also* "Ship of State," "Torch of Liberty"

"Woodbury House," Long Island, 211, 212–14

World War I, 214, 220, 221, 230–32, 238, 240, 243

Wunderlich, H., gallery, 54–55

Yarrington, B. M., 29

Yerkes, Charles Tyson, 117

Zandomeneghi, Federigo, 87

Ziem, Félix, *Canal in Holland,* 58

Zola, Emile, 111, 147

PHOTOGRAPHIC CREDITS

The author and publisher wish to thank the museums and private collections for permitting the reproduction in color and black-and-white of works of art in their possession. Photographs have been supplied by them except for the following, whose courtesy is gratefully acknowledged: Christie's, New York: Plates 38, 39, 88, 96, 132, 136; Documentation photographique de la Réunion des musées nationaux, Paris: Plates 14, 15, 87, 92, 123, 133; Jeanne Hamilton, New York: Page 202, upper left; Sotheby's, London: Plate 53; Sotheby Parke Bernet, New York: Plates 46, 47, 64, 75, 80, 106, 112, 114, 119, 131, 146, 148; Wildenstein & Co., New York: Plate 43

ABOUT THIS BOOK

Text set in Bembo, one of the earliest roman typefaces, cut by Francesco Griffo for Aldus Manutius in Venice in 1495. Recut for machine composition in 1927; the italic face was added at that time, a revision of the 1524 calligraphy of Giovantonio Tagliente.

Display type is in Centaur, the roman face designed by Bruce Rogers in 1912–15 after that of Nicolaus Jenson in Venice in the 1470s. In 1925 Frederic Warde added the italic face, on the 1524 model by the calligrapher Ludovico Arrighi. Roman and italic were cut for machine composition in 1929.

Typesetting by ComCom, Allentown, Pennsylvania, a division of The Haddon Craftsmen, Inc.; text composed in videotype, display on the typositor machine.

Text printed by Arcada Graphics Halliday, West Hanover, Massachusetts, on Paloma matte 60-pound paper.

Plates printed in one-color and four-color offset by Toppan Printing Company, Japan, on top-coated paper, 228 grams per square inch.

Binding by Arcada Graphics Halliday.